Never Sang for Hitler

The Life and Times of Lotte Lehmann, 1888–1976

Lotte Lehmann ranks among the most celebrated singers of the twentieth century. She was a favorite of Richard Strauss, and over her lifetime she became the friend of other famous men: Bruno Walter, Arturo Toscanini, and Thomas Mann. She had a famous encounter with Hermann Göring, in which he claimed that he wanted to make her the foremost singer in Nazi Germany. By the time of her final major performance in 1951, she was considered one of the finest singing actresses of all time. Rather than a traditional biography, this book aims to be both a descriptive narrative of Lehmann's life and a critical analysis of the interconnections of the artist and society. Michael H. Kater describes the varying phases of Lehmann's life, as well as the sociocultural settings in which she finds herself – whether in the Wilhemine Empire, the First Austrian Republic, Nazi Germany, or the United States. Kater's use of Lehmann's personal and other papers reshapes much of what is known about her life and career.

Michael H. Kater has studied history, sociology, and music at the Universities of Toronto, Munich, and Heidelberg. Since 1967, he has taught at York University, Toronto, from 1991 to the present as Distinguished Research Professor of History. Kater has served as Visiting Hannah Professor of the History of Medicine at both McMaster University in Hamilton and the University of Toronto. He is a Fellow of the Royal Society of Canada, a Guggenheim Fellow, and a Canada Council Senior Killam Fellow and the recipient of the Konrad Adenauer Research Prize of the Alexander von Humboldt Foundation. His main research interest is the society, politics, and culture of modern Germany, and he is the author of many books, several of them prize-winning.

Other Books by Michael H. Kater

Das "Ahnenerbe" der SS, 1935–1945: Ein Beitrag zur Kulturpolitik des Dritten Reiches (1974)

Studentenschaft und Rechtsradikalismus in Deutschland, 1918–1933: Eine sozialgeschichtliche Studie zur Bildungskrise in der Weimarer Republik (1975)

The Nazi Party: A Social Profile of Members and Leaders, 1919–1945 (1983)

Doctors Under Hitler (1989)

Different Drummers: Jazz in the Culture of Nazi Germany (1992)

The Twisted Muse: Musicians and Their Music in the Third Reich (1997)

Composers of the Nazi Era: Eight Portraits (2000)

Hitler Youth (2004)

Never Sang for Hitler

The Life and Times of Lotte Lehmann,
1888–1976

MICHAEL H. KATER
York University

CAMBRIDGE
UNIVERSITY PRESS

CAMBRIDGE UNIVERSITY PRESS
Cambridge, New York, Melbourne, Madrid, Cape Town, Singapore, São Paulo, Delhi

Cambridge University Press
32 Avenue of the Americas, New York, NY 10013-2473, USA

www.cambridge.org
Information on this title: www.cambridge.org/9780521873925

First published 2008

Printed in the United States of America

A catalog record for this publication is available from the British Library.

Library of Congress Cataloging in Publication Data
Kater, Michael H., 1937–
Never sang for Hitler : the life and times of Lotte Lehmann, 1888–1976 /
Michael H. Kater.
p. cm.
Includes bibliographical references (p.) and index.
ISBN 978-0-521-87392-5 (hardback)
1. Lehmann, Lotte. 2. Sopranos (Singers) – Biography. I. Title.
ML420.L33K37 2008
782.1092–dc22 2007025323
[B]

ISBN 978-0-521-87392-5 hardback

To Barbara, who inspired me to write this book and whose constant support sustained my efforts.

Contents

Illustrations

Acknowledgments

The number of people I have to thank for helping me write this book is very large, and I cannot possibly list them all by name. First in line are interlibrary-loan librarians at York University, who satisfied my constant craving for books and articles, which arrived from North America and Europe. Without them, this book simply could not have been written. Their names are Mary Lehane, Gladys Fung, and Sandra Snell. This biography, however, is based for the most part on primary documents, as they became available for first-time use in the late 1980s and during the 1990s. Those documents contrasted sharply with three preexisting biographies and Lehmann's own memoirs of 1937, which were of only limited value. In the former category, Beaumont Glass's *Lotte Lehmann: A Life in Opera and Song* (Santa Barbara, 1988) is the work of a former piano coach who had assisted Lehmann in her California teaching, and while on the basis of, at that time, limited evidence it gets many facts right, it is in essence a product of hagiography. The second volume of this genre is the English music critic Alan Jefferson's *Lotte Lehmann, 1888–1976* (London, 1988), which resembles a travelogue and discography more than the retelling of an artist's life. Most egregiously deficient is Berndt W. Wessling's *Lotte Lehmann: "Sie sang, dass es Sterne rührte": Eine Biographie* (Cologne 1995), because for the most part it is a construct of half-truths and outright lies, so that even what could be statements of truth must, by association, be doubted. Lehmann's autobiography, *Anfang und Aufstieg: Lebenserinnerungen* (Vienna, 1937), on the other hand, is reliable to a point, yet covers only the first half of her career. She retold many of its episodes in public interviews, letters, and personal memoranda, but the volume is of necessity porous and skewed in her favor.

Archivists, therefore, deserve my deepest gratitude, chief among them David C. Tambo and David Seubert of Special Collections, Davidson Library, University of California at Santa Barbara, not to forget their able associate, Ursula Clarke, who are the conscientious keepers of the bulk of Lotte Lehmann's papers. Their colleague, the University of California oral historian David Russell, apart from often-rendered advice, made a precious source available to me, in the form of transcripts of his own extended interview with Frances Holden, of Santa Barbara, shortly before her death in 1996. In New York I was aided by the curators of the Constance Hope Papers, at Rare Books and Manuscripts, Columbia University Butler Library, and by Robert Tuggle, the archivist of the Metropolitan Opera, who proved especially helpful on later,

unforeseen occasions. And in Vienna, Jarmila Weissenboeck of the Theater-museum opened her hitherto shielded Lehmann Collection to me, as Gabriele Strauss, Richard Strauss, and Christian Strauss did with their grandfather's correspondence, in the composer's villa in Garmisch.

I have received crucial assistance from two experts during the research and writing phases of this project. Gary Hickling, the founding president of the Lotte Lehmann Foundation, based in Kailua, Hawaii, not only helped me out with a variety of documents from his own collection and supplied me with countless sound samples and DVDs, but also gave advice even before he read parts of the manuscript very critically. No question was too trivial for him, who had known Lehmann in her old age, and he always replied instantly. I owe an equal debt to Jens Malte Fischer of Munich, who, after reading the manuscript in its entirety, made many important suggestions for improvement. Gerhard Botz read and improved sections in Vienna, as did István Deák in New York. Edward Baron Turk supplied me with copies of Jeanette MacDonald's correspondence, and Shirley Sproule gave me a film of Lehmann's *Winterreise* paintings, as well as valuable insights into her complex personality. Hertha Stodolowsky-Schuch received me in her Vienna apartment repeatedly, to share with me her memories as well as precious original documents.

Commentary and critique were invited from the members of a special seminar that Albrecht Riethmüller, accompanied by Gerhard A. Ritter, arranged at the Musikwissenschaftliches Seminar of the Freie Universität Berlin in November 2003, and I benefited greatly from that session. The same holds true three years later, when the book was almost completed and I was invited to air remaining doubts, concerns, and queries at a seminar organized at the Charles Warren Center of Harvard University, hosted by Carol Oja, Nancy Cott, and Anne Shreffler. I extend my thanks to everyone who participated so constructively in these events.

Research and writing were supported by various funds from York University, notably its Atkinson College, and by the Canadian Centre for German and European Studies, where I am based. More help came via a generous Standard Research Grant from the Social Sciences and Humanities Research Council of Canada in Ottawa, and the Alexander von Humboldt-Stiftung in Bonn, which kindly reinvited me to Europe as a former Konrad Adenauer Research Prize winner.

Special thanks must go to Jean and Kevin Cook, who aided me at the Music Academy of the West and, more important, offered personal friendship to my wife and me on many research visits to Santa Barbara over the years.

The close scrutiny of archivists, colleagues, and friends has undoubtedly eliminated potential mistakes from the final manuscript, a process in which my knowledgeable editor at Cambridge University Press, Eric Crahan, has aided. This does not mean that errors have not remained, and for those I alone must bear responsibility.

Abbreviations

AAKB	Archiv, Akademie der Künste Berlin
Agfa	Actien-Gesellschaft für Anilin-Fabrikation
AKB/CCA	Akademie der Künste Berlin, Charlotte-Berend-Corinth-Archiv
APA	author's private archive
ATW	Archiv, Theatermuseum Wien
ATW/TNLL	Archiv, Theatermuseum Wien/Teil-Nachlass Lotte Lehmann
BAB	Bundesarchiv Berlin
Barsewisch	author's interview with Bernhard von Barsewisch, Gross-Pankow, Sept. 26, 2004
BBC	British Broadcasting Corporation
BC	University of California at Santa Barbara, Davidson Library, Special Collections, Lotte Lehmann Papers, Business Correspondence
BS	Bayerische Staatsbibliothek München
Bumbry	author's interview with Grace Bumbry, Salzburg, Sept. 29, 2004
BW	Bruno Walter
CBE	Commander of the British Empire
CBS	Columbia Broadcasting System
CU	Columbia University, New York, Rare Books and Manuscripts, Butler Library, Constance Hope Papers
CW	University of California at Santa Barbara, Davidson Library, Special Collections, Lotte Lehmann Papers, Creative Writings
EMA	Erika-Mann-Archiv in der Handschriftenabteilung der Stadtbibliothek München
EP	Baronin Emmy zu Putlitz
Facs.	facsimile
FBI	Federal Bureau of Investigation
FH	Frances Holden
FL	Fritz Lehmann
GC	University of California at Santa Barbara, Davidson Library, Special Collections, Lotte Lehmann Papers, General Correspondence

Grove	*Grove Music Online*, ed. L. Macy (accessed mm/dd/yyyy), [http://80-www.grovemusic.com.ezproxy.library.yorku.ca]
GStBAB	Geheimes Staatsarchiv Berlin, Stiftung Preussischer Kulturbesitz/I/HA/Rep119neu/2817
HMWA	Haus der Musik Wien, Archiv
HAPAG	Hamburg-Amerikanische-Paketfahrt-Aktien-Gesellschaft
Hickling	Gary Hickling, Lotte Lehmann Chronology (Kailua, 2004–6), PA Hickling
HMP	Heimat-Museum, Perleberg
Holden	The Education of Frances Holden: Frances Holden with David Russell, typewritten protocol, Davidson Library Oral History Program, University of California, Santa Barbara, © The Regents of the University of California, 1998
Hvølboll	author's interview with Eric Hvølboll, Santa Barbara, April 20, 2005
KL	Karl Lehmann
LBI	Leo Baeck Institute, New York
LL	Lotte Lehmann
LLFA	Lotte Lehmann Foundation Archive, Kailua
LLLN	*Lotte Lehmann League Newsletter*
MAW	Music Academy of the West, Santa Barbara
MAWA	Music Academy of the West, Santa Barbara, Archives
MGM	Metro-Goldwyn-Mayer
MH	Mia Hecht
ML	Marie Lehmann
MOA	Metropolitan Opera Archives, New York
MOA/O	Metropolitan Opera Archives, online [http://66.187.153.86/archives/frame.htm]
NBC	National Broadcasting Corporation
NC	University of California at Santa Barbara, Davidson Library, Special Collections, Lotte Lehmann Papers, Newspaper Clippings [Lehmann's scrapbooks]
NYT	*New York Times*
ONBW	Österreichische Nationalbibliothek Wien, Musiksammlung
ORF	Österreichischer Rundfunk, Wien
OSAW	Österreichisches Staatsarchiv Wien, Archiv der Republik, Bundesministerium für Unterricht, Österreichische Bundestheaterverwaltung
PA	private archive
PC	University of California at Santa Barbara, Davidson Library, Special Collections, Lotte Lehmann Papers, Photography Collection
RAVAG	Radio-Verkehrs-Aktiengesellschaft, Wien
RCA	Radio Corporation of America
RG	Richard-Strauss-Archiv, Garmisch
RKO	Radio-Keith-Orpheum Company

RM	Reichsmark
RS	Richard Strauss-Institut, Garmisch
SBNP	*Santa Barbara News-Press*
Schornstein	Herman Schornstein, "From Fan to Friend," Jan. 26, 2003, APA
UCSB	University of California at Santa Barbara
WTA	Wiener Tagblatt-Archiv, Stadt- und Landesarchiv Wien
Zytowsky	author's interview with Carl Zytowsky, Santa Barbara, July 23, 1997

Never Sang for Hitler

The Life and Times of Lotte Lehmann, 1888–1976

Childhood and Apprentice Years

Perleberg and Berlin

In no great hurry, the short, simple train rumbles across the flat North German landscape. "Today the small train of my childhood is still running," writes Lotte Lehmann in her autobiography of 1937, from Wittenberge through the thinning pine woods of sandy Westprignitz County, straight to Perleberg, some twenty miles away.[1] It was still running when I was in Perleberg one misty autumn day, driving from there to the estate of Gross-Pankow, to interview Bernhard von Barsewisch. A retired professor of ophthalmology, Barsewisch had still known Lotte Lehmann as a young man. He was the grandson of Konrad Gans Edler Herr zu Putlitz, a baron who lived on the ancestral Gross-Pankow estate with his family and was an important patron of Lehmann in her youth. I wanted to ask Barsewisch not just about the singer, but also about the origins of his family, who were Prussian nobility, as well as about the origins of Perleberg and its environs, almost halfway between Berlin and Hamburg. As Barsewisch's story unfolded, it turned out that the rise of Perleberg in the Mark Brandenburg was closely tied to the fate of the Putlitz clan, and that Lotte Lehmann's development as a young singer was intimately connected with the history of both.

Perleberg and Wittenberge were founded in the twelfth century by Johann Putlitz, in the Stepnitz River region.[2] Perleberg soon prospered on the trade axis between East and West, dealing in salt and cloth, and joined the Hanse League. After Bismarck's unification of Germany in 1871 it was a Prussian garrison town, with respectable businesses and schools.[3] Among the former was the hotel Deutscher Kaiser in the center of town, which featured "dejeuners, diners, soupers" and had a midsize auditorium, where small plays, recitals, or cabaret could be performed.[4] When Lotte Lehmann was born on February 27, 1888, the municipality had approximately 8,000 inhabitants.[5]

Since the High Middle Ages, the Perleberg region and the Putlitz family had been closely interdependent. Through feudal privileges, generations of Putlitz barons prospered as vassals of the Brandenburg Margraves, who by the eighteenth century were also the kings of Prussia. Members of the Putlitz family settled on several estates around Perleberg and served in hereditary ceremonial functions at the Berlin court. Eventually, they married into other Brandenburg regnant families; by the nineteenth century, the Putlitzes were related to the Hohenzollern kings through connubial ties.[6]

Like most nobles of Brandenburg, the Putlitz barons subsisted on agriculture, on professional military service and positions in the Prussian diplomatic corps. Their hereditary estates at Gross-Pankow, Laaske, and Retzin, all in Perleberg's hinterland, were not vast, but through prudent exploitation of the soil a comfortable living could be made, with second homes maintained in Berlin. But what distinguished the Putlitzes from all the others was their interest in arts and letters. In the eighteenth century, one Gebhard zu Putlitz was prevented from joining the Prussian army by an injury and instead became a learned rentier. Having studied law, he possessed a large library of Latin, English, and French works. Far and wide, this disciple of the Enlightenment was known as the "Learned Baron." His grandson was Gustav zu Putlitz (1821–1890), who wrote novellas and plays and took an active interest in theater and opera.[7] He served first as director of the Schwerin Theater and then of the stage in Karlsruhe, in the Grand Duchy of Baden, from 1873 to 1888. In between he stayed in Berlin, where as a member of the Prussian Upper House he also officiated at court. While there, he closely befriended the composer Baron Friedrich von Flotow, a fellow noble from neighboring Mecklenburg and famous for his opera *Martha*, for whose opera *Indra* he wrote the libretto. In Berlin, Gustav zu Putlitz also counted as his friends leading men of letters, such as Gustav Freytag and Theodor Fontane. During his years in Karlsruhe, he was host to Cosima Wagner, Franz Liszt, and Clara Schumann, who performed at soirées in his home, and he started and oversaw the professional career of the Austrian conductor Felix Mottl, who would move to Munich in 1903.[8]

This remarkable man had four sons, three of whom were again much more interested in learning and the arts than in cultivating their sandy acres. One of these was Joachim, who eventually became director of the Stuttgart stage, until 1918 under the king of Württemberg. Whenever in Brandenburg, he resided on the family estate of Retzin. Baron Gustav's third-born was Konrad (1855–1924), who lived in Gross-Pankow. He too subsisted only nominally on the fruits of his soil, for his real interest lay in prose and poetry. Having visited Italy in his youth, he was at work on a translation of Dante's writings during the last decades of his life. Whereas he tended to his agricultural chores only hesitantly and with moderate success, he could afford to do so, for he had married Emmy Lürmann, the daughter of a banker from Bremen, who had supplied him with a rich dowry. Besides, Konrad zu Putlitz spent much time in Berlin as representative of a distillers' lobby.[9]

Such commercial activities are an indication that even the old sword nobility toward the end of the nineteenth century could not escape losing its privileges of political standing, economic advantage, and social superiority. For the Putlitz clan, as for their compatriot neighbors, those privileges had been considerable, commensurate with their dominance over the small-town folk and, especially, the peasants tilling the land. Although the aristocrats of the Mark Brandenburg were monarchist and politically conservative, the Putlitzes were more pronouncedly so by virtue of their family legacy. Their ancestors had founded settlements and defended them against Slavic Wends many centuries ago, and they were politically distinguished through their ceremonial high offices, because of their immediacy to the Prussian court. On the whole,

it turned out well for the Putlitzes that the feudal overlord they served did not just remain a regional potentate in one of the many splintered German states, but became first the king of Prussia, which was the largest of those states, and, after 1870, the emperor of a united Germany.[10] Although certain peers of the realm were decrying the gradual decline of feudal privileges in the nineteenth century relative to the pre-Napoleonic period, the Prussian representational system still guaranteed aristocrats like the Putlitzes sociopolitical superiority.[11] In the Prussian electorate they were doubly favored: first because of their inherited position in the Upper Chamber (Herrenhaus), which they used exclusively to further their class interests, and second because of their wealth, which they used to help control a surfeit of political power through the Lower House, the Prussian Landtag, again to benefit merely a privileged few.[12] The Putlitzes thrived on and drew capital from their personal acquaintance with members of the royal family; Kaiser Wilhelm I and the empress came to visit Gustav zu Putlitz's theater at Karlsruhe, and later Prinz August Wilhelm von Hohenzollern, a son of Kaiser Wilhelm II and interested in music and the arts, had a retreat at Retzin where he communed with Baron Joachim, the director of the Stuttgart Theater.[13] The Putlitz family socialized (and tended to intermarry) with other nobles such as the Von Salderns and Von Jagows. Traugott von Jagow was head of Westprignitz County, with Perleberg at its hub, until in 1909 he became the police chief of Berlin; in March 1920 he would assist an ill-fated attempt to resurrect the fallen monarchy during the so-called Kapp Putsch.[14] Siegfried von Saldern in 1888 was director of the Ritterschaft, a corporate credit union dating from the eighteenth century, based in Perleberg and servicing all the noble families in the area.[15] One of his nieces was Elisabeth von Saldern, who as a young lady spent years at the imperial court as governess to Princess Viktoria Louise, August Wilhelm's only sister, until in 1910 she became a gentlewoman at the girls' school for aristocratic daughters, the Abbey Heiligengrabe near Perleberg.[16]

These conditions fostered conservatism and a belief in monarchist legitimism not only among the aristocratic clans themselves, who stood to gain the most from such bearing, but also among the commoners who worked for them and whom they influenced. Perleberg's character as a garrison town intensified the public love of king and emperor; indeed, this was the predominant sentiment among its burghers. In this social and political setting, and geographically in the center of town, Karl Lehmann, Lotte's father, worked as the secretary of the Ritterschaft, where he answered to Direktor von Saldern. As manager of the credit union, he received a modest salary.[17]

If the lower middle class tended to be politically conservative, as a minor civil servant in expectation of a state pension Karl Lehmann was pronouncedly so, and the aristocratic masters he served only encouraged this attitude. As for his daughter Lotte, throughout her life she remained conscious of her small-town, lower-middle-class origins, and politically, she always leaned to conservatism. A photograph of her as a small child of perhaps six shows her with intense eyes and short brown hair framing a round face, clearly betraying the early influence in the family of Slavic Wends once resident in the area (Figure 1). Both parents had been born in Prenzlau in the Brandenburg region of Uckermark, Karl in

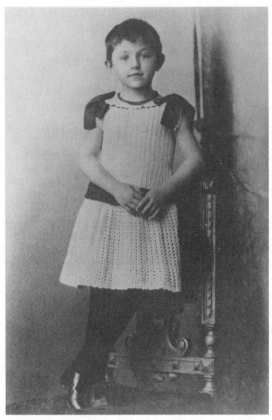

FIGURE 1. Lotte Lehmann in Perleberg, ca. 1894. Courtesy Special Collections, David-
son Library, University of California at Santa Barbara (UCSB).

1849 as the son of a court clerk, a subaltern civil servant. Lotte's mother, Marie
Schuster, born in 1950, was the daughter of a – somewhat better-off – master
miller.[18] Marie's beloved siblings lived in Berlin; she was particularly close to
her youngest sister, Lieschen, who was proprietor of a household odds-and-
ends stall at a Berlin market.[19] The rotund Marie was simple and emotionally
always on the verge of tears. Her schooling having been rudimentary, the let-
ters to her children tended to be grammatically faulty, and her worldview was
touchingly limited. When her then famous daughter embarked on a tour of
South America in 1922, she warned her of strange people she would encounter
there – "Negroes, Indians and however many wild folks, who can frighten you
terribly – so do take care."[20] The father, mustachioed, gaunt, and handsome,
prided himself on his position as Ritterschaft secretary, and he aspired to greater
heights. He liked to read popular literature, was fastidious in dress, daily tended
to his small garden belonging to their Ritterschaft house, and collected postage
stamps.[21] The Lehmanns always had a maid and could send their children to
secondary school. Most significantly, Karl Lehmann would take summer vaca-
tions, however modest, with his family in Warnemünde on the Baltic coast.[22]

It is said that Marie had married Karl only after her first fiancée – the true love of her life – had not returned from the Franco-Prussian War of 1870–71. Be this as it may, the parents quarreled a lot because money was always scarce, and Marie suffered from stomach cramps and bad eyes – ailments that her husband dismissed because they were costly and he thought his wife a hypochondriac.[23] Although this family of four was close-knit, loyalties were unevenly spread. Lotte revered her mother (who cared less for her) and on the whole disliked her father, until his last years in life before he died in January 1925. Mother Marie preferred Fritz, who had been born in 1882, but father Karl loved Lotte, even though he seldom let this shine through his formal Prussian veneer.[24] Fritz adored his younger sister, and she admired him back. The mutual devotion of sister and brother would become one of the main themes in Lotte Lehmann's biography.[25]

Music was in the family. Marie Lehmann had a beautifully dark contralto voice and in her youth would have had formal training, had her father not forbidden it. The highlight of every Christmas Eve for the family was when she sang, without accompaniment, the German seasonal song "Es ist ein Ros' entsprungen aus einer Wurzel zart." Karl Lehmann had a resonant tenor and was a member of the Perleberg men's choir. Family legend had it that one of his forbears had been the Paris Opéra soprano Sophie Arnould, who had enjoyed her greatest success as Telaira in Jean Philippe Rameau's *Castor et Pollux*, with which she delighted Madame de Pompadour. Arnould had borne four illegitimate children to Count Louis de Lauraguais, one of whom, a soldier in Napoleon's army, had been stationed in Frankfurt an der Oder, east of Berlin.[26] Until his vocal cords were ruined by careless teachers, who had him sing soprano while his voice was breaking, Fritz was believed by all to show the greatest promise as a singer, and it was he who had to demonstrate his talent in the modest living room when visitors arrived. But the whole family often joined in song together, especially traditional German folksongs like "In einem kühlen Grunde," which father Karl would accompany on his zither. Lotte's voice was not deemed promising until she participated in a school play entitled *Königin Luise*. On this occasion the teacher commended her and told her father that she should receive singing lessons, but Karl Lehmann thought a regular job with a guaranteed pension like his own more sensible.[27]

Much of this musical activity, on Fritz's and Lotte's part, was inspired by occasions on which popular-culture events took place in town. Musical recitals, mostly on the stage of Hotel Deutscher Kaiser, often were of a military stamp, such as when the trumpet corps of the resident infantry regiment gave a fanfare recital.[28] But the town also had its own band, and itinerant theater companies staged operettas and even operas, however simply, such as Albert Lortzing's *Der Waffenschmied* in 1902.[29] Other exotic things occurred to spur the imagination of the impressionable Lotte. She must have seen the children's play *The Christmas Fairy* by one Werner Heim, staged at Deutscher Kaiser on December 25, 1898, when she was ten; yet she was certainly too young for a variety show by African-American singers directed by "Mister Harry Cliften," in August of 1892.[30] Perhaps Fritz told her about it. Gypsies passed through, and so did Slovak youths with interesting traps for rodents; there was a man

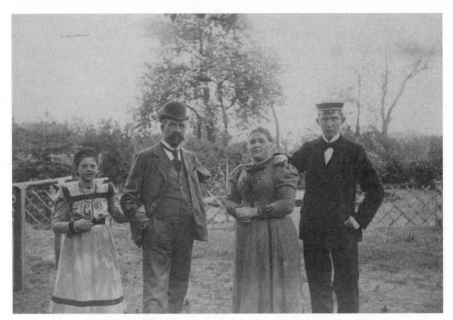

FIGURE 2. Lotte Lehmann, Karl Lehmann, Marie Lehmann, and Fritz Lehmann in Perleberg, ca. 1900. Courtesy Special Collections, Davidson Library, UCSB.

with a contraption fixed upon a barrel organ, showing images of a murderer and his flaxen-haired female victim, the organ grinder cranking out the horrible tale young Lotte delighted in. She was particularly impressed by a theater troupe composed of husband and wife, where he played all the leading roles and she various mistresses, of which the girl understood little. When later Lotte met the haggard actress off stage, she struck her as a woman already broken by life. But how she fascinated her! "I thought nothing more desirable than the life of this tired, run-down woman in need of peace and quiet, who must have buried many, many dreams."[31]

Lotte walked to school from the Ritterschaft house on Berliner Strasse along a picturesque path, past the Roland statue, the medieval town hall, and the imposing St. Jacobi Church, a redbrick Gothic building. The advanced girls' school (Höhere Mädchenschule), where she could learn some English and French and the rudiments of German literature, was nearby.[32] Impulsive, open, and with a pleasant disposition, which included a pronounced love of animals, Lotte made friends easily and got along well with her teachers. She was not difficult to like. In the 1950s Elisabeth Brünig, who had a walking disability, remembered how Lotte had, without much ado, helped her up the staircase, actually carrying her up many times.[33] Lotte's favorite teacher was the young singing instructor Konrad Strey, "Konny" to his pupils, on whom she developed a crush at twelve. Lotte was devastated when later he took as his bride a "very beautiful girl" from her own class.[34]

Even then, her relationship with brother Fritz, who visited the Realgymnasium facilitating a university entrance examination, cannot be overestimated.

Lotte idolized her brother and wanted to be like him, share his friends and their rough-and-ready games. Highly intelligent, Fritz was difficult and unruly, often making a nuisance of himself in public. Because he did not have to study hard to pass in class, he was lazy. But endowed with charismatic leadership qualities, he was always surrounded by followers; his sister, although similarly gifted, in this phase of her life was much more demure and accommodating.[35] Hers was the comportment of Prussian teenage girls at that time.

The political culture of Perleberg, in which Lotte, in the bosom of her caring family, was socialized, was as thoroughly conservative as was the landed gentry. The period in which Lotte was born, late winter and early spring of 1888, was one of high alert in the capital, with reverberations throughout Perleberg. On Lotte's day of birth, February 27, members of the court along with all loyal Brandenburg subjects were anxiously watching out for signs of deterioration in the health of Kaiser Wilhelm I as well as his son, the Crown Prince Friedrich Wilhelm. The Kaiser was getting weaker by the day and was expected to die soon, while the crown prince was suffering from terminal throat cancer. Every news item was immediately transferred to the Prussian provinces, and in Perleberg was printed by the local paper. Wilhelm I died on March 9 and was buried a week later; the funeral was covered in detail by the paper.[36] The health and habits of Kaiser Friedrich III, who would reign only for ninety-nine days, after which his oldest son was crowned Kaiser Wilhelm II in June, were then monitored and reported on very closely, such as details of his daily diet.[37] As Lotte Lehmann was growing up, news about Kaiser and court, about the royal Prussian regiments stationed in the little town, and about the local royal servants to whom her own father, Karl, owed his livelihood, dominated everyday life. Perleberg's citizens celebrated the anniversary of Germany's victory over France and the subsequent founding of the empire in 1871, and sided with the Boers against the British in South Africa in 1902 – collecting relief money for them.[38] Military conscription, promotions, and the awarding of medals and distinctions in the region, even as weekly routines, were extremely well publicized.[39] Some political events even infiltrated popular culture, so that the public, and no doubt as curious an adolescent as Lotte Lehmann, could participate enthusiastically. This occurred, for example, one week in January of 1902, when Hotel Deutscher Kaiser put on a display of moving pictures, with scenes from the Boxer Rebellion in China, as it was mercilessly subdued by the troops of Wilhelm II.[40]

Present at many of the official functions was County Commissioner von Jagow, whose villa stood next to the Lehmanns' house.[41] Lotte hated him because he had shot her beloved tomcat Maunzi, but nonetheless, he was a person deserving of respect. She also was in awe of the aristocracy, loved playing games of "Countess" with the maid, and approved of the maid's admiration of all soldiers.[42] When Lotte moved to Berlin in the summer of 1902, she saw more of pomp and circumstance, but serious study soon left her little time to regard them with more than a passing glance.

Around the turn of the century, newspapers in the German capital frequently printed stories extolling upward mobility as a function of social success – and

a sensible alternative to emigration to America.[43] Signally, when in Berlin, Karl Lehmann was promoted to senior secretary. Although his actual position is not clear, he was probably put in charge of the Berlin headquarters of several combined Ritterschaften of the Brandenburg province, including those of West-prignitz and Uckermark. His pay could not have improved significantly, for the family resided in one of the grubby apartment buildings on Hochmeisterstrasse in Berlin's proletarian North. "The structures resembled military quarters in their monotonous utilitarianism and disregard for basic human comforts. Typically five stories high, they filled entire blocks in a dense honeycomb of apartments built around inner courtyards just large enough (5.3 meters square) for a fire engine to turn around in. The innermost dwellings, accessible by long passageways from the street, received virtually no sunlight."[44] Here, the Perleberg garden was sorely missed.[45]

As a by-product of modern industrialization, of which the Hochmeisterstrasse tenements constituted particularly repulsive examples, Berlin with its two million inhabitants was then feverishly growing into the Second Reich's capital, and in the genteel parts new sandstone buildings were being erected and elegant streets and broad avenues built. Kaiser Wilhelm II was culturally ambitious, yet lacking in taste; what he had of it was arch-conservative, cheap, and overblown. As a sailor-buddy of his uncle Edward in England, he drew ship models, and he composed a play entitled *Sardanapal*, featuring a naïve, fictitious king.[46] His increasing hubris showed in the way he allowed his tasteless sense of style, which bespoke grandeur without refinement, to be imposed on all major objects of construction. Hence the Siegesallee, a broad avenue leading from the Rolandsplatz near the Tiergarten to the Königsplatz with its Reichstag, was studded with thirty-two white marble monuments of princes of victory. "The monument of each prince was surrounded by a low semicircular wall which was further enhanced by busts of two of the prince's advisers who were considered worthy of the honor." Throughout the capital, there were monster monuments celebrating the main heroes of German unification: William I, Bismarck, and Field Marshall Count Albrecht von Roon. The Kaiser Wilhelm Memorial Church was built at the entrance to the Kurfürstendamm, commemorating the first Kaiser. A picturesque mark of modern Berlin only after its partial destruction in World War II, it had originally been done in a fake neo-Gothic style toward the end of the nineteenth century and – like the Siegesallee – was the butt of jokes by the usually irreverent Berliners. Other churches and official buildings were neo-Gothic, neo-Baroque, and neo-Romanesque, like the new Kaiser Friedrich Museum, featuring huge staircases and marble lounges.[47]

For the benefit of military parades or the reception of foreign luminaries the huge avenues were closed to traffic, including pedestrians, by the new Police Chief von Jagow, Karl Lehmann's former neighbor, who now resided in the "grim, red Police Presidium," as novelist Alfred Döblin dubbed it.[48] Normally, Berliners and a growing mass of tourists traversed the city by streetcar, strolled on the showcase avenue Unter den Linden on weekends, and frequented outdoor picnic places, such as those on the many lakes in the Southwest, or listened to brass bands in beer gardens. They could get themselves lost in the huge new

department stores such as Wertheim's and have pea soup, bacon, and beer at the Aschinger chain's fast-food place on Alexanderplatz.[49]

In culture, Berlin was conventional in literature, the just-deceased Theodor Fontane and the rising naturalist playwright Gerhart Hauptmann excepted, as well as in art, save for the works by masters of the so-called Berlin Secession, under the patronage of museum director Hugo von Tschudi, such as the Impressionists Max Liebermann and Lovis Corinth. Sterile, painstakingly representational academy art reigned in the galleries and affluent homes, dominated by the Hohenzollern-craven Anton von Werner, who was beloved by the court.[50] In theater, Max Reinhardt at the Deutsches Theater was just beginning to make significant inroads after 1905; members of the military were forbidden to attend it.[51] Expressionism had yet to struggle against the gaudy taste of Wilhelm II, who thought himself an expert in everything from automobiles to opera. He tried to dictate from above: "Art which transcends the laws and limits set by me ceases to be art," he declared publicly in 1901.[52] In 1898, Richard Strauss had succeeded Felix von Weingartner, as kapellmeister extraordinaire and was conducting opera in the capital alongside the older Karl Muck. In fact, Strauss had barely been appointed against the protests of the Kaiser. In 1903, one year after Lotte Lehmann's arrival in the capital, Strauss wrote a euphoric letter to his parents about how enthusiastically the audience had recalled him to the stage "after every act" during a performance of Richard Wagner's *Die Meistersinger*. But in 1905 he had to have his new opera *Salome* premiered in Dresden, the capital of the Kingdom of Saxony, because Empress Auguste Viktoria, who was as prurient as she was dim-witted, disapproved of it.[53] Nevertheless, and not least because of Strauss's presence in Berlin, foreign musicians continued to flock to the metropolis and prospered there: the violinist Joseph Joachim, originally from Budapest, the singers Julia Culp from Groningen and Geraldine Farrar from Boston. Young, beautiful Farrar, who was engaged at the Berlin Opera from 1901 to 1906, was smitten with imperial Germany as "a magnificent country," not just because she was managing to have a dalliance with the pleasure-seeking Crown Prince Wilhelm. In her judgment, Berlin "quite measured up to one's earliest dreams of royalty and picturesque glitter."[54]

Lighter forms of entertainment were also beckoning in the capital at that time. The soprano Frida Leider, who was Lotte Lehmann's age and enrolled in a commercial high school, remembers – along with the lieder singers Julia Culp and Elena Gerhardt – Yvette Guilbert from Paris, "a piquant figure with reddish hair and long, green gloves, the mistress of French chansons," who performed regularly in Berlin. And she also remembers the Danish star Asta Nielsen, one of the pioneers of silent movies, as Berliners admired her in films that were just now maturing after their mechanical slapstick and street-ballad phase. In 1909, when the Union Theater opened on Alexanderplatz, in the center of Berlin's entertainment industry, it was the first free-standing, upscale movie house.[55]

In the little spare time she had, Lotte Lehmann enjoyed much of Berlin and its culture, both high and low. She joined her family for outings on the wholly electrified streetcars, or the brand new subway line, to the open-sky beer gardens where one could eat a hearty meal and sing along with the um-papa bands. And

she was impressed by the broad avenue Unter den Linden, though she missed the linden trees that actually did exist in Perleberg. The side streets from Unter den Linden to Friedrichstrasse, heavily frequented by prostitutes, she would avoid. But she visited the Opera, sometimes in the company of Fritz, where they were standees in the fourth gallery. Wagner's *Lohengrin* she savored there, with Wilhelm Grüning, a well-known Bayreuth heldentenor, in the lead role. She listened to *Mignon* with the Czech soprano Emmy Destinn, and Farrar, who was not older than her brother, very much impressed her.[56]

All the same, during the first two years in Berlin Lotte was less concerned with opera and, for that matter, singing than with her standing in the new school, which was to segue into a seminary for public school teachers. This was according to the wishes of her practical-minded father, who continued to believe that his daughter should be trained in a sensible skill guaranteeing her job tenure and a pension. Although Lotte agreed in principle, she thought it more likely that she would marry her newfound boyfriend, Willy Hilke, the blond, practical son of a neighbor. But she also developed yet another kind of puppy love for Principal Ulrich of the girls' school. He alone and another teacher made her school life worthwhile, not because of music, but because Lotte excelled in literary composition, especially the writing of poetry. Indeed, she kept sending her poems to Berlin newspapers for publication, until *Der Tag* accepted one and paid her ten marks for it. (This was when a goose cost around five marks and visiting a public swimming pool fifteen pfennigs.)[57] So she saw herself more as a future writer than as a singer, especially since all the other subjects she was taught bored her, notably mathematics. Her teacher Frau Vogel encouraged her writing, and the man she affectionately thought of as "Ulli" found it difficult to believe that the polished pieces of prose she delivered were really from her own pen. The other subject she loved was declamation – reciting the parts of plays that were analyzed in class. So could she perhaps become a stage actress? When she did sing folk songs and the hits of the day at home, accompanying herself on the piano, she dreamt of a future at the side of her husband Willy, although she found not thinking of "Ulli" difficult.[58]

Her career concept appears to have changed shortly before she was to graduate, a few months before entering the seminary. For in February 1904, just before her sixteenth birthday, she wrote to her old school pals in Perleberg, "I do not wish to become a teacher any more, it's actually terribly boring, don't you agree? I think I shall devote myself to song, for music delights me endlessly."[59] In the same year, the Lehmann family moved to the Berlin suburb of Gross-Lichterfelde, where the air was cleaner and there was yet another, albeit smaller, garden. Karl Lehmann had resigned his position with the Ritterschaft, was working in the suburb's communal service, and, as a side job, had taken on managing the airy apartment building they lived in. Rent was free.[60]

Lotte was successful in convincing her father that she was not born to be a teacher. Instead, he now wanted her to enroll for commercial schooling (of the kind that Frida Leider was then taking) so that she could become a middle-range administrator, perhaps to serve the Ritterschaft. This would still afford her security and a pension, in case she could not depend on a level-headed husband such as Hilke.[61]

During the summer of 1904 Lotte was mentally prepared to enter commercial college, just as her father wished. But at home she would continue doodling on the piano and singing popular songs, so that one day a young neighbor complimented her on her lovely voice. One thing led to another, and since the young woman's uncle was working in the canteen of Berlin's Musikhochschule, Lotte, with Fritz's moral support, was encouraged to take preparatory lessons from an advanced conservatory student this uncle knew. The student, convinced of the quality of her voice and Lotte's talent, coached her to the extent that even father Lehmann thought something might come of it.[62] Lotte passed the Musikhochschule entrance examination. She would now be a regular college student like Willy.[63]

Things had not been going well with Willy lately. Even back in North Berlin he had quarreled with her, criticizing her for not knowing enough of history or the other subjects that did not interest her in school. He would need five years to complete his own education – a period Lotte found too long – until they could marry. Besides, even in music he seemed to get the better of her, for when she accompanied his violin solos on the piano and sang to them, she could never keep time. So now, having been accepted by the Musikhochschule, Lotte decided to make short shrift of this relationship and wrote Willy a goodbye letter.[64]

It was at this point in Lotte Lehmann's life that her brother Fritz entered into it in a major way, most certainly deciding her career. The problem was that, although for a three-year course the conservatory offered scholarships, the first semester had to be financed entirely by the student, and the Lehmanns were still notoriously tight. Fritz, who himself was always between jobs, either saved or borrrowed enough to get together the 150 marks Lotte needed so that she could properly register for a course of studies. This was an act of generosity his sister never forgot.[65]

Eventually aided by a Prussian scholarship, Lotte studied vocal technique at the conservatory with Helene Jordan, oratorio with Adolph Schulze, and opera with Felix Schmidt. Elise Bartels was her enunciation instructor, and since she was reciting much-beloved poetry, this subject was dear to her heart. Only theory, with Heinrich van Eyken, gave her problems, and she asked, successfully, for dispensation from his class.[66] On the whole, the teachers did good work. "I began to develop the ambition so sing at concerts," Lehmann wrote later, "and then slowly the thought of opera became more than just a dream."[67] The school was at that time still headed by its erstwhile founder, Joseph Joachim, and Lotte positioned herself strategically to get a glimpse of the famous musician whenever she could. Academic standing in the conservatory was rated on a par with that in Gymnasien, but not with a university.[68]

Professor Schulze's opinion that Lotte was destined to be an oratorio singer found her less and less in agreement, because after a year or so she was thoroughly convinced that she had to be in opera. After hours of deliberation with Fritz, she decided to withdraw from the conservatory during 1907 without attaining a diploma and to visit instead one of the several well-placed Berlin private music schools, which would be able to mold her more individually. Her choice was the renowned establishment of Etelka Gerster, whom she

approached by letter, explaining her situation and not failing to mention her indigence, thus expressing hope for a bursary.[69]

Gerster was duly moved, and Lehmann began her studies with her in January of 1908. The new teacher's credentials were impeccable. Originally Hungarian and now fifty-three years old, this coloratura soprano had studied with Mathilde Marchesi and been a protégé of Verdi, had sung in London's Covent Garden and in New York in the 1870s, and had established a famous rivalry with Adelina Patti. Already retired in the 1890s, she taught singing in New York and Berlin.[70] Gerster accepted Lotte as a scholarship student in her music school, but had her trained under faculty member Eva Reinhold, with a view to taking on the young girl herself later.[71]

The experience turned out to be a disaster. "What is right for one may be wrong for another," cautions Lehmann. "Etelka Gerster was a wonderful teacher for many, but her method of singing was almost fatal for me." The stumbling block – under Reinhold – turned out to be the part of the Countess in Mozart's *Figaro*. Lotte could not hit the required high notes the first time, and subsequently she was forced to repeat the attempt ad nauseam, rather than being assigned another role more congenial to her voice.[72]

What compounded the situation was that Lotte – before her time, Gerster and Reinhold thought – was invited to sing for the benefit of Baron Joachim zu Putlitz, the intendant of the Stuttgart Opera, who was often in Berlin and at his nearby estate of Retzin. The recital had been arranged by Nanni von Saldern, the wife of Karl Lehmann's former superior in Perleberg, who had asked Lotte out to her hometown to give a charity recital for the local women's circle, which Saldern chaired. Despite all her skepticism, however, Reinhold tried to help Lotte study the parts, an Agathe aria from *Der Freischütz* and "Elsa's Dream" from *Lohengrin*, by supplying her with a piano accompanist. As it had been with Hilke, Lotte's problem still was keeping time. But the little concert itself, in Berlin's Exzelsior Hotel on September 28, 1908, went very well; the baron had recognized a talent. Nonetheless, for whatever reasons, which must have had to do with bad personal chemistry more than anything else, Gerster and Reinhold decided to rid themselves of Lotte. They arranged a term examination for the end of December 1908, during which Lotte was tested, once again, with a technically most difficult piece. Predictably, she failed and was immediately dismissed from the music school. To add insult to injury, Reinhold wrote her a personal letter that contained the absurd statement that her progress was not even that of a mediocre student. Lotte was out on the street, without funds, and once again did not know where to turn to realize her dream of becoming an opera singer. No sooner had Karl Lehmann learned about the mishap than he suggested, as he had before, the decent, reliable course of training at a commercial college. Lotte was to enroll on January 15, 1909.[73]

But she thought better of it and decided to fight for a career in opera one more time. On January 9 she wrote a letter to Mathilde Mallinger, outlining her dilemma and asking for special consideration financially, if not an outright scholarship. She mentioned her audition with Joachim zu Putlitz and that he

had been favorable. In her memoirs, Lehmann claims that she detailed her lack of success at the Gerster School, but the preserved draft of her letter is silent on that. It would actually have been strange for her to dwell on such misfortune, especially since thus far, she had not blamed herself.[74]

A lyric soprano, Mathilde Mallinger had a record as a singer even more illustrious than Gerster's. Born in Zagreb in 1847, she made her début at the Munich Court Opera as Bellini's Norma in 1866. While at Munich, she was Richard Wagner's first Eva in the *Die Meistersinger* premiere of June 1868. Thereafter, she sang in Berlin until she retired from the stage in 1882. She taught voice in Prague and Berlin, and by the time Lotte wrote to her, her singing school was one of the most renowned in the capital.[75]

Although it must have been difficult for him, Karl Lehmann finally came around, in silent admiration of his daughter's perseverance, and decided to intervene directly with Joachim zu Putlitz's brother Konrad, whom he knew from his previous position at the Ritterschaft, since he lived in Gross-Pankow near Perleberg. Unbeknownst to Lotte, he wrote to Konrad, asking for financial support. When sometime in February 1909 Mallinger decided to accept Lotte as a new student, with details of her fee still in the open, Baron Konrad, after consulting with his brother in Stuttgart, had made up his mind to lend the Lehmanns a helping hand. He thought of himself sufficiently as a patron of the arts to justify such beneficence to his wife (who had brought the money into the family), and he even believed it was his duty to help out the other, poor but deserving, subjects of his realm. For instance, around this time he also assisted Albert Hoppe from an adjoining farmstead, who wanted to become a teacher. After receiving annual loans from Putlitz and succeeding in his career, Hoppe remembered him fondly in his memoirs in 1973: "The old baron really was a kindly man, he assisted people as much as he was able to."[76]

As for Madame Mallinger, Lotte Lehmann describes her in retrospect as a physically imposing, voluble woman who could swing from flattery to cutting criticism in a flash.[77] The experienced opera star immediately recognized the young woman's extraordinary voice and her overall musicality; at the same time, she realized the need to work on Lotte's "musical mistakes" (her deficient sense of rhythm!) and "every vocal insecurity and negligence." They studied Agathe's arias from *Freischütz* together, Lotte's first major project ever, and within about a year Mallinger thought that her student was ready for a beginner's engagement.[78]

Meanwhile, Lotte had thanked both the baron and the baroness for their generosity; her letters were modest and humble and genuine, and Baroness Emmy wanted to meet her. Lotte paid her a visit, and obviously made a good enough impression at Gross-Pankow to be reinvited. She quickly became friends with the two straw-blond daughters Erika and Elisabeth (Bernhard von Barsewisch's mother), but not with their brother Gisbert. Lotte, somewhat older, joined the family on excursions into the fields and forests. The baron in particular – whom Lehmann describes from memory as "generosity personified. Always a bit absent-minded, always in thought, a poetic soul" – singled her out for attention with such gestures as seating her next to him on the

horse-carriage box. He was a tall, blond, good-looking man, and she looked up to him transfixed.[79]

Then on August 11, 1909, during one of Lotte's stays in Gross-Pankow, Baron Konrad's family drove over to Retzin, his brother Joachim's estate, in order to have the girl audition for him once more. She offered songs by the popular Robert Franz and Robert Schumann. Only a day later, the result was an invitation from Joachim zu Putlitz to Lotte to join his Württemberg Hofoper in Stuttgart, for the fall 1910 season starting in September. Baroness Emmy was to help out with the required wardrobe, and so would Elisabeth von Saldern, Nanni von Saldern's relative at the royal court.[80]

Lotte's début at the Stuttgart Court Theater might have been unsatisfactory, because the stage was then under an impermanent improvised roof, after a fire had destroyed the original building in January 1902. Two new theater buildings were to be completed only in 1912, one for chamber presentations and the other for substantial stage works. (And indeed they were, with Richard Strauss's first version of *Ariadne auf Naxos* premiered there in October, produced by Max Reinhardt and with the gorgeous Vienna soprano Maria Jeritza starring in the title role.)[81] Besides, because the pay was only 150 marks a month, even Baron Konrad thought that Lotte should be able to secure for herself a better deal, at a comparable or higher-rated stage. He encouraged her – as did Mallinger – to seek out the services of Berlin agents, even though Lotte was loath to approach them and produce herself. Lotte also took lessons from Felix Dahn, the renowned Regisseur of the Berlin Court Opera – at a special rate of fifty marks a month – as well as being coached by the matronly Madame Mallinger.[82]

Apart from the shadow of direct baronial patronage that was now hanging over the budding stage artist and could have given rise to malicious gossip, Lotte had yet another problem to overcome. Spurred by the success with *Der Tag*, she still could not tear herself away from writing poetry, an almost obsessive activity that potentially distracted her from what should always have been her focus: singing. There was also more than a trace of hubris in her thinking that she was good enough to do both, and on professional terms, which people who wished her well regarded with disapproval. After she had sent her prize-winning poem to her old conservatory teacher Elise Bartels, the declamation expert cut her back quickly: "You have a nice talent for lyrical poetry." Suggesting changes here and there, Bartels advised: "Give it up until one day you are a famous singer. Then people will fall all over them." Not realizing the irony in this admonition, Lotte also approached her Perleberg sponsor Nanni von Saldern, seeking approval. "You certainly have poetic talent," answered von Saldern, "but your greatest talent lies in music, that is the art of singing, and this you should be pursuing exclusively."[83]

In March of 1910 the reputed Berlin agent Karl Harder, to whom Lehmann had been recommended by both Dahn and Konrad zu Putlitz, brokered for her a concert tour with fellow artists in the Balkans as far as Bucharest, at first for eight weeks but with subsequent prospects in Vienna. Timewise, this would not have endangered the Stuttgart venture. The pay was to be 160 marks a

month – 10 more than Stuttgart was offering. Although she was elated at first, Lotte's parents were afraid for her, and her father would not sign the required contract. They also may have recognized the transient nature of this less-than-solid engagement. Indeed, the traveling company floundered already in Sofia, and Lotte had reason to thank her father for his circumspection.[84]

The young singer's decisive break came in late spring, when Harder was able to recommend her to the Hamburg Stadttheater for the 1910 fall season, starting at 200 marks a month. The contract was to be for three years, with annual increments of 100 marks per month. There was even a possibility with the Berlin Hofoper, as Intendant Count Georg von Hülsen-Haeseler had her sing for him and considered preparing a contract; however, there was no vacancy.[85] The young singer signed with Max Bachur, the chief of the Hamburg Opera, in early July.[86] Whereas brother Fritz was employed, in some minor position, by Berlin's Wedeking publishing house, Lotte's parents were prepared to move with her to Hamburg. She had "hit the jackpot," exulted Madame Mallinger.[87] Jackpot or not, Lotte Lehmann's career had been launched.

Coming Out in Hamburg

In July 1910, when Lotte Lehmann and her parents rented a small apartment on Isestrasse near the Alster River, Hamburg's inner city had not quite 300,000 inhabitants. But the greater metropolitan area with its rural hinterland already was home to more than a million people. This leading seaport on the Elbe River had been a stalwart of the medieval Hanse League. At the lower end of its society there were masses of sailors, longshoremen, and metalworkers. At its upper end it was ruled by a small group of wealthy wholesale merchants as well as ship and shipyard owners ("Old Hamburg"), joined by a slightly less prosperous professional class who, owing to Hamburg's reliance on world trade, were cosmopolitan and Anglophile.[88]

As Hamburg was expanding – much like Berlin after German unification in 1871 – its population and new settlements were spilling over into surrounding Prussian territory, such as Stellingen, where the new and unique Hagenbeck Zoo had been constructed, and Altona, where the Hamburg Stadttheater housing the Opera had a branch.[89] Hamburg was a city-state in the federation of the Kaiserreich; constitutionally, it was Prussia's coeval and immediate only to the Kaiser, who, however, also happened to be the Prussian king. Hamburg's proud burghers always enjoyed emphasizing a sense of distance from Prussia, reinforced by their predelections for anything British.[90] But this is not to say that Hamburg's citizens were not nationalistic; they actually cheered Kaiser Wilhelm's plan to build up the German Reich's navy in open rivalry with Britain's, as it would protect Hamburg's merchant fleet in perpetuity, and the Kaiser and his imperial regiments were welcomed during imperial maneuvers in 1904 and then again during Lehmann's time in 1911, which Wilhelm himself directed from Stellingen, precisely because it was Prussian.[91] Hence the known patriotism of the Lehmann family, which had been transplanted from Perleberg to Berlin, was not out of place when transferred from there to Hamburg; indeed,

it was safely embedded within the patriotism of the great majority of ordinary Hamburgers, notwithstanding the cosmopolitan leanings of many of the city's ruling caste.

This caste had been greedy and callous enough to cling to its money and prevent the necessary reform of its water filtration system along with a long-overdue renovation of the rotten proletarian living quarters between the landmark Michaelis Church and the harbor, so that in 1892 cholera had struck and wiped out a large segment of Hamburg's population. But the architectural rebuilding had been swift and led to modern, sanitary housing for the poor and modest of means, and it went hand in hand with the construction of a remarkable public transit system.[92] In 1910 Hamburg possessed, much like Berlin and unlike any other German city, the makings of a viable underground railway network, elevated city trains, electric trams, and even water buses serving its Alster waterways and several canals. After 1912, gasoline-powered taxis were allowed. Old, leafy city districts like Harvestehude and Uhlenhorst were comfortably accessible from practically any point in town, as were new generously laid out residential streets over the entire urban area. As well, stately new public buildings and two representative train stations impressed the visitor, one of which, the Dammtorbahnhof, was close to the Stadttheater and to the apartments where Lehmann would successively take residence.[93]

The imposing Elbe harbor was home to several spectacular ships, at a time when many people, especially from Central and Eastern Europe, were in the habit of emigrating overseas. Among the largest steamers were the *Vaterland*, the *Bismarck*, and the *Imperator*, larger even than the *Titanic*, which had sunk on April 15, 1912, one month before the *Imperator* was actually launched. These steamships usually went to North America, Africa, or Australia, whereas sailing ships, built by the Hamburg firm of Laeisz, dominated the South American route. Up to six Hamburg shipping lines monopolized international traffic from imperial Germany, among which the HAPAG was by far the most important. Its president was Albert Ballin, and Ballin was a Jew.[94]

After Berlin and Frankfurt, Hamburg had, proportionally speaking, the largest Jewish population of any city in Germany. Hamburg's Jews were assimilated into the citizenry, where even the most conservative of its senators possessed enough liberalism to provide for a certain measure of tolerance. And Ballin, who led his company in exemplary fashion and was a frequent adviser to the Kaiser, particularly regarding England, was not just tolerated, but admired. Yet even he, along with other Jews such as his friend Max Warburg, knew the limits of this assimilation. Thus Warburg wrote to his brother Abraham in 1913: "In Hamburg, there is no open anti-Semitism, but much latent anti-Semitic feeling." Significantly, having mingled on the trading floor during the day, Jews and Gentiles sat at separate tables during coffee hour in the early evening.[95]

As in other places in Germany, political anti-Semitism burst onto the scene in Hamburg in the 1880s and 1890s. Ironically, because relatively speaking, liberal Hamburg society had accepted Jews into its midst more quickly than other communities, isolated cases of anti-Semitic backlash were also more vehement. As in Berlin, Jews were becoming predominant in public, artistic, and commercial

circles. In 1898, several anti-Semitic citizens' groups were initiated, henceforth constituting the nucleus of organized Judeophobia in the Hanse town. They were supported by an anti-Semitic press, among which the well-established *Hamburger Nachrichten* tended to take the lead. Fortunately for Hamburg and its Jews, the growing Social Democratic movement, which sent duly elected members to the national parliament and city councils, more than canceled out the voices of the tiny anti-Semitic factions. However, anti-Semitism certainly played a role in the reluctance of city elders to put up a monument in honor of Heinrich Heine, who after 1816 had intermittently lived in Hamburg yet heaped much scorn on it. But a Heine-Denkmal was finally consecrated in 1910, Lotte Lehmann's first year there.[96]

Although Heine was unequivocally recognized as one of Germany's greatest poets, Hamburg's literary culture, perhaps because of Heine's bad local reputation, did not aspire to emulate his legacy. At the turn of the nineteenth century, the two leading literary figures were Detlev von Liliencron, an impoverished baron who originally hailed from Kiel and lived in Hamburg's suburbs, and Richard Dehmel. A former officer himself, Liliencron wrote lyrical poetry of an impressionistic hue. Although he was a pioneer of naturalism, Liliencron was not a pillar of Germany's literary establishment, and neither was his friend Dehmel, another naturalist lyricist. Born in Brandenburg, Dehmel turned from social themes to love and sex, which he came to view as the basis for a higher spiritual life. Both Liliencron and Dehmel were precursors of German Expressionism, and their poems lent themselves to songs composed by Brahms, Strauss, and Hugo Wolf.[97] Dehmel's pan-naturism directly influenced the early work of Arnold Schoenberg, a member of the modernist Viennese Secession.[98]

In the fine arts, Hamburg's achievements during this period fell somewhat short of the highest standards as well, although its progressive style was on the ascendance. Its artists did not belong to modernist schools of the stature of the Secession in Berlin, the Blaue Reiter in Munich, or Die Brücke in Dresden.[99] However, it was home to the dynamic champion of progressivism Alfred Lichtwark, the director of the art museum. He was connected to the Berlin Secession and especially akin to Corinth and Liebermann, whose paintings he would purchase for his gallery, often against a relatively conservative Hamburg Senate. But even Lichtwark stopped short of the ascending Emil Nolde, Max Beckmann, and Pablo Picasso.[100] As for local painters such as Valentin Ruths, Karl Rodeck, and Ascan Lutteroth, they were known in the seaport for their landscapes, but hardly garnered fame for anything on a wider scale.[101] On the other hand, some of them were close to Hamburg's own local Secession, the Hamburgischer Künstlerclub, which Lichtwark patronized in the late 1890s with uneven success.[102] Near the turn of the century, "modernism never became popular with Hamburg's middle class," as was manifested not only in paintings.[103]

Suiting every taste, Hamburg was home to several stages. At the low end was the Ernst Drucker Theater, featuring crude comedies rooted in the local milieu. The Thalia Theater and Deutsches Schauspielhaus performed plays by the likes of Gerhart Hauptmann, August Strindberg, Henrik Ibsen, and Arthur Schnitzler. After 1905 Altona had its Schillertheater, which offered similar fare. At least two stages played operettas, such as those by Walter Kollo and Franz

Lehár; this genre was becoming more popular after 1900. Cinemas were pro-
liferating in Hamburg as they were in Berlin at that time.[104]

Grand opera played under the roof of the Stadttheater. More recently, it had
seen its heyday under conductors Hans von Bülow (regular guest conductor,
1885–92) and Gustav Mahler (*Erster Kapellmeister*, 1891–97). The 1897–98
season marked a crisis, when Mahler left for Vienna and such great singers
as Anna von Mildenburg and Leopold Demuth joined him. The prominent
mezzo-soprano Ernestine Schumann-Heink went to London and New York.
New directors took over, with Regisseur Franz Bittong responsible for the artis-
tic and accountant Max Bachur for the business part. The pragmatic-minded
Bachur was a shrewd counter of pennies; he had moved himself up from the
original post of theater cashier. After the death of Bittong in 1905, Bachur car-
ried on as intendant on his own – without an artistic overseer. But at least he
had the good sense to hire as his musical director, in 1903, the young Gustav
Brecher, a protégé of Strauss, who would preside over Lotte Lehmann's début
at the Opera in September of 1910.[105] Born in 1879 near Teplitz (Teplice) in
Bohemia, Brecher had previously conducted in Leipzig and alongside Mahler
in Vienna. In Hamburg, Brecher tried to stress operas by his idols Wagner and
Strauss and other reputable masters rather than the dubious novelties of some
also-rans, and he was no fan of badly texted libretti.[106]

Until Brecher's arrival there and for the previous dozen years or so, the
Opera's artistic quality had been on the decline, due to Bachur's lack of sophis-
tication and his unrefined program, personnel, and stage policies. It did not
help that the Stadttheater had always been a private venture rented out by
the city's Stadt-Theater-Gesellschaft to entrepreneurial lessees, who could then
treat the stage not as a public, but as a private domain, designing policy as they
saw fit and often with only a glance at the cash register. In the case of Bachur
this meant paying out huge salaries to trademark guest artists, such as conduc-
tor Arthur Nikisch and, regularly every fall beginning in 1906, tenor Enrico
Caruso. A few solid singers were also permanently engaged, such as basso
Max Lohfing, tenor Alois Pennarini, contralto Ottilie Metzger, and soprano
Katharina Fleischer-Edel. But this was a repertory theater obliged to perform
ten months a year, which required great outlays of money to cover routine costs
(and to finance routine staff) on a reliable, ongoing basis. When in 1910 Bachur,
budget-stricken, asked for subsidies from the city senate, these were refused,
and he resigned. His successor in 1912 became Hans Loewenfeld.[107]

Thus at a time when Berlin's and Dresden's Operas were the foremost in
the land, Hamburg's roster of performances after 1897 was above the provin-
cial level, but not at the top. Bittong and Bachur initiated their new season in
September 1898 with *Die Meistersinger*, but this performance was marred by
the lack of a large-caliber heldentenor – a weakness that persisted into Loewen-
feld's seasons. The conductor was Hamburg's regular Karl Gille, not of first-rate
reputation. What followed was a succession of mediocre local premieres, such
as Otto Lohse's *Prinz wider Willen*, really more of an operetta, and Eugen
d'Albert's *Die Abreise*. Bachur developed a particular propensity for the works
of Siegfried Wagner, whose first opera, *Der Bärenhäuter*, was staged as early as
March 1899. Next in line were Wagner's *Herzog Wildfang*, his *Kobold*, *Bruder*

Lustig, and *Sternengebot*. This last was performed in January 1908, at a time when Brecher had already been engaged for five years. Under Brecher's musicianship, new singers came to blossom: Anny Hindermann, Charlotte Schloss, and the New York–born mezzo-soprano Edyth Walker. Furthermore, during Brecher's tenure the early work of his mentor Strauss, *Feuersnot*, was staged in January 1904 (with Strauss himself conducting it in February). Brecher in turn conducted *Salome*, with Walker in the title role, on November 6, 1907, as well as *Elektra* in February 1908. Less successful during this period was the opera of another great composer, Hugo Wolf, better known for his lieder, whose *Corregidor* lacked "dramatic power," as Hamburg's preeminent critic, Heinrich Chevalley, remarked years later.[108]

When Lotte Lehmann began at the Hamburg Stadttheater on September 2, 1910, she had the good fortune of being directed, not only by the expert Brecher, but also by his deputy, the mercurial Otto Klemperer. Klemperer gradually helped Brecher to improve the repertoire. Having arrived coterminously with Lehmann, he was three years older than the singer, but Brecher's junior by six years. Born in Breslau, he had moved to Hamburg as a child and studied at Frankfurt and Berlin, where he was Hans Pfitzner's pupil. On Mahler's recommendation, he had become choirmaster in Prague in 1907, before he left as kapellmeister for Hamburg. His conducting was energetic, even passionate, and, at that time, not noticeably influenced by his many moods.[109]

Lehmann's first role was that of the Second Boy in Mozart's *Zauberflöte*; the Queen of the Night was sung by Hindermann. Brecher conducted.[110] The next day Lotte wrote to Fritz that her début had turned out "very well and everything had gone without a hitch." Brecher had congratulated her afterwards, and her parents too had found it all wonderful. Then followed similar small roles befitting a beginner. The Second Page in *Tannhäuser* was next, and Pennarini assured her that she had chosen wisely to make her start at a stage like Hamburg's, so she could gain experience and build up her repertoire.[111]

But later in September she was already asked to sing Freia in *Rheingold*, the goddess who may promise eternal youth, under guest conductor Nikisch. This was a small step up from that opera's Rhinemaidens Woglinde, Wellgunde, and Flosshilde, who were on a par with the boys and pages she had sung earlier. The reviews, however, were devastating. One paper wrote that Lehmann had been "a fairly helpless Freia, theatrically as well as vocally." Another quipped that "Fräulein Lehmann looked quite nice as Freia, but still sang too much like a Fräulein Lehmann." Although her mother thought she was mortified, Lotte took it all in good spirit, consoling herself that Bachur, Nikisch, and Brecher, knowing the growing pains of young beginners, had done everything to encourage her further. As far as the notices go, this was the first and last time in Lotte Lehmann's entire career that she received such unanimously bad reviews.[112]

Indeed, Lehmann's next role, as Anna in *Die lustigen Weiber von Windsor* on November 27, was truly major and went much better, with Lohfing singing Falstaff and Brecher conducting. She later remembered it as her "first really agreeable part." Her father noted that she had shown much professional discipline and had committed not a single mistake, and the audience called

FIGURE 3. Lotte Lehmann as Agathe in *Der Freischütz*, Hamburg, 1911. Courtesy Special Collections, Davidson Library, UCSB.

her back on stage twice. She had made "noticeable progress," judged the *Hamburger Fremdenblatt*, which had panned her only a few weeks earlier as Freia.[113] She sang Sophie in *Der Rosenkavalier* on April 10, 1911 – a role that she had been promised for the beginning of the year but that had so far been denied her. The critics were divided over her performance: one judging that in spite of her beautiful voice, she was not yet ready for the part, the other lauding her "unbelievable lightness, with brilliant gloss" at her vocal heights, although he too thought that growing self-confidence would improve her stage presence over time.[114]

The year 1912 was a decisive one for Lehmann for two reasons. First, there was the change in management from Bachur to Loewenfeld, which would affect her contractual situation. Second, on Klemperer's urging, she was assigned the

FIGURE 4. Lotte Lehmann as Elsa in Wagner's opera *Lohengrin*, Hamburg, 1914. Courtesy Special Collections, Davidson Library, UCSB.

role of Elsa in *Lohengrin*, which marked her coming out in Hamburg as a local star.

The last performance under Bachur's aegis, on May 31, 1912, was *Fidelio* (without Lehmann), which also signified the end of Brecher's and Edyth Walker's careers in the Hanse town. Brecher was succeeded by Selmar Meyrowitz as *Erster Kapellmeister*, later by Egon Pollak, with Felix von Weingartner as permanent guest conductor. When in early September Loewenfeld became Bachur's successor, he continued to rent the Stadttheater for commercial gain, thereby prolonging the difficulties that had plagued previous proprietors. Loewenfeld's prior job had been in Leipzig as theater director. Born in 1874, he was the son of a well-known Hamburg stage actor and, not unlike Brecher but different from Bachur, was something of an intellectual. Formally schooled in music and versed in the art of conducting, he had written his Berlin doctoral dissertation on the significance of the sixteenth-century Pforzheim organist Leonhard Kleber. Hence, despite commercial pressure similar to those that had always plagued Bachur, Loewenfeld followed in Brecher's footsteps by attempting to restore true art to the Hamburg stage. Like Brecher, Loewenfeld hired new singers deemed to increase Hamburg's reputation as an Opera not yet at the top in Germany: the tenors Heinrich Hensel and Karl Günther, Theo Drill-Oridge

as dramatic soprano, the American heldentenor Francis Maclennan and his English wife, soprano Florence Easton, as well as Polish-born mezzo-soprano Sabine Kalter.[115]

Loewenfeld's assumption of his duties caused Lehmann to reconsider her prospects seriously. At Hamburg, her original three-year contract had been extended to 1915 (later to be prorogued to spring 1916), and it was not clear to her how easily the new director would let her go if she saw a better opportunity. The question was moot, of course, if he appreciated her sufficiently to offer her superior conditions and corresponding roles right away. She herself had the feeling that even though she had done quite well in a few parts (and also had acquired a regional reputation by giving recitals outside the Opera, including in nearby Perleberg),[116] she had not really been featured as one of Hamburg's out-standing female singers. Hamburg critics commented accordingly. After she had sung Martha in Wilhelm Kienzl's *Evangelimann* on October 11, 1912, the local papers spoke of "the youthful freshness of her musically honed soprano" and "how earnestly and successfully this very young, vocally gifted lady is work-ing on herself."[117] That was at best condescending, for Lehmann was at that time already twenty-four, and although she now took lessons with Hamburg's Alma Schadow, she was no longer in the training stage proper. She was longing for a leading part like that of Elsa in *Lohengrin*, something she mentioned to Loewenfeld, and while the director dithered and kept her at bay, she consid-ered breaking her contract and moving to a smaller but more welcoming stage, such as Schwerin's, Darmstadt's, or Kassel's. With this in mind, she wrote to her agent Harder in Berlin, who once again mentioned nothing less than the Prussian Hofoper.[118]

Luckily, Kapellmeister Klemperer was still in the house. In contrast to Loewenfeld, he had sized up Lehmann's talents correctly and tried to convince the director that he really should cast her in the role of Elsa, especially since at the time there was no one else suitable to sing it. *Lohengrin* was planned for the Christmas season, and finally Loewenfeld relented. On November 29, Lehmann, who had been studying the role just in case, turned out to be a sen-sation. "Elsa was such a great and unusual success," Lotte wrote to Baroness Putlitz, "the audience clapped wildly and shouted 'Else,' the curtain went up about 18 times!" The reviews were ecstatic. "Finally an Elsa who was nothing but Elsa," enthused the *Fremdenblatt*. Fräulein Lehmann was "an Elsa of touch-ing gracefulness," raved the *Correspondent*. Overnight, the new lyric soprano had become a prima donna at the Hamburg Stadttheater. Both Lehmann and Klemperer agreed much later that it was this event that launched the singer's international career.[119] From then on, writes Lotte Lehmann in 1974, "I was given one role after another" – mostly the youthful dramatic parts.[120] On March 12, 1913, she excelled as Dorabella in *Così fan tutte*. Critics found her "very attractive" and an artist employing "the entire charm of her youthfulness."[121] On May 15, she was Echo and First Singer in *Ariadne auf Naxos*, on a visit to the Schauspielhaus in Berlin.[122] Lehmann's eighth run in *Lohengrin* occurred in early September of that year: she presented a credible Elsa, it was said, "credible because of the virginality of her appearance, of her voice, of her

non-selfconscious depth of feeling and, for that, her even more sincere mien and comportment."[123]

This was the time when Lehmann was beginning to arouse interest outside of Hamburg, even abroad, enabling her to consider, again, new opportunities. In September 1913, after she had sung the Iphigenie of Christoph Willibald Gluck's opera *Iphigenie in Aulis* – a work that was particularly close to Loewenfeld's heart – she was positively reviewed.[124] At the beginning of December, Siegfried Wagner offered her Ortlinde the Valkyrie, and a Flower Girl for the coming Bayreuth season. But those were minor roles, and no agreement was signed, because it would have conflicted with two preplanned days in Cologne.[125] Later in the month, Lehmann made her début as the Countess in Mozart's *Figaro*, the very role that had helped to compromise her studies with Gerster. This time, she earned accolades. "Genuine warmth," "lively profile," and "enchantingly beautiful vocal sound" were the phrases used to characterize her achievement. There was not a word about difficulties with the heights, which Gerster had accused her of, even if one critic noted the lack of "superior calm" that the Countess should display, intimating that Lehmann would acquire this naturally with advancing maturity.[126]

According to one letter by Lehmann to Baroness Emmy, Intendant Hülsen-Haeseler had wanted to come from Berlin to listen to her Countess, with a possible contract in his pocket for the Royal Opera. Evidently he never made the journey; nonetheless, on January 22, 1914, Lehmann wrote to Baron Konrad that she had had "great success." Apparently she already had an offer from Berlin, starting at 9,000 marks a year (she had begun at 2,400 in Hamburg), which, however, she considered too low a salary for a singer of the first rank. If Hamburg would pay her 15,000 and increase this in a short time to 18,000, she would remain in the Hanse port, but perhaps one could also motivate Hülsen?[127] Be this as it may, having sung a minor role in *Ariadne* at the Berlin Hofoper in May 1913, she sang *Lohengrin*'s Elsa there in February 1914 and was a Flowermaiden in *Parsifal* in April.[128]

While Lehmann seems to have been undecided between Hamburg and Berlin, an entirely different opportunity was coming her way. Probably in the fall of 1913, Hans Gregor, the intendant of the Vienna Hofoper, had traveled to Hamburg to sound out for possible employment a tenor singing Don José in *Carmen*. What happened instead was that he was captivated by Lehmann's Micaëla, and so he decided to hire her instead. The matter took months to transpire, and Lehmann knew about a possible offer by December 1913 at the latest. Her new Berlin agent, Norbert Salter – he was then representing many artists, including Leider – thought she might get 20,000 kronen to start, the approximate equivalent of 16,000 marks, more than she had wanted from Loewenfeld or Hülsen-Haeseler. This was indeed part of the contract that she signed with Gregor on March 11, 1914, and that was ratified by the administration of the Habsburg Royal Theater on November 10. According to those terms, she was to receive 28,000 kronen in her sixth year; the starting date for her contract was fixed at August 18, 1915, which was later changed to 1916, since she wanted to fulfil her contractual obligations in Hamburg.[129]

In April 1914, Lehmann was invited to her first guest performance on foreign soil – to sing the part of Sophie in Strauss's *Rosenkavalier* at London's Drury Lane Theater with the Beecham Opera Company, Sir Thomas Beecham conducting. This was to take place on June 2 and 4, and the honorarium was to be 80 pounds. Frieda Hempel would be the Marschallin, Michael Bohnen was to sing Baron Ochs auf Lerchenau, and Joanna Lippe would be Octavian. Once again, agent Salter had brokered this; he had heard Lehmann sing Sophie in Hamburg and had been impressed. She was to substitute for the ill-stricken Claire Dux, a Polish-born soprano who was a regular member of the Berlin Hofoper and had been Covent Garden's first Sophie in 1913. Lehmann's appearance in London was inauspicious; she found Beecham's direction distorted and complained about it to Hempel, who replied to her, laughing, that music was not important in the British capital, only London itself and the generous fees, to which Lehmann could not but agree. Her two performances as Sophie were later to be considered "unsuccessful" by British critics.[130]

In spring 1914 Gregor had also committed her to the Vienna Hofoper for a guest cameo at the end of October. This was part of the March contract – a tryout on whose success the upcoming permanent engagement would depend.[131] Ironically, because she had now become so popular in Hamburg and been promised what she thought might be an even better contract if she spoiled the March one, she resolved to sing badly to invoke Gregor's rejection.[132] But money aside, by this time it was simply impossible for the perfectionist Lehmann even to try to sing badly. As could be expected, in Vienna she acquitted herself in the role of Eva Pogner in Wagner's *Die Meistersinger* with integrity and verve. Although not all of the discriminating Viennese critics were won over, as her voice was not yet used to a large auditorium, most reviews were very favorable. She was a "thinking actress," wrote the *Wiener Fremdenblatt*. "She grew in song and play from act to act, led the quintet charmingly and already after this first début can be recommended in the warmest terms."[133] Little did the critic know that Lehmann was a future Viennese stage idol.

In Germany too Lehmann did more work outside Hamburg. At a Cologne festival, right after London in June 1914, she sang *Die Meistersinger*'s Eva under local conductor Otto Lohse, and *Der Freischütz*'s Agathe under Pfitzner.[134] The usually cantankerous Pfitzner was so impressed that presciently he wrote to her as "one of the greatest hopes of the German stage." In July and August she spent a few days at the Waldoper in Zoppot, near Danzig in West Prussia, where she performed as Agathe – for 400 marks per appearance and for a guarantee of 1,500 marks. It was comfortably earned money, especially in the company of such a pleasant partner in song as Richard Tauber, who was constantly surrounded by young female fans and himself was full of practical jokes.[135] And in April 1914, Lehmann was invited to the Berlin studio of the French recording company Pathé, which used the cylinder-and-disk procedure, to cut records. In 1975, she remembered "singing in these horns" – in those pre-electric recording years. She made six cylinder cuts, but only the two Elsa arias from *Lohengrin*, "Einsam in trüben Tagen" and "Euch Lüften, die mein Klagen," were released. Although she had received a one-year contract, international developments preempted it.[136]

For meanwhile World War I had broken out. According to his contract with Hamburg's Stadt-Theater-Gesellschaft, Loewenfeld would have been justified in closing the Opera. But he accepted the personal risk and continued on. This was difficult enough, for over seventy members of the company had been drafted and had to be replaced in order to avoid interruptions. A lower audience turnout was also to be expected. But the director merely reduced the fees of lesser company members by 10 percent, and those of the established ones, including Lehmann, by 50 percent. Still, at the end of the 1914–15 season Loewenfeld was able to return 30 percent of the losses to his cast, not least because the Theater-Gesellschaft also made financial concessions.[137]

As far as the repertoire was concerned, works by English, French, and Russian (and later Italian) composers were to be avoided, except for classics such as Verdi's or Georges Bizet's *Carmen*. Instead, more German composers were to be featured, chief among them Wagner, who was duly represented on eighty-two evenings in the first year of the war. Premieres were not allowed.[138] This was reflected in Lehmann's schedule. She sang mostly German and Austrian composers' roles: Octavian of *Der Rosenkavalier*, *Tannhäuser's* Elisabeth, *Figaro's* Countess, the breeches part of Orlofsky from Johann Strauss's *Die Fledermaus*, and so on.[139] A novelty dictated by contemporary exigencies were patriotic concerts for the benefit of war invalids or widows and orphans. Hence Lehmann found herself presenting lieder by Brahms, Richard Strauss, and Max Reger, and arias by Smetana.[140]

Alas, by the end of 1914 Hamburg's culture-loving citizens had learned of Lehmann's impending departure. The young artist had become their most favorite singer; they endearingly called her "unsere Lotte" and bombarded Loewenfeld with letters of complaint for having been unable to retain her.[141] Although by early 1916 Lehmann was actually looking forward to a resumption of her career in Vienna, since the Hofoper was inarguably superior to the Stadttheater, publicly she let it be known that she was "very sorry" to leave the Hanse port.[142] Her protracted departure appears to have been carefully planned and orchestrated. At the end of her last Hamburg season, in March 1916, she starred in *Die toten Augen* as Myrtocle, the blind wife of an ugly man, who after regaining her sight and committing adultery, allows the sun to blind her once more and returns contritely to her husband. This contemporary opera by master pianist Eugen d'Albert was right for the occasion: although banal, its heroine was capable of eliciting floods of tears from a profoundly moved audience. "As Myrtocle, Fräulein Lehmann made a wonderful contribution," wrote the critic Hans F. Schaub, predictably. The stage was a sea of flowers, and the audience carried her to the car taking her home.[143] Enlarging on her final success, Lehmann presented D'Albert's aria "Amor und Psyche" again in a special farewell recital in Hamburg's Coventgarden hall on Saturday, June 3, framing it with offerings from earlier triumphs as Elsa and other Wagner arias, as well as lieder by Schumann, Brahms, and Strauss.[144]

Hamburg represents the formative phase in the professional career of Lotte Lehmann; after arriving in Vienna in 1916, she would soar to her greatest heights. One measure of how good she already was in Hamburg – or, putting it differently, how quickly and seemingly without effort she learned scores and

picked up an operatic singer's special skills – is a random comparison of her performances with those of her colleagues over time. In the various Hamburg reviewers' eyes and ears, Lehmann had a few downs, but many more ups. Yet it was quite different with others, with the possible exceptions of bass Max Lohfing and soprano Katharina Fleischer-Edel, who were much more advanced in their careers.

The dramatic soprano Theo Drill-Oridge, for instance, was frequently chided for the shrillness of her voice, although Chevalley liked the spirituality of her singing.[145] The baritone Heuser, the Herald in *Lohengrin* in September 1913, was said to sound as if calling from a padded telephone cell. Another writer observed that "even if a herald is not exactly a cheerful person, there is no need for him to look so sad."[146] In the case of the "giant American" Bennett Challis, who sang Telramund, his forte and accented German did not pass muster. Besides, he was said to press his voice at the heights and overdo his vibratos. Later critics found this Telramund comical because he had a tendency to overact.[147] The leading heldentenor at the Stadttheater, Heinrich Hensel, played Lohengrin merely "with variable fortune and ability," said one critic, while the leading contralto, Ottilie Metzger, exaggerated her Ortrud.[148]

In the following fall Wilhelm Grüning, whom Lehmann had once admired while a student, came from Berlin. Whereas, in Wagner's *Rienzi*, her own Irene was touted as "the best vocal achievement" of the evening, Grüning's Tribune was said to be less than perfect. His resonance was "too monotonous," his voice suffering from "a loss of lustre and of bloom."[149]

One month later, Mark Oster's Count Almaviva in *Figaro* was characterized as "very proper" and lacking a strong personality. In March 1915, Wilhelm Buers was Wolfram in *Tannhäuser*, producing "thick, penetrating tones." Jean Stern sang the Landgraf "in rasping harmony," and Gertrud Stehmann's Shepherd Boy was "somewhat boring." Only Lehmann was said to adhere completely to "the musical line."[150] In January 1916, in Weingartner's opera *Kain und Abel*, the composer's own wife, Lucille Marcel, was observed to be trailing Lehmann.[151] And in one of her last appearances on the Hamburg stage, Lehmann's soprano, as Elisabeth, was said to have grown to "a power and greatness that did not in the least infringe on her touching simplicity." Anna Scheffler, on the other hand, sang Venus too aggressively, and Stehmann's Shepherd was too sentimental.[152]

Hamburg's less than first-rate standing manifested itself not only in its chorus of voices (even though some of those mentioned here were taking care of minor roles), but also in the orchestras, stagings, and directors. Hamburg's own critics thought that even during Brecher's tenure as chief music director the "devil of slackness" by and large held sway on stage – his efforts to excoriate this devil were commendable, but futile.[153] And the directors who then followed Brecher were never quite his equal. Although Kapellmeister Meyrowitz was no Klemperer, he was credited for his "courageous fight against the retarding powers of a paralyzed tradition." But he himself committed errors, such as conducting *Lohengrin* in a rhythmically uneven manner and holding back the orchestra in *Iphigenie*, both in September 1913.[154] Uneven tempi became a nasty trademark of the Hamburg operatic pit and pulpit.[155] Other characteristic evils

were the unreliable quality of the choir and, during overtures, the sound of human voices behind the curtain.[156]

In hindsight, one can argue that Lehmann would have been better served by one of Central Europe's first-ranking stages, and that she should have found a way to accept Count Huelsen's repeated offers of employment. In Berlin, her taste might have been shaped more appropriately in the direction of a serious-quality repertoire than could have been the case at the second-class Hamburg Stadttheater. Such education was necessary, for in her lower-middle-class home she had been brought up with folk and popular German songs; she had become acquainted with solid operatic literature only after beginning at the Berlin Musikhochschule. And so in Hamburg she found herself too often serving up lighter fare, without even finding very much wrong with that. This happened especially during recitals. Sometimes she chose such programs deliberately, as in October of 1911, when she wrote to Baroness Emmy that she had just sung a "nice new role," that of May in Karl Goldmark's *Das Heimchen am Herd*, which today is characterized as a work of "unabashed sentimentality."[157] "The music I find strongly saccharine," wrote Lehmann, "but the role suits me and I can shape it to my advantage."[158] In March of 1912 she offered in recital a song by Max Loewengard, who was a critic of the *Hamburgischer Correspondent*. She knew his family socially; he liked to read her poems, and she was aware that he favored her voice. When all was said and done, Loewengard, a former Berlin composition teacher, was a good critic but no renowned composer of songs. In the same concert she sang songs by the Romantics Robert Franz and Anton Rubinstein – popular, but hardly mainstays of high-level classical song.[159]

It is true that Lehmann was also featured in several less meretricious operas on the Hamburg stage, but that was hardly her doing, for Loewenfeld, for all his love of early music such as Kleber's and Gluck's, happened to have a penchant for light opera. He especially wished to enliven the repertoire by moving away from the grave, heavily symbolic works of Wagner and into some of the brighter ones, even if that meant excursions into risky experimentation and qualitative flimsiness. Hence he found Albert Lortzing "lovable," Otto Nicolai's *Lustige Weiber von Windsor* "unique," and Gustav zu Putlitz's friend Flotow's *Martha* not a warhorse, but equally delightful. Some of the older, more forgettable works, such as *Der Barbier von Bagdad* by Peter Cornelius, he wished to see resurrected, "for it does a spoiled stomach good not always to be forced to digest the heaviest diet."[160]

Der Barbier von Bagdad was staged in Hamburg in 1915, with Lehmann singing Margiana. One critic wrote: "Seldom has a work risen from the dead as often as the Barbier von Bagdad by Cornelius. This could happen only because he has been dead so often." According to this writer, many agreed that the opera had always been a masterpiece. Nonetheless, "failed masterpieces" were also known to exist. This latest resurrection, thought the critic, was "quite decent" and Lotte Lehmann verily "brilliant."[161] Another opera yet again performed in 1915, as it was palatable for many even in its near-banality, was Kienzl's *Der Evangelimann*. Designed for the Christmas season and created in rural Styria, it was found by some "folksy," if rather faithfully rendered. Lehmann's *Martha* showed the emotional capacity that was well called for here and that

was by then one of her recognized specialties.[162] In 1916, along with *Die toten Augen*, Jacques-François Halevy's *La Juive* was featured, a particular favorite of Loewenfeld's. Although it was "yesterday's art," as one columnist observed, it had an inner life, and Lotte Lehmann's depiction of the heroine Recha, who is boiled in a kettle of oil, had made the staging worthwhile.[163] With *Die toten Augen*, composer D'Albert attracted the ridicule of most critics; the only good thing that could be said about it was that, again, Lehmann's singing rescued the venture. Chevalley, the doyen of the Hanse critics, would nonetheless have preferred Lehmann's Elsa from *Lohengrin* as her parting gift, or her Eva from *Die Meistersinger*.[164] Loewenfeld's concept, it seems, was not working, earlier efforts by Brecher and Bachur aside.

When young Lotte Lehmann started out in Hamburg in late summer 1910, she lived there with her parents and Martha the maid, who had come along from Berlin. Fritz stayed in the capital, because he had taken a job there as a Prussian Landgerichtssekretär, a medium-level civil-service position that his upwardly mobile father was extremely proud of but that the entire family tried to relocate to Prussian Altona, so that he could be close to them all. This he never managed. Lotte, who until her success as Elsa in late November 1912 was still finding her way, both professionally and as a slowly maturing woman, would have welcomed the additional emotional support from her six-years-older brother; as it happened, living with her parents provided some of that needed support.

Perhaps it was the family's mistake not to let the young artist strike out on her own, but her being tied in with her closest relatives in this manner said as much about her small-town origins, and about the concomitant petit-bourgeois mentality that was a hallmark of the entire Lehmann clan, as it did about her own lack of security. It is touching to see how she attempted to make her parents' move from Berlin to Hamburg worthwhile: by contributing much of her meager wages to the family pool for meeting living expenses, or by supplying free theater tickets to a proud pair of parents who craved witnessing their daughter's budding success from close by. There were problems with all three of them. Mother Marie continued to be ailing, and she was missing her son. Father Karl was left with only a tiny pension, at the age of sixty-one was work-shy, and never ceased talking of how much he wanted to move back to Berlin. And last but not least, Lotte herself felt a growing need to emancipate herself from her progenitors; while she found them querulous, she did little on her own to defuse the ever-increasing tension. Fritz was her soulmate, with whom she corresponded almost on a daily basis and on whom, for the first few months, she was also dependent materially.[165]

The protective parental aura became so stifling that by 1914 the twenty-six-year-old Lotte had moved away from the original flat and taken a new one, sharing it only with her beloved mother. Her father, still impecunious, was living elsewhere in the Hanse port, substantially supported by his daughter. In the fall of that year Lotte had reason to be worried about Fritz, because he was due to be drafted to the front, but as it turned out, owing to a weak heart he was merely posted to a Berlin-based reserve regiment for back-area duty. During

the last half of her Hamburg stay, as the father left them alone, her mother adopted a more reasonable attitude toward her daughter vis-à-vis her devotion to her darling Fritz. As her professional successes multiplied and – a natural consequence of this – material cares receded into the background, Lotte's self-confidence grew, and she became ready, emotionally and intellectually, to cope with the increasing challenges facing an artist developing into some prominence: her international sojourns in London and Vienna, various calls to Berlin, and the guest appearances in Cologne, Zoppot, and Rostock. The one constant in this series of changes leading to greater personal maturity was her unstinting loyalty to Fritz, whose continued trust in his sister's potential was the bedrock of what stability she possessed. Had he fallen at the front, she would have been totally at sea.[166]

To the extent that Lotte's Hamburg salary remained low in the first few years but served to support three people rather than one, the Lehmann family continued to be dependent on the financial support of the Putlitzes. This all the more so, because they lived beyond their means, for neither Karl Lehmann, nor his daughter – nor Fritz in Berlin, for that matter – was thrifty. "I really want to know if we can ever make ends meet," wrote Lotte to Fritz in November 1910, "it is always the same story."[167] And only days later: "I will give you 100 for Christmas. Obviously beforehand, otherwise it will surely be spent."[168] The flat in the Isestrasse, where they took in Martha the maid – for a maid was de rigueur for self-respecting households – was relatively expensive; it was situated in a well-to-do residential area usually favored by young professionals.[169] A pair of sandals cost twenty marks in 1910, to have one's hair coiffed 1.70, and Lotte's agent Harder required ten marks per month.[170] Lotte was earning 200 marks before deductions.

There were, then, altogether four sources of money that served to support Lotte and her parents. First was her salary, which was later complemented by extra fees for private and outside public engagements. Next came Karl Lehmann's minuscule pension, which could have been supplemented had he not been lazy. Even the baroness was of the opinion that he should look for a job, but instead, he used up money from a Berlin pawnbroker who held his golden watch chain.[171] Then there were funds Fritz sporadically sent from Berlin, some of them earned, the rest borrowed. And finally there were additional monies from the Putlitzes, ostensibly in the form of loans, but as far as the documents indicate, those were never repaid. (Beyond that, the baronial family shipped produce like potatoes from their fields.)[172] Lotte begged for such loans herself a few times, but her father too swallowed his pride in asking the baron for money.[173] Both Lotte and Karl Lehmann remembered well what the baroness had communicated to Lotte at the beginning of her Hamburg stay: "I feel motherly toward you," she had written in her God-fearing way, "never do trust anybody. You have your parents, and you have us to whom you can turn."[174]

And turn Lotte did, also in matters concerning her profession, even if she used mediators along the way. Lotte may have been insecure and shy at first, but because she was convinced of her qualities as a singer and her vocational choice from the start, she was determined to advance as quickly as possible.

And as she had been able to influence people and steer them in her direction in Berlin, she practiced this also in Hamburg, with considerable success. The singer Anny Hindermann, who knew the Putlitz family, thought that Lotte should use her connections to the baron to intervene with Director Bachur, in order to obtain better roles. Lotte agreed, not without cynicism: "Bachur is a Jewish parvenu, who would be flattered. I shall write this to Putlitz." This was as early as September 1910. In October, with a letter having been sent off to Gross-Pankow, her father was to speak with Putlitz in Berlin. She again pushed the point with Baroness Emmy and also asked Madame Mallinger to intercede. Mallinger finally wrote to her in November that Bachur had told her Lotte was already being considered more than a beginner at a theater like Hamburg's could expect, but he promised larger roles like those from *Der Rosenkavalier*, and was Lotte not currently singing the part of Anna in *Die Lustigen Weiber*?[175] To be sure, as roles such as these materialized, her economic situation was palpably improving.

By about 1914, extra work was netting her hundreds of marks more an evening, in addition to what the staggered contract clauses brought. Hence in the spring she sang at the silver wedding anniversary of HAPAG director Ballin for 300 marks, and for the same sum again in the spa of Bad Neuenahr.[176] In the fall of that year, at the beginning of World War I, which caused some food and supply rationing in all the major German cities (in Hamburg affecting bread and coal), she was still comfortably off.[177] Prices, especially for foodstuffs, were rising, but so had her income, despite the Stadttheater salary limitations she had had to bear. Hamburg's opera losses were much smaller than anticipated, because the auditorium was mostly full, so that Lehmann could write to the baroness in December: "I am living just as I used to, so that I am actually ashamed at suffering so little."[178] By the summer of 1916, at the end of her last season, the singer was earning 15,000 marks annually, whereas her good friend Elisabeth Schumann, who had arrived in Hamburg one year earlier, got only 9,500.[179]

With her colleagues in the theater during the first few months of the beginning season Lotte Lehmann was apprehensive, especially because her narrowminded family had warned her about rampant immorality in the place: "The director and the conductor and everybody want to seduce you."[180] Yet, having arrived as a naïf, she gradually developed self-confidence and a sense of humor as she got to know her peers. Being among the youngest at first, she was regarded as "The Child" who had to be initiated, taught the ropes, and sometimes made the butt of jokes. Sexual mores and the position of women being what they were in those patriarchal times, she was pinched in the cheek and impulsively embraced by the males, yet Lotte good-naturedly tried to tell herself, as well as her overly protective brother, that all this was harmless and in good fun.[181] Beneath the cover of "The Child" she was working extremely hard to get ahead of everyone else in her group, and when she had made some strides by about 1913, she tactfully distanced herself from her peers without reaping any ill will.[182]

Among her male colleagues she liked best Paul Schwarz, a tenor buffo originally from Vienna. "He could stand in for any tenor who failed to show up,

no matter what his specialty." Lotte was in awe of "Paulchen's" versatile musicality, but she recognized that Mime from *Der Ring des Nibelungen* was his true forte.[183] On September 2, 1910, the first time she sang on the Hamburg stage, her two partners in *Die Zauberflöte* were Annemarie Birkenström and Elisabeth Schumann, as First and Third Boy.[184] Birkenström proved very loyal and a good sport, so that Lotte found no difficulty rooming with her intermittently as the messy situation with her parents was sorting itself out. Once, when they had bought lottery tickets, they were projecting the future if one of them won. It was decided that the winner would give her friend the other half. Annemarie was going to place Lotte's share of the money in the bank, where she would have no access to it without Annemarie's permission. "I boiled with fury," remembers Lehmann. "'And may I ask why?' I asked with icy disdain. 'Of course,' she answered quietly, 'if I give you the money, you will give it away immediately and will have nothing from it'." Generous to others but a spendthrift nonetheless: this was not an altogether unrealistic characterization of Lotte Lehmann at that time, or later.[185]

Until her untimely death from cancer in 1952, Elisabeth Schumann was Lotte Lehmann's closest friend, from among all the singers she knew, but early on their relationship was somewhat problematical and brought out the worst in Lotte. Lotte was immediately struck by this colleague who was her own age: "she had a ravaging sweetness." Indeed, Schumann impressed everyone, especially men. "Schumann was small and provocatively pretty," writes the English tenor Nigel Douglas, "and her voice was characterised by a purity of tone and ease of emission ideal for the expression of childlike heedlessness."[186] Fittingly, her specialty was to become Mozart arias, and lieder.

Things went famously between Lotte and Elisabeth at first; Schumann even offered her the role of Peppa in D'Albert's *Tiefland*. She was "a very fine girl," Lotte thought early in the 1910–11 season; she also was impressed with her fiancée, a dapper Hamburg architect.[187] However, after Bachur and Brecher had led Lotte to believe that it was she who would get to sing Sophie in the upcoming performance of *Der Rosenkavalier*, and after she had studied that part diligently for months, it was Elisabeth who sang it on February 21, 1911, with Lotte merely as an understudy.[188] Schumann took the audience by storm, and Lotte was beside herself, even though there had been solid musical reasons for the casting. Schumann had the greater experience, and Edyth Walker, who sang Octavian, had specifically asked for Schumann. But Lotte saw only that Walker was Brecher's mistress and with his connivance ruled the Hamburg stage with an iron hand.[189]

For a while this was a serious test of friendship, for Lotte thought that Elisabeth had intrigued against her, and even when she realized the decision had been justified on objective grounds, the young singer discovered one of the personal characteristics of her craft that was never again to leave her: professional jealousy. She was full of "envy and of jealousy," she wrote to an acquaintance; just by the manner in which she would "begrudge any colleague a success, you would abhor me, yes, even colleagues whom I *really* like."[190]

Potential rivalry did not exist in the case of male colleagues, but Lotte's relationship with men around the Hamburg stage was determined by her gender

and certain love interests. This led her, early on, to consider her physical appearance. Comparing her to Elisabeth Schumann, Klemperer's biographer Peter Heyworth has pronounced Lotte Lehmann a "plain Jane."[191] To be sure, she was not as immediately fetching as the sylphlike Elisabeth, but a plain Jane Lotte was not. She was tall and somewhat strongly built, with a broad face that unfortunately did not emphasize high cheekbones.[192] But photographs of the period show her with lovely eyes and a winning smile, and her natural demeanor added to the charms of her personality, among which a disarming openness and a quick wit were outstanding. Yet the pictures also show that she was overweight.[193] And indeed, this was Lotte's greatest problem at the time, and it remained her problem, even considering the fact that in those days the current trend toward extra-thin figures, which drove a Deborah Voigt from a London stage in 2004, did not obtain and that ampler female figures could be forced into corsets.[194] Admittedly, then, Lotte was not stunningly good-looking, either by the Hollywood standards of today or by the standards of her own time. "I wish I were very beautiful," she lamented to Fritz in September 1910, "but perhaps my smartness will do it."[195] On stage, she knew, she could be made up to look a lot more beautiful than she really was, and carefully tailored period costumes could enhance her as well. This always consoled her somewhat.[196]

In her mature years, especially when interacting with her students, Lehmann always insisted that a broad range of emotions be expressed when representing a character in the opera. This, she claimed, could be done only after having experienced the entire gamut of emotions in real life oneself.[197] With that she implied that a female singer playing a mistress or even a strumpet had to have had expressed sexuality in her personal life – even if this meant sexuality bordering on promiscuity. She herself, she remarked several times to others, had had a wild time when starting professionally in Hamburg: "I was never a 'virtuous woman.' I was rather bad when I was young." Once, when she was asked whether the first man she had had an affair with in Hamburg had not been a tenor, she insisted: "No! He was a baritone."[198]

As far as Hamburg is concerned, we can safely dismiss these claims as post factum posturing, and posturing she did even in Hamburg. However, if she intended, in old age, to enhance her legacy, she was quite successful.[199] Early in her life in the Hanse town, in her self-awareness as prettily attractive but not stunning, she tried to impress certain males short of running after them, and she exaggerated near-conquests in her letters to brother Fritz. This path she followed until about 1913, when she was becoming more successful and, as a result, more sure of herself. Until this time, there were four men she was interested in, all of them more or less simultaneously, which suggests that she was trying to play them against one another to her best advantage. Apart from possibly sincere romantic interests, she also displayed a certain shrewdness in her use of men as objects of professional advancement – a manipulation of people she would employ frequently later in life.[200]

Assuming that Lotte had lost her virginity as the fiancée of Willy Hilke in Berlin, the first male she encountered in Hamburg was her superior Gustav Brecher, who in 1910 was thirty-one, as opposed to her age of twenty-two.

She found him intriguing if moody, and of course – power being a most potent aphrodisiac – attractive, as he was boss of the Opera. Although he looked her deeply in the eyes, and she was using her eyes to best advantage, she was sorry that he was not really interested in her because his paramour was Edyth Walker. "If only I were his type, I would have it made," she remarked in October. But even though she fancied that he might be tempted to take up with her, in reality she knew that he was too elevated, "godlike" really, and therefore one who might be charmed into artistic concessions rather than lured between bedsheets. Her attentions to him had waned by 1911, as he had reneged on his first *Rosenkavalier*-Sophie promise, and she had become more seriously involved with one of the lesser kapellmeisters.[201]

His last name was Hermanes, and he was mostly in charge of choirs. Lehmann has referred to him in her recollections as "the benign guardian angel of my beginner's phase." History has kept no known record of him, but he was around forty in 1910 and still a bachelor – which mother Marie found perilous and father Karl an opportunity of sorts. Lotte liked working with him in rehearsals and raved about his kindness; at the same time, she worried about his reputation as a playboy with plenty of other young females in his pool. In the case of Hermanes, the thought of marriage crossed her mind, the more so since she liked to imagine that he loved her, although he was most certainly Jewish and she a Prussian, albeit nonpracticing, Lutheran. (While Lotte's occasional asides against Jews were harsh, in the direct manner that was her character trait, they were not heartfelt expressions of anti-Semitism, such as her father's, but concessions to her social class and the zeitgeist. Anti-Semitism was, after all, a typical attribute of the German lower middle class and a mentality steeped in Prussian chauvinism. But since many of her colleagues in Hamburg were Jewish, Lotte soon accepted Jews on an equal footing, her bigoted mouthings notwithstanding.) There is no proof of love or sexual play on Lotte's part, and the pair's socializing possibly remained relegated to movie visits – but officially, they were dating. When colleagues started gossiping about them, however, Hermanes became more reticent, and Lotte herself withdrew somewhat.[202]

She would then give in to the beckoning of a rich Hamburg Jewish gentleman by the name of Gerstenberg, who was already in his fifties and no doubt harbored amorous intentions, knowing that Lotte Lehmann – the typical parvenu already somewhat up the social ladder – wanted to have "elegance" and "much money," not to mention instant professional success.[203] Gerstenberg, a connoisseur of culture, knew both Bachur and his deputy, Siegfried Jelenko, well. He would tell Lotte how pretty she looked, fetch her for restaurant suppers, try to show her off as a trophy to his wealthy friends, appear regularly as her loyal fan in the audience, and attempt to exploit her sexually, perhaps as his mistress. After all, this was something many men of means and varying tastes did all over Central Europe at that time, with some preferring soubrettes or chorus girls from the operetta, others young actresses or ballerinas, and less discriminating ones circus or *Varieté* artists. In search of possible advantages, Lotte obliged the older man socially, albeit with obvious distaste. "This morning I saw Gerstenberg in passing," she informed Fritz in September 1910, "as he stood at the billboard and studied the theater program. Now one has to be

very, very smart." And later: "He most certainly has no good designs. This old
Jew. He asked me to go out and eat with him and 'some friends.' Who these
friends were, he could not exactly say." After the cynical Fritz had evidently
suggested that she seduce him systematically for tangible gain, she nevertheless
wrote back: "This I really cannot do. This for me is too revolting. I can make it
without the old Jew. He may be useful, no doubt. For instance, if he gets me pri-
vate engagements and so on. But not really professionally, no. On the contrary.
It casts a very bad light on me." As it turned out, Gerstenberg did get Lotte
private engagements, which she accepted, as she badly needed the money.[204]

The great love of Lotte Lehmann's early Hamburg years was Otto Klemperer.
He seems to have enjoyed chasing her around tables as much as she liked flirting
with him, using her eyes. She found that the gaunt, dark-haired man with intense
eyes of his own and that intellectual forehead looked like a mad genius, and he
amused her with his constant physical advances. At the same time, she realized
that he was, artistically, somebody very special. Whenever Klemperer could, he
tried to throw his arms around her, and he asked her more than once why she
still did not love him. Whereas his ardor enthralled Lotte, she could not have
discerned the precariousness of his manic state, which caused this mentally ill
man to act so obsessively toward young women, now and in later life. She sent
him poems anonymously, but of course he knew whom they came from.[205]

How serious was Klemperer about Lotte beyond the proverbial one-night
stand? In June 1961, the seventy-six-year-old conductor wrote to the seventy-
three-year-old singer that it was a pity they had never got together, but the
water had been too deep. This was a poetic allusion to an old German folktale
that told of two princely adolescents who could never be conjoined in love
because they were not able to cross through the deepest well.[206] Klemperer
was referring to fate that had caused him to fall in love at that time not with
Lotte Lehmann or any of the other opera ingénues he may have routinely been
after, but with Elisabeth Schumann, whom he met upon arriving in Hamburg
in autumn of 1910, when she had already been there for a season. When he
first saw her, he seems to have been thunderstruck.[207] The relationship between
the two was at first intensely artistic but by 1912 had developed into love, a
dangerous state for Elisabeth, who had wed the young architect Walther Puritz
not long before. The drama was approaching its climax when on November 29,
1912, immediately after Lotte's début as Elsa in *Lohengrin*, Kapellmeister
Klemperer eloped with Schumann. Not only had they thereby put themselves
into a breach of contract with the Stadttheater, but after their return Puritz
challenged Klemperer to a duel with pistols, which he refused. From then on
Klemperer, who was now living with Schumann, appeared at the Opera only
sporadically. He was there on December 26, to conduct *Lohengrin* once more.
During that performance, Puritz was sitting with some friends in the front row,
immediately behind the conductor. Lotte, who was singing Elsa, reported to
Baroness Emmy what happened. At the final chorus, Puritz called out from his
seat to Klemperer: "'Turn around,' and then hit him across the face with a rid-
ing whip. It was an awful scandal. And for me it was an unforgettably horrible
evening. Klemperer is now dismissed and last night he left town with Schumann.
She was also slated for dismissal, but has been put on leave for 4 weeks on her

husband's urging. According to him, she is sick. And once she returns to sanity, he wants to take her back!! But whether Dr. Loewenfeld will ever let her perform again is very questionable. Is all this not terrible? I feel deeply sorry for all three of them. I cannot condemn Schumann, as so many are doing. All this is not child's play. She must have struggled honestly."[208] Klemperer then departed from Hamburg, whereas Schumann returned to her husband and, eventually, also to the Stadttheater.[209]

Lotte Lehmann's relationship with Klemperer, therefore, never got beyond the limitations of a flirt. In fact it is doubtful that Lotte had any serious friendship, let alone love affair, with a male from 1910 to 1916, because until 1913 or so several attempts had misfired, and thereafter she was very busy grooming herself in her new role as Hamburg's, and soon Vienna's, prima donna. There were, however, three more men she had dealings with, and the manner in which she talks about, or is silent about, those relationships as well as evidence from the relationships themselves is indicative of the relative innocence of each.

As stated earlier, Lehmann tried to defend her image as a lady of early sexual adventure once she had reached a matronly age, whatever her reasons for that. One of her favorite ploys was an allegedly dangerous potential encounter with Enrico Caruso, on his 1911 annual tour to Hamburg – a tour he always managed to undertake in the fall. In her recollections, she pictures a Caruso who heard her sing Eurydice in Gluck's opera and was enchanted. She was a member of a dinner party the Stadttheater had organized for his benefit and, according to her, was very much at the center of his attention. The next day, so she tells her readers, Caruso sent her an invitation to another dinner that made her believe that it was to be just for the two of them, and, so she writes, she came to harbor great expectations of seduction by the greatest tenor in the world. Yet ever since the 1930s she had used these images merely to uphold her reputation as an early femme fatale. The reality was quite different, for after the first dinner she knew exactly – as she announced to the baroness – that the second one was a return invitation by Caruso to the entire opera company staff, not to herself alone in an imagined *chambre séparée*.[210]

The next possible lover was none other than Baron Konrad zu Putlitz himself. Significantly, she is completely silent about this, in letters and in memoirs. As Putlitz's grandson Bernhard von Barsewisch tells it, he had to travel to a funeral in Bremen on behalf of his wife, which made it easy for him to pass through Hamburg to catch Lotte as she was about to perform her first Elsa. He then took her out to dinner, and they exchanged poems; Barsewisch mentions that an intimate relationship "cannot be totally ruled out." The baroness had been ill with arthrosis for many years, was practically immobile and an austere, joyless middle-aged lady, whereas the baron loved the brighter side of life and was still very attractive to women. Barsewisch's account would set the date of this encounter near the end of November 1912; an ongoing relationship could have lasted for the next four years. There was hushed talk about this in the Putlitz family, and eventually Emmy zu Putlitz ordered Lotte to have all her husband's poems burned. Lotte is said to have obeyed.[211]

Several pieces do not fit here to make this puzzle whole. There is no doubt that Putlitz came to listen to one of Lehmann's Elsa performances, but of the

sixteen she put on following her début on November 29, 1912, it is most likely
that he heard one of the five she did in early 1914, for it was in April of that
year that an intense if brief exchange of letters between the two took place, and
it was on April 8 that Lehmann wrote to Emmy Putlitz that she was "incredibly
glad that the Baron liked me as Elsa."[212] It is also interesting that in January, as
a possible prelude to a Hamburg rendezvous, Lehmann had again been writing
to the baron regarding her job situation, and she must have felt obligated.[213]
But even if the baron had forced himself upon her after the Elsa performance –
though she had apparently warned him then that it was Elsa, not Lotte, whom
he was infatuated with[214] – she would not have had the nerve to continue
her innocently loquacious correspondence with his wife the baroness for years
thereafter, especially since she was sexually and emotionally so inexperienced.
(Nor would the baroness have agreed to a continued correspondence herself.)
This holds true even if she thought she owed the baron sexual favors as a sign
of gratitude – although in those days, before the end of the monarchic order
in Germany, some noblemen were still in the habit of taking advantage of the
young women in their realm as their consecrated right.

The strangest relationship Lotte Lehmann had with any man during her
Hamburg seasons occurred after she met the painter Paul Jaensch, from Berlin,
in Hiddensee. This was a small but beautiful island in the Baltic Sea near
Rügen, where after 1910 she went vacationing in the summers, characteris-
tically always with Fritz. Although it remained entirely platonic, Lotte wrote
"Herr Jaensch" long letters explaining to him aspects of her professional life
and assuring him how highly she thought of him. Whatever the purpose of this
relationship and the meaning of the many accompanying letters (we have only
hers to him), they throw no light whatsoever on Lotte Lehmann the romantic,
the amorous temptress, or the self-confident bride. She was obviously a tease
to Jaensch because she called him "Nikisch," after the great conductor, and
reminded him many times of how bad a person she really was, as if to scare him
away from her. But she may have used him to test her powers as a woman in
a coquettish manner merely as an exercise, for she wrote him that she also got
playfully involved with a man in Hiddensee called Pontini, who was married.
Apparently – at least according to her letters to Jaensch – the poor man fell so
hopelessly in love with her that his wife called her a harlot, and one sad day
Pontini put a gun to his head and shot himself, whereupon his wife followed
suit. If true, Lotte does not seem to have felt any remorse over this, but instead
continued her rather innocuous correspondence with Jaensch, whom she
promised to visit in Berlin yet apparently never did. It is possible that she was
using the painter as a trial target to see just how far she could get with a man
until she had to commit herself mentally and physically, or else as a sounding
board, to test the effect of news of her professional development on him.[215]

Apart from what this may say about Jaensch, it would be strange for any
young woman to maintain a correspondence with an eligible bachelor for
years without the slightest move toward, or chance of, romantic involvement.
Other girls truly in love would have wanted to consummate such a relationship
rather than waste their time with idle chit-chat. At least Lehmann could have
experimented emotionally and sexually with Jaensch, found him wanting, and

then let him go. Instead, the relationship remained a sterile friendship with "such a rare person" well into her Vienna seasons.[216] Given her other experiences thus far, the possibility exists that Lehmann simply could not find the right man, no matter how hard she tried, or else that she was not physically interested in men, even though she liked their company and knew that they could help in her career. For by spring 1916 she had met Mia de Peterse, who sent her at least one full-fledged love letter. Mia, from a real-estate-rich family in Hamburg, had been part of a group of teenage girls who were in the habit of ambushing Lehmann at the Opera exit after rehearsals, and even in front of her apartment. Mia was special because she regularly managed to deliver a bunch of mayflowers to Lotte's backstage dresser or even when she entered the taxi, until Lehmann finally grabbed her hand and did not let go. She wanted to get to know the girl who had written her in June 1916: "My heart is longing so much for you, for some words from your dear hand.... Oh I wish my love could build golden bridges for you!" In August, Mia wrote Lehmann of her alternating feelings of acceptance and rejection, and of a kiss she dreamt Lehmann had planted on her face. Lehmann answered: "You make me ashamed with your great adoration and love." The artist in her would rejoice about this, but as a person she would ultimately disappoint Mia. "Your love has been a rich joy for me." Lehmann offered Mia a picture of herself, to be fetched at a certain time between two and three in the afternoon. Lotte really wanted to meet this girl in person.[217]

They finally met, and Mia de Peterse, who after World War I married a German-born Jew who managed a metals-recycling business in Atlanta, would remain her lifelong friend. Her first-born daughter would be called Mialotte. For Mia de Peterse-Hecht was merely the first of several women in the singer's life to whom Lehmann was strongly drawn.

2

Rise to Fame in Vienna

From Empire to Republic

October and November 1916 were two eventful months for the Viennese. On October 21, during lunch at the upscale Hotel Meissl und Schadn, Prime Minister Count Karl Stürgkh was shot dead by the Social Democrat Friedrich Adler. "Down with absolutism," shouted Adler, "we want peace!" For the historian Eric Hobsbawm, who was to move to the city of his mother's birth from Alexandria three years later, this later appeared as "a protest against the First World War"; others have stressed it as a demonstration against autocratic rule, for Stürgkh had abolished parliament and suspended individual liberties.[1] With the country on the brink of chaos, Emperor Franz Joseph died on November 21; he was eighty-six. The war was going badly. Already in the summer, during the Russian Brusilov offensive, Czech and Ruthenian soldiers had deserted to the tsarist side. In early October, Russian and Romanian forces were pushing heavily against the Austro-Hungarian army in the East, whose soldiers were barely able to fend off Italian assaults on the Isonzo front in the South.[2]

Not all Viennese citizens would have paid attention to such unsettling news. On October 4, habitual patrons of the Hofoper were more interested in the premiere of Richard Strauss's opera *Ariadne auf Naxos*, which had been newly fashioned from his earlier work premiered under Intendant Joachim zu Putlitz in October 1912 in Stuttgart. On that Wednesday, Lotte Lehmann had been asked by Strauss himself to sing the part of the Composer, which had been added to the original plot. The cicumstances leading up to this were not altogether comfortable ones for Lehmann. She had initially been designated as an understudy to the famous soprano Marie Gutheil-Schoder, whom Lehmann had seen in *Elektra* and much admired.[3] So when Gutheil-Schoder came down with a cold, Lehmann was asked by Intendant Hans Gregor and Music Director Franz Schalk to sing during the two rehearsals. Strauss liked her so much that he decided to substitute her for Gutheil-Schoder in the October 4 premiere, no matter what her state of health. Lehmann could not even have guessed that Strauss had known the older singer since age sixteen from his Weimar days (1889–94), when she had venerated him. But Lehmann was embarrassed that she should replace Gutheil-Schoder as a mere beginner, and so she sent the prima donna flowers.[4] She also asked her three directors to rescind the replacement, but Strauss would have none of this. As in Stuttgart, the premiere starred Maria Jeritza, whom Lehmann admittedly found "moving in her beauty," as

Ariadne; Selma Kurz, not an outstanding actress but "irresistibly warm," as Zerbinetta; Georg Maikl as the Dancing Master, "good and ever reliable," and Hans Duhan, "a charming singer and actor," in the dual role of Music Master and Harlequin.[5]

In her autobiography of 1937, Lehmann underlined the significance of her unexpected success in the Composer role by stating that on the morning after the premiere "all of Vienna knew, so to speak, who Lotte Lehmann was."[6] Her statement was based on the review by Vienna's prominent critic Ludwig Karpath, who had written in November 1916 that even on the evening of her performance Vienna knew the identity of the singer.[7] Complementary to this is Lehmann's immediate subjective impression of a "sensational success," and historically quite accurate is her assessment years later that the reception she received by the Viennese reviewers started her "world career."[8] Julius Korngold, the most influential voice among those critics, commented in the leading *Neue Freie Presse* that Lehmann had sung a "winning part by virtue of her personality and temperament, as much as through blossoming mellifluousness." By mentioning that the young artist, a conspicuous talent, had quickly secured for herself a place in the Opera ensemble, Korngold was making a correct reference to the fact that Lehmann, although she had just excelled, had already been known to Vienna's music lovers since she began at the Hofoper earlier in August.[9]

The capital of the fin-de-siècle Dual Monarchy to which the singer had moved was different from Hamburg, the proper Hanse Town, and certainly much different from its opposite pole in the German Empire, Berlin. The Viennese-born writer Stefan Zweig at that time found Berlin's center around Friedrichstrasse dreary, compared to the inherited architectural beauties of Vienna. There was no ornate corso for ostentatious or intimate strolls, as Vienna had with the Graben, and characteristic Prussian thriftiness had rendered all of Berlin without elegance. Here women went about in self-tailored, drab-looking dresses, whereas in Vienna lavish fashion marvels could be made out of any fabric strips. In Berlin, the coffee was weak; food was barely nourishing; and cleanliness and strict order reigned everywhere, instead of the artistically inspired, but hardly punctual, coming and going in Vienna.[10]

In 1916, the Habsburg Dual Monarchy, allied in World War I with the German Reich, was desperately trying to keep its various parts together. On the surface it appeared that it would, for society and politics did not seem to have changed since 1866, when Franz Joseph I had lost his last war at Sadowa, against Prussia. For half a century there had been a tranquility that signalized, to the outside world, nothing but stability. But as a polity, the Dual Monarchy was riven with dissention and division, and bordering on disintegration. Vienna was an entity of its own, governed by its individual, distinctive rhythms, a veritable hydrocephalus on top of an assemblage of nations different by tradition, culture, and language and mostly anti-urban. In the partnership between Austria and Hungary, Austria was the senior to the point that Hungary perpetually resented it. This imbalance would lead to attempts by either partner to align itself more closely with other portions of the empire, so that the carefully constructed political equilibrium of 1867 (*Ausgleich*) was in constant danger.

K. K. Hof= Operntheater

Mittwoch den 4. Oktober 1916

Im Jahres-Abonnement 4. Viertel Bei aufgehobenem Saison-Abonnement

Für das Pensions-Institut dieses Hoftheaters

Zum ersten Male:

Ariadne auf Naxos
(Neue Bearbeitung)

Oper in einem Aufzug nebst einem Vorspiel von **Hugo von Hofmannsthal**
Musik von **Richard Strauß**

Spielleitung Hr. v. Wymetal Musikalische Leitung: Hr. Schalk

Personen des Vorspiels:

Der Haushofmeister	Hr. Stoll	Ein Lakai	Hr. Madin
Der Musiklehrer	Hr. Duhan	Zerbinetta	Fr. Kurz
Der Komponist	Frl. Lehmann	Primadonna (Ariadne)	Fr. Jeritza
Der Tenor	Hr. v. Környey	Harlekin	Hr. Reuber
Ein Offizier	Hr. Arnold	Scaramuccio	Hr. Gallos
Ein Tanzmeister	Hr. Maikl	Truffaldin	Hr. Betetto
Ein Perückenmacher	Hr. Stehmann	Brighella	Hr. Nemeth

Personen der Oper:

Ariadne	Fr. Jeritza	Zerbinetta	Fr. Kurz
Bachus	Hr. v. Környey	Harlekin	Hr. Duhan
Najade	Fr. Dahmen	Scaramuccio	Hr. Gallos
Dryade	Fr. Kittel	Truffaldin	Hr. Betetto
Echo	Frl. Jovánovic	Brighella	Hr. Maikl

Das im Orchester zur Verwendung kommende Schiedmayersche Meisterharmonium ist von der
Firma Josef Saphir, Wien, zur Verfügung gestellt. Klavier: Bösendorfer.

Das Textbuch ist an der Kassa für 1 Krone 60 Heller erhältlich

Während des Vorspieles und der Oper bleiben die Saaltüren geschlossen

Der Beginn der Vorstellung sowie jedes Aufzuges wird durch ein Glockenzeichen bekanntgegeben

Nach dem Vorspiel eine größere Pause

Abendkassen-Eröffnung vor ½7 Uhr Anfang 7 Uhr Ende ½10 Uhr

Der Kartenverkauf findet heute statt für obige Vorstellung und für:

Donnerstag den 5. Wiener Walzer — Die Puppenfee — Sonne und Erde (Anfang 7 Uhr)
Freitag den 6. Ariadne auf Naxos (Anfang 7 Uhr)

Weiterer Spielplan:

Samstag den 7. Elektra (Anfang halb 8 Uhr)
Sonntag den 8. Margarethe (Faust) Anfang 7 Uhr

Die Besichtigung des k. k. Hof-Operntheaters ist täglich von 9—12 und 2—6 Uhr (Sonn- und Feiertage Nachmittags
ausgenommen) gestattet. Eintrittsgebühr per Person 60 Heller.

FIGURE 5. Handbill announcing Lotte Lehmann's début as Composer in Richard Strauss's opera *Ariadne auf Naxos* at the Vienna Hofoper, October 4, 1916. Author's private archive.

Because of linguistic and cultural differences, centrifugal forces were at work that militated against a continuation of unity. Nationalist leanings toward the end of the empire led, for example, to Czech aspiration for sovereignty and sentiments of closeness with Slavs in St. Petersburg rather than with German-Austrians in Vienna.

The arts in fin-de-siècle Vienna, which became home to Lotte Lehmann two years before its final demise as hub of empire, had been an outgrowth of the Baroque and Biedermeier eras until challenged by the revolutionary Jung-Wien movement at the end of the century. To give but one example from the realm of painting: the champion of convention here was Hans Makart, whose specialty was tapestry-like canvases designed for large halls. He was hugely popular. His theatricality helped the Viennese to forget military defeat in the 1860s and economic recession in 1873, and it satisfied their appetite for the spectacular. Since he also painted nudes, this catered to the erotic. "Art dealers boasted that some society ladies had consented to model au naturel," writes William Johnston. "The eagerness of a few ladies to flaunt this feat accented the duplicity that in Vienna governed matters of sex." Toward the end of his life Makart got married – to a ballet dancer. He died of syphilitic paralysis in 1884.[11]

By far the greatest achievement in the arts before 1900 had been the Ringstrasse project, the completion of which spanned decades and changed the whole appearance of the city. The territorial belt surrounding what is now the Erster Bezirk or city core was divested of its military uses and made into a representative, semicircular avenue starting and ending at the Donaukanal. Along the Ringstrasse, most important structures were built: Parliament, museums, the Burgtheater, Town Hall, the Palace of Justice and, not least, the Opera. As well, sumptuous apartment complexes were erected. But there were glaring inequities. The style of the buildings represented a curious mix of everything from phony Renaissance to neo-Baroque, which seemed to encourage the Viennese to ignore reality and look back into the past – in an act of escapism that was practiced equally well in other contexts. And the private dwellings were so expensive, since no heed had been paid to social housing, that only the richest burghers could afford them, which widened already existing social gaps.[12] The project encouraged modernism in the arts, particularly because the progressivist architect Otto Wagner was responsible for putting up one of the last apartment buildings before 1900, when the project was ended.[13]

Wagner along with the painter Gustav Klimt was a founder of the Secessionist movement in art by 1897, which then attracted the writers and other artists of Jung-Wien who pioneered modernism in Austria before World War I.[14] From the literary side, Arthur Schnitzler and Strauss's friend Hugo von Hofmannsthal were the most prominent protagonists. Schnitzler brilliantly etched human psychology at the fin de siècle, sharply but not without humor exposing all the weaknesses of society, including sexual ones, so that Sigmund Freud thought of him as his doppelgänger. When he revealed the sham that was the code of honor of the army, with the publication of his novella *Leutnant Gustl*, he was stripped of his commission as an officer in the reserve.[15] Hofmannsthal even as a youth practiced a novel lyrical aestheticism, using language evocatively. Schnitzler was Jewish, Hofmannsthal partially so; they were beholden to

the Liberalism that had supported the emancipation of Jews in Vienna earlier and were alarmed at the anti-Semitism officially taking hold at the turn of the century, and they realized that modernism in art was tied to the progress of the Jews, and by extension of Liberalism, in the empire.[16]

The artists of Jung-Wien were controversial and shunned by important salons; they were celebrated instead in the salon of the Jewish Bertha Zuckerkandl.[17] The conservatively influential Princess Pauline Metternich fought most of them fiercely.[18] In particular, she hated the few musicians among them, singling out Arnold Schoenberg.[19] Avant-garde music was, indeed, the art form of Jung-Wien least accepted by the Viennese public. This applied not only to Schoenberg, who left Vienna – for the second time in his life – for Berlin in 1911, but also to Gustav Mahler, who was tolerated as musical director of the Opera, but not for his symphonies. (He too tried to escape, to New York.) Schoenberg's Viennese pupils Alban Berg and Anton von Webern remained in the Austrian capital, eking out a less-than-satisfactory living.[20]

Within the modernist stream, the Vienna Court Opera (Hofoper), which was often visited by Princess Metternich, remained staunchly traditionalist. Its few liaisons to Jung-Wien were via the stage designer Alfred Roller, who was a cofounder and president of the Secession in 1902; the singer Anna von Mildenburg, who had been Mahler's mistress in Hamburg; and Marie Gutheil-Schoder, an admirer of Schoenberg and an early Mahler disciple. But the Opera was the personal fief of the emperor, who would always arrive late and then fall asleep in his box. Avant-garde music would have woken him up and to him and his aides would have sounded like cacophony, and modern drama and staging would have struck them as chaotic. On the other hand, Strauss's *Elektra*, the composer's most advanced work ever, was performed at the Hofoper from 1909 on, and *Salome*, with similarly daring harmonies, was placed on the index in 1905 not because of the music, but because of the opera's risqué libretto.[21]

Nonetheless, already before Mahler's directorate the Hofoper enjoyed the reputation of being the best in the world. Mahler's reign lasted from October 1897 to December 1907, followed by that of Felix von Weingartner, from January 1908 to February 1911. In contrast to Mahler's regime, Weingartner's was not held to be a fortunate one, programmatically or commercially.[22] In March 1911, Weingartner was replaced by Hans Gregor, who signed on Lotte Lehmann in Hamburg in 1914 and stayed in Vienna until November 1918.[23]

Even before he was forced out by a cabal, Gregor's mandate was controversial. Not a conductor, but an actor and regisseur by training who had directed the Komische Oper in Berlin, this Saxon's barking command style and no-nonsense business manners were ill regarded by the more easygoing and messy, but always beguiling Viennese.[24] This manifested once again the classical difference between properly sober Prussianism and liltingly intoxicated Austria.

It is true that, like Max Bachur before him in Hamburg, Gregor's chief aim was to ensure some variety in programming and to bring money back into the till. But beyond that, there were significant differences. Whereas Bachur had graduated from the cash-register academy and got stuck ignominiously in its tradition, Gregor was a theater artist in his own right, belying his pronounced business sense. His detractors – among them the distinguished Viennese critic

Heinrich von Kralik – accused him of subordinating mind to money, of valuing the Opera's "material well-being over the spirit."[25]

In particular, Kralik and his fellow critics blamed Gregor for a star system, because he had dared to engage Caruso and the celebrated Russian baritone Georges Baklanoff. Being a regisseur, Gregor had placed more emphasis on text direction than music direction and detracted from the stature of resident conductors like Schalk and Bruno Walter. There were tiffs with conductors, Walter leaving for Munich in 1913 (for his first autonomous position, to replace Felix Mottl), Schalk staying on independently, and others, like the Pole Grzegorz Fitelberg and the Italian Antonio Guarnieri, unexpectedly canceling or fleeing engagements. Stage designer Roller left in 1911 (only to return in 1918). In 1916, Mildenburg is supposed to have turned her back on Gregor in disgust, but she might just as well have preferred Red Cross service in Salzburg during World War I to work in a Vienna Hofoper without her idol Mahler.[26]

Unlike Bachur, Gregor today is actually best remembered for positive innovation. He performed and premiered, during difficult times in Vienna, more masterworks than was thought feasible, among them a successful *Rosenkavalier* staging as early as April 1911 (pending work inherited from Weingartner and with Roller designing the sets) and original Mahler-imprint productions of *Figaro* and *Fidelio*. Gregor put on truly modern works, such as Stravinsky's ballet *Petrushka* and Alexander von Zemlinsky's one-act opera *Eine Florentinische Tragödie*. He supported the Viennese prodigy Erich Wolfgang Korngold's astonishing productions *Violanta* and *Der Ring des Polykrates*, both in 1916. He played what was being played at most premier stages all across Central Europe then: much Wagner, Verdi, Puccini, and Strauss. After the beginning of the war he kept performances going impressively, as Hamburg had done, and Verdi was not shunned. Apart from welcoming back Leo Slezak from America, he hired four new singers on his watch: the English tenor Alfred Piccaver; the eruptively temperamental soprano Maria Jeritza, originally from Moravia; the light baritone and Mozart specialist Hans Duhan; and Lotte Lehmann. His production of *Ariadne*, with Lehmann as Composer, Jeritza as Ariadne, and Duhan as Music Master, was without question the most significant creative act Gregor performed during his Vienna tenure. Yet because of his lingering reputation as an amusical money pincher, he was replaced at the end of the Habsburg era by a dual directorship of Schalk and Strauss, which had been engineered by the last imperial theater intendant, Baron Leopold von Andrian-Werburg, a member of Jung-Wien and a close boyhood friend of Hofmannsthal, who had singlehandedly advised "Poldi" how to proceed in this matter.[27]

It is beyond question that Hofmannsthal himself was influenced by the maestro from Garmisch. Richard Strauss always liked guest conducting in Vienna, as he was fond of several of the Hofoper's stars – Kurz, Jeritza, Gutheil-Schoder, and, since October 1916, Lehmann. He also saw eye to eye with Kapellmeister Franz Schalk, who himself anticipated enthusiastically a permanent cooperation with Strauss in Vienna. It helped that Strauss shared Schalk's antipathy for Gregor's nonartistic reputation – however unjustified – and that both evidently visualized a future for themselves together, without Gregor but in collaboration with Jung-Wien's set designer Alfred Roller.[28] Strauss's contract became

effective on October 11, 1918; parallel instructions for Schalk were in place on November 10, just as the Second German Empire, in whose capital Strauss still had a guest-conducting function, was expiring, and two days before the Austrian Republic was proclaimed in Vienna.[29]

Lotte Lehmann arrived in Vienna in August 1916, enthusiastically welcomed by Intendant Gregor, who was relieved that her and Loewenfeld's attempt to renege on the March 1914 contract had been thwarted. The terms of this contract were strict but fair. Apart from her vacation time, she was not allowed to sing outside the Hofoper without its directors' permission; her vacation would normally coincide with the Opera's. She was held financially liable for any performances she missed, but would receive extra remuneration for additional work. Medical leaves had to be attested by a physician; if she were to be incapacitated for a longer period, she could receive six months' salary after giving three months' notice. Immediate suspension of the contract was possible in case the new member did not comport herself politically correctly – at home or abroad. (This was, after all, an Opera functioning solely at the pleasure of the emperor.) The same applied in case of other unseemly behavior. For women, any planned marriage had to be approved in advance by the directors. In case the Hofoper suspended its legal existence, all contracts could, after three months, be rendered void. The contract was deemed to be automatically extended if the member did not make use of a possibly existing annual right of renegotiation. Participating in the Hofoper's pension plan was obligatory.[30]

Although Lehmann did not come to Vienna as a complete unknown, especially since she had guested there as Eva in 1914, Kapellmeister Schalk, a naturally suspicious and sarcastic man, was skeptical and somewhat icy. Even before she set foot in the capital, as he was discussing with Strauss possible roles to be filled for the *Ariadne* premiere in October, he wrote to the composer that anybody new arriving at that time would be too late for that opera, except perhaps for a Fräulein Lehmann from Hamburg, and did Strauss by any chance know her?[31]

He need not have worried. Lehmann's first big role at the Hofoper turned out to be Agathe in Weber's *Freischütz*, on August 18, the emperor's birthday. The prestigious *Neues Wiener Journal* led other Vienna dailies in printing a flattering notice. Lehmann was introduced as the youngest member of the Opera; her singing was characterized by adjectives such as "heartwarming," "soft," "warm-blooded," and "velvety." She was presented as a "thinking artist" who was particularly good at acting.[32] The review could not have been more complimentary; other notices were similar, echoing these judgments. There were some drops of water in the wine, however. One paper commented on Lehmann's "chubby-cheeked face," another mentioned her "audible breathing" – alluding to an awkward breath-gathering technique that Lehmann would control and turn to her advantage only later in her career.[33]

As she started working in Vienna, Lotte Lehmann knew that she was up against the competition of several famous artists, the most venerable of whom had established their reputations already under Mahler.[34] Chief among those was the beautiful Selma Kurz, whom Mahler had almost married, before he wed Alma Schindler. Kurz, who eventually studied with Mathilde Marchesi in Paris,

hailed from a poor Jewish family in Galicia. Via the Hamburg and Frankfurt Operas she came to Vienna in 1899. She sang the first Mimi from *La Bohème* at the Vienna Opera, as well as the first Madame Butterfly. After she married the gynecologist Josef Halban, the couple became pillars of Viennese society.[35]

Richard Mayr was a bass from Salzburg who had been persuaded by Mahler himself to interrupt his medical studies in order to take up singing. By 1902 he was working under the great conductor. He became particularly known for his Wagner parts: King Heinrich in *Lohengrin*, Veit Pogner in *Die Meistersinger*, and Gurnemanz in *Parsifal*. But after 1911 his strongest role was that of Baron Ochs auf Lerchenau in Strauss's *Der Rosenkavalier*. It virtually defined him. "He was Viennese in an easy-going way," Lehmann wrote of him later, "but he was at the same time an aristocrat. He was coarse, he was a peasant, he was a boorish aristocrat, his impersonation always gave one the feeling of a man of 'class'."[36]

Leo Slezak, the famous tenor from Moravia, four years older than Mayr at forty-three, was in his vocal prime when Lehmann met him in 1916. He had been with Mahler since 1901, but also sang at the Metropolitan Opera in New York as early as 1909. "There were certain flaws in his technique, but at his best he combined great warmth and brilliance of tone with clear enunciation and a most delicate use of *mezza voce*," judges the critic Desmond Shawe-Taylor, who also admired Lehmann. Slezak often delighted the new singer from Hamburg, but at the same time annoyed her, as he annoyed his other colleagues, because his behind-the-stage antics could not keep them from bursting out laughing during performances at the most inappropriate times.[37]

Marie Gutheil-Schoder, forty-two years old when Lehmann met her in 1916, was by intellect and temperament a much more cerebral singer than Kurz. Her early acolyte Lehmann held that as a role player "her characterization came from the head, from the mind, out of deep knowledge." She was able to sing for Mahler (as she had since 1900), under whom she became known for her depiction of Frau Fluth from *Die lustigen Weiber von Windsor*, but could also, uncannily, analyze his every approach to opera and its stagings. Mahler's intellectual intensity was a perfect match for her own. Because of the brittle timbre of her voice and the pronounced spirituality of her acting, she was not exactly popular with Viennese audiences.[38] But Strauss, with one foot in the Jung-Wien camp, liked precisely that. Not overly attractive yet erotically suggestive, she was a must for him as Elektra on the Viennese stage as early as 1914, and then also his top choice for the Composer, although his colleague Schalk thought as early as June 1916 that any text sung by her was difficult to understand. Later she also sang Octavian and Salome; but Schalk, who disliked her mannerisms, remained skeptical of the singer, just as he increasingly came to appreciate Lotte Lehmann.[39]

There were two singers Lehmann performed with who had been hired by Gregor before her own time: the tenor Alfred Piccaver and the soprano Maria Jeritza. Piccaver had been born in England in 1884 and grew up in the United States, where he had been captivated by Caruso's singing at the Metropolitan Opera around 1907. Piccaver came to Vienna permanently in 1912 via Prague, where he was soon beloved both by the opera fans and most of his colleagues.

He had a powerful voice, but with a velvety, sweet quality that enthused his listeners. Lehmann, with whom he appeared many times as a pair, remembers him fondly: "There are voices which are so beautiful that they make you oblivious of everything but their quality so that you don't even think of considering whether the singer is a good actor. Such a voice was Piccaver's." In acting, Piccaver sometimes was less than perfect, and he particularly did not get along on stage with the soprano of equally sweet voice from Moravia, Maria Jeritza.[40]

Jeritza was born the daughter of a concierge in Brünn (Brno), the capital of Moravia, and if it is true that a special "opera train" ran between Brünn and the Vienna Hofoper in those days, it must have been built especially for her.[41] She was a tall, willowy, blue-eyed blonde born in 1887, and although she actually had no need for it, she constantly dissembled. She built a number of legends around her persona, in order to make herself more interesting than she already was, especially to men. One legend subtracted four years from her age; at one time she claimed to have been on an operatic stage as a teenager, when in fact she was already in her twenties. Another legend had it that after she arrived from the Opera in Olmütz (Olomouc) in Vienna in 1910, at the lower-rated Volksoper, mostly for singing operettas, Emperor Franz Joseph heard her once during a special performance, as Rosalinde in *Die Fledermaus*, and exclaimed: "I cannot understand why I have not heard her at the Hofoper!" This then caused her relocation to the Hofoper under Gregor, although her Volksoper contract still ran on. It was also in keeping with her legendary character that she was fond of singing inexactly and frequently out of tune. But what was lacking in her singing (which most contemporary composers, including Strauss and Puccini, found wrong yet utterly charming) she more than made up for in histrionics. This she did with such verve that the audience was usually thrilled, even if purist critics grumbled.[42]

After a failed first marriage (which she made disappear, another little legend), Jeritza became the wife of Baron Leopold Popper de Podhragy, a Hungarian millionaire heir of questionable talents, who happened to be the grandson of the legendary voice teacher Mathilde Marchesi. This too enhanced her reputation. Yet what created her trademark sensation was the way she delivered the aria "Vissi d'arte, vissi d'amore" from Puccini's *Tosca*. According to Jeritza herself, it happened first in 1913 during a rehearsal in the composer's presence that she tripped and fell in front of the threatening Scarpia and was thus forced to sing the aria lying on her stomach. Puccini was delighted and insisted that this was the only way to sing it. (Puccini's part in this may again be another legend of Jeritza's; a second version has it that Regisseur Wilhelm von Wymetal proffered that advice.) In any event, virtually every audience was enthralled by these *verismo* antics thereafter, except, later in America, for the jealous veteran Geraldine Farrar, who gleefully noted a protruding, not-so-aesthetically-pleasing posterior, as Jeritza was lying there.[43]

Strauss, who had experienced Jeritza earlier in 1912 at the Hofoper, immediately decided she had to premiere Ariadne in the signature role in Stuttgart in October of that year. After the formidable Emmy Destinn, he wrote in May, she had "the most beautiful voice, great figure, beautiful person, full of talent."[44] The singer effusively thanked Strauss for singling her out in this manner in July,

assuring him that the role "interests me enormously and suits me famously."[45] Although Strauss conceded later that the soprano had not really mastered the role "musically" or "vocally" or "in terms of phrasing," Jeritza became his favorite artist of the period.[46] He wanted her as Chrysothemis in *Elektra* as early as January 1914, and as Ariadne, for 1916, although Schalk agreed with him that the star, even with her "outrageous talent," was "difficult to train."[47] But Straus felt that Jeritza had acquitted herself well as Ariadne, in Vienna, and Schalk too thought in 1917 that she could be held in check.[48] A further public success as Jenůfa in Leoš Janáček's eponymous opera in February 1918 pleased both Schalk and Strauss, who gladly entrusted her with the role of Salome in the Austrian capital on October 4.[49]

Although in her mature years Lotte Lehmann conceded that Maria Jeritza was the *prima donna assoluta* in Vienna when she herself arrived there and gave her much credit for "theatrical effect," she actually found this unexpected competitor very hard to take.[50] Even though Jeritza was one year older than Lehmann, she was infinitely more physically attractive to men; she also had a super-rich baron for a husband and a playfully intimate way with Strauss and Puccini. It may have been meant as flattery but was molded around a bitter kernel of truth when the critic of *Die Zeit* wrote, on the occasion of Lehmann's respectable success as Agathe on August 18, 1916, that the newcomer could soon become a "darling" of Vienna's Opera crowd, along with the venerable Selma Kurz and "Frau Jeritza, that enchanting temperament."[51] Lehmann could face the arrogant Jeritza for a while, but in early 1917 she lost her composure. The press reported that the newcomer from Hamburg had made a snide remark to a colleague at the Opera backstage, which cast aspersions on their boss, Hans Gregor. We can only assume that Lehmann had implied that Jeritza had slept herself into the Hofoper. Whatever it was, Lehmann had to undergo disciplinary proceedings that entailed a fine, and during that period she was forbidden to perform. According to article 13 (d) of the 1914 contract signed in Hamburg, she could have been summarily dismissed. That she was not most certainly was due entirely to the fact that, within a relatively short period, she herself had become – what that newspaper had presaged months earlier – a favorite of the Viennese Opera crowd.[52]

At the time of Lehmann's arrival in the capital of the Dual Monarchy, it had about two million inhabitants; since the beginning of the war the population had been constantly increasing because of refugees from the East, mostly poor Galician Jews who were afraid of advancing, pogrom-minded Russian soldiers.[53] More than in Hamburg, Lehmann found herself in a city with a supply-and-distribution crisis; in fact, during the war, Vienna suffered from an essential-substance shortage more than any other European city, including Berlin.[54]

The initial reaction by governmental agencies consisted in the introduction of a staggered-rations regime, combined increasingly with a qualitative dilution of essential products such as bread and fabrics. The second response amounted to the commissioning of private distribution centers, which by late 1916 were to dispense goods to consumers according to certain allocation keys. But since they

were staffed by often-corrupt middlemen and not logically coordinated with the rationing scheme, they proved a failure.[55] The population's angry reaction was a large-scale attempt to queue up for supplies, and since the endless line-up threatened the social peace, the authorities tried to clamp down on the entire practice.[56] This angered the people even more, so that they decided to move into the surrounding contryside to see what they could buy or, if necessary, steal from peasants.[57]

The net results of these disorders were malnutrition, disease, suicides and other deaths, and ultimately food riots. Because goods became scarce, they became increasingly expensive, and this had set inflation on its course already by 1915. On an indexed basis, prices in October 1918 were almost six times what they had been in July 1914, while the amount of currency in circulation multiplied by a factor of ten.[58]

These economic anomalies produced a new social type: the war profiteer, or *Schieber*. At the time, this was an epithet used widely by the Viennese public against anybody who was suspected to have profited, illegally or not, from the war economy. One unfortunate side-effect of this was the renewed spread of anti-Semitism, for several of the Jews from Galicia, being used to commercial dealings back home, assumed the role of middleman at all levels of trade and currency exchange, and although many fulfilled legitimate functions, some did not and gave the entire group a bad name, so that *Schieber*, toward the end of the war, became synonymous with "Galician Jew."[59]

Inflation turned out to be an even more acute problem after the end of the war in November 1918 for the additional important reason that to a large extent the war had been financed, as in Germany, with war bonds, which now defaulted. Bank credits were constantly needed to keep the national economy going. This led to more budget deficits and increasing living costs. As the value of the krone fell, prices in Austria rose; by the summer of 1920, prices on the whole were up to forty times higher than before the war.

By the spring of 1919, the new Republic of Austria was ruled by a constituent assembly comprised of left-wing and right-wing parties, under the Socialist Chancellor Karl Renner. After the appearance of "Soldiers' Councils" in autumn 1918, communist-led bands tried to overthrow this balance by causing havoc in the streets.[60] But the right-wing Christian Social Party, promising law and order, was on the ascendance, until its leader, Ignaz Seipel, became chancellor in May 1922. His cabinet was able to solicit foreign fiscal help under the auspices of the League of Nations, so that on October 4, 1922, the Geneva Protocols formed the basis of a more solid financial future for the nation. By December 1924 the schilling was replacing the krone, and between 1925 and 1931 the U.S.-dollar rate of exchange for the Austrian currency remained fairly stable.[61]

Yet the new Austrian governments could not improve the social and economic conditions of daily life, at least not for ordinary people. Essential goods were coming into Vienna slowly, especially since the Allied blockade of 1914 was lifted only in the spring of 1919.[62] Since German Austria was on its own now, it was cut off from the coal of Czechoslovakia and agricultural produce from Galicia and Hungary, nations separated from the former Dual

Monarchy.[63] More refugees were entering the capital from Galicia, along with soldiers returning from the fronts, which compounded the already existing housing shortage, because no one wanted to rent out under debilitating rent controls.[64] Hence the rationing of essential supplies continued, and so did illicit foraging excursions to the surrounding countryside.[65] Pawnbrokers in the capital were having a field day; at market stalls, spoiled goods such as rotten poultry were being sold at horrendous prices.[66]

Altogether, the social consequences of the collapse of the monarchy in November 1918 and the resultant Treaty of St. Germain in September 1919 were devastating. War cripples begging for money dotted the inner core of Vienna, making the showcase thoroughfares of Kärntnerstrasse and Graben extremely unsightly.[67] Prostitutes increased their traffic in broad daylight, and with so many indigent war widows, the rate of secret, illegal prostitution rose the fastest. Some mothers offered their teenage daughters.[68] Everywhere children were begging, inasmuch as they were not at home in their dank and crowded rooms, having fallen victim to malnutrition and illnesses like tuberculosis, soon called the "Viennese Disease," which was steadily on the upswing and could not easily be curbed even by postwar American war relief.[69]

The term *Schieber* now assumed a new meaning, because de facto there were more of them and the definition had been amplified, while public perception created categories that had not been known before. Some of those groups overlapped. But entirely new were the foreigners who arrived in Austria with hard currency during times of kronen inflation, so that, as Stefan Zweig noted, Dutch typists stayed in luxury hotels, and Swiss hotel porters and even the British unemployed were gorging themselves in five-star restaurants.[70] There were the old-style, small-time profiteers in the countryside and city shops who would not lower prices even when in reality they had already fallen (as did those for meat in December 1921). Viennese courts continued to slap fines on those traders, with little visible effect.[71] The Galician-Jewish middlemen were also still active, but often their membership coincided with the small group of big-time *Schieber* who, already rich from the war, got even richer by engaging in shady dealings with the postwar governments.[72] Then there were those who had always been rich or who had recently profited, quite legitimately, from the new manufacturing or export trade; they were regarded with suspicion simply because they chose to spend heir money profligately, as they saw fit. Among them were wealthy Hungarian noblemen who luxuriated in Vienna rather than in the isolated castles of their homeland, living high on the hog in Ringstrasse hotels.[73] Others, Viennese, and often members of assimilated Jewish families like the Gutmanns, Mandls, and Friedmanns, had held on to their riches and caused a stir not through how they had obtained them but what they were observed doing with them. Hence a Baron Groedel, as noted by the satirist Karl Kraus in his journal *Die Fackel*, lost one and a half billion kronen during April 1923 after placing bets, and the actress Hilda Radnay entertained guests for games of baccarat in her flat in the Invalidenstrasse. There was a City Bar in the Liliengasse where only the in-crowd went, fashionable ladies and elegant gentlemen who listened to the bar pianist Urban. Some of these people were seen purchasing expensive gift baskets filled with delicatessen, and first-class

restaurants were never short of the choicest raw materials for their dishes. This contrasted negatively with hospitals, which found it "almost impossible on account of the prohibitive prices" to obtain badly needed eggs and other rudimentary staples.[74]

Surprisingly in this socioeconomic environment, culture, low and highbrow, was kept alive by those elements that still were able to hang on to money and wealth, no matter how ill-gotten these may have been. Because in the Habsburg monarchy Burgtheater, Volksoper, and Hofoper amounted to national status symbols as well as international tokens of prestige, they were not closed but kept open with public funds, first from the imperial coffers and, after a brief closure in the autumn of 1918, with the people's tickets and taxes. The Viennese were simply too pleasure-loving, habitués of cultural venues of all kinds, to forgo these theaters. During the war, cafés stayed open, as did nightclubs (for officers home on furlough) and respectable restaurants like Meissl und Schadn. The amusement district Prater featured a huge war exhibition in 1916–17 with plenty of entertaining diversions, despite its serious overall theme, and race-horses kept running at the Freudenau track as usual. Cinemas proliferated, and there were private and public lectures as well as poetry readings. Classical music concerts continued, and so did the Opera.[75]

After the war, when Vienna had six million inhabitants, there were doubts whether the Opera, in particular, could be maintained, but because it had had a full house during times of hostilities, this was ultimately thought possible, and Andrian-Werburg's contract with Strauss was validated in March 1919. Toward the end of the conflict, the audience had been changing; it was the "war profiteers" of greater means who had supplanted some, if not all, of the regular patrons. This trend continued after 1918. Artists like Jeritza and Lehmann at first felt offended by this turn of events, for the *Schieber* seemed to pay little attention to their singing, but rather conversed among themselves and showed off their wives' new wardrobes. Lehmann saw one "munching sandwiches and opening cans of tuna fish during the perfomance." But they also brought in the hard cash that needed to be put back in circulation, and this was especially true during post-1918 times of inflation. Of course, for both the Burgtheater and the Staatsoper, as it was now called, deficits climbed despite ever-increasing ticket prices, but the government stolidly made up the difference. Along with the nouveaux riches, Social Democratic institutions now were sending a new clientele of formally uneducated men and women to the galleries; traditional patrons came to occupy their old seats, rich people their privately owned boxes; and so the Opera continued to be sold out every night.[76]

A Prima Donna in the Staatsoper

After her remarkable success as Composer in *Ariadne*, Lotte Lehmann rode out the Hofoper's last few seasons without much fanfare. On the one hand, in the dying days of the empire the Opera itself did not schedule any spectacular performances, let alone premieres. On the other, she was still only on the threshold of fame. Some operas she was featured in were downright mediocre. For example, in an unassuming work, *Die Schneider von Schönau*, by the Dutch

composer Jan Brandts Buys, with a folklike leitmotiv and themes, she was noted as "a charming widow" in March of 1917.[77] Nonetheless, in her first Vienna season Lehmann managed to sing an astonishing twenty-one roles, among them new ones, such as Massenet's Manon and Thomas's Mignon.[78] Beyond that, she kept herself busy with recitals, sometimes paired with one of the better-known male singers of the Opera, as she was in December 1916, when she sang Mozart's Pamina–Papageno duet with the renowned bassist Richard Mayr and, on her own, compositions by Gluck, Liszt, and Strauss. Schalk directed the Tonkünstlerorchester. Here she was not an unqualified success: critics remarked on her "beauteous voice," but also observed that she frequently missed her cue and that her timbre lacked Viennese warmth.[79] In these patriotic times, to which she was herself attuned, Lehmann participated in special benefit concerts for the war effort, such as when she sang from Beethoven's *Musik zu Goethes Egmont* for a women's auxiliary organization, for a nominal fee, in January 1917.[80] A year later, she gave her first solo recital, as she mixed arias from *Figaro*, *Eugen Onegin*, and *La Bohème* with songs by Strauss and Brahms. While she was credited with a "bell-clear, silver-light" organ, she was pronounced "not yet at the crest of fulfillment," in that her singing still showed "some unevenness." Her choice of program was also criticized, even if the enthusiastic audience, on the whole, could not get enough of her.[81]

With the beginning of the Republic in 1918, matters improved again at the Opera, with Lotte Lehmann as an organic part. A representative cross-section of her work demonstrates the talents of an artist who was moving inexorably to the zenith of her career, temporary setbacks notwithstanding. *Der Musikant*, by the Austrian retired jurist Julius Bittner, became one of the first operas of the new era. Like Brandts Buys's, this was a folklike, musically rather mediocre work, but a vehicle that allowed Lehmann to excel as the girl-like, lovable Geigerlein Friederike – under Schalk's musical direction.[82] In October 1919, however, Lehmann starred as the Dyer's Wife in Strauss's new opera, *Die Frau ohne Schatten*, and thus made music history.[83] Of note thereafter were her Micaëla in *Carmen*, conducted by Strauss in May 1920, of which a critic judged her large aria "well-nigh perfect," and her portrayal of Puccini's Suor Angelica.[84] For the Viennese premiere of this eponymous opera, Puccini, whose works had been banned during the war, had taken the trouble to travel to the Austrian capital, and even though Lehmann sang the lead role in German, the composer was smitten, making this clear to her in a handwritten letter after the event.[85]

Lehmann sang Marta of Eugen d'Albert's *Tiefland* in early 1921, and although the leading Viennese critic Julius Korngold usually loved her, this time he thought that the soprano lacked "the full dramatic dynamics" to do justice to Marta's passionate side.[86] In March 1921, the Staatsoper produced *Die Walküre*, a difficult endeavor because, in these times of uneasy money, star Viennese singers had gone abroad to earn hard currency, and the Opera had to import others in their stead, such as the German bass-baritone Michael Bohnen, who sang Wotan. Lehmann incarnated Sieglinde, which would become one of her favorite roles over time. Her critics were mostly exultant, even though one thought that she sang the part a bit too flatteringly.[87] This being Vienna

and Strauss wanting to feature contemporary local composers, Bittner was on
again with the premiere of his *Kohlhaymerin* in April, with Lehmann in the
title role. She was not a genuine Viennese, wrote the *Neue Freie Presse*, but
nonetheless in her singing she proved "charming and warm as always, espe-
cially in the last act."[88] Only slightly less maudlin than this premiere was for-
mer Wagner epigone Wilhelm Kienzl's *Der Kuhreigen* of 1911, where Lehmann
sang Blanchefleur, in whose parlando style she was especially lauded. But how
long would it take her finally to lose her North German image? Was it fair if
Der Morgen crabbed that in her overall impression she was still much more
"the German girl rather than a French marquise"?[89]

In January 1923, Lehmann was a "bewitching Tosca." She was called "a suc-
cess, even a great success." Indeed, Lehmann was developing into something
like a Puccini specialist.[90] The composer himself returned again to Vienna in
October of that year to witness her creation of Manon Lescaut, which she did
with the help of Alfred Piccaver's Des Grieux – he brilliantly serving as her
partner as in so many Staatsoper roles. Lehmann shone where she was devel-
oping a reputation for being the best: with a warm voice suggesting kindness,
humility, and humanity. For the second time in her career she later received
a letter from Puccini: "I would like to tell you how happy I was about your
interpretation of Manon – your art which is full of feeling accompanied by your
beautiful voice has given my *Manon* great projection, and I would like to thank
you cordially." A picture postcard showing the "Villa Puccini" in Viareggio
followed in December.[91] On the third of that month, Lehmann presented the
other Manon, by Jules Massenet, again with Piccaver as Des Grieux, who was
between lengthy foreign tours.[92]

Lehmann's outstanding achievement of 1924 was her performance as Chris-
tine in Strauss's new opus *Intermezzo*, in which she used a kind of *Sprechstimme*
not usual in opera. She performed this premiere not in Vienna but in Dresden,
under Fritz Busch's baton.[93] For Vienna in 1925 one might single out Walter
Braunfels's *Don Gil von den grünen Hosen*. This work of 1924 has been charac-
terized as "a skilfully conceived sequence of through-composed ensemble scenes
coloured with elements of Spanish folklore." Whereas the work was a comedy,
Braunfels was influenced by Wagner as much as by Berlioz, who after the mid-
1920s, along with Humperdinck and Pfitzner, ventured more and more into the
mystical and religious. This particular premiere was an important sign that even
after his departure, Strauss's policy of scheduling contemporary composers was
to be continued even after his formal leave taking at the end of 1924. About
Lehmann, by now one of the top stars of the Staatsoper, it was said that "by
virtue of her voice, vocal artistry and straight-forward histrionics she played
everybody else against the wall."[94] Apart from her regular opera offerings,
the soprano followed her usual practice of singing in local concert and recital
settings, with piano or orchestral accompaniment, as she mixed popular arias
with lieder of her own choosing, usually by her favorite composers: Strauss,
Wolf, Brahms, Schubert, and Schumann.[95] By the middle of the 1920s, some
said that she was among a mere handful of world-class sopranos. "Lotte was
the idol of the Viennese audience," acknowledges Frida Leider. In recognition
of such distinction, Federal President Wilhelm Miklas awarded her the title of

Österreichische Kammersängerin, which she had long coveted, on February 17, 1926.[96]

It is not known whether Schalk stood behind that well-deserved move. Lehmann had complained to him as early as 1923 that she was not yet a *Kammersängerin*.[97] Be this as it may, as codirector with Strauss, Schalk seems to have made Lehmann's well-being one of his personal priorities. This musically conventional Bruckner pupil, who had worked with Mahler, was a conservative in matters of administration as well as in personal relations, slow-moving and ever on the well-considered defensive, which he usually hid behind a mask of abrasive sarcasm. A stickler for details, whether in negotiations for contract renewal (as institutional director) or matters of musical interpretation (as conductor), he was usually feared by musicians, singers, and other Opera workers, until they came to appreciate his subtleties. A nationalist and not free from the anti-Semitic sentiments of the period, he took a Vienna orchestral ensemble to Geneva in September 1922 to impress the League of Nations, which was just then considering international fiscal aid for Austria. In 1924, he insisted on the use of the German language during a guest appearance by his musicians in Paris – six years after the end of World War I.[98]

From the time they first met until his death in 1931, Schalk served Lehmann faithfully in three functions: emotionally as a surrogate father, musically as her coach and conductor, and, cautiously, as her contractual superior in business negotiations. Lehmann, ill at ease with her own father, repeatedly during her life referred to the fact that she always looked upon Schalk as a "father," whom she "consummately revered." In 1922, she wrote a paean to him, the essence of which stressed his humanity: "You go to him with a care, to ask for a favor. And he has the time to listen to everything," she rhapsodized.[99] She recognized his toughness as a musical director and at first was irked by it, like others, when she studied for her first Viennese Eva during the 1916–17 season. But, being less interested in the acting side of opera, he inspired her musically: "Schalk gave me my love for the soaring phrase and my joy in it. He could lose himself so completely through music, could find such liberation through tone!" And he was especially effective at encouraging her to go through with studying for a new part rather than sending back the as-yet-unfamiliar score, as she did, for example, before accepting the part of the Dyer's Wife in 1919.[100]

Apart from growing very fond of her as a person over time, Schalk had recognized Lehmann's genius as a singer early on, as had Strauss. Always less aggressive than his codirector, who would push for star wages for his singers regardless of circumstances, Schalk supported Lehmann's bids for increases, especially in inflationary times, although within reasonable limits. "It hardly needs pointing out again that Fräulein Lehmann absolutely belongs to the first staff members of the house," he wrote to the cultural administrators in June 1920. Six weeks later, he rejected her accusation (of which she typically launched many) that she had been financially neglected during the most recent inflation-related wage adjustment and assured her that, comparatively, she was already doing very well. He also allowed her to sing roles she demanded for herself, not with perfect equanimity, but nonetheless realizing that a star had her justified claims.[101]

In Lotte Lehmann's opinion, the alliance between Franz Schalk and Richard
Strauss in the directorship of the Staatsoper beginning in August 1919, when
Strauss actively took up his Viennese appointment, was a precarious one. She
saw in Schalk, the traditionalist, too much of a retarding agent militating against
the unreflecting, impulsive nature of the composer, who wanted to get every-
thing done quickly, instantly.[102] Although this was not altogether misperceived,
and she clearly was on the side of Schalk when asked whose conventional
views on music she shared, she enjoyed a special relationship with Strauss that
advanced her much creatively, while rendering their personal relationship quite
problematical.

The most striking observation Lotte Lehmann has made about Strauss, and
one she repeated frequently, is that she always found the man less interesting
than the artist.[103] (On the face of circumstantial evidence, one could imagine
her saying quite the reverse about Schalk.) Lehmann thought Strauss grand-
seigneurial, amiable, and often full of humor, but also surrounded by a cloud
of impenetrability, which rendered cordial contact impossible.[104] Did she sense
that in the final analysis Strauss was interested only in his own music, always
at the expense of other people save his immediate family? At one time dur-
ing their professional relationship he himself confirmed this when he admitted,
half in jest, that should she die, he would grieve not for Lotte Lehmann the
human being but for Lotte Lehmann the artist who could no longer perform
his songs.[105]

There may have been three other reasons why until the mid-1920s (there-
after things became more complicated) the composer and the soprano never
really became personally close. One was rooted in Central European realities, in
that Strauss's social and educational background was so superior to Lehmann's
petite bourgeoise origins that she felt awkward around him and his (by birth
aristocratic) wife, Pauline, even though over many years she had developed
casual, if always demure, deportment in her interactions with the Putlitz fam-
ily. There are indications that when Lehmann visited Strauss's Garmisch villa in
the summer of 1919, the couple treated her kindly but with more than a whiff
of condescension.[106] This ties in with Lehmann's possible misapprehension of
Strauss's relationship to other singers, inasfar as she could have been deceived
by his attention to her; but in contrast to how she might have overinterpreted
that, Strauss never singled her out, for he was always surrounded by favorite
singers, among them Kurz and Jeritza.[107] Finally, Lehmann may have com-
mitted a tactical blunder at the beginning of Strauss's formal tenure. In spring
1919, goaded by Strauss's enemies, the artistic corps of the Opera voted almost
unanimously to reject his engagement. The notable exceptions, those who left
their signatures off the protest lists, were Jeritza, Kurz, and Schalk, but not
Lehmann. This was despite the fact that she had already welcomed Strauss,
who, after all, had showcased her in the Composer role two years before, in
a stilted letter on October 22, 1918: "Even at the risk that you might think I
am a person who wishes to tell you pleasantries for egotistical reasons, I must
express my great, heart-felt joy over this opportunity to welcome you as our
director."[108]

There was no question that Strauss's genius had been convinced of Lehmann's powerful potential ever since she had premiered the Composer. He was disappointed after *Ariadne* was performed in Berlin in November 1916 because Lehmann's equivalent for the role could not be found there. The singer too felt Strauss's music was congenial. Altogether, she sang the Composer twenty-five times during the 1916–17 and 1917–18 seasons, and Octavian three times during the 1916–17 season.[109] In January 1918, she interpreted some of Strauss's orchestral songs, such as "Wiegenlied" and "Cäcilie," and did so again during Strauss Week in April of that year.[110] By July, Strauss was so taken with Lehmann that he wanted to cast her as Salome, albeit as an understudy for Jeritza or Gutheil-Schoder – a role she really was not made for, and so this fortunately did not come to pass. But in December he was sure Lehmann had to be the Dyer's Wife in his new opera, *Die Frau ohne Schatten* – for, as he wrote to Schalk, she was without equal, with her "blooming voice, a brilliant height and plenty of temperament."[111]

This proposal, when Lehmann learned about it, took her somewhat aback, because she had originally planned to have a restful summer and lose some weight. Moreover, she did not think she could master the score, on which count both Schalk and Strauss had to reassure her, Strauss enjoining that she would study it with him. She had to be reminded several times that it was important for her as well as for the success of the opera to sing the Dyer's Wife, opposite Jeritza's Empress, and still, as late as July 1919, she declined an invitation extended to her by Strauss to visit him for a few workshop weeks in his Garmisch villa. It may have been when he threatened to have Jeritza sing it (and someone else the Empress) that Lehmann finally relented and traveled for three weeks to Garmisch.[112]

During those August weeks, Lehmann was overawed by Strauss's musicianship and the ease with which she could learn her role under his tutelage. In the evenings they would perform songs for his wife, whom he had met when she was a budding opera singer herself, with him at the piano. Lotte thought the Garmisch experience so important that she published a rather sentimental essay about it in Vienna's *Theater- und Musikwoche*.[113] But she also noticed that Pauline Strauss, the Bavarian general's daughter, henpecked her husband, even though he always took it in stride. She should have married not him but a "dashing young hussar," Frau Strauss announced, thereby perhaps reviving images within Lehmann of soldiers and trumpet fanfares and military parades, from her garrison Perleberg childhood. Besides, said Frau Strauss, Richard's music was not as good as Massenet's. She also cut her teeth on Lehmann, whom she found too plump, so that the younger joined the older woman in daily exercises. One day, they were sitting on the edge of a fountain in the sprawling garden, cooling their feet in the water. "Why, you have piano feet," snapped Frau Strauss, who herself was very slender. It was a gratuitous reminder to Lehmann that her legs were very thick-set, something she had difficulty accepting all her life.[114]

Die Frau ohne Schatten premiered in Vienna on October 10. Joining Lehmann and Jeritza were the Norwegian tenor Karl Agaard Oestvig as the Emperor and bass Richard Mayr as the Dyer.[115] This extremely long opera,

characterized by "occasionally overwrought polyphony," was difficult to listen
to. Its heavy libretto by Hofmannsthal was criticized at the time; Lehmann later
found it "intricate, ornate, overloaded, and very hard to follow."[116] Contempo-
rary writers like Frankfurt's Paul Bekker also criticized the work's score. Sub-
sequently it was not very popular on German stages. But the Vienna premiere
was splendid, owing largely to Schalk's conducting and the skill with which all
five main singers mastered their vocal parts.[117] Lehmann herself thought it a
"great, jubilant success," as she wrote to Baroness Putlitz.[118] Vienna's dailies
agreed: Lehmann had ably portrayed "a thousand facets of a wavering female
character," judged the *8-Uhr-Blatt*, and the *Mittags-Zeitung* commended the
manner in which the soprano had mastered "the most complicated Strauss
passages."[119]

Lehmann continued to sing the Composer, to critical acclaim, but did not get
to sing the role of Ariadne until February 23, 1923.[120] Thereafter Strauss invited
her to take on the part of Christine in his newest opera, *Intermezzo*, for which
he himself had penned the libretto. This time the first world performance of this
modern-genre *Zeitoper* would be not in Vienna but, in a more intimate theater
setting, in Dresden, Strauss's favorite premiere venue where he had introduced
Salome, *Elektra*, and *Der Rosenkavalier*.[121] Again, Lehmann was apprehensive,
because Christine's *Sprechgesang* in this opera was new to her, and the score
seemed to present "almost insurmountable obstacles." Compounding the dif-
ficulties was the fact that Strauss himself would not be in Dresden for the first
rehearsals and that he had warned her of a certain hostility on the part of the
Semper Oper corps, in which he seemed to take some impish delight. When
she got there in the fall of 1924, conductor Fritz Busch found that she "swam"
through her role, rather than singing it firmly, which, however, did not faze
Strauss when he finally arrived. The opera, of course, alluded to the composer's
own marriage (as had, in a different way, *Die Frau ohne Schatten*),[122] although
Strauss came off less henpecked and Christine-Pauline more charming than
someone like Lehmann, who had experienced the couple in person, might have
expected. After the premiere on November 4, Lehmann met Frau Strauss in the
hotel elevator and told her that the opera was really "a marvellous present to
you from your husband," to which she replied: "I don't give a damn." Amid
the embarrassing silence, Lehmann recalls, Strauss stood smiling.[123]

Lehmann was sufficiently pleased to write home that she had attained the
greatest success of her life, and if one goes merely by Paul Stefan, the most
critical of critics in Vienna, her exuberance seemed justified. She lent the role
spirit and not just moods, wrote he, and did almost more for the work than
Strauss himself as composer.[124] The Who's Who of the German opera world
were present, from Klemperer to Brecher to Max von Schillings, the intendant
of the Berlin Staatsoper, and his wife, the opera singer Barbara Kemp. Even
Julia Culp, whom Lehmann had heard in Berlin in her teens, attended. The
German critics were triumphant as well, Oscar Bie identifying Lehmann's effort
as "one of the greatest experiences of the modern opera stage." Others spoke
of a "masterpiece of the first rank" and of Lehmann having outdone herself
in the complicated role of Christine, who had to find a fine balance between
troublesome and alluring.[125] It was clear that this opera, which was to prove

much more popular than its predecessor, had placed Lehmann, now thirty-six years old, close to the pinnacle of her career.[126]

November 1924 was also the time when Lotte Lehmann's career could have been broken, or at least damaged, by the long-running feud between Strauss and Schalk, which had reached its apex in that month. This was not so much because of contractual ramifications, since the contracts were legally secured, but because of an atmosphere poisoned by the disagreements between these men, which made relations difficult at a professional and personal level and caused Lehmann to complain about her work atmosphere at home.[127]

After Strauss had been, in principle, signed on by the Habsburg government in late fall of 1918, solidly backed by an enthusiastic Franz Schalk, he came to have some concerns that could not be immediately resolved in his favor. One centered on the entire issue of subventions to the Vienna Opera by the new Republic, which, he thought, were necessary, but about which he had received no assurances. The second involved his own salary and working conditions, and here he was in a position of strength, since his post as permanent guest conductor of the Berlin Hofoper (after November 1918 the Staatsoper) was assured, and he received a good honorarium in return for an acceptable workload.[128] Those questions having eventually been resolved to Strauss's satisfaction (he would not quite as yet give up his Berlin obligations and receive 60,000 kronen for five consecutive months of work in Vienna, less than he had been used to), the matter was coming down to a sensible division of labor between himself and Schalk. In this area the original agreements were too vague to safeguard against any future friction, because the two men were appointed "codirectors" and potentially could encroach on each other's jurisdictions. Although Schalk was to have prerogatives on the administrative side, with responsibility for artists' wages, for example, and Strauss in artistic matters, in reality the lines were blurred.[129] By the summer of 1922 it had become clear that Strauss not only exerted artistic direction, but also micromanaged the Opera's bureaucracy, which, to all observers, identified him as the true and final director of the establishment. In Schalk's eyes and those of Strauss's detractors, additional sources of discontent were the fact that Strauss liked to be absent from Vienna as much as possible, usually composing in Garmisch. Strauss had a stooge at the Opera, Direktionsrat Karl Lion, whom he used against Schalk as his agent and with whom artists like Lehmann had to find a modus vivendi, without insulting Schalk. Strauss also, as was his wont and as he had done in Berlin previous to 1919, attempted to get as many of his own operas staged as possible, at the expense, some thought, of other contemporary composers, such as Hans Pfitzner, Alexander Zemlinsky, and Franz Schreker.[130]

In July of 1922 Strauss threatened to resign, but an open talk with Schalk cleared the air. Not for long, however, for the old complaints against Strauss continued, forcefully upheld by a strong faction surrounding Julius Korngold and Felix Weingartner. Korngold feared in Strauss an overly strong competitor to his son Erich Wolfgang, the erstwhile child prodigy composer. Weingartner, who had helped to contrive the signature action against Strauss in May 1919 and was then at the helm of the Volksoper, perennially envied the more celebrated conductor.[131]

In early 1924 things came to a head when Strauss demanded from the education minister that, for him to stay on, Schalk's contract had to be retired at the end of the 1924–25 season. The minister first promised this but then had Schalk's contract renewed instead. As soon as he heard about that on November 1, Strauss handed in his resignation, effective immediately. Hence it was already public knowledge by the time of the premiere of *Intermezzo* three days later – significantly, not in Vienna but in Dresden.[132]

But Strauss's retirement did not translate into the composer's departure from the Austrian capital. On the contrary, now that the affair was settled, he was free of the burden of policy and planning and could devote himself more exclusively to purely musical matters. Schalk, having gained complete autonomy, bore him no grudge and continued to be in awe of Richard Strauss the composer, whose operas he would gladly schedule and conduct, as they acted as powerful magnets for the Opera. The city of Vienna saw it the same way when it made a deal with the master from Garmisch: he would receive a prestigious plot in the Belvedere Gardens, on which to build a house, in return for the original score of *Der Rosenkavalier* and some future conducting commitments, to be determined. Strauss was happy not to lose his fine group of Viennese instrumentalists and superb cast of singers; artists like Lehmann were satisfied to be able to continue performing, now without quavers, the music of the composer most of them adored, the earlier machinations of Weingartner, Korngold, and their cohorts notwithstanding.[133]

For Lotte Lehmann, one of the more pleasant consequences of her rise at the Vienna Staatsoper was being invited to sing outside Vienna. This she did, in Austria, Germany, and further abroad, something she liked especially because she was adventurous in her youth and this brought in extra money. For example, she was offered 4,500 post-inflation marks for a Hamburg song cycle in the fall of 1925, and 3,000 marks to participate in a production of Mahler's Fourth Symphony.[134] Early on, she was invited to Vienna's former satellites of Budapest, Prague, and Pressburg (Bratislava), as well as to Dresden and Breslau and, in 1918, even to Constantinople.[135] She received invitations to Milan and Rome, which she declined, and traveled to Buenos Aires and Montevideo with the Vienna Philharmonic under Weingartner in 1922, a tour she disliked.[136]

None of this stood any comparison to her favorite touring ground, which was Hamburg, where she was loved and where the Stadttheater's Intendant Hans Loewenfeld, until he died in 1921, would gladly have hired her back. Lehmann concertized there, in opera and song, up to the mid-1920s, every year except for 1922–24, in remarkably rich performances.[137] Because most established Hamburg critics knew her, as did many members of the audience – whom one paper in 1921 described collectively as her "old fan club" – Lehmann was able to capitalize on a large degree of familiarity in the Hanse port.[138] Conversely, it gave especially the critics a chance to judge her, against both her past performances prior to 1917 and her more recent ones since her development into a leading prima donna. This sense of mutually empathetic familiarity not only made Lehmann very comfortable, but also allowed the critics to be franker

in their judgments than they might otherwise have been and to see whether improvements in her already impressive performances were discernible.

Lehmann returned to the Stadttheater in May 1917, not coincidentally as Elsa, for that role had been the foundation of her fame in November 1912. After emphasizing this historic fact, the veteran critic Wilhelm Zinne lauded the immediacy, the warming qualities, and the indelibly exciting elements as typical for a Lehmann role. His colleague Heinrich Chevalley concurred, singling Lehmann out as "presently *the* Elsa impersonator anywhere."[139] That Lehmann had objectively progressed on the operatic stage was attested in April 1919. For as Myrtocle in D'Albert's *Die toten Augen*, a role with which she had bid Hamburg goodbye three years earlier, her voice was said to have developed a more bountiful sound and her expressiveness to have become "richer, richer for several in-between stages."[140] In May 1919, Zinne also liked Lehmann as a more mature Sieglinde than she had been earlier in Hamburg during the 1913–14 season, when altogether she had sung that part eight times.[141] Moreover, he felt she had ripened as Eva Pogner in *Die Meistersinger* one year later, even if another critic thought her somewhat too capricious.[142] For Mimi, however, of Puccini's *La Bohème*, she was, histrionically, not deemed ideal, for whereas her voice was beautiful, Lehmann's ample proportions did not resemble those of the tubercular Paris seamstress. Still, all told, she managed to come across as convincing to the local press.[143]

There were those critics who did not unequivocally approve of all her roles, as she was now primarily regarded as a Wagnerian soprano. Hence her part as Marta in *Tiefland* in December 1920 was questioned, and there was similar criticism a year later, when she presented a rather too matronly Madame Butterfly, whose character Puccini had conceived as that of a slight teenager.[144] Like Mimi's, this was a new role Lehmann had not played for the Hamburg audience before. Those parts the aesthetically conservative Hamburgers liked to see her in were the classic Wagnerian ones – Elsa, which she did again in May of 1921; Elisabeth, which followed shortly thereafter; and Eva, whom she impersonated once more in October 1925. At that time, she had been at the Vienna Staatsoper for almost twenty seasons, and to some Hamburgers it showed. There was a foreign element in her depiction of the Pogner girl, one critic complained, something pompous reminiscent of a court theater, which did not fit the loveliness of "our Lotte Lehmann." There was a "prima donna touch" to her appearance, said the critic, and he wanted it removed.[145]

These Hamburg reviewers were even less charitable whenever Lehmann gave recitals. In December 1920, in a concert in which she was accompanied by her old colleague Gustav Brecher, most recently of Frankfurt, the soprano was taken to task for her weak rendition of Rezia's Ocean Aria from Weber's *Oberon*, in that she could not be expressive enough and reach the required heights, which last point was also mentioned after a song recital in November 1921.[146] In certain cases her deficient breath control and sense of rhythm were indicted, both of which allegedly got worse the more nervous she had been beforehand.[147] It was said that she designed her programs indiscriminately, sometimes catering to a cruder taste by choosing kitschy songs by less renowned composers, and

certain critics were bothered by the fact that she had to read the music. The
overall impression conveyed until late 1925 was that Lotte Lehmann was not, as
yet, the ideal lieder singer and that, as an interpreter of arias on a concert stage,
her comportment was still too much beholden to a fully costumed operatic
setting.[148]

Next to Hamburg, the second stage outside Vienna that Lehmann was inter-
ested in was Berlin. It is possible that she wanted to return to the Mark Bran-
denburg, her home, and to the place of her musical origins as early as 1917,
despite her popularity in Vienna, because as a Prussian she had fit into Vien-
nese society only gradually. She was able to do a concert, albeit not an Opera
engagement, together with her old conductor colleague from Hamburg, Elmar
Meyrowitz, whose orchestra accompanied Lehmann's arias by Gustave Char-
pentier (actually a living composer of a belligerent country who should not
have been played during the war) and Erich Wolfgang Korngold.[149] In 1921,
she managed to be contracted to the Charlottenburger Oper, which had existed
since November 1912 as a popular reissue of the royal Oper Unter den Linden
(Hofoper, now the Prussian Staatsoper). Undoubtedly, Lehmann would have
preferred to perform there, but as things stood she could sing only one role in
Berlin-Charlottenburg, that of Myrtocle for two evenings in late August, under
the directorship of Georg Hartmann and the baton of Hans Zander, neither of
them distinguished. Lehmann was billed as a virtual unknown, and the house
was not full. As before in Hamburg, this opera was ridiculed by the Berlin
cognoscenti. One mocked: "It would surely be necessary to press shut two liv-
ing eyes, in order to render these 'Dead Eyes' very valuable." But in a repeat of
her Hamburg feat five years earlier, Lehmann rescued the piece with her singing,
as the critics credited her with "perfect vocal technique and moving drama."[150]

Ambitious as she was, Lotte Lehmann still wanted to get to the Berlin Staat-
soper, and in November 1921 she began using her own negotiating skills, espe-
cially since she knew that her Vienna contract would expire after the 1921–22
season.[151] She probably thought that a time-limited guest performance might
open the door to a permanent situation. And so she got directly in touch with
Intendant Schillings (whose companion, Barbara Kemp, she knew as a col-
league) and suggested a visit of one to two months, perhaps as early as autumn
1922, after her upcoming tour to South America. Schillings at first discour-
aged her, as far as her repertoire was concerned, because not all of her roles
were deemed suitable for Berlin, but in April 1922 he offered her a contract
for two weeks in late October, preferring her to sing Eva, Elsa, Cio-Cio-San
from *Madama Butterfly*, and Mimi. Yet because of the short time period and,
undoubtedly, because she was able to renegotiate her Vienna terms, this engage-
ment did not come to pass. Lehmann successfully signed a new agreement,
however, for a guest period from the middle of March to the end of April 1924.
That was after the end of the German inflation, and she was to receive 900
marks per performance for a total of eight performance.[152] As it turned out,
the soprano worked eleven evenings.[153]

Singing at the Staatsoper was a significant improvement over Lehmann's
earlier tour in Charlottenburg, and not just because of the impressive offer-
ings, as she was able to star in *Lohengrin*, *Parsifal*, *Madama Butterfly*, *La*

Bohème, *Tosca*, *Tannhäuser*, and Korngold's newest, *Die tote Stadt*. Here she sang Marietta five times, and she and her partner, Richard Tauber, were said to have been "insurpassable" in the two main roles. Moreover, in contradistinction to her Charlottenburg stint, the directors were all first-rate: Schillings as the intendant, Erich Kleiber as *Generalmusikdirektor*, and Georg Szell as conductor. Judging by her newspaper notices, Lehmann could now nourish hopes for a permanent Berlin engagement with some justification.[154]

This possibility returned in late 1925, when Lehmann was again called to Berlin, with the help of conductor Bruno Walter, who also had a hand in getting her to London in 1924 – the soprano's first significant assignment abroad. Against some national opposition, the industrialist Samuel Courtauld had decided to sponsor a German season of Wagner and Strauss, as the first international event at Covent Garden after World War I. The intendant of such a sensitive program was the Germanophile Colonel Eustace Blois, while the overall musical directorship had been handed to Walter, who had been eased out of his Munich position in 1922 by a (partially anti-Semitic) cabal surrounding the new conductor, Hans Knappertsbusch. Bruno Walter then decided to engage the best singers he knew, from Germany and Austria.[155]

Walter wished to present Wagner's *Ring* and *Tristan und Isolde* as well as Strauss's *Der Rosenkavalier*, *Ariadne*, and *Salome*. Lehmann was called upon to sing Sieglinde, Ariadne, and, for the first time, the Marschallin from *Der Rosenkavalier*. Presumably when he asked her, Walter, who had never met Lehmann, did not know that she had not previously sung the Marschallin. But rather than returning the new score to him, as she was known to do, Lehmann accepted for fear of losing out on the entire contract. When she arrived in London in May, she admitted her inexperience with the role to Walter, who showed himself angrily surprised, but then faithfully studied it with her at the piano. Lehmann never forgot this act of kindness, and the incident started a lifelong friendship. It seemed that he was taking over from Schalk as potential mentor.[156]

Lehmann's Vienna colleague Elisabeth Schumann did not have a problem with her role of Sophie, for she had already sung it with Walter in Spain.[157] Other brilliant members of that cast in *Der Rosenkavalier*, which was staged on May 21, were Delia Reinhardt, whom Walter had contracted from Munich, as Octavian, and Vienna's Richard Mayr as Ochs. Other stars were, from Germany, Maria Ivogün, Friedrich Schorr, and Leider, and from Vienna Piccaver, Kurz, Emil Schipper, and Maria Olszewska. There was also a promising young Dane by the name of Lauritz Melchior making his début as Siegmund. It was as stellar a cast as had ever congregated to sing opera as a company, within or outside of Central Europe, and it took the Londoners by storm.[158]

Although Lotte Lehmann had never before sung the part, she turned out to be a memorable Marschallin. Three young men, who later got to know her more closely in a professional capacity, made her aquaintance on May 21 from the audience floor for the first time and were impressed. "Lotte was the most lovable of all the Marschallins I have known," remembers Sir Neville Cardus, the distinguished critic. "Once her performance of the Marschallin, as beautifully acted as it was sung, had been seen, everybody was talking about her,"

asserts pianist Ivor Newton, who later accompanied Lehmann in Britain frequently. The American writer Vincent Sheean already thought her Marschallin "a finished work of art," and, he continues, "she awoke the next morning to find herself famous."[159]

Indeed, Lehmann had acquitted herself in this role so well that she rated a mention in the *New York Times*, along with Reinhardt and Schumann, both of whom had already sung at the Metropolitan.[160] In Walter's own opinion, Lehmann's work as Marschallin "was even then surrounded by the brilliance which has made her portrayal of that part one of the outstanding achievements on the contemporary operatic stage."[161]

In London in May 1924, Lehmann had also excelled as Sieglinde and Ariadne, and Walter, who was to remain director of the German season there until 1931, called her back as Marschallin, Elsa, and Eva in 1925.[162] However, the first order of business for the conductor after such success was to arrange for the singer to come to Berlin in order to help him bolster his newfound but tenuous position at the Städtische Oper, under Intendant Heinz Tietjen.[163]

The Charlottenburg Opera, increasingly in financial difficulties and ultimately bankrupt, had been acquired by the city of Berlin in time for the 1925–26 season and renamed the Städtische Oper. Its new intendant beginning in May 1925 was Heinz Tietjen, hired away from the Breslau stage, a brilliant multilinguist with an English mother born in Tangiers, who was himself an able conductor, cellist, and timpanist, while Walter was the new *Generalmusikdirektor*, in whom, at first, Tietjen found a very congenial partner.[164]

The season opened on September 18 with *Die Meistersinger*, Lehmann starring in the role of Eva and Bruno Walter conducting. In the person of Walter, said one review, "a leading authority in matters musical" had been gained. About Lehmann, it judged that she stood out from among her peers on the stage; her Eva represented "the triumph of the *Meistersinger* evening, the beauty of her voice and clarity of her expression being unapproached." However – hardly Lehmann's fault – the acoustics were found to be wanting, since the refurbishing of the Opera house had, for lack of funds, not been complete. This detracted somewhat from Lehmann's initial success.[165]

On the following night a modern opera was staged, *Die heilige Ente*, by the Austrian composer Hans Gál. Walter surprised the audience and his intendant by not conducting himself, instead leaving that task to one of his subordinate kapellmeisters, Fritz Zweig. The next evening, Lehmann was again scheduled, this time to sing Elsa in *Lohengrin*, yet Walter once more employed a no-name substitute.[166] Thus, although the soprano was described as "an Elsa, second to none on any German Opera stage," she was lacking the cachet of Walter's own musical direction and, according to the critics, was surrounded by singers not quite her equal.[167] This beginning did not bode well for a more permanent position in Berlin, one that could supersede what she already had in Vienna. Nonetheless, in the following few months experts were still of the opinion that as long as Walter was taking the trouble to personally conduct on stage, the Städtische Oper not only was respectable and getting more so every day, but also had the potential of surpassing in quality the Staatsoper, which was going through a crisis after the dismissal of its intendant, Max von

Schillings, by Prussian Minister of Culture Carl Becker "over artistic policy."[168] And so, hoping for future success that might pay off, and being driven by both Tietjen and Walter, who well realized her qualities as a drawing card for opera-loving audiences, Lehmann made further arrangements early in 1926 for guest appearances in Berlin.[169] In early January, she received renewed permission for an unpaid vacation from Schalk, so that on February 27 she could star as Lisa in Tchaikovsky's *Pique Dame* in Berlin. Walter also planned to cast her as Ariadne, Tosca, Sieglinde, and Myrtocle.[170]

During years of stellar performances, one could have expected Lotte Lehmann's net income to rise over time. This was indeed the case. Apart from what she made during her contractual vacations on tour and with a few record companies, she did very well at the Vienna Opera, allowing for the uncertain economic circumstances of the period but also taking into account the fact that she was never shy to ask for what she thought was her due.

By the terms of her March 1914 contract with Hans Gregor, she was to receive 20,000 kronen in her first season (1916–17) and 28,000 kronen in her sixth and last season (1921–22). According to a letter by her superior Schalk of October 1918, those monetary terms were still in effect for at least the first two years of her stay in Vienna, even though the war had already caused inflation.[171] In early fall of 1916, a pair of ladies' shoes cost around fifty kronen and a pure silk blouse up to forty kronen. The wartime distribution centers offered salt water fish for three kronen per kilogram and pork for around eight kronen. The most expensive ticket to hear Lotte's famous namesake Lilli Lehmann sing in a recital on October 20 sold for twenty kronen and sixty hellers.[172] Hence Lehmann's starting salary was good, but certainly not luxurious. She was surprised that after Emperor Franz Joseph's death in November 1916, when the Opera closed for a while, she was not allowed to pursue an invitation to Hamburg, which, she insisted, was her right.[173]

In the spring of 1918 Gregor, having realized her worth, tried to keep her at the Hofoper until 1932 by offering her a new contract with more money. But Lehmann refused this, for fear of being unfairly tied down.[174] In the fall of that year, as Gregor was being isolated and with the Hofoper's official status in flux during the political regime change, Schalk offered to renew her stay until 1928, promising 50,000 kronen by that time and immediately increasing the length of her vacations. The premise for this was Loewenfeld's attempt to lure her back to Hamburg, for the German equivalent, as Lehmann seems to have suggested to the Viennese, of 50,000 kronen. However, it appears that she never produced an offer in writing, so that until today this issue remains unresolved. All the same, both Schalk and Strauss felt that special efforts should be undertaken to keep the soprano happy by modifying her original contract generously and in keeping with the, by now stinging, inflation. An added incentive for them was that the United States was beckoning after the end of the war, as it had beckoned German-Austrian singers, for the Metropolitan Opera's German seasons, long before the conflict. One who would soon follow the siren call was Maria Jeritza, and it was feared that other sterling singers like Lehmann might be tempted as well. In order to stay in Austria, both Jeritza and Lehmann maintained

that they would have to be remunerated at the top of the Vienna scale.[175] A further complication in December 1918 was that certain artists of the Hofoper-turned-Staatsoper were now advocating their right to dissolve contracts dating back to imperial times, in order to negotiate new ones. However, whereas the Opera administration, at least according to Lehmann's contract, had such a right itself, the artists it employed did not, so that Schalk and Strauss need not have worried unduly. Nonetheless they were nervous, and so tried to convince their superiors in the bureaucracy (primarily in the Education Ministry) of the intrinsic value of their most celebrated singers, which was in accord with the new official definition of Austria as a land of culture, with the Burgtheater and the Staatsoper at the center.[176]

By March 1919 Lehmann, always firmly insistent, had been granted a wage increase to 50,000 kronen, whereas by her original contract terms she should have been earning only 22,000 kronen. As well, the previously allowed winter holiday of four weeks (presumably granted by Schalk in the fall of 1918) was extended to six weeks, with the summer months free in any case. By this time, the war inflation had escalated, with sugar costing upward of 7 kronen per kilogram, a fox fur stole 400 kronen, and a ladies' costume at least 180 kronen. Still, for Lehmann, the price-to-wages ratio was now such that she could call herself a wealthy woman. There were others who still earned more, as did the experienced soprano Lucie Weidt, who was eight year older than Lehmann and received an annual salary of 72,000 kronen, but certain others received much less – for instance, the bass Josef Manowarda, who, two years younger, was only in his fourth year at the Staatsoper and earned 34,000 kronen.[177] However, Lehmann again was annoyed that she was not allowed to breach one of the original terms of her contract: a typically Viennese Varieté had offered her to sing in a small operetta by Franz Lehár every evening for a month, for the princely amount of 120,000 kronen, which directors Schalk and Strauss rejected outright.[178]

As the inflation worsened, the Vienna Staatsoper was at pains to compensate for any financial fallout its members would suffer. It did so by paying out monthly adjustment supplements. In Lehmann's case, she also received irregular increments in vacation time, which she could use for touring. By June of 1920, Schalk himself considered her annual income of 85,000 kronen to be below the norm payable to a singer of her credentials and asked the administration for redress. Still, Lehmann felt neglected, so that she wrote Schalk that everybody else's salary was being increased but hers. The judicious Schalk answered calmly that for some stretch of time she had been favored above almost everybody else and that the others were now catching up. Besides, she already had "very long vacations, during which we had to miss you most painfully."[179]

In October 1920 Lehmann was earning considerably more than her friend Schumann, who, her own age and already with Metropolitan Opera experience, had arrived at the Staatsoper only in 1919.[180] A year later, at a time of hyperinflation when a ladies' coat cost around 20,000 kronen, Lehmann, after further representations, was making over two million kronen per year. Woefully, she remarked to Baroness Putlitz that "the price increases are so insane that the

moment one has received a wage improvement it is canceled out by the latest cost buildup."[181]

This led, from late 1921 to early 1922, to Lehmann's considerations regarding the upcoming end of her original contract and her contacts with Berlin. As it turned out, she would have been free to move elsewhere or do continuous runs as a guest artist, in the manner of Bruno Walter after his dismissal from Munich in 1922. However, she arrived at a new accord with the Vienna Opera directorate, the exact details of which are not known, because that particular contract is missing. But Schalk must have acted quickly on the seriousness of the situation, for in April 1923 he wrote that losing Lotte Lehmann was not an option, since there were "artistic and economic factors determining the indispensability of the artist."[182]

A year later, when toward the end of the inflation a pair of shoes sold for about half a million kronen, Lehmann received 12 million per performance and, at sixty-four stagings, made close to 800 million a year. The young Norwegian singer Karl Aagaard Oestvig, who was now earning eight million per performance, found out about the difference and was chagrined. This system of staggered raises and the secrecy surrounding them, which was all very Viennese in its Byzantine machinations, did little to foster the spirit of collegiality among even the most generous of artists.[183]

That factor, however, was only one of many contributing to the animosity between Lotte Lehmann and Maria Jeritza. Jeritza was the highest-paid singer at the Opera and always miles ahead of whatever Lehmann might be earning. After autumn 1918, Strauss typically supported even her maximal demands; he liked star singers for his operas.[184] By June of 1920, when Lehmann was unhappy with her 85,000 kronen per year, Jeritza was offered 336,000 kronen. Schalk explained this to the administration in terms of current supply and demand and that diva's "rapidly increasing fame." He stressed that the "power of attraction of Frau Jeritza is a constantly rising and absolutely certain one. The artist has attained a position which appears to justify such demands, not only in Vienna, but also in foreign countries, which pay her exorbitant honoraria." He thought that "no sacrifice seemed large enough, in order to safeguard her services for the house."[185]

Lehmann could not help feeling set back amid all the fanfare surrounding the blond prima donna, who, with every breath she took, knew how to make the most of it for publicity. Performance comparisons between Jeritza and Lehmann at that time, against the wages paid, would often have favored the latter. The purely showy side of Jeritza's stage actions was seen through often enough. Thus she sang and danced Strauss's Salome in October 1918, and the papers emphasized her strong histrionic talents (admittedly her forte) and her "warm, sensuously colored voice." But the musicians in the orchestra pit had professional qualms. They were annoyed because Jeritza liked to shorten her parts according to her every whim, and there were so many jumps in the score as sung that the opera appeared "like a torso."[186] After the premiere of Die Frau ohne Schatten, Jeritza as Empress enacted parts more reminiscent of operetta than opera, a calculated act which motivated her claque of paid admirers to

try to bring the house down. Laudably, Lehmann was not associated with such antics.[187] Jeritza's Carmen in May of 1920 was said to have been such that, on the stage, there was no "Jeritza as Carmen," but rather a "Carmen as Jeritza." She was not an ideal Carmen, wrote another critic, because she transfigured that character poetically, in order to avoid the image of the strumpet, yet in doing so she missed out on the demonic sense necessary for the role. Lehmann's Micaëla, by contrast, was described as "moving."[188] There were operas in which each of the singers, with her own integrity, appeared as superb, even ideal, sometimes almost simultaneously, as when in October 1920, Jeritza starred as Georgette in *Il Tabarro* and Lehmann as the Nun in *Suor Angelica*, both by Puccini, who personally showed himself enraptured by both actresses.[189] Other works were vehicles strictly for Jeritza, like the part of Rosalinde in *Die Fledermaus*, conducted by Strauss in January 1921, or Marietta in Korngold's *Die tote Stadt*, which she premiered around the same time. In these roles Jeritza impressed with her striking appearance and her acting ability but also proved, as the critic Elsa Bienenfeld once wrote, that "one could declare La Jeritza to not actually be a vocal artist."[190] Much about Jeritza, however, made Lehmann very nervous, and, even more made her envious, so that she rendered herself vulnerable. When in July 1919 Strauss had to fear Lehmann might not undertake the role of the Dyer's Wife, he coaxed her to Garmisch by writing her that surely it was not desirable that "Fräulein Jeritza will have to assume your role, because Fräulein Lehmann cannot handle it." That would certainly be suicide.[191]

It was an open secret that Jeritza was going to America as soon as the Great War ended, especially when she announced to Schalk in December 1918 that in future she did not wish to perform more than forty-five times per year at the Staatsoper.[192] Others had gone to that country before 1914: Leo Slezak, Lucie Weidt, and, of course, Mahler and Schalk as conductors. It was uncomfortably clear to both Schalk and Strauss that the highest wages were being paid there and that this alone, in a ravaged, inflation-ridden postwar Vienna, acted as a huge attraction.[193] So it does not take one by surprise that Lehmann too was casting her eyes in the direction of the United States, which she must have done at least by April 1919, when she wrote to Baroness Putlitz that from America she had heard nothing positive yet, as if her Berlin agent Salter had been working on a prospect.[194] By January 1920 she had had an America clause built into her current supplementary contract, and half a year later she wrote to Richard Strauss's son Franz, who was to accompany his father and Elisabeth Schumann on a tour of the States: "God, how nice! I envy you a lot – how many beautiful things you will see and experience."[195] Indeed, by that time the New York Metropolitan Opera director Giulio Gatti-Casazza had suggested to his assistant Edward Ziegler that he might "find out about value of Soprano Lotti [*sic*] Lehmann," because Jeritza as the favored candidate was acting pretentiously. Jeritza had first come to Gatti-Casazza's attention as guest star in Offenbach's *La belle Hélène*, produced by Max Reinhardt in Munich in 1912; he had then sought her out again in Venice in June 1914, wishing to hire her. The war had prevented that. However, by 1920 he had also heard of Lehmann.[196]

Gatti-Casazza knew of what he spoke, for by 1920 not only could he look back on some respectable experience with music in the United States, and especially at the Metropolitan Opera, but he was also a former director of La Scala in Milan. The Metropolitan had French and Italian seasons, but in particular distinguished German seasons, not least because New York's second-largest population contingent was German. In 1890, by the mother-of-birth country criterion, 27 percent of New York's one and a half million inhabitants were German.[197] Hence the popularity of German music in New York, especially Wagner's – but not only there, for in Boston, for instance, the entire orchestra spoke German, most of its members having immigrated from Central Europe. Not surprisingly, Germans also were instrumental in the founding and early development of music academies in the eastern United States, such as the New England Conservatory and the Eastman School of Music.[198]

Founded in 1880, the Metropolitan had its first German season in 1884–85; Wagner had been played in America since the middle of the century, almost exclusively by German immigrants.[199] In 1885, conductor Anton Seidl arrived from Germany to preside over a contiguous series of German seasons at the Met, mostly consisting of Wagner's music. Seidl was eminently qualified to lead these, as he did until 1890–91, for he had been Wagner's trusted assistant in Bayreuth. The other prominent German who also arrived in New York in 1885 for her début was soprano Lilli Lehmann, joining Emil Fischer, the resident Wagnerian bass.[200] Lilli Lehmann, who mastered a repertoire of 170 roles in 119 operas, not only in German but also in Italian and French, spent eight years altogether in America before returning to Europe, where she would perform in Bayreuth and teach Boston's Geraldine Farrar after her arrival in Berlin in 1901.[201]

By 1889–90 some of the influential Anglo-Saxon stockholders of the Metropolitan Opera Company had become tired of, in fact opposed to, so much Wagner, with the result that the Italian and French were accorded more weight. In 1903, Caruso was poised to succeed Lilli Lehmann as the most popular star; his chief metier was of course Italian opera; he was joined by other luminaries such as Lillian Nordica, Jean de Reszke, Emma Eames, and Nellie Melba.[202]

The year 1907 was an important one for the Met. Farrar began her regular employment there, and Otto Hermann Kahn, a rich banker, purchased enough Metropolitan stock to increase his influence on its board of directors, on which he had been sitting since 1903. (He had not increased it sufficiently to undo the banning of Strauss's *Salome*, after it had been performed only once, in January 1907 – as he would gladly have done, but other, more prudish board members were too powerful.) In 1908, Kahn became chairman of the board of a newly reorganized Metropolitan and was responsible for the engagement of Gatti-Casazza as general manager, who brought with him, from La Scala, his friend, the conductor Arturo Toscanini. In 1908–09, Toscanini would conduct the French and Italian operas, and Gustav Mahler the German. Moreover, Kahn purchased the contracts and some properties of Oscar Hammerstein, German-born and a self-made impresario, who had been running a rival institution, the Manhattan Opera House, since 1906. By 1910, Hammerstein had been bought out completely and was no longer able to produce any opera.[203]

The banker Kahn, born in 1867, came from a very wealthy Jewish family in Mannheim with a strong interest in culture. Once in New York in 1893, Kahn married into an even wealthier banking family whose affairs he now represented, built himself huge mansions, and became a leading patron of the *beaux arts*, which, he felt, should be accessible to the greatest number of people.[204] Because of his interest in music, the Metropolitan Opera became his chief beneficiary in philanthropy.[205]

When World War I broke out in August 1914, the German Kahn was at pains to demonstrate his loyalty to the United States. Apart from his own investment and banking business, he was also thinking of the Metropolitan, whose main shareholder he now was and whose operating deficits he had unflinchingly covered in the past with his own money. Continuing as chairman of its board of governors, he was in accord with changes that were deemed necessary to keep the institution afloat in difficult times, the German music tradition aside.[206]

After the beginning of the conflict, the influence of German music in the United States, which despite its large German population sided more clearly with the Entente powers, hardly receded. From the Metropolitan, Toscanini departed, wanting to be in his home country, as Italy had joined the Entente by the Treaty of London in April 1915; he was replaced by the Austro-Hungarian Artur Bodanzky. A few Central European members of the Metropolitan left for Europe of their own free will. For the moment, German repertory, including Wagner's operas, continued to be performed.[207]

However, as Frances Alda, a Met soprano and then the wife of Gatti-Casazza, noted, "it was inevitable that the war fever and the hatred it fostered should have its effect on the popularity of German opera and German artists in America."[208] With more and more Americans, including some members of the Met, having been lost through Germany's ruthless submarine attacks on passenger ships like the *Lusitania*, President Wilson declared war on Germany in April, and on Austria-Hungary in December 1917. Now the mostly German Kneisel Quartette was hounded off the stage; in Boston, the German-born conductor Karl Muck, albeit a recent Swiss citizen, was interned and then deported. At the Metropolitan, opera in German continued for the balance of the 1916–17 season, but in 1917–18 six singers, citizens of Germany or the Dual Monarchy, departed, and no German operas were given. Among very few exceptions up to and including the 1918–19 season were Mozart's *Figaro* in Italian and Weber's *Oberon* in English.[209]

After the war, it fell to Kahn and his board and to Gatti-Casazza, both judicious experts, to restore conditions at the Met to the status quo. But this was not so easy, for American Legion members were able to demonstrate their picketing power outside the Opera building. During the 1919–20 season, Wagner's *Parsifal* – his least controversial work – was performed, but in English. In 1920–21, a mixed German-American cast staged, in English, *Tristan und Isolde* as well as *Lohengrin*, after tenor Johannes Sembach returned from Germany. He was the only formerly dismissed Metropolitan company member to do so.[210]

It was against this background that Maria Jeritza came to New York in November 1921 in order to sing Marietta of *Die tote Stadt* on the nineteenth – in German. For Gatti-Casazza and Kahn she was to reintroduce the German

season, and since the general manager knew about her charms and audience charisma from personal experience, he thought her fully capable of doing so. (Strategically brilliant, Elisabeth Schumann and Richard Strauss were then also touring the East Coast in order to resurrect the cause of German music.)[211] Was it coincidence that Kahn had seen and heard Jeritza creating Ariadne at the Stuttgart Hoftheater under Intendant Joachim zu Putlitz in 1912? For as soon as Jeritza arrived in New York, lonely in a hotel suite without her alienated husband and hardly knowing any English, she was taken under the wing of the debonair banker and became his mistress. Kahn had always been a ladies' man and, with the tacit understanding of his wife, Abby, was in the habit of entertaining girlfriends.[212] In the spring of 1922, Kahn came to visit Strauss, whom he admired, in Vienna, openly in the company of Madame Jeritza.[213]

On November 19, 1921, Marietta in *Die tote Stadt* was a qualified success for Jeritza. Whereas in her "blond piquancy" Richard Aldrich from the *New York Times* found her "an actress of native ability" and with a voice that was "powerful, of youthful and sympathetic quality," he also thought that it had a tendency to degenerate "unpleasantly into stridency" because Jeritza "scooped" her tones. From perceptive critics, these were the kind of mixed comments Jeritza had become accustomed to over time in Europe. Other, less perceptive observers concentrated mainly on her beauty and spellbinding theatrics.[214] But for her, that performance was merely a warm-up exercise. Predictably, her Tosca less than two weeks later became the sensation it had long been for many Europeans. One who stood at the top of the Opera with her mother that night was a very young Jeanette MacDonald, who was awed by a carefully staged "Vissi d'arte" scene, wondering whether she should abandon the musicals she was entering for the sake of opera.[215]

Jeritza also sang other parts during that 1921–22 New York season – Elsa, Sieglinde, and Santuzza from *Cavalleria rusticana* – but none impressed as much as her Tosca, which she gave several times.[216] In New York, the role of Tosca had so far been monopolized by Geraldine Farrar, who now felt herself upstaged by the newcomer. For the only forty-year-old singer, it was time to retire. By April 1922 the Boston belle, who until his death in 1921 had been rivaled only by Caruso as the preeminent star of the Met, sang her last role, as Zazà of Ruggero Leoncavallo's lyrical comedy (1900), a demimonde character who, as had Tosca, would at least suit her own temperament.[217] Although she found Jeritza always "a great showman," judged their Tennessee-raised colleague Grace Moore, "she never had the subtlety or beauty of Farrar's art."[218] No matter: Jeritza would be the new number one star at the Met for a decade, having to contend, in the male department, merely with Beniamino Gigli and Fyodor Chaliapin. Later she disingenuously pronounced Farrar "a remarkable artist," claiming that she herself had been totally innocent in the Tosca affair.[219] Being assured of great financial and artistic success and enjoying the unquestioned support of her Wall Street lover, she alternated between New York and Vienna until 1932, usually honoring contracts with her home Opera only from early spring to late autumn and taking other European engagements as the occasions arose.[220]

When Jeritza returned from her first American tour to sing Elisabeth in *Tannhäuser* at the Staatsoper in spring 1922, the house came down.[221] Here in

Vienna, and especially when Jeritza chose to be there, Lotte Lehmann continued to be rattled by her existence. It was not just that with her talent for self-promotion, Jeritza made the most even out of a scandal that should have harmed her, but instead placed her in the gossip columns of the Vienna papers for the sake of ever-greater publicity.[222] In one characteristic incident, contralto Maria Olszewska tried to spit on her colleague from the stage, as Jeritza was sitting in the wings chatting with contralto Hermine Kittel. The conversation allegedly was about tenor Emil Schipper, Olszewska's husband, a handsome man whom the blond diva currently had her eye on. As it happened, instead of Jeritza, Kittel was hit by Olszewska's venom, but Jeritza posed as the innocent victim, and the contralto was fired, if not for long.[223] This made wonderful copy for the journals, which never passed up a chance to mention details from Jeritza's colorful life or to present her on their covers.[224] Although the notorious satirist Karl Kraus derided her, because she had been lauded in the press as Austria's foremost "diplomat" in America, Jeritza could point to the more respectable title of *Kammersängerin* given her under the Hofoper regime, that in 1923 she was made an honorary member of the Staatsoper, and that she had been appointed an honorary member of the League of Nations a year before. In 1925, Jeritza even invaded the space Lehmann had created for herself abroad by concertizing at Covent Garden. Not only that, she was accorded an honor so far denied to Lehmann when she was received by the king and queen.[225] Whatever, Jeritza was consistently superb at manipulating people and events, thereby also using America. She honed her personal relationship with Strauss to her advantage, currying favors, such as dangling the prospect of a *Salome* staging in New York before his eyes (to be accomplished in cahouts with Otto Kahn), which was to the ultimate disadvantage of her rival.[226]

Lehmann had to compete with Jeritza on stage; to a certain extent her relationship with the Moravian diva resembled that of other historic prima donna rivalries; Maria Callas and Renata Tebaldi in the 1950s come to mind.[227] This would presuppose that both singers starred in the same roles, which Jeritza and Lehmann did relatively seldom, as with Tosca, Sieglinde, Elisabeth, or Ariadne. More credible was their competition as opposites, as in *Die Walküre*, with Jeritza's Brünnhilde to Lehmann's Sieglinde, or in *Die Frau ohne Schatten*, Jeritza's Empress singing opposite Lehmann's Dyer's Wife. Fans of each, as they were often organized in claques on the payroll of their favorite singer, in fact all the patrons of the Vienna Staatsoper, recognized that each had her own specialty, was best in her own metier, Jeritza excelling in the showy, sexy, steamy, roles and Lehmann in the sincere, sweetly innocent, and deeply emotional ones. This really need not have been an issue for either one of them, unless they chose to make it so, which of course they both did, making copiously sure to avoid one another, for example, by using separate exits from the Opera when both should have left the house through the one main door that was dedicated to the female singers.[228]

It was unfortunate for Lehmann that in those few Jeritza roles she duplicated critics were immediately sharpening their pencils for comparisons. This happened in the case of Elisabeth and Ariadne even as these critics were ready to admit that Lehmann's enactments were autonomous and unique in their

integrity – Jeritza's name could not fail to surface.[229] Undoubtedly, it was a mistake for Lehmann to sing Tosca on January 26, 1923, during Jeritza's customary absence in America, as her father had warned her not to do. Lehmann herself had admitted to him that it was "Jeritza's showpiece," against whose success there was not a chance of winning approval from the audience.[230] And although Lehmann did well in that role, the critics could not help but mention her rival. "La Lehmann is no Jeritza, but a Lotte Lehmann." This sentence encapsulated all the credit that was due to La Lehmann, and more, yet still it left no doubt that she was singing this part as a surrogate Tosca, in the shadow of Vienna's *prima donna assoluta*.[231] As bad luck would have it, Jeritza returned, once again triumphantly, from New York to sing Tosca herself, in her well-worn hyperbolic manner but to notices which could have made Lehmann scream with anger: "The tremendous enthusiasm about Jeritza's return to the Opera as Tosca illustrated perfectly how poor we had become and how grateful we have to be and indeed are that a world star does not totally forget us."[232]

Lotte Lehmann was clearly unhappy with Maria Jeritza constantly breathing down her neck. But what could she do to escape from this conundrum? Only two avenues were open to her. She could try to improve her situation in Vienna, so that Jeritza might leave for good, or she could leave (as she had essayed in Berlin since 1922), preferably for America, thereby again emulating her rival.

And so in October 1923 she sat down to make a principal statement not to Strauss, of whom she was suspicious because of his proximity to "Mariandl," as he affectionately called Jeritza, but to Schalk, of whose overall devotion she was certain. Her letter became a bitter screed. More and more, she was being played against the wall while, at the same time, she was at pains to shun cheap publicity. Yet it was she who was the real artist, one whom the directorate of the Opera had not yet placed where she belonged. She felt defenseless against "this wave of American tastelessness." The local press was obviously biased, and yet "there are other artists next to the Only One!" Because of the political changeover she had missed being appointed a *Kammersängerin*, and among the prominent singers of the Staatsoper, she was now the only one without a title. "Why have my directors never looked for ways to honor me, not just in words but also deeds?" Not even an "honorary member" of the Opera could she be! It would not do merely to stare hypnotically into the glow of those fireworks, which darkened everything around it. "There still are stars on the firmament."[233]

Apart from seeing to it that Lehmann did not lag behind in terms of her honoraria and had ample vacation time – though never as much as Jeritza, on both counts – Schalk was in no hurry to make changes. For Lehmann, this made American prospects a matter of some urgency. Of the two main opera houses in that country, those in New York and Chicago, only the Metropolitan would be acceptable. And her agent in Berlin, Norbert Salter, was indeed looking into that possibility. Or so he may have pretended to her – for although he also represented Gatti-Casazza in Berlin at the time, among his colleagues he did not enjoy the best of reputations.[234] However, apart from Gatti-Casazza's noticing her in 1920, Lehmann was already being mentioned in the *New York Times*, if only sporadically.[235]

Jeritza knew full well about Lehmann's high ambition. Once, when they were both standing behind the stage, she asked her dresser provocatively "what roles one could give Lotte Lehmann at the Met."[236] In reality, the Moravian diva was scheming to prevent Lehmann from being assigned any roles. Because she knew him intimately, she used her influence with Otto Kahn as chairman of the Metropolitan's board of governors to make sure Lehmann never got an offer.[237]

If Jeritza proved to be a pugnacious rival to Lehmann in Vienna, there was yet another colleague who did not make life easy for her, because Lehmann would not subordinate herself. That was Marie Gutheil-Schoder. It is possible that, just as Lehmann had feared since October 1916, Gutheil-Schoder never forgave the younger singer for having stolen from her the premiere role of the Composer. The tension that eventually developed between the two artists possibly was masked at first by the profound admiration Lehmann still felt for the more experienced singer.[238] Nonetheless, Lehmann knew she was always being compared to Gutheil-Schoder, who excelled, not unlike Jeritza, in roles she herself had difficulty singing, such as Elektra, Salome, and, in 1922, Potiphar in Strauss's new ballet, *Josephslegende*.[239] Even when Lehmann created her first Tosca in 1923, according to the press she was in competition as much with Gutheil-Schoder as with Jeritza, and this could not have pleased her.[240]

In later memoirs written from a teaching perspective, Lehmann admitted to certain differences: "To-day I see that our ways were worlds apart. She was fanatical about exactness. Her roles were always worked out to the last detail to the point of perfection. She never altered anything, not even the slightest detail. She was deeply disturbed by any deviation from what had been found good and definitely established, to which she had become accustomed. Any variation seemed to her inartistic and indicative of a lack of discipline." By way of distinction, Lehmann explained her own propensities: "Such exactness is far from my nature. I could never be tied down to a definitely prescribed gesture or movement, no matter how convincing it might be. I would inwardly perish if I always had to do the same thing."[241]

Matters approached a crisis when by 1926 Gutheil-Schoder had stopped singing and instead was directing opera, first at the Staatsoper and then also in Salzburg.[242] After Lehmann had given the Marschallin (but not under this colleague's direction), Gutheil-Schoder, who had herself sung the role of Octavian many times, voiced several criticisms. Lehmann had looked "very pretty but to my mind not nearly characteristic enough," too youthful to be convincing as a Marschallin in her prime. She had worn certain costumes and pieces of jewelry awkwardly and was not trusting her body sufficiently. Moreover, she should have listened more to Alfred Roller, who had been the director of stage design. "I would have to explain and demonstrate all of this to you personally one day, but actually it won't help, for in this respect you unfortunately have too thick a little head." Gutheil-Schoder, fourteen years older than Lehmann and long a *Kammersängerin* herself, added insult to injury by congratulating Lehmann on having just received that honor and stressing that she was looking forward to the new "close collegiality," as if such a relationship were dependent merely on titles.[243]

Whereas Lehmann's reply is not known, later in the year, after she had sung Christine in Vienna, she received another letter of criticism from her colleague. This time Lehmann was furious and rejected every bit of advice, although she acknowlegded having much admired her colleague's "genius" earlier. Her retort to Gutheil-Schoder culminated in the comment that "perhaps this rapturous veneration, which could not have escaped you, was responsible for the fact that ultimately you neglected to recognize a mature artist who successfully defends her reputation everywhere in the world and who is not a small beginner."[244]

Despite all the earlier admiration Lehmann had held for Gutheil-Schoder, the fundamental difference between the two singers, and one that constantly must have sparked their mutual ire, was that the former was an adherent of tradition and the latter a disciple of the avant-garde. Not coincidentally, it was Gutheil-Schoder who, although she frequented the salon of the antimodern Princess Metternich and performed mostly traditional roles, premiered Schoenberg's The Woman in his monodrama *Erwartung* in Prague's Neues Deutsches Theater on June 6, 1924.[245] By contrast, when Alban Berg later asked for Lehmann to sing the role of Marie in Vienna in his partly atonal opera *Wozzeck*, premiered in Berlin in 1925, she refused.[246] In this context, it is significant that Gutheil-Schoder referred, in her letter to Lehmann regarding the Marschallin, to Alfred Roller, who, like herself, had been a member of the Jung-Wien Secession and, like her, continued his work as a champion of modernism. Moreover, Lehmann's scarcely tempered accusation in later years that her colleague had "only one head and no heart (which I don't believe)" is of significance, for the cool rationale of the avant-gardists was the complete opposite of the emotional romanticism that this traditionalist soprano clung to.[247] If the Vienna Opera's getting stuck in the rut of convention, for which Schalk and, despite frequent protestations, Strauss were responsible, was the main target of Paul Stefan's contemporary criticism, Lehmann had no problem whatsoever working in precisely that convention.[248] The progressive Stefan, a friend of Schoenberg who himself was driven out of town, had complained about the reactionary state of the Vienna Opera in 1922, and he complained about it again in 1924, when he wrote that the Opera was approaching a crisis because it had for decades been relying merely on Verdi, Puccini, on Sundays a little bit of Wagner, and, of course, Korngold and Richard Strauss. Such a crisis cannot fail to occur, he warned, if one constantly shies away "from the great Moderns." The issue was later compounded when the music critic Max Graf wrote in the *Frankfurter Zeitung* that musical life in Vienna had become totally stuck in the past, that Vienna had become the site of famous musicians' graves and that progressive composers were now living in Berlin.[249]

Quite apart from such friction with colleagues, as far as her overall career was concerned, it was Lehmann's good fortune to be conservative in her taste. When certain critics, as one did in January 1919, wrote that Lehmann had performed "the Moderns," as she did with lieder, what they really meant was that she had sung contemporary music, such as Strauss's, Humperdinck's, Korngold's, or Leo Blech's, none of whom could at that time be identified with the avant-garde.[250] In 1921, when she had to sing Els from Schreker's *Der Schatzgräber* (1920), she

found this interesting but complained to Baroness Emmy that "the bad thing about these hyper-modern pieces is that one wracks one's brain and tortures the voice – and then those operas never become repertory pieces anyway and the work is half in vain."[251] She rather catered to the conservative tastes of the Vienna Opera's core clientele, who by the middle of the 1920s were admittedly different from the patrons of several German Operas. Next to Frankfurt and Darmstadt, Berlin became known especially for its modernism; it was in this city that Schoenberg had taken refuge, and here he was surrounded by other experimental musicians such as Paul Hindemith, Kurt Weill, and Franz Schreker on the composer side, as well as by the likes of Erich Kleiber in the conductors' camp, later to attract Klemperer, Hans Curjel, and Alexander Zemlinsky. Of course, Berlin was not exclusively a modernist haven, or else Lehmann would not have received her sundry invitations from Schillings, Tietjen, and Walter.

The other important reason Lehmann had for traveling to Berlin in those years – apart from venturing on to Perleberg and surroundings – was to be at the service of recording companies, for she had been able to conclude a contract with Deutsche Grammophon Aktiengesellschaft as early as October 1917. The agreement was for three years, from January 1, 1918, to January 1, 1921, and was to cover at least twelve solo or duet recordings of pieces from her standard repertoire per year, for an honorarium of 1,000 kronen each, plus other engagements in larger-group settings, which would pay half that amount.[252] This first contract was in large measure due to Hofoper director Hans Gregor, who was related to one of the Berlin functionaries of Deutsche Grammophon, repeatedly urging this man to reach an agreement with Lehmann.[253]

According to the meticulous discography by Gary Hickling, Lehmann recorded more than forty arias and a few lieder, such as Strauss's "Cäcilie" and "Morgen," during the period specified by this contract. The 78-rpm records were either one- or two-sided. The arias covered the length and breadth of her already extensive opera repertory, including standards such as Wagner's "Dich, teure Halle," "Du bist der Lenz," and "O Sachs, mein Freund." Also represented were operas as diverse as *Mignon*, *La Bohème*, *Der Freischütz*, and *Die toten Augen*, not to mention Mozart's *Don Giovanni*, *Figaro*, and *Die Zauberflöte*. Inasfar as they were acoustic and not yet electric playbacks, these numbers also appeared on the Polydor and sometimes Vocalion labels. In some instances, Lehmann teamed up with baritones Michael Bohnen and Heinrich Schlusnus, as well as with tenor Robert Hutt. Only two of these recordings, "Ich sprach, dass ich furchtlos mich fühle" from *Carmen* and "Wie nahte mir der Schlummer" from *Der Freischütz*, remained originally unpublished.[254]

The singer signed her next contract with the Odeon label, which was owned by Berlin's Carl Lindström Aktiengesellschaft, on February 13, 1924. This time – the German inflation had barely been defeated – she was to receive 100 dollars per recorded side, within a total of three years; in addition, she was to get 10 percent of the net sales receipts during the second and third years. The selections were to be made by the company, and pieces she had never previously sung could be included.[255] No doubt because of the increase in her touring, she recorded barely thirty items, all acoustic, a few of them with chorus, and a much larger number remained originally unpublished. Especially notable was

the aria "Glück, das mir verblieb" from Korngold's *Die tote Stadt*, which she committed to wax on April 17, 1924, along with Richard Tauber and conducted by Georg Szell; they had just performed this successfully at the Berlin Staatsoper. It became legendary, regularly being sounded by a Ringstrasse record shop through open-air loudspeakers, next to Vienna's neo-Gothic municipal hall.[256]

This time there was also extra publicity, for Lehmann was advertised in the firm's prospectus as a "vocalist of genius" in her recording of Mimi from *La Bohème*. The aria "Man nennt mich jetzt Mimi" was said to have been revealed as one "of touching beauty," in fact a "masterpiece," in the rendition by Lotte Lehmann. Odeon did clever marketing by falsely introducing Lehmann as a *Kammersängerin*, a title that she was only to receive two years later. Lehmann allowed this to happen, not least in her correspondence with the company, presumably because, judging by her 1923 letter to Schalk, she thought she had deserved that honor long ago.[257]

Today one can hear many of those selections on a three-disk box set entitled *The Young Lotte Lehmann*.[258] Since arias for the Deutsche Grammophon and Odeon sessions were duplicated and because of the bad technical quality of the recordings, it is hard to say exactly when, between 1918 and early 1926, they were made. But they still convey a faithful impression of that brilliant young voice and make one understand why Lotte Lehmann became so famous so quickly. Even against the background noise of a scratching needle, these arias are beautiful and redolent of genius.

As one listens to these renditions, two particular qualities of Lehmann's voice stand out, even today. One is a sweet, almost sensuous tone, without ever becoming overpowering, the other a steady purity without vibration or any insecurity in its linear movement, up or down. Even in the early years German critics were fond of identifying Lehmann's delivery of song with *Innigkeit*, a German term that is difficult to translate. According to the dictionaries, it denotes heartfeltness, depth, chastity, and intimacy, to which I would add intensity, serenity, and sincerity. Perhaps soulfulness enhanced by chastity captures it all. The essence of these qualities constituted the opposite of showiness, harshness, and superficiality, which one could have ascribed to Jeritza, but also of intellectual brittleness, which was the specialty of Gutheil-Schoder. *Innigkeit* corresponds with *Innerlichkeit*, which in Lehmann's case would have meant having internalized the meaning of a text and expressing it truly, not as if she were *playing* her character on stage, but as if she *were* the character herself. So when Lehmann was complimented on her *Innigkeit*, it usually meant that her voice was ideally expressive of the contextual meaning of her aria or song, combined with her ability of facial expression, gesture, and overall stage comportment. As a lyric soprano she became famous for conveying human emotions to her audience, at the risk of overdoing it – some listeners, in fact, might have taken her for a dramatic soprano.[259]

Approaching the climax of her career by 1926, Lehmann did not sing perfectly, like a machine, but astute critics realized that even the greatest singers had their human faults. Whereas her rhythmic control seemed to have stabilized, she herself – throughout her career – admitted to problems with heights.

She went to take more lessons with Vienna's Felicia Kascowska, a distinguished Polish vocal coach, who inspired Lehmann with confidence. "The high Cs, of which I was always afraid, I could sing in her presence with great ease, because she just coaxed them out with her praise."[260]

Another handicap had remained, in the form of her deficient breath control. In the worst of cases, she had to breathe often and audibly between phrases, so that eventually the solution seemed to be to change her phrasing. Hence in her best moments she would master the singing of long phrases without interruption, until her breath came at a strategic pause. This struck one critic as if Lehmann "did not sing tones, but gestures, not phrases, but feelings."[261] That of course was the very essence of her art.

A last flaw of Lehmann's art was that apart from her often tasteless mixing of dubious arias and lieder for recitals[262] she was, until much later in the United States, not really at home in the lieder idiom. Few people dared tell her this. Even the relentless Paul Stefan, who called her voice "silken," was impressed when Hugo Wolf's old friend Ferdinand Foll accompanied her on the piano. But Foll himself, otherwise a very shy and deferential man, finally told Lehmann, and she has faithfully recorded his judgment for posterity: "The only objection he ever voiced was, when after one of the always audience-beloved concerts he said to me: 'You could really be a good lieder singer if only you would concentrate, but you always do everything much too quickly, you study too flightily, you do not take lieder seriously enough.' I was very surprised! I thought I was good as a lieder singer. For did not the audience cheer me?"[263]

Private Times

After she arrived there in the summer of 1916, Lotte Lehmann did not like much of what she saw in Vienna. Compared to the manicured districts of the noble Hanse port she had just left behind, the streets of the Habsburg capital were dusty and messy and full of strange people, and garbage was flying everywhere. With her parents still in Hamburg, she took a cheap *Pension* in the city's inner core near the Opera, spent most of her time by herself and studied her scores. She hardly went out when not working, except for attending the Opera to listen and learn from her colleagues, paid no attention to the Prater, and never even visited one of those typical Viennese wine pubs, the Heurigen, where society's highest mingled with the lowest and everybody enjoyed it. Of course this was war, and the rationing of goods was much sterner here than in Hamburg, so she tried to watch her kronen, which were losing their value by the week. As she had no contact with the black market, she found it difficult to obtain groceries, until the wily and streetwise Richard Mayr from the Opera, a prince of a friend, helped her out with his local connections. But whether she tried or not, she did not fit well into this Austrian landscape; her Prussian accent marked her as one of those haughty North Germans, and she equated the proverbial Viennese charm with insincerity. Indeed, her bearing was so stiff at first that Director Gregor, originally from Dresden but long acclimatized, laughingly ordered her to relax. "Vienna! You have to feel that," he cried. "This is a special atmosphere. But watch it: You will fall hopelessly in love with Vienna."[264]

As she became more accustomed to the local ways and, rather swiftly, a celebrity and to some an icon, she came to resent the gossip mongering that was going on around her, disliked what some papers chose to write about her, and tried to escape from any publicity.[265] When she had to be in company, she shunned small talk, social dancing, or any sort of merrymaking. Her first social contacts outside those with her immediate colleagues were facilitated by the shipping tycoon Albert Ballin of Hamburg, through whom she met one of the industrial kingpins of the capital, obviously without serious consequences. She avoided banquets, which her father thought a mistake; but in January 1918 one local paper mentioned the "pillars of Viennese society" who had congregated in the Hofoper "in order to celebrate their new star."[266]

When the war ended, Lehmann was afraid of the social turmoil tearing Vienna apart; she feared revolution and pined for the Old Order, which had given her security.[267] Although she protested to the Putlitzes several times into the early 1920s that she was much alone and too disinterested in society to encounter any people of note, we can read between the lines of her letters that she did get around sufficiently to meet not only eligible bachelors, but also older men and women of accomplishment. At various times until she met her lover, later her husband, Otto Krause, in early 1922, she had sufficient reason to be in salons such as that of the aging Princess Metternich, where, with her hankering for monarchy and aristocracy, in all likelihood she was introduced to the woman who then became her best friend, Countess Gabrielle von Rechberg.[268] One reason to be there was to honor invitations an artist of her stature just could not afford to decline, and another was to perform in recital for a healthy honorarium.

Metternich, who died in September 1921, kept social gatherings open during the winter until about the end of the war; apart from Gutheil-Schoder, she was good friends with Jeritza, and Lehmann could not have avoided being at some of her soirées.[269] Other likely salons with the soprano as a guest were those of Selma Kurz-Halban, her colleague who was married to a famous gynecologist, Jenny Mautner, and Adele Strauss.[270] Mautner was the wife of a wealthy industrialist, in whose circle Richard Strauss, Max Reinhardt, and the Korngolds moved. Adele Strauss was the widow of the Waltz King Johann; hers was a most fashionable salon. If we believe the satirist Kraus, some of these salons were as pronouncedly pro-Jung-Wien as others were against it, but just as likely the lines could have been blurred.[271] Bertha Zuckerkandl, whose father had founded one of the premier newspapers and whose husband was yet another famous physician, may have organized the most cosmopolitan, intellectual, and pro-avant-garde salon of all – reasons why Lehmann would have wanted to avoid it.[272] Zuckerkandl takes historic credit for having initiated the union between Mahler and Alma Schindler, who later had her own salon, together with her third husband, Franz Werfel – with his belcanto voice that favored Italian arias a participant in any artistic or intellectual function in the Austrian capital.[273] There is proof that Lehmann and Alma Mahler knew each other, but Mahler's self-loving widow was nine years older. Her musical ambitions as a composer and pianist had flagged, so that Lehmann, not posing a threat, could have been a welcome guest, either at her apartment on Elisabethstrasse

or, later with Werfel, in the villa on the Hohe Warte. Whatever: in old age Lehmann mentioned that she had met Frau Mahler-Werfel only once and had of her a "rather unpleasant memory" – it might have been with the Walters in 1936.[274]

Lehmann was impulsive and outspoken; she did not mince words and was quick in her judgment of others, which did not always endear her to people but, on the other hand, also won her friends.[275] Her social skills were influenced by mood swings that she found hard to control, and those depended not only on what was happening around her, but also on how she felt about her art and what she thought others might say about it. A certain insecurity obsessed her, therefore; it may have lessened as her fame increased; doubts about herself, however, always remained, alternating with outbursts of omnipotence.[276] "Perhaps I am not born to be happy. There is always something torn in my life," she confessed to Emmy Putlitz in May of 1918, "somewhere always a blue distance beckons to me like a promise, but then there is nothing behind it. Yet the longing lingers. That is perhaps the most dependable thing of all: this urging unrest, always telling me: go on – what now – whereto?"[277] Hence she impressed those around her as never satisfied; she wanted to climb to the top of the highest mountain and thought herself a failure if she got stuck just below. Her moods deteriorated as she continued to be single, until, at the age of thirty-three, she fell in love with a married man and a few weeks later was close to a nervous breakdown. The tenuous nature of that relationship, which lasted until they could marry in April 1926, contributed to her overall emotional instability, which was only partially compensated for by her ever-growing artistic successes.[278]

Overwhelmed by this self-image of insecurity and given her outspokenness, she could strike out at people. The early Vienna Opera incident in which she hurled venom at Jeritza and Gregor and almost got herself fired, was a telltale sign. A little later Wilhelm von Wymetal, the artistic director, after noting her deficient social skills, took her aside to ask if she could not possibly indulge her colleagues' craving "for somewhat more elaborate formalities." Would it cost her to say "Good morning, Frau Kammersängerin," instead of simply "Good morning"? And could she add "How do you do?" With devastating candor, she replied "that it would not cost me anything, but that I saw no reason for asking, since I really was not, after all, the least bit interested." Wymetal made her see the folly of her ways, and so she improved.[279] Another time she met a young man who was working in the offices of Heller-Bukum, her Vienna agent. He came from one of Vienna's upper-class Jewish families, loved a good game of tennis, and was, as she even then admitted, "a beautiful young man." But she found him "arrogant and dislikable," and when her agent was away and Rudolf Bing – that was the young man's name – took over her portfolio, she sent a furious telegram to the manager saying: "I forbid you to allow this rascal to handle my affairs."[280]

With her sense of merely partial fulfilment, Lehmann sought other creative outlets. The one that offered itself automatically was writing, since she had never given up the old practice of composing poetry. But because she always needed public recognition in order to prove her worth to herself, she had to

have everything published. Indeed, in 1919 she had printed in one of the daily newspapers a poem that was emotionally expressive in the manner of much of her singing; but whereas the latter was generated by a true professional, the poem was that of a dilettante. It had a nice rhyme to it, dealt with an organ, a harp, laughing and crying and life and soul. One would not go wrong in assuming that the only reason she ever got it accepted was because her name was Lotte Lehmann.[281]

Precisely because she already had a name as a singer, she was also able to publish prose, for the samples we can read today could never have been published on their own merit. These short pieces, too, are hyperbolically emotional, in fact not at all free from the "cheap sentimentality" that at one time she thought the revered Franz Schalk had liberated her from.[282] In a pretentious style, she published reminiscences from her excursions to exotic places such as South America and Constantinople or concocted fairy tales, spoke of harems, princes, wild storms, and huge oceans. The palette of conjured colors is endless. Her naturalism is touching, but the style she uses to express it is pompous and lacks the very sincerity that characterized her personality, and especially her musical art, in real life.[283] She attempted a synthesis of that art and writing when she published a sketch of her visit to Strauss in 1919 – its content conveys no message, and its style is so bombastic as to be embarrassing.[284] The Lotte Lehmann who wrote this was not the sophisticate of her own dreams; it was the Lehmann of whom Schalk said that she was really "straight-laced" (*brav*) and whom Hofmannsthal judged, the latter ascription true only in this respect, "petite-bourgeoise and unimaginative."[285]

Even more than she had earlier in Hamburg, Lehmann clearly sought to grow beyond the humble origins of her family, although she remained as devoted to Fritz as ever, and the umbilical cord with her mother was not cut. If things had been somewhat better during the last years in Hamburg, on the whole the relationship with her father continued to be troublesome. Notwithstanding the fact that he identified himself with her achievements, he was harsh and demanding and never showed his emotions to Lotte in his letters, and he was cruelly disdainful of Lotte's beloved Aunt Lieschen, who liked to come on visits from Berlin. He knew full well that Lotte preferred her mother to him, so that at one time he complained how much he was aware of the fact "that you think more highly of Mamma than of me."[286]

As she got settled in Vienna, Lotte Lehmann's parents moved from Hamburg, not back to Berlin but to the small village of Westerland on the island of Sylt in the North Sea, where Fritz bought a house with the dowry of his wife Clara, after his marriage in June 1921. As before, mother Marie was nursing her ailments and broke into tears as much on bad as on joyful news; her letters to Lotte were always suffused with emotion.[287] Father Karl loafed as much as he was able to on his small pension, forever well-groomed and otherwise being supported by his children. What must have made this relationship an extra burden to their daughter was that neither Marie nor Karl missed an occasion to remind her how grateful she had to be to her older brother for what he had done for her in the past, but they also constantly implied that as a model daughter she would never allow her parents to starve.[288] These hints implanted

an ever-lasting sense of obligation in Lotte to the point where eventually she allowed her father to start looking for a property, in Germany or Austria, for them to settle down, one that she would purchase.

This, then, became the main occupation of her father well into 1924: searching out plots and real estate and overseeing renovations. He thought himself eminently qualified to do so because of his accounting background, but after January 1922 he was also aided in this by Lotte's new lover, Otto Krause, who had some experience as a broker. Karl Lehmann looked mostly at properties in South Germany that were not terribly far from Vienna, and some of them were grandseigneurial. One was a castle in Württemberg on forty-one acres and with thirty rooms, the other a villa in Munich's noble suburb of Bogenhausen. There were estates in rural Bavaria that could have been farmed for commercial gain, and others that would have been suitable to comfortable living, but all of them only served to illustrate Karl Lehmann's megalomania and unjustified sense of entitlement. What complicated the searches was that they were taking place during times of incremental inflation, so that it was difficult to settle on a realistic price. In addition, they were hampered by the nationalistic and anti-Semitic Lehmann's morbid fear of a French invasion of Bavaria; Jews were lurking everywhere.[289]

By early 1923, the older Lehmann couple had moved to a *Pension* in Bavarian Reichenhall near the Austrian border that their daughter financed for them, and the singer eventually bought a property in Hinterbrühl, some ten miles southwest of Vienna, where an already existing house was available for renovation. This was actually a prudent investment for Lotte, because even before her parents' death she would have been able to move into that house with her partner while still being close to the Opera. As it turned out, by the time her parents were established in the Hinterbrühl villa she herself had rented a spacious apartment on the Arenbergring in the respectable residential Third District (Landstrasse), which bordered on the city core with its Opernring. It was large enough for a grand piano and, eventually, a big portrait of herself as the Marschallin.[290]

Lotte was at pains to repay Fritz for the support he had given her earlier in life, and so, after his Berlin service with the army, which had never taken him into battle, she secured for him a position in Vienna. Fritz worked for the German consul general, to whom the singer was, of course, no stranger.[291] By 1920, Fritz was trying his luck in the world of theater; he played a small role at the Renaissance Stage, and his sister asked a friendly critic – it may even have been Julius Korngold – to put in a good word for him in a review.[292] Fritz Lehmann seems to have shown talent, for in December he received a contract from the famous Burgtheater for a year, but he lasted only a few months.[293] Evidently Fritz had not changed much; he was still leading his old unsteady life of changing jobs and moving from place to place. This time giving up employment did not matter much, for meanwhile he had met Clara, whom he married on June 23, and since she had money, he could afford to do what he liked. So he taught a bit at an arts academy and learned the ropes of a director. He helped direct Johann Strauss's operetta *Der Zigeunerbaron* at the reputable Theater an der Wien, before he and his wife bought the house in Westerland,

where later his parents joined them. There he raised goats, pigs, and chickens, but sometime during the inflation the couple lost a lot of money, so that Fritz was forced to find new work in Vienna, leaving Clara, whom Lotte did not like in any case, to carry on by herself in the Westerland house.[294]

It is not known whether Fritz Lehmann became an alcoholic at that time or several years later, after Clara had died painfully of throat cancer in 1931. Never a featherweight, he gained a lot of pounds during this period, and his nervous state was poor. By 1924, Karl Lehmann was pressing Lotte to do something for Fritz at the Opera, something along the lines of directing, but his daughter's influence did not reach that far. Fritz eventually went back to the academy, apparently giving acting as well as singing lessons.[295]

By the time Lotte, encouraged by her parents, was starting her work in Vienna and was also earning some money (despite the galloping inflation, which made budgeting so difficult), she had paid Fritz back what she owed him from the Berlin days or was in the process of doing so. She probably supported him in Vienna until he got the job at the consulate. While married to Clara, Fritz did not need Lotte's financial assistance because of his wife's dowry, but how seriously the German inflation ravaged that, the records do not divulge.

In 1945, it was Fritz who told Lotte that whereas she currently had nothing substantial to hold on to and had no money to speak of in the bank, she surely had known what it meant to be rich. His sister qualified this almost thirty years later by confessing that "I always spent whatever I made."[296] This was a true statement, and it applied to her Vienna period as much as it had in Hamburg. The singer was pathologically incapable of saving money, and as soon as she acquired what she had earned, she spent it, often needlessly, on herself; but just as much, she spent it on others. When she did not have money, she was liable to borrow it and had difficulty repaying her debts, as in the case of the Putlitz family. When she received advances, as from the recording companies, the money tended to be gone before she had actually earned it.[297]

Regarding the splurging on herself, it is not assumed to have been extravagant. She lived in several modest *Pensionen* until she could afford the flat on the Arenbergring, which, according to photographs, seems to have been somewhat more sumptuous – in keeping with the lifestyle the public expected from a prima donna. However, according to a tale she tells from her 1924 tour of London, she enjoyed a "passion for nonsensical shopping," which one may interpret to mean that she was a compulsive shopper. In London in May of 1924, the person who indulged that passion with her was Elisabeth Schumann. They had to go out frequently to make "'urgent purchases'. We went to such extremes that we invariably had to buy a new trunk to pack all our treasures." When Maria Olszewska questioned them about it, mentioning the need for old age savings, Lehmann laughed her out of the room.[298] On another occasion, in Vienna, they had been on an "orgy of shopping," with Lehmann doing all the buying. Toward the end, Schumann wanted to get something for herself, but Lehmann now had had enough. The gentle Schumann was fuming. "'You egotist!' she screamed in a flaming temper. 'I run around with you the entire day, while you make your stupid purchases, and the moment I think about my own needs you're too tired.'"[299]

If Lehmann financed a comfortable life for herself, her chances of going broke were increased by the amounts she spent on her parents. Even before the Hinterbrühl property purchase that she finally made for them in 1923–24 (and that would benefit herself eventually), she allowed them to have regular incomes, which were increased during those times when Karl Lehmann chose to live on his own in an apartment in Vienna or in the suburb of Baden, which he justified with his real estate curatorship in nearby Hinterbrühl. His daughter was getting nothing from her lover Krause, whose sources of income were dubious.[300]

In earlier years, and as long as Lehmann was able to demonstrate some modesty, she could always appeal to the Putlitz family for financial help. But apart from not returning what she owed them, the singer's lifestyle was now too profligate to make such appeals, and the Putlitzes too were suffering through war, revolution, and inflation. Nonetheless, Lehmann remained in touch with the family, sometimes paying visits to Gross-Pankow. These might have been awkward, for she was aware that the baron had long cast his romantic eye on her and that his wife could view her with suspicion. But Emmy zu Putlitz was a magnanimous person, and she knew that Lotte was not a schemer and genuinely grateful, after her own fashion. The baroness remained a surrogate mother to Lotte, to whom she could talk about people and feelings that mother Marie would never understand and that her father was too distant and emotionally cold to consider, such as what was happening with her love life. She was not close to the youngest daughter, Elisabeth (who earlier had often accompanied her on the piano), but Erika, the oldest, stayed her friend for life.[301]

Another one of Lehmann's pre-Vienna friendships remained potentially more problematical, yet not without promise of some rewards. The singer was still intrigued by Mia de Peterse, whom she had barely met when she had to leave Hamburg in the summer of 1916. Although it was to become a habit for her to ward off droves of teenage girls fawning on her after opera performances, she thought there was something special about this girl.[302] So it was Lotte who encouraged Mia to continue the relationship. In 1917, Mia had a serious crush on Lotte, with the singer – as usual – suspicious that she was loved only for whatever character she happened to be playing. "I am often sad that few know me how I really am. And I want to be loved for the way I am. What do you love in me? I wish to look into your soul. Your picture, which I have before me, smiles at me. And it is a strange and mysterious smile. Mia, are you full of riddles? It is such a pity that we did not know each other when I was still in Hamburg. You interest me a lot, I do want to know you." These lines suggest that if Mia was more than just platonically interested in Lotte, it was Lotte who was goading her, without being herself sexually aglow. Or was she? When she wrote this, it was November 1917, and there still were no significant men in her life.[303] This changed later when Lotte's circle of male acquaintances had widened and Mia, too, had met Robert Hecht, who took her to Atlanta. It was then that the relationship between the older and the younger woman resolved itself and became yet another friendship for life between equals.[304]

That Mia de Peterse's love for Lotte might not be returned was suggested in

of her exposed position she had to make the rounds in society, including "enormously rich families," and thus could not help meeting men. In fact, she had become engaged to one of them, Wilhelm Dessauer, an academic painter who had done her portrait in pastels as Lotte, the idol of Goethe's Werther. Dessauer was a highly sensitive man of thirty-six, the son of the deceased Adolf Dessauer, a very rich Jewish banker. Adolf Dessauer had been an idealist who believed that Jews should socialize and in fact intermarry with Gentiles; he would have extolled the example of his son. He had propagandized his beliefs in a novel, *Big-City Jews* (1910), in which he described fictitious members of the Viennese Jewish community, from poor to rich, and how they interrelated with the city's Christians of corresponding socioeconomic standing. At the end of the book, which to non-Jews also served as a mirror of Jewish society in the Austrian capital, the male hero, a Christian, marries the female heroine, a Jew.[305]

There was another reason why Adolf Dessauer would have been overjoyed at the prospect of this union: his son Wilhelm sprang from his own marriage with the popular operetta singer Antonie Link (1853–1931). Originally a child actress at the Burgtheater, she had turned to singing and had become the first Boccaccio, a trouser role in Franz von Suppé's operetta of the same name, premiered at the Vienna Carl-Theater in February 1879, the year she married Adolf Dessauer.[306] However, nothing came of Lotte's engagement. Wilhelm Dessauer turned out to be of very noble character, as she wrote to her motherly friend, the baroness, for he was always at her beck and call. "He was too good for me. A man without a will except my own. Who once said to me: 'The power which you have over me frightens me'." He was will-less to the point of wishing only to be ruled by her. Lehmann discovered that he was congenitally neurasthenic, and hence she listened to her parents and dissolved the engagement after only three weeks. According to her, Dessauer took this decision as graciously as only a man of selfless character could, and he even let her keep the portrait, which henceforth accompanied her on her further road to fame.[307]

In Adolf Dessauer's novel there is a scene where, in a luxurious salon attended by the Viennese *beau-monde*, a pianist accompanies a hired singer, performing arias and lieder.[308] This is the role Lehmann was playing on January 29, 1922, when she was entertaining the guests at a birthday party given by the wife of Otto Krause for her husband, who on that day turned thirty-nine. The twenty-nine-year-old Grete Krause was the daughter of Ludwig von Gutmann and thus hailed from one of the richest Jewish families in the capital. She had met her husband, a one-time *Rittmeister* (captain) in the Habsburg army, before the war, when she was in a carriage and he on horseback in his splendid uniform, during one of those tours of the Prater that all the Viennese so loved, no matter what their mode of transportation. They married in 1912. Beginning in 1914, they had four children, the youngest of whom was now two.[309] Krause had been born in Budapest, of Catholic German parents, who had migrated there from Saxony so his father could become head of the municipal firefighters. Otto eventually attended one of the military preparatory schools and then became a career officer with the Wiener Reitende Artillerie Division (Mounted Artillery).[310] According to István Deák, the leading expert on that army, the equestrian artillery was the equal of the cavalry, which ranked only below

mostly in Galicia, seldom coming home on furlough. After war's end, he was cashiered rather than being taken over by the new republican Volkswehr; yet he did not have to work as he took some nominal position in the Gutmann's far-flung industrial empire. He now called himself "banker," even though he had no knowledge of business; what he did know was horses and whatever agriculture was related to equestrian commerce. Decidedly musical, he was a habitué of the Opera, and since returning permanently to Vienna and with money being no object, he had secured a Staatsoper box for himself and a few wealthy fellow ex-officers. La Lehmann, whom he admired only from afar, became his favorite singer. Because Frau Krause knew of his predilection, she commissioned the prima donna to sing at the party, as a special birthday gift. Grete Krause would soon regret having done so, for Lotte immediately fell in love with Otto, who – tall, with a mustache and dark, slicked-back hair – was earthily handsome and possessed of great charm.[312] The union immediately fed Vienna's rumor mill, which greatly oppressed Lehmann, all the more so since she knew that she was in the process of destroying the life of a younger woman, who now was alone with four children not even ten years old.[313]

There is no reason to believe that Krause's social and professional path in the army deviated significantly from that of other professional officers of his genera-tion. Like many from Hungary, he was fluent in both Hungarian and German.[314] But he had a higher sensibility for culture than his comrades, although that appears to have been confined exclusively to opera and did not entail intellectual insight. Finally, in 1912, he married an extremely rich woman. That this woman was Jewish was in itself not so noteworthy, for several Gentile officers had (often wealthy) Jewish wives. Besides, there were nonbaptized Jewish officers in the Habsburg army, as opposed to the German imperial one – even though as career officers like Krause they were proportionately underrepresented.[315]

At least until the first reversals of World War I, Austro-Hungarian society thought it by and large prestigious to serve as an officer in the Dual Monar-chy's army, especially in the case of middle-class men. A number of perquisites compensated them for comparatively low pay. The first was the closeness to the imperial court; at least in theory, officers, like members of the high aristoc-racy (but not the low), enjoyed unrestricted access to functions at which Franz Joseph or his deputies officiated. If they were not themselves of noble birth, career officers enjoyed the right to apply for patents of nobility after forty years of uninterrupted service, provided their reputations were untarnished. They stood on points of honor that they were allowed to defend in duels, although these were becoming fewer toward the turn of the nineteenth century. They had servants and kept horses and rode only in first-class train compartments. Their singular source of pride was their colorful uniforms, which were custom-tailored and which contributed to a cult of virility that officers could make full use of in trying to conquer women, often after jaunts in the Prater. Depending on their name, their rank, their place in society, they could take their choice from among pretty salesgirls who lived on the outskirts (*süsse Mädel*) to Opera stars and Burgtheater actresses, right up to ladies of the social elite, not excluding married ones. Schnitzler has described such relationships specifically pertaining to the officer corps, and as girlfriends of one of his most famous literary char-

be assumed that Krause went through a similar lineup of girlfriends before he married Grete von Gutmann, and given the ardor with which he then pursued Lotte Lehmann and what we know of his later adventures, his eyes were always roving. What is certain is that he must have made use of the free stalls in the Hofoper reserved for officers while still impecunious; it was only later that he could afford a private box.[316]

These young officers were compelled to seek out mistresses – however romantic the motif – because they were not allowed to get married, unless they forwarded a marriage bond (*Heiratskaution*), which amounted to five years' salary for a *Rittmeister* but was much higher for a lieutenant, the rank at which, presumably, Krause met Grete Gutmann. The bond was usually posted by the bride's father, and so "young officers were constantly on the lookout for the right *Partie*, the family rich and foolish enough to part with such an enormous sum and to entrust their daughter to a nomad." This explains why Krause prowled the Prater and how he met and married Gutmann. The marriage bond was supposed to guarantee an officer's family disability insurance and a pension, especially if he was killed in war at an early age, but it proved such a burden that, historically, seldom more than 40 percent of a corps ever got married.

When the Great War ended, the vast majority of the career officers were alienated from society, which blamed them for defeat in war, and from the new Republic of which they were now supposed to be citizens. Only a tiny minority could enter the new Volkswehr. For most of them, their future was at risk, for they had learned nothing to guarantee them jobs, and their pensions, if they even received one, were pitiably low. By 1925, inflation had sounded the death knell of those as well. Career officers in mufti, often doing odd jobs such as waiting on tables or driving cabs, became the dregs of society, in an experimental Republic whose inept governments were abused by the political right and left alike. And still, *Rittmeister* Krause was very unlike the *Rittmeister* Karl Kraus described in *Die Fackel* in November of 1921. This man from the journal was sixty-eight, had kidney, bladder, and heart disorders and was unable to work. He had no pension or income and could pay no rent for his single room, and he suffered from chronic hunger.[317]

When Otto Krause married Grete Gutmann in 1912, her father Ludwig had been dead for twelve years, and her grandfather David died that very same year. David and his older brother Wilhelm's Vienna-based empire included a private bank that probably put Krause on its payroll; after 1912, banks were multiplying in Vienna. Grete's oldest brother, Wilhelm, born in 1889 and designated the principal heir by his grandfather David, felt responsible for his seven younger siblings. Whereas the family had more than enough money, complete parental authority was lacking, and so he assisted his widowed mother, Mathilde, who came originally from a Jewish baronial family. From the point of view of the Gutmanns, the marriage-bond policy was useful, for not only did it help to secure a desirable husband for Grete – as desirable as Habsburg officers then happened to be – but Wilhelm Gutmann also encouraged the marriage of Grete's younger sister Clarisse to Captain Ferdinand Hieffer, in 1916.[318]

A pressing problem that had to be solved before Grete's wedding was that of religious conversion. Until the end of the Dual Monarchy, couples of Christian

faith of the other or made a legal declaration of religious neutrality.[319] David, his wife Sophie, and his four children had staunchly adhered to the Jewish faith, since very rich Jews in Austria at that time had seen no more need to convert to Christianity.[320] Otto Krause, on the other hand, grew up as a Roman Catholic, so that he or Grete Gutmann had to change upon marriage. Since it is verified that the four Krause children were raised as Catholics,[321] Grete must have undergone baptism. At the time, this was an unusual move for a young woman from the Jewish elite, albeit not entirely unheard of; what it suggests is that Grete sincerely loved her husband-to-be and that the family, without whose consent such a religious changeover would not have been possible, welcomed this opportunity to receive a dashing officer in their midst.

Grete Gutmann's full name was Margarethe von Gutmann. The Gutmann brothers, Wilhelm and David, had been ennobled in 1878; according to Otto Krause's son Peter they had "bought" this title "with much money."[322] In the latter half of the nineteenth century, acts of ennoblement were much more frequent in Austria than in the German lands. As the emancipation of Jews was progressing, it was possible for the most wealthy of them (as it was for Gentiles), who were the monarchy's most loyal subjects, to acquire a title.[323] This cost them much money in donations as well as taxes, unless they were officers, after their fixed term of service.[324]

The Gutmann brothers were born in the small Moravian town of Leipnik, Wilhelm in 1827 and David in 1835. Their father had a flourishing wool business. The brothers moved mainly into coal, railway, iron, and sugar enterprises, which by midcentury were booming; their competitors – who eventually turned business partners – were the Rothschilds. The Gutmanns arrived in Vienna in the 1850s, before the large waves of impoverished Galician Jews, who settled in already heavily Jewish Leopoldstadt, across from the center of town. But this is where the Gutmanns also took residence until, upwardly mobile as they were, like the Rothschilds they established themselves in Wieden, one of the better Vienna neighborhoods.[325]

Eventually, Wilhelm Gutmann married Ida Wodianer, who hailed from another entrepreneurial Viennese Jewish family, as were the Todescos, Friedmanns, Hirschs, and Springers.[326] Owing to a rigorous work ethic that spawned palpable accomplishments, which contrasted with the pleasure-craving and often inchoate ways of normally Catholic Austrians, Vienna's Jewish entrepreneurs, after Max Weber's model, have been likened to the Protestants of Germany – one reason why a significant number of Jews, when they did convert, preferred Protestantism over Catholicism (as did, in the world of arts and literature, Arnold Schoenberg and Karl Kraus).[327] These entrepreneurial families kept their distance from and often disdained the poorer Jews from Hungary, the Bukovina, impoverished parts of Czechoslovakia, and especially Polish-Austrian Galicia, although it was their contributions to those Jews' social and economic welfare that tended to gain them their reputations as benefactors and resultant patents of nobility.[328]

As the Jewish population of Vienna swelled, especially with the influx of more Jews from Galicia and even from Russian territory because of the tsarist pogroms of the 1880s, so that around 1900 Vienna's population was close to

9 percent Jewish (and all of Austria's over 4 percent, more than any other non–
Eastern European country), families like the Gutmanns solidified their positions
as pillars of society, economically and politically. By about 1900, even in the
face of growing anti-Semitism, there was established something that the bril-
liant Jewish femme fatale Gina Kaus has called "the great Jewish society."[329]
Apart from acquiring more land, estates, and assets in the Habsburg realm,
influential Jews founded and controlled the main Viennese newspapers, such
as *Neues Wiener Tagblatt*, the brainchild of Zuckerkandl's father, and *Neue
Freie Presse*, where Theodor Herzl began his work as a *belles-lettres* editor.[330]
They also made intellectual and scientific contributions disproportionately to
their numbers in the universities (as did Freud and Schnitzler's father, the laryn-
gologist Dr. Johann Schnitzler), generated donations benefitting not just Jewry,
and patronized the arts. In the *beaux arts*, writes Stefan Zweig, Jews were
"the actual audience, they filled the theaters, the concerts, they bought the
books, the paintings, and they visited the exhibitions." In her earliest years in
Vienna, the soprano Selma Kurz, hardly having left her poor Galician back-
ground behind, was supported by both Ida and Sophie Gutmann, David's wife,
not least financially.[331] Otto Krause's artistic pretensions aside, it is therefore no
coincidence that Grete Gutmann-Krause conceived the idea of employing Lotte
Lehmann's talents for an evening of culture, honoring her husband's birthday,
on that late January night in 1916. It was to be an act of private pleasure and,
typically, of artistic patronage.

After their marriage, Otto and Grete Krause took up residence in a Gutmann
family villa in Hietzing, close to Schönbrunn with its imperial palace. Soon
after, still in the first half of the 1920s, Grete developed a degenerative nerve
disease – possibly multiple sclerosis – that increasingly confined her to bed. She
was partially paralyzed and unable to speak, with two Catholic nuns tending
to her. This was particularly hard on her children: Peter, the youngest, only
four years old in 1923; Otto-Hans, who was five; Manon, who was eight;
and Ludwig, who was nine. The children saw their mother only once a day, not
knowing if she even recognized their presence. They had to be educated entirely
by nannies, with their uncle Wilhelm (Willy) assuming major responsibilities
as steward, such as administering their fortunes in trust and inviting them to
his country seat in the summers. Their father, Otto, had moved out and was
living in the Inner City near the Opera and Arenbergring, dropping in to see
his children perhaps three times a year, at the most.[332]

Otto Krause's new mistress was immediately aware of the potential trauma
of the situation, even though she could not emotionally disentangle herself.
Already in February 1922 she committed herself to a sanatorium near Vienna,
hoping to defeat her depression.[333] In March, when she was back in her Aren-
bergring suite, she admitted to Baroness Emmy that morally, she was doing
something very wrong. As she was getting ready to set sail for South America,
she poured out her heart: "This time I did not find my way to you, for I was
not entirely sure of your understanding. You are of such a straight, sternly judi-
cious nature. And what has now become my fate, deviates from the straight
and narrow. This interferes with a marriage, separates a man from his wife and
a father from his children. I was sure you would condemn me. I am kissing

your gracious hand for not doing so. I have suffered much, much hardship and already found myself on that narrow bridge that leads into the eternal night. If I were not so totally convinced that in the end this will take a good turn, *must* take a good turn – I would not have lived through it. And hence, I move on in the deep belief that the man whom I love will be free when I come home. I cannot do more than put an ocean between him and me, until he is free." She added that she could not stand being in Vienna any longer and that she did not want this to be just another adventure – probably more as far as he was concerned, for so far hers had not exactly been a life of promiscuity.[334]

These troubles contributed significantly to her dislike of the South American tour that summer. To make matters worse, Krause followed her to the continent and caused her great embarrassment.[335] A year later, things had not improved. As Grete Krause fell seriously ill, Lehmann's own agony was increased, especially since it was obvious that – contrary to her hopes as expressed earlier to the baroness – the duped wife was not going to liberate her husband. Crying uncontrolled on the telephone to her parents, Lehmann was beginning to realize that because of the flawed fundament of her love for Otto, this love itself could be in jeopardy: "We are almost too tired to be happy."[336] Grete's illness and his precarious circumstances also were taking their toll on Otto, the war-seasoned officer, whom his prospective parents-in-law never suspected of having a case of weak nerves.[337] By 1924, the affair had not only become common knowledge in Opera and society circles, especially Vienna's, so that even Bruno Walter became concerned in Berlin, but members of Marie Lehmann's family were also dragging Lotte into the mud, for having a married man as a lover.[338] When at last – in early 1926 – Grete Krause agreed to a divorce, Lotte admitted to Mia that her emotional state was so bad that it was affecting her ability to perform, especially because the never-ceasing insults were too much to bear.[339]

Otto Krause and Lotte Lehmann were married in a civil ceremony in Vienna on April 28, 1926, and by Austrian law this meant that the singer exchanged her German citizenship for an Austrian one. Grete Krause, of whom Lehmann wrote to Mia that she was "deathly ill," may have surrendered power of attorney to her older brother Wilhelm, if she herself were unable to make decisions on her own any more, and Wilhelm Gutmann may well have acceded to his brother-in-law's wish for a divorce, realizing the hopeless condition of his sister. In the future, relations between the two men remained civil, not least in the interest of Krause's four children, over whom Wilhelm continued to hold his protective hand, since enough money, of course, was in their trust. Grete Krause died in 1936.[340]

What sort of man was Otto Krause, and did his personality actually fit Lotte Lehmann's? With his Hungarian cavalier looks, always impeccably dressed, with correct and polished manners, he impressed most women as handsome.[341] "A Viennese gentleman of the type that songs are written about," observed the American writer Marcia Davenport, "courtly and dashing, he seems always to be just out of the saddle." His proverbially Viennese smoothness also impressed many men, so that one got the impression he could never be anything but obliging.[342] His very figure bespoke physicality; his face lacked the refined features of men with introspection, mental powers of abstraction or spirituality. If

he had been a movie star, he could have played exactly what he was in real life: a gentleman horseman or a gentleman officer, or the gentleman horseman who also likes theater. It makes perfect sense that his pastime was horses, but that he was partially in charge of the famous *Hofburg Lipizzaner* breed is certainly a fabrication – one of several this couple was to create in the future.[343] Apart from his ostentatious love of horses, he had retained other predelections and habits from his Habsburg officer period, one being the chain-smoking of cigarettes and rare cigars, the other his habitual consumption of red wine.[344] He loved luxury and external show, the *accessoires* of privileged life – tastes he may have acquired in the officer corps but that were, more than likely, heightened as a denizen of the Gutmann empire.[345] He cannot be said to have possessed intellect, and his general intelligence was also palpably lower than that of his new wife. After his death, Fritz Lehmann, who actually liked him, used to make fun of the way in which he uttered officers' mess platitudes, with routine smoothness, but never much more. He was a man of stock phrases. When things were awful, they were "deepest Asia," and on all occasions he loved the word "unique."[346] Fritz, especially with a view to business, described him as naïve to the point of being a Don Quixote, but his one redeeming quality was his musicality, which stood out from his other pretensions. In fact, because of this and his excellent manners he fitted in with certain members of the Opera crowd, especially since Alfred Muzarelli, a bassist who had served in Krause's regiment before the war, would join the couple horseback riding in the Prater.[347]

As for compatibility, there is no doubt that Lotte was hopelessly in love with Otto, and that this feeling was mutual, until it began to wear off toward 1926, because of that prelonged premarriage strain.[348] Beyond the emotions and physical attraction, Otto fulfilled certain service functions for the busy singer, who needed musical empathy as much as human support in many of her professional dealings. Otto became a friend and comrade who calmed her down when necessary, who dried her tears in her sadness. This was a role he played well and with dedication. One of his recurring if endearing platitudes was: "100 percent, I am attuned to Lotte." The intensity of that part of their relationship became even stronger after Karl Lehmann died in January 1925, not entirely unexpectedly; beneath his outward gruffness, Lotte knew well that she had been his favorite, even though she had found it difficult to abide him.[349] Otto now took that spot.

What Krause actually did professionally from the time he met Lehmann until they married is much in the dark, but that murkiness only barely conceals the fact that he did little of anything. In January 1922 he still had access to his wife's money through the position he had been handed, whatever that may have been, and presumably he was able to withdraw as much cash from a Gutmann account as he wanted. The question is how long that situation lasted and when he was formally dismissed. If he followed Lehmann to South America in late summer of 1922, he must have done so on his own, that is, he had diverted the Gutmanns' money, and he may have put enough on the side to boot to afford an apartment for himself and engage in speculation, first with banks in the inflation era, and then in real estate, mostly in Berlin, sometimes involving Fritz. At the same time, Fritz accused him of having been gullible in business and having

lost money, once in a deal involving saddles. The various titles Krause craved
to be known by, such as "industrialist" and "banker," since *Rittmeister* yielded
comparatively little prestige, were hardly more than labels to prop up his self-
confidence, for he resented being known as "Mr. Lehmann," notwithstanding
the fact that he soon did secretarial chores for his mistress and almost certainly
expended funds of hers. Thus it was unfortunate that the spendthrift diva had
entrusted herself to a spendthrift lover, who had found himself adrift when
removed from the familiar environment of the military. Karl Lehmann, who
was a penny-pincher, clearly saw the dangers of that. A few months before his
death he complained that he was never sure whether, in trying to acquire the
new home, he was dealing with Otto's or Lotte's money. But for what it was
worth, the older Lehmann used Krause's know-how in his own efforts to secure
a home for the extended family, perhaps even including Krause's mother and
sister, first in Germany and eventually in Vienna's hinterland.[350]

All this raises the final question of how mature parents such as Karl and Marie
Lehmann could have condoned this friendship between their famous daughter
and a veritable mountebank, and a married one at that. The question has several
answers, none of them satisfactory. For one, they were perfectly aware of the
fact that their daughter, thirty-three when she was introduced to Krause, had
not met the right man yet. They had assumed responsibility in helping to destroy
their daughter's engagement with Dessauer. From Perleberg days, they had felt
responsible for Lotte, far too much so, in fact, for part of Lotte's slow, delayed
growth to adulthood was owing to her unduly tight interdependence with her
immediate family. On the other hand, Krause's comportment was such as to
instill confidence; after all, he was a *Rittmeister*, above father Karl's station. In
addition, Krause came across as being in some position of high industry and
commerce. The parents thought, along with Lotte, that Krause would secure
a divorce for himself quickly, until Karl Lehmann realized the futility of it all.
Moreover, there was that proverbial charm of the Habsburg officer, who knew
how to dress well, how to come visiting with chocolates and flowers in his
hands and flatter these Germans far beyond what they were used to. Father
Karl and Otto Krause got along as potential business partners as well, and
mother Marie was once again overflowing with tears, knowing that her Lotte
was being loved and cared for by such a handsome man who was so lovable
himself. Indeed, she was totally unscrupulous when her daughter spoke to her
of the hardship she had to go through as a punishment from God. It was God
himself, replied Marie, unshaken, who put love of the kind the wonderful Otto
had for her in rightful people's hearts. Not a word about adultery, about leaving
small children in the lurch. In the end, of course, it was Lotte Lehmann herself
who had to make a case for her preference in males to her parents, and here
she had made it convincingly enough to win them over.[351] Her life with Otto
Krause would go on.

3

Climax and Crises

New Challenges in Vienna

After her marriage in April 1926, Lotte Lehmann reached the height of her career – not a peak but a plateau at which she then stayed for several years, into the very early 1930s. As Siegmund Stransky, one of Austria's leading industrialists, said in April 1928, she was "the star of all stars, the darling of the Viennese." She was also the darling of the musicians, the singer whose quality of voice, whose emotional warmth was affective like nobody else's. Everyone wanted to see and be with her, all the time. She herself recalls how her Staatsoper dressing room "always seemed transformed into a reception room – it was almost like the levee of the Marschallin: visitors came and went." She constantly had "terribly much to do," which had its advantages but also got her into much unforeseen trouble, and her professional leave period away from Vienna was always "phantastically over-drawn."[1]

During this time, she performed on the Vienna Opera stage approximately 130 times, in addition to appearances with the Vienna Philharmonic and Viennese recitals.[2] Roles she sang for the first time at Vienna, which she had not sung anywhere else before, were Puccini's *Turandot* (October 1926), Beethoven's *Fidelio* (March 1927), Korngold's *Wunder der Heliane* (October 1927), Hermann Goetz's Katharina from *Der Widerspenstigen Zähmung* (February 1928), and Massenet's Charlotte from his *Werther* (February 1929). *Turandot* and *Heliane* were, at the same time, premieres for the Vienna stage.[3] Of these five performances, the ones from *Fidelio* and *Heliane*, both in 1927 and about half a year apart, were perhaps the most remarkable and constituted milestones on her path to musical perfection: Fidelio, because the role touched the core of Lehmann's soul, and Heliane, because it brought out to the utmost her artistic capabilities in this drama that dealt with the theme of redemption. Musically, it was more advanced than Korngold's earlier *Die tote Stadt*, but was not as progressive as the concurrent works of Ernst Krenek and Kurt Weill.[4]

When Schalk approached her about singing the role of Fidelio for the Beethoven centenary on March 31, 1927, Lehmann first had qualms for a number of reasons. For one, she feared that the trouser role of Fidelio might show off her legs to bad advantage. For another, she was afraid that it would take her voice out of the realm of the lyric-dramatic and push it into the regions of the high-dramatic. For, as one critic has said, it requires "a voice suitable for a fire engine" in a soprano to sing this part. And third, Leonore/Fidelio was

the kind of faithful wife that she had to identify with totally – as she *identified with* and never just *played* every character she ever sang, to near-perfection – and she found that difficult at a time when her own fidelity to husband Otto Krause was beginning to falter.[5]

But then it turned out to be none other than Schalk himself who encouraged her by assuring her that he would pay close attention to her vocal cords, so that no damage in the low or high registers would occur. Her appearance was pleasing, in the high brown suede-leather boots she had helped to design. Eventually Lehmann found the role exciting, moving, and always new, so that it became her favorite part ever.[6] In spring 1927, the Viennese critics were full of praise. Although this was not a part one could conquer at first try, because it was "one of the most difficult of female roles," Lehmann was described as "touching and attractive, and, as always, possessed of the warmest of feelings and a mellifluous voice."[7]

Das Wunder der Heliane, offered by the Staatsoper on October 29, three weeks after its world premiere in Hamburg, also presented difficulties. Its thirty-two-year-old creator, Erich Wolfgang Korngold, whose ego was as large as the composer himself was young, had originally sketched the orchestral passages as too loud and had to make last-minute revisions in order not to drown out Lehmann and her partners, Alfred Piccaver and, alternately, the sensational new tenor from Poland, Jan Kiepura.[8] At the Vienna premiere, Kiepura appeared on stage as the Stranger, with Piccaver scheduled for a second Vienna premiere the next day, which did not materialize, one reason being that Piccaver, who was notoriously indisposed, at the zenith of his fame found it too laborious to learn an unfamiliar-sounding part. (Lehmann called him "this lazy pig.") The other reason was that the plot of the opera was not popular with the critics, while the music met with mixed reactions from the audience, so that Korngold's *Die tote Stadt* was substituted – *Heliane* was not put on again until November 12. Moreover, Lehmann herself had difficulty appearing in this work, for the part of Heliane had originally been conceived for Maria Jeritza, Korngold's favorite singer, who, however, had capriciously refused to sing it and already departed for her New York season. Heliane was a willowy character who for a brief moment was supposed to reveal her unclad body to the love-struck Stranger, something that was so ill-suited to Lehmann's petite-bourgeoise persona that she had to be shrouded in a veil. In the end, the star collected the usual accolades for her glorious singing, but she could not have been happy with a plot in which she, the wife of the Ruler, approaches a captive Stranger doomed to death, moves toward him (naked) to simulate copulation, and for her sacrifice to love is burned to death. Her beautifully rendered aria "Ich ging zu ihm" was to become one of the staples of her future repertoire, even for the concert stage – from an opera that, for once in the history of that starchy, conventional institution on the Ringstrasse, was harmonically somewhat bolder than its usual fare.[9]

An artistically rewarding event sponsored by the Staatsoper but held uproad was a performance of *Fidelio* in Stockholm. Extra fees for this had been negotiated beforehand. Here, at the Stockholm Royal Theater on February 22, 1929, Schalk conducted the Vienna Philharmonic (also the Staatsoper's

orchestra), and Lehmann was joined by her Viennese colleagues Maria Nemeth and Richard Mayr, in addition to Swedish artists such as Margit Mandahl, who replaced the bedridden Elisabeth Schumann. Other singers, such as bass-baritone Hans Hermann Nissen, had come from elsewhere. The otherwise sanguine Swedes were beside themselves with joy and generated applause and curtain calls, the likes of which Lehmann was not even used to from Vienna. She more than anyone else was celebrated on stage, where her singing was interrupted with much scenic applause. The gala visit was crowned when she and the Hungarian soprano Nemeth, who had been with the Staatsoper since 1924 and had recently risen to significance, were honored by the Swedish king with the gold medal "Litteris and Artibus," which was handed out rarely. This jubilant tour emphasized Lehmann's international stature as one of the leading singers of her time.[10] During a longer tour by the Staatsoper ensemble under Schalk's direction at the Grand Opéra in Paris during May, Lehmann sang Fidelio, the Marschallin, and Sieglinde, again to enthusiastic applause. It was her first time in the French capital, and she, Schumann, and others received the order of an Officier de l'instruction publique (the "Golden Palm").[11]

Lehmann enjoyed this exalted phase of her national and international success, while Schalk directed her musically and continued to be largely responsible for her Staatsoper entitlements. Because of this dual function, Schalk's relations with her became more complicated than they had been before 1926, since Lehmann's increasing fame multiplied her opportunities to sing outside Vienna. The latter, however, went against Schalk's policy, and he not only came to deplore the soprano's growing absences but also found it difficult to meet her wage demands. Nevertheless, personally the two had as much respect for each other as ever, some kind of father-daughter love, which is documented in many a personal letter. (As before, there was nothing at all sexual here; since 1926 the married Schalk's mistress had been reputed to be the attractive Hungarian soprano Margit Schenker-Angerer.)[12] Just after his leave taking in July of 1929, Schalk wrote to Lehmann that her "Director" he had been, yet that forever he would remain her "admirer, devotee and friend." When after an illness her "artistic leader" died in the fall of 1931, Lehmann told Mia Hecht how shaken she was and that she "painfully" missed him.[13]

Although we have no reason to doubt the sincerity of that statement, Lotte Lehmann, more likely than not, wished one part of Schalk to the devil during contract negotiations from 1926 on, because while trying to concede his most distinguished soprano as much as he possibly could, on essential issues he always remained as stubborn as an oak tree. Some of his attitude was dictated by his new superior, the republican bureaucrat Franz Schneiderhan, originally a hat manufacturer, who as *Generaldirektor* in September 1926 was switched between official establishments such as the Burgtheater and Staatsoper on the one side and the Ministry of Education on the other. While a connoisseur of culture, Schneiderhan, not unlike Hans Gregor before him, displayed a shrewd business sense, and because both theaters received subventions from the state and he always had to ask the Finance Ministry for funds, he kept a close watch over theater expenditures, which had been the purpose of his appointment. Schalk, the student of Bruckner, came to resent the hat maker's stewardship to

such an extent that it hastened his retirement in 1929, effective August 31, one year before his 1924 contract would have expired. It was only with loathing that Schalk, the antimodernist who had already driven the experimental Paul Hindemith out of Vienna, agreed in late 1927 to have his kapellmeister, Robert Heger, stage and conduct Ernst Krenek's "jazz opera" *Jonny spielt auf*. For this work was proving sensationally successful in the German Republic, and the hatter wanted it to attract crowds and bring in money to Vienna as well, which it did, quite unlike even the most popular among the traditional operas.[14]

Schalk's, and later Schneiderhan's, negotiations with Lehmann regarding working conditions, wages, and perquisites took place against the backdrop of the Austrian Republic's feeble postwar economy. Even after the League of Nations' grant of financial aid in 1922, there were only intermittent improvements; a fall-back to instability was inevitably aided by the contortions a right-leaning government had to endure, until after clashes between Social Democrats and nationalists in July 1927 the new democracy began to dissolve, with the Austrofascist systems of Dollfuss and Schuschnigg replacing it in the early 1930s.[15]

Between 1918 and 1938, Austria suffered a decline in its gross national product of 0.2 percent, whereas that of Germany rose by 2.1 and all of Europe's by 1.6 percent. Among other maladies, there was unemployment, which affected not so much the manual laborers as the middle-income earners – white-collar workers and civil servants, mostly in the towns and cities, particularly Vienna. Those were the people who normally frequented restaurants and shops, but also entertainment venues such as theaters, *Varietés*, operettas, and not a few the Opera. Because now there was less money in the pockets of the Republic's citizens, more restaurants and stores went bankrupt, and there was an incipient crisis in the banking sector.[16]

In the realm of low to high culture and notably in Vienna, the economic losses by managers of entertainment establishments were palpable. As a rule, those suffered the most who could not rely on government subsidies. In 1928 alone, such well-known venues as the Bürgertheater, the Stadttheater, the Apollotheater, and the Kammerspiele, but also the Volksoper, where Jeritza once had come to notice, either closed or were seriously endangered. This happened despite attempts by stages – as the Staatsoper tried to do with *Jonny spielt auf* – to mount especially racy shows like the vaunted *La Revue Nègre* with the black dancer from St. Louis, Josephine Baker, in order to bring in needed cash. In her début in Paris of October 1925, Baker had arrived on stage "scantily clad, on all fours with her bottom high in the air, before launching herself into a frenzied demonstration of the Charleston, followed by an undisguisedly sexual tree-climbing act."[17] Even if this original show was toned down in Vienna, the consequences for the local entertainment industry were curtailed wages or outright dismissals for artists, so that a goodly number of them fell into poverty. Hence an artists' lobby was created, the Eckartbund, whose sole purpose was to raise money for starving musicians, singers, dancers, and actors.[18]

At the state-supported Opera after April 1926, Lehmann and her lawyers dealt at first with Schalk and then with both Schalk and the even more

intractable Schneiderhan. Apart from the long-standing attempts to have her contractual vacations extended or additional ones granted, in order to honor professional invitations elsewhere, the major problem for her was a satisfactory renewal of her current contract, which was to run out in late spring of 1928.[19] She was at an advantage insofar as she knew that she could subsist well enough by going on tour alone; besides, she had a standing invitation from Bruno Walter and Heinz Tietjen to do a series of guest performances at the Städtische Oper in Berlin, with the option of a permanent appointment.[20] What she desired from Vienna was two things. First, she wanted to get out of a convention that in 1926 had been signed by the directors of certain stages in Berlin, Dresden, and Vienna (Deutscher Bühnenverein), whereby no artist was to be paid more than 1,000 marks per performance, or the equivalent in schillings. Lehmann thought she had a right to that exception because, on the Austrian side, the top singers, Piccaver and Jeritza, had previously been exempted. Besides, Kiepura had just been paid 4,000 schillings for impersonating the Stranger in *Heliane*, rather than the stipulated 1,700, which further strengthened her case. Not surprisingly, the other concession concerned vacation time: the prima donna wanted her Viennese obligations relegated to only five months in a calendar year, of which two were to be dedicated to constituent vacation time, to be spent by her as she pleased. That would leave at least seven months for touring.[21] To underline her claims and show how popular she was with the Viennese public, the diva, who was at that time receiving 1,700 schillings from the Opera and thus, after Jeritza, was the highest-paid female singer, gave a specially scheduled recital in mid-February 1928. She offered carefully chosen pieces, such as "Zueignung" by Strauss and arias from the Viennese-beloved Korngold operas, to convey a message of deep-felt devotion – the quality that was her trademark.[22]

After Schalk had shown signs of compliance early in 1928, he was overruled by Schneiderhan, who dealt with the singer in his office only peremptorily. Insulted, Lehmann made a show of wanting to leave Vienna, when at the last minute the Opera relented.[23] According to a new contract of early March she was to get 1,800 schillings of salary for six months of active work, plus 1,500 per performance, to be pegged at a minimum of nine per month, for eight years. These amounts were indexed to the U.S. dollar. If any singer were to receive more than she did, she was free to renegotiate or cancel the agreement. After four years, she was entitled to cease singing at a permanently fixed pension. Nonetheless, extracurricular leave time had to be individually negotiated on a case-by-case basis, as before. The contract was to last from September 1, 1928, to August 31, 1936.[24] One other benefit of the arrangement, one she had expressly asked for, was that she be made an Honorary Member of the Staatsoper, as had Jeritza and Marie Gutheil-Schoder before her, as well as such male stalwarts as Piccaver and Leo Slezak. That appointment, emphatically endorsed by Schalk, was made official on September 26.[25] In view of the dire straits of the economy in general and the cultural establishment in particular, this was indeed a stellar settlement for Lehmann, not to mention a moral victory.

However, as much as Lehmann liked her new contract,[26] her quarrels with the Staatsoper continued, sometimes because an evening of sick leave was not

recognized as such by the directorship (over which she almost threatened to sue), but most times because, in the directors' eyes, she still continued to ask for too many free days on tour.[27] In March 1929, Schalk complained to her that the current season had just passed without the star creating a single new role, to which she replied that this was not her fault, since none had been offered her. As she did every year, she was determined to sing her guest role at London's Covent Garden that spring, and Schalk had better not try to stop her.[28] Things were coming to a head later in the summer when the Staatsoper would not grant Lehmann leave to participate in the annual Salzburg Festival, where she had been a fixture for three years now, short of ministerial intervention. And this despite the fact that to a large degree that festival served as an extension of the Opera's own cultural programming and was customarily staffed by many of its cast members.[29]

Because it was known in Vienna that Schalk would be gone by September 1930 at the latest, the search for a successor was on early. Schneiderhan's first choice was Wilhelm Furtwängler, forty-four years old in 1928, who most recently had made a name for himself in Berlin and Leipzig but had also guest conducted the Vienna Philharmonic. Schalk, supporting Schneiderhan's decision, invited the German to direct *Das Rheingold* in 1928, and by the fall of that year it was agreed that he should get the nod. However, Berlin's bureaucrats quickly turned around, offering the star conductor sweeping powers over Berlin's musical life as *Generalmusikdirektor*, a villa in nearby Potsdam, and other bonuses. In the face of these challenges, the Vienna Opera had to capitulate.[30]

The next candidate was Bruno Walter, who had not been happy in his Berlin position with Tietjen since at least 1927. In his memoirs, the conductor later maintained that he played it very cool, since he did not wish to appear in need of a job, but in reality the opposite was true. Behind the scenes, he mobilized whom he could – for instance, his friend Lotte Lehmann, who understandably would have been only too glad to see him in Vienna. Walter faced a similar problem there as had Furtwängler because of the frequent presence in the Austrian metropolis of Richard Strauss, who was not particularly fond of either man, but who liked Walter least.[31] It was Lehmann who told Walter as early as September 1927 that a "Mahler Clique" was working against him in Vienna (including, without a doubt, Schalk), which claimed that he himself had spoiled his chances by talking publicly about a possible appointment before anything had been vouchsafed. The *Neues Wiener Journal* informed its readers a year later that Walter had had no choice but to signalize disinterest immediately because of "over one hundred-and-twenty obligations abroad." Hence he wanted far too much money and extra vacation time. Moreover, Strauss was certain Walter had said he could "no longer accept a position Herr Furtwängler had thrown away." Be this as it may, it is clear that had Walter accepted a call to Vienna, Lehmann would have saved herself a ton of troubles, as future events were to show.[32]

The third man on the 1928 short list was Clemens Krauss, whom Schneiderhan hired in December, so that he could start working on September 1, 1929. While as a person Krauss was charismatic, his conducting owed more to a punctilious reading of the scores and conscientious rehearsals than to intuition.[33]

He was born in 1893, the illegitimate son of Clementine Krauss, a solo dancer at the Opera, and, as indeed his physiognomy betrayed, Archduke Eugen von Habsburg. The precociously gifted Clemens – who later would cut a figure like a Spanish grandee, with his sideburns, black cape, and Calabrese hat – was a Vienna Choir Boy before he learned piano and conducting at the conservatory; one of his teachers was Schalk. The year 1921 found him in Graz as director of the local Opera. Because he loved performing Strauss's oeuvre, the venal maestro called him to Vienna in 1922 as *Erster Kapellmeister*. In 1924, Frankfurt offered him the post of *Direktor*, then as intendant of its Opera, and there he honed the style he had already begun to develop, that of a conductor who worked closely with a tightly defined cohort of devotees and a musician sympathetic to the moderns. As an example of the latter, he was fond of directing the famous Museum Concerts, which had a reputation for progressiveness. But as part of his Frankfurt mandate Krauss also took care of the traditional repertory, albeit in new productions whenever he could (of Wagner's *Ring*, for instance), in which task he was aided by the avant-garde producer Lothar Wallerstein, until that artist's departure for Vienna in 1927. In Frankfurt, Krauss also continued to pay homage to Strauss; in his five years there he played Strauss operas no less than ninety-two times. His ensemble, which he shaped in close accordance with his artistic concepts, included the likes of tenor Franz Völker and sopranos Gertrude Rünger and Viorica Ursuleac, with whom he began a liaison that years later, during the Third Reich, would lead to marriage.[34]

Strauss and Schalk attempted to draw Krauss back to Vienna on, at first, conditions not ideal for a musical director of the Opera, Strauss being guided, of course, by the prospect of having his works performed at the Staatsoper with metronomic regularity whenever he himself could not conduct them.[35] As predicted, this is what happened after Krauss had begun to work in Vienna in September 1929; he was able to import his "ensemble style" because many of his artistic associates, Völker and Rünger included, followed him to the Austrian capital. His friend Wallerstein was already there, and Ursuleac, whose Frankfurt contract ran until 1931–32, arrived as a regular guest performer in fall of 1930.[36]

During autumn of 1929 Clemens Krauss moved to Vienna at a bad time, for politically the country was as disunited as ever, and economically it was now on the verge of the Great Depression. In Austria, that was caused in part by the demise of the Boden-Credit-Anstalt, which had been the bank of the Imperial House and to be saved had to be fused with another bank, the Creditanstalt für Handel und Gewerbe. And that institution crashed outright in May of 1931, marking Austria's fall into deep economic depression, coupled with deflation. Relatively speaking, there was less money available than ever for public establishments, and therefore the salaries of state officials and employees were cut, those of Opera workers included. Unemployment, already a problem, particularly within the broader middle classes, worsened precipitously, until the country had over 400,000 jobless in 1932–33. In addition, there were tens of thousands of unregistered unemployed. Apart from hampered trade and other economic drawbacks, Austria's famous tourism industry suffered, especially as far as influx from her northwestern neighbor Germany was concerned, for in

1931 the Berlin central government issued an emergency decree imposing an exit fee of 100 marks on citizens wanting to leave the country. This affected many opera-loving Germans, who otherwise would have traveled to Vienna. Moreover, in June of 1933 the annexation-bent Nazi government imposed the horrendous levy of 1,000 marks on any German wanting to cross into Austrian territory.[37]

These conditions prompted one cynical foreign observer to remark that "an Austria of 7,000,000 inhabitants can no longer afford banking, operatic and theatrical amenities on a scale designed for an empire of 50,000,000."[38] Indeed, the Education Ministry was aiming for savings rather than larger subsidies in the realm of theater and opera with renewed efforts beginning in the late 1920s. In 1932, for example, the office of the *Generaldirektor*, which Schneiderhan had overseen, was abolished, and the Opera itself was to be combined with the state radio corporation, RAVAG. Krauss came under great pressure to reduce the existing Opera deficit by cutting his operating budget and all salaries, including singers' overtime, while money magnets such as the photogenic Jan Kiepura were to be handed the largesse resulting from oversized engagements.[39] Soon prospective international opera lovers were being scared off by notices such as this one from the *New York Times* in August 1931: "Owing to lack of money, the ballet performances will not be as pretentious as during former years." Indeed, in October 1933, when Strauss's *Arabella* had its Vienna premiere, decorations from Richard Heuberger's reworked operetta *Ein Opernball* had to be used.[40] Krauss's problem was that fewer and fewer people had the money to pay for ever-dearer Opera tickets and that for this reason performances frequently played to houses not even half full. The visual impression of smaller audiences was increased by the abolition of free standing room (as if one could have sold that space for money!). But many opera-obsessed students had made use of the time-honored institution of the standees' gallery, and apart from the visual effect, this measure now had the added result of depriving Opera stars of some of their most devoted fans.[41]

The decrease in salaries did not go over well at all with stars like Piccaver, Schumann, and Lehmann, who had for years been pampered with premium rewards. But even before this happened, at the beginning of the 1930s, Lehmann committed herself to a spat over money with Krauss, when he had hardly entered through the Opera's main door. Presumably this was to demonstrate to him what she perceived to be her special status on the premises (now that Jeritza was usually away) and to put him, five years younger, in his place. She missed a performance as Margiana in Cornelius's opera *Der Barbier von Bagdad* on September 26, 1929, although she was present for rehearsals just before and after the event, on the grounds of being overworked, expecting to be paid her 1,500 schillings nonetheless. When Krauss protested, her lawyer, Max Fürst, contended that under Schalk she would naturally have gotten paid, and (a less credible claim) that Schalk would sometimes pay her fully for all nine of the required monthly performances when in fact she had sung only eight. At the end of the day, after protracted and very stubborn negotiations, Lehmann won this round when Krauss offered henceforth to pay the artist for a ninth monthly

performance, which she did not actually have to sing, and to extend her monthly fixed payment of 1,800 schillings to all of her vacation months.[42]

No sooner had these negotiations concluded in November 1929 than, for Lehmann, the next specter appeared on the horizon in the person of bass-baritone Wilhelm Rode, newly hired at what the diva believed to be a salary higher than hers.[43] She now declared herself to be contractually able to break her eight-year March 1928 contract and start looking for a permanent engagement elsewhere, unless the Viennese would meet her new demands. Rode, one year her senior, was a *Heldenbariton* from Munich and Berlin who was engaged from 1930 on to sing Scarpia from *Tosca* and other roles, but mostly the Wagnerian heroes for which he was famous. His employment in Vienna was to be for ten months a year, at altogether more money than Lehmann had just been conceded. Her disagreement with Krauss over this lasted until April 1930, when, once again, she secured for herself a better contract, above the fixed monthly salary of 2,000 schillings she had lately been granted.[44] Lehmann made the most of this for publicity purposes with her Vienna audience. Under the title "May I Defend Myself," she launched an article in one of the daily newspapers, where she wrote, in her florid style: "Avaricious, unfaithful, ungrateful, stubborn: Under the impact of these accusations I am probing with the lamp of critical objectivity the depths of my heart. But I only find one thing: the idea of 'Vienna,' in unadulterated love, as ever and always."[45]

This comfortable financial arrangement lasted until the fall of 1931, when deflationary pressures began to affect all of the personnel of the Staatsoper momentously and incrementally. If by October Lehmann had been informed that she would lose 30 percent of her Vienna salary, a few weeks later she had to register an additional deficit of 30 percent, and so on, so that by Christmas of that year she was out of pocket by 64 percent.[46] In January of the following year her fixed monthly salary had vanished completely, and her performance fee had been reduced to a mere 1,026 schillings per event.[47] For January 1933, a further huge deduction was announced. At that time, the ambitious Maria Nemeth's loss consisted of 26.7 percent and Elisabeth Schumann's of 7 percent of basic salary; *Operndirektor* Krauss himself went without almost a quarter of his approximately 20,000 schillings a month. With Jeritza's value having already fallen, Lehmann was now the premier, and highest-paid, female singer of the Vienna Opera.[48]

If she thought, rightly or wrongly, that Krauss was responsible for at least some of the disagreeable financial arrangements at the Staatsoper after 1928, it was his musicianship that irked her more. The prima donna was exercised over what was called Krauss's "ensemble style," the manner in which he closely trained with and then conducted favorite singers. He did this using his superior musical expertise, his considerable personal charm, and also chicanery, which later annoyed singers such as bass-baritone Hans Hotter.[49] His ensemble style entailed working very closely and as a superior director with artistic intimates, among whom were singers he brought from Frankfurt (such as Völker and Rünger, Adele Kern, and, eventually, Ursuleac), some whom he found already working in Vienna, like Josef Manowarda, and others who were

hired afresh, among them Rose Pauly (as a permanent guest from the Kroll Opera in Berlin), Jarmila Novotná, Erich Zimmermann, Karl Hammes, Margit Bokor (as a permanent guest from Berlin and Dresden), Anny Konetzni, and Friedrich Schorr, already famous as a Wagnerian bass-baritone, who visited from the Berlin Staatsoper.[50]

Those singers Krauss called in for many rehearsals, during which he studied with them to the point of near-perfection. He was especially able to guide them vocally because as a former member of the Vienna Choir Boys he knew something about voices. Krauss hated the claques, who supported individual stars through noise and uncalled-for applause, and he forbade them. He also abolished the practice of frequent, interruptive scenic applause. As in Frankfurt, he liked conventional operas in new productions, and although he loved a lot of Strauss, he had a penchant for something few Viennese abided: progressive and even atonal works, such as Alban Berg's *Wozzeck*, which was performed in 1930, with Pauly as Marie (after Lehmann had refused the part). Ideally, every role had to be sung by the same singer from his ensemble repeatedly, and he shunned outsiders. For Krauss, the most egregious outsiders were those who came only for cameo performances costing a lot of money; he was more easily mollified, however, when a guest star attracted large audiences to the point of filling the coffers, as did Kiepura.[51]

Other outsiders were really insiders, those who had been with the Opera longer and hardly thought they needed never-ending repetitive rehearsals. They had their routines memorized and resented even having to study new roles, as this would only mean precious time away from touring. Principals in this group included Piccaver, Schumann, Nemeth, Schenker-Angerer, and Lehmann.[52] She was opposed to everything that Krauss stood for, including what she considered to be the machinations of his producer and artistic director, Lothar Wallerstein. This brilliant man had a doctorate in medicine, but he was also an impressive pianist and able conductor. He was aesthetically influenced by the consummate British theater expert Edward Gordon Craig, who since the beginning of the century, when the German impresario Count Harry Kessler had lured him onto the continent, had placed so much emphasis on the actors' movements, their ideal function as a director's marionettes. He also preferred simple but stark shapes, the use of much light against darkness, and the crassest colors, not to mention innovative stage designs through the use of portable folding screens.[53] Upon being hired at Vienna in 1927, Wallerstein displayed similar tendencies, and the prima donna watched in horror, trying to argue with the man who, as Alfred Roller had done under Mahler, was again breathing some life into the staid, old-fashioned theatrical routines of the Staatsoper. After the Vienna Opera company had guest performed *Turandot* in Breslau in early November 1927, with herself singing the title role amid Wallerstein's modern set design and direction, Lehmann complained to her mentor Schalk: "A parody. No other description will do. The one thing that was used lavishly was shrill, screaming colors, which pursued me literally in my dreams. My 'costume' (oh God!) consisted of a terrible violet lining, painted all over." Lehmann later claimed to have established a dialog with Wallerstein even before Krauss arrived and that thereafter they got along well enough, but in a letter to her

dearest colleague Schumann of July 1929 she expressed her dismay over the fact that, just as they had feared, Wallerstein had become the Opera's deputy director.[54]

If Lehmann and Krauss never got along, this had as much to do with the conductor's artistic commonality with Wallerstein as with Krauss's ensemble style and their differing personalities. Lehmann's somewhat ordinary appearance and her unsophisticated background, as well as her directness in interpersonal relations, contrasted with the handsome, polyglot scion of aristocratic background, his grandeur and inbred Viennese charm and a manner of communication that could be elegantly vague or acid. At a time when the slightly older diva was feeling the onset of middle age, which, especially with a female singer, would gradually but ineluctably show in her voice, Krauss's reputation was that of a young man with a future who, for all people knew, would still be conducting at eighty.

Lehmann claims to have liked Krauss at first, and she certainly said so publicly, but she later admitted to having reacted unduly negatively to his aesthetocratic ways, in situations where she could easily have obliged him.[55] But even in her memoirs she pretended that she could not be accepting of a man who had taken the place of her beloved Schalk – when in fact she knew that Schalk himself, and the respected Strauss, had favored Krauss's return to Vienna and that Schalk's personal demise at the Staatsoper was not the result of Krauss's arrival, but, on the contrary, its cause.[56] In any case, Lehmann had collaborated with Krauss already during his early Vienna and then during his Frankfurt years. In September 1926, Krauss had offered her the lead role in a new production of *Ariadne*, which at that time she did not accept, probably because she shunned working with Wallerstein – she had sung it under both at the August Salzburg Festival.[57] In January 1929 she participated in Krauss's famous Museum Concert series; whether she sang a "modern aria," as she had been requested, is not recorded, but may reasonably be doubted.[58]

Since Krauss had signed in December 1928 to begin working in Vienna the following September, he seized the opportunity to get a head start with his planning. By way of a prelude, he invited Lehmann to participate in a new production of *Der Rosenkavalier* at the 1929 Salzburg Festival, but her immediate reaction was to turn him down under the pretext of needing a holiday and possibly not getting the required vacation time from the Staatsoper. In the event, she finally was able to sing the part five times in August, as if she had not known this earlier.[59] In the months to follow, it became obvious that the combination of Lehmann's generous contractual vacation prerogatives and her prima-donna-like proclivity to refuse especially first-time roles made adequate planning increasingly difficult for Krauss, unless he resorted entirely to his loyal Frankfurt ensemble. When he released a directive to the Vienna old guard seeking information about roles that had lain fallow for some time, this must have greatly displeased Lehmann, who, to Strauss's regret, at that time just could not be bothered to devote herself to a study of the lead character in his *Ägyptische Helena*. Until the end of 1929, when Krauss had barely started, these were not auspicious beginnings under contracts designed to last for five years in the conductor's case and almost seven in the soprano's.[60]

In the years to follow, Lehmann managed to sing as little as possible under Krauss and, lest she run afoul of the terms of her 1928 Vienna contract, as much as possible with permanent guest conductor Strauss, other visitors, and less-than-first-rate kapellmeisters, such as Karl Alwin, Hugo Reichenberger, and Robert Heger. Her absence from the Opera was conspicuous whenever Krauss scheduled a more modern work, such as *Wozzeck* or, in 1931, *Die Bakchantinnen*, by Schoenberg's pupil Egon Wellesz. Her communications with Krauss remained polite but evasive, even though she taunted him that she would sing for him Wagner's Isolde, a role she knew she was having much difficulty with and one that she would possibly never master. Krauss kept offering her parts that subsequently she refused, or had parts for her to sing during her off-time. Although he realized what a uniquely wonderful singer she was and that she was now in the halcyon years of her career, he was also aware that she was bent on exploiting the power of her prominence to the fullest. Bitterness was in his heart when he complained to his benefactor Strauss that Lehmann "really was never here for six months, but preferred to sing in Aussig, if she received more there for an evening of recitals," Bohemian Aussig being just about any provincial stage beyond Vienna's orbit.[61]

Today there are two schools, one arguing that Lehmann could not have sung enough in Vienna even had she wanted to, because Krauss was giving all the good roles to his lover, Viorica Ursuleac.[62] The other holds that because Lehmann refused so many roles over time, Krauss had no choice but to ask Ursuleac to jump into the breach and sing them.[63] There is no doubt that soprano Ursuleac was the member of Krauss's ensemble Lehmann believed she had reason to fear almost as much as Jeritza.[64] She was born in 1894 in Czernowitz (Czernovtsy), the capital of the Bukovina in the Habsburgs' eastern realm, as the daughter of a Romanian Orthodox priest, and had started her singing career in Zagreb. By 1926 Krauss had hired her for Frankfurt, where they became romantically involved. As an admirer of Jeritza, she had a voice that was capable of great sustained heights, but many critics found it cold, even glacier-like. Yet exactly that trait qualified her for certain Strauss roles. The composer himself came to Frankfurt in late 1925 and was impressed when he heard her as Freia in *Das Rheingold*. It can be assumed that Lehmann knew of her as a singer in December 1928, when Krauss had been engaged, and that she feared her eventual entry on the Vienna stage both as a member of Krauss's vaunted ensemble – and one able to hold long high notes at that – and as his paramour. But Krauss did not actually sign her to the Staatsoper until the fall of 1930, on a visiting basis only, and he expressly justified this to Strauss as a measure to counter the negative effects of Lehmann's preciousness and prolonged absences. However, although Strauss came to like this newest faithful interpreter of his oeuvre over time, dedicating a photograph of himself to her as early as April 1931, the informed consensus was that she could not come close to the overall quality of Lehmann's singing and lacked, especially, Lehmann's emotional power, the essence of her *Innigkeit*. The American Vincent Sheean expressed this succinctly, after hearing both sopranos as Marschallin in Salzburg. By Ursuleac's one-time performance alone, observed Sheean, "the rarity of Lehmann's achievement could have been framed and lighted."[65] As it

turned out, in Vienna Ursuleac took on only a few roles that she shared with Lehmann, such as Desdemona from Verdi's *Otello*, specializing instead in others that the older and established soprano, whose shadow always hung heavily over her, never touched. Among these were Elisabeth from Verdi's *Don Carlo*, and the Strauss roles of Elektra, the Empress from *Frau ohne Schatten*, and Helena. Lehmann managed to be on stage with Ursuleac but six times during her career: always when she had to sing the Dyer's Wife opposite Ursuleac's Empress, in both Salzburg and Vienna, and all in the short period from February 1931 to October 1932.[66]

There was one role that Viorica Ursuleac, rather than Lotte Lehmann, did sing in July of 1933, and the fact that Lehmann had virtually thrown this to her would-be rival was to bother her into old age.[67] It was at the world premiere of Strauss's latest opera, *Arabella*, in Dresden, whose eponymous lead part, as she knew, had been written especially with her in mind. The reasons why she did so are still not entirely clear, but they seem to be rooted as much in her far-from-ideal relationship with Krauss and Ursuleac as in her affiliation with Richard Strauss.

In a New York interview of 1936, Lotte Lehmann was asked why she and Strauss had lately drifted apart. "I don't really know myself what happened," she replied. "Perhaps nothing. Certainly not in any way anything that is tangible. He is well aware that there is no greater champion of his operas than I, for I happen to love them all and know they will live forever. No one sings his lieder more often than I do, and this he also knows. But he considers Clemens Krauss to be the greatest conductor of his works, and of course the latter admires Ursuleac. People drift away from one another, and it is sad."[68]

This was a remarkably candid statement from the singer and one that came close to the truth in most, if not in all, respects. In that scenario, Krauss and Ursuleac were only incidental. A fundamental fact was that Strauss and Lehmann after the premiere of *Intermezzo* were becoming alienated without outside interference and that the blame, if blame there was, could be apportioned almost equally to both. Before details are scrutinized, it is fair to generalize that Strauss, in his immense musical and personal vanity, offended Lehmann, because even if he had told the soprano that she was unique, he kept other sopranos at his beck and call as well, choosing to flatter them or offend them, whatever was needed to serve his every purpose. His great personal charm was at the same time an enigmatic, if fascinating, screen to keep the singers both at hand and at bay, a thespian mask of smiles that was convenient for a composer who wrote all his mature operas exclusively around single-character heroines. "He is egocentric in the extreme and to such extent that his indifference often borders on cruelty," was Lehmann's later, entirely correct, observation. But at the time the singer failed to realize any ramifications of this egocentricity that could touch her personally. She did not know, or did not want to know, that whenever Strauss told her she was the only singer in his life, he had said this to other singers before and would do so again, during her own career with him and after – Kurz, Jeritza, Gutheil-Schoder, and, after 1926, also Ursuleac. Not to be able to comprehend this and put it in perspective was the gullible Lehmann's

first mistake. Her second was her own unwillingness to make material and intellectual sacrifices, swallow a prima donna's pride, and give up more of her precious time. All this happened during a phase after 1924 when Lehmann's voice, relative to her earlier years and to other, younger up-and-coming colleagues, was gradually finding it difficult to cope with the constancy of high notes that characteristically defined any of the typical Strauss lead roles, from Salome to Arabella.[69]

The demise began when after the premiere of *Intermezzo* Strauss, sitting next to Lehmann during a festive dinner in Dresden in early November 1924, assured her in the presence of witnesses such as Schneiderhan that she would be Helen in his next opera, *Die ägyptische Helena*. Strauss was double-crossing her, however, for he had agreed with librettist Hugo von Hofmannsthal as early as 1923, when that opera was in full gestation, that the lead role – representing the most beautiful woman in the world – could be sung by none other than Jeritza. Whereas the choice of Helena that early is documented, Lehmann's claim is contained only in a letter she wrote to Strauss in December of 1927. But she could not have made it up, for Strauss himself substantiated it indirectly on a postcard he sent her from vacation in Greece in May 1926 – Greece, as he prophetically alerted her, "the home of Chrysotemis, Ariadne and Helena."[70]

During 1927, as Strauss and Hofmannsthal were planning the world premiere for the following year, a number of factors crystallized. If the premiere were to be in Dresden again, Strauss's favorite spot for such occasions because of the intimate atmosphere provided by the Semper Oper, there could be a problem with Jeritza. Dresden would not be able to pay her more than the 1,000 marks prescribed as a maximum by the Austro-German stage convention, whereas Jeritza was known to have been paid 6,000 by a noncompliant Berlin theater only recently. To circumvent this difficulty, Strauss proposed a singer other than Jeritza, one who would be content with 1,000 marks and might be more easily accepted by the Dresden directorate as well. Strauss's and the Semper Oper's choice was Elisabeth Rethberg, a native Saxon, who since 1922 had been singing Wagner, Strauss, Verdi and Puccini at the New York Metropolitan and would meet these requirements.[71] But Hofmannsthal thought her too plain for a Helena and proposed instead the fetching Margit Schenker-Angerer, whom Strauss in turn thought too immature as an actress. A compromise was reached toward the end of the year among Strauss, his librettist, and the Dresden *Generalintendant*, Alfred Reucker, when it was decided to have the world premiere in the Saxon metropolis on June 6, 1928, during a Semper Oper anniversary, with Rethberg singing Helena, and a Vienna premiere on the eleventh, Strauss's birthday, with Jeritza. It was thought that the glorious prima donna would be able to take care of that role at her home base as part of her normal contractual obligations.[72]

Meanwhile Lehmann had gotten wind of these plans, which led her to write her furious December letter to Strauss. She claimed that public media such as newspapers had already mentioned her future role as Helena and that any change thereof could only be taken as an affront to herself. "The enthusiasm over my success as Christine was doubtless greater than that of the actual opus," she had the cheek to tell Strauss. The composer himself had admitted this to her,

but then again, one could discount that compliment, because, as she observed in a rare moment of insight, "you are in the habit of being nice to whoever has been left with the new chore of a Strauss premiere."[73]

For the time being, however, Strauss had other problems. He had to assure himself of the collaboration of Jeritza, who, as she had already cabled Schneiderhan, would only consent to sing at a world premiere, whether it be in Dresden or in Vienna. With Dresden and the lower-rated Rethberg fixed for June 6, 1928, Strauss had to use all his powers of persuasion to get Jeritza to perform in a post–world premiere in Vienna. This he proceeded to do with a long letter on December 30, 1927, in which he conjured up their friendship. Its key sentence referred to "your Helena: conceived for you from the beginning and written for you."[74] Jeritza consented to sing the role on January 17, but only if Dresden's *Generalintendant* formally asked her (as if she owned that Opera) to concede the premiere to the Saxon capital. In the following days and after several transatlantic cables, Reucker did not quite get this done in the prostrate manner the diva had required, but in the end she acquiesced and allowed Strauss to have his way.[75] The Rethberg-Jeritza arrangement was officially announced at the beginning of March 1928.[76]

But as soon as Jeritza had returned to Europe from New York, she played the *prima donna assoluta* again, so that Strauss, Hofmannsthal, and Schneiderhan did not know what would happen next. The reason for her fickleness was the treatment she had received during the Vienna Opera's recent guest performance in Paris, where – her first time there – she was poorly received by audience and critics and, unlike Lehmann and Schumann, was accorded no official distinction. Especially for the latter mishap she chose to blame the Staatsoper's functionaries, for those things were usually agreed upon by the partner institutions beforehand. It was not until the end of May 1928 that Strauss could be absolutely certain Jeritza would honor her June 11 commitment, after he had authored a press release in English. This was destined for American newspapers, who knew both Jeritza and Rethberg from the Met, and stated that "from the beginning on the role of Helena was intended for Madame Jeritza" and that only because "insurmountable difficulties prevented Madame Jeritza to sing in Dresden Madame Rethberg was invited to sing the role there." Moreover, because Jeritza had threatened to leave the Staatsoper for Budapest and had absented herself from Vienna rehearsals for the *Helena* premiere, Strauss had to implore her in person; she then declared in an interview with Hungarian journalists that Strauss had made a statement to the directors of the Staatsoper.[77] In it, he had said that he had written *Die ägyptische Helena* just for her, Maria Jeritza, and that he viewed it as the main work of his career. If she did not sing it during the Vienna festivities of what was to be officially a "Strauss Week," then he could not care less who would subsequently sing it. This interview was then reprinted in the Viennese press.[78]

As for Lehmann, after she had fired off her angry letter to Strauss, she was still hoping to be assigned the role of Helena, presumably in Vienna, because she knew that while the deal with Rethberg in Dresden had been quite set, Jeritza could be a problem. She was not even totally averse to the idea of singing the role in Vienna alternately with Jeritza, as long as she would not

appear there as the second choice. With this positive prospect in mind, the wily Strauss resumed his courtship of her.[79] For Reucker in Dresden as well as for Strauss in Vienna, Lehmann was still useful, for it had become clear that both Rethberg and Jeritza could sing only on the night of the premiere; in either one of those cities, Lehmann could then continue. For Vienna, Lehmann herself left that possibility open, yet as far as Dresden was concerned, she had to be firm with Reucker that this was quite impossible, because he could not go above the maximum of 1,000 marks. She even refused to sing in Dresden during any of the Opera festivities programmed there.[80]

The Dresden and Vienna premieres of the opera transpired as planned, and to mixed reviews. The stage plot took place after the Trojan War, with Helena in the center as the beautiful wife who had betrayed her husband, Menelaus, king of Sparta, with the Trojan Paris, while in captivity. At the end, Helena and Menelaus are reconciled as a couple, and thus this was another one of those marriage dramas of which Strauss had lately been so fond. Not unlike *Die Frau ohne Schatten*, Hofmannsthal's libretto was generally thought to be obtuse and ponderous, and even Strauss's music was not exempt from criticism. In Dresden, after a credible performance under the baton of Fritz Busch, the astute German reviewer Hans Heinz Stuckenschmidt described his feelings as "not very happy." The doyen of critics, Alfred Einstein, found it to be a "magic opera with all the gadgets." The modernist Paul Stefan, visiting from Vienna, ceded it only polite applause. In Vienna, where the Austrian premiere with a truly spectacular Helena had gone better, Strauss's habitual follower Richard Specht pronounced the musical style dated.[81] After a New York Metropolitan premiere with Jeritza on November 6, critic Olin Downes judged it all "a libretto which is somewhat rambling and dramatically futile, and a score that runs for one act with plausible routine, and a second act that is sheer emptiness, the whole being signed by a composer of international reputation."[82]

On Sunday, June 10, 1928, one day before his sixty-fourth birthday and the Vienna premiere of the new opera under his musical direction, there was a reception for the composer at the cultivated home of Elisabeth Schumann and her second husband, Kapellmeister Karl Alwin. The pillars of Viennese society were there, among them many old aristocrats, Hofmannsthal, the widow of Johann Strauss, the Staatsoper singer Vera Schwarz, the pianist Ferdinand Foll, and Wilhelm Furtwängler. Conspicuous by her absence was Lotte Lehmann, who was best friends with the Alwins. She was not on an out-of-town assignment, for she had sung Turandot on the seventh and was scheduled to sing Pamina on the thirteenth, both in Vienna. Indeed, she was absent because she was, once again, angry at Richard Strauss.[83]

The composer probably did not know it yet. For while Vera Schwarz had been singled out, as Rethberg's successor in the lead role at Dresden, after that singer's departure for the Met in New York, he was confident he could secure Lehmann for Vienna by October, after Jeritza's departure for New York.[84] But then, in the middle of July, Strauss received a letter from Lehmann in which she took umbrage at his having ordained Jeritza as the only designated singer in the role of Helena, the notice of which had been in the newspapers. She would sing Helena only on condition that Strauss retract his remarks to Jeritza (that

Helena was written just for her) in public, "without having to twist any of her precious, golden-blond hairs." Because: "Should you really have made this astounding remark, then you should be neither pleased nor offended whether I sing or not. In that case, I probably would not have to assure you that I, too, would never be interested in this work. Even if I *wanted* to sing Helena, I would not do it." Lehmann went on to express her doubt that Strauss could have insulted "an artist like myself, whom you pretended to value and whom to value you certainly have cause, just to do another artist a favor."[85]

How was Strauss to emerge from this quandary? He countered by assuring her that he had never singled Jeritza out in this manner, although the phrase Lehmann accused him of was almost exactly the same one he had used in his letter to Jeritza of December 1927, and that was then repeated in the media. He would make a public denial, as soon as Lehmann sent him the offending newspaper clippings. Even though he once again flattered her on her magnificent representation of Christine and all her other Strauss characters, hoping that she would now set her mind on being a superb Helena, the singer sent him no clippings, pointing instead to the article that recounted Jeritza's words in *Neues Wiener Tagblatt* of May 26.[86] Against his better judgment, Strauss kept denying ever having harbored thoughts of favoring Jeritza, blamed duplicitous Hungarian reporters, and continued to urge Lehmann to sing.[87] This situation lasted into September, with Lehmann remaining completely silent, until on the eleventh she bombarded Strauss with yet another accusation, that he had said to others that one single motion by that woman, Jeritza, "was worth more than all the acting of the others combined." Adding insult to injury, Lehmann told Strauss that although she had begun to study Helena's role with Alwin, she would not allow herself to be pushed to hurry, for it was an extremely strenuous role and far from her own nature, one that she would have to conquer slowly. And for this she needed time.[88]

As it turned out, Lehmann would never sing Helena, which was obvious enough already in the fall, so that a very nervous Strauss finally did ask Schenker-Angerer to study it.[89] There were admonitions to Lehmann by friends of both that she really should do it, but she held fast, until Hofmannsthal informed Strauss in November that from what he had heard, Lehmann refused the role because of dangers to her voice.[90] The librettist modified his statement five days later by letting Strauss know that the real reason for Lehmann's refusal was not "a few high notes" but, rather, her "acrimony over Jeritza."[91] In the event, both reasons were fully valid.

In the years to follow, Strauss and Lehmann buried the hatchet sufficiently to adhere to an unwritten rule, knowing that it would benefit them both. Strauss knew by then – as the singer never failed to remind him – that there was no better interpreter of certain of his major operatic roles and all his lieder anywhere than Lotte Lehmann, and she in turn was well aware of those as the ideal media for her own continued success. Hence Strauss, for his part, insisted whenever he was able that none other than Lehmann should sing, and he also wanted to make sure that she was physically present in Vienna or elsewhere when he needed her. Undeterred, he was after her again to impersonate Helena as early as April 1929 (which she did not), but he also wanted her to resuscitate

FIGURE 6. From the left: Richard Strauss, Lotte Lehmann, Alfred Jerger, and Lothar Wallerstein in Salzburg, date unknown. Courtesy Special Collections, Davidson Library, UCSB.

the Dyer's Wife in *Die Frau ohne Schatten* (which she did).[92] Lehmann, on the other hand, made no secret of the fact that she was very fond of Strauss's music, that she liked the composer as a person and took pride in considering herself a "Strauss singer." Hence she would interpret his songs and arias whenever and wherever she could, including sound recordings, and she would continue to star in Strauss's operatic roles, especially the Marschallin, a part she was now reliably being identified with internationally.[93]

This pact of convenience worked well for both artists until the Salzburg Festival of 1932. That was the one time at this prestigious event when Lehmann had to present the Dyer's Wife opposite the person she now hated most, Viorica Ursuleac – her Empress. On one of the two days on which this was to happen, in August, both Richard and Pauline Strauss were in the audience, as if Lehmann were not already nervous enough. It is not exactly clear what the soprano did to cause one of those stinging remarks Frau Strauss was notorious for, but it most certainly had something to do with her appearance on stage or how her voice compared with the soaring, if arctic, instrument of her rival, or both. Whatever it was, Lehmann recalls, "I was in a state near collapse and felt incapable of going on. Weeping, I pulled off my wig and started getting out of my costume." She had to be consoled in her dressing room by Krauss, Strauss, and Wallerstein, who finally persuaded her to continue with the second act.[94]

For the summer of 1933, not quite a year after that, the world premiere of Strauss's newest opera, *Arabella*, was planned in Dresden. That Strauss was

working on this with Hofmannsthal had been made public as early as 1928; the librettist himself had died suddenly a year later.[95] It was agreed that Lehmann should sing the premiere and perhaps a few subsequent performances, but then be replaced by an alternate.[96] Sometime early in 1933, Reucker scheduled the day of the premiere for July 1, 1933, in his appointment book, with several July performances. Rehearsals were to begin on June 1.[97] But when these dates came around, Lehmann never appeared, and she never performed at the premiere. What had happened?

Apart from saying that she totally forgot,[98] Lehmann has given three different explanations for not showing up. One was her statement, already mentioned, that she gave the role back to Krauss out of spite and later lived to regret that, because he then employed his favorite, Ursuleac.[99] A second was that she was too exhausted from an already strenuous season and therefore declined, while keeping another appointment – to sing the Viennese premiere of *Arabella* in Vienna on October 21.[100] A third was that Strauss and Krauss had decided, if not actually conspired, to designate Ursuleac for the role from the very beginning, because she was very capable, the younger of the two singers, and, of course, a special friend of Krauss and, more recently, of Strauss.[101] With the exception of the first, there are kernels of truth in these explanations. However, the fact that Lehmann also said she had "forgotten" and, contrary to her 1936 New York interview, that she had always disliked that opera[102] strongly suggests that she was concealing the real reason why she avoided the Dresden performance.

What had occurred was that the Dresden *Arabella* world premiere had been thrown off in its planning by the capriciousness of regional Saxon Nazi leaders. For after Adolf Hitler had taken over power in Germany on January 30, 1933, several states of the federated republic reorganized themselves under National Socialist auspices, and this went on haphazardly and not without turbulence, sometimes for several months. In Saxony, there was a boorish Nazi Party chief, Martin Mutschmann, who meddled with the Opera, because he and his underlings did not approve of its world famous conductor and Strauss favorite, Fritz Busch. Busch was not a Nazi, but neither was he an anti-Nazi or a Jew, nor were most of his fellow artists and cultural administrators, as has sometimes been maintained.[103] That Busch and his family left Dresden as opponents to the Hitler regime was a legend fabricated after they had permanently emigrated, both by himself and by his wife, Grete, for they had to conceal a few unpleasant truths. Busch had been fired by the Mutschmann clique on March 7, on the pretext of previous irregularities and excessive leaves of absence (some of which charges were valid), but mainly because Mutschmann did not like him. Busch thereafter visited Hitler's lieutenant Hermann Göring, whom he had known socially long before that, and tried to get a new and more prestigious Opera job in Berlin. When this failed, he allowed himself to be sent by the Nazis on a cultural propaganda tour to South America, and only after his return to the Third Reich, when there were still no fleshpots, did he decide to settle abroad.[104] The man who fell by the wayside during these machinations was Dresden's *Generalintendant* Reucker, who was provisionally relieved of his duties in mid-March, before being permanently retired in September.[105] His

successor was Paul Adolph, a jurist acceptable to the new rulers but married to a Jew, which would keep him on the Nazi straight and narrow. With the dismissal of Busch and Reucker, to whom, as old friends of Strauss, the new opera score had been dedicated, and Adolph's new appointment, the Dresden premiere of *Arabella* was momentarily placed in limbo.[106]

But Strauss was optimistic. Until the end of March, he believed that the premiere could still be held in Dresden, on July 1 as planned, and with both men at the helm. He was also counting on the influence of Tietjen in Berlin, who was known as Reucker's friend and would doubtless be able to gain high-level Nazi support in overriding the rash decisions of the Saxon government. But whether Tietjen tried to intervene with his immediate superior, Göring, or even with Hitler is extremely doubtful; the German Führer, who had bigger things on his mind, refused to micromanage. In the worst possible case, Strauss thought, he would have to plan for a premiere later in the year, still under Busch's conductorship, but in a jurisdiction outside Dresden.[107]

Unlike Strauss, the new Acting Intendant Adolph felt no loyalty for Busch and only contempt for Reucker. He would have none of Strauss's plan to wrest the premiere away from Dresden, instisting on the Semper Oper's legal right and even issuing veiled threats.[108] By the end of March, it was becoming clear that a new conductor would have to be found for a premiere to be held in Dresden at the preordained time. The names bandied about were those of Erich Kleiber, who conveniently was on an official short list as Busch's possible successor, and Clemens Krauss, for whom Strauss had already been making political hay with Tietjen to conduct the opera in Berlin at a later time.[109]

By the middle of April, it had become clear that Kleiber would not be able to conduct *Arabella*, not least because he had conflicting tour obligations.[110] Adolph himself had no problem accepting Krauss as the second choice, for he could rely on Strauss's good judgment regarding Krauss's musical abilities.[111] By mid-May, rehearsals for the premiere were under way as planned and Krauss had been confirmed as conductor, even though Busch's official successor at the Semper Oper was to be neither Kleiber nor Krauss, but yet another Austrian, Karl Böhm.[112]

Lehmann knew that she was Strauss's dedicated Arabella by early March at the latest. It was a mixed blessing, for she was near the end of a strenuous season, and just when Busch was ousted she was suffering from pains in her windpipe. This did not augur well for a premiere under any circumstances, let alone singing a role that, as the Munich theater scholar Jens Malte Fischer asserts, "demanded a strong middle register and even stronger high range, a combination that was rare and mean" - but typically Straussian. Although she had been singing Strauss scores for years, Lehmann had been young enough to master such ranges, to say nothing of middle registers, but this new score with its abundance of high notes was already somewhat beyond her capabilities. How, then, was Lehmann going to accomplish this feat? For the time being she could not be certain until she had seen the entire score.[113]

Although the intendant had to refuse her demand for a larger fee than the conventions allowed, Lehmann was reassured by both Tietjen and Adolph that

Strauss's original casting of her as Arabella would be respected.[114] Strauss himself seems to have been oblivious to a possible vocal problem, for he wrote Lehmann on April 20 that "the Arabella part is situated very comfortably and should not strain you!" Lehmann seemingly concurred when she answered him that she was "heartily looking forward to fill with musical life" such a wonderful role as he had written.[115] But, hinting at financial stipulations, she let Adolph know that she would make her final decision to sing only after her deliberations with Strauss had been completed. At about this time, by the twenty-fifth of May, Strauss and Krauss had decided that Lehmann should sing the first four Arabella performances in Dresden and that thereafter Ursuleac would take over. And now Lehmann capitulated. As she wrote to a close friend, she had been getting very anxious, not knowing how to master the part until mid-June when she had to appear for rehearsals. On May 29, she sent a telegram to Strauss informing him that because of "serious nervous exhaustion" she had to cancel, but that she was hoping – as Strauss had earlier – that the premiere could be postponed until fall.[116]

This was not to be. On July 1, 1933, the first-ever performance of *Arabella* went ahead in Dresden, now with Ursuleac in the title role. Immediately, she became the ideal impersonator for both Strauss and Krauss.[117] At the premiere Ursuleac, already well known for her technically perfect if emotionally cold heights, acquitted herself to everyone's enthusiastic acclaim; the opera received over one hundred curtain calls. With *Arabella* she created a vehicle for herself that would not only make her famous in the Third Reich, as she now would be singing this role – and others – repeatedly under Tietjen in Berlin, but that also established her as Strauss's new *prima donna assoluta*.[118]

From all this it is clear that Lotte Lehmann had wanted to ward off a humiliation. She had had no intention of allowing herself to be compared, at a vulnerable point in her career, to one of her keenest rivals. For judging from how she must have felt about herself in May and June of 1933, it was certain that she would be put at a disadvantage in as difficult an opera as *Arabella*, should Ursuleac's act follow her own as closely as it was envisaged, all under the baton of the other diva's lover, Clemens Krauss.

The question then poses itself why Lehmann consented to sing Arabella at the Vienna premiere on October 21. The fact that she did is comprehensible only in the context of her emotional state after July 1, her contractual situation within the Vienna Staatsoper, and her personal and professional relationship with Richard Strauss.

The fact that she had canceled pushed Lehmann, already physically out of sorts, into a depression that lasted until late fall. She had to answer to friends who had made special arrangements to be at the premiere in Dresden on July 1 and could not understand why all of a sudden Lehmann would not sing. One of these was Gustav Brecher, who gave a hint that he understood the complicated relationships involving Strauss, Krauss, and especially Ursuleac.[119] Kapellmeister Robert Heger in Vienna, who had become her confidant, tried to cheer her up, at the same time reminding her that she herself had made the decision not to sing irreversible and that, all things considered, it had probably been the

right thing to do.[120] Lehmann even found it necessary to launch an official explanation in the international press to the effect that she had not been able to travel to Dresden because of border troubles due to strained Austro-German relations – an excuse that was trumped up.[121] She tried to explain how she felt to a friend in October, after she had sung the Vienna premiere: she had been forced to do it in order to save that performance, for no one else was available. What she really meant to say was that she had to save herself, her professional honor, and what was left of her relationship with Strauss.[122]

Despite the difficulty with the Arabella tessitura, Lehmann thought that she should sing the Vienna premiere, not least because she could do this most easily as part of her contractual obligations to the Staatsoper and, this was significant, because Ursuleac would not be present. As it turned out, Furtwängler had engaged Ursuleac to sing a Berlin premiere on the very same day, after he had vainly tried to get Lehmann – but in declining Lehmann had allowed him to believe she would oblige him some other time.[123] What Furtwängler's interest proved to her, however, was that despite missing Dresden she was still in demand elsewhere, even in a role that she herself was starting to have doubts about. Moreover, Furtwängler was important, for with her situation in Vienna under Krauss becoming increasingly critical, she could not afford to compromise her potential in Berlin.[124]

As far as Strauss was concerned, he sent her one of his typically charming letters in late July, in joyful anticipation of her Arabella performance on October 21. This proved to Lehmann that he bore her no grudge, while it might also have become crystal clear to her by that time that his favorite soprano was now called Ursuleac. That must have hurt, but being the disciplined Prussian she was, Lehmann proceeded with her Staatsoper engagement as planned, under Krauss's direction. It was a particularly bitter evening for her, because her mother had died only the day before. Despite all the preceding turmoil and the dangers with the sustained high notes, she came through extremely well, as the Vienna daily press later attested. One special and unexpected triumph for her was that Arturo Toscanini, whom she had never met before, was in the audience. According to one foreign critic, he "rose to his feet after the second act and applauded with hearty vigor."[125]

Lehmann sang Arabella five more times until the summer of 1934, but never after that and never in Berlin.[126] In the capital Ursuleac had ensconced herself with that role, sure of the public's and Strauss's full support; hence Lehmann could not risk a comparison.[127] Ursuleac did sing it for Hitler. But from Lehmann's repertoire the opera remained as distant as would Richard Strauss, its creator, in her circle of acquaintances during the remaining decades of her life. It was the end of a chapter – as if she had reached the edge of that highest plateau of accomplishment and now had to start her descent.

Professional Life and Private Affairs

The continuing travails at the Staatsoper, her increasing friction with Strauss, Krauss, and Ursuleac prompted Lotte Lehmann to turn her back on Vienna whenever she could, even more so than before, with greater monetary incentives

being the other prominent reason. On the European Continent, the most important venue for these exploits once again was Berlin, with England holding pride of place among foreign countries.

In Berlin, while Lehmann's collaboration with Bruno Walter deepened at the Städtische Oper, her presence there was threatened on account of the ill-seeded triangular relationship among Walter, *Generalintendant* Tietjen, and the Berlin authorities. Of the first two, it appeared that whenever either one did anything, the other reacted negatively, until the pair had a permanent falling out in 1929, while Berlin city officials looked on in disbelief. The causes for the mishaps lay with Walter, who had been promised an annual salary of 60,000 marks, but asked for another 25,000 to subsidize the cost of his apartment, where he lived with his wife, Else, and two daughters. This was, of course, on top of everything else he was earning, particularly during his annual sojourns in New York and London. When that postcontractual favor was granted, it was found that the members of his family were disturbing rehearsals in an auditorium that had never lent itself to good acoustics in the first place.[128] As had occurred until spring 1926, Walter was often away, leaving the rehearsal and even conducting business to lesser, younger men – wicked tongues maintained the younger and less experienced the better, allowing Walter to shine all the more during gala performances. To the detriment of the Opera, however, younger conductors such as Robert Denzler and Georg Sebastian were all too often critized by the press.[129] At one time, as the youthful Viennese impresario Rudolf Bing, then in Berlin, complained to Lotte Lehmann, a promising American singer was prevented from auditioning because *Generalmusikdirektor* Walter had chosen to be absent.[130] At another, Lehmann was supposed to sing Tosca (which, being unsuited to her, she refused) rather than Ariadne, which she wanted, because the Strauss opera had to be rehearsed especially with Walter, and he was not there.[131] By 1927 Walter was actually unhappy in Berlin, which certain critics managed to discern from the listless way in which he sometimes conducted the orchestra when he chose to be there, although they politely refrained from mentioning the reasons in their reviews.[132]

Those reasons had to do mostly with Tietjen. This overly ambitious Mephistophelian, who showed even more proficiency as intendant than as conductor, by late 1926 had agreed with Berlin city and Prussian state authorities to preside over a fusion of the successful Städtische Oper with the money-losing Staatsoper – a fusion he himself had evidently schemed for even while the hapless Staatsoper intendant Max von Schillings was being dismissed. When he had first aired his thoughts on the matter to Walter, the conductor was given to understand that under a joint directorship he would become the musical chief of both institutions. Walter was therefore dismayed when he was told in early 1927 that there was not yet to be a fusion, but that Tietjen would assume the artistic and business direction of the Staatsoper along with that of the municipal Opera. Naturally, Walter now wanted to conduct in the Staatsoper as well, but among city officials as much as with Tietjen, his plea fell on deaf ears.[133]

The Städtische Oper had been organized around the principle of combining a very few permanent singers with an ever-changing star cast that had to be continuously renewed – among which was Lotte Lehmann. Because this made

stylistic as well as repertory continuity well-nigh impossible – to say nothing of the underlying economics – it was a most unsettling situation for audiences, critics, and the Berlin cultural bureaucracy alike.[134] Walter had attracted a few good new singers from other stages, among them Maria Ivogün, Maria Müller, and Jarmila Novotná, and now Tietjen was trying to hire them away for his Staatsoper. Lehmann was, potentially, in a similar situation.[135]

In early summer of 1927 relations between Tietjen and Walter reached a first nadir. Walter wrote Tietjen that he had been duped after the *Generalintendant* had been offered the Prussian Staatsoper, because he himself had not been allowed to follow him there. Walter felt that his "artistic and personal integrity" was at risk and that he had nothing to look forward to but a dark future.[136] In a conciliatory letter, Tietjen tried to mollify his colleague, reminding him that much that he, Walter, had done over the past two years had also not been "above board."[137] The city bosses watched this altercation with alarm but also bemusement, because they knew that the slippery Tietjen was being attacked from other corners of the Städtische Oper and that from all of those spats he had always walked away victorious, and "with a self-effacing smile."[138] Walter now reached for a last straw by asking Tietjen to replace his deputy, who was anathema to the conductor, with Klaus Pringsheim, a dramaturg and conductor who was the brother-in-law of Walter's close friend Thomas Mann.[139] This Tietjen would not comply with, so that Walter threatened to depart. But as far as a permanent position was concerned, Walter had nowhere to go, so he could not afford to burn his bridges yet. In September, his wife, Else, assured Lehmann that all was not yet lost: "Tietjen would like to get him the stars from the skies, in order to assuage him; he constantly swears that *he* would rather go than have Berlin lose Walter."[140]

Knowing Tietjen as much as one could, such a scenario was highly unlikely. In any event, Walter had to stick it out in the capital until the spring of 1929. For he could neither move to the Vienna Staatsoper, nor could he succeed Furtwängler as director of the Gewandhaus-Orchester in Leipzig – at least not until the fall of that year. And he did not leave Berlin without having attempted, belatedly, to get an extension of his four-year contract from the city government, which was not forthcoming on the overgenerous terms he had asked for. In April 1929, Walter's final opera performance at the Städtische Oper was *Fidelio*.[141]

Walter's difficult situation in Berlin, if not Tietjen's, was compounded by worsening conditions for both theater and concert in the capital; critics spoke of a permanent crisis. At the root of it all was that great cultural ambitions were stifled by a fundamental lack of money, even in the more affluent years of the Weimar Republic between 1924 and 1929. Berlin was home to a third Opera, the Kroll, formerly a privately operated operetta stage, which had been taken over by the Prussian state in 1924 and by 1927 had as its director Otto Klemperer, who embarked on a more modern repertoire. Hence even before the economic depression hit hard in autumn of 1929, three Operas were competing for the same audience. This Prussia could not afford, not to mention Berlin, so that in 1931 the Kroll was closed and Klemperer provisionally shifted to the Staatsoper, under Tietjen's leadership. Not only that, but there were two ailing orchestras, the Symphony and the more prominent Philharmonic, which by fall

1932 had been fused; but until Hitler's political takeover in 1933 the single, newly organized Philharmonic, even under Furtwängler, survived only with great difficulty.[142]

It was in this precarious economic and cultural environment that by mid-1926 Lotte Lehmann was attempting to continue her collaboration with Walter and, to a lesser extent, Tietjen and Furtwängler, with a possible view to resettling in the German capital, should matters in Vienna become intolerable. Because she knew about the tension between Walter and Tietjen (as she had known about that between Schalk and Strauss), she had to maneuver carefully so as not to be crushed between the two of them, or between the Städtische Oper and the Staatsoper. Her original loyalties were with Walter, of course, and she wished to continue to participate in the relative success of the municipal Opera under his distinguished guidance. However, she was also aware that he was a candidate to become Schalk's successor in Vienna, which on the one hand, would have benefitted her home position, while on the other, she was waiting, like the Prussian municipal governors for a commitment from him to extend his Berlin contract beyond the spring of 1929.[143] Walter's hedging on that, together with his failure in Vienna, made her very nervous.

Hence she decided, through the intervention of Louise Wolff of the renowned Berlin concert agency Hermann Wolff und Jules Sachs, who revered her unconditionally, to explore further opportunities at the Prussian Staatsoper, as soon as it was clear that Tietjen would be in charge there.[144] At the same time, she concluded a permanent guest agreement with Tietjen for the municipal Opera by the middle of 1927, which was to run for three years. Meanwhile, the cognoscenti in Berlin were spreading a rumor that La Lehmann was about to move to the German capital, which was not unreasonable speculation, since her three-year guest contract could always be made permanent. In Vienna too during this period, people in the know were aware not only of Lehmann's star status but also, despite the institutional malaise, of the rich opportunities that the variegated operatic scene in Berlin currently represented over those in Vienna. By early 1928, as her regular Vienna contract was up for renewal, Lehmann was maintaining good relations not only with both Walter and Tietjen, but also with the Wolff–Sachs agency and the up-and-coming impresario Bing, who in his cocksure manner seemed to know everything that was going on in Berlin.[145]

A year later Lehmann was becoming more anxious, because, whereas she had a new Vienna contract, her friend Schalk's days were clearly numbered and she did not like Walter's rumblings about wanting to leave Berlin. Her three-year contract with Tietjen was for the Städtische Oper, not the Staatsoper; if Walter left the former, her own prospects would be uncertain there. Hence she tried in the spring of 1929 to get out of her municipal Opera commitment, but Tietjen would not realease her. In March she wrote to "Professor Walter" that after having watched the Berlin "war theater" with great interest, it had become clear to her that should he leave the Städtische Oper, "I do not wish to sing there any more." Walter, who at that time was on what was probably a well-deserved sick leave, responded to her in April, saying that he could do nothing for her and that, hinting at a switch to the Staatsoper, she would have to rely on the goodwill of Heinz Tietjen.[146] By the fall of that year Lehmann

had stopped working at the Städtische Oper, as had her new mentor Walter. At the same time, she was making another pitch with Tietjen to allow her to honor the balance of her Berlin contract, with one more year to go, at the Staatsoper, where he was now fully in charge.[147]

Tietjen appears to have heeded the singer's wish by the middle of 1932, when Lehmann was scheduled to begin starring at the Staatsoper, as Sieglinde, Ariadne, Marschallin, and Eva. She began her engagement on June 23, when she impersonated *Die Walküre*'s Sieglinde under conductor Leo Blech, and ended it on October 25 with *Die Meistersinger*'s Eva, under Furtwängler.[148] These were six performances that, by the terms of her three-year Berlin contract, she had owed the municipal Opera until summer 1930. But in this way, two birds were killed with one stone, as she herself maintained a visible presence in Berlin, just in case her position should become untenable in Vienna, and Tietjen enjoyed the benefit of that soprano's high art in the Staatsoper.[149] Two of those performances were favorite roles: Sieglinde and the Marschallin. Under Tietjen's artistic and Walter's musical direction at the Städtische Oper earlier, she had not been accommodated that happily, because of the logistic difficulties that were often tied to Walter's irregularities. Thus she had performed in several parts that were not necessarily to her liking, D'Albert's Myrtocle, Tchaikovsky's Lisa, and Puccini's Turandot among them.[150] At that time, critics had generally praised her voice, but had faulted her acting. For example, although Walter had given her some advice on how to portray the cruel Chinese Princess Turandot, who dispatches suitors to their deaths as easily as she utters riddles, Lehmann had not been convincing in that role. According to reviewers, the coldness of her Turandot had been so artificially strong that it had formed an unnatural contrast to the womanly warmth – Turandot's rarely displayed other side – that Lehmann always radiated so naturally.[151] When she had sung and acted Verdi's Desdemona in early January of 1929, Lehmann had been found too old for that youthful role.[152] Leonore/Fidelio, moreover, on whose impersonation she always prided herself, had also not been quite right, as critics thought that the Fidelio male side of Leonore's persona had been unduly submerged by the genuinely feminine elements of Florestan's wife.[153]

Lehmann's Berlin performances of 1932 were, on the whole, better received, which also had much to do with the fact that under Tietjen's aegis at the Staatsoper there was now not just one superior conductor, as Walter had been at the munipical Opera, but at least four, namely, Blech, Kleiber, Klemperer, and Furtwängler. Lehmann sang her *Meistersinger* role under Furwängler as her parting gift in October, and although Herbert F. Preyser of the *New York Times* reported that she was a "maturely stolid Eva, who projected acidulous tones that often warred disastrously with the pitch," German critics were much kinder. Friedrich Deutsch spoke of the "ideal-sound of Lotte Lehmann," and others mentioned that her voice was "free and great" and, alluding to her *Innigkeit*, that her entire Eva was "so humanly warm, in song and play so equally mature and moving."[154] Erich Simon, Louise Wolff's partner in that vaunted agency, wrote to the Metropolitan Opera's Edward Ziegler about Furtwängler's new conception of *Die Meistersinger*, under Tietjen's artistic direction, as "beyond any praise," singling out Lehmann.[155] The soprano

enjoyed working with Tietjen and Furtwängler; she had joined the great conductor earlier (as she had already in 1927) in a concert recital of works by Hermann Goetz and Strauss.[156]

Next to Berlin, London turned out to be Lehmann's most important performance stage, apart from Vienna itself. The reason was that it signified the soprano's entrance on the international scene, for appearances in London facilitated similar ones in Paris and, eventually, the United States. London's had been her first venture abroad. After her initial success at Covent Garden in spring 1924 and 1925, Lehmann continued to appear there every spring and at other times during subsequent calendar years. Special concerts were scheduled for her, usually in prestigious Albert Hall or Queen's Hall and often with Bruno Walter at the piano, for he was also in charge of the Covent Garden affairs and Lehmann's name was already artistically linked with his. In opera, she sang her usual best roles, led by the Marschallin, to ever-greater acclaim: in 1927, a young Walter Legge, who later would marry another Marschallin, Elisabeth Schwarzkopf, noted her as superb in any role she presented. "Lehmann's Sieglinde... perfect, a finer performance is beyond imagination," he observed during May, and "Lehmann surprised me by her exquisite art. I do not hope to hear a finer Desdemona. I cannot even imagine one."[157] In the 1930s, the critic Neville Cardus echoed Legge when she sang Sieglinde, "with vocal and visual appeal and mastery not equalled," so he thought, "before and since."[158]

A number of novel difficulties surfaced as Lehmann continued singing in London. One was that Walter's habitual proximity to her there meant that he tended to be too expensive as an accompanist in the long run (even though he was not popular with all British critics), and whereas Lehmann did not have to make any decisions regarding his replacement with an English native pianist, she was placed in a musically uncertain situation, apart from not wanting to offend her mentor.[159] Another difficulty arose from logistics, for she ran the danger of having to be idle for too long between performances, without substitute events nearby, such as radio engagements or even some in Amsterdam or Paris, and this was expensive and incommodious.[160] A third problem resulted from her income tax situation as a foreign artist. As she was always keen to earn the highest possible amounts, she did not wish the British government to deduct taxes.[161] Other difficulties paled by comparison, such as those arising from the nationwide general strike in 1926, which impeded Opera patrons (who turned out regardless, if not festively attired), and the near-cancellation of the Opera season in 1932 because of depression-related financial shortages – though the regular German events were then replaced by a special Wagner festival, at which not Bruno Walter, but Vienna's more affordable Robert Heger conducted.[162]

In 1932, the economic depression also affected the Salzburg Festival, where Lehmann had sung every summer since 1926. The Festival suffered even more than the Vienna Opera from the 1931 German border fee of 100 marks, which tended to keep German patrons out; this problem multiplied many times with Hitler's outrageous tariff in 1933. At that time, Austrians – and many foreigners – conceived Salzburg as an antipode to the Bayreuth Festival, dedicated to the anti-Semitic Richard Wagner, which Hitler was placing under his own patronage.[163]

The Salzburg Festival, which institutionally was somehow an extension of the Vienna Opera, interested Lehmann as a showcase because she usually was able to star there in two of her signature roles: the Marschallin and Fidelio.[164] But what she must have found problematic was that her favorite conductors did not always work for her there; Schalk died in 1931, and Strauss usually allowed Clemens Krauss to take his place. Krauss to her was anathema, especially when his lady friend Ursuleac was present as well, and no two days could have been worse for Lehmann than those on which she had to sing the Dyer's Wife opposite Ursuleac's Empress in *Die Frau ohne Schatten*, August 19 and 26 in 1932. Lehmann no doubt would have liked to perform at Salzburg under Walter, but had to make do with him as piano accompanist, as she was presenting lieder in August of 1933, which were well received.[165] Lehmann's banner year at the Festival was 1929, when the critics simply could not praise her enough. She was described as "the most significant artistic personality of the Festival ensemble"; another reviewer assured his readers that by now she had surpassed her famous namesake Lilli Lehmann. Her Fidelio was thought to be inimitable.[166]

Because of her obligations in Vienna, Berlin, London, and Salzburg since 1925, but also because she was beginning to perform in the United States by 1930, Lehmann did not have as much time for other stages of the German-speaking realm as she might have liked. Instead, she was touring the cultural capitals of Europe, from Monte Carlo to Rome, Brussels, and Amsterdam. Within Austria, she might visit Graz or perhaps Innsbruck; in Germany, she still tried to be in places like Cologne, Breslau, Munich, and Leipzig.[167] Hamburg's music lovers, to be sure, rued the relative infrequency of her appearances, for she returned there only about once a year, and had it not been their Stadttheater that had served as her platform to fame?[168]

New possibilities were opening up for her in Paris, however. In spring 1927, Heinz Friedlaender, the young Viennese secretary of pianist Alexander Brailovsky, was establishing himself as an agent for artists like Lehmann in Paris; he was about to sign on Piccaver and Schumann. He promised Lehmann engagements for concerts and, eventually, opera, but the soprano hesitated, because his pecuniary prospects were modest. Besides, she had to wait until Schalk had taken the Vienna Staatsoper on its official Paris visit in May of 1928. In principle, Lehmann was interested because Friedlaender also offered her private recitals, so-called at-homes, in Paris at feudal soirées, such as in the palaces of the Barons Rothschild, but also events in other western and northern European countries she had not yet been to.[169] After Lehmann had had her phenomonal success with the visiting Staatsoper ensemble and become famous in Paris virtually overnight, Friedlaender, in conjunction with the Austrian Ambassador Alfred Grünberger, began to make regular, lucrative arrangements for her. On June 29, the soprano gave a *récital de chant* at the home of Baron Eugen Rothschild, during which she sang her favorites from Strauss, Wagner, and Schubert.[170] Thereafter, Friedlaender brokered more guest performances, in Paris and other western European cities, for honoraria that Lehmann always found at first too low but then was able to increase after she threatened not to appear.[171] On January 23, 1929, she created a sensation when she sang Elsa in German – a first after World War I – while the other singers performed in French.

The Paris critic Emile Vuillermoz commented in *Excelsior*: "La Lehmann represents the really great style and great tradition – and her powerful voice fills everything she sings with a new and individualistic attraction."[172]

At a lieder recital later in the year the French politicans Briand, Painlevé, and Herriot were in attendance; Marshal Petain listened to it from a radio studio.[173] The climax of Lehmann's musical series in Paris occurred when in late March 1931 she was awarded membership in the French Legion of Honor. She was the first foreign female, and only the eighth woman overall, to receive it.[174]

As Lehmann was being invited to recital halls and opera stages all over musical Europe, her relationship to agents and some theater intendants became more complicated, to the same degree that she was increasing her earnings. In her halcyon months, around 1928, before the Great Depression lowered wages everywhere, she was charging a maximum of 600 dollars per evening, or the European-currency equivalent, with recitals generally paying more than operatic guest performances. Usually, as in the British case, she insisted that this be a net amount, meaning that her hosts had to pay the income tax, and she also expected, as was customary, reimbursement for first-class travel expenses and, where applicable, the services of an accompanist. She herself had to bear the extra costs of a maid (where needed), meals, and hotel accommodations.

In her old age, the diva made two contradictory statements, both in 1967. On the one hand, she claimed that she was "far from being a business woman." On the other, she asserted that she knew her worth and had always had her "feet on the ground when I made a contract." For the period of the late 1920s and early 1930s, the latter statement came closer to the truth, and it also belied something else she maintained in old age, that now everything was "business" and that the "idealism" of earlier days was dead.[175]

Certainly, when she was wheeling and dealing in Europe before she agreed to a guest performance, the only idealism she knew was the one that served her interests best. From her innocent beginnings even in Vienna, and having been hardened by several contract negotiations with the likes of Schalk and Tietjen, Lehmann had developed the savvy of a Hamburg fishmonger when it came to making a deal. It began with the currency. Whereas in Austria she sang for schillings, in Germany for marks, in Britain for pounds sterling, and in France for French francs, she asked for dollars in the uncertain Balkans but accepted Czech kronen from Prag, because that republic in the interwar years had a stable currency. She was becoming more expensive annually, she wrote without false modesty in June 1926 to her Viennese agent, at a time when there was no inflation, because she was getting better by the year. A year later, during negotiations with Hamburg, this was still her maxim.[176] Her agents might not have cared, had they been able to get her committed to fees that other top-level performers also commanded, but she often wanted more. A case in point was Budapest, where in July 1927 she was offered an engagement at the People's Opera rather than the Royal Opera, because the latter could not meet her demand of 500 dollars per evening. When she was told by her agent that Piccaver, Chaliapin, and Titta Ruffo also sang there for such amounts, she immediately asked for 600.[177] Her agents were always living in mortal fear that she would ask so much as to

price herself out of the market, and hence they constantly beseeched her to use reason and coldly view the realities. She was usually open to arguments that she was getting more than other famous colleagues, but less so to explanations that a certain place, especially a smaller one, just could not afford to pay any more but was doing its very best.[178] Hence she missed singing in Darmstadt and Wiesbaden altogether, although those two German towns had fine orchestras and stages and excellent musical traditions.[179] When she turned down a generously endowed date with the Concertgebouw Orchestra in Amsterdam in 1929, her French agent Friedlaender was livid, because, as he pointed out to her, famous conductors like Klemperer, Furtwängler and Walter appeared there regularly every year for publicity reasons alone, ignoring fees.[180] Friedlaender was also afraid that she would decline to sing for French Radio for 10,000 francs, even though her friend Schumann had recently worked there for the highest-paid amount thus far, 6,000 francs, a sum Madame Lehmann would not even get out of bed for.[181]

Lehmann's relations with her commercial agencies were particularly fraught because of her unwillingness to communicate with them or, when deigning to do so, only on her terms. She employed about six agents by the turn of the decade: one each in Vienna, London, Paris, and Hamburg, and two in Berlin, including Bing. She used them as she saw fit, not having an exclusive arrangement with any of them, except for the British Isles and early in the 1930s with Friedlaender.[182] Why she kept them waiting, often for months, before answering urgent letters is not entirely clear; her usual excuse that she had no time is hardly valid, since she herself was fond of writing letters and did so aplenty, if in bursts. She also composed prose or poetry for pleasure and by the late 1920s was in the process of preparing a novel as well as her autobiography, both to be published in 1937.[183] Besides, she had a husband serving as private secretary, helping with lawyers and handling her mail. Why, save for telegrams, she could not have dictated her correspondence to him remains unfathomable; instead, she typed business letters herself and often drafted telegrams. Obviously, she could have sent many more of those to her agents than she did, just to keep them at peace, so did she deliberately want them to be clueless, the better to manipulate them?

It is possible that she did not answer mail as a result of a faulty upbringing and bad manners. But since the Lehmanns were, one and all, very proper Prussians, this must be discounted. Instead, it is much more likely that she juggled several requests from different agents in order to settle for the best opportunity to sing, which in her case invariably meant the most money, but her keeping them at bay for unreasonable lengths of time left them disgrunteld. The tone of their letters suggests that the ultimate reason they kept up even a semblance of politeness was that she was already too famous and they did not wish to lose her business. In 1926 alone, Lehmann kept the most prestigious agency in the country, Berlin's Wolff und Sachs, unduly in the dark several times. In March of 1927, the firm's senior partner had had enough and wrote her: "We note with extreme regret and, at the same time, are at a loss as to why you are paying absolutely no attention to all our letters and any of our requests for answers."[184]

Rudolf Bing, who as head of the Metropolitan Opera after 1950 has often been described as excessively cold and arrogant,[185] actually had a very charming

side and a wicked sense of humor, and when he was Lehmann's second agent in Berlin he used both wit and chutzpah with her in order to make her respond. But she also left him without answers – in 1927, for instance, when he wanted to schedule two recitals for her in Saxon Chemnitz, albeit for less than the 2,000 marks she then customarily demanded. She waited for a full six months before she definitely let him know that she was not interested.[186] Also in 1927, she was reminded by her Vienna agent, Arthur Hohenberg, that she had ignored him for two years before making a decision about concertizing in Zagreb. Although the fees were below her standard, she was to be treated "like a real queen in the realm of art."[187] Some of the delays became embarrassing and could even have placed those impresarios in a legally sensitive spot, as almost happened 1928 in Hanover, after a verbal half-commitment by Lehmann, which she would then neither confirm nor cancel.[188]

On several occasions Lehmann thought nothing of risking her relationship of trust, let alone personal sympathies, with her impresarios in Vienna, Berlin, or Paris, because she put greed before decency. Those cases revolved around her attempts either to delay or withhold the commission of 10 percent that was owing to those men by contract or convention, or to get out of previous arrangements for concert dates, because she had found something more attractive. Hence in June 1926 Bing declared that he would forego his commission only so that Lehmann would honor a recital commitment in Dresden; her idea had been, as it was with the personal income tax, that for that the concert organizers should be charged extra.[189] "Why don't you allow us to make a living, too!" Bing cried three months later, when he suspected that the singer was trying to bypass him in arranging an appearance in Hamburg.[190] Erich Simon of Wolff und Sachs became incensed after Lehmann had single-handedly agreed to a concert date in Bremen for which he had been providing all the leads, and in the end was ignored.[191] "It is an unbearable feeling for us to be cut out of the action, as the reward for all we have done," complained Jules Sachs, Simon's other partner.[192] In April 1928, Simon mustered sufficient courage to remind Lehmann once and for all that "by law it is the artist who has to pay the commission, not the company engaged in the hiring," and, later: "you could not possibly want that my firm should work for free."[193]

In 1928 and 1929 Lehmann got into serious trouble because she refused to sing in Bucharest and Zagreb, even though contractual agreements between her Vienna impresario Hohenberg and those stages were in place and she and Krause had given binding verbal consents, which neither of them could deny. The Romanians threatened to sue, which was averted only through Hohenberg's intervention.[194] He seemed ready to break off his dealings with Lehmann himself when he informed her in June 1929 that through groundless accusations and neglect she had "grievously offended" him.[195] And in Hamburg, too, the Stadttheater of all places almost found itself in the absurd position of having to take Lehmann to court, because she did not want to keep concert dates arranged months earlier.[196] Meanwhile, Lehmann had given a performance in Holland after once again bypassing her Paris agent Friedlaender.[197]

It may seem irreverent to fault a singer for her relations with her impresarios, a singer whose voice at the time was generally described as a model for all others

and who was even said to be superior to her namesake Lilli and the divine Australian, Dame Nellie Melba.[198] But these details must be pointed out for the sake of a fuller picture, if only to dispute Lehmann's frequently repeated claim that in her overall bearing she never resembled a prima donna. She certainly acted like one when it was to her advantage, even though she eschewed the paraphernalia of a famous singer's professional existence indulged by a show business type like Jeritza: flashy displays, provocative speech in public, titled companions, or the advertisement of material wealth. The differences between them were more of temperament than of human motivation; they were differences of means, not intent. Whereas Lehmann practiced understatement, the Moravian flaunted her goods. Nature had given Lehmann nothing to flash about physically; she honed a public image as that of an honest, soulful ingénue even in her early forties and preferred to keep any existing riches hidden from the people's view.

Until the onset of mature age and the beginnings of wear and tear in the first half of the 1930s, Lehmann, from 1925 on, benefitted from a great improvement in singing technique perceived by most critics. That she sometimes forced her voice and had problems at great heights did not go unnoticed (other sopranos had even more); rarely did she stray from pitch.[199] Her breath control had improved markedly, and occasional lapses were seldom criticized.[200] More serious was her enduring tendency to allow her emotions to overpower her, so that a surfeit of feeling caused her to sing too loudly. This was a problem especially with lieder.[201] "The reviews are all wonderful," she observed once, "but they all say that I often allow myself to be overwhelmed by my temperament and overdramatize. This could well be."[202] During lieder recitals, her dramatic persona as an opera star tended to submerge the lyricism required by the *Kunstlieder* of Schubert, Schumann, or Wolf.[203] Yet another criticism was that she still liked to choose composers who counted little on the scale of renown, such as Robert Franz and Adolf Jensen.[204] Today, one senses nothing of these irregularities, not to mention faults, as one listens to reissues of earlier recordings, such as the CD *Lebendige Vergangenheit*, which features her singing arias from Mozart to Korngold, 1927 to 1932.[205]

By 1927 Lehmann had started to become obsessed with singing the role of Wagner's Isolde, in order to test her vocal limits, but also because she was fascinated with the emotions inherent in that character. That part is one of the most challenging. As Helen Traubel, who has sung it at the Metropolitan, has explained: "The vocal demands are so tremendous that Wagner himself had more than fifty rehearsals before he could launch it and at one time actually thought of two sopranos – dramatic and lyric – to conquer the portrayal. A dramatic voice in that sense is one that is powerful and stunning, capable of long bravura passages, full of drive and sustained tone; a lyric soprano is lighter, capable of more vocal gymnastics. Isolde had to be both." Lehmann could handle the lyric side, but the dramatic, which called for accentuated high notes and "terrific stamina," was difficult to master.[206] In the sustained dramatic parts, which had to be held with full force against a strong orchestra, her voice could be irreparably damaged. It was therefore a dangerous obsession, which she had to manage with the help of her musical advisors. Schalk and Walter half encouraged her and half constrained her, for they both longed to hear her

in that role and yet feared for her vocal cords, and in 1927 and 1928 there were plans by both conductors to accompany her on stage with their orchestras.[207]

But from then on the whole thing turned into a never-ending story of procrastination, and it demonstrated not necessarily Lehmann's physical limitations but, rather, her psychological inhibitions. At the end of the 1920s, the singer herself did not contradict any rumors that she was studying Isolde's score. Knowledgeable critics thought that because she had recently mastered Fidelio, the next logical step for her would be to impersonate the doomed Tristan's doomed lover.[208] When in October of 1928 Strauss, who wanted her badly as his repertory Helen, received word about it, he wrote to a friend: "What a pity, this wonderful singer will ruin herself with parts like that of Isolde."[209] Schalk still had not committed himself, so that in March 1929 Lehmann informed him that "for Isolde, the one I am pining for, I shall take plenty, plenty of time."[210] However, Lehmann would surely have failed at Isolde, because for the few yet important high notes, which in the first and second acts would have to soar above the orchestra, she had neither enough power nor security.[211]

At the end of 1929 she spread word that she would sing Isolde, soon, in a new production under Clemens Krauss.[212] Was her ambition stirred because she so wanted to show it to the younger maestro? There can be no doubt that this personal obsession, apart from being blindly self-propelling, became an added catalyst in her embittered relationship with the equally ambitious conductor. Stubborn as she was, by 1931 she had put Isolde's famous "Liebestod" on record.[213] Obviously, she knew the entire score by then. In July 1932, she informed Krauss that he should schedule rehearsals with her for the fall, so that she might possibly perform by the next April. But come October, she contrarily announced that she would sing the role in April with Brecher in Leipzig, while putting Krauss off until the summer, for the Salzburg Festival.[214] Krauss, already skeptical, told her to just keep studying.[215]

By then she knew she was losing that battle. After singing "Liebestod" in a concert in Rome in March of 1933, she confided to Emmy Putlitz that she had postponed the project. "I still do not find the right courage, I still have the feeling that it would be better to wait. Perhaps next year."[216] In July, she wondered aloud to Walter whether she would ever be able to fulfill her dream.[217] "I just cannot decide to do it," she confessed publicly in November, "'Isolde' is my perennial dream, it is my artistic ideal, it is my life."[218] Around that time the critics, some of whom were judging by her recorded "Liebestod," were making bets that if she ever were to sing the part, it would come from a beautiful voice such as had never been heard before.[219]

Lehmann's conscientious struggle to maintain her voice – which eventually she would do for much longer than most of her contemporaries – and to meet difficult challenges such as singing the part of Isolde defined her as an artist of true integrity, beyond any of the prima donna airs that were the stock-in-trade of all prominent members of the theater. And whereas she shared those airs with Jeritza in certain of their social and professional relationships, she had progressed beyond the erstwhile superior diva in other important respects. In comparing the two sopranos, Vienna critics and the general public alike were discovering more value in Lehmann, and more superficiality in Jeritza, even

though many loved, in perfect balance, the former's soulful virtuosity in singing as much as the latter's witchlike mastery of histrionics.[220] Both always had had their own camps as well as mutual admirers, but what was starting to take Jeritza down after 1921 was that she stayed too long in America and always returned with typically loud American attitudes, upsetting the Viennese's more refined store of values. Moreover, Jeritza continued to rely on her dramatic Tosca routine, meaning that she tried literally to throw herself down on the floor not only when Puccini's Scarpia was pursuing her, but in other operas as well. The effect of that was wearing off.[221] The quintessential woman, mused Schalk in 1930, Jeritza had perhaps been once – say, twenty-five years ago – and had she worked on her personality, she might have made something of it.[222]

There is no denying that more often than not when she performed, the Viennese press gave Jeritza excellent reviews, especially for roles, intimately her own, that she could turn to perfection, such as Salome and Turandot.[223] But neither is there doubt that Jeritza sought to catch publicity in situations that had nothing to do with opera, whether she sounded off about future vacations, a clumsy impostor of a relative she encountered, or lawyers attempting to confiscate her jewelry.[224] The brilliant music author Ernst Decsey wrote her biography in 1931, so favorably that it seemed he had been bought.[225] Later salacious gossip harmed rather than helped her, when it was reported that she had married the U.S. film producer Winfield Sheehan before her Arizona divorce from Baron Popper had become legally binding.[226]

If Jeritza was on her way out in the United States as the end of the 1920s was approaching, she was hardly faring better in Europe. Telltale signs that her great powers were waning were her Covent Garden performance of June 1926, the way she left her erstwhile friend Korngold in the lurch before the Vienna premiere of *Heliane* in October of 1927, and how shabbily she was treated in Paris in May 1928. In London, she underwhelmed the audience as Sieglinde, opposite a young Lauritz Melchior, who as Siegmund did not throw her to the floor as she wanted, thus making yet another enemy of a tenor, as she had done with Piccaver in Vienna and Beniamino Gigli in New York.[227] In Paris, she did not receive any official honors (hence threatening Strauss that she would retreat from his *Helena*), because contrary to some Vienna newspapers, her performance had been wanting, as both agent Friedlaender and Else Walter assured a gleeful Lehmann.[228] Weeks before Paris she had been in Copenhagen – another musical fiasco, which would forever prevent her return there, even though she was received by royalty.[229] Was it any wonder that by the early 1930s a hapless Jeritza returned to her artistic beginnings, namely operetta? After 1933 she also increased her presence in Viennese music films.[230]

Irrespective of artistic merit, it is certain that during this period Jeritza was still earning much more money than Lehmann, by virtue of her American income alone. But apart from that, the years from 1926 to 1934 yielded to Lehmann the highest income ever. Still, as she earned much, so too would she spend much, so that by the time she had to settle in the United States she had few portable European assets and was dependent almost entirely on what she could earn in the New World.

It is impossible to give a comprehensive accounting of Lehmann's wealth, if only because she herself was unable to keep proper records. All one can do is go by contractual wage figures and singular payments, compared to common costs and spot prices, all of which suggest that she must have been rich, at least on paper. For instance, in 1928, by her new contract, she was to receive a fee of 1,800 schillings per month plus 1,500 for each performance, before taxes, and she had just bought a black Chinese silk scarf for 27 schillings and a pink felt hat for 59 schillings – a mere pittance from those earnings.[231] At that time, standees paid three schillings to hear her sing at the Staatsoper, and at the Salzburg Festival, where in summer 1928 she sang Fidelio, tickets for that event ranged from ten schillings for the cheapest seat to fifty schillings for the first row.[232] By comparison, she was collecting 1,000 schillings for an evening of arias at Austrian Radio in October 1927.[233] From Germany in 1927 and 1928 (as in other years), she was receiving varying payments for her recording work with Odeon in Berlin – for example, 454.20 marks for January–March 1926, and 1,100.40 marks for July–September. With the mark then yielding not quite two schillings, she was making approximately 2,900 schillings on that contract for a half-year's earnings.[234] If she had spent 1,100 marks in Germany, she could have stayed many nights at the hotel from her childhood, Deutscher Kaiser in Perleberg, where the daily room rate was then 2.50 marks, with 1.25 marks charged extra for breakfast. The Continental Hotel in Berlin, where she actually did book, charged her a room rate of 25 marks, with an à-la-carte dinner costing her anywhere from 13.25 to 30 marks and a sweet liqueur 2.60.[235] A skilled worker in Berlin's transportation industry at that time was earning a weekly gross wage of 51 marks and 10 pfennigs, out of which he had to pay 44 pfennigs for a rye bread, and 2.20 for a kilogram of beef stew.[236] Then again, at a resort hotel in Berg, south of Munich, the prices were lower for Lehmann, if not as low as Perleberg's: she was charged 10.50 marks per day for room and board, with 7 marks for simpler accommodations for her maid. Lehmann could even bring her two favorite lap dogs.[237] In 1932, when the depression had deflated prices, the singer was offered 550 marks per performance at the Berlin Staatsoper, while she made 8,000 dollars (ca. 57,000 schillings or 24,000 marks) from an operatic tour of Chicago and Boston alone. In that year, a senior postal worker in the capital was paid 89.9 pfennigs an hour, having to shell out 36 pfennigs for rye bread plus 1.40 marks per kilogram of pork. All the while, physicians were grossing just under 10,000 marks per year on average, not much by the standards of the opera singer, who was veritably thriving during this period of unemployment and reduced pay.[238]

Nevertheless, the more money Lotte Lehmann earned, the less she had, and this for good reasons. As before, she continued to be extremely generous with others. Although her father had died in January 1925 and thus ceased to be a financial liability, and brother Fritz had become wealthy through his wife, her mother was still completely dependent on her, especially as she needed expensive medications and doctors, until her death in October 1933. Marie Lehmann lived in the singer's villa in Hinterbrühl or in a specially rented city apartment not far from her daughter's, unless she was visiting with Fritz, who would then look after her, in Westerland. Moreover, Lehmann not only supported her husband

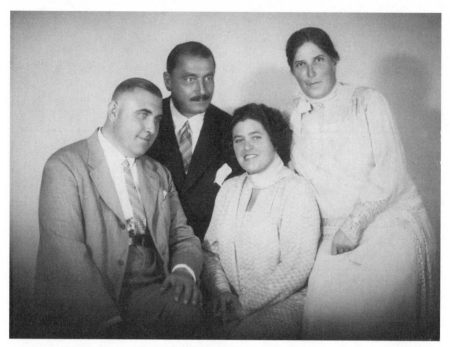

FIGURE 7. Fritz Lehmann, Otto Krause, Lotte Lehmann, and Fritz's wife Clara, ca. 1930. Courtesy Special Collections, Davidson Library, UCSB.

but also helped out his mother, Betty, and his sister Grete, who both had moved to Bavarian Partenkirchen. Lehmann claimed in 1930 that she kept a fund for needy people whom she became aware of, and as a celebrity she certainly received her share of unsolicited letters from persons begging for money.[239]

But although it is clear that much of her haggling for the highest fees was for the sake of prestige rather than material needs, when she did get what she asked for, she did not know how to save, preferring instead to spend. Her shopaholic attitude starting in the first half of the 1920s, when she was beginning to experience real wealth, remained unchanged, especially because she now had a husband who cost more than he earned, as he indulged expensive tastes. She had to support him, and did so as he accompanied her on concert tours such as to Monte Carlo or later the United States, unless he tried his hand at some business.[240] Lehmann maintained three properties – the Hinterbrühl villa in addition to her rented, generous flat in the Third District near the Opera as well as her mother's, and there were always reasons to spend on furniture, upkeep, and garden. She also had a personal maid and a cook, and a servant for her mother, and she employed a chauffeur, since she did not drive. Her first car was a relatively modest Austrian-built Steyr, but later she owned a German Horch and then a Buick, on both of which she had to pay import duties. Later in Salzburg, to show it to Toscanini and the Walters with their Cadillacs, she drove a Lincoln, seating seven.[241] Furthermore, spurred by Krause, she took up the expensive habit of horseback riding, in Vienna's Prater as well as in Westerland when visiting Fritz.[242] Add to that expenses for wardrobe and regular vacations,

not to mention dogs, and it becomes clear how her lack of proper budgeting would get her increasingly into trouble.

Not that she did not see reason in some of her more sober moments. She never afforded herself the luxury of a Rolls Royce, as the gossip press had it, and she knew the value of a four-star rather than a luxury hotel when in London, for example. Moreover, she could be downright tight when she felt pressured to buy something, which would lead to embarrassments. In 1932, on one of her Atlantic crossings on the *Bremen* to New York, she pestered a young shop salesman about reading matter. Eventually she settled for an Ullstein paperback for one mark, after having found all the other books too expensive. This was strange behavior for a rich woman and, after having his time wasted, salesclerk Erich could hardly believe her stinginess.[243]

Lehmann found herself in acute financial difficulties virtually from the time of her marriage to Krause, because he now relied on her income and was sharing her Vienna residence. In the summer of 1926 she had to ask the Staatsoper administration to forego collecting an advance granted earlier, and asked for a new advance. She was going to repay all of it at an interest of 10 percent. That was granted.[244] By the fall she admitted to owing taxes going as far back as 1924, complaining to the Third District that because of her expenses as a free-wheeling artist and obligations to needy relatives, she was being assessed too highly.[245] In the spring of 1927, after her accountant had warned her that she still owed the government an accounting of total gross earnings, she asked Mia Hecht for a loan from the United States. Mia's husband, Robert, conceded an immediate payment of 400 dollars in the fall – around 2,800 schillings.[246] But only two weeks later she asked Mia again, this time for 2,000 marks (approximately 3,500 schillings) from her Hamburg holdings, as Lotte owed her seamstress 3,800 schillings. "My bank account has been exhausted by the back-tax payments – this always goes into the thousands." Mia sent half that amount.[247] Lehmann took many months to liquidate these debts, and that caused friction, particularly between herself and Robert.[248]

Nonetheless, the singer continued to buy on credit and kept owing money to businesses and governments.[249] As she entered into negotiations with the Staatsoper for a new contract in early 1928, she was 13,000 schillings in arrears to the tax collector.[250] Her accountant negotiated some easy back-tax remission terms for her, warning that a steady monthly payback rate of 600 schillings was mandatory, at nasty penalties.[251] By the fall of that year she was in panic lest her vocal cords give out causing her to miss performances – and money.[252] Although she was always at pains to avoid local withholding taxes wherever she sang (as an example, the Berlin Staatsoper deducted 5 percent from her fees in 1932), she owed in particular the British government, so that she compromised her London impresario into paying half her debts.[253] Because in the spring of 1929 she still owed the Austrian government almost 5,000 schillings for 1927–28 alone, she sold her life insurance for 1,120 dollars.[254]

In the fall of 1929 Lehmann was informed that according to submissions to the Austrian Finance Ministry, understated by design or carelessness, she had had a gross income of 92,044 schillings in fiscal 1928 and owed back taxes of more than 11,000 schillings. Her accountant advised her that he had

secured an especially favorable solution: paying back 1,000 schillings monthly, on top of her debts for fiscal 1929.[255] In the fall of 1930 matters worsened when the consultant informed her that he had filed for out-of-town expenses of 34,000 schillings, with the tax men countering that her earnings from the Salzburg Festival alone had been five times that amount. Lehmann was asked to be precise in her listings, including earnings from Odeon, in view of what the ministry already knew. Besides, the accountant added, his own bill was still unpaid. He urged speed, lest Lehmann be found in contempt and become subject to a tax evasion trial.[256] Although from then on Lehmann seems to have been on schedule, in early 1932 she admitted that now it was Krause who owed large sums in back taxes, which was calamitous, because "he hardly earns anything during these difficult times."[257]

Krause's back taxes most certainly stemmed from speculative deals he did using Berlin real estate before 1926, in which he had also involved Fritz, many of which must have failed. In 1927 he tried a mega-deal in real estate, flipping 100 properties in Berlin. Through Lotte, he tried to enlist collaboration from Berlin friends, but in the end this fell through.[258] Krause also speculated unsuccessfully with common stocks, probably after using Lotte's money to buy them.[259] From 1927 to 1929 he was dealing in real estate again, not excluding Lehmann's own villa in Hinterbrühl.[260] "As far as business is concerned," rued Lotte to Mia in October 1927, "he is virtually pursued by misfortune. No sooner has he started something promising than it vanishes in his hands."[261]

It is obvious that Otto Krause's "freelancing" meant extended phases of unemployment after he had had to give up whatever nominal position as *Direktor* he had held with the Gutmann multiconcern. All this ostensibly changed for the better when the ex-officer, probably through old connections, was appointed a director at the Phönix insurance complex in January of 1930.[262] In the 1920s, Phönix was one of the largest insurance companies in Europe. But it is not clear what functions or earnings his title of *Direktor* entailed. Since the Gutmann years, in a country where much social and economic success was still predicated on some title or other, Krause had continued to call himself *Direktor*, even without a job.[263] (Sometimes he also flaunted the title of *Bankier*, meaning financier, and in America after 1930 he had himself addressed as "Doctor Krause.")[264] In practice this new director appears to have been – as he was in the Gutmann empire – a nominal one only, because when Phönix went bankrupt in the spring of 1936, his name did not appear among those legally accountable.[265] According to letters from his wife in 1932 and 1933, he made little money, suggesting that he was on commission, hoping to sell policies through Lehmann's incipient connections in the United States.[266] Moreover, Phönix itself was already in decline by 1930. The demise of the Creditanstalt für Handel und Gewerbe at the end of the 1920s and longtime business malpractices began to affect Phönix directly by 1931, at a time when Krause had already been hired.[267]

It was not because of Krause's earlier business failures that Lotte Lehmann later declared: "When I signed the marriage contract with Otto, it was over."[268] Nor was it because Otto continued his earlier habits of philandering, if discreetly, mostly when Lotte was on tour.[269] Lehmann, who confessed in 1927 that "the main content" of her life was work, may have known before her

marriage that he could be no more than the object of a fleeting passion.[270] It was this exclusively physical aspect of their relationship that caused Lehmann's love for Krause to cool, against the backdrop of the guilt she felt for having contributed to his wife's unhappiness and, by extension, that of their four children. This despondency comes through tellingly in one of her brutally honest letters to Elisabeth Schumann.[271] What depressed Lehmann was that at the same time that Krause ceased to be her dream lover, the two of them were being portrayed as an exemplary couple in the media, and she was embraced by opera audiences everywhere as the perfect Leonore, the "good wife," as she once wote to Schalk, who lived this role in the real world as much as on stage.[272]

For outsiders, then, Lehmann upheld the trappings of a happy relationship, when romantically they were starting to go their separate ways, while still assisting each other as partners. This partnership was something Lehmann needed in her everyday business, but also to recoup her energies at home. Krause was bodyguard, personal secretary, and her most dedicated fan all in one; during performances in Vienna he sat in the first row, beaming at her; when they went out socially he came along, immaculately dressed, always reminding her of the time to go home. He was patient with her and helped her to relax – for instance, by teaching her how to ride horses and then accompanying her on horseback whenever possible. His dry if shallow humor and constant sanguinity entertained and reassured not only his wife but her relatives and friends as well.[273] When she was on tour, they stayed in contact regularly, exchanging words of love.[274] He filed her mail and rudimentarily managed dictation.[275] But there are few letters he himself conceived, and as someone assisting in legal matters and concert scheduling he was a flop, often embarrassing to Lehmann, her lawyers, and her agents.[276]

Lehmann enjoyed the sympathies of Krause's mother, Betty, who lived in Partenkirchen, not far from the Straussian villa in neighboring Garmisch, with Otto's younger sister, Grete. That sister developed partial paralysis late in 1930, which potentially made Lotte feel responsible financially.[277] Betty Krause moved to Hinterbrühl in 1933 for an extended period, to take care of Marie Lehmann.[278] Her comments regarding Otto's tendency to ignore her, and her opinions on his children, in particular Manon, who proved to be least able to accept the family's demise, are revealing.[279] Lehmann herself never warmed to these children, except for the youngest, Peter; she must have tried repeatedly to make Manon understand her father's new relationship, but never succeeded.[280] In 1933, at age eighteen, Manon found herself in trouble with some boyfriend, something that even her caring uncle Willy could not rectify; nonetheless, he and Krause tried to solve what must have been a deep crisis for this young woman left adrift.[281]

In old age, the singer liked to flirt with the notion that the only person she had ever really loved in her life was her mother, but she knew herself that this had been a different kind of love from that she had always felt for men and which came to bloom in Vienna, at last.[282] After 1926, her conquest of Krause was followed by others. In 1945 Fritz wrote her, only half in jest, that "it is generally known that you got every man whom you wanted to get" and, referring to the turn of the 1920s, dismissed her pangs of conscience after deceiving Otto

as a sham.[283] As she had spied Otto with chorus girls, the maid had seen Lotte come home to their Arenbergring apartment with plenty of catches for one-night stands, presumably younger men, as Lotte later intimated, and her confession of 1974 that she was unfaithful to her husband is unequivocal.[284]

Naturally, no records of her affairs with men were kept, and about any details all her own letters are silent. It is therefore difficult to piece things together, in order to substantiate Fritz Lehmann's claim about his sister's voracity. But there was generally no one more honest with the singer than her brother, as she accorded the same honesty to him. One young man who might stand for others during Lehmann's European phase was Horst Wahl, the recording engineer with Odeon whose father was a friend of Vienna Intendant Hans Gregor.[285] He writes that she had met him already in May of 1925 in Berlin, when he was twenty-five and she thirty-seven, but the month of September seems more likely, as she was then singing Wagner under Walter at the Städtische Oper. Lehmann entered Odeon's retail outlet on Leipziger Strasse once, where Wahl then served on the sales staff. Although he knew her from photographs and the Berlin stage, "I did not immediately recognize her as she was wearing the latest rage in women's hats of the period. It was rather a pot-like affair and covered her face down to the eyes. When she asked me which sopranos I would especially recommend, I replied with cool placidity and the deepest certainty: 'Well, if you ask my opinion, madam, there is only one – Lotte Lehmann. She is the greatest of them all'." Whereupon, "from under the stylish helmet came the vigorous reply, 'Thank you, young man, that is who I am'." They certainly clicked musically. Hence from then on young Horst was Lehmann's Odeon recording engineer, and this until 1935; when exactly the love affair began and in what year it ended is unknown.[286]

Wahl and others after him may well have been replaced by Fritz Wolff, a Wagnerian tenor who surfaces in the role of Lehmann's lover on the pages of the notorious Lehmann biography by Berndt Wilhelm Wessling.[287] Judging by the overall shoddiness of that book, I would have been inclined to dismiss his version were it not for two solid facts. For one, Wolff performed a lot with Lehmann on stage, in places where no Krause was in sight. For another, Lehmann commanded Wessling in 1968 to ignore letters Wolff had written her earlier; Wessling wanted them for a festschrift.[288] Those letters today are missing from any Lehmann papers – presumably destroyed by the soprano. Wolff certainly was the kind of male Lehmann might have been attracted to: handsome and masculine-looking like her husband and a giant of a man. For the sake of demonstration of the possible, I shall therefore assume that Lehmann had an affair with Wolff from the late 1920s into the early 1930s, for if she did not have one with him, given her frequent bragging on the general subject in mature age, it is not stretching the imagination to picture her having one with somebody like Wolff.

Fritz Wolff was born in Munich on October 28, 1894; hence he was six years younger than Lehmann. By 1925 he had made his début as a Wagner specialist in Bayreuth, in the role of Loge in *Der Ring des Nibelungen*. In Bayreuth he met another budding Wagnerian tenor, Lauritz Melchior. Melchior and his wife Kleinchen and Wolff with his wife Claire soon were best friends; both tenors were pallbearers at Siegfried Wagner's funeral in August 1930.[289] By 1928 Wolff

was a member of the Berlin Staatsoper; after 1929 he was an annual guest at Covent Garden.[290] He also sang in Paris and Prague, and in Vienna every year from 1929 to 1932, as well as portraying Stolzing in 1934 and 1935 in Cleveland.[291] Around 1930, both Krauss and Strauss tried to win Wolff over to Vienna on a more permanent basis, but Wolff preferred Berlin.[292] Also from 1932 on, based on Wolff's success in London, there were attempts to invite him to New York's Metropolitan Opera, but in the end these failed.[293]

Lehmann therefore had many occasions to meet with Wolff, even in Vienna, and their first encounter was during the Munich Festival in 1926, when she sang Sieglinde and he Siegmund, with an "earthy, light" voice.[294] On March 24, 1929, Wolff presented Lohengrin in Vienna, with Robert Heger conducting. Wolff appeared with a slender figure like a character out of a fairy tale, wrote one reviewer, blessed with the "mellifluousness of a wonderful tenor voice." Not to be outdone, Lehmann's Elsa was said to have been "poetic."[295] The good news traveled, so immediately impresario Friedlaender asked her to critique Wolff for him, so that he might be invited to Paris.[296] A few weeks later, Wolff joined Lehmann in London, where they repeated *Lohengrin*. The soprano was characterized as having performed "with that control she has of every operatic situation," while he was described as "a comely figure, an ideal Lohengrin," with a voice "pure, sweet, easily produced," and as "already master of phrasing and diction."[297] In May, there followed another staging of the two in *Die Meistersinger*, to equally rapturous reviews.[298]

There were numerous additional joint performances by Wolff and Lehmann in the years to follow, in London, Berlin, Vienna, and provincial backwaters like the West Prussian town of Zoppot, where Lehmann had once starred with Richard Tauber, and it might have been difficult to create the anonymity of a metropolis that was ideal for trysts. As far as can be discerned, the last time they worked together was October 7, 1932, during *Die Meistersinger* in Berlin; Lehmann was by then already traveling to America, although it may be doubted that they met in Cleveland.[299] And by 1934, when both artists concertized in the United States, that liaison must have been over, for in March of that year Lehmann had fatefully met Toscanini.

Reflecting on the great man toward the end of her life, Lehmann never admitted that she had had an affair with him, but did say that "he always was in my heart. His dark eyes were depths into which I sank, without really knowing whether I would ever escape from them again."[300] Toscanini was a notorious skirt chaser; his most celebrated affair during his first phase in the United States before 1915 had been with Geraldine Farrar. However she may have dealt with Wahl and Wolff, in the case of Toscanini, just as her brother Fritz had insinuated, Lehmann had taken the initiative. For some two weeks before, when he was in Paris, she had heard Toscanini might be in Vienna and, through a mutual friend, had invited him to her Austrian premiere of *Arabella* in October 1933. The conductor responded immediately by sending her his photograph, which enthralled her. After the performance, he had risen to applaud her. Toscanini, of course, much like his on-and-off friend Giulio Gatti-Casazza, knew an artist of genius when he heard one. But he also had an "exaggerated masculinity" and, virile as always, was still bent on conquest, often pursuing more than one

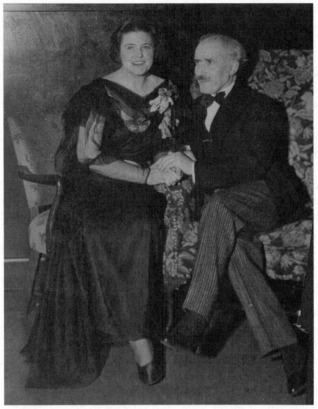

FIGURE 8. Lotte Lehmann and Arturo Toscanini, date unknown. Courtesy Special Collections, Davidson Library, UCSB.

love affair at once. Madame Lotte, who must have known his philanderer's reputation, had given him a hint he could not ignore.[301]

It is virtually certain that during the fall of 1933 Toscanini and Lehmann talked of her upcoming tour of New York in early 1934, including her first appearance at the Met in January. Hence it stands to reason that they arranged beforehand how and when to meet in New York. The matter was a delicate one, because Lehmann knew even then that her husband would accompany her, which, however, did not faze either soprano or conductor. Perhaps in order to give their beginning affair an innocently professional air, Toscanini arranged for Lehmann to perform with him. He had a New York agent ask her whether she would sing three renditions of Beethoven's Ninth Symphony and three of his *Missa solemnis* with the New York Philharmonic Orchestra under his, Toscanini's, direction, in February and March 1934. She declined, saying both parts were too high for her soprano, but wished for another kind of concert with the maestro. That became possible on February 11, when she sang at a radio broadcast concert, *The Cadillac Hour*, with Toscanini conducting the General Motors Symphony Orchestra from Radio City Music Hall, for station WJZ. Lehmann went to hear him, for the first time, at Carnegie Hall a few days

before, and was struck by him as a "Ruler," as a "King, who comes to charm his people." Already well kindled, the fires were burning high when Toscanini attended Lehmann's sold-out Town Hall concert on March 4, at which she sang lieder by Schubert and Brahms, Strauss and Wolf. There were enough love songs in the program – for instance, "Rastlose Liebe" by Schubert and "Meine Liebe ist grün" by Brahms.[302]

Although encumbered, the affair then took its course. "This man, who terrifies everybody who sings or plays under him," she enthused a few days after her concert, "behaves so *wonderfully* towards me that I am quite beside myself." Apparently he had told her that no one could equal her and that no superlatives were too exulted to describe how enchanted he was.[303] But during the first half of March, there was no opportunity for them to meet, only to write letters. When exactly they began to have rendezvous, how often, and how they kept the secret from Krause, is not known. Harvey Sachs, Toscanini's authoritative biographer, has credibly ascertained that these meetings took place toward the middle of the month, with Lehmann giving her last New York recital on the nineteenth, at the Institute of Arts and Science at Columbia University, before embarking again for Europe two days later.[304]

It must have been still in the letter-writing phase when Lotte confided to Mia: "I am half-crazy. These intensifying letters are killing me." Lehmann recounted typical Toscanini braggadocio theatrics, as she explained how the conductor treated her letters. "He wrote me really marvellously that he holds them to his heart at night and kisses them like someone insane and that he is dying of longing for me." He said he deplored the impossibility of getting together physically, since he seemed to be well guarded by his wife, Carla.[305] (Lehmann's letters to Toscanini were returned to her by his family after his death, whereupon she burned them.)[306]

Toscanini's letters to her were no less ardent. They were kept in French, so that Carla could not read them, even if they were found. Lehmann tried to burn them in an open fire later in her life in Santa Barbara, but they were rescued from the flames by her companion, Frances Holden.[307] "Have pity on me!! You are going to kill me with your fiery letters full of feverish desires. Tonight, lust tormented me until I was crazy." And: "Tonight I had a sort of hallucination which made me dizzy.... I saw you in my bed entirely naked and I, I was kneeling and was caressing with my knowlegeable hand your breasts, which I don't know yet, while my mouth and my lips were engulfed in the divine source of all pleasure." Toscanini too was tormented by the separation. "It's a fact that this terrible distance which separates us only reinforces the chain which ties me magnificently to you – but what suffering one must endure!"[308]

And so it went. Toscanini was disconsolate over Lehmann's departure from New York on March 21, but at least they finally seem to have spent time in private, although it is doubtful whether their passion for each other was fully consummated even then.[309] For on April 4, the conductor wrote his new mistress that "there are some places on your beautiful body which I have not yet caressed. I will press my mouth and my hands the length of your lovely hips – I will shelter my head between your thighs and with my fingers and my tongue I will make you die of sensual pleasure.... I want to see you spent and

vanquished."[310] During the whole of March, people were beginning to suspect something. When Krause and Lehmann were invited to dinner by the eminent *New York Times* music critic Olin Downes, he allegedly joked to her: "What is that with you and Toscanini? I think your husband must take care of you."[311] Lehmann later claimed that Krause knew every step of the way what was going on.[312]

There is only this much about the men in Lotte Lehmann's life – at the height of her womanhood, when art was everything, matrimony a bad option and children farthest from her mind – if, in fact, it is symptomatic. If the erotic quality of Lehmann's relations with a few chosen men is undeniable, what is significant is that any shade of promiscuity in her character surfaces only *after* rather than *before* her marriage to Otto Krause, which she obviously came to judge as a mismatch. However, as we have seen, her sexual proclivities extended not only to men but also to women. Lehmann had reached out to Mia de Peterse quite openly at the end of her Hamburg tenure in 1916; she had all but completely fulfilled Mia's unabashedly sexual interest in her. This relationship with Mia on the edge of society was carried on as a platonic one with strong recurrent sexual undertones, as both of them got married – Mia in the early 1920s and Lotte in 1926. Mia would invariably address Lotte as "My Beloved" and would tell her (as she had before) that she had dreamt of her. She talked of "longing" for her friend sometimes, when her relationship with her husband, Robert, was not going well. Her heart was not in this marriage, Mia wrote to Lotte in March 1930; one can just imagine Lotte's heart resonating strongly with pangs of sympathy.[313]

For as far as she was concerned, she needed conquest, of an audience and of people, and if it was erotic, that was a sign of real human victory, whether over men or women, but preferably men.[314] This explains why Lehmann continued to be so interested in intense friendships with select men and women and became herself the object of sensual desire, especially by throngs of admiring young women. One of these was Hella Müller, who had been the official Karl Lion's secretary at the Vienna Staatsoper until his death in 1926. Lehmann's physical attraction to the much younger Hella, who was of course an unflappable fan of the singer, was so strong that she not only got her a new job with her Vienna agency but continued to befriend her uncommonly closely from then on. How intimate this friendship turned out to be is another unknown in this biography, and it really does not matter, except as another telltale sign of human conquest for Lotte Lehmann, most likely with a strong erotic component. Hella was as gushy as the rest of the older teenagers who swarmed Lehmann when they caught sight of her leaving the Opera, but unlike them she joined the singer like part of the family in Westerland and composed for her maudlin poetry that left no doubt about the strength of her passion.[315]

Another female follower Lehmann acquired in 1931, who was to become Müller's bitter rival for signs of Lehmann's affection all their lives, was Hertha Stodolowsky of Vienna, whose wealthy parents owned textile mills in Bohemia. Hertha's father played some cello; her mother had a beautiful mezzo-soprano voice and had dabbled in opera. Hertha was in her early twenties and had studied the piano; she lived a fifteen-minute walk from the Opera. She was

rich enough to travel to London and hear Lehmann sing there on her annual Covent Garden jaunt; she then approached Lehmann with flowers and promises of photographs. Lehmann immediately opened the door to a personal visit by communicating to Hertha her private address in Hinterbrühl. Hertha was shy, and later she claimed that it was some time before Lehmann really warmed to her. But when she did, Lehmann knew that she had acquired another very loyal friend, who would die for her music and probably make even greater sacrifices.[316] Still, friendship with Hertha Stodolowsky was but a prelude and a sideshow for a much more significant, more consequential relationship.

In the novel *Of Lena Geyer*, published by Lotte Lehmann's New York friend Marcia Davenport in 1936, the heroine Geyer is a world-famous soprano, modeled on the U.S. opera star Olive Fremstad. Through many concerts, in Europe and America, Geyer is accompanied by an enigmatic, young and beautiful woman, who always sits in the first row, hanging on the singer's every word, until they get to know each other and become inseparable.[317] Davenport's character was not inspired by, but paralleled, the flesh-and-blood Viola Westervelt. Since early 1931, when Lehmann was commencing her phenomenally successful concerts in Paris, she had found a strikingly attractive young woman sitting in the front row, always joined by a slender, dark-haired young man, who, it then turned out, was her husband, Andrew Castle Westervelt.[318] Before Toscanini came on the scene, the blond Viola became Lotte Lehmann's greatest woman love, perhaps even the greatest love of her life.

She came from Kalamazoo, the daughter of a housing superintendent, and when Lehmann was first struck by her uncanny beauty she was twenty-four years old.[319] Her origins are as mysterious as the woman herself, for there is not a single letter of hers preserved in the voluminous Lehmann correspondence. Of modest means, she had apparently attended Oberlin College and there in 1927 had married Andrew, born 1906, very likely a fellow student. His family was cultured and, owing to the sugar industry, very wealthy. Andrew's father, William D. Westervelt, was a scholar of Hawaiian mythology, and his mother, Caroline Castle, wrote on early church music.[320] In 1928, Andrew obtained his master of arts degree in English literature at the University of Chicago. What he then did for a living is not much better known, but after university, he appears to have worked as a writer, perhaps a journalist, and upon his death in 1989, the *New York Times* described him as a New York City "educator." By then he had long been divorced from Viola and had remarried – as would she.

The first sightings of Viola Westervelt in Paris excited Lehmann so much that she felt compelled to mention them later in her memoirs.[321] This is how she approached her new fan by letter, from the Paris hotel Majestic, at the end of March in 1931, after she had somehow found out the lady's name; it was one of her first compositions in English: "Please tell me: are you the young blond lady (very sweet and very lovely!) who was sitting always with her kind husband (a young gentleman with dark hair) in the first line – and we were greeting always – and my heart was always glad to see you?" Whereupon followed that meaningful invitation to her Vienna abode. She entreated Viola to come to hear her always: "That would be very, very sorry for me – not to see your lovely face in my concerts." Lehmann told Viola that she would be performing in New

York the following January more than seven months away, and spontaneously invited Viola to visit her backstage.[322] Westervelt wrote back to Lehmann, but had missed witnessing her induction into the French Legion of Honor, which deeply hurt the singer. Lehmann replied saying that whenever she was in Paris, she was always looking for Viola's face: "Often I sang many a song just for you." Then followed further instructions for a meeting in New York.[323]

It says a lot about the intensity of this friendship that after no further communication, Viola Westervelt actually showed up, with her husband, in the front row for Lehmann's first New York recital on January 7, 1932, at Town Hall. It was a momentous occasion for the singer, deserving of another entry in her 1937 autobiography.[324] From then on, the Westervelts were switching back and forth between New York and Paris, on business hitherto unknown and money probably from his family, and so was Lehmann – sufficiently at least for this relationship to grow. They met in Paris in March of that year and hoped for a meeting at the Salzburg Festival a few months later.[325] That may not have taken place, but later in the fall Viola declared her love for Lotte, which the singer gladly acknowledged – now changing over to the more familiar *Du* in her regular German missives. Lehmann told Viola to let things be, that it certainly was no "sin" for Viola to love her and that *talking* about certain "secrets of life" would only destroy them.[326] It was a full-blown love affair for both, although nothing physical may have transpired, if only because of the ubiquitous presence of Andrew Westervelt and the continued existence of Otto Krause. However, even if they had been ciphers, both men could have been encumbrances as much as covers in an affair of this nature, so that a biographer might discount them one way or the other. Lehmann's letters to Viola, more or less ardent, full of longing and fear of rejection and always praising her beauty, continued without fail, and apparently the two saw each other when they could – in Paris or New York, until Viola had a daughter in the autumn of 1933. This displeased Lotte, as she had been displeased by Mialotte Hecht's birth.[327] But the relationship endured into 1934, when Toscanini's enthusiasm temporarily robbed it of luster.[328] By the time Lehmann moved to the United States on a permanent basis in 1938, Viola Westervelt had become a constant in her life. Throughout the 1930s, she sent photographs of herself to this new acolyte, dedicated especially to her: "To My Viola!"[329]

America

Through the early 1930s, Lotte Lehmann had established herself in Vienna and the rest of Europe, had hobnobbed with the famous and the wealthy and dined with royalty, but she had not yet established herself in the New World. The catalog of her European acquaintances was indeed impressive. She was routinely invited to official receptions by the Austrian federal president.[330] In November 1928, Vienna's mayor asked her to meet socially with Thomas Mann. Max Reinhardt invited her to parties at his famous Leopoldskron castle near Salzburg.[331] The German-born film actress Käthe Dorsch counted among her closer friends, and Bertha Zuckerkandl urged her to come to her soirées, even though she understood Lehmann's reticence.[332] Indeed, the diva complained to

the telephone company in 1927 that her secret number was once more in every-body's hands, and asked to have it changed.[333] Lehmann kept her own social gatherings rare and small; among her more frequent guests was Rudolf Kassner (b. 1873), a philosopher and one-time companion of Rainer Maria Rilke and Hofmannsthal. Interested in questions of aesthetics and dilettantism in art, he venerated Lehmann's artistry and sent her admiring letters.[334]

Raised a Prussian royal subject and having had barons and counts as patrons and close friends, Lehmann was now given plenty of opportunity to indulge her penchant for aristocracy. Her correspondence with Emmy zu Putlitz was sporadic yet constant, and by the late 1920s she still called the oldest daughter Erika zu Putlitz, now married to Albrecht von der Schulenburg, one of her closer women friends.[335] The Viennese Countess Gabrielle von Rechberg remained her loyal confidante, and she was thrilled to be received by the British king and queen in London in 1930.[336] The Parisian Baron Robert de Rothschild, for whom she sang at musicales, was especially devoted to her, and she maintained a personal friendship with King Manuel and Queen Auguste Victoria of Portugal, albeit deposed and living in exile in England; the king would accompany her on his house organ.[337]

With all these connections and fame, however, guest appearances in the United States eluded Lehmann throughout the entire 1920s. It was not that she did not get noticed there. After 1925, mentions of her artistic exploits became more numerous, particularly where it mattered, in the *New York Times*. The U.S. media concentrated on her London performances, but also on the Salzburg Festival, since it was frequented by more and more Americans.[338] They reported on her Vienna, Berlin, and Paris appearances as well and did not fail to mention recordings.[339] Positive critiques outweighed negative ones by a large margin. But what did her more damage than good – although she still had reason to be flattered – was the occasional yet poignant confusion with Lilli Lehmann, on the assumption that the two singers were one and the same, or at least close relatives.[340] Lehmann could not read these notices, but if she had been able to, she might have wondered why the Metropolitan Opera in New York or the Chicago Civic Opera still would not make her an offer.

Of these two opera houses, the Met of course was the older and more pres-tigious, whereas the one in Chicago intermittently was reputed to have more artistic daring as well as greater financial volatility. Both employed star singers from Europe, and in Chicago they could earn even more than at the Met.[341] But opinion on the Old Continent was divided about where, of these two, a non-American singer should début. It was generally accepted there that an artist as famous early in her career as Jeritza logically would start at the Met in New York, but that if this was impossible, the Chicago Opera might serve as a strate-gic point of entry. Uncompromising purists who knew the United States, like Strauss, disagreed with this, holding that chances for singing at the Met would be forever spoiled if one started at the lesser-known Chicago Opera.[342] Others thought – as did one critic in the specific case of Lehmann – that the Met might be too large a hall for certain voices, and Chicago's Auditorium more intimate, like the Dresden Semper Oper.[343] In principle, Lehmann appreciated the supe-rior cachet of the Met, "the dream of all opera singers," and thought – like

Strauss – that starting at Chicago would amount to selling out one's talents.[344] Whereas she knew that Jeritza had no influence in Chicago whatsoever, she continued to suspect that the blond diva was behind the Metropolitan Opera's stubborn reluctance to engage her. "If a goddess rules in America, who will tolerate no one at her side," she wrote in mock resignation late in 1926, "then I will just have to live without America."[345]

As Lehmann's search for a place in America's opera scene dragged on, she was hampered by the confusion created for her by a number of agents, all of whom claimed to be well-meaning and, naturally, well-connected. First, there was her old impresario from Berlin, Norbert Salter, who thought he had a hold on her because he had once moved her from Hamburg to Vienna and who had dangled New York before her eyes as a prospect before. Salter, who had relocated his office to New York, pretended he had the best connections, especially to the Met, and that in the world of artists he represented the *crème de la crème* – at least according to his stationery letterhead.[346] His specialty was to taunt Lehmann about the ongoing New York success of Jeritza, although she was not even his regular client anymore.[347] It consumed the energy of Lehmann's more credible agents, especially Erich Simon's, to convince the singer that she could not go with the in some ways increasingly fraudulent Salter, who as late as 1928 pretended he could do something for Lehmann even in Chicago.[348] Then there was an agent in London and one in Hamburg, and finally Berta Geissmar, Furtwängler's secretary, who freelanced as an agent on the side.[349] They all promised Lehmann to get her to America, some with the help of the powerful New York impresario Arthur Judson, who represented artists like the African-American contralto Marian Anderson and the European conductors Artur Rodzinski and Eugene Ormandy.[350] Judson, however, seemed less interested in furthering Lehmann's operatic career than in employing her on exhaustive recital tours, which would have made her some money but certainly have kept her out of the Met.[351]

In the end the matter came down to a power play between Lehmann's agency in Vienna and the one in Berlin. In September of 1926, the heldentenor Lauritz Melchior, with whom Lehmann had become friends after their celebrated joint appearances in London, recommended Judson, "who has done excellent work for me, for a tour of the United States."[352] Contemporaneously, Simon of the Berlin Wolff und Sachs agency asked the singer to travel to the German capital in order to audition for Edward Ziegler, Gatti-Casazza's right-hand man, and the Met's conductor, Artur Bodanzky. According to Simon, there was the possibility of a Met contract for the 1927–28 season.[353] In a polite yet very firm letter to Simon's partner Louise Wolff, Lehmann declined this offer, because "in my opinion you can judge a stage artist fairly only on the stage, especially if this artist is a *personality* of the kind which I flatter myself to be."[354] Lehmann thought she was in a strong position to maintain that because she had just been handed an offer by her Vienna agent, which opened up Chicago for her.[355] Simon then used the old line already uttered by Strauss that starting in Chicago would spoil whatever future a European might have at the Met. Nonetheless, he then traveled to Vienna to talk the matter over with her.[356] Lehmann kept insisting that she would have to accept the Chicago Opera offer, combined with

a concert tour à la Judson, unless something more concrete was forthcoming from the Met, even without an audition, assuring Simon in the process that she would prefer the Metropolitan "20 times over," but also voicing her old suspicions about Jeritza.[357] To Bing, however, then working for the Vienna agency, Simon had to admit behind Lehmann's back that it was in no way certain that a New York contract for the 1927–28 season could be secured. Clearly, Simon was trying to keep the potential benefits of brokering Lehmann to the Met for himself, using Judson as his American counterpart, without being able to offer any guarantees, while at the same time attempting to prevent the Viennese from signing the singer to Chicago.[358] For the time being, Simon's tactic won the day, because at the end of 1926 Lehmann declined the offer from Chicago, in the hope that Simon might yet produce his quarry.[359]

In 1927, there was another possibility of an American tour through the Judson agency via Simon, but Lehmann, hoping against hope, kept holding out for the Metropolitan well into 1928.[360] Then, in April of that year, Chicago seemed to be opening up again, this time offered through the Berlin brokers.[361] In the summer of that year, Chairman Otto Kahn from the Metropolitan traveled to Salzburg and heard Lehmann in her feature role of Fidelio. As he told Simon, who then informed the singer, he was impressed and would wield his "great influence" in order to get the artist to the Met.[362] But although Lehmann thought her New York dream had finally been realized, the Met still withheld an offer.[363] Instead, in late 1929 Simon, after having again urged the Met, was able to finalize an arrangement for Lehmann in Chicago for the 1930 season, and thinking that a bird in the hand was worth two in the bush, Lehmann accepted.[364]

In America at this time, did Jeritza continue to cast her spells in order to prevent Lehmann from appearing at the Met? There can be no doubt that she kept on scheming against her colleague in cahoots with Kahn, as she had done until the mid-1920s. But in the second half of that decade her own situation in New York was actually weakening. As in Europe, she felt best when she was in the headlines, no matter what the cause. She loved scandal, loved a day in court, and loved to win. A typical example is that of the Bronx cigar manufacturers Louis and Isadore Cohen, whom she pursued because they had branded their products with her name. In spring of 1926 she sued them for the respectable amount of 25,000 dollars.[365]

Not that she needed the money. At the Met alone, she was then earning an amount in the vicinity of $2,000 per performance, the highest sum paid to any singer and one that steadily increased over time.[366] But whereas as a box office magnet she did not lose her luster for the general public, connoisseurs were getting tired of her antics and deplored the increasing carelessness in her musicianship. Once in October 1926, when she had traveled from London to New York to sing Turandot, it was alleged that a member of the Met's music staff mingled with the chorus in costume to give her some of her cues on a pitch pipe.[367] A year later, the *New York Times*'s Olin Downes excitedly announced "the indefatigable Mme. Jeritza" as Carmen, only to be sorely disappointed when she sang the role the following January. She had sung badly, with poor tone quality and with no regard for pitch. Her French "would have been repudiated

in the Franco-Prussian War," and Downes was surprised "that a singer of her experience, intelligence, and observance of tradition in other roles would have been willing so recklessly, ineptly, crudely, to violate every principle of technique, style, or even effective stage presence as she did on this occasion." Summing up, Downes thought that Jeritza's Carmen was so far "the poorest thing that she has done on the Metropolitan stage. She is apparently unfitted for this role, by physique, style, technical accomplishment, or appreciation of the nature of the opera."[368] William J. Henderson, who had a pronounced fondness for Jeritza, also thought that "with all her energy she did not seem to get far beneath the surface" of the role.[369]

Contrary to earlier days, Jeritza was also enjoying less success with the works of her great friend Richard Strauss. By late 1928 she was complaining to him that Elisabeth Rethberg had arrogated bragging rights to the effect that she was the creator of the Egyptian Helena, after her world premiere of that role in Dresden earlier in June. According to Jeritza, however, she herself had been the true impersonator of that character a few days later in Vienna. Jeritza demanded of Strauss that he officially set the record straight by assuring the American public that this part had been written exclusively for her.[370] Strauss sent a cable with exactly that content that cost him nothing, but after the Moravian diva had sung the role at the Met under Bodanzky, she was again accused by Downes of having been shrill in the upper register and having rendered the lyrical passages "unsteady in tone and frequently off pitch."[371] This did not help in the context of an opera generally scorned by Downes and one that Lawrence Gilman of the *New York Herald Tribune*, too, called a "spendidly vacuous score."[372] When in autumn of 1929 Jeritza represented Count Octavian of *Der Rosenkavalier*, Downes accused her of "horseplay," referring broadly to the "athleticism" she was always prone to exhibit in her operas, including Puccini's *La Fanciulla del West* just a few days before. Jeritza's long-standing specialty was now beginning to haunt her, and she became the victim of her earlier success. "Mme. Jeritza's first tumble was in Tosca," mocked Downes; "there were several tumbles in 'The Girl of the Golden West'. There is a fresh tumble in the last act of the 'Rosenkavalier', and this is accompanied by a wealth of gestures and of silly demonstration by an apparently intoxicated woman."[373] Jeritza next tried to get Strauss committed to helping her star in *Arabella* at the Met, but the master remained mute on this, and when Jeritza finally sang Salome again in New York, as she had promised to do long before, it was only in excerpts and in a symphonic setting.[374]

By the early 1930s Jeritza was so obviously becoming uncomfortable as an operatic prima donna that she was instead seeking her fortune elsewhere, first in operetta, then in broadcasts, and finally in Hollywood films, until, in summer 1932, the Swedish soprano Goeta Ljungberg was unabashedly touted as her replacement. Ljungberg physically resembled her, was six years younger, and had earned herself accolades with the Swedish Royal Opera and at Covent Garden.[375]

By that time Jeritza was no longer with the Metropolitan. As the economic depression deepened, the Met had to fire some singers and cut the salaries of others. In 1930, Jeritza still had three years left from her last contract. By

that time, there was no talk of her leaving; in fact, she was preparing to sing operetta at the Met because, as Gatti-Casazza well knew, this would bring in money. Yet in October of 1931 Kahn retired as chairman of the Met's board of directors, because he felt personally responsible for the Opera's increasing financial decline since the 1929–30 season, although he remained a director. In the following year, Gatti-Casazza wired Jeritza that her services were no longer required after the termination of her contract, even though she had agreed to cuts in her salary, as had all the operatic corps. As the English tenor, Piccaver student, and biographer of singers Nigel Douglas writes, the Met committee had "grown weary of her shenanigans." Using a protest by Beniamino Gigli, not otherwise a friend of hers, who had refused to have his salary reduced, Jeritza put on a show of joining forces with him and resigned her post, although she maintained, for appearances' sake, that money had had nothing to do with it.[376] It was the end of an era – and, to return to the situation of Lotte Lehmann, the path to the Metropolitan Opera finally seemed open to her.

However, Jeritza's intrigues had not been the only reason for Lehmann's delay, apart from the question of how effective Jeritza really could have been in the last, questionable years of her career at the Met. In early 1928, the bass Richard Mayr, who was Lehmann's very old friend, returned from his début season at the Met to Vienna, only to tell his colleague that in his opinion Jeritza had nothing to do with her misfortune. Instead, Mayr said, German opera was not important over there, and "a typically German star" such as Lehmann was not needed. Besides, he had found New York awful, totally without feeling and much too frigid.[377] Mayr was certainly wrong to attribute a possible rejection of Lehmann in New York to a resentment of German opera, for what had happened was that he himself had been somewhat unkindly received, both as Veit Pogner of *Die Meistersinger* and as Ochs auf Lerchenau in *Der Rosenkavalier*. In *Die Meistersinger*, for which Downes had initially hailed him as "a most accomplished bass" in October 1927, the critic found him wanting in November. "His resonance did not always fill its spaces. His tone color, in the upper register, was inclined to be pale." Whatever else was said about him that was good, Downes again criticized the basso a mere two weeks later when he opined that Mayr had "passed the period when the voice is at its best." Instead of singing optimally, Mayr had engaged too much in a parlando style.[378] The celebrated artist found such criticism difficult to suffer and hence cultivated a grudge against the Americans, whom as late as November 1929 he described to Clemens Krauss as immutably opposed to German opera.[379]

Mayr, unfortunately, had taken personal rancor and falsely turned it into the consequence of a national phenomenon. In reality, German opera at the Met was as vibrant as ever. The problem with the repertoire was a different one: American opera lovers customarily tended to prefer Wagner and perhaps Strauss, and there were enough specialists for such performances at hand. The entire Metropolitan Opera stage was becoming too crowded with (German-repertory) singers, particularly in the early 1930s, when it was hardly justifiable, for depression-related reasons, to hire newcomers from overseas.

Jeritza's influence in New York was obviously still strong in 1927, when, during that spring, critic Henderson received a Viennese report regarding

Lehmann's splendid Fidelio and then pronounced, satirically, "well, we need none of her magnificence here. The dollars can be drawn without it."[380] And dollars they drew, as there was a stock-market boom, ticket prices were high, and under Kahn's proud patronage the Met was staging not only Wagner and Strauss, but also the experimental Ernst Krenek, in the 1928–29 season, the final one before the Wall Street crash. There were plenty of good German-genre singers there then: Elisabeth Rethberg and Jeritza, Grete Stückgold and Maria Müller, to say nothing of males like Melchior, Friedrich Schorr, and Michael Bohnen.[381] In 1929, when the Met enjoyed its greatest income ever, Geraldine Farrar even criticized the Opera of being run like a stock company. It was then that the largest stockholder, Otto Kahn, who had heard Lehmann as Fidelio, in Salzburg a year before, wrote in a letter to Gatti-Casazza: "I have long thought that we ought to have Lottie [*sic*] Lehmann here. If, as I understood from you, Madame Jeritza has announced her intention not to sing here if Madame Lehmann were at the Metropolitan and if it is granted that we take such a threat into serious consideration, I cannot see why we should not engage Madame Lehmann during the period that Madame Jeritza does not sing here." Even though it is certain that it had been Gatti-Casazza who had been given to understand by Kahn that Jeritza would not perform at the Met in the presence of La Lehmann, it is just as clear that the directorate of the Met was moving closer to the thought of sending that other Viennese prima donna a contract.[382]

When, in December 1930, Lehmann had begun her first American engagement at the Civic Opera in Chicago and the Met was not yet in financial straits, Erich Simon had to remind Gatti-Casazzi's deputy Edward Ziegler that Lehmann was contracted to Chicago also for the 1931 fall season and therefore not available to New Yorkers. Nonetheless, as a hint, he sent Ziegler the singer's current repertory list, including the roles of Elsa, Sieglinde, Eva, Fidelio, and the Marschallin.[383] But although Kahn retired from his Metropolitan leadership in 1931, and a year later Jeritza was only some name, box office income declined in the 1931–32 season and the Met incurred a heavy financial loss. At the same time, there was outright criticism of German performances – all an unhappy combination of factors that offset the good prospects ceded to Lehmann by the removal of the Jeritza factor. With the Chicago Opera having gone bankrupt, theatrical tours in the United States thinning out, and South American cities like Buenos Aires no longer in strong competition for singers, there was little opportunity to hire novel European talent in the face of the many German opera singers on the Metropolitan stage.[384]

However, even during an enduring financial crisis and after singers' salary cuts in 1932–33, the Metropolitan still had reason to employ new German talent, albeit, admittedly, for the sake of its Wagner repertory. New ways and means were found, such as financial help through the novelty of radio broadcasts, special fund-raising mechanisms, an additional mortgage, and cheaper tickets because of a new tax-exempt status. Hence Frida Leider came, and so did Lehmann's old colleague Maria Olszewska (both previously with the Chicago Opera), the one to feature her celebrated Isolde, the other to be broadcast as Brangäne.[385]

On January 7, 1932, Downes heard Lehmann, during her second visit to the United States, in her first New York recital, at Town Hall. A day later he wrote in the *New York Times* that the concert had "thrilled" him. "Mme Lehmann swept her listeners from their feet. She has a voice of magnificent range and color. Above all, it is an intensely communicative voice, one that stirs with feeling and that immediately affects those who hear it. She herself is a woman of superb temperament and capacity for the expression of great and varied emotions." With that, Downes had presented to New Yorkers who could not hear the soprano the essence of Lotte Lehmann. Noting that the singer was currently a member of the Chicago Opera, he continued that without a doubt she would be heard in New York again and that she would be "welcomed and thanked for her appearances."[386] This was the strongest endorsement Lehmann had yet received from a distinguished American. Simon seized the occasion to write to Ziegler in May that before her upcoming U.S. concert tour the following January Lehmann might have some time to put in a few guest performances at the Metropolitan, although he understood that currently she was hardly a good fit. Ziegler replied – as was well enough known – that in a shortened season the contracts of too many existing female singers had to be honored first.[387]

For January 1933, when Lehmann was indeed in America, she received no invitation from the Metropolitan. But a month later, *Musical America*, the influential music journal, published a large photo of her and advertised that she was beginning her third American tour, from January to March 1934, and that she was "now booking."[388] As if on cue, the Met directors asked Simon, who, as a Jew, had had to move his office from Third Reich Berlin to Paris, whether Lehmann would consider two guest performances between January and March of the following year for 600 dollars each. Lehmann immediately accepted, reportedly "very pleased." As in Chicago, her agent in New York would be the multilingual Francis Coppicus, originally from Cologne, who had built up his business in conjunction with the Met in the 1910s and, an ironic twist, was now also Jeritza's American manager.[389] By early May, Gatti-Casazza had made Lehmann's new assignment public. Lehmann's potential roles were to be exclusively Wagnerian ones, yet those she was very firm in: Elsa, Eva, Elisabeth, and Sieglinde.[390] At the end of the year, a public announcement declared the Metropolitan Opera as "saved," with a new guarantee fund of $300,000 backing the enlistment of seventy-nine principal singers, twelve of whom were new appointments.[391]

By that time Lehmann had already sung at Town Hall in New York, had toured the United States to the West Coast, and had performed for two seasons at the Chicago Civic Opera. She had learned that musical life in the United States was lively, that there was a sophisticated audience, especially in the large cities, and that critics such as Downes could be as knowledgeable, even learned, as the best in Europe. It had also been a revelation to her that – contrary to her earlier expectations – the Metropolitan Opera was not the be-all and end-all of musical culture in America. For opera alone, there were two other fine institutions on the continent, the San Francisco and Chicago Operas, of which

the latter, albeit precariously financed, had given the Met a good run for its money a number of times.

As in New York, there had been opera in Chicago already in the nineteenth century, more of the traveling-company kind, and it had never been of a pronouncedly German color. But the meat-processing city possessed a very large German population, and so *Salome* was staged there as early as 1921. Wagner's operas followed Strauss's. There were plans for more Wagner for the turn of the 1920s, which led to the engagement of Leider and Olszewska in 1929–30 and shortly thereafter resulted in the engagement of Lotte Lehmann.[392]

The lyric soprano approached her first American adventure with considerable trepidation.[393] Although she had wanted to go to America for such a long time, she could not shake off the average German's prejudices against the New World, let alone begin loving that country automatically upon arrival. Her previous social contacts with Americans had been scarce; colleagues such as Edyth Walker in Hamburg had always acclimatized themselves to fit in well with the Europeans. Negative stories such as Mayr's about New York did not help, and Lehmann's own experience in South America, when she had been much younger, had not exactly made her worldly-wise.

So this is why she needed Mia and Robert Hecht to help her. Living in Atlanta, they were well-to-do, and Robert had many connections through his business. He helped with arrival and departure, logistics, luggage, the reservation of hotels.[394] Mia had to come to receive her and Otto Krause at the pier in New York, then stay with them at the Drake Hotel in Chicago. Later, after Krause had returned prematurely to Vienna, Lotte would spend time in the bosom of the Hecht family in Atlanta.

The Krause couple boarded the *Europa* in Cherbourg on October 16, 1930, after the singer had given another recital in Paris. On the ship they were accompanied by Olszewska and Leider, and the excellent conductor Egon Pollak, with whom Lehmann had already worked in Hamburg. There was a huge storm in the Atlantic, and Lehmann got woefully seasick. The skyline of New York was intimidating, and the fastidious searches of U.S. customs agents humiliating. Had she hidden any alcohol in the cloak of Wagner's Elsa, or in the nun's bonnet of Elisabeth, during this period of official Prohibition? The mass of cars in New York's streets was confounding; the elevators in the skyscrapers caused dizziness when one got off at a top floor and looked out the window. This was not like Paris, or even London! It was simply not Europe.[395]

The journey to Chicago in the well-organized train was impressive, as were the white-dressed, polite, and clean-looking Negro servants. Lehmann, brought up with a Prussian sense of order and one's proper place on earth, was beginning to like this. They did their job well, as she did hers. But then the dreary neighborhood of the new opera house in Chicago was again depressing; near Lake Michigan the atmosphere was foggy, darkish, gray-in-gray. Once more a never-ending queue of cars. The idea of Chicago as the slaughterhouse of the American nation frightened this animal lover, who was fond of traveling with her own small dogs. And then the overheated rooms and halls, in both the Drake and the Opera. What an unpleasant contrast to the frigid gales of

wind that greeted visitors and tore at their hair at the entrance of the theater!
Outside it was so cold that none of Lehmann's expensive fur coats could provide
protection.[396]

But then the music was surprisingly good and conductor Pollak convinc-
ing.[397] She made her début on October 28 as Sieglinde, with Olszewska singing
Fricka and Leider Brünnhilde; Hans Hermann Nissen was Wotan. This per-
formance was repeated on November 10; she also sang Elisabeth, Elsa, and
Eva, a total of eight appearances, with the last one as Eva on November 26.[398]
Although she thought she was merely average and the spark was missing, the
local reviews praised her.[399] Her fame had preceded her, and critics were not
disappointed. "Her Sieglinde is perfection itself – perfection of voice and of
action," wrote one enthusiast. "A woman of great intelligence, she displayed
histrionic talent such as is seldom encountered among Wagnerian exponents.
Her Sieglinde may be looked upon as a creation. Though generally follow-
ing so-called tradition, she brought out so many new characteristics as to add
materially in making the part stand out in bold relief."[400] After *Tannhäuser*'s
Elisabeth, it was written that "this is surely one of the great voices of the present,
joined to a superbly confident art that can fashion and project the mood with
certainty."[401]

For the lieder recital in Minneapolis in late November Lehmann sang at
Northrop Memorial Auditorium, in conjunction with the University of Min-
nesota, where she was accompanied by the local pianist Katherine Hoffmann.
She presented her usual dependable staples, such as Schumann's "Der Nuss-
baum," Strauss's "Zueignung" and the Ocean Aria from Weber's *Oberon*.
Again, praise was ravishing, but one critic could not understand why she would
choose Schumann's "Ich grolle nicht," which was said to be a man's song or,
at best, one for the contralto range. But Lehmann was beginning to be more
careful with her voice now and did not wish to take any unnecessary chances
singing in a high range.[402]

Then there were the reporters. For publicity's sake she had memorized one
line, which now she kept repeating machinelike to newspapermen, without, of
course, believing it herself: "I have seldom experienced such enthusiasm for
opera as in Chicago. My only regret is that I could not stay longer there but I
am happy to say that I shall return early next year."[403] The line was cynical, as
was she herself, for an extended tour – as had been announced beforehand in
the *New York Times* – simply had not materialized, with the exception of that
singular recital in Minneapolis. New York had not called for her, and that was
disappointing.[404] Later, in Atlanta and with Krause gone, Lehmann could relax
somewhat at the home of the Hechts on Peachtree Battle Avenue. Again she was
interviewed by reporters, and in her droll English she embarrassed herself in
this town in the land of Dixie by flogging jazz – where it had originated. "Jazz?
I detest it. Yes, it is quite popular in Europe. But good music goes on weaving its
spells."[405] Good music? Did she really mean this, or was she jealous of popular
music's commercial success? On the way home by December 5, on the liner
Bremen, she was sailing with a nephew of her revered patron Baron Konrad zu
Putlitz. Wolfgang zu Putlitz was returning from a German diplomatic posting
in Washington. With them sailed Marlene Dietrich, traveling back to Berlin

for the first time since her Hollywood début. Putlitz desperately wanted the famous prima donna to introduce him to the famous film star. But Lehmann's eyes were glued to the slender figure of La Dietrich every time she walked by, and when she did, the prima donna began to sing Lola Lola's song, quietly, but in what she thought was a very smoky voice: "From head to toe, I'm made for love...." Dietrich had sung Friedrich Hollaender's song in her famous film of a few months before, *The Blue Angel*, to the accompaniment of a jazz band. Lehmann did it again and again until Putlitz finally told her to stop, for she would never get it. Lehmann continued nonetheless until the end of the journey: "From head to toe, I'm made for love...."[406]

As interesting and novel as much of this tour had been, back in Vienna the soprano was glad to be able to recover from the shocks and disappointments of her first sojourn in the United States. She starred as Elisabeth at the Staatsoper on December 21 and found the reaction of her homegrown audience so much more congenial than that of "those stupid Chicagoans." Having merely attained what she thought was an average success in America was not good enough; she was not closer to the Met than before and had not even had a recital in New York. However, her U.S. manager Coppicus rescheduled that for 1932, and 1931 turned out to be the year in which her Viennese salary was beginning to be reduced. With Bruno Walter gone, Berlin too was no certainty, and with her husband earning little or nothing, she could not simply dismiss new opportunities in the New World. Besides, there had been noises about her possibly being welcome at the Met, if only her enemy Jeritza could be neutralized. And so she decided to honor her second invitation from the Chicago Civic Opera for 1932 after all.[407]

She sailed for New York – this time by herself – on December 29, 1931. Her first New York recital in the Town Hall was to be on January 7, and she was surprised to hear from Coppicus that it was already sold out. After the event, Downes's triumphant review in the *New York Times* was not the only one; there were similarly hymnic pieces by other New York critics – for instance, William Henderson and Irving Weil.[408] Lehmann's quest for satisfaction was fulfilled when she noticed that next to her dear friend Viola Westervelt, her longtime idol Geraldine Farrar was also in the audience.[409]

At the Chicago Opera she starred as Elsa and Eva from January 13 to 29. As the Civic Opera was still affluent, she had been guaranteed eight performances at $1,000 each. This was a lot for her, but still modest when compared to other contracts. Unbeknownst to her, Leider was being paid the same amount but had twenty-five guaranteed performances; Claudia Muzio got $1,700 and twenty performances. The highest-paid singer was Tito Schipa – thirteen performances at $2,000 each. But in Chicago Lehmann only sang three Elsas and one Eva, with an additional Elsa in Boston on February 4, on the Civic Opera's contractual tour there.[410] The reviews were the usual accolades, but this time also contained some criticism of her high notes.[411] Having sung only five times out of the required eight (though this was not her own doing), Lehmann sensed that she was getting too expensive for Chicago – and still she had nothing definitive from the Met. Of course, she could not know that the Chicago Opera was near bankruptcy and about to crash.[412] The singer rounded off this second

American tour with yet another recital in Town Hall on February 7; she sang to "the largest audience" that the hall had seen that season and was declared the creator "of the most distinguished singing of this season and many others back."[413]

Lehmann and Krause left Europe for her third tour of North America on November 17, 1932, to give concerts in New York and, after a long train ride to California, where they initially arrived in Los Angeles, in Berkeley, San Francisco, and Sacramento. She then traveled to Kitchener-Waterloo, Mennonite country west of Toronto; the Canadian Mennonites were known to love music. Thereafter she went southwest to St. Louis, then back up again to Minneapolis and from there to Winnipeg (more Mennonites). That was followed by performances in Philadelphia, New York, Oberlin, and Boston; Oberlin College was renowned as an artistically oriented institution. She rounded off her journey at New York's Town Hall once again, so that she arrived back in Cherbourg on March 4, 1933.[414]

In Philadelphia as well as during the second visit to New York, from January 23 to 29, she sang with Bruno Walter, conducting the New York Philharmonic; he also accompanied her at the piano. But her regular pianist on the American tour now was Ernö Balogh, a thirty-five-year-old Hungarian and former student of Béla Bartók and Zoltán Kodály. He had lived in New York City since 1924, had helped Bartók on his first American tour in 1927, and was an experienced recitalist. The singer had probably met him through the good offices of her New York manager Coppicus. At first the two got along very well, in musical and human terms. "Lehmann radiated a constant glow of warmth," Balogh later remembered fondly, "she could mould an audience after a few songs into a happily united group which seemed to enjoy a holiday reunion." She loved him especially for his "magnanimity and loyalty," a man not afraid to share in the grueling hardships of long-distance travel and a European who could make her understand those strange American idiosyncrasies, the gas stations, keep-smiling commands, power advertising, and concert-sponsoring women's clubs.[415]

Lehmann still did not like America much, especially not the large and impersonal cities and the – for her – incomprehensible routines and taboos in social relations.[416] But this changed completely after she had visited California. Mia Hecht had originally wanted her and Krause to spend Christmas with her family in Atlanta, but Lehmann opted for a stay in Florida, until she remembered that she would be in California just before and could spend Christmas in either of two places she had just heard about, "Santa Barbara or Coronado Beach, both near Los Angeles." As it turned out, after singing in the Bay area, she and Krause vacationed in Santa Barbara, where they stayed in the Samarkand Hotel and every day went riding on white beaches. She fell in love with the place and decided to return at all costs.[417]

It was not just the beauty of the scenery and the temperate climate of the Pacific West that slowly made her change her mind about America. It was the people also. In New York's Carnegie Hall, Eleanor Roosevelt, whose husband had just been elected president, led her onto the stage, before giving a short speech on behalf of unemployed women in the Depression. Olin Downes, who

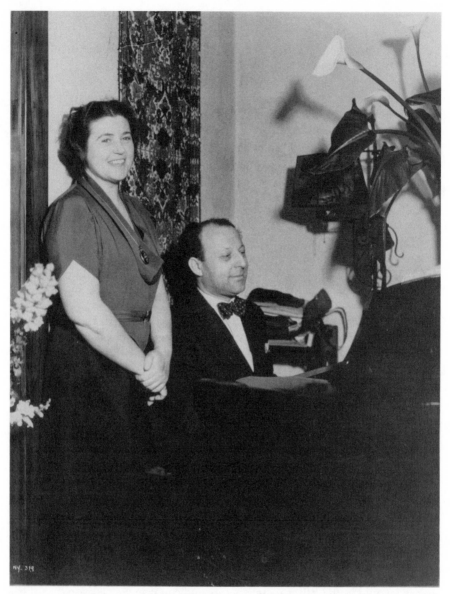

FIGURE 9. Lotte Lehmann and Ernö Balogh, 1934. Courtesy Special Collections, Davidson Library, UCSB.

moderated one of her recitals, received her privately for tea, telling her that in her case he was not a critic, but instead was lying at her feet – an outrageously dishonest compliment perhaps, but one that thrilled an artist like Lotte Lehmann. Another person who extended her friendship to Lehmann and helped her understand things better was Lily Petschnikoff, the widow of the Russian violinist Alexander Petschnikoff, whom Lehmann had met earlier in Berlin. Petschnikoff was originally from Chicago and was now living in an

ivy-covered house in Hollywood, where her son Sergey was involved in the film industry, which also intrigued the singer.[418]

Critics like Downes and lieder and aria recitals in college and university settings such as Berkeley and Oberlin taught Lehmann about the high level of musical taste and discriminating standards in the United States, which in typical European fashion she earlier had either tended not to notice or dismissed out of hand. In fact, on this, her first extensive American tour, whereas praise for her art abounded much as she was used to from her European essays, reviewers did not lack informed judgments. Significantly, their criticisms revolved around vocal technicalities much like the ones she had always been caught on, even if a hundred times outweighed by the near-perfection of her singing. Hence overpowering emotions getting in the way of her delivery of melody were rued after her recital at Carnegie Hall on November 28 and again at the final Town Hall concert on February 25.[419] Voice forcing in high registers disturbed critics at the Carnegie Hall recital as much as when she later sang with Walter.[420] And insufficient breath control was mentioned after the Carnegie Hall début.[421]

Thus far, each American tour had been important to Lehmann for a specific reason. The first had introduced her to the continent and opened it up through the portal of the Chicago Opera. On the second tour, the discriminating music lovers of New York had got to know the singer through her first Town Hall concert. During her third tour, Lehmann had learned to appreciate the West Coast and, through this, received a new and positive understanding of America's customs and people. And the fourth tour in early 1934 was to become significant to her because of the entry it provided to the Metropolitan Opera.

Lehmann and Krause arrived again in New York on January 4, 1934. Since the last trip, her situation with the Americans had solidified; she had signed a recording contract with RCA Victor and had had the benefit of rehearsing with Balogh during his stay in Europe. Balogh had the additional advantage of advising her regarding her dealings with Coppicus, who would soon be his manager as well.[422]

Lehmann's contractual agreement with the Met was not generous; its leanness was contingent on the financial straits the Opera still found itself in – the danger had by no means passed. Guarantees had been provided in 1933 to prevent complete and imminent collapse. But in early 1934, when Lehmann had just arrived in New York, Eleanor Robson Belmont, an influential new director on the Met board and a millionairess, was informed by Kahn's successor, Paul Cravath, that "unless real money were found within a month, a notice would be placed backstage indicating the Metropolitan Opera must end its career." More money was secured, but the season remained abbreviated, and the kinds of honoraria Chaliapin and Gigli had been commanding – $3,000 per performance – could no longer be paid. A new ceiling of $1,000 per singer/event was set, and Lehmann received only $600, for just two appearances each initially, Sieglinde and Elisabeth, until a third one for *Die Meistersinger*'s Eva could be added.[423] The other singers of German tongue to be enlisted during that season were males: the Austrian bass Emanuel List (who held U.S. citizenship as well) and the German tenor Max Lorenz, who had returned after an absence.[424]

To be sure, Lehmann's tour included not just her coming out at the Metropolitan, but also recitals in New York, in addition to those in Buffalo, Chicago, Milwaukee, and several other places in the northeastern United States, and even a sojourn in Havana.[425] But her big evening was her début at the Met under the baton of Bodanzky on Thursday, January 11. For the *Walküre* feature of that night, Lehmann's Siegmund was her old friend Lauritz Melchior, of whom she later said that she had always been his Sieglinde, and he always her Siegmund.[426]

For her, the long-sought-after event became another triumph. The record producer and music impresario John Coveney was eighteen when he attended that staging of *Die Walküre*; he was not one of the lucky 3,500 who could sit down in the auditorium, but could afford standing room only. He was enraptured and never forgot the performance. "Every nuance of Sieglinde's character was implicit in the shadings of her beautiful voice, and explicit in her appearance and actions; her musical and dramatic instincts, unerring." Downes's colleague Hubbard Hutchinson wrote in the *New York Times*: "Her finished phrasing, precise in definition yet always plastic, and her crystalline diction, were no surprise. Yet even her admirers in the recital field were not altogether prepared for the other qualities she brought to her superb impersonation; the dramatic fire, the capacity to endow the vocal line with a breadth befitting Wagner's immense canvas yet to retain always the purely musical finish she might have bequeathed to a phrase of Hugo Wolf; her telling restraint and sureness as an actress. At the end of the first act a cheering audience recalled her seven times."[427] Two weeks later, Downes found her Elisabeth a figure of "dramatic logic and a virginal intensity of feeling," and not quite a month after that he pronounced her Eva as possessed of "warmth and sincerity."[428] Lehmann's conquest of the Metropolitan was therefore complete, although she also gave recitals in Town Hall, at the ballroom of the Waldorf-Astoria Hotel, and at Columbia University. And with Toscanini she sang on the radio *Cadillac Concert*.[429] Lehmann was extremely pleased that March – if emotionally totally exhausted, in large part due to Toscanini – and she was hoping for more.[430] Before she left again for Europe, she accepted a contract proposal from Coppicus to appoint his firm "sole and exclusive agents" for the United States, Canada, and Cuba, excepting the Metropolitan. Her average fee was to be 1,350 dollars per event. The contract was only for the 1934–35 season, but could easily serve as a blueprint for future years.[431] It was an option the singer might have to make use of, depending on her fortunes in Europe.

A copy of the contract went to the Manhattan-based Constance Hope, who had been engaged in 1932 as Lehmann's public relations manager for the United States. She became a new, important factor in the singer's life and one on which a continuous professional presence in America would depend. In a way, her appointment was the result of phenomena Lehmann found to be typically American and, originally, repulsive. One of these was the tendency in New York, Chicago, and Hollywood to pry and then drag the most intimate details of an artist's life into the open and abuse them for publicity. At first Lehmann had no idea that publicity in the United States was at all necessary, especially for a European artist like herself whose name was a household word among the

educated from Vienna to Berlin, from Prague to London, but not in America. So when during her first tours of American cities she was being asked about her husband (who had to leave early on the first tour) or her pets, she was annoyed. The banalities were endless. In Minneapolis, she heard herself saying to pestering reporters: "I weep and I weep and I weep until my husband he tell my friend Mrs. Hecht to spank me," in what she explained was "English-English, not American-English." In early 1932, Americans were treated to the overwhelming news that she, the overweight lady, liked "all food, particularly vegetables," whereas she hated the Hungarian goulash "that her husband, Otto Krause, especially appreciates."[432]

At first Balogh, who knew a thing or two about America from his own professional work there, especially after the problems he had had with Bartók's tour, assumed the task of basic publicity, beyond the things that manager Coppicus could not handle. He volunteered to deliver ad materials to the *New York Times*, especially when rumor had it that Lehmann was to be invited to the White House to sing for the new president – a false rumor, as it turned out. Lehmann could go along with this as long as it did not get under her own skin, but when Balogh informed the newspapers in one of his press releases that Lehmann's mother had just died, she furiously reproached the poor man.[433] Before that happened, and doubtless because he found this side job onerous, Balogh already in fall 1932 had conspired with fellow Hungarian Krause and Coppicus to hire a person ready to assume these tasks.[434]

That was Constance Hope. In 1932, this daughter of the concert pianist Eugene Bernstein was twenty-four years old, had graduated from Barnard College of Columbia University and then had become the personal secretary of opera star Grace Moore. Lehmann later said of her that she would use any item vaguely suitable for publicity, unscrupulously, even if she had to make it up. Indeed, Hope could make things happen. In 1931, she had arranged for Moore to rendezvous with the handsome socialite Val Parera, after they had all met on an ocean liner (and after Moore had stopped seeing the skirt-chasing Otto Kahn, with whom she had had an affair early in her life). Parera proposed marriage on that trip. It is no wonder that Moore, who sang at the Met from 1928 to 1932, when she went to Hollywood to star in pictures, remained Hope's friend for life, until she died in a plane crash near Copenhagen in 1949.[435]

The brash New Yorker had formed her public relations firm Constance Hope Associates on a shoestring budget by early 1933; it was located in downtown Manhattan, and Lehmann was her first client. Overlapping with Balogh's last publicity efforts, from now on she would manage the singer's success in the United States, and that included relations with her manager Coppicus (who had also been Moore's manager).[436] Hope was a dynamo of a person with chutzpah to spare, talented in music as much as in languages. Lehmann, whose English was still halting if steadily improving, could speak and write to her in German, and Hope, as well as her assistant, Edith Behrens, could respond in kind. By early 1934 Hope, who evidently knew what was going on between Lehmann and Toscanini, was making suggestions regarding advertising, contracts (via Coppicus), whom to see, and general publicity strategies. When a private dinner was held on Park Avenue in honor of the Krause couple and Balogh, Constance

Hope along with her mother was also invited.[437] When Lehmann was leaving New York in March 1934, after her fourth American tour, the singer was quite happy to have Hope. She wrote her a letter from the steamer, thanking her and saying that her life was one big rat race, but this was just how it was, "and it is well that it be so. I do not want it any other way."[438] Lehmann would yet have to make up her mind whether she wanted it to go on like this back in Old Europe or in the New World.

4

Between Third Reich Seduction and American Opportunity

Lotte Lehmann, the Lion, and the Third Reich

In 1966, Lotte Lehmann published an article entitled "Göring, the Lioness and I." In it, she told of a meeting with Hermann Göring, the Nazi minister of education, his fiancée, Emmy Sonnemann, and the director of the Berlin State Opera, in approximately 1933. She had "never taken any interest in politics" and knew "next to nothing about Hitler." The meeting with Göring had come about because she had received a telephone call from the Opera director, saying that Göring personally was inviting her for "a few guest appearances." Doubting any material improvement, Lehmann wanted to dismiss the invitation right on the telephone. But the director assured her that "you will get whatever you ask." The singer then agreed to come to Berlin for an interview during a recital tour to Germany in four weeks' time. Sometime later, when she was giving concerts in Germany – the soprano did not remember in which town – an official tried to interrupt her in midsong to get her to answer a telephone call: it was the minister's adjutant. He was brief: "Frau Kammersängerin, we shall be expecting you here at the aerodrome at eleven o'clock tomorrow morning. May I ask you not to be late."

The next morning she proceeded to make her way to the plane. Soldiers were barring her, but her name worked wonders: "I was escorted as if I had been at least a princess." At the Berlin airport, the director was waiting for her. "He looked thin, and his face seemed tired and anxious." He was nervous, and at one time his voice was trembling, because he was afraid Lehmann would be too forthright with His Excellency. After regaining control of himself, he said that Göring wanted the singer for the Berlin Opera, "not only as a guest artist, but as a permanent member of the company." Any conditions and personal wishes would be granted, as long as she did not anger Göring.

At the Education Ministry, Göring kept them waiting; it happened to be Hitler's birthday. Finally, Emmy Sonnemann entered, and then the minister, with a riding crop and a wide knife in his belt. After some bantering, which included stabs at Lehmann's personal friend Kurt von Schuschnigg, Göring broached the subject of a contract with the Berlin Opera. But she said to him, under the imploring looks of the director: "I am not in the habit of discussing contracts between a knife and a whip." (Later the director told Lehmann this remark could have gotten her into a lot of trouble, but it was probably a new experience for Göring to be so challenged, and her fearlessness obviously

pleased him.) The singer was then offered a fee, "a fantastic amount. I think I could have asked double." She would also be given a villa, a life pension of a thousand marks per month, and a riding horse, so that she could have morning rides with Göring. When he asked for a special wish, the singer mentioned, laughingly, "Oh yes! I should like a castle on the Rhine." This later made the rounds in all of Germany. In concurring, Göring expected the prima donna never to sing outside of Germany again. When Lehmann protested and insisted that music was an international language, Göring reminded her icily that she was, "first and foremost," a German. At this point the director was looking on in "deathly terror." So Lehmann half agreed to a contract with Berlin, taking the Germany-only provision not too seriously. Göring, "highly delighted," ordered the contract to be drawn up at once, adding his personal guarantees for everything promised. Lehmann laughed at Göring's additional remark that no critic would be allowed to write bad notices, otherwise he would be "liquidated." Sonnemann, although suspicious of her fiancée's interest in the diva, had been rather silent thus far, except for saying: "What good fortune it will be for you to be allowed to sing for our Führer!"

After lunch, Lehmann remembered that the timid director had mentioned in the limousine that the minister had a lioness. In order to further relieve the tension, she now asked if she could see the feline, not in the cage, but free. The director blanched, while Sonnemann frowned and averred that Hitler was too concerned over the "priceless life of His Excellency" to have it put at risk. Nonetheless, Göring delighted in telling Lehmann that the lioness had recently torn a workman's trousers, so that "the coward nearly died of fright." Then the lioness entered, came over to the singer, "and she, Göring and I looked out of the window." On the way back to the airport, the director expressed how frightful a day this had been for him, and that she did not have the slightest idea "of what you were risking."

When Lehmann received the contract, "it contained no word about all that Göring had promised," and so she complained to the director, in a "very honest and frank letter." This letter, intended solely for himself, he showed to Göring and Hitler. But at the time of committing her reminiscences to paper, Lehmann had forgiven him, for he had had no choice. Because it was intercepted, the letter must have been read by many others before him. "Had he tried to keep the letter secret, it might well have meant his end."

For in it Lehmann had said that she refused to sing only in Germany and that the guarantee "for all the extravagant promises" was missing. "And what would happen if Göring were to lose his position?" And where were the opportunities for "guest appearances" in America and her "beloved Vienna"?

The result was that henceforth Lehmann was "forbidden to sing in Germany." Reportedly, when Hitler saw the letter, he had a fit and may well have chewed through yet another carpet. Göring dictated a reply, "a terrible letter, full of insults and low abuse. A real volcano of hate and revenge."

Lehmann concluded her story with the remarks: "That was the end of Germany for me. Hitler's Germany!" Later the Nazis tried to get her back with promises; all would be forgiven and forgotten. Her Viennese lawyer was commissioned to persuade her to return when she was concertizing on the

Riveria. However, "my eyes had been opened to their crimes, and nothing would have induced me to return."[1]

Thus far Lehmann's chronicle. It was based on an actual meeting with Göring and Heinz Tietjen, whom she had never mentioned by name, in Berlin, on April 20, 1934. But the course and consequences of this meeting were different from what Lehmann had written. Before she published her carefully constructed story, she had penned a few drafts to be used in building a personal legacy for Lotte Lehmann, the anti-Nazi and almost-resistance fighter against the Third Reich. In order to support this victim legend and add to her heroic image over time, she allowed bits and pieces of this tale to slip out, as soon as she thought it was both safe and expedient to do so. (Potentially held hostage, brother Fritz lived in the Third Reich until 1939.) The legend grew, commensurate with her increasing conviction that as a professional alternative to Vienna her old haunts in Berlin were losing currency and America was gaining profile. In America, the legend had to be accepted as nothing less than truth.

In the summer of 1934, as soon as Lehmann knew that a contract with Berlin would not materialize and certain that as a Jew he would sympathize, she informed her Paris agent, Heinz Friedlaender, that because of the "scandal" with Göring she had declined his offer.[2] Half a year later in America, she found it opportune to tell the influential journalist Marcia Davenport that Göring had tried to confine all her singing to German stages and that "on artistic grounds" she refused and was flown back to Vienna.[3] A few months later, the *New York Times* learned from her that she had not sung in Germany for the last two seasons.[4] To her old Hamburg friend Magda Hansing she wrote in 1936 that she had been asked to sever all business ties with Jews – something that she did not even mention in her 1966 story.[5] This she complemented in 1938, after the Anschluss of Austria by Hitler, with the assertion that she would have left Central Europe even if she had had nothing to do with Jews.[6] Later that was amplified to mean that she herself had been accused by Göring of having "a Jewish junk-dealer's soul" and that she could not have returned "without endangering my life."[7] By 1940 she was telling her friends that she was banned from Germany and prohibited from singing there.[8]

As Lehmann slipped more and more into the role of a personal enemy of Hermann Göring, she fabricated a broader political canvas against which to view this very specific fate. Here she employed two scenarios interchangeably, an older one that artists always like to use – that of an essentially apolitical person[9] – and a newer and sharper one fitting the increasingly monstrous reputation of the Nazis: that of an all-round enemy of fascism. She invented the persona of an outspoken adversary of Göring, who stood on principle, for her friend Magda in 1935, and that of an enemy of racism when writing Mia Hecht, whose husband was a Jew.[10] After World War II, her standard line was that she had always been a fanatical opponent of National Socialism, that the Nazis knew this and hence compelled her to leave Central Europe for "purely political reasons."[11] She reached the apex of such argumentation when she maintained, in 1955, that many in America thought she herself was Jewish, "because I was such a fanatical anti-Nazi."[12]

Lehmann's efforts bore much fruit, of the kind that she had wished to seed. Already in 1948 Friedelind Wagner, the friend of Toscanini, helped cement her anti-Nazi political reputation when she wrote that Göring had given the singer a choice "of accepting engagements in Germany only or finding the borders closed to her for ever."[13] This was more loosely interpreted by others to mean that Lehmann had been "summoned to Berlin" and that the man who had intercepted her in Dresden had been an SS officer.[14] It was said that Lehmann had "renounced her native Germany" in 1933 and, being expressly forbidden, had not performed there after Hitler's ascension to power. Lehmann's friend Erika Mann, who simply loved her lion story, Furtwängler's former secretary Berta Geissmar, fellow soprano Astrid Varnay, and her first biographer, Beaumont Glass, all pandered to the last-mentioned myth.[15] Lehmann, just as she had made it out to be, was credited with political acumen and courage for having stood up to Göring and Hitler (who, one source said, had personally been behind the summons) by protesting vigorously against the criminal regime.[16] Thus, "trembling with rage, she walked out."[17] And she of course would have been mercilessly persecuted had she stayed, what with her prior massive protests in the name of humanity.[18]

What really happened can be explained on the basis of correspondence that Lehmann later thought was lost but that, having survived World War II, I discovered in an obscure archive in Vienna. The events that transpired did so as the result of a confluence of two themes: one the planned reformation of the Prussian Staatsoper, the other the professional ambitions of Lotte Lehmann. As far as the Opera was concerned, its fate after Hitler's *Machtergreifung* was in the hands of three men: Hermann Göring, Heinz Tietjen, and Richard Strauss. Göring was president of the German Reichstag in Berlin after the Nazis' landslide parliamentary victory in July 1932, and even before the Nazis' final triumph on January 30, 1933, he met with Tietjen to discuss the Opera's future. Göring, who came from an educated upper-middle-class background, knew that he would be appointed not education minister, as Lehmann had written, knowing it was wrong, but minister president and minister of the interior of Prussia. In both capacities the State Opera would fall within his jurisdiction. By no means ignorant of traditional culture and its consumers, he desired as little change in Prussia's cultural landscape as possible – unlike his rival Joseph Goebbels, who as Reich propaganda minister would soon assume control over most other cultural institutions in Germany. For his purposes Göring was counting on the proved expertise of the urbane Tietjen, wanting him to maintain the Prussian Staatsoper in its traditional form and, if possible, even to upgrade it, for it had suffered much during the ongoing Depression. Goebbels, meanwhile, was in charge of the municipal Opera over which Tietjen had lost stewardship in 1930, trying to propel it in a more pronouncedly National Socialist direction and thereby diluting its quality.[19]

Tietjen, not anything near like the pusillanimous weakling Lehmann had characterized him as in her 1966 story (and as she herself had never known him), but instead a totally controlled, manipulatively aware if enigmatic figure, seized upon this opportunity to remain in his accustomed position of influence under the Nazis. Cognizant of standards, he could not but agree with Göring

that the Staatsoper needed improvement and that Goebbels's half-baked ambitions at the municipal Opera would have to be checked. Tietjen, who had been given carte blanche by Göring after January 1933, also may have realized chances to shield veteran Jewish artists who otherwise would have been curtailed in their professional activities, if not driven out of the country. (He thus protected the conductor Leo Blech and others for years.)[20] Regarding all of this, he knew himself to be in agreement with Strauss, potentially an additional check on Goebbels, as he had been elevated to the presidency of the Reich Music Chamber created by the Reich propaganda minister by November 1, 1933. If the State Opera could maintain, or even improve, the artistic quality of its core performers and salvage a traditional repertory, Goebbels would get nowhere with his municipal stage. Since Tietjen and Strauss were old friends, the intendant could introduce the composer to Göring and hence deploy him against Goebbels.

Strauss was looking for allies in achieving broader reform goals; hence while he engaged in discussions about music policy with Minister Goebbels, he also met with Hitler and conferred with Göring, in the second half of 1933 and early 1934.[21] He told Göring not only that his Opera would need more money, but also that the repertory would have to be moved more out of the French and Italian realms and into the German one. For Opera singers, he deplored the low wage ceilings so long enforced by the Deutscher Bühnenverein and, having consulted about this beforehand with Tietjen, urged the establishment of a "special class" of singers, who should receive superior emoluments, not least to forestall their notorious practice of absconding to America.[22] Göring responded jovially that he had already neutralized the Bühnenverein (not yet true) and that, in accordance with Tietjen's views, he was planning to attract "great artists" to Berlin at once. He was especially looking to Vienna and wanted Strauss's help in making his stage "the best Opera in the world."[23]

These plans fortuitously coincided with Lehmann's personal ambition to get away from Clemens Krauss as much as possible around that time, either by singing more in the New World or, as she had contemplated so often before, by establishing a more or less permanent base in Berlin. All politics aside, money and enhanced career opportunities seem to have been her only motivation. The question then arises how much she knew about the Nazis both in Austria and Germany and, if she did know, how much she was affected by moral qualms. In Vienna, she must have been aware that up to one-third of the Staatsoper's orchestra members were National Socialists – openly until the Dollfuss regime declared that party's Austrian branch illegal in July 1933.[24] Even before Hitler's *Machtergreifung*, Lehmann's German concerts were reviewed favorably by the Nazi daily *Völkischer Beobachter* – at least one notice she clipped and pasted into her scrapbook like all the others but, in this case only, carefully penciled in the provenance.[25] One day before Hitler took power, on January 29, 1933, she was singing with Bruno Walter at the Brooklyn Academy of Music, and two days later she was a guest of the German ambassador in Washington, while Walter stayed away.[26] One wonders how she reacted to friends like Emmy zu Putlitz, who wrote to her how much she welcomed the "new Germany," but also to others like Walter, who was booted out of his permanent guest

conductor posts in Berlin and Leipzig in March.[27] Walter, already an Austrian citizen, chose Salzburg as his new European base, and there were many other German musicians who provisionally moved to Austria and could have made Lehmann think.[28] The admired Toscanini headed a much-publicized protest against Hitler in April, which eventually resulted in his refusal to conduct at the Bayreuth Festival.[29] In late summer, the pianist Ernö Balogh described to her the plight of her Berlin agent, Erich Simon, whom he knew to be on the run from the Nazis and who had had a terrible breakdown, while Walter conjured up memories of the past and implored her to keep the faith. At the same time Lehmann thought nothing of writing to her Odeon record producer in Berlin recommending a German friend for a job, whom she described as very qualified and "(very important!) in the National Socialist Party."[30]

Indeed, after January 30, 1933, Lehmann continued her German professional contacts as if nothing had happened. The fact that both Strauss and Furtwängler, two of her favorite conductors, were ostensibly in the service of the Third Reich early on merely reinforced her.[31] That she might create Arabella in July in Dresden was not an issue for her, and when she stayed away it was not meant as an embargo of Hitler's regime. During 1933, she gave six performances in Nazi Germany and managed two recording dates, and she enjoyed vacationing in Westerland during June and July.[32] That on November 9, a Nazi High Holiday, she performed at the Gewandhaus in Leipzig, Walter's old haunt, must have been particularly galling to the conductor. On November 13, she sang in Berlin under Furtwängler's baton, as Strauss was initiating the Reich Music Chamber there. Strauss's friend Hugo Rasch, a Storm Trooper and music critic at the *Völkischer Beobachter*, enthused that Lehmann's art was opening a new era of Nazi-organized music in the Third Reich, lauding her "unblemished way with song."[33] But later in the month, after observing this activity, if not Walter himself, his wife Else had had enough. In an earnest letter, she chided Lehmann for her insensitivity, merely for the sake of money, while decent artists such as Toscanini were placing sanctions on the country. "How I deplore the fact that you sing so much in Germany," she wrote. "You know very well that all artists who have been excluded from Germany, Aryan and non-Aryan, German and foreign, heartwarmingly declared their mutual solidarity and stayed away. It would have pleased me if you, too, had joined that protest and intermittently had turned your back on Germany."[34]

The contact between Lehmann and Göring was facilitated, over several months in 1933 and 1934, by Furtwängler, Tietjen, and Robert Heger. Kapellmeister Heger had been at the Vienna Staatsoper since 1925 and conducted performances during several German seasons under Walter at Covent Garden. He and Lehmann had become good friends. Strauss was dismissive of him, because of the uninspired way in which he conducted his operas, and Heger also had problems with Krauss.[35] He had been born 1886 in Strasbourg when it was part of Bismarck's Reich, but now it was the capital of French Alsace, which Heger could not accept. Driven by nationalism, he was in the process of creating an opera, *The Lost Son*, which had as its main theme "the swarming of peoples back into their home-specific landscape spaces."[36] Imbedded in such convoluted language was a *völkisch* theme in the manner of the Nazis,

who were now constantly wallowing in blood-and-soil propaganda. Indeed, after the momentous change in Germany Heger had given notice to the Vienna Staatsoper, so that in September 1933 he could start in a new kapellmeister post under Tietjen in Berlin. (He became a Nazi Party member four years later.)[37] Since his relationship with Furtwängler was as excellent as his relations with Lehmann, he eagerly supported the maestro's attempt to engage the soprano for *Arabella* performances in Berlin, after her scheduled Vienna début in October.[38]

While these appearances did not materialize, on October 30 Lehmann concertized with the Berlin Philharmonic under Furtwängler, and in preparing for this event, the two artists' mutual respect deepened.[39] The concert itself, in which Lehmann sang three Strauss songs, was a huge success.[40] Meanwhile Heger had learned, whether from Tietjen or Furtwängler, about the reformation scheme involving the Berlin Staatsoper. Sometime in November, after he had set some of the singer's own poems to music, he got together with her to discuss this matter, and since Lehmann did not wish to appear too eager by approaching anyone in Berlin directly, they decided that Heger should speak with Furtwängler about her possible relocation to Berlin. Furtwängler immediately approached Göring, who was totally in favor. An opera lover himself, Göring naturally knew who Lehmann was; but the fact that the actress Käthe Dorsch, a former intimate, was the singer's friend may also have helped. Heger had suggested a Berlin engagement on a trial basis – twenty guest performances at the Berlin Staatsoper for at least 1,500 marks each, which was Lehmann's current German rate, and she agreed that this was a good starting point.[41]

The matter then took its course. In early February of 1934 Tietjen telegraphed Lehmann in New York, asking her if she could return to Vienna via Berlin to discuss these prospects. In two subsequent letters he explained that the Staatsoper was seeking an exclusive contract with her (to eclipse Goebbels's municipal Opera), and that she should try to reserve as many non-Vienna vacation days for Berlin as possible. The Prussian minister president was enchanted, and her honorarium would be generous. Back in Vienna in late March, Lehmann talked to Tietjen on the telephone and, extremely pleased, in principle agreed to a forthcoming contract.[42] On April 2, Göring personally sent her a telegram, expressing his delight and offering to fly her to Berlin in his private airplane, to meet with her in person and fine-tune the contract.[43] Lehmann cabled him thanks with all her heart and asked him for his plane on April 20, in the morning at the Leipzig airport, if she could be back that night in nearby Dresden.[44] Ironically, on the very day of her telegram, Rudolf Bing, who as a Jew had also been forced out of Berlin, wrote her that he had just accepted a posting in Glyndebourne, England, where he had been asked by the millionaire John Christie to organize a new, permanent music festival; would Lehmann not be interested? This represented the singer's last chance to escape from the Göring affair: had she been as leery of the Third Reich as she later claimed she was, she could have chosen Bing's over Göring's invitation, thus avoiding the hot spot she was now getting herself into.[45]

Shortly before April 20 – it would be Hitler's forty-fifth birthday – it was clear that Lehmann had to do a recital on the nineteenth in Dresden, and another one on the twenty-first in Leipzig. She would have to take a train from Dresden

to Leipzig early on the twentieth and then be back in that city for the concert the next day. And so it actually happened. Göring's aide phoned during the Dresden recital to give last-minute instructions for catching the flight the next morning. Early on April 20, as Lehmann walked to Göring's swastika-adorned plane, "Richthofen D-2527," someone took three photographs, which show a smiling Lehmann surrounded by at least two SS guards. In these pictures, her German accompanist Rupp is also shown; he often performed in Berlin. Upon arrival at the capital's airport, Tietjen, whom she had of course known well for nearly a decade, was there to pick her up.[46]

What exactly Göring, Tietjen, and Lehmann discussed at the official residence of the Prussian minister president is not known, for no minutes have survived. But much can be inferred from later comments. That a lioness was present is possible, for the eccentric Göring was known to surround himself with lion cubs at Karinhall, his retreat in the heath northeast of Berlin, and possibly kept some near his office in cages. Lehmann could have made this up as part of her yarn, but then she would not have asked Tietjen after the war whether he remembered the "lions."[47]

After the conference, which must have taken place around noon and most certainly included lunch, Lehmann sent Krause an "urgent" telegram saying: "meeting astonishingly positive. Fritz will tell all. A thousand kisses."[48] She had communicated with her brother before her husband, because his situation had been an integral part of the conversation.

Lehmann must have read much into her talk with Göring, for after her recital in Leipzig the following day, as she was proceeding to take part in the regular German season in London, she and Krause remained jubilantly expectant.[49] Toward the end of April and into May, as she was waiting for something final in writing from Tietjen and Krause was holding out in Vienna, she acted toward others as if the whole thing was a done deal. In particular, she gave the exiled Simon, who now could use the money badly, the impression that he would soon collect commission on the first twenty Berlin performances. (The poor Jewish agent then felt impelled to commend her on having secured such a wonderful arrangement with the Nazis.)[50] As the days were passing, Lehmann and her husband were becoming nervous to the point that Krause considered traveling to Berlin to speak with Tietjen. But the intendant, in control as always, let them know that such a visit was unnecessary.[51]

After Tietjen finally sent what he took to be a first contractual draft to London for Lehmann's consideration, she was sorely disappointed. As far as she could discern, there was a discrepancy between what had been mentioned in Berlin, and what she now was reading on paper. Her negative reaction may have been due to three factors. In Berlin she could have taken some of Göring's jocular remarks too seriously, as when he was promising her a castle on the Rhine. Second, by now she had such an elevated opinion of herself that she imagined the highest emoluments as being due as a matter of course, both during the Berlin discussions and thereafter, hence considering them granted when they had barely been mentioned. Not least, this process was abetted by the bane of her professional existence, which was greed. And third, while Göring had done all the wooing and charming at the table, Tietjen the realist

had been standing silently in a corner taking notes and, after the chatting, had calculated what was doable.

Tietjen's April 26 communication to Lehmann in London consisted of a contract proposal offering her twenty guest performances per Opera season from September 1, 1934, to August 31, 1937, and more, after agreement with Vienna. Lehmann was to sing exclusively at the Staatsoper and show up regularly for rehearsals. All performance dates were to be set by mutual agreement, and she was to receive RM 550 plus a complement of 450 per event.

What bothered Lehmann was that in order for her minimal honorarium of 1,500 to be met, an extra RM 500 was to be paid from a special minister president's fund contingent on Göring's person. "For example, he could die," she wondered in her answer, and in that case, would the Staatsoper revert to the meager basic contract? Also, her brother Fritz's appointment at her old Musikhochschule, which she had stipulated in Berlin, was not expressly mentioned. And what about a six-room flat, should she decide to move to the German capital, and why was there no word of her being anointed a *Preussische Kammersängerin*? On the other hand, she had no problem certifying instantly that her pedigree was fully "Aryan."

On May 16, Tietjen's reply to this, her letter of the eleventh, was devastating. He indicated that many of the clauses in question had been inferred and not put in black and white and that she was taking excessive liberties by making assumptions, such as the gift of an apartment. Hence Göring had been furious that "a racially arch-German artist," who was a quasi-Berliner, did not feel German enough to consider serving the German people a special honor. Her sentiment as outlined, that singing only in Germany did not interest her, had struck the minister president as cynically businesslike and something one could not possibly make public in the German Reich. Besides, one had talked about a preliminary contract first and a more permanent arrangement later and mentioned that under any circumstances she would receive sufficient vacation time to sing abroad. For Göring himself had an interest in exporting the fame of the Berlin Staatsoper, apart from fully understanding that she wanted to reap personal dividends from her international standing. As far as the money was concerned, did she not remember that there had been talk about a special bonus for her and that beyond that the Führer and Göring were in the process of establishing as a guarantee for artists like Lehmann a permanent, and generous, life pension? Regarding her brother, Tietjen had received him immediately after the audience, for a pedagogical appointment at the conservatory. This understanding, however, would now have to be revoked, as would the entire attempt to attract her services to the Prussian Staatsoper. And so, forthwith, the offer was withdrawn.[52]

Back in Vienna, Lehmann was shocked by Tietjen's response. On May 20 she sent a long telegram to Göring, regretting the "misunderstanding" arising from her letter and assuring the minister president that "my purely idealistic, artistic conception of my life's work is, and always has been, to carry German art into the whole world." This was part and parcel of her "international career," which she viewed not as a business, but a vocation. She pleaded with Göring to believe her and to consider the letter she had, simultaneously, sent to Tietjen.[53]

To him she admitted having erred. By confusing the guest proposal with a subsequent permanent one, she might have given the impression of a purely business-minded woman, which, however, did not describe her true nature in the slightest. Business was a "necessary evil," rather than something to live for. It would be painful to condemn her error, for "every error is excusable."[54] Notwithstanding these apologies, Tietjen curtly advised her on June 5 that Göring had decided to decline her "offer."[55]

What had happened was that, because of Lehmann's behavior and Göring's change of heart, a contract had never materialized, as Tietjen drily observed after World War II.[56] When that reality had sunk in during June and July, the singer had to take stock of her situation and decide what to do, vis-à-vis not only her business contacts in the Third Reich but also her new partners in America. For at the very time her recordings were being advertised in German trade magazines, she had a number of German concert dates in her appointment book, including one for Berlin in September.[57] Would it be politic to return? While she was pondering this dilemma, telling Mia Hecht that the Berlin guest performances had been voided by "a great clash," she received a letter from a Zurich-based emergency association representing anti-Nazi refugees, asking her to join. None other than Walter had added in his handwriting that "it would be very nice if you could lend your name." It may be doubted whether Lehmann replied as Walter had wished, for then a copy or draft of that letter would have survived in her records. Although the dealings with Göring were now over, perhaps there were other interests in the German Reich that could be salvaged – for instance, her regular income stream from Odeon recordings.[58] After Lehmann had told him what was necessary, already in the mold of the legend-in-the-making, Simon advised her from Paris that for now it might be wiser not to concertize in Berlin.[59] But in order not to burn all her bridges at once, she accepted a recital date in Reichenhall, Bavaria, for August, which she actually kept on the twenty-fourth, and she also sang in Munich on October 17. These turned out to be her last appearances on German soil.[60]

At the end of August, Friedlaender informed the singer that Wolff und Sachs, her agency in Berlin, had been instructed by Nazi authorities in a circular dated August 16 that henceforth, "a performance by Frau Lotte Lehmann in Germany was not desirable."[61] That was the official death knell for her planned recital in Berlin, and it signalized that the Prussian government had briefed the Reich Propaganda Ministry under Goebbels, which oversaw the rest of Third Reich culture. Late in October, when Lehmann sang again in London, she mentioned in a newspaper interview that although she had been born in Germany, she could not perform in that country as it was today. This was picked up by the Nazi leader Alfred Rosenberg's spies and carefully stored in Goebbels's Reich Music Chamber files.[62] By now it was obvious that to the extent that the Nazi rulers came to resent Lotte Lehmann, she herself wanted to be seen by the world as an enemy of the Third Reich.

Yet she still had to tread lightly for two reasons. One, her brother still resided in German Westerland, although he later moved to Vienna; but Austria was annexed by the Nazis on March 13, 1938. Second, she had unfinished business in Vienna. Even after the Anschluss, Lehmann wished to rescue the pension

that had accrued for her at the Vienna Staatsoper and to which she was legally entitled. So she decided to risk a double game. Although persona non grata with central authorities in Berlin and in the process of reestablishing herself in New York, she correctly surmised that far away in Vienna at the Staatsoper, she would still be remembered fondly. Hence in April 1938 she asked the Opera administration to be officially pensioned, indicating that she was currently living in the United States.[63] The Nazi chief (*Gauleiter*) of Vienna himself granted her this request, although Opera officials held that she, because of frequent absences, could hardly be said to have fulfilled her contractual obligations since her last contract (still under Chancellor Schuschnigg) of December 1934. The other qualms aired at that time touched on her failed negotiations with Göring. Vienna politicians had heard that she had wanted to move to Berlin but that this had been prevented, "because the material conditions, which the artist established, were supposed to have been unacceptable."[64] Nonetheless, because everybody in Vienna lovingly remembered "our Lotte," she was scheduled to receive a pension of 588.40 marks a month, later of varying amounts, beginning September 1, 1938, which was placed for her in escrow. Since Lehmann could not convert anything into dollars for use in the United States, the money was transferred to her mother-in-law Betty and daughter-in-law Grete Krause in Partenkirchen, minus some taxes she owed. The funds were paid into the account until August 1941, by which time the singer had collected, altogether, close to 17,000 marks. When she met with the lawyer Alois Klee in Deauville on the French Riviera during the summer of 1938, it was not because he wanted to persuade her to return to the Reich, as stated in her lion story, but to settle the details of her pension transfer. Her reason to meet him there was to look after her sick husband, en route to the United States; she did not concertize.[65]

In light of the fact that Lehmann, not yet a U.S. citizen, had automatically regained her German citizenship after the Anschluss of March 13, 1938, and Germany was at war with the western Allies by September 1939, her Vienna special treatment until August 1941 was quite extraordinary. And Lehmann did everything in her power to keep it that way. After the outbreak of war, she sent a declaration to her Viennese lawyer Klee, for use with the authorities, explaining: "My intention to visit Vienna this fall had to be reversed on account of the beginning of hostilities. I am therefore forced to continue my stay in America for the duration of the war. Because there is no other possibility for me to return to the German Reich any time soon, I am asking for permission to retain my pension as Kammersängerin of the Vienna Staatsoper in the German Reich, despite my foreign residence."[66] In February 1941, the Reich Finance Ministry expressly allowed Lehmann to reside – as a German citizen – in the United States while she was collecting her Viennese pension.[67]

Why the money transfer should have ended in August 1941 and not in December, when Germany declared war on the United States, can only be explained in terms of incrementally negative intelligence on her that the Gestapo was collecting and copying to Goebbels's files as of 1940. Already in December 1938, and unbeknownst to the Viennese, who were still trying to steer an independent course from Berlin, especially in cultural affairs, the Gestapo and the Reich Propaganda Ministry had colluded to place Lehmann's autobiography,

Anfang und Aufstieg, published 1937 in Vienna, on the index. Ostensibly, the reason was that she had composed a paean to Walter and favorably mentioned other Jewish artists.[68] By 1942 – Fritz was now safely ensconced in New York and Lehmann was forever vocal against the Nazis – the Gestapo had effectively denaturalized the singer, confiscating her property in her two Vienna residences (although in the basement of her Hinterbrühl villa and in Fritz's rented apartment some of her possessions had remained, including the Göring correspondence).[69] Owing to the Nazis, Lehmann was technically stateless from 1942 until June 1945, when she acquired American citizenship.

While in early 1934 Lehmann was hoping for a meeting with Göring even from New York, she had to be careful how she broke any of this news to her American friends, especially since the United States was also poised to offer her professional opportunities. At this time, and until she received the disappointing tidings from Tietjen early in June, she ideally would have wanted to stay based in Vienna for security reasons, with the freedom to work as much in Nazi Germany *and* the United States as feasible. It became obvious to her that she would want to move from Vienna to Berlin only if the German conditions were far superior and, this was important, if she could continue her sojourns in America. The latter possibility was indeed guaranteed to her by Göring. Alternatively, in the first half of 1934 a complete move to the United States could become viable only if she were to be overwhelmingly welcomed there (which had not exactly happened from 1930 to 1933) and if eventually she received an offer from the Metropolitan that was nothing short of spectacular. As it turned out, she decided to stay in the United States permanently only in 1938, once she knew she was not wanted in the Third Reich and Vienna had become part of Hitler's fief, where her four half-Jewish stepchildren were endangered.

Even before she sailed for America in January 1934 and then met with Göring back in Germany, Lehmann was perfectly aware of the disposition especially of her New York audience and of her sympathetic collaborators there. Already in 1930 it could not have escaped her that of the city's close to seven million inhabitants, up to two million were Jewish, and that New York's musical public had grown from a predominantly German-American to a German-Jewish-American one. The *New York Times*, which was hugely influential as a base of expert music critics, was published by the Jewish Adolph S. Ochs.[70] Toward the end of 1933, when the extent of Hitler's first acts of anti-Jewish discrimination had become sufficiently known, the *Times* was running scathing reports on the interrelationship between the decline of Berlin's musical culture and the persecution of its Jews. Ironically, Lehmann's name even figured in some of that reportage as that of one of the few foreign artists who actually consented to perform there (thus propping up the city's musical quality).[71] In September 1933, Lehmann's accompanist Balogh wrote her from New York that the "mood against the political Germany of today has grown considerably here." Hamburg's daughter Mia Hecht, who despite her Jewish husband became increasingly chauvinistic, wrote her from Atlanta how Germany was lately being harassed in the daily U.S. press and that it was getting worse with every passing day.[72]

After Lehmann had left New York again at the end of March 1934, Balogh worked closely with manager Francis Coppicus and publicity agent Constance

Hope to arrange further concert and opera dates for the 1934–35 season. All three were Jewish, as was Hope's business partner Edith Behrens. Hope and Behrens were writing sentimental letters to the singer telling her how much they missed her, and no doubt they meant it.[73] Lehmann's personal charisma, on and off the stage, which had already captivated thousands of Europeans, had not failed to work on them. Apart from what might happen at the Metropolitan, which for the time being chose to keep silent, they were planning an extended tour across the Midwest to the West Coast, where Lehmann was to sing in San Francisco and Los Angeles. As Hope was writing Lehmann, in mid-April, about an assured net profit of 800 dollars (around 2,000 marks) multiplied by fifteen individual events, thus totaling about $12,000 within two months, Lehmann fully realized her income potential in America, which could later have given her pause as she was comparing Göring's figures.[74]

As the meeting in Berlin approached, the Krauses had to be especially careful with Hope, who then was infatuated with both. So it was at first decided to dissemble. Two days before Lehmann's Berlin date, as she was on her way to Dresden, Krause wrote to Hope that his wife had left that day for London.[75] Coppicus then cabled on April 28 that a San Francisco Opera engagement was in the making for November 23, with others to follow.[76] This startled Lehmann, who thought – her Göring audience over – that such scheduling might interfere, that early, with the beginning of her new Berlin routine. Coppicus was in touch with the Met's Edward Ziegler, who constantly corresponded with Simon. As Lehmann's German agent, Simon knew of the Staatsoper arrangements at least in principle; hence the singer reasoned that it would only be a matter of time until Hope learned the truth. She therefore told Hope on May 4 that she had seen Göring and that the first twenty Berlin commitments would interfere with San Francisco; thus the West Coast had to be skipped. The news struck Hope like a thunderbolt: "Frankly, I was very much upset." Hope tried to make Lehmann change her mind, spelling out to her that a no-show on the West Coast would cost her at least $9,600. Of course the agent, like manager Coppicus, stood to lose much money in that case herself, but Hope got to the heart of the matter when she asked what would happen if Americans learned Lehmann's reasons for the cancellation. "I am very much afraid that there will be some unpleasant publicity about your singing there. As you know, there is a somewhat strong feeling about the matter in this country. I do not believe it will affect your concerts so much out of New York, but I am afraid that it will affect your appearances here." Hope sounded a more than cautious note when she warned her friend: "I do wish you would consider this matter very seriously, as your career in this country is at such a critical point." There were enormous opportunities right now but they could easily be scuttled.[77]

On May 24, Lehmann was informed that Elisabeth Rethberg had accepted the San Francisco assignment.[78] Lehmann, still in London, must have felt terrible, for while – after Tietjen's first discouraging letter – she was still holding out for a last chance from Berlin, budding opportunities in America seemed to be vanishing, and her friendship with the New Yorkers was endangered. To make matters worse, by early June, after having been informed of Göring's final decision in the Berlin matter, she received notice from the Met that she would

be reengaged, but only as Octavian and for a pittance of 330 dollars, plus insufficient funds for the crossing.[79] A few days later, Gatti-Casazza offered her four evenings at the Opera at 700 dollars each but, still short of money, continued to hedge on the fare.[80] It should now have been clear to Lehmann that reaching for the stars, while making a pact with the devil, had its price. After Berlin had fallen through, the Metropolitan finally came around but with less-than-perfect conditions, even though the cross-country tour looked attractive, save for the Rethberg factor. Still unreservedly on the plus side, however, her acolyte Constance finally wrote in June that she was "frankly, very glad that your other plan has not gone through."[81] It had been one rough ride.

New York

After 1933, whenever Lotte Lehmann was absent from North America, she would render her services unto the Vienna Opera though less than she was contractually obligated – the Salzburg Festival, and other continental operatic and recital venues such as London's Covent Garden. The Republic of Austria was politically and economically unstable, and to the extent that Lehmann's financial status suffered and protesters roamed in her Viennese Third District, political uncertainty coupled with social unrest gave her cause to worry. Over the years, these were contributing factors in her attempt to move to Berlin and, concurrently, her various musical excursions to the New World.

Beginning in the early 1920s Austria changed from a Social Democratic and Christian Social coalition government to a clerically sanctioned parliamentary democracy, dominated, most of the time, by the Catholic prelate Ignaz Seipel as chancellor and ending, in 1933, in an authoritarian dictatorship with fascist proclivities, ruled by Engelbert Dollfuss and Kurt von Schuschnigg. From 1920 on, this was a steady development in which the forces of the political left were fought to the point of defeat by those of the right – the more easily for Austria to be annexed by Hitler's Reich on March 13, 1938. From the beginning, the two ruling parties, the Christian Socials and Social Democrats, worked with paramilitary troops – the former with the Heimwehr and the latter with the Schutzbund. There were frequent clashes in the streets, and on July 15, 1927, Socialist demonstrators set the Palace of Justice on fire and were shot dead by the dozens. Even before the National Socialists began getting stronger in the Weimar Republic, the Heimwehr acquired many sympathizers, whose critical support derived from the rural provinces and who harbored in their midst advocates of a political union with Germany. By the end of the 1920s, the Heimwehr for the most part was backing the Christian Socials, who preached a specifically Austrian-Catholic brand of nationalism, condemning union with Germany. Leaning heavily toward Mussolini, who promised to guarantee Austrian independence, Christian Social–led regimes adopted, or paid lip service to, many of the trappings of Italian fascism, such as corporatism in the national economy, the abrogation of a multiparty parliament in favor of a one-party system, rule by decree, as well as intellectual and artistic censorship. One unique feature of Austria's political right was that it was split into pan-German Nazism of the Hitler type and predominantly pro-Austrian Heimwehr fascism that, until

the early 1930s, continued its reliance on organized Catholicism and Catholic dogma, conservative politicians, and quite a few priests.

The finally decisive phase of what some historians have labeled "Austrofascism" began in May 1932, when the agrarian-rooted jurist Dollfuss became chancellor. Backed by the Heimwehr, he ushered in a personal dictatorship that in March 1933 led to the legal suspension of parliament. Political parties were rendered oblivious by a one-party Vaterländische Front. With Heimwehr leader Ernst Rüdiger Starhemberg in the cabinet, Dollfuss embarked on the elimination of the political left with its Schutzbund, which he accomplished after civil war–like street fights in February 1934. By May he had proclaimed an authoritarian constitution, suspending customary civil liberties and industrial labor unions. Democratic parties were now forbidden; the Heimwehr became the dictatorship's paramilitary core. In July of 1933, Dollfuss had already outlawed the Austrian Nazis, who had committed terrorist acts throughout Austria, as he believed fascist Italy would continue to back the Republic's sovereignty, as whose "Führer" he increasingly saw himself.[82] A League of Nations loan of 1932 helped the country to get on its feet again, but starting in 1934 economic progress slackened, with the high unemployment rate being the country's major economic scourge. In July 1934, after Dollfuss had been assassinated during a putsch attempt by illegal Austrian Nazis, Schuschnigg became the chancellor; this jurist from a low aristocratic family had been justice and education minister in Dollfuss's cabinets. Although by temperament and intellect Schuschnigg was a gentler Austrofascist than Dollfuss had been, his continuation of the authoritarian course was steadfast. Deeply religious, he upheld the union with the Catholic hierarchy, favored industry and business over wage earners, and exercised censorship.[83]

Throughout these developments, the fate of the Jews was not uniformly positive, but on the whole it was bearable. Although there was anti-Semitism in all camps, affecting to some extent even the Socialists, Jews participated in virtually all facets of public life. As a rule, the higher up socially and richer they were, the more right-leaning they were also. Seipel, Dollfuss, and Schuschnigg were marked by Catholic versions of anti-Semitism, to say nothing of the Nazis' racist brand and that of Starhemberg, who had smuggled Göring into Austria after Hitler's Beer Hall Putsch of November 1923.[84] Nevertheless, these politicians employed the Jews' services when necessary, even if, like Dollfuss, they engaged in anti-Semitic rhetoric. As long as the Austrian Nazis were active, even illegally, they were the most aggressive against Jews: they attacked them in the universities – bastions of right-wing extremism – and threw stink bombs in the Staatsoper in early June 1934 when the Jewish baritone Friedrich Schorr impersonated Wotan in *Die Walküre*.[85]

But overall, the fate of the Jews in post-World War I Austria must be measured against their history in Italy and Germany, particularly after 1933. Mussolini did not adopt anti-Semitic policies until 1938, the year Austria fell to the Nazis, and exhorted his Austrofascist friends to practice tolerance toward Jews as long as they cooperated politically. Austrian Jews considered themselves on a par with Germany's in terms of individual liberties, until after 1932 they became aware of the many German Jews seeking refuge in their country. Dollfuss and

Schuschnigg were bent on exploiting these phenomena for political purposes, for being seen by the outside world as champions of German-Jewish victims allowed them to camouflage their own fascism. Projected onto a larger screen, the very reputation of this Austrofascist regime was rescued in world opinion by the fortuitous presence of neighbors to the south and north, both of whom were more virulently fascist than was Austria itself, with more dire existential consequences both for institutions and for citizens, "Aryan" and, especially, Jewish.[86]

How this worked culturally was demonstrated, in particular, by the Salzburg Festival.[87] A victim of German Nazi prohibition via a boycott more broadly aimed at the tourist trade, in 1933 and 1934 the festival became, internationally, a symbol of Western democratic values in a country that was itself in the process of losing its democracy. In making use of these circumstances, Dollfuss and Schuschnigg upheld the festival as an extension of Austrian Baroque and Catholic culture and, more importantly, as an embodiment of their political claim to national sovereignty. With its emphasis on Mozart, Beethoven, and Strauss, the Salzburg Festival tried to constitute a counterweight to the Wagner-heavy Bayreuth Festival of Adolf Hitler. This scenario continued to be carefully orchestrated by Vienna's political and cultural elite even when, in 1935, Hitler lowered the prohibitive border fee of 1933 and German festival goers were allowed to cross into Salzburg again, and after an Austro-German agreement of July 1936 had established the trappings of friendship between the two countries, which in reality was a sham. The festival symbolized little Austria's brave will to survive, between the two fascist colossuses of Germany and Italy. The anti-Mussolini Toscanini's presence there, since 1934, helped immensely. More and more Western foreigners, among them many Jews, were replacing the Germans as visitors. They sympathized with those adorable Austrians in their cute small town of Salzburg and with their delectable culture – Mozart, folk dancing, lederhosen and all.[88] This helped foreigners and Austrians alike either to ignore or not even to detect Vienna's own homegrown brand of fascism.

How did Lotte Lehmann fit into these politics? With her deeply conservative disposition stemming from her childhood and early upbringing and with a concomitant respect for law and order, she had abhorred the social turbulence in immediate postwar Vienna (she herself had needed black market goods) and condemned the radical socialists, who had threatened to take over power. As Austria settled down under more or less right-wing cabinets, the singer was feeling increasingly protected, all the more so since in 1926 she married a former officer of the Austro-Hungarian monarchy. Whether Krause joined a right-wing political organization like the Christian Socials or the fascist Heimwehr is not known; many retired officers favored the Heimwehr. The insurance company Phönix, Krause's employer, operated close to the Heimwehr and Dollfuss.[89] Given their ideological stance, there can be no doubt that the Krauses had welcomed Dollfuss's entrenchment in power, even though they could hardly have forseen, or understood, the incremental constitutional finesse with which he would solidify his position as a dictator. Dollfuss's exemplar being Mussolini, *Campo di Maggio*, a recent play coauthored by the Duce, who had always had literary ambitions, was performed in German translation at the Burgtheater in

spring 1933 – to excellent reviews.[90] It celebrated Napoleon's authoritarianism. Around that time Lehmann gave a recital in Rome – lieder by Schubert, Brahms, and Strauss – that was graced by Mussolini's presence.[91] In September of 1933, as Dollfuss had replaced parliamentary rule with that of his Vaterländische Front, Lehmann was invited, as an honored guest, to a major celebration by this core fascist organization on the giant Heldenplatz next to the Hofburg, only a short walk from the Opera.[92] A few months later she joined the "British Empire Salzburg Society," a high-level lobby on behalf of everything that Salzburg stood for, but having as its aim the strengthening of its British ties. Nonetheless, apart from the British themselves, the Society's membership encompassed fascist Italians, Heimwehr stalwarts such as Starhemberg, Robert Heger and other Opera stars, all under the patronage of Chancellor Dollfuss.[93]

It was while Dollfuss was still alive that Lehmann must have got to know his education minister, Kurt von Schuschnigg, for he was her ultimate superior. He had been appointed in 1933 and stayed on through May 1934, when the definitive authoritarian, corporatist constitution was enacted. Schuschnigg, an awkwardly shy man lacking Dollfuss's charismatic touch with the masses but a brilliant speaker, was said to love classical music, especially Beethoven. In correspondence after World War II, the singer could not emphasize enough how much she had admired Dollfuss's successor as chancellor; she told Fritz that he had been interested in an affair.[94] It is possible that Lehmann met Schuschnigg directly after one of her performances, which he sought out with uncanning regularity even from his nearby office, notably her Fidelio. He also honored her with a medal.[95] Another possibility is that she met him through Bruno Walter, who got close to him after seeing him in the company of his friends Alma Mahler and her husband, Franz Werfel, both of whom were intimates of Schuschnigg, especially in his last months as chancellor.[96] Under Schuschnigg's regime, Lehmann, usually in conjunction with Walter, contributed her musical services for the Heimwehr's purposes more than once, and she attended receptions at Starhemberg's residence.[97] And three weeks before the Anschluss, in February 1938, she sent the chancellor a telegram from California with the words: "Heil Schuschnigg!"[98]

At the Vienna Staatsoper, Lehmann continued in 1934 under Clemens Krauss's direction, until he was called to the Berlin Staatsoper as part of Göring's upgrade plan, starting January 1, 1935. That the Viennese did not renew his contract was due in part to finances (he was as unhappy with those as the rest of the Opera corps), but also to aesthetics. For the reactionary taste characteristic of the Opera for years now converged with the personal taste of Chancellor Schuschnigg, which in turn had much to do with his political conservatism. Krauss, who together with Wallerstein had been a pioneer of modernism in Frankfurt but had been restrained since coming to Vienna, wanted to make good on his commission of an opera by Ernst Krenek, *Karl V.*, and set a premiere date. Although the libretto celebrated the union of Catholicism and political power in the Austrofascist mold, the music was atonal. Krauss pleaded with the powers that be to let him perform it, but to Schuschnigg this music constituted cacophany, and he himself used a veto.[99] As far as Lehmann was concerned, she must have been glad for two reasons. For one, the alien atonality did not

gain a foothold on her home stage, and for another, the hated conductor finally made his exit.

Thereafter Felix Weingartner returned for an unremarkable run until September 1, 1936, to be followed by Erwin Kerber, administrative director of the Salzburg Festival. As Kerber was not an artist, Schuschnigg himself had a hand in assigning him Bruno Walter as artistic adviser and conductor, thus making him the power behind the throne.[100] This could have portended halcyon days for Lehmann.

For years, it had not gone unnoticed in Vienna that the singer's unhappiness with her situation was increasing, what with her regular trips to America and her dalliances with Berlin, the recent failure of her talk with Göring notwithstanding. Lehmann herself realized that she had done her share in breaking her existing contract by ignoring Vienna too many times, and feared being held legally accountable. Thus it was decided to offer her a new five-year agreement, starting on September 1, 1935. She would receive 1,600 schillings per evening for six months, at fifty performances.[101] Agreeing to the fees, Lehmann secured herself the option of singing as few as forty performances per season, in as short a time span as five months; in 1936 she asked for and received a minimum of twenty-five appearances for the balance of the contract.[102] This would give her ample time to realize her various professional interests outside Vienna. Pursuant to the original new contract date, Lehmann continued at the Vienna Opera more or less listlessly, singing fewer dates than mandated under Walter, the few times he was there, so that in February 1937 she found herself concluding: "When you think about it, the Vienna Opera makes no sense for me any more. In a way it would be better for me to take my pension. It is only a feeling of belonging that I have for this house, which makes me hesitate to take that step. As soon as I am pensioned off, I don't belong any more, and this would hurt me. And so I have to keep relying on the benevolent forgiveness of my directors." She thought she would not continue singing opera for much longer, for recitals were easier to do and also more lucrative.[103]

To compensate her for Vienna and with Covent Garden and the Opéra de Paris as annual guarantees, she could have toured more of continental Europe. But Germany was now out of the picture, and metropoles in other countries were becoming increasingly unsafe because of mounting social and political uncertainty. Thus in Prague, Czech or other Slav songs were demanded for recital, and Lehmann resented traveling to Budapest (where the fascist Gömbös regime was now installed) and even to Graz, one of the headquarters of the unruly Heimwehr. From Paris early in October 1934, she was told of the assassination in Marseilles of the Yugoslav King Alexander and the French Foreign Minister Louis Barthou, who had personally shaken her hand after storied performances.[104]

Instead, she found more satisfaction at the Salzburg Festival. The summer of 1934 was the last season for Krauss but also the first for Toscanini, who would remain until the Anschluss of 1938. Bruno Walter accompanied her there on piano in 1936 and 1937.[105] There were moments of tension with Toscanini when in 1936 the capricious conductor remarked that she was now too old to sing Wagner's Eva, looking like her own mother-in-law – a point others were

making also, including American critics. Else Walter seems to have gloated over that news, for Lehmann wrote her defiantly that if she now was too old for that role, she would simply never sing it again.[106]

Any time Lehmann met or sang with Toscanini in Salzburg she must have been nervous, for in the summer of 1934 the two were continuing their affair of the preceding spring. This came at a time when, in all likelihood, they had had a chance to revive it in Paris, as she was returning from London to Vienna via the French capital in mid-May. Toscanini had written her on March 7 that he would be in Paris for one month following May 12. Lehmann was again available between the fifth and ninth of June, when she had to sing at the Opéra and the conductor was, presumably, still there. The affair reached its apex in Salzburg during August, as Lehmann sang under the maestro's direction at a benefit for the Vienna Philharmonic on the twenty-sixth. At that time, the soprano almost left her husband. As Krause was staying with her in a nearby villa, it got to be too much for her and she wanted it all to end. A year later, she performed her first Festival Fidelio under Toscanini, but by that time, despite more letters, their passion had cooled. Toscanini had visited Lehmann in New York, Mia was informed in March 1935, and "the flame is extinguished, no longer can I pretend."[107]

Lehmann began her 1934–35 Metropolitan season with a performance as Elisabeth in *Tannhäuser* on New Year's Day 1935. As she had become accustomed to in America by now, the reviews were most flattering. She impersonated Elisabeth "with the vocal and theatrical resources possible only to an artist of the first rank," wrote the *New York Times*. "There were ineffable tenderness and faith and purity in her singing and acting," the paper continued, although her voice betrayed her in the top notes of the aria "Dich, Theure Halle," at the end.[108] Her Tannhäuser was Lauritz Melchior, with whom she had sung many times, especially in London. His conception of the tortured poet was said to be well "in the spirit of the character and music."[109] For Lehmann, Melchior was to become a constant and reliable partner on the Met stage, one of the two or three artists she got to know at the New York Opera really well, although eventually their relationship became problematic. At first she could not help but laugh at this hunk of a man, whose three passions, apart from singing and his diminutive Bavarian wife, "Kleinchen" (legally Maria Anna Hacker), were feasting, hunting, and showing off his many medals. Melchior was legendary for devouring huge meals for late supper after singing, but even his "light lunch" consisted of "layers of sausages, potatoes, and onions in a white sauce flavored with bouillon and Worcestershire sauce, accompanied by aquavit and beer."[110] His fastidious preparations for hunting, which in America he liked to leave to Constance Hope, were legendary; he once asked to be picked up by airplane at the end of an excursion in the Canadian Rockies, to be flown directly to a recital he had to sing. Although many found him "simple and lovable as a child," he could coldly pull strings from behind the scenes (as when he tried to prevent Erich Leinsdorf from succeeding Artur Bodanzky at the Met after the latter's death in 1939), and many of his practical jokes really hurt, as Lehmann, not exactly squeamish herself, was to experience over time.[111]

Lehmann's second Met role that season was as Marschallin in *Der Rosenkavalier*, on January 4, an opera that had not been presented for five years or so. The Marschallin had been one of Lehmann's signature roles in Europe and in the United States became the operatic part she would be best known for. Although she had a cold, noted Olin Downes, this character was "most eloquently, and with the utmost art, revealed to yesterday's audience." It combined "amused detachment with intensity of feeling, troubled wisdom with dignity and strength," remarked Bernard Haggin in the *Brooklyn Eagle*. Henderson from the *New York Sun* thought Lehmann's Marschallin "singularly cool and dispassionate."[112]

Lehmann repeated this performance ten days later and then regularly over the years, after 1937 frequently with lyric mezzo-soprano Risë Stevens as Octavian. Altogether, she sang the Marschallin at the Met, or at events sponsored by it, thirty-three times.[113] Stevens, the daughter of Norwegian and Jewish parents, was born in 1913; she was beautiful and the very embodiment of the fresh American talent that was making it big in high art on U.S. stages then, often after European sojourns. She had taken training with Marie Gutheil-Schoder in Salzburg and there experienced Lehmann under Toscanini. Later Stevens confessed that Lehmann had "a kind of charisma that very few people possess." Her admiration for the older singer and her familiarity with Lehmann's beloved Austria (where her mother was from) helped to forge a friendship between the two women that endured despite disagreements.[114]

There were other roles in which Lehmann excelled at the Met, such as Elsa and, one of her old favorites, Sieglinde, and with the exception of the occasional mention of "constricted top notes," the critiques were usually superb.[115]

For a number of reasons, however, not necessarily interrelated, Madame Lehmann's Metropolitan seasons after 1934 as a whole were not brilliant ones. In the first place, she stumbled in the role of Tosca in March of 1935, so that the old unfavorable comparisons with Jeritza were conjured up. Also, around the time this happened a new potential rival burst onto the New York scene in the person of the Norwegian singer Kirsten Flagstad. And finally, she was never entrusted with enough performances at the Metropolitan, receiving the same modest fee for each, at least until the end of the 1930s.

As for Tosca, Lehmann sang that part on March 21, 1935, with the American Lawrence Tibbett playing Baron Scarpia and Vincenzo Bellezza conducting. The opera was done in response to popular demand; the last one had been with Jeritza in February 1932.[116] With Geraldine Farrar in the audience, who had *been* Floria Tosca even before Jeritza, Lehmann found herself in bad voice, representing a composed and sedate heroine rather than a temperamental tigress. Subsequently, key New York critics accorded her mixed reviews. The usually sympathetic Downes led the pack when he commented on her "pseudo-melodramatic" singing style and the presentation of a "German Tosca, rather heavy."[117] Henderson, while more positive, criticized her "flights into the upper regions," and Pitts Sanborn too complained that she had cheated "on the highest notes." The event was not a total disaster, however, because some reviewers thought her voice rather splendid, and it was generally appreciated that she

sang the important "Vissi d'arte" aria "from the sofa, where it belongs, not the floor, as the athletic Maria did."[118]

Lehmann herself was quite hurt, blaming her demise, in a detailed letter to Met Deputy Director Ziegler, on a medical condition affecting her vocal cords.[119] To Hope she admitted that the press reaction had been a "shock" to her nerves, and to another fan she wrote: "I was so depressed, because I have said to myself: I have *felt* the Tosca, I *was* the Tosca. And they have not felt it with me. Therefore perhaps I was bad."[120]

In retrospect, it is difficult not to blame Lehmann for what had happened, but the Met's directors must also be faulted. Although the role was in her contract for the Italian repertory, they should never have offered it to her, knowing full well the defining standard Jeritza had created with it, which had to summon comparisons. If Lehmann had a problem with her vocal cords, she herself could have called the performance off beforehand. But these were technicalities. In a wider sense, as modern critics have averred, she should have known that she was not cut out for a role in the Italian genre, however much she publicly flirted with that idiom. Because her interpretive devices were far too Teutonic, she was doomed to turn any "Roman prima donna into a provincial character." In those days she might have gotten away with La Tosca in Vienna, where even at her somewhat advanced age she was still the regnant diva, but in New York, where the almost fifty-year-old matron was in the second year of establishing an opera cachet, audience and critics were somewhat less forgiving.[121]

Lehmann's situation in New York was not helped by the fact that a few weeks before her conflicted Tosca performance Kirsten Flagstad had scored a spectacular success at the Met with Sieglinde, the very role Lehmann had used as an introductory opera vehicle just over a year before. Born in 1895, the Norwegian was a mere seven years younger than the German, and she had plenty of European experience. She had made her début in 1913 in Oslo, while still a student, as Nuri in D'Albert's *Tiefland*. In 1932, she had sung her first Isolde, and then further Wagnerian roles in Bayreuth. She had been auditioned by Bodanzky and Gatti-Casazza between Bayreuth sessions in St. Moritz in the summer of 1934, having almost cancelled the date the way Lehmann had done at the height of her foolish pride; in both cases, Erich Simon was the intermediary. Fortuitously, the peripatetic Otto Kahn had already heard her in Oslo as Tosca in 1929.[122]

The occasion for such pursuit was that the Metropolitan Opera directors were interested in a replacement for Frida Leider, who had first sung at the Met as Isolde, in January 1933, with her last part being Brünnhilde, in April 1934; these were her signature roles. Leider wished to return to Berlin mainly for two reasons. She was unhappy with the shortened Met season and disliked the curtailed honoraria, which at the currently low dollar netted her little profit. More importantly, perhaps, she was married to the Jewish conductor Rudolf Deman, who was now at risk in Nazi Germany, and she did not want to leave him in the lurch.[123]

In the final analysis, Flagstad's hiring too had everything to do with money, for the Met was still in financial straits in 1934, and experience had taught

its directors that only popular Wagner operas would fill the auditorium.[124] Lehmann was known for some, but not the heavier female Wagner roles and had never sung in Bayreuth. Flagstad exceeded all expectations when she had a full house, starring as Sieglinde in a matinee on February 2 and becoming an instant success. Her singing was so magnificent that she even caused her Siegmund, Paul Althouse, to miss his cue as soon as she opened her mouth. Vincent Sheean, who was in the audience, later wrote: "This regal lady had the greatest voice any of us had ever heard – greatest in volume, range, security, beauty of tone, everything a voice can have, and all of one piece, never a break in it, all rolling out with no evidence of effort or strain even in the most difficult passages."[125] Then, when she personified Isolde "gloriously" (Downes) four days later, her impression was even more sensational, in a role Lehmann had tried in vain to master![126] After a few more Wagnerian parts that season, as one critic remarked, who knew both Lehmann and Flagstad, the Norwegian established herself "as the greatest soprano of her time."[127] Currently, was that title not reserved for Lehmann? Indeed, as far as the singer from Perleberg was concerned, insult was added to injury when Farrar, whom she had been considering her mentor, took an impulsive liking to Flagstad. "A new star has been born," so Farrar had introduced Flagstad authoritatively to the audience during her *Walküre* début, and well into the 1950s Farrar's enthusiasm would not wane, while she remained condescendingly kind to Lehmann.[128]

On March 24, 1935, three days after Lehmann's problematic Tosca performance, the *New York Times* mentioned that in addition to many other roles, including Anita in Ernst Krenek's *Jonny spielt auf* (a score that Lehmann would not even look at), Flagstad also commanded the part of Fidelio in Beethoven's eponymous opera.[129] In August of that year, the paper noted that she might actually perform Fidelio at the Metropolitan, a role that she knew in Norwegian and would now be preparing in German.[130] Then, in January of 1936, Edward Johnson, Gatti-Casazza's successor as general manager since the fall of 1935, confirmed in the paper that Flagstad would sing Leonore/Fidelio in February, because Beethoven's only opera had not been presented at the Met since the 1929–30 season.[131] The work was finally scheduled for March 7, and later it was announced that with Flagstad in the lead role, a "sold-out-house" was "virtually assured."[132] On March 8, Downes reported that the previous evening's event had "attracted an immense throng, and moreover was a pronounced success with the audience." Flagstad had sung "cruelly difficult music, that asks almost the impossible of the singer, because of its prevailingly instrumental character, which takes little account of the range of physical aptitudes of the voices, and the range of two full octaves, and the length of phrases which must seem to stretch to the ends of the earth for any but the greatest singers." Alas, Flagstad was said to have negotiated all this "with a very high degree of technical mastery, and, more than that, made it the vehicle of warm and womanly feeling."[133]

When Lotte Lehmann read this, she experienced profound humiliation. For only a few months before, in London, she had been hailed as "the greatest of living Leonoras."[134] Nonetheless, the circumstances surrounding the choice of Flagstad rather than Lehmann as the lead character until now have not

been entirely clear. There are those who have maintained that once Flagstad became so famous so suddenly, Lehmann was never offered the part.[135] Others have held that it was indeed offered to her, but that she herself declined to impersonate Leonore, knowing of Flagstad's presence.[136] The truth consists of a combination of these factors, constituting incontrovertible evidence suggesting that Lehmann's replacement as Fidelio at the time was a further symptom of the gradual denouement of her opera career, in progress even before her début at the Met in 1934. It was part of a sad and humanly touching story, whose origins coincide with problems she was having already before *Arabella*.

When in the middle of June 1934 Lehmann received her Metropolitan contract for the 1934–35 season, Fidelio was mentioned in first place, among her six German-repertory parts.[137] Not surprisingly, the *New York Times* reported a few days later that the role of Leonore/Fidelio was "one of Lotte Lehmann's greatest interpretations and she will undoubtedly appear in the Metropolitan presentation."[138] A couple of months after that, Hope advised Lehmann to bring her own, specially tailored Fidelio costume from Vienna to New York, because the possibility of the Met's revival of the opera was very real.[139] In late 1934 and early 1935 – Lehmann was then in the country – the New York press preordained the revival as a "special presentation" for the artist.[140] But that was the last anybody heard of it – what followed after that was the heralding of Flagstad.

It was true that Fidelio was one of the more difficult roles for a soprano to sing, in particular the aria "Abscheulicher, wo eilst du hin," written in the key of E. Although Lehmann had always been superb in the part overall, she had been having difficulty with this aria as early as 1930, a time she was also starting to have trouble with Straussian soprano ranges. After Lehmann had given Fidelio at the Salzburg Festival twice that August under Schalk, the music critic Heinrich Eduard Jacob had written that whereas she was still exceptional as the Marschallin, she was a Fidelio "no more." Strauss had taken this review, penciled "more" in the margin and put a question mark beside it.[141] Years later, just after the time of the New York press announcements, Bodanzky had written the newly appointed Met manager Johnson that scheduling *Fidelio* was not a good idea, especially with Lotte Lehmann in the lead. But Johnson disagreed, holding that Lehmann was "magnificent."[142] Then, during the summer of 1935 at the Salzburg Festival, as Lehmann was about to sing the role for the first time under Toscanini, she asked the maestro to transpose the difficult aria down a half-tone, from E to E flat. The conductor, still on the wings of love for Lehmann, uncharacteristically obliged – something that was noticed with astonishment by musicians and fans alike, even if as musical a connoisseur as Thomas Mann, visiting from Zurich, found the interpretation "wonderful."[143]

Although in future Lehmann was able to ask her favorite conductors to continue with that transposition practice (as Toscanini would at the Salzburg Festival of 1936),[144] she could not very well ask a Metropolitan Opera conductor to do the same for her, especially if his name was Bodanzky. Hence Robert Tuggle, the director of the Metropolitan Archives, today is right to suggest that Lehmann withdrew from this role on her own, for she "probably couldn't have stood criticism of the voice" had she been forced to sing the challenging aria in

the original key.[145] Yet it is equally possible that Bodanzky, who was slated to conduct *Fidelio* on March 7, 1936, prevailed with Johnson over time to have Flagstad assigned to that role.[146] After the March 7 staging and Flagstad's stupendous success, Lehmann decided out of personal pride never to sing the part at the Met again. She agreed with Hope that some kind of official explanation would have to be found indicating that she was not "insulted" on account of Flagstad, but also wondered how they could possibly make her refusal credible to the public, without anyone losing face. When Johnson – her former singing colleague at the Met – visited her at her Hinterbrühl house in June, he walked "arm in arm" with her in her garden, trying to persuade her to perform the role, for he had just heard her sing it under Walter in Paris, but Lehmann did not know how to escape the quandary. Her nerves were sufficiently frayed to agree to his request, on condition that the aria again be transposed (which he, congenial director that he was, found quite acceptable), but by the end of June the soprano had decided to drop the matter.[147] The Marschallin, she rationalized later, was, after all, much more significant.[148]

Flagstad was very different from Lehmann, in voice as well as character, and both women had a specific throng of admirers – most ideally for roles the other one did not sing: Flagstad as Isolde and Lehmann as the Marschallin.[149] Flagstad possessed a controlled, Scandinavian demeanor; she was placid and usually not excitable. As the record producer Charles O'Connell put it, hers was a "cold, rather inflexible, brilliant voice, powerful and broad-ranged, well-routined in the Wagnerian music drama."[150] Plain in overall looks but with regular features and attractive dark blond hair, Flagstad was not as heavy as Lehmann, but neither was she willowy.[151] "Curiously impersonal," as *Time* magazine observed after placing her on its cover, she would take to playing solitaire in the wings between acts or read movie magazines, and some even saw her knitting (though for the record she denied that). She was always fond of good champagne, especially after performances.[152] Her acting was craftsmanlike but not spellbindingly alive like Lehmann's, who generally preferred the description "singing actress," and as perfect and voluminous as her voice was, from a low to a very high register, and as consistently even her tones, it was also said to lack emotional warmth.[153] Sheean, who greatly admired both singers but always preferred Lehmann's Fidelio, observed about Flagstad's Isolde, probably her finest role: "I missed a great many meanings that should have been in the part. When I thought it over afterwards (even between the acts) and could hear that voice echoing in my ears, I realized that the meanings were not there because the singer had not put them there."[154] O'Connell was convinced that she simply was "not capable of expressing warm feeling, and that is fatal to an artist."[155] Fellow singer Nigel Douglas found her passion wanting.[156] By contrast, Lehmann was less perfect technically but had the full emotional range.

There was no love lost between the two sopranos. Flagstad, in keeping with her coolness of character, with one remarkable exception in 1937 seems to have been unmoved by Lehmann, either positively or negatively, whereas the older singer's more temperamental nature invariably suffered harm. As in the case of Ursuleac back in Austria, but unlike that of Jeritza, Lehmann and Flagstad

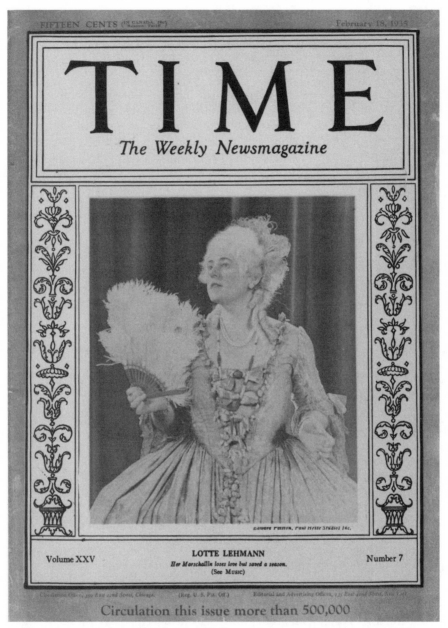

FIGURE 10. Lotte Lehmann as the Marschallin on the cover of *Time* magazine, February 18, 1935. Courtesy Special Collections, Davidson Library, UCSB.

did appear together on stage five times during their careers. For example, at the San Francisco Opera in 1936 and 1937, they performed Sieglinde and Brünnhilde, respectively, and once repeated this in Milwaukee for the Chicago Civic Opera.[157] At the Met they were never paired, but joined the *corps d'opéra* in the annual Grand Operatic Surprise Party on March 31, 1935, in a skit

called "Opera-Tunitis," in which the Great Dane Melchior held tiny coloratura soprano Lily Pons aloft by one foot, a scene that made Met Opera history. The clowning must have left Lehmann and Flagstad, both new and still sorting out their feelings for each other, bewildered, as they made cameo appearances as "other sopranos."[158]

Later Lehmann wrote that Flagstad's singing never turned "the divine calm of her soul into stormy fury," but that on stage with her as Sieglinde she felt "oh so greatly Brünnhilde's inferior."[159] As true as this was to the libretto of *Die Walküre*, in real life Lehmann did not feel inferior at all, quite the contrary. For she bore Flagstad a grudge nursed by an artist obviously her senior and better versed in the art, as well as more cosmopolitan, relatively speaking, than this elementary Norwegian. That Flagstad received $50 more per performance and also more engagements per season was rankling, and Lehmann came to the natural conclusion that after Jeritza and Ursuleac, this was the third nemesis of her operatic career.[160]

When in January 1937 Lehmann pasted a positive *New York Times* review of her own performance as Sieglinde in her scrapbook, she carefully omitted the next note commenting on another staging of *Die Walküre*, with Flagstad's first Brünnhilde, which had "sold out last week."[161] As acolytes of both artists were writing to the *New York Times* for and against, Flagstad, during a bridge game with Melchior and her accompanist in Rochester, New York, excoriated Lehmann's singing, claiming that Hope was using her own name in publicity in order to promote Lehmann's business.[162] Lehmann, not pleased, wrote to Else Walter that Flagstad was obviously taking on too much – Brünnhilde, Elsa, and Isolde in three days – and could not do so without penalty.[163] Later that year, Lehmann complained to Hope that in Milwaukee Flagstad had listened to her Sieglinde in the wings, without saying anything at all, not even something critical.[164] In 1938, on the West Coast, Lehmann found the grand publicity done on her colleague's behalf to be in inverse proportion to her modest success there, but wanted Hope (who never worked for Flagstad) to do similarly impressive promotion for a Lehmann appearance.[165] There was further carping against Flagstad both that year and next,[166] but after the end of World War II, long after the Norwegian had returned to Oslo, Fritz Lehmann had to tell his sister that she was wrong to assume she would have done so much better in America had Flagstad never shown up.[167]

Flagstad had had nothing to do with the fact that for the 1934–35 season Lehmann received merely six role assignments in the German category, and three in the Italian. The German parts were Fidelio, Elsa, Eva, Marschallin, Elisabeth, and Sieglinde, reflecting the Met's heavy emphasis on Wagner, and the Italian ones Mimi, Cio-Cio-San, and Tosca. She was only to sing four performances until March 31, 1935, and the fee was kept at $700 per event – low compared to the ceiling of $1,000.[168] In the ongoing American Depression, these were not the fleshpots of Europe (if fleshpots they were), and her working repertory now was just a shadow of what it had been in Vienna! Lehmann communicated her disappointment to Hope, who got Ziegler to extend her contract to the end of 1935, with six additional appearances for the same fee.[169] But instead of the promised ten, she sang only seven performances, and when she and

Hope tried to deliberate with Gatti-Casazza's immediate successor, Herbert Witherspoon, he let her wait in the reception room and for the following season offered her a mere four evenings (from December 16, 1935, to March 22, 1936). Lehmann found him "a repulsive fellow," not knowing that he was to succumb to a heart attack on May 10, 1935, and be replaced by the more affable Johnson. In particular, she complained about the miserly $700, especially after Hope had informed her that Flagstad was making $50 more, so that eventually her overall wage too came to $750.[170] Lehmann had other reasons to deplore the continuation of her Met career in 1935, for in February *Time* magazine, after referring to the "racy" singers Mary Garden, Farrar, and Jeritza, had introduced her as "just a singer" with a "feeble-minded grandfather in an embroidered velvet cap," even though it had mentioned her stellar Marschallin. In December, moreover, the journal mentioned her as just one of several sopranos working for the Met that season – Grace Moore, Gertrude Kappel, Florence Easton, Lily Pons, Rosa Ponselle, and, of course, the old stalwart Elisabeth Rethberg. And that in the issue that featured Flagstad on the cover![171]

By the end of 1935, with her future at the Met uncertain and still unhappy with the $750 performance fee, it may have dawned on Lehmann that Flagstad was indeed preventing her from getting more engagements. For in 1935 and 1936 combined, the Norwegian was singing at fifty-five events, including Met-sponsored concerts and dates out of town, with Lehmann left at thirteen.[172] Alas, Lehmann's Marschallin alone could not bring money into Metropolitan tills, whereas Flagstad's many Wagner roles would.

The problems of the puny schedule, which persisted into 1937, were exacerbated when Lehmann learned that mighty Melchior, who was younger than she but just as busy as Flagstad, was earning $1,000 an evening, a fact that Johnson could hide from her only with difficulty. For lack of work, she wanted to turn on the gas and take her life, Lehmann melodramatically informed Hope, in June 1936.[173] She must also have complained to Downes, for in January 1937 the *New York Times* printed a notice that "Lehmann's remarkable singing and playing of the role of Sieglinde in 'Die Walkuere' last week elicited demands that she be engaged by the Metropolitan for more than a limited number of performances. This year, for example, it is understood she is to sing about half a dozen times. She could be obtained for more. She likes to sing at the Metropolitan and could make herself available for a long season."[174]

It is true that for the 1937–38 season, she received eight firm dates, but Eva was struck from her repertoire (with the comment: "only in case of necessity"). While Lehmann knew that this measure had been overdue, noticing the emendation in the contract hurt. At the same time, Fidelio was merely penciled in, Cio-Cio-San was gone, and Mimi had been replaced by Desdemona. The next season she also had eight performances, but that number shrank to six in 1939–40. By that time only the Marschallin, Elisabeth, and Sieglinde were left for her to sing.[175] In April 1939, Hope wrote to Ziegler: "May I remind you that it would be grand if she did some '*Sieglindes*'? As I told you, she hasn't done this since her debut at the Metropolitan, and it is her 'lieblingsrole'." (Hope, characteristically, was making this up, as Lehmann had sung Sieglinde twice in early 1937).[176] The soprano herself raised a cry of help to Hope in 1938 when

she wrote that she needed money more than ever and wondered, a year later, whether she still had performances left at the Met.[177]

Hence already in autumn of 1936 Lotte Lehmann was brutally frank when she told the sympathetic interviewer Lanfranco Rasponi that "the Metropolitan does not have much to offer me in terms of repertoire." But she went on to say that while she was in the United States, she gave lieder evenings, "which are very rewarding and afford me the chance to visit this great country."[178] Lehmann may have sounded more confident than she actually was, but by now she could have learned something about effective publicity from Hope and thought that Rasponi might help her get more engagements.

Before Lotte Lehmann began her lieder-singing routine during the 1934–35 season, she put in a few appearances on American opera stages other than the Met's. At the San Francisco Opera in November 1934 she presented a Tosca and a Cio-Cio-San, and she won both praise, mostly for her voice, and scorn. As she was no longer believable as Eva in *Die Meistersinger*, so she failed to convince as a portly Madame Butterfly. Here the comparison to an earlier, well-remembered Farrar impersonation did not reflect favorably on her. But in Philadelphia later in the month, she was hailed as possibly "the greatest singer of the day" as she played the Marschallin under Fritz Reiner, in a staging by the Philadelphia Orchestra Association. Then, with the Chicago Civic Opera in December, she sang a most credible Elisabeth.[179]

Lehmann embarked on her lieder and aria singing for the season in Toronto's Massey Hall in mid-December, where she essayed only Wagner arias, including her beloved "Liebestod" from *Tristan und Isolde*, all under Ernest MacMillan. She was honored by the presence of both the Canadian governor-general from Ottawa and Edward Johnson of the Met, who had been born in nearby Guelph. According to local critics, her "noble tone came through in glory," and "there was only greatness." Not a note of displeasure was sounded.[180] In the following seasons until the end of the decade, Lehmann continued in this vein all over the continent, usually with Ernö Balogh at the piano, but sometimes with orchestras under various conductors. She was honing her lieder-singing style, as opera arias were becoming less important, and usually she was superb, in a sphere where no other soprano could touch her, including the opera-centered Flagstad. Criticisms of her singing, although they were lessening over time, were the same ones she had been encountering in Europe: that she left herself short of breath, experienced stress at high notes, allowed emotion to overwhelm her delivery – a habit inevitably deriving from operatic practice – and that her choice of songs was not faultless. For this she could not often be blamed, for she tried fairly to adjust her taste to that of her – often Midwestern – auditors, more than she had to do in Europe. For instance, in what she thought would be a lighter section, she would sing Balogh's own "Do Not Chide Me," followed by "Joy," by Charles Wakefield Cadman. A former organist, opera and film composer and cofounder of the Hollywood Bowl, Cadman had admired the music of the American Indians and had once specialized in "emotionally appealing household songs."[181] Also into this lighter group fell the movie composer Richard Hageman as well as Peter Cornelius and Anton Rubinstein, of whose "Es blinkt der Tau" Henderson acidly remarked that the dew had now "evaporated."[182]

The Philadelphia critic Thomas Sherman decried that to hear "Joy," with all its "cloying prettiness," was disconcerting. "A series of vocal exercises that meant absolutely nothing would have been more enjoyable, for then one could have given oneself wholly to the mere sound of her voice. As it was, there was no escaping its triviality."[183] And, not least, Lehmann also assisted Downes once more in his lecture series at the Brooklyn Academy of Music. After a recital at Town Hall in November 1937, he certified that "few artists before the public today equal Lotte Lehmann in warmth and feeling, and capacity to communicate emotion to an audience."[184] Downes had captured the essence of the singer's singular achievement in America: to introduce German lieder to the public as they should be sung. This became even more obvious toward the end of the decade, and in the next.[185]

A contributing factor here was the change from Ernö Balogh to a new accompanist. As close a friend as the Hungarian had become to Lehmann (and to Otto Krause) for human reasons, as disadvantageous he had turned out to be as her longtime pianist. He lacked the musical refinement she needed to be ultimately successful and insisted that one, sometimes two, of his own mediocre songs be performed. There were too many critical comments, and both Melchior and Toscanini took Lehmann to task for her poor choice.[186] But the singer, one of whose virtues was loyalty, made sure that Balogh had other professional opportunities before letting him go, and their mutual friend Hope did not take this well at all. Balogh himself accepted his dismissal gracefully, and the two musicians remained friends.[187] In his stead, Lehmann engaged twenty-nine-year-old Paul Ulanowsky, another Jewish refugee from Vienna, a shy and self-effacing man, whose musicality was staggering. He could transpose themes from one key to another at a nod and, unlike Balogh, did not insist on pianistic grandstanding – he would never even play a solo. He commenced his services for her in April 1937, in Honolulu, on the way to Australia.[188]

Whereas Lehmann's mediator in dealings with the Metropolitan ultimately turned out to be Constance Hope, it was Francis Coppicus who handled her concert dates. The soprano came to be as unhappy with what he got for her by way of engagements as she was, over time, with the contracts received from the Met. Although her agreement with him provided for a recital fee of $1,350, almost twice what the Met would yield, she had to pay him a commission of 20 percent (much more than in Europe), and he could not guarantee her a fixed number of events per season. She also had to pay her accompanist and all travel expenses. What was worse, even taking into account low inflation, her honorarium never increased, and in some cases even decreased.[189] More than anything, her supposedly close friend Constance was in cahoots with Coppicus, for she was still in charge of publicity per event and paid extra by Lehmann for it. Time and again, while knowing better, Hope encouraged Lehmann in deals that were either nonexistent or underpaid, as in September 1935, when she was supposed to sing with the exiled conductor Otto Klemperer, three times for a mere 1,200 dollars. (Although she knew Klemperer well, the incorrigible Lehmann wrote Hope that she would prefer Toscanini.)[190] As Hope falsely kept assuring Lehmann with regard to Coppicus, pretending that

he always had more bookings for her than he let on, the singer smarted under the suspicion that Melchior, who had become Hope's second very important client after herself, was being paid as much as $3,000 per event, at $2,000 a guaranteed average.[191] At the end of 1937, Lehmann had had enough, after all those lost opportunities due to colds and seeing that her future schedule was barren. Rather than blaming Hope, however, on whom she was dependent, she rebuked Coppicus, threatening to return to Europe permanently, where her concerts would be immediately "overbooked." She was overplaying her hand here, for everyone by now had heard her story about her (alleged) victimization in Nazi Germany, and shrewder men like Coppicus were undoubtedly aware – as she might herself have been – that her second home, Austria, was about to fall to Hitler.[192] This was after she had made a tour of Australia in the summer that had netted her some money, but because she had had to take the unemployed Krause along, nothing much was left. After the Anschluss of Austria in March 1938, her earnings potential in Europe was running out fast, and when – an expensive adventure – she had financed the immigration to the United States of Krause and his four half-Jewish children, she was in dire financial straits. In August 1938 she thought that her best years as an artist in America were over and she had better start preparing for a teaching career.[193] Yet another concert tour to Australia in summer 1939 provided transitory relief, but the adjoining tour to New Zealand proved a money-losing proposition, largely because Hope had arranged things sloppily and with mostly selfish interests at heart.[194]

To review the singer's earnings situation in the 1930s: She was drawing a contractual income from the Vienna Staatsoper until the Anschluss in 1938 and then a pension that she could not touch, plus honoraria from European tours and recordings. In the United States, she had her Metropolitan fees as well as what she made extra on tour, including the two to the Australian realm. However, if this sounds like a lot of money, it could not cover her many expenses. She was always painfully aware that she did not have enough and hence had to look for further sources of income.

Some of those were American recordings she did first with RCA and, after 1939, with Columbia.[195] Other income derived from the radio hours at which she was singing, first with Toscanini in February 1934 and later, with both General Motors and Ford.[196] These riches, however, were never large enough to be embarrassing. So for further sources of money she allowed herself to be hired by NBC's *Kraft Music Hall*, which Bing Crosby and Jack Benny had started on a back lot of RKO in Hollywood in January 1936. This became a very popular show, during which Crosby chatted, joked, and crooned with both famous personalities of high culture and popular stars of show business. Well represented were kings of jazz such as Louis Armstrong, Paul Whiteman, and Tommy Dorsey, whose band provided the instrumental background. Crosby developed an easygoing routine with his guests, and most of them loved it so much they longed to reappear. Artists as different as Gloria Swanson, Gregor Piatigorsky, Robert Taylor, Jascha Heifetz, Cary Grant, Henry Fonda, Yehudi Menuhin, and Leopold Stokowski were regular guests, encouraged to let their hair down and be more themselves than they could ever be on a formal stage or movie set. Among the serious singers who appeared were Grete Stückgold,

Rose Bampton, Ernestine Schumann-Heink, Risë Stevens, Fyodor Chaliapin, and Gladys Swarthout. Lehmann was thrilled to take part whenever she was in California; until 1939 she was paid $ 1,500 per appearance, and she always received a huge cheese tray. This way she grew extremely fond of Crosby, of whom she said: "It is very difficult whether the charm of his personality or the charm of his songs is more appealing to me." This from a lady who all her life had hated jazz.[197]

Whereas professionally Lotte Lehmann had to struggle in the 1930s, she was, all things considered, able to maintain her artistic preeminence. Her personal life, however, was approaching turmoil. This was predicated as much on the momentous political changes of the decade as on the affiliation with new people she was meeting in America. The entire constellation was, to no small degree, complicated by the relationship she had with her husband and what fate had in store especially for him.

Even before Otto Krause had lost his tiny income (camouflaged by a bombastic title) at the Phönix insurance company of Vienna by April 1936, he was trying to generate new business deals in the United States through the connections of his famous wife. Thus in 1935 he attempted to market his own inventions – a mosquito trap and then a can opener. For appearances' sake, he continued to use the rank of colonel or the title *Doktor*, probably because the wily Hope had put him up to it, but with Lehmann's connivance. Yet even with such posturing his business came to nothing and, as before, he was reduced to living on the proceeds of his spouse, while his four children were supported in Vienna by funds their uncle Willy Gutmann held in trust for them. From New York, and using Hope's offices, Lehmann also continued her financial support of Krause's mother and sister in Partenkirchen.[198]

Whenever Krause was not with Lehmann in America, his main preoccupation seems to have been equestrian pursuits in Vienna, but from April to July 1937 he joined her on her first Australian tour. Thereafter he was busy sorting out the inheritance for his children after Grete Krause's death in 1936; most of this fortune consisted of coal mines in Czechoslovakia. The children were around twenty, at that critical stage where one enters professional training or might even get married; the attractive Manon was, in fact, engaged. Krause's (and Lehmann's) problematic relationship with her had not improved, but both loved the youngest son, Peter, who had been born in 1919 and was entering the army.[199] Lehmann had joined Krause in Vienna after the Australian trip, was set to sing at the Salzburg Festival, and then would embark, on October 8, for America, with two maids, two dogs, and her luxurious Lincoln. Initially, Krause had been scheduled to accompany her, but then it turned out that legal matters would keep him, and he had also developed what seemed to be a case of smoker's bronchitis, aggravated by damp tropical air. Except for Manon, Lehmann now got along reasonably well with the four children, even if she found her new role as their stepmother awkward.[200]

Soon Krause needed special treatment at Semmering near Vienna; he had to lie still for several weeks and gain weight. This would be an extra expense for Lehmann, whose resources were already strained in the face of diminished financial returns.[201] But by October Krause was feeling better and putting on

pounds; he stopped smoking, so that by the end of December he was able to join Lehmann and her growing coterie in New York.[202]

The Anschluss on March 13, 1938, found her in New York, between appearances in Roanoke, Virginia, and Boston. Her situation in the old German Reich already precarious, she felt uncertain with regard to her assets in annexed Vienna – what with her house being close by, her status of having fallen out with Göring, and the future of her Austrian pension, to say nothing of her brother Fritz's continued presence in the former Habsburg capital. And even though by now it had become clear to her and Krause that they wanted to settle permanently in America, they had to immigrate on the quota stystem, with American money guarantees and affidavits backing them, like every other refugee, and they also had to do something about Krause's four non-"Aryan" children. Although they were not immediately endangered, as according to the Nuremberg Race Laws of 1935 they were *Mischlinge ersten Grades*, their status was not entirely clear to the anxious Krauses. Their inheritance was due them from Central European sources, and under Hitler one just did not know how things would turn out, from one day to the next. There was no question that they had to be brought to America.[203]

Both Krause and Lehmann had to return to Europe at the end of April – he to settle definitively the affairs of his children, she to give a series of performances in London. Krause's presence there was necessary because his brother-in-law Willy Gutmann had moved himself and his business to Chur in Switzerland, and his constant stream of support for his niece and nephews had necessarily ceased. Besides, Krause's health had taken a turn for the worse again; he had to go to Davos to have his chest reexamined and seek a lasting cure.

While she was singing the Marschallin at Covent Garden on May 4 under Erich Kleiber, Lehmann, in the middle of an act, cried out that she could not go on, made her way to the dressing room and fainted. She recovered with the help of a doctor, while the performance was continued with Hilde Konetzni from Vienna in her role. Konetzni happened to be in the audience and was fitted with Lehmann's costume, with assistance from Berta Geissmar, then serving as Sir Thomas Beecham's secretary. News of Lehmann's stumbling traveled around the world; she later said it had been due to a combination of factors: consequences of a very rough ocean crossing just before, sudden news from Davos of her husband's deteriorating health, and the behind-the-scenes pressure of German Nazi singers, who had been invited to London. Of those factors, only the first two can be accepted as valid, because the confirmed Nazi singers there, coloratora Erna Berger and soprano Tiana Lemnitz, were too low in the pecking order to know about Lehmann's altercation with Göring, or about her official status as "undesirable." Instead, it is clear that Lehmann invented this version *post festum* to further embellish her Nazi victim legacy.[204]

Most likely, the news from Davos just before, that Krause did in fact have pulmonary tuberculosis and needed six months' rest in bed, was the decisive cause of her collapse.[205] The events to follow were nothing less than dramatic. Lehmann sang the Marschallin twice again, without problems. Then she cut short her London stay, losing more money that she badly needed, and made her way to Davos. She secured affidavits from New York and had the three

boys move, via Switzerland, to Paris, whence they traveled to America. She had Krause released from the very expensive Davos sanatorium and moved with him to Deauville, near Monte Carlo, where he recovered sufficiently to travel to the States again from Cannes, joined by Manon, while she sailed independently, from Le Havre. By August, Krause was in a private sanatorium near Lake Saranac in upstate New York, while his wife had to crisscross America – to honor concert obligations and earn the, by now desperately needed, funds.[206]

During 1938 and 1939, Lehmann tried to live up to her new duties as stepmother by providing for the four children. Helped by her New York women friends and the Hechts and their connections, she found them jobs with film and broadcast companies on the East Coast or in Los Angeles. The flighty Manon moved to Hollywood, ostensibly to keep house for her brother Otto-Hans, but in reality to land a job in broadcasting or with the film industry. This never happened; she eventually married an alcoholic Irishman, had a daughter by him, and died in the 1970s. Lotte's favorite, Peter, who reminded her of Octavian in *Der Rosenkavalier* and for whom she experienced much more than just motherly feelings, was able to apprentice with Agfa in Binghampton but was then drafted into the air force during the war. In good time the three boys too became American citizens, married and had families of their own. But they never saw their part of the vast Gutmann fortune.[207]

It would have been helpful if they had, for the singer's resources were further drained by the ongoing expense of caring for these young adults. Generous to a fault, Lehmann did what she could, but sometime in 1939 she found it impossible to continue. Already toward the end of 1938 her savings were being exhausted by Otto's pricy sanatorium stay. The American physicians substantiated the Davos diagnosis of tuberculosis, and toward the end of the year the prognosis was gloomy. Krause, for decades used to a sybaritic lifestyle, and a previously healthy man who had prided himself on his virility, resented being caged up in an unknown part of the world, with only medical staff and one of his wife's Austrian maids to care for him. He felt emasculated, knew no English, hated the American food, was not the book-reading kind, and was without his beloved horses. Sometimes one of the New York friends came visiting, even Geraldine Farrar.[208] Lotte herself could be with him only sporadically because of that dire need for money, provided chiefly by her touring, always with her other maid in tow.[209] By the end of the year, the Saranac doctors hinted at some progress; Lehmann continued her performances and even planned a second trip to Australia for March. She expected Fritz to arrive from Vienna, so he could keep Otto company. But on January 19, Henry Leetch, the doctor in charge, cabled her to Spokane: "Otto has had a setback past few days. There is no need for immediate alarm or for you to come back sooner."[210] That was the wrong message, for a few days later Otto was near death. Lehmann rushed east to see him while still alive, but he died on January 23, with Lotte on a train near Syracuse in a ferocious snowstorm. During the next few months, the singer would not stop accusing herself for not having been at his side; his death once more conjured her bad conscience, as it had been conjured during her affair with Toscanini and, years before, the betrayal of Grete Krause and the four small children. Between guilt and depression, she drowned in self-pity and bathos.[211]

FIGURE 11. Lotte Lehmann and Otto Krause on the French Riviera in the summer of 1938. Courtesy Special Collections, Davidson Library, UCSB.

When in early February 1939 Fritz Lehmann arrived in New York, it was too late to succor Otto Krause. Fritz was accompanied by his housekeeper, thirty-two-year-old Theresia Heinz, who, slavishly devoted to him, had become his lover. Unstable as ever, he now was looking for a chance to give voice lessons. How he had learned to be a singing coach has never been fully revealed; both Lehmann siblings had that brilliant gift for vocal music; still, it was hard work, apart from genius, that had made Lotte into the world star she became. After Fritz's death, his sister characterized him aptly: "He went through many stations, as actor, director, poet – he divided his talents in perennially striving forward. I think he could have found his calling in any of the occupations I have mentioned, but he did not have the stubborn determination which showed me on my way."[212]

While living in his wife Clara's house in Westerland in the late 1920s, Fritz had written and directed plays, mostly oriented toward *Heimat* or fairytale themes, in Hamburg as well as on the island of Sylt.[213] After an unsuccessful attempt to relocate more permanently to Vienna, to be near his adored sister and find steady work, he had also assumed the directorship of a small museum

on the island, dedicated to local folklore.²¹⁴ But after Clara's death of cancer in Vienna in 1931, he had definitively settled there by 1934, working at Neues Wiener Konservatorium as an opera coach. He also taught privately, but seems scarcely to have had a life beyond that. A heavy drinker then, Theresia kept house for him. In his work, he probably started with acting and consequently, highly musical as he was, moved further into voice training.²¹⁵

Because she had been in debt to Fritz and never ceased feeling indebted, Lotte tried to motivate him to move to the United States, as she herself was in the process of doing, after the deal with Göring had fallen through, which would have included a professorship for him in Berlin. In late 1934 she took him (and Otto) with her on her seasonal U.S. tour, hoping to find him a job in New York through her established connections.²¹⁶ It was there, in early 1935, that Fritz met Lotte's alluring friend Viola Westervelt, just then getting a divorce. Fritz fell in love and almost married her – which would have guaranteed him permanent residency in the United States and probably have solved many problems. At that time Lotte, still or again, owed him money, a habitual situation for her.²¹⁷ He returned to the Vienna Konservatorium and Theresia, however, and in 1937, when Krause was sorting out his wife's affairs, the two men saw much of each other.²¹⁸ After the Anschluss, Fritz felt uncomfortable, thinking he was being pressured to join the Nazi Party, like so many other employees. By November 1938, as Krause was languishing in the Saranac sanatorium, Lotte had succeeded in persuading Fritz to emigrate; an affidavit would come from the Hechts. Lotte also paid a $1,000 bond; Theresia traveled as a tourist.²¹⁹

Once in America, the question of how Fritz should earn subsistence for himself and his live-in housekeeper became paramount. He knew little English, and his skills as a Viennese vocal coach were not unique, given the cornucopia of Jewish talent from Central Europe already spread amply around the United States. For the time being, Lotte told Hope to pay him a monthly stipend of $215, which she, who did not like him, consented to only grudgingly.²²⁰ Fritz and Theresia stayed in New York with Lotte's friends, while she toured the Fifth Continent; thereafter the three met up in Hollywood. Here Lehmann knew the baritone Nelson Eddy, who in 1924 had sung at the Met, through the Crosby show. But no job opportunity materialized, and to complicate matters, Fritz developed expensive dental problems and had a near-fatal accident with the Lincoln, with Theresia succumbing to a gallbladder infection. On top of all this, Fritz was due at a weight-loss clinic. When they all returned to New York in the fall of 1939, Lotte found herself facing those many additional costs, apart from the responsibility for supporting her brother, who so far looked unemployable, and his Austrian housekeeper-mistress.²²¹

One of the constants, perhaps the most important one, in Lotte Lehmann's life in the United States throughout the 1930s was her relationship with Constance Hope. The singer came to depend on the manager for admiration, money, professional contacts, and social relations, for better or worse. Hope had several attributes that helped her feel superior to Lehmann, not the least of which was her excellent knowledge of German, so that she could always manipulate the singer, whose English was quite deficient. When she was not in New York,

Lehmann would write to her in her own tongue for years, frequently and in over-flowing prose, as was her wont, whereas Hope, after the first gushes, answered in a more businesslike way and with increasing reserve. There occurred an emotional break in their relationship, much to Lehmann's disadvantage, after she had revealed details of her dealings with Göring. For not only was Hope Jewish, she might also have lost an important investment had the German contract been ratified. The fact that Lehmann was Hope's first publicity client flattered the singer initially, but it also meant that she was being pushed into the background, as Hope acquired others. Giving a reception for Lehmann in November 1934, Hope got herself into the *New York Times* for the sake of her own publicity, but after collecting names like Lauritz Melchior, Lily Pons, and Erich Leinsdorf, there was no need for more receptions. Besides, Hope extended her agency to Los Angeles and even acquired expertise in other types of promotion, such as for imported children's wear. She, rather than Lehmann, got invited to the most important Manhattan luncheons, such as the one for the ambassador to Denmark.[222] Hope also knew the Metropolitan and Lehmann's other agent, Coppicus; she knew publishing and recording and the banking system. All told, this woman-about-town had so many advantages over Lehmann that the singer, in characteristic fashion, was foolish always to open up her heart. In her boisterously impulsive way, Lehmann frequently stepped over bounds, thinking this was very funny or an especial token of trust, but crude jokes from provincial Brandenburg just were not jokes in New York. Hence when young Constance acquired a boyfriend, Milton Berliner, who would become one of the most sought-after ophthalmologists of the city, Lehmann perennially poked fun at her and "Tio," for the former's alleged virginity and the latter's possible impotence.[223]

"We handle her checkbook, keep the records, and pull in the reins when Lotte is ready for a *Kaufi-Kaufi* jag," Hope wrote succinctly in her memoirs.[224] "Kaufi-Kaufi" was the two women's silly speak for Lotte's old shopping addiction, which she found next to impossible to shake off on her own. Hence she surrendered her decision-making powers to Hope, who would set up an account for her, collect all checks from her touring, pay the bills, and carefully issue cash to the singer when she seemed in need of it.[225] This had its salient effects, for Hope also pushed for debt reduction, even if Lehmann was apt to create new debt (for instance, with Mia Hecht).[226] In the summer of 1937, inspired by the extremely business-minded Mrs. Melchior, Hope also bought stocks for Lehmann, but then asked her opinion about them, knowing full well that Lotte lacked investment skills.[227] In August 1938, Lehmann wrote to her manager friend that she was "terribly thrifty and do no Kaufi kaufi (only a little!)," but two months later the singer realized that surrendering all control over her financial matters had rendered her totally immobile. As friction was increasing between them, she wanted to know from Hope what her earnings amounted to and insisted that Hope "finally reveal the truth!"[228] At that time, in California, Lehmann was barely capable of going to a bank for cash, so dependent was she on Hope's direct money transfers. Concurrently, Hope surmised correctly that Lehmann had impractical ideas about how to go on financing her living standard. For example, in order to offset the great cost of maintaining her

Lincoln, Lehmann wanted to buy a second, smaller automobile, refusing to sell her prestige symbol.[229]

As far as Hope was concerned, Lehmann's financial practices were even more chaotic because, always magnanimous, she wished to distribute what largesse she thought she had not only to herself and her family, but also to others. Lehmann's motives for the latter are not clear. While it is understandable that she liked to help people in need, especially refugees from an evil empire that had almost captivated her, her propensity for giving money to total strangers suggests that she wanted to be known as saintly, whereas she looked on herself as a sinner. That last image takes shape in view of her guilt feelings over sexual escapades and the way she had behaved with the Gutmann-Krause family. Another explanation, which also applies to ancillary activities such as writing and later painting, is that she was developing doubts about her future fame as a singer – the Ursuleac-and-Flagstad syndrome – and wished to be remembered for something.

Thus Lehmann forced Hope to cut checks for the conductor Karl Alwin, Strauss's protégé in Vienna and now the divorced husband of Elisabeth Schumann, who, as a Jew, was looking for work in New York.[230] Schumann herself, who had remarried a Jewish Austrian physician now living in New York with her, was waiting for her husband to obtain his U.S. licence, and hence had nothing to make ends meet. In June 1939, Hope had to give her $3,000 of Lehmann's money (a good car then cost much less, and a negligee 6 dollars).[231] The concert agent Heinz Friedlaender, still in Paris, would get a check, and so would Lehmann's new pianist, Ulanowsky. Particularly bizarre is the case of Greta Bauer-Schwind, a tuberculous young poet in Czechoslovakia, whom Lehmann had never met but of whom she wrote to Mia that "she sees me as an angel." This woman was put on a regular monthly stipend. Equally strange was the case of a young artist who simply begged her for money in Buffalo, with Lehmann promptly complying.[232]

Meanwhile, the singer was becoming more reliant on Hope because of her literary ambitions. Both her memoirs and a pulp novel were to be sold to American publishers, a coup that Hope actually managed and that propped up Lehmann's pride immensely. And last but not least, Hope played real estate agent for Lehmann, as she was always searching for an appropriate home in the New York area, either an apartment in Manhattan, preferably on the East Side, or a house further north in Riverdale.[233]

Moreover, Lehmann justifiedly continued to mistrust Hope's publicity maneuvers. Hope was unscrupulous, even if some of her clients went along with her, while others, such as Leinsdorf, did not.[234] One who did so enthusiastically was Melchior, about whose wife Hope had invented a story of how she had floated down into the singer's Munich garden beneath a parachute, while she was working as a stunt artist. Kleinchen and Lauritz were introduced this way and promptly got married. Hope disseminated this fairy tale to the press agencies and published it in her memoirs as truth; without flinching, the ego-dominated Melchior did likewise. In reality, the tenor had met his future bride in a Munich cabaret and then started dating her, years before he divorced his first wife.[235]

In Lehmann's case, Hope made a composite template from various bits and pieces her friend Lotte had told her and what she had seen and heard, and also from some of Lehmann's writings – for instance, her prepublication autobiography. Hope manufactured the persona of a demure German *Hausfrau* who was fond of certain specifically American staples, such as apple pie, tomato juice, and milk shakes, as her waistline was living proof. Some of that, including the "feeble-minded grandfather," made its way into *Time* magazine for February 1935.[236] In a *Time* edition of October 1938, Lehmann, "a plump, homey individual" (as a dreadful photo purported to show) was meant to be Pilsener beer to Farrar's champagne. (The exactly six-years-older Farrar was shown in a most favorable photo).[237] A few weeks later, as press conferences for her books had taken place, Lotte Lehmann blew a fuse. "I simply cannot stand it any more to be represented merely as a food-greedy vulture," she threatened Hope, continuing that as a book-publishing artist she wanted to be taken seriously and credited with brains. No more tomato juice and milk shakes; the entire advertising concept had to be turned around.[238] To Kleinchen she complained somewhat later that Hope was dragging her "through the hells of publicity if she thinks it necessary."[239] This was after the death of Krause, when Lehmann was blaming Hope for having done her share to prevent her from seeing her dying husband, for fear of losing concert dates, and money.[240]

As time progressed, the tone of their communications became colder on Hope's side, but more heated on the singer's. Already in March 1937 Lotte had pleaded with Constance telegraphically to "be nice with me I am so down with my nerves I cannot bear it if you talk over the telephone how you did."[241] In the fall of 1938, Lehmann thought Hope's last letter had been "like an ice-cold shower." Did her new boyfriend, Tio, have something to do with it?[242] In May 1939, she protested once more against that constant control, insisting that she would "not be ruled."[243] And in August she gave notice that even her servants were afraid of the manager and that it was she, Lotte Lehmann, who was in charge of them, rather than Constance Hope.[244]

Especially in the early years of their acquaintance, Hope was fond of referring to the growing circle of New York admirers of Lotte Lehmann as "Lehmaniacs." Besides herself, to this group also belonged the writer Marcia Davenport, Hope's senior by five years. Like Hope, she had a professional musician for a parent and had been socialized in the world of music. Her mother was Alma Gluck, an uncommonly beautiful soprano born in 1884 who had been taken to America from Romania as a small child. In New York, she had briefly been married to an insurance salesman – Marcia's father – who had fled the pogroms of Russia. After singing lessons, Gluck had started at the Metropolitan in 1909 and stayed there for ten years. Conductors she sang under included Mahler and Toscanini. Having profited financially from the first RCA recordings, she became wealthy and moved into the center of cultural and social life of Manhattan, in 1914 marrying the émigré Russian violinist Efrem Zimbalist. His first accompanist was Samuel Chotzinoff (later the brother-in-law of Jascha Heifetz), who became the music critic at the *New York Post* (where he got to be fond of Lehmann) and eventually worked for NBC. They were all close to Toscanini, who acted as a fatherly friend to young

FIGURE 12. Constance Hope's wedding, New York, 1936. Kleinchen is third from the left; behind Hope's mother stands Ezio Pinza, beside him Lotte Lehmann. Lauritz Melchior is chatting with Edith Behrens, behind the bride and groom. Courtesy Special Collections, Davidson Library, UCSB.

Marcia. She married a journalist, Russell Davenport, but the union did not last. From 1928 to about 1930 she was on the staff of *The New Yorker* and then traveled to Prague and Vienna to research a biography of Mozart, which appeared to critical acclaim in 1932.[245]

In 1930, Davenport heard Lehmann sing in *Die Walküre* under Schalk. Not a Wagner fan, she saw Sieglinde come in "with a single phrase which as closely as I can describe it, knocked the breath out of me. I came up rigid on the edge of my seat and remained transfixed throughout the act. No voice had ever hit me in that way." As a soprano's child, her mother's singing had affected her quite differently. Here "the voice, the artist, the personality were all of a piece." Lehmann was like someone Davenport had never come across before. "She was both feminine humanity and total dramatic illusion through the beauty of her voice and the immense sincerity of her fusion with the character." Later, Lehmann's Fidelio and Marschallin impressed her equally.[246]

Davenport was a freelance lecturer, music critic, and journalist and had already heard Lehmann sing in New York when, in November 1934, she approached Hope for the possibility of an interview on behalf of *The New Yorker*.[247] The article that resulted highlighted Lehmann's musical genius and did much to encourage the Metropolitan to contract her on a more permanent

basis. But it also contained the old *Hausfrau* stereotypes that Lehmann so hated, for it described her as "a woman of simple German sentiment. She is gentle and jolly, of medium height, and plump. Her hair is short and brown." Later in the article, there was that emphasis on Lehmann's diet again, the tomato juice, the ice cream that she refused for herself but then, as observed by Davenport, polished off from other diners' dishes. Predictably, Lehmann was offended, but she later met with the journalist, convinced of a new devotee. As it turned out, Davenport visited Lehmann in Salzburg privately, remaining one of her most loyal women friends in New York, as she helped the singer with public relations and was in touch with the others.[248]

Of those, Viola Westervelt was the third constituent member of the New York "Lehmaniacs." In a manner of speaking she had really been the first, for Lehmann had initially met her in 1931. Lotte apparently did not see Viola during the first quarter of 1934 when she was obsessed with Toscanini. Back in Europe at the end of April, Viola seems to have got wind of the affair, or whatever passed as such, for, offended, she wished to cut her ties with Lotte. But perhaps she was just playing hard to get, because Lotte entreated her to remain in her life, assuring her of extraordinary feelings for her. By the end of May, Viola had taken back her threat and Lotte was announcing to her young friend her upcoming stay in Paris for the summer when, as the records indicate, she was also plannning to meet Toscanini there.[249] In the fall of 1934, Lotte made known to "sweet Viola" her impending arrival in New York in the company of Otto and Fritz, and it must have been at the end of that year that Viola was separating from her husband, for she took a job arranging lectures on opera at the Roerich Museum in the city.[250] Viola was living in southern Connecticut, but seems to have moved in and out with Lotte in the city also, whenever she was in New York. Hope was coordinating things and recruited Viola in months-long searches for a suitable New York abode, with Lotte long uncertain whether she should be residing in or outside the city limits.[251] Subsequently Viola was courted by a new young man, Robin Douglas from England. By June 1937 Lotte thought that she loved Viola "in manifold ways." Perhaps her motherly instinct now was strongest. Viola was such a "truly good person, so full of life, so interesting and, on top of that, so beautiful." Had she exaggerated, or seen this through "the rosy-red glasses of love?"[252] Toward the end of 1937 Lehmann almost moved into Viola's house, but it did not happen.[253] When Otto lay dying, Viola was with him in Saranac Lake, at the end of 1938.[254] At that time Viola too accepted money from Lotte.[255]

With her bony physique and slim build, Frances Holden was not particularly attractive; she dressed simply and unobtrusivly. She did not try to stand in the limelight or exert power over anyone. She was self-effacing and tried to keep to herself, mincing few words, in speech or with a pen. Unassuming, her personality at first sight was bland, but it was more stable than most. She turned out to be the fourth leading member of the Lehmann aggregation of fans.

Holden was born on March 17, 1899, into an aristocratic New York family with a Mayflower pedigree. Her grandfather was Edwin R. Holden, the first vice president of the Delaware, Lackawanna and Western Railroad, which in the nineteenth century had exclusive ownership of the anthracite coal mines in

Pennsylvania. It shipped the coal to New York City, where it was distributed for retail sales. A passenger service added to lucrative earnings. Since top managers usually controlled the voting shares in such businesses, it made them very rich.[256] Edwin's Sr.'s son was Edwin Babcock Holden, born in 1861, who graduated from Columbia College in 1883, wishing to become an architect, but because of his weak eyesight his father gave him a senior executive post in the coal division of the railway company instead. Edwin Babcock resided in a sumptous house he had built on Riverside Drive overlooking the Hudson, shortly after the ground had been converted from farmland and farmers' markets into a paved road. Holden turned most of the villa into a private museum and rare book library. In fact, until his early death in 1906 he directed his undivided attention to his collections, the art of bookbinding, and, eventually as president, the Grolier Book Society. His other hobby was cooking for like-minded friends. "Almost every Saturday night there was a 'midnight' supper in the blue room on the third floor, where the Americana collection was housed," remembers his son Arthur, a fellow bibliophile.[257] There he would host other Grolier members like Richard T. Halsey, but also outsiders like Frank Dempster Sherman, a poet and professor in Columbia's School of Architecture. After Edwin B. Holden's death, expensive china, Staffordshire blue-and-white pottery, oil paintings, and valuable books were auctioned off in sections – major events for New York's elite. Among the books there were first editions from the Elizabethan period, works by early American authors such as Ralph Waldo Emerson, and old French miniatures.[258] Hence young Frances, who adored her father, grew up with books of the most precious kind, and not only English ones. Upon her father's death, his four children were each allowed to choose books for themselves, and among Frances's was one adorned with fine architectural drawings in the margins by her father's hand.[259]

Frances's mother, Alice, was lacking in affection. But Alice Cort Holden had wanted to be a singer and had infected her daughter with a love of music. It was in the Whistler Room, where the Whistler prints were hung, that the mother's piano stood. Frances heard Caruso at the Metropolitan and at the age of twelve, during her second trip to Europe, visited the Opéra in Paris. "It was Lohengrin. I was very excited and I remember it well," she mused in her late nineties.[260]

Endowed with an exquisite intelligence and sheltered in such privileged surroundings, Frances Holden grew up a special child. Apart from books and music, she shunned dolls but liked baseball and, after attending private schools in Manhattan, became captain of her baseball team at Smith College. Majoring in psychology, she was also president of the Philosophical Society. From the Smith campus, two letters to her mother have survived – polite and proper, but scarcely emotional. There is nothing of the crazy exuberance that characterized the impulsive Lotte as a girl. Frances was well behaved, with books and academic pursuits on her mind. Boys were absent. "Five of us are trying to study together and I'm afraid not succeeding very well," she wrote in March 1918. "At any rate I'm mastering the art of conversing and writing at the same time." And in October, soberly: "My present roommate and I are still getting along amiably and very pleasantly." And she asked for books, *Alice in Wonderland* and "any books in Psych you may find in the bookcase beside my desk."[261]

At Columbia University, Frances initially wanted to study medicine, but finding that this regimen took too long, she switched to psychology, in which she graduated with a doctorate in 1927. Her research centered on an attempt "to measure the drive, or motivation value, of starvation in the white rat in terms of objective behavior."[262] She would continue to be concerned with talent and incentive, in both her professional and private life, and having worked with six hundred rats and a maze at one time, her love of animals deepened. By 1926 she had begun to teach biology at New York University, and she was an instructor in psychology there one year later. In 1931, she was promoted to assistant professor of psychology – one woman among sixteen males.[263]

In that family of high achievers, Frances would throughout her life be encouraged by her two prolific brothers, Arthur Cort and Raymond. Arthur, born 1890, went to Princeton and then Columbia, where he trained as an economist and architect. Despite his wealth, he developed a social conscience and started thinking about public housing in New York. With his inherited sense for the arts, he also wrote sonnets and books about communal living, and later his own architectural firm teamed up with Frank Lloyd Wright in the construction of the Guggenheim Museum.[264] His younger brother Raymond became a writer interested in the popularization of science, in which field he authored several books, apart from mystery novels. He was a senior staffer at *The New Yorker* around the time that Davenport was there and married to Louise Bogan, who regularly reviewed poetry.[265]

In 1932, Frances moved to a six-room penthouse at 173 Riverside Drive, together with Lucia Dunham, the widow of a man who had committed suicide, allegedly because of Dunham's incessant jealousy.[266] Once a noted singer in New York and beyond and now a voice teacher at Juilliard, Dunham had been introduced to Frances by Alice Holden, for Alice thought that her daughter's previous roommate had been too wild with men. It was Dunham who dragged Frances to Lotte Lehmann's Town Hall recital on January 7, 1932. Thereafter, Frances started to buy Lehmann records and soon had a photograph of the singer on a shelf beside her bed.[267]

Despite this picture, it was the scientist in Holden who had fallen in love with an abstract. It was frequencies – a voice, not a person. Idiosyncratically, and herself near genius, Holden did not want to meet the person behind the voice, but made sure to see and hear Lehmann almost every time she performed in New York, and she kept sending flowers to the dressing room anonymously. Holden could not tear herself away from the singer, whose art she found so beguiling, and as a psychologist she imagined that it would be interesting to discover the secrets behind such genius, as she had also been intrigued by the boy wonder Yehudi Menuhin. One way of doing this was to go back in those persons' lives in order to find something unusual, so now she wanted to know more about Lehmann's background. One day in early 1934, previews of the singer's forthcoming biography were appearing in the New York daily press, based on Hope's intricate composites. Holden visited Hope's office, was put off by Constance's cold, arrogant manner but became friends with her assistant, Edith Behrens. With her she began having regular lunches in Manhattan. She also wrote a letter to Lehmann, in care of the Metropolitan, on her university

stationery. Mentioning the "series of articles" about the singer's early life, she then dared to add more personal lines: "May I tell you, though I am sure you must have heard the same thing from thousands of others, that you have given me more than any artist I have ever heard. Every year I am increasingly grateful that Lotte Lehmann lives. Much that I might never have appreciated otherwise has come to me through your art." She concluded by saying, "For that conception of what true and great art can mean – habe DANK." Although Holden was showing off her superior knowledge here, Lehmann must also have been suitably impressed by the university letterhead, so her eyes lit up, and – always putting store in titles, fame, and authority – she wanted to meet this new fan.[268]

Eventually Lehmann started pestering the professor by telephone trying to meet her, at the same time engaging in a letter exchange, which on Holden's part kept emphasizing Lehmann's great art, while Lehmann stressed her gratitude for that never-ending stream of flowers.[269] At the end of November 1935, the unbending Lehmann arranged what she wanted, a Thanksgiving dinner at her New York apartment, to which she invited all the Lehmaniacs. Their newest chartered member Frances came as well. In Holden's ironic language, the apartment was "Austrian to the core. Lotte always loved to create excitement, and she certainly succeeded at that dinner. She invited all the people that hated one another." Today one can just imagine the miniature cowbells, edelweisses, and reproductions of mountaintops. There was Viola with her new but difficult boyfriend Robin Douglas, Marcia Davenport with the husband she was just divorcing, and Frances all by herself, all seated in awkward array. Frances and Lotte did not get along at all, and Frances "never wanted to see her again."[270]

Although the interpersonal chemistry during Lotte's and Frances's subsequent meetings was deficient, Frances slowly made friends with the other members of the circle, especially the seductive Viola, who was living in her vicinity. That way Frances also got to know the famed Farrar. In 1937, she took a sabbatical from the university and moved to a house in South Salem, a family country property about an hour's drive north of Manhattan near the Connecticut border. (Her mother had died in 1935 and left her independently wealthy.)[271] It was then that Lehmann's autobiography was published in German, and after Frances had read it in full, she thought she knew Lotte much better. Now being very close to Viola, Frances's relationship with Lucia Dunham had receded into the background, but it was by no means over. Still, anticipating a better future with the German soprano, Frances Holden wrote, with Viola in mind: "We both love you more than you can know. There is so much I long to say to you dearest Lotte, but perhaps such things are better left unsaid. I only hope you have some understanding of the way in which I love you."[272] Lotte too was relieved "that now the bareer is fallen [sic], which always seemed to be between us," and she took it as a good sign that Viola was harmonizing well with Frances.[273] That there was something sexual between Viola and Frances at the time is very likely, even though Viola was dating Robin Douglas simultaneously and was soon to marry him. It may be assumed, however, that at that time Lotte and Frances were just platonic friends.[274]

FIGURE 13. From the left: Frances Holden, Geraldine Farrar, Lotte Lehmann, and Viola Westervelt-Douglas, New York, ca. 1939. Courtesy Special Collections, Davidson Library, UCSB.

The slowly developing friendship between Lehmann and Holden received an important boost in 1938, as in the wake of the Anschluss Lehmann was moving herself and Krause to the United States, bringing over her four stepchildren and trying to get financial, legal, and logistic aid for colleagues and friends like Alwin. On this last count Holden clearly was far more understanding and financially more forthcoming than Hope, who continued to see Lehmann's impulsive munificence as foolish and tried to restrain her. By contrast, Holden was helping with lodgings, affidavits, and money. Like Viola, she played a key role in assisting Lehmann during the last weeks of Krause's suffering, though she had hardly known the man. After Otto's death in January 1939, his widow became available for closer relationships with others, even though she interjected a longer span of absence because of her months-long journey to Australasia and the associated stay in California. Back in New York in late 1939, Viola, irrespective of her marital status, thought she could place a stronger claim on Lehmann and, during intermittent dementia, physically attacked Frances in a drugstore. Brahms's song, so often done by Lehmann, was carousing through her head: "Meine Liebe ist grün," green being the color of hope. She was briefly hospitalized, after Lehmann had run down a Manhattan street clad only in a bathing suit crying "Help, help, someone has gone crazy," and being taken for the lunatic herself.[275] That Kafkaesque incident cast a momentary shadow on these women's friendship, which was lifted only slighty after Viola and Robin Douglas's departure for Chicago, where he was to work as a salesman – a far cry from Westervelt's sugar millions.

For the rest of her stay in New York, Lehmann moved into a rented house in Riverdale, north of Manhattan, in the general area where Elisabeth Rethberg, Arturo Toscanini, Geraldine Farrar, and Frances Holden now resided. The problem with Viola Douglas having been resolved by her departure and the unsentimental Constance Hope now reduced to little more than a business manager, Frances moved in with Lotte. She changed her sabbatical into a permanent leave without pay, living entirely on family investments. Fritz stayed in the metropolis with Theresia, attempting to give private singing lessons. War had broken out in Europe; it portended the end of an era. In 1940, with Lehmann and Holden's move to Santa Barbara, a new era was about to begin.

Between Touring and Teaching, 1940–1950

Frances Holden, Santa Barbara, and the New World

Santa Barbara, so it is said, lies on the "American Riviera," and anyone who has set foot on its soil will understand why Lotte Lehmann could never tear herself away from it for long, since first staying there over Christmas 1932. This sun-blessed spot – surely one of the most beautiful on earth – originated in 1768 as one of the Franciscan missions then gradually dotting the California coast. By the late 1800s, the native Cumash Indians having been fully absorbed, the population consisted of Spanish-Mexicans and mostly Anglo-Saxon migrants from the eastern United States. The original mission and military fort had been melded into a small town with a beautiful natural harbor in the state of California, created in 1848. Commerce and trade flourished, and in 1873 the Italian José Lobero, who owned the Brewery Saloon, established a playhouse at Canon Perdido and Anacapa Streets. On Washington's birthday of that year, he opened it with an operetta, *La Culumala*, composed, choreographed, and directed by himself. Located in the Chinese red-light district, with its opium dens and rat-infested buildings, it was then the largest adobe structure in California. Residential areas expanded in lockstep with the population. One eventually was to be called Hope Ranch Park, outside the town center, on former sheep-grazing grounds. By about 1900 there was train service for the population of more than 6,000, to and from Los Angeles – some hundred miles to the south – and San Francisco.[1]

With the development of Montecito and its large country estates on the outskirts, reaching from the Pacific to the Santa Ynez Mountains, the rich and powerful were arriving in Santa Barbara, often by private palace car: John D. Rockefeller, Andrew Carnegie, and Teddy Roosevelt. Motion picture production was established in 1910, when Bronco Billy Anderson filmed a Western in the San Marcos Pass area, and more studios were built. By 1920 Santa Barbara was beginning to be systematically beautified, in a Hispanic adobe style that characterizes the city to this day. In the process, the old Lobero Theater was replaced by a more modern structure. On June 29, 1925 – the film industry had meanwhile relocated to Hollywood – an earthquake struck. A visitor from Los Angeles was just pulling out of the city on a train when he looked out the window and saw "trees shaking, houses moving, chimneys falling and people running from their homes." Although thirteen residents died, the reconstruction

of the town spurred the beautification. In 1940, after the construction of an art museum, Santa Barbara was home to just under 35,000 residents.[2]

Over the years since 1932, Lotte Lehmann had been rekindling her fantasy of moving to Santa Barbara and perhaps retiring there.[3] A more concrete plan took shape when she was scheduled to perform with the Metropolitan on a tour to Dallas, New Orleans, and Atlanta during April 1940.[4] Frances Holden, with whom she had been sharing a rented house in Riverdale for several months – each on separate floors – offered to drive her there in her convertible; what was more, they could drive right through to Santa Barbara for a vacation. Lehmann embraced this offer enthusiastically. For while she had never managed to obtain her own driver's licence, she enjoyed being chauffeured around by friends, especially in Holden's roadster. Holden herself looked upon such a trip as a welcome diversion; her sister Mary lived in Santa Cruz, up the West Coast; and while she did not particularly get along with her, she had made the trip across the continent several times. This time around, she considered driving her friend to Santa Barbara, staying with her for a while, and then, perhaps, moving on to Santa Cruz.[5] In April, Lotte prepaid two months' rent in Santa Barbara; Frances was to follow up with an extension for another three months.[6] The entire trip, then, was to be more or less improvised; there was no master plan of settling permanently, as partners for life, on the Californian Riviera. In any event, Lotte had to be back East for her Met season by November.

But a permanent settlement is exactly what eventually resulted. Looking upon this trip as an escape from the more restrictive East, Lotte hugely enjoyed traveling with her newest friend Frances, taking special delight – world-famous prima donna that she was, with her name well publicized over the radio alone – in entering random hotels in the evenings, incognito, with tousled hair and in impossible getups, such as slacks. She experienced the April performances as "a fairly idiotic interruption," being much more interested in acquiring a suntan and sketching the varied scenery she was encountering en route.[7] Once in Santa Barbara by May, although they had rented, both women immediately began looking for a property to buy. This suggests that Lotte and Frances had examined and reconfirmed their decision to stay together – living on the West Coast for part of the year and in the East during opera season, with Frances's unbeloved sister in Santa Cruz a nonissue. By the fall of 1941, it was in fact clear that the Santa Barbara house in which they then resided was considered "our permanent home," while the New York rented property was to be sublet or terminated. Concert and opera seasons in the East were to be spent in hotels.[8]

The residence Frances and Lotte found to buy in June was known as "Knapp's Lodge," on a rocky promontory in the mountains near the San Marcos Pass on East Camino Cielo and hopelessly romantic. Holden paid for it – $1,000 for the lot and $10,000 for the building, having been pushed into the deal in large part by her enthusiastic friend. The Chicago utilities tycoon George Owen Knapp had built it as a weekend retreat in the early 1930s; there were several buildings, including servant quarters and an observatory, containing fireplaces and a pipe organ, which found the favor of two early visitors from Los Angeles, Bruno Walter and Otto Klemperer. The organ was coordinated with colored lights falling onto a small waterfall outside, which Frances belittled

but Lotte loved. The lodge, constructed of local golden-toned sandstone and clapboarding, was completely isolated. Looking across the Santa Ynez River Valley one's gaze barely reached the outskirts of Santa Barbara on the edge of the turquoise Pacific below. This was a uniquely picturesque site that inspired rapturous wonderment on the part of both women and encouraged Lotte to pursue her newfound art of painting. But apart from its awkward distance from the town with all its amenities, there were other drawbacks. The streets leading up to Knapp's Lodge were steep, cumbersome, and dangerous. One had to have a car "hardy enough to withstand two trips a day down the bumpy road to the pumphouse. We had to go down there to turn on the electric pump in the morning and down again to turn it off every night," cavils Holden. There were tarantulas in the stairways. And during that July and August, the heat rising up from the stone base was such that the two women had to sleep outside on the terrace, which, on the other hand, they found hilariously adventurous.[9]

Then, after exactly forty-six days, adventure turned into catastrophe, as the entire property fell victim to one of the wildfires that so often threaten Santa Barbara.[10] Visiting from Atlanta, Mia Hecht happened to be a house guest then, and she rhapsodized about the *Götterdämmerung*, about "the beauty of this wonderful drama, eternally in my memory. I could not tear myself away from the magic of this fire." Lehmann and Holden, who finally fled with Hecht in three cars, left to posterity more sobering accounts that detailed the loss of most of their possessions, including the singer's costumes and what she had begun to paint. Fortunately, Holden had taken out insurance in the nick of time, so that she could use the money to buy another property in the Hope Ranch Park area for virtually the same amount, close to the ocean and much more convenient for getting into town – with its railway station, the Lobero Theater, and the developing airfield. Holden baptized the new house at 4565 Via Huerto "Orplid." Lehmann had often performed Hugo Wolf's "Gesang Weylas," with a text by Eduard Mörike, "Du bist Orplid, mein Land! Das ferne leuchtet."[11]

The new house was on six acres of land that extended right down to the ocean; it needed much work in developing the garden, and at Lotte's behest, Frances had a pool installed at the end of the 1940s. Although it was legally Frances's house, according to Lotte she had initially wished to register it in the Lehmann name, insisting, in any case, that "what is mine is yours." Yet although Frances was always generous, declining Lotte's offer to share in any of the property expenses, she was financially extremely prudent, seeking to secure whatever she possessed in real estate and liquid assets, which were mostly conservative stocks – in her case, shares of solid firms such as General Electric and General Motors. Frances did well by living off the dividends and never touching the capital. Later, when her aunt and sister died, she inherited even more money. But she continued to be frugal, purchasing unobtrusive cars for herself and making her own furniture, to say nothing of all the money-saving work she did in the huge garden as well as shaping the grounds and terrace.[12]

Subjectively, the singer continued to find her financial situation precarious, not so much because she did not have any money but because, as before, she could not budget, lent and borrowed indiscriminately, and went on buying and gift-making binges. The resulting lack of fiscal transparency was compounded

by the fact that despite her dislike of Constance Hope's managerial fiat she continued to rely on that friend from the early New York days, even though on the emotional side their relationship was cooling. In addition, Holden now sometimes conspired with Hope to keep Lehmann's finances in check, but just as often acted on her own to rein in her friend's buying urges.[13]

Figures from the messy bookkeeping reveal that Lehmann grossed between 20,000 and 30,000 dollars annually during the decade of the 1940s. During this period she also owned some stocks and a small house on a modest Santa Barbara street, as well as – briefly – a fancy one near Hollywood, after a short film career.[14] Lehmann claimed she was losing about 40 percent of her earnings to taxes, but that may just have been her faulty perception.[15] The truth is that because she lived rent-free on Via Huerto, her incoming funds represented a considerable amount, taking into account some of the typical prices of that era: In early 1941 at the Metropolitan, the most expensive ticket cost $6.00, and the cheapest $1.50. Later in the year, a quilted lady's robe could be had for under nine dollars, and a fifteen-jewel, gold-plated Bulova lady's watch for less than twenty-five. A gallon of medium-priced red wine (which Lehmann was fond of) would set her back around three dollars, and a record with her voice on it cost about a dollar.[16]

The continued folly of Lehmann's economic ways is exemplified by a number of financial episodes, or, rather, escapades. When in the early 1940s Lotte's cousin Else Block, who was married to the Baltimore pediatrician Walter Block, had a baby boy, she sent them a coupon for the baptism worth hundreds of dollars. The family was able to buy a series of baby outfits as well as a complete furniture suite for that amount.[17] But if she gave a lot, she also expected a lot for herself. So when she was hired to play a minor role in the 1947 film *The Big City*, she whined about her low weekly salary, which her impecunious brother Fritz found hugely generous. Earlier, she had lamented that in all likelihood she would have to die "without that greatest happiness of being immeasurably rich" – a statement that Fritz took as blasphemy.[18] One of the luxuries she afforded herself after World War II was to bring her old maid, Marie, over from Vienna, not least because of a misplaced sense of loyalty. But such hubris backfired badly; she had to deal not only with immense costs, including those for lawyers, but also with grating arrogance on the part of the spoiled domestic.[19] Lehmann was able to collect but trickles of repayment on the $3,000 she had lent Elisabeth Schumann in 1939, trusting the singer's assurance that she had as collateral a precious Gobelin worth thousands of dollars.[20] She kept holding on to her rental of the Riverdale house, thinking that she might be able to live in it while doing concerts around New York. She found it next to impossible to sublet, however, until the expensive lease ran out in September 1943.[21] Witnessing all this, the parsimonious Holden kept her back, trying to prevent any unnecessary "kaufi kaufi." Sometimes, however, Holden went too far, not comprehending a woman's joy as she buys the latest fashion. When Lotte wished to purchase a hat, Frances snapped: "You *have* a hat!"[22]

On the whole, the relationship between Lotte Lehmann and Frances Holden, after hesitant starts and stops over several years, became a success because the two women represented opposites attracting each other, while at the same time

FIGURE 14. Lotte Lehmann and Frances Holden at Hope Ranch, Santa Barbara, 1948.
Courtesy Special Collections, Davidson Library, UCSB.

commonalities bonded them. Lehmann was an organic, emotional, intuitive, round and soft creature; she was physical and gushy: in Nietzschean terms a Dionysian. Holden was rational, analytical, intellectual, cold in an angular frame; she was a cerebral and visceral academic and ruled by mental control. She was Nietzsche's Appolonian. Lest such analogies be taken too literally, the Freudian psychiatrist Herman Schornstein, who knew them both well in their later life, characterized Holden as "anal" and Lehmann as "oral (but not arrested at that level) – [she] loved great food – was a good sport – warm and

giving [and], although she might deny it, compassionate."[23] But whatever the wellspring of their mutual attraction, which culminated in a state of love, it is difficult to ascertain whether sex played any role in that relationship, because according to several close witnesses,[24] both Holden and Lehmann kept denying it. Naturally, there was always gossip from narrow-minded citizens – one reason why both women became integrated into the small town very slowly.[25]

Some of the salient differences between these two remarkable personalities, as well as some commonalities, help to explain them better. As for the differences, there was, above all, Holden's Puritan work ethic, uncannily passed on to her by her Mayflower ancestors, but – at this extreme – alien to Lehmann. She would rise very early in the morning, getting busy in the garden or with carpentry; eventually she had a workshop put in, next to her garage.[26] She would go for a swim even when it was frigid, but warned Lehmann, who gratefully complied, against doing the same.[27] Lehmann was in awe of her. "Frances works like mad and when ever she rests God alone knows. . . . I have a spell of laziness." And: "Frances is so dreadfully busy always with building walls and painting and doing the impossible in house and garden."[28] Frances herself observed about Lotte: "I have pictures of her, that she wanted sent to her friends in Europe, with her holding a watering can and any gardening tool, and she had never held one before. She didn't garden, she loved the results but not the work, but she liked to make it seem that she did."[29] Frances did all the cooking, often pushing bothersome servants aside and inventing new recipes during wartime, when staples were scarce. When Lotte tried it, she was expected to burn the bread or explode dishes in the kitchen.[30]

In 1997, one year after Holden's death, the empty sprawling house, offered for sale, was but an empty shell when I saw it, except for the inside walls, still lined with many book shelves and record spaces that Holden had lovingly constructed. True to her early upbringing, books were Frances's passion; she had them brought by the truckload from the East. And whereas she read voraciously and also listened to records, Lotte could not be bothered; reading was too strenuous, and in principle only listening to vocal music interested her, but ultimately had to be avoided because of her automatic comparisons to other singers. She did not have the discipline it takes to consume culture, let alone consume it selectively, but instead created her own cultural cosmos – the one on the stage, which guaranteed her livelihood (and therefore often was just work and even worthy of avoidance), and the one she enjoyed but dabbled in, as in writing poetry or short stories, more and more painting as the weeks grew long, and even fashioning tiles and pottery.[31]

What Frances and Lotte had in common was their sense of mutual commitment, enjoying the other person's company, as uniquely different as they were. This included some very nasty clashes they indulged in ritually, employing foul language. Yet both were extremely sensitive and with an unusual range of intelligence and emotion, although in Frances's case the former was broader, as was the latter in Lotte's. They shared lifestyle values: a great love of nature, which impelled them both to remain in Santa Barbara's paradise, and a sense of social exclusivity, which in both may have originated with personal shyness but eventually solidified into an acknowledgement of the fact that few people

anywhere could understand them. This is an additional reason why they rarely went into town, except for a certain Chinese restaurant, and why they received guests seldom, and never for long. But they sought out company if it was of the right kind: fellow artists and literati from Los Angeles or New York; Frances's favorite brother, Arthur; old and sometimes newer friends and, increasingly, mature voice students. They both loved a good meal (Lotte grudgingly but inevitably succumbing), to be washed down with Frances's potent liquor or Lotte's local red wine. They would travel on all tours together, except for two in 1949 and 1951, when Frances stayed home and Lotte found being alone on trains or in some dreary Midwestern hotel repulsively unbearable. Frances played "doctor" to Lotte when her spirits were down (she was prone to crying bouts) and displayed touching care; often she would put the singer in her open car and take her for a wind-chilled ride. Hence they would drive to Carmel up the coast, to say nothing of Los Angeles; but a carefree cross-country tour was never attempted again. Fritz analyzed the situation succinctly when he wrote that surely Frances knew what she was doing, for without Lotte she might just have withered away on the East Coast, and he agreed with his sister that for both, their companionship was the best possible solution next to a marriage.[32] Toward the very end of her career as a singer, in early 1951, as Lehmann found it impossible to continue, it was Frances who held up her spirits by mail, cable, and telephone from California, helping to ease the agony she was experiencing before each of those very last concerts.[33]

In that first decade at Hope Ranch, two things potentially endangered the two women's harmonious cohabitation. One was a singular incident and the other a drawn-out affair. The incident revolved around a shift by the young singer Anne Brown from Lucia Dunham to Lotte Lehmann as a teacher. Born in 1912, Brown was an accomplished African-American soprano who, after working with him on the score and story line, had created Bess in George Gershwin's Negro opera *Porgy and Bess* at New York's Alvin Theater in October 1935. She had attended Juilliard, where she met her vocal instructor, Dunham, then living with Holden. In 1942, Lehmann gave Brown a few lessons in Santa Barbara, which incensed Dunham, who claimed that the European soprano had taken away from her not only her companion but subsequently also her most illustrious student. Frances defended Lotte, trying to explain to Dunham that she had ceased living with her long before joining Lehmann and reminding her that Brown had come to see Lehmann of her own free will and that, moreover, Dunham should consider it an honor to be succeeded as a teacher by someone as famous as the prima donna. The incident passed, with Fritz Lehmann, who as a vocal coach would also have contact with Brown, expressing some sympathy for Dunham, but at one time Frances was seriously afraid that Lucia's violent temper would get the better of her and cause her gun to be used against Lotte – the very same weapon that her former friend's husband had shot himself with.[34]

The other potential disturbance arose from Holden and Lehmann's shared love of animals. There were several problems here, the least of which was that birds, dogs, and cats had to be looked after when the house was empty, which happened frequently in the first half of the decade because of Frances's travel with Lotte. But even day trips to Los Angeles had to be cut short, for

one had to be back for feeding time.[35] Another was procuring the right food for them during the rationing of wartime. At any one time, there were seven dogs on the property and over forty birds, with the odd stray cat and her kittens.[36] Lehmann had always had dogs, even on her travels, and being the cuddly woman that she was, those tended to be small canines who could sit in her lap. The athletic Frances, on the other hand, preferred large dogs, which were good for protection. Generally it was held that for upkeep, the dogs were Frances's responsibility and the birds Lotte's.[37] For any visitor, the animals were a source of amusement and, perhaps, annoyance. Lotte had Oskar, the wild bluejay, trained to eat crumbs from her scalp. Jocko, the mynah bird, would startle visitors with the cry, "Sorry, time to go!"[38] He could imitate Lotte's voice and call "Franceees" on the terrace, so that Holden did not know whether it was serious enough to climb up the garden slope or not.[39] While the dog Adagio ate Lotte's paint brushes, the German shepherd Fritzi adored being dressed up in a military outfit someone had left behind, and another dog was a bride.[40] Lotte also taught some dogs to "love music" under the piano and, so she claimed, to sing.

But brother Fritz was concerned that for all their love of animals the two women might not eat their chickens during ration time. He also discerned trenchantly that these women, who did not have (and did not like) small children, progressively humanized these animals, thereby lowering their own standards of behavior and risking their dignity. The most visible sign of this was the use of baby talk, first with the animals and then with each other. Once when Lehmann applied cologne to Fritzi's eyes, her brother told her to go see a doctor to have her head examined. Would birds and dogs not be much happier if allowed to be what nature had intended them to be, namely, animals?[41]

Fritz Lehmann was the other capstone in the singer's support structure of personal relationships. In the United States since February 1939, and with minimal command of English, he had been unsuccessful, even with his sister's connections, in landing a job training vocalists in the Hollywood area. Hence he returned to New York with his girlfriend, Theresia Heinz, where they were supported by $250 per month from Lotte's purse. In February 1940, on the strength of his sister's name, he joined the David Mannes Music School, a private conservatory, where several Europeans taught, many of them faithful to the principles of Heinrich Schenker (1868–1935). But always prone to losing employment wherever he had found it, Lehmann lost this position in about a year, hoping instead to find private students, in New York and even Nantucket, where he liked to spend his summers. This never materialized to the point where he was able to make an independent living, so that Lotte, as she was gradually settling into Santa Barbara, wanted him back on the West Coast. Fritz remained reluctant; while he dearly loved his sister (and was confident that she loved him), he knew full well that they would quarrel as soon as they were together, and he also feared her dominance as it expressed itself by way of her (relative) economic power. To wit: by 1942 Lotte had been able to buy a small house on modest Verde Vista Drive, not far from Hope Ranch, whence she forced Fritz and Theresia to move by reducing his monthly stipend to a mere $100.[42]

Fritz was unhappy in Santa Barbara. His situation was difficult from the outset because in that small town, where even Lotte Lehmann was regarded with suspicion, people were gossiping about him and Theresia, which annoyed especially her, as he would not even bother to stand up for her. Because Lotte was now beginning to teach for money, Fritz was forced to prepare some junior students for her, without receiving compensation, which made both siblings unhappy – him because his hands remained empty, and her because the students turned out badly. Other than that, Fritz was expected to look after her house and animals whenever she and Frances traveled. By the end of 1942 – Hollywood, of course, had never beckoned – Fritz Lehmann was resolved to return to New York, perhaps even taking his sister with him, but that was out of the question for Lotte. As she was just starting to coach some more accomplished singers like Brown, Fritz was hoping to be able to skim the cream off the top by taking on whomever she had finished with. His self-esteem was at a low ebb. "Finally to have the feeling not to be despised any more nor even laughed at: 'That poor Lotte is straining her vocal cords for her lazy, fat brother'." An occasion presented itself when in summer 1943 he was indeed able to do some rehearsing with Brown and Mary van Kirk, who had had a Metropolitan début as Grimgerde in *Die Walküre* on December 6, 1941, and then had honed her interpretatory skills with his sister. On September 12, 1943, Fritz and Theresia moved back to New York, leaving behind a disappointed Lotte who nonetheless knew full well that as far as finding work was concerned, Santa Barbara had been a wasteland for her brother.[43]

Lotte rented out her Verde Vista house in order to help Fritz move into an apartment on the Upper West Side near Broadway, furnished with inventory from the Riverdale house.[44] As a vocal coach, Lehmann faced tough competition, especially among the many Jewish émigrés. From Vienna alone, there were at least two of Lotte's former associates in New York, the mezzo-soprano Bella Paalen and the multitalented Lothar Wallerstein. Yet another colleague of Lotte's from Hamburg, the native American Edyth Walker, had hung out her shingle as a private teacher around 1936.[45]

As an instructor in vocal interpretation, Fritz was facing a small dilemma because the students he inherited from his sister were all somewhat established and reluctant to pay him, thinking that it would be great advertisement for him to be associated with them. Unknown beginners who would compensate him decently were few and far between, so that he continued to depend heavily on Lotte's contributions, especially since Theresia, in the United States on a visitor's visa, was not allowed to work.[46] (Fritz himself had arrived on a German immigrant's visa and was a candidate for American citizenship.) He instructed Brown, who, although she had been commended by Olin Downes for her "fresh tone, admirably competent technic, and dramatic delivery" as the first Bess in October 1935, had not found her way to the Met, because that institution still clung to an anti-black hiring policy.[47] Then there were the Met veteran Van Kirk and Rose Bampton, a graduate of the Curtis Institute of Music who had made her Met début as Laura in Ponchielli's *La Gioconda* in November 1932. He also coached the Czech-Jewish émigré Mona Paulee, whose Met début was as Gianetta in Donizetti's *L'elisir d'amore* in November 1941 – neither

of these a momentous role.[48] And soprano Maria Schacko was his client, originally from Germany; she did not get her feet on the ground for years, even though she had been the wife of the increasingly well-known conductor (and fellow émigré) Maurice Abravanel and, which may have hurt her more than it helped, the mistress of the by now seriously manic-depressive Otto Klemperer. Schacko had had a few New York radio spots and the odd recital with either Abravanel or Klemperer (who, more than anything, liked her to perform his own compositions), but around 1947, when she was consulting Lehmann, she was preparing for a Mendelssohn song recital in New York, which then came off, after Lehmann's efforts, with "style and feeling," but a voice "hardly adequate."[49] His most promising student appears to have been Anne ("Betty") Bollinger, who débuted at the Met in *Carmen* in January 1949 and then stayed on for more than one hundred performances.[50] Even though with his characteristic arrogance Lehmann looked down on most of these women students, of whom there were fewer than he and his sister had originally anticipated, he was compensated for their spotty attendance by what he thought to be their erotic interest in him, especially the sensuous Anne Brown's. Grossly overweight and ignoring the demure Theresia, Fritz Lehmann fancied himself a ladies' man; perhaps not to miss out on any amorous opportunities, he wasted no time with males.[51]

This amounted to a luxury, for even with his sister's subsidies, Lehmann's earnings did not take him very far – supporting two people in expensive Manhattan and with a regular summer vacation at the New England seaside. As he taught for merely eight months a year (plus the odd Nantucket summer class), receiving an average of $5 per lesson, he altogether had less than $950 a month to live on before taxes, but he and Theresia managed. In such a case nothing remained for emergencies, such as medical or dental mishaps (for which once again his sister was liable); and any property he might have left behind in Europe, like Clara's house in Westerland and certain stocks, after 1945 would be either worthless, destroyed, or forfeited. By September 1946 Fritz rather smugly had figured out that his sister had expended $21,000 on him since his arrival in the country, not counting any housing costs – a year later he reckoned $30,000. Although Lotte, for appearances' sake, wrote in 1950 that it worried her that Fritz "works too hard," in reality she knew that he was lounging about at her expense, as he had done for many years, which left her rather bitter.[52]

And so the relationship between sister and brother, as had been demonstrated before, was indeed a complicated one. On the one hand, they loved each other dearly, and on the other there was mutual resentment. On her part, the love was deeply felt and based, as she often stressed, on blood ties. She considered Fritz the dearest person in her life, dearer than any of her men had ever been, and in time rivaled only by Frances.[53] She could never forget how Fritz had stood by her emotionally and helped her financially when the going was rough in her youth. He shared many of her views, just as he himself constantly imparted to her much of his value system, including a reactionary outlook on aesthetics and politics. As he had encouraged her in her past as a young singer, he was now doing the same as she was trying to find her way as a teacher of voice interpretation. She could share with him all manner of gossip and vulgar stories, of the kind that

were rooted in the coarse soil of their Brandenburg homeland and that were out of bounds among New York sophisticates such as Frances. Fritz admired his sister's undeniable uniqueness and took immense pride in having helped her art to blossom. He bonded with her emotionally in ways he could not with Theresia, and when they were on opposite coasts, he would write to her twice a week. He delighted in charming her with his encyclopedic knowledge, much of it half-baked, but he knew Lotte would be awed nonetheless. He was infinitely grateful for her unqualified stipends, always protesting that she was overgenerous and that he would repay her, while knowing that she knew this would never happen. He credited her with having pulled him away from a chronic state of alcoholism after Clara's death and for virtually having dragged him from Austria to safety in America.

But that was only one side of this sibling relationship. The other consisted of mutual resentment, on her part over his job uncertainties and "lack of dignity," on his part based on jealousy.[54] Every overstated compliment he paid her, that she was the "genius" in the family, contained the stinging reminder that with his talent, if he had had the right opportunities, he could have equaled her.[55] He took the knowledge that he had learned so many things on the fly in relatively short periods of time as proof that he was a Renaissance Man who, six years older than his sister, still had a lot to teach her. If the tone of his weekend missives, which he would pedantically entitle "Sunday Letters," was often sharp and disrespectful, he was reacting to complementary outbursts of belligerency on her part, which at their worst were intentionally offensive, meant to put her sometime mentor in his place. It is interesting that Lotte never reacted negatively to any of Fritz's many anti-Semitic slurs, especially about people they both knew, such as the Walters and Hope, which suggests agreement on her part (at one time he even cautioned her to watch her language so as not to appear to be a Jew hater).[56] She could get quite exercised, however, over incidental things that led to misunderstandings, as if she wanted a fight just to vent some rage. Be this as it may, the essence of this correspondence, from which only his many letters have survived (although he habitually quoted her verbatim in response), is that despite their need for each other, she was resentful over her financial support for him, and he because she had become the Golden Girl.[57]

Difficulties between sister and brother were exacerbated over the one person each was very close to but not related to: Frances Holden on the one side and Theresia Heinz on the other. Although Fritz declared himself fully in favor of Lotte's companship with Frances, he feared her superior intelligence and cutting logic and was conscious of her dislike for him. Not unlike Hope, Frances objected to her best friend's money being squandered on a freeloader, and she pointedly avoided any mention of Theresia, certainly as long as Fritz seemed merely interested in a concubinage. Fritz was sensitive to such patrician contempt, so that the subject of Frances, a rival for the affections of his sister, remained a touchy one in correspondence and telephone conversations.[58]

Theresia Heinz, some twenty years younger, had came to the attention of Fritz Lehmann after she had been hired to care for his dying wife, Clara, at the beginning of the 1930s. Hers was a vintner's family near Poysdorf, a small place

in Lower Austria, sixty miles northeast of Vienna. Theresia had lost her father and a brother in World War I; she had two sisters and had raised a younger brother. Somewhat rotund but with attractive features, she was a practical-minded woman who had learned housekeeping skills during the war and was never shy of work. After Clara's death in 1931, she continued caring for Fritz, to whose charismatic personality she became beholden. Fritz must have valued her highly enough to bring her over with him to America in early 1939, on a tourist's permit.[59]

Since, in a manner of speaking, Theresia and Lotte were rivals for the same man, they predictably did not get along smoothly, even though the singer always seems to have appreciated Theresia's dedication to the welfare of her brother. She may have taken solace in the fact that Fritz, for appearances' sake, continued to treat her like his housekeeper. Indeed, he felt free to play with other women, particularly when traveling to Nantucket – always by himself. This "freedom" was important to Fritz, and Theresia meekly accepted it, just as she was in the habit of addressing her master in the third person, as if their household were a Baroque Viennese court.[60]

But in June of 1946 a disaster struck that caused Lotte to become some-what more involved in her brother's relationship than she might have cared to be. Because of her tourist status, Theresia was in imminent danger of being expelled. This had not been a problem during World War II, probably owing to bureaucratic laxity rather than compassion, but now regulations were enforced. Deportation to Austria was at first planned for any time after July 15, but this date kept being pushed forward until May 29, 1947, loomed as the final, non-postponable day. It was due to whatever connections Lotte had that Theresia could receive several reprieves. At the same time, Lotte started posting care packets to Theresia's family in Poysdorf, which suggests that she began to think of Fritz's housekeeper as a future sister-in-law. At the end of 1946 she sent an old mink coat to Theresia, which Fritz now accepted as a hint that he should marry, to keep her in the country. By April 1947 he was in agreement, and he and Fräulein Heinz legally became man and wife on May 20. In this whole situation, Fritz had behaved the worst, for he had never paid attention to the legal status of his paramour, had craved only his independence, and now was concerned – although he protested otherwise – what the people would say. Lotte came off better, although she seems to have thought of marriage only as a last resort, rather than urging Fritz much earlier to legalize the union with his housekeeper. The matter left a bitter taste in their mouths. Although Lotte continued to invite Theresia back to Hope Ranch as before, their relationship would henceforth be rather less than cordial.[61]

Living so closely with Frances Holden in Santa Barbara in the 1940s, Lotte Lehmann – who, like her friend, disdained crowds and partying – enjoyed the company of fewer friends than in either New York or Vienna. Brother Fritz, despite all the bickering, again became a fixture of her existence, as he had been in Berlin and Hamburg, because she was new in America and needed his emotional support. But of course she still had Mia Hecht and her husband Robert, who, however, could seldom be enticed to leave Atlanta for visits to Santa Barbara. Lehmann herself found the entire U.S. South too humid and

unattractive to want to travel there, even for Mia.[62] Viola Douglas, now in a new violent marriage with Robin in Evanston, again attempted to insinuate herself into the relationship between Lotte and Frances – with some success, at least as far as Lotte was concerned (for she needed her admirers), as she repeatedly painted portraits of her devotee. Whereas Frances remained truculent, Viola used several visits to Fritz in Nantucket to win and retain both his favor and that of his sister. Letters suggest that he, the would-be Casanova, had an affair with her on the island, while she pretended to take voice lessons from him, but renewed attempts on her part to marry him, during which she dangled money from her Westervelt divorce settlement before his eyes, apparently came to naught. Viola was a complex, neurotic woman, her exquisite beauty fading, who sought no satisfaction in an occupation of her own, living instead on some of the wealth she had saved after her divorce and trying to use her old friends. Frances saw through this much more astutely than Lotte, and it was undoubtedly due to Frances's influence that Viola did not show up more often on the California coast than was the case.[63]

With Krause and Toscanini absent, there was no new significant man in Lotte Lehmann's life during this decade, with the exception of Noel Sullivan, a rich bachelor from Carmel, who was fond of the arts and supported her in a local recital.[64] With his refined facial features and cultivated demeanor, Fritz, undoubtedly jealous, found him effeminate and a homosexual, a judgment Lotte thought he had no right to make, so that Sullivan became the object of one of their typical quarrels. Lotte knew full well that her marrying days were over, what with her advancing age, her concert schedule, and her personal commitment to Frances. But, characteristically, she was intrigued by Sullivan's elegance and wealth, even if she also liked to flirt with other men.[65] There was young, handsome Peter Krause, her erstwhile "Octavian," who came visiting and whom she considered seducing.[66] And there was the actor Gene Raymond, film star Jeanette MacDonald's husband, whom she met in Hollywood while coaching MacDonald in singing and whom she deemed intriguing, like everyone else from the film industry.[67]

Lehmann's self-chosen isolation in Shangri-la Santa Barbara, interrupted only by concert tours to the continent's provincial outposts and occasional visits to cosmopolitan New York, unquestionably contributed to her social solitude. This does not mean, however, that she did not connect to the wider world around her – for example, that of other German émigrés and even facets of regional and national American politics. Lotte Lehmann loved America, and she wanted to become an American.[68] In that respect, she may have differed from many of her fellow refugees, even Jewish ones, and certainly from her fellow musicians, who did not think the United States had enough culture to sustain their eclectic European tastes, whether they had found satisfactory new work or not.

Lehmann's desire to integrate fully into American society and culture was nurtured, to be sure, by her realization of the fact that, by her own design, she had almost been claimed by Nazi Germany, and that such integration after 1938 represented the only alternative guaranteeing survival. Perforce she had

to cement her status as an émigré, a refugee from Nazi tyranny, whether that phrase reflected reality or not, had to continue honing her "resistance" legend and making sure that those who could puncture it would not do so. That is one of the main reasons why her relationship with Constance Hope, while becoming more tenuous, was never severed after 1938, when a return to either Germany or pre-Anschluss Austria had been rendered impossible. Besides Fritz, there was no one else who knew the details of her true relationship with Göring; until her last days, Frances Holden too thought that the singer had been a victim of the Nazis.[69]

Lehmann's path to American assimilation was not without hurdles, but smoother than most. Like Bruno Walter and other world-famous artists, she enjoyed the incalculable advantage of having been a brand name on the U.S. cultural scene *before* Hitler's coming to power, so when it became public in late 1938 that she was applying for her first citizenship papers (the precondition for naturalization), this was cause for celebration among many. Hence a dinner was given for her at New York's Astor Hotel in December by the American Committee for Christian German Refugees, "as a symbol of the cultural contribution brought to this country by refugees from Nazi persecution." Being fully aware that her status as a refugee from persecution was subject to interpretation by educated skeptics, Lehmann had hesitated to accept this honor, but in the end she thought it wiser to attend, thanking America in her speech for having granted shelter to oppressed exiles and pledging to try with all her heart to be worthy of her new country.[70]

When World War II commenced in September 1939, Americans began to show their sympathy for the Western European countries and particularly Britain with various actions, including a Selective Training and Service Act for draft-eligible men, until in March 1940 Congress provided goods and services for the defense of friendly nations through its Lend Lease Act. German nationals in the country deemed most dangerous were already being interned. In May, President Roosevelt proclaimed an unlimited state of national emergency. Although Lehmann had had her brother safe in the States since the spring of 1939, she well understood the gravity of the situation, in personal as well as U.S. national terms, and was overcome by a hysterical fear, which led to crying fits. Her condition may have been calmed by further signs of acceptance, as when in January 1940 she was invited, along with Melchior, to give a recital on behalf of some rich and influential patrons in Washington, among whom her old supporter Eleanor Roosevelt was the most prominent. But she was frightened again by Hope, who wanted her to honor the promise of a recital in Vancouver by the fall of that year. Although Hope may only have thought of the money, Lehmann and Holden feared, with good reason, that the singer would be at risk in Canada, which had lagged Britain in declaring war on Germany by only five days. As a (newly reverted) German citizen and therefore an "enemy alien," Lehmann could have been immediately interned or, worse, could have been sent to Germany in exchange for British artists held by the Nazis. In the event, the visit to Vancouver was canceled.[71]

In June of 1940, Congress passed the Alien Registration Act, ordering the fingerprinting of over three million foreigners.[72] By the fall of 1940, public

sentiment in the United States had turned decidedly anti-German (although it never approached the hysteria of World War I), with the result that the *Hollywood Citizen* maligned Lehmann after her performance in San Francisco as Marschallin on October 16, without mentioning her by name, but calling for her deportation.[73] Although the singer felt safe because of her citizenship application and a few friends in high places, her situation changed for the worse when, four days after the Japanese attack on Pearl Harbor on December 7, 1941, Germany and Italy declared war on the United States. This was notwithstanding Roosevelt's famous quip that as "a lot of opera singers," Italians were not to be feared, but that Germans were different – "they may be dangerous": as a German opera singer, she could not metamorphose into an Italian. In January 1942, restrictions with respect to more stringent internment came into effect. At the lower end, these included a local curfew of 8:00 P.M. and the necessity for special authorization if wishing to travel beyond a predefined range. Such would turn out to be extremely onerous for a working artist on tour, as Lehmann was. As it happened, the rulings were farcical and inconsistently enforced, so that Lehmann spoke of a comical odyssey she went through to find out who was in charge and had to grant what permission – at least in Santa Barbara County. In New York City, where she still had the Riverdale house (legally situated in the Bronx), she made a point of reporting to the United States Court House in Foley Square, as she had to register there a week before traveling to Raleigh, North Carolina, and other places. She had a *New York Times* reporter with her to document that she had to fill out "some twenty questionnaires, listing the points to be covered in her tour." If Santa Barbara may have been comparatively lax, the violation of any of the New York rules was liable to "subject a person to summary internment."[74]

Matters were heating up even on the West Coast in early 1942 when the two Hope Ranch residents learned that Santa Barbara townsfolk were questioning Madame Lehmann's loyalty. "Because they had heard so much German language used in and about her home and some of it sounded like fierce arguments" – an obvious reference to the two women's lively discussions of repertoire and to the foul language that both of them often used. (Or was this a reference to one of the frequent quarrels between Lotte and the visiting Fritz?)[75] Yet Lehmann thought she had slight cause for worry because on January 27 she received an award at the annual theater luncheon, given to her by the board of trustees of New York's Town Hall, for her ten-year anniversary there.[76] In early February, ominously, Mia Hecht warned that the West Coast might be too susceptible to a Japanese invasion, wanting her to move to Florida.[77] A few days later, authorities ordered Holden to turn in her radio for removal of the shortwave band.[78] Then, on February 23, a Japanese submarine fired twenty-five rounds of shells at the Banklin oil refinery, twelve miles west of Santa Barbara: "Slight damage was done and no casualties were reported."[79] Frances Holden recalled later that the good burghers of Santa Barbara had been spreading a rumor that she and Lehmann had ordered a chauffeur to the top of a hill so that he could signal to the enemy. The truth was that Lehmann and Holden were on tour in the East at that time.[80]

Later, in the summer of that year, Lehmann was still being sent from pillar to post in an effort to fulfil Enemy Alien regulations. She took some comfort from the fact that Henry Morgenthau, the Treasury secretary, had taken a liking to her because she had volunteered her art to benefit his office, as part of the so-called Treasury Programs. It also helped that, whenever in New York, she was giving the secretary's sister, Alma Morgenthau Wertheim, occasional singing lessons. But even in California, she could not travel more than five miles from her house without permission.[81] These matters remained at their incomplete, chaotic state, with the singer potentially in limbo, until the war was won and she was granted her citizenship on June 13, 1945.[82] With that, Lehmann's integration into American society had taken a great leap forward, and it was accentuated further on February 17, 1948, when she was honored by the official presence of President Harry S. Truman and the first lady at a recital in Constitution Hall, Washington, D.C.[83] Fourteen months later, she received her first honorary doctorate, in music, from the University of Portland in Oregon.[84]

Around that time, did Lotte Lehmann experience survivor's guilt because until now in America she had been uniquely favored? Evidence from her correspondence with Fritz seems to suggest that she did. He tried to reassure her that she had earned everything she possessed, reminding her of the guilt so many Jews must now be feeling merely because they had had the money to buy their way out of the Holocaust or had been otherwise sufficiently circumspect to find refuge here.[85] Although he forgot to mention the refugees who were merely lucky, his point was valid, for in comparing herself to other European émigrés Lotte Lehmann would have found few equals.

Any German's fate in the United States, including that of so-called refugees, could be hazardous. Suspicious or known-to-be hostile Germans in America were interned on the notorious Ellis Island or held in other locations, one being the relatively comfortable former resort of White Sulphur Springs in West Virginia, for the purpose of deportation.[86] Others were questioned not for pro-Nazi, but for Communist sympathies, especially after 1945, as were Lehmann's friend Erika Mann and even Thomas Mann.[87]

These conditions did not apply to the vast majority of refugees who had fled to American shores since January 1933; by 1945 there would be 132,000 German-speaking ones alone. Most of these were Jewish, and some were artists whose accomplishments equaled Lehmann's.[88] However, who did as well as she? Ernst Toch, originally from Vienna, languished near Hollywood as an anonymous film composer. Artur Schnabel, the pianist, and Fritz Kreisler, the violinist, never regained their former levels.[89] The violinist Adolf Busch, under whose conductor brother Fritz Lehmann had premiered *Intermezzo* in Dresden in 1924, despaired and lost his former magic. The composer Ernst Krenek, also once from Vienna, was spied upon at Vassar College, where he taught music, and in 1942 his contract was not renewed. The pianist Erich Itor Kahn from Frankfurt eked out a meager existence as a piano teacher in New York.[90] The Viennese-born Arnold Schoenberg, who permanently settled in the United States in 1933, wrote about his first "American year" to friends: "I cannot be

silent about the fact that all the disappointments, troubles and illnesses have superseded in severity much that I have had to endure heretofore." Worse things were to come for Schoenberg, who in Los Angeles, for the rest of his life, could hardly make ends meet.[91]

Some of these colleagues Lehmann had known in the past and continued to meet, if fleetingly. Otto Klemperer's mental bipolarity made him as sexually obsessive as he was financially insecure; he developed a brain tumor and had to endure his wife Johanna's alcoholism. The Jewish intendant Leopold Sachse, with whom Lehmann had worked in Hamburg, arrived at the Metropolitan to find employment as a stage director, but his European hypersensitivity caused him extreme unhappiness over conditions and working practices at the Opera that he could not control, and he was constantly on the verge of a nervous breakdown. Sachse's colleague at the Met would be Lothar Wallerstein, who experienced similar frustrations, after having tried to make a name for himself as a vocal coach in the city.[92] Quite by accident, Lehmann got to know one of these unfortunate artists in Santa Barbara. A former actress from Berlin and now displaced, this Jewish wife of a physician was a cultured lady, yet had to accept a job as housemaid at Hope Ranch. Whereas Lehmann could pity her, perhaps causing her to reflect on her own good fortune, Holden found her awkward. "It is a lady of far more elegance than ourselves. Her pearls are quite lovely. Her slack suits impeccable. We are slightly in a fog as to how to handle the situation," she wondered. "However, she cooks well and diswashes which delights my soul no end."[93] As if Holden did not enjoy dishwashing!

Lotte Lehmann, with her love of America and Americans increasing, used every opportunity to help the cause of American patriotism. But of course it was politic of her to serve the country that now fed her; this was better than suffering in an internment camp or being shipped back to Germany, and perhaps in this way the restrictions on her could be eased.

Hence she performed at the Hotel Astor, after the dinner in her honor in December 1938, along with the baritone Lawrence Tibbett, for the benefit of refugees. She gave similar recitals, accompanied by Walter, in the summers of 1940 and 1941, for the Red Cross and the British Royal Air Force.[94] In order to help Morgenthau's Treasury Department raise war bonds, she sang on the radio, because she found it "a patriotic duty."[95] She recorded messages, sometimes via the BBC, directed to the people of Germany and the former Austria, although her shock at the German citizens' "privations," professed in a message of January 1942, at the height of Nazi victories and full prosperity in the country, rang hollow.[96] She appeared for annual Christmas seal drives in New York and placed her talents at the service of "Internees in Unoccupied France" and the American musicians' "Emergency Fund."[97] In April of 1943, she especially enjoyed singing to thousands of American soldiers (as she had always favored men in uniform) at Camp Roberts. This military base had first opened in 1941 as one of the world's largest training sites, and by 1944 would house as many as 45,000 soldiers in tent cities. It was located in the Californian Salines Valley near Paso Robles, northeast of Santa Barbara. Holden and Lehmann were driven around in a Jeep, in the company of commanding Brigadier General Warren Fales. Lehmann received one of the most heartfelt compliments of

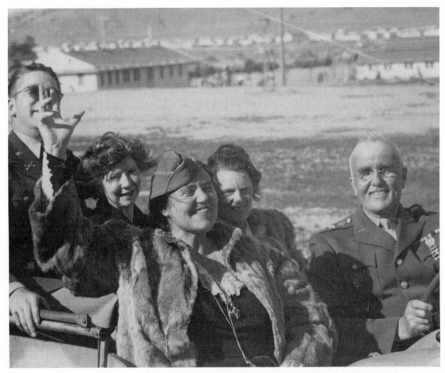

FIGURE 15. From the right: Gen. Warren Fales, Frances Holden, and Lotte Lehmann at Camp Roberts, California, April 1943. Courtesy Special Collections, Davidson Library, UCSB.

her entire career when after the recital a soldier solemnly declared: "You sing just like my mother."[98]

Because she was not Jewish, was living in Santa Barbara, and lacked the more typical experience of anti-Nazi émigré artists, Lehmann had only a few friends in the circle of German-speaking refugees who had settled in Los Angeles and New York.[99] She did not communicate with Erich Wolfgang Korngold, who was writing film music in Hollywood; neither did she know Erich Katz, a pedagogue from Heidelberg and former friend of the composer Carl Orff, who eventually joined the music faculty at the newly constituted Santa Barbara campus of the University of California.[100] One whom she did commune with was the author Franz Werfel, who liked to seclude himself in the beautiful town to write there in the early 1940s. After he died of a heart attack in August 1945, his wife, Alma, asked Walter and Lehmann to minister musically at the Los Angeles funeral, although she herself remained absent. No doubt this was not just because she had never liked Lehmann and tried to avoid meeting the singer, for she was also friends with Walter. After Lehmann had sung her Schubert songs, she received a polite telegram from Werfel's widow.[101] There was the famous operetta diva Fritzi Massary, who after the terrible Knapp Lodge fire of July 1940 helped Lehmann with new costumes.[102] Also living in Los Angeles, off and on, was Otto Klemperer, who stayed in touch, dedicating one of his precious songs to

her.[103] As well, Bruno and Else Walter together with their daughter Lotte were living there, as was the Mann clan.

After Frances Holden, Thomas Mann's oldest daughter, Erika, became one of Lehmann's closest women friends. Erika was chain smoking just as Lotte's husband had done, which did not help her voice, but she had championed the singer in New York's émigré circles as early as 1938.[104] She visited frequently in Santa Barbara, sometimes with her father, and her correspondence with Lehmann was intense.[105] Bisexual, she had a clandestine affair throughout most of the 1940s with Bruno Walter, whom from Munich days she had always venerated as "Uncle Bruno," the neighbor and friend of her parents. Because Lehmann's own relationship with Walter was close and complicated, Erika most certainly did not tell her friend about this.[106] But in June 1949, after her beloved brother Klaus had committed suicide (he too had known Lehmann quite well),[107] Erika confided to her friend: "I cannot even be imagined without him. We were parts of one another, as only siblings can be who are very close to each other."[108] Lotte must have empathized, but the ties with her own brother were of a different kind.

Lehmann also met with Thomas Mann, yet their relationship remained tenuous. It may be summed up in the judgment that whereas he was genuinely fond of her music, he found her personality shrill and cloying, while she, on the other hand, was awed by his erudition, yet repelled by his cold formality.

They had first met in Vienna in 1928 and then again at the Salzburg Festival in 1935, when Mann was already an exile in Switzerland and she still a free citizen of Austria.[109] In December 1938, when Mann was in Princeton and Lehmann was to be honored at the refugees' dinner in New York, Mann received an invitation but declined.[110] Although this could have set the tone for a frosty relationship, the mutual friendship with Bruno Walter encouraged a resumption of personal meetings during their common exile in California. It helped that, as Hans Rudolf Vaget has demonstrated, Thomas Mann especially loved German lieder.[111] Hence Mann and Lehmann met at the Walters in Beverly Hills in July 1940, before the two musicians rehearsed for a private benefit concert at the house of film director Ernst Lubitsch. Aloof, Mann noted in his diary: "Splendid person."[112] Then, on August 5, he and Erika drove up to Knapp's Lodge, joined by Klaus and the Walter couple. Although Holden and Lehmann tried their best to make the Olympian feel at home, Mann, in that infernal heat and surrounded by what he unflatteringly called a "moonscape," was visibly uncomfortable. (Later, he described Knapp Lodge as a "horrifying abode" that only someone endowed with a "nerveless sense of romanticism" such as Lehmann could indulge.)[113] Characteristically, the singer took the "moonscape" description as a compliment and was nonplussed when the Nobel laureate later asked her, "but who wants to live on the moon?"[114] At the time, Lehmann made the questionable decision of passing on to Mann poems by the tuberculous Greta Bauer-Schwind she was patronizing; Mann thereupon sent her an ironic letter in which he bade the unknown poetess his heartfelt thanks.[115]

Mann came up to Santa Barbara thrice more, now to Hope Ranch, and again with the Walters. Holden and Lehmann did barbecues on the terrace, and the third time, in July 1942, Fritz was there (without Theresia, of course)

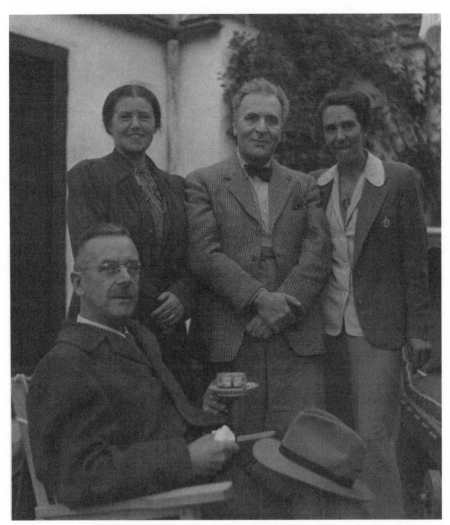

FIGURE 16. Thomas Mann, Lotte Lehmann, Bruno Walter, and Erika Mann at Hope Ranch, Santa Barbara, early 1940s. Courtesy Special Collections, Davidson Library, UCSB.

and Lehmann's colleague Risë Stevens. Then, as always, Mann enjoyed the two sopranos' performance, with Walter at the piano; earlier, he had called Lehmann *Frau Sonne*, Mrs. Sun, which must have delighted the singer, but again was a phrase redolent of irony. He had told her, truthfully, that he loved to hear her sing, and that it was a "weakness," adding pejoratively: just like any other. So he, who owned several Lehmann records, then sent her a photo of himself, depicting him reading a book in an easy chair and smoking a cigar, dedicated, as it was, to "Lotte Lehmann, my immortal beloved."[116] Could he have meant it, thinking of Beethoven's Antonie Brentano, for whom the song cycle *An die ferne Geliebte* was conceived?[117] Fritz Lehmann, a keen observer, wrote later

that at Hope Ranch Mann had looked down upon them all, "smiling kindly and good-naturedly upon the pygmies."[118]

Of all the émigré artists in the United States, Lehmann continued to know Bruno Walter best and dealt with him most frequently, at both a personal and a professional level. Their relationship was not always easy, because both were celebrities, with her star beginning to fade somewhat more quickly than his, but also because Else Walter often interfered. She was, by all accounts, a cranky woman in an unhappy marriage, who in Europe had relished criticizing not only Lotte Lehmann, but the much younger Mann children as well, who were known as unruly brats when growing up in Munich. When in America in late 1939, it did not help that the Walters' younger daughter, Grete, had been murdered by her jealous husband, a German film producer, after the family had had to flee from Austria.[119]

By 1940 Else Walter, who might taunt Lehmann that her face looked like a "pancake," had gratuitously advised the singer that Toscanini had been interested in her only because at that particular time no other woman had been available.[120] Lehmann incurred her wrath because she embarrassed both Walters through an indiscretion involving an affair between Elisabeth Rethberg and the basso Ezio Pinza, a notorious womanizer, when she should have been silent. During one of the barbecue parties with Thomas Mann, Else got back at Lotte by suggesting that she throw the steaks she had burned to the goats, implying that Lehmann was feeding all her many animals like "hotel guests."[121] None of Lehmann's professional handlers had any idea that Else Walter was in the habit of going around saying that the soprano was too old to sing and, in any case, owed her entire career to Bruno.[122] This situation improved for Lehmann when in the summer of 1944 Frau Walter fell very ill; she succumbed in the following year. By then Fritz Lehmann was hearing rumors in New York that the widower was now intent on wooing his sister, but the world of gossip knew nothing of the true romantic interests of the conductor.[123]

After 1933, Bruno Walter was without a doubt among the most successful refugee musicians in the United States. He had established a firm base there before the Nazis' coming to power and by 1940 had conducted in the Hollywood Bowl, at the New York and Los Angeles Philharmonics, and with Toscanini's original NBC Symphony Orchestra.[124] Apart from recitals, he also had his Metropolitan Opera début, on February 14, 1941, to fanatical applause with Flagstad in *Fidelio*, "whose greatest part is not Leonore" (Olin Downes).[125] Lehmann naturally resented this (especially since Walter had not made a point of asking her first), but in the end she knew she could lay no official claim to the role.[126]

In recitals, Walter and Lehmann worked harmoniously together, as they had in the past; the singer openly recognized him as her mentor, while he said sweet things about her to her brother. In private, too, their tone was always cordial.[127] But by now there was much that Lehmann resented about the man, personally and as a musician. It was not his reactionary weltanschauung, which culminated in bigotry, certainly when his affairs with women were concerned. (Thomas Mann derided his "museum-like conservatism," and Fritz Lehmann sneered at him as that "Mozart Monkey.")[128] In matters of aesthetics and style, at least,

Lotte Lehmann always concurred with him. Rather, it was the way in which he imposed his sense of professional and moral superiority on her. Thus in mutual recitals he asked for as much money, if not more, as she did, when she could have hired Paul Ulanowsky, who as a regular accompanist would command lower fees. Besides, she preferred singing with Ulanowksy because he would not dictate the program in the manner of the great conductor. In 1946, toward the end of her mature singing career, she complained that Walter "makes me sing as he wants, not as I want," whereas of Ulanowsky she thought that he played "so wonderfully," by subordinating himself to her delivery, rather than upstaging her, as did Walter.[129]

Underlying tension was exacerbated in August 1947, after a European concert tour had been planned for months, a tour that was to crest at a music festival in Edinburgh – arranged by Rudolf Bing from Glyndebourne – with a song recital by Lehmann and Walter. The conductor, who in that late phase of his career did not like accompanying singers at the keyboard any more, with the sole exception of Lehmann, had made his plans and was looking forward to events. Lehmann, however, for reasons to be probed more fully, was developing more and more qualms about the journey – one factor being that she feared Walter's posturing, another that she hesitated to present her art to an audience many members of which remembered her from her prime. It was from a selfish motive, and in an action unfair to the conductor, that she notified him at the last possible moment that she would not go, as she had a throat irritation. Angrily, Walter had to make do with Elisabeth Schumann, who herself felt she was being treated as the replacement that she was, an embarrassment Lehmann cared little about. To his old friend Lotte, Walter wrote: "I must tell you how unfair I find the harm and disappointment you caused the people over there, without being able to justify it by a real illness." He thought hers "the behavior of an inconsiderate egocentricity, which allows you simply to cancel your obligations with a doctor's notice." Although the matter was superficially patched up by Christmas, it had put a serious dent in their relationship.[130]

This was, not least, because for a considerable time Walter had been kept in the dark about a movie role offer Lehmann had been anticipating from MGM. Once again she had kept more than one iron in the fire. Although the press release regarding the final signing of the contract for this engagement technically occurred after the singer's rejection of the tour with Walter, the conductor had every right to suspect that Lehmann had led him on, waiting until the last possible moment to cancel.[131]

For Lotte Lehmann, the invitation to sing in Edinburgh with Walter brought to a climax a crisis that had been simmering since the war years. It was rooted in the fact that she had been forced to come to grips with her new status as an American who had turned her back on Hitler-dominated Europe, ostensibly as an enemy of the Nazis. She had her resistance legend to support this, and not much could go wrong. But after the American victory in Central Europe in May 1945 she became increasingly uneasy, for not only was she forced to reconsider her own identity as a German – just weeks before her naturalization ceremony – she also had to start thinking about returning to Germany or Austria, there to

be confronted with not only her musical but also her political past, such as it had been.[132] She knew that some of the key witnesses to her meeting with Göring were still there, notably Heinz Tietjen, who later would offer Walter a visiting conductorship in Berlin, which he, for reasons of his own, refused.[133] What if Tietjen started telling everybody what had really happened in April 1934? Moreover, Wilhelm Furtwängler, who had assisted in the Göring matter, was reported in the American press to have been invited by Egon Hilbert, the new director of the Austrian State Theaters, to resume conducting at the Vienna Opera. Hilbert himself – an uncomfortable thought for Lehmann – had spent seven years in the Dachau concentration camp.[134] To overcome bad feelings, Lehmann reaffirmed her loyalty to America and started moralizing about the crimes of the Nazis to her German friends, resulting in emotional overkill. "I am not sure what to do about the rotten youth of Germany," she mused to her egregiously right-wing friend Mia Hecht, three weeks before becoming a new citizen, "one should render all the people between 8 and 25 years harmless. Either kill them or deport them. Otherwise peace will not come. This mob is too deeply poisoned."[135] She refused to acknowledge the connection between such poison and the artistic support she herself had been willing to render unto Hitler's henchman Göring.

Much bad news was coming out of Central Europe that she now had to cope with. It was no secret that the opera houses of Berlin and Vienna had been bombed and would take years to rebuild.[136] Her old Parisian agent Heinz Friedlaender – a survivor – wrote about "impoverished Europe" and his own desolate status, causing her considerable worry.[137] To assuage her conscience, she made him one of the first persons to receive care packages from her – on a list of many Europeans she would henceforth generously endow.[138] The news from her own and Fritz's family was not good. Aunt Lieschen from Berlin seemed to have been raped by Russian soldiers, even in old age, and Theresia's younger brother remained missing at the front.[139] Gebhard zu Putlitz, a cousin of her old friend Erika von der Schulenburg, had been taken by Russian soldiers, dragged away from his wife and small children, and his gold fillings pried out with screwdrivers. He committed suicide by jumping over a banister.[140] Subsequent tidings about the desolate state of Vienna, the hopeless condition of her erstwhile real estate, and the uncertain fate of her other possessions, even her future Austrian pension, were negligible in comparison to those manifold chronicles of human suffering.[141]

Lehmann approached the thought of a visiting tour to Europe and reacquaintance with old friends with trepidation. While the possibility of returning for concerts was discussed with her agent as early as the end of May 1945, she knew about the performance-absence shock that her changed voice might cause and was warned about unbearable living and travel conditions.[142] A first tour was envisaged for the fall of 1946, with a strong focus on England, because continental countries would be too impoverished to pay decent fees. Lehmann seems to have excluded Germany, if not Austria, from the outset.[143] But then the date was pushed forward to summer 1947 and finally to the fall of that year, at which point Bing with his Edinburgh festival offer had fallen in. That date, with Walter, was made official by November 1946.[144] By April 1947 Lehmann had

also settled on visiting Vienna, with other offers from Stockholm, Copenhagen, and Oslo pending.[145] But as the spring and summer months dragged on, she was visibly unhappy about the forthcoming schedule, and the developing problems with Theresia Heinz's residency did not help. Understandably, Fritz wanted to keep his sister in the country during those trying months, but apart from that, he as much as anyone could foresee the complications in Europe, especially with Walter, and he prophesied Lotte a series of nervous breakdowns.[146] By August 1947, when she finally canceled, Frances mentioned her "terrific emotional sensitivity," that she had "constant fits of weeping over anything and everything, she doesn't sleep, she is too tired to do this or that. Now if that is how she is under the best of circumstances, what will happen when she meets with the real difficulties of working in Europe where crying will make her unable to sing?"[147] Becoming unable to sing was something Lehmann was worrying a lot about during those months, until it finally motivated her to change professional course.

Professional Transformations

According to newspaper reviews and many fan reports, Lotte Lehmann progressed from triumph to triumph on the opera and concert stages during the 1940s, seemingly in inverse relationship to her advancing age. Assuming this to be true, the reasons for it would have been strategic, as dictated to the prima donna by her increasing maturity and incomparable wealth of experience. In opera, she relegated herself to a few roles she knew how to control well and without risk, whereas the genre of the German *Lied*, of which by now she was justly celebrated as the pioneer in North America, she could shape judiciously by specializing in exactly those compositions that showed off her distinctive timbre to best advantage. In this metier, Paul Ulanowsky was by far her favorite (and most pliable) accompanist, but she also knew how to create a sensation with Bruno Walter at her side, if less frequently. After 1943, for recitals on the West Coast, the Canadian Gwendolyn Williams Koldofsky supported her on piano; she blended well with Lehmann, if never as symbiotically as Ulanowsky.[148]

Typical of many superb reviews was Noel Straus's *New York Times* write-up of her recital at Town Hall on January 28, 1940, when she sang Schubert's "An die Musik" and parts of his *Winterreise* cycle, followed by a Schumann group and Johannes Brahms and Richard Strauss songs. Noel Straus noted recent improvements due to the restraint of her "exuberantly rich temperament," resulting in a "greatly increased beauty of texture, a haunting loveliness from which every vestige of shrillness has been eliminated." His laudation culminated in the verdict that "the finesse in the handling of melodic line in all of these offerings could not easily be overpraised."[149] When she presented the Marschallin in Strauss's *Rosenkavalier* at the Metropolitan three days later, it was said of this role that she had almost made it "her own."[150] As to be expected from her, it was "a portrayal unrivaled in sensitiveness and voiced with superb command of tonal resources."[151] Her performances with the Met on tour – as the one in Atlanta in April 1940 on the way to California – tended to be routinely sold out.[152] She was also heard on radio broadcasts, so that she became well known

across the land.[153] Apart from the press, expert praise was not wanting. An associate of her agent Coppicus wrote her in January 1942 that "your concert last night in the Town Hall was one of the best you have ever given and was a thrill from beginning to end and a noble exposition of the art of song."[154] That event had been her ten-year anniversary at Town Hall; the house was packed, and the singer "was greeted by an ovation the moment she appeared." Her Town Hall concerts, invariably with Ulanowsky at the keyboard, became an annual ritual for New York City's concertgoers during every year's winter season, and one of its identifying characteristics was an auditorium so full that listeners were pouring onto the stage.[155] The peculiarly haunting quality of her voice and her emotional power of expression during the interpretation of an aria or song found auditors spellbound and kept them in thrall even after her appearances. No one expressed it more graphically than Dorothy Waage, a broadcast specialist in New York, after one recital in January 1943: "My knees trembled as I went down the subway steps after the performance, but when I went to bed – at 1:45, more than six hours later – I couldn't sleep. The music and her voice singing it, and her beautiful expressive face depicting it, kept running through the corridors of my mind," she enthused to a friend. "She began with Schumann's 'Widmung,' not an easy thing to open a program with, and it floated out, free, rich, and utterly thrilling in its intensity. Then came the two 'Brautlieder,' palpitatingly done; then 'Marienwürmchen,' the only light number on the program, really. Have you ever heard her do it? She is, of course, completely captivating. After that, 'Frauenliebe' and then 'Dichterliebe.' A truly tremendous recital, and she emerged at the end of it just as fresh as she had begun."[156]

At Lehmann's last operatic performance in New York as Marschallin on February 23, 1945, she set a monument for herself. "Her every phrase was so replete with meaning and so deeply communicative that never has her artistry in the role worked with greater conviction or impressiveness," observed Noel Straus. "She has become familiar with every slightest detail of the part to such a pronounced degree that last night there was not a moment when her portrayal failed to find her completely identified with the character of the Marschallin down to the slightest vocal inflection and gesture."[157] Lehmann was then informed that "all New York" was talking "about the sensation on Friday night," and as much as a year later the Met's Edward Johnson reminded her of the still-existing "legion of friends and admirers."[158] Having quit opera, she continued her recitals – in New York and Cincinnati, in Baltimore and Winnetka, as well as on the West Coast – and enchanted critics of the calibre of the discriminating Claudia Cassidy in Chicago.[159] At her Town Hall concert of February 12, 1950, which, at age sixty-one, was her fiftieth since she had started giving annual lieder recitals in the metropolis in 1940, there was an audience of 1,630 in the auditorium and on stage.[160]

What strikes the reader of those reviews today is that public criticism of Lehmann is either muted or absent. By the 1940s the singer had attained such an iconic status, certainly in cosmopolitan New York and elsewhere on the sophisticated East Coast, that reviewers felt it was moot to point to well-known weaknesses – some of them accentuated with age – such as trouble with high

notes and breath control. Downes put it well after Lehmann's Town Hall concert of February 3, 1941, when she had presented the entire *Winterreise*: "Details of her achievement do not concern us here, and did not concern us yesterday. To quibble over the non-essential would be impertinent in the face of an achievement which transmitted the very essence of the composer's spirit."[161] These words, from such a discerning critic, were a sign that Lehmann had conquered a place in people's hearts that many singers aspired to, but few even came close to attaining.

What had helped to propel her success over the years was that more and more Americans had been listening to Lehmann's recordings, first with RCA Victor, since early 1933, and in addition, since 1939, with Columbia, who had also signed on Walter.[162] By the 1940s, some of those records were garnering excellent reviews of their own. Hence in December 1940 Howard Taubman, the record reviewer of the *New York Times*, was listing eleven songs from *Die Winterreise* she had recorded with Ulanowsky on piano, still on RCA, as one of a handful over the year "that have appealed to us."[163] Her first Columbia album appeared in May 1941, a four-record set (ten-inch and twelve-inch) with Ulanowsky, of ten Brahms songs, which Taubman lauded for the "penetration of the interpretations."[164] In late summer, Columbia released a *Winterreise* album with the remaining songs missing from the Victor album. If the critic Vincent Sheean always felt that no recording ever could do justice to Lotte Lehmann's art (something that is hard to believe when listening to her numerous rereleases today),[165] Taubman was generous in stating that "there are almost none of the forced passages that have marked recent records of hers."[166] In early 1942, Columbia marketed Schumann's *Dichterliebe* cycle, accompanied by Walter. Taubman's review was positive, albeit not enthusiastic.[167] There followed arias and songs by Brahms and Mendelssohn and, again with Walter at the keyboard, Schumann's cycle *Frauenliebe und -Leben*, which was later rated "among the better issues of 1943."[168]

Meanwhile, there was another Lehmannesque drama beginning behind the scenes. She was complaining that since having joined Columbia, the firm was not placing enough copies of her records on the market or producing enough new ones with her. People she knew could not buy them in stores. Lehmann protested to her publicity manager Hope about this and also mentioned her unhappiness with the slowness of older releases from RCA. However, Hope was the wrong person to ask, for significantly, she was in a conflict of interests as both Lehmann's agent and, newly appointed, a representative of RCA Victor.[169] Pressured by Holden, Hope then looked into the possibility of signing Lehmann back to Victor, rereleasing some older shellacks, and arranging some live performances on some of the company's broadcast spots (which, according to available evidence, never happened). As it turned out, Lehmann was committed to Columbia until spring 1947; hence the singer wrote angrily to the label's executive producer, Goddard Lieberson, asking him to set her free. In May 1945 she remonstrated: "I am not happy any more with your firm. They don't pay any attention to me – they don't bring out records." She pointed to her current indisputable popularity, doubting the business sagacity of a house that could not see that. Her last sentences were vintage Lehmann: "I don't consider

your firm very clever in this case. And I don't want to be tight [*sic*] to a firm which is neither interested nor clever enough to please me." But instead of accommodating her, Lieberson cabled her ten months later that Schubert's *Schöne Müllerin* cycle with Columbia had just won a prize for best vocal album of 1946, and invited her to a celebration dinner. However she felt about this, Constance Hope had Lotte Lehmann back in the RCA Victor fold by March of 1947.[170]

At the end of 1949, Lehmann had reason to complain that that company, in spite of or because of Hope, was giving her the same production problems as had Columbia. At that time a good friend, the impresario Richard Pleasant, informed her that by changing over she had bet on the wrong horse, because Columbia, rather than Victor, was now emerging with new long-playing records and that, for this reason, all of Victor's sales would be "very slow now."[171] This would have explained to Lehmann why her last recording date with Victor had been as far back as March 9: songs by the French composer Reynaldo Hahn, whom Lehmann had always favored, Emile Paladilhe, Henri Duparc, and Strauss.[172] In 1949 and 1950, in the words of Pleasant, "the bottom dropped out of the record market," and he was certain that sales of her own disks would fare badly.[173] In December of 1950, the singer was wondering what to do with the balance of her RCA contract, which would run till February 1951, and what to do after that. "As long as I am under contract they should at least add my name to their publicity lists," but they had not done that. When she asked Hope for advice, the manager stayed mute.[174] Incrementally, these developments portended little good for the future.

Objectively speaking, Lotte Lehmann's performances, whether for the microphone or on the stage, were still a marvel of the singer's art. As historic recordings attest, she now more than made up for what she may have lost in technique through her sharpened sensibility and the maturity of her interpretation. But in relation to her prime – say, in the mid- to late 1920s – physical limitations brought on by advancing age, occasional ailments (especially those affecting her vocal cords), and the duress of long-distance travel did affect the quality of her singing during the 1940s, and this was entirely normal. After all, she had been a professional singer since 1910, gathering around her a huge community of fans – in North America almost to the same degree as in Europe. The tragedy of her ripe age was that once again in her desire to get it all and keep it all, she refused to accept the denouement, doing battle against the world around her as much as against herself, in a futile attempt to make the clock stand still. Although until the end of her career she was singing, a hundred times, what the Marschallin utters, anticipating resignation, in *Der Rosenkavalier* – "jedes Ding hat seine Zeit" ("there is an end to everything") – and while she always professed to understand that particular maxim of the Marschallin so very well, she herself was trying vehemently to go against the grain of what was an incontrovertible truth.

Commensurate with her already limited vocal range and in keeping with practices begun in the late 1930s, the Metropolitan Opera offered Lehmann a mere five performances for the 1940–41 season, at an unchanged $750 per

event. Her engagements, for the same amount of money, decreased over the years, and when she dropped Sieglinde after the February 16, 1943, performance, the Marschallin remained as her last role.[175] Alas, she did not sing at all in 1944, and even the Marschallin only one more time, on February 23, 1945.[176]

Already in 1941 she was far behind other women stars – Kirsten Flagstad, who in the female category ranked first with twenty appearances that season, and even Elisabeth Rethberg, who had eight. (In the male department, Melchior was third with a total of twenty-three.)[177] In spite of this situation, and although Walter had had to commission Flagstad for his Metropolitan début in 1941, Lehmann continued flirting with the possibility of singing Fidelio until 1942, and the role was even written into her contract, probably because the overcourteous manager Johnson graciously deferred to her great tradition, nonetheless knowing full well that she could never reattempt it.[178] Apart from the continuing problems with Fidelio, there were two other factors rankling the soprano at the Met. One was that she was required to undertake specially scheduled tours to other venues in the eastern United States, which constituted a bothersome interference with her private and recital routines, so that in April 1942 she participated in a tour to Cleveland only after being paid a higher fee. The other related circumstance was that scheduling Met Opera dates from the West Coast turned out to be a hassle, as she was wanted in the East on days when she was least willing to travel there.[179] Lehmann's last operatic appearance at the Met, as Marschallin in February 1945, might have floundered had it not been for conductor George Szell, who allowed her to modulate the high notes in the third and fourth bars of the Tercetto. After the performance, Noel Straus commented politely that her voice "was used with caution on top notes," and she herself later wrote apologetically to Richard Strauss that in *Der Rosenkavalier* she now was leaving out "many high notes. . . . you will remember that heights were never my forte."[180]

Lehmann could have sung more frequently at the Met, and perhaps with more financial and emotional gain, had she not missed work, usually because of illness. Thus on December 7, 1940, when she had a cold, the Austrian soprano Maria Hussa substituted for her as Marschallin. In the United States for three years, Hussa had just sung the role in Chicago, and although she would never sing at the Met again, an unsigned review in the *New York Times* (certainly not by Downes or Straus) must have stung Lehmann, as it claimed that "no one would have known that the production was not exactly as had been planned and rehearsed."[181] A much more celebrated case is that of December 6, 1942, when Lehmann's indisposition "catapulted" onto the stage as Sieglinde the young Swedish-Hungarian soprano Astrid Varnay, who thereafter made her way to international fame.[182] Lehmann also missed dates on the concert stage, two in a row in January 1944 alone.[183] And she stopped doing duets with Lauritz Melchior, for "a thousand reasons," as she wrote to Hope, for her relationship with the tenor was becoming increasingly threadbare.[184]

On the recital circuit, just as in the 1930s, matters were hardly better. Lehmann's concert agent, Francis Coppicus, was losing interest in her, as manifested by insufficient bookings on the East Coast. Constance Hope, the original

friend of Coppicus, was turning ever more into a hard-nosed, money-making shrew, branching out into a variety of businesses, including press promotion at the Met. Because of her imperious manner, she had serious run-ins with beginners there – the soprano Eleanor Steber, whom she taught a harsh lesson about decorum, and Varnay, whom she treated with utter arrogance.[185] Although she feigned kindliness in her letters to Lehmann and continued to pretend she had the singer's best interests at heart (while it was really only her money), she never once, despite being begged to do so repeatedly, visited Lehmann in Santa Barbara, even from her branch in Los Angeles.[186]

Between fall and spring of every year, Lehmann wanted to go east less and less, because, like the situation at the Metropolitan, the few concert bookings did not make this worthwhile.[187] The truth is that if she was losing some of her savoir faire in opera, the same was naturally so for lieder recitals. In any event, for the 1940–41 season her concert schedule looked dreadful: she would have to travel east and spend idle time between recitals, often not in New York, which strained her financial and emotional resources. As the war progressed, she was blaming some of these misfortunes on her German nationality (and the fact that she specialized in German lieder), but it became ever more obvious to her that it was all Coppicus's and Hope's fault, no matter how the latter tried to placate her by painting the skies golden and comparing her engagements favorably to those of colleagues. Compounding the difficulties was the fact that Coppicus's corresponding agent on the West Coast was seen to be doing equally shoddy work.[188]

The Bing Crosby act fell off in the fall of 1941 for no good reason, and by the summer of 1942 Lehmann once again had had enough.[189] After she had met Walter Surovy, the Hungarian-born husband of mezzo Risë Stevens, who was succesfully managing his wife's career, she naïvely asked Hope why she could not change over to his music management. The publicity manager predictably discouraged her.[190] But finally acknowledging that Coppicus was worthless (which also caused her to lose her own percentages), Hope came up with another candidate, Marks Levine of New York's National Concert and Artists Corporations (NCAC). Levine, who had been born in Berlin, promised guarantees and better concert schedules. A new contract with him was signed at the end of 1942 for the following season, but although at first Levine got her more singing dates, Lehmann still had to waste much time in between.[191] The situation was particularly galling because according to a report in the *New York Times* in September 1943, the fortunes of recitalists had much improved. Still, to show her goodwill, Lehmann accepted a concert tour to New Orleans for November of that year – with a total of three days and two nights each way on the train and scarcely any earnings after expenses. As expected, it turned out to be a horror trip – travel was then being rendered more cumbersome by massive troop movements. As for the recitals, not much of an improvement was visible: for the months of January to April 1944 inclusive, Lehmann had been able to sing only about 40 percent of the promised concerts, with merely two events in mid-April.[192]

By the end of the decade and with the war long over, so that Lehmann could no longer blame any lack of success on her being German, concert prospects

were looking even more gloomy. In one instance, the soprano's own attitude led to cancellations because she was waiting for a movie contract extension that never materialized.[193] Moreover, concert organizers found her customary fee of around $1,000 too high, with no willingness on her side to compromise.[194] Showing off her displeasure in public more than was advisable, Lehmann herself came across as wanting to retire completely from the singing business, and when these rumors were spread and feedback reached managers and friends, everybody was near panic.[195] In early 1950, the soprano found herself totally disillusioned. As she was sitting in her room in New York's Savoy Plaza in February, she wrote to Holden: "I could spit when I look out of the window. No 'silverclouds above the blooming trees' – slush and snow and Dreck where ever you look. What a place! I can't wait to go away."[196] It would be twelve more months before she was finally able to turn her resolve into action.

Because she thought she was neglected, Lotte Lehmann came to doubt her professional qualities, out of proportion to her, still formidable, art. She exaggerated her own weaknesses to the same degree that she maximized the virtues of her colleagues, without wanting to discount natural biological differences and sometimes mere luck. As if to defeat a conspiracy against her, she played a kind of make-believe game, expecting all her admirers to deny realities in her favor and reassure her that even if she was not getting better, she certainly had not changed. Some of this discourse was taking place with great pathos – she played the prima donna that she was, and followers obliged her by feeding grist to her vanity mill.[197] Edward Johnson did this when, against his better judgment, he wrote Fidelio into her contract as late as 1941, and for her brother this became one of several habitual modes of communication with her, on which, alas, his very subsistence depended.

If Johnson acted out of courtesy and Fritz Lehmann of necessity, Constance Hope, who possessed the persuasive powers to adapt to the real world, was driven by ulterior motives. Therefore, she was especially wary as Lehmann contemplated, however seriously, a transition from concertizing to teaching, because the latter would remove the singer from her influence and money from her coffers.[198] The psychologist and true friend Frances Holden, on the other hand, saw the situation in perspective better than anyone, as she sympathetically acknowledged Lehmann's fears while at the same time encouraging her to continue as long as this still made sense.[199]

Lehmann might have looked around to see how her former colleagues were doing. Elisabeth Schumann, for example, though teaching at the Curtis Institute from 1940 till 1947 and doing recitals, had no contracts with the Metropolitan and continued to owe her money. In 1947 Schumann left for England, only to succumb to cancer five years later.[200]

Maria Jeritza had entered the world of musicals and was not taken seriously by opera lovers anymore. Granted, as was her wont, she had had more luck with rich men. In the Santa Barbara Missions Church in 1935 she had married the film producer Winfield Sheehan, who as the boss of Fox Film Corporation discovered Rita Hayworth and Shirley Temple. If they changed at all, Jeritza's financial fortunes increased.[201] In April 1946 she attempted a serious comeback with a recital in Carnegie Hall, at which she sang Strauss songs, among others.

She still looked striking and created a sensation with her on-stage eccentricities, but Downes commented wrily the next day that "Mme. Jeritza now sings very badly."[202] Fritz Lehmann, who was there, sent his sister all the reviews, but because some of them were politely understated, Lotte figured that La Jeritza, who was one year older, was about to reappear on New York stages, which had her quite worried. Fritz had to remind her that Jeritza, currently rumored to be having an affair with Erich Maria Remarque, Marlene Dietrich's old lover, was "THE JOKE" of the town. Although henceforth Jeritza did little local concerts and after Sheehan's death married another American millionaire, Lotte Lehmann was hardly able to lay that particular fear to rest.[203]

Even though the fortunes of that other major rival, Kirsten Flagstad, were also on the decline in the 1940s, Lehmann had reason to think that the Norwegian continued to be responsible for her setbacks at the Met. Flagstad decided in 1941 to return to Norway to be with her husband after the invasion by the Nazi Wehrmacht, but not before she had sung Fidelio with Walter in February, which once again drove home to Lehmann that she had been put in "the second row." While Flagstad was still in the country, Lehmann also worried that she could sabotage her duets with Melchior, because she had the requisite staying power to match that heldentenor's immense reserves. After her departure, which began to expose the Norwegian to American suspicions that she was sympathetic to the Nazis (which was untrue), Lehmann still refused to believe that she would not return, while continuing to be obsessed with the Fidelio project.[204] When Flagstad did come back, first for the 1947–48 season, to sing, in Chicago, and in 1951 again at the Met, Lehmann was able to relax, for she herself had stopped doing opera and Flagstad was no lieder recitalist. But it may have hurt her that it was Flagstad, not she, to whom Richard Strauss had entrusted the first performance of his *Vier letzte Lieder*, in 1950.[205] (Little did Lehmann know that Strauss had written a fifth Last Song and dedicated it to Jeritza, who then kept it to herself until after her death, which was, mercifully, after Lehmann's.)[206]

When St. Louis's own Helen Traubel presented Sieglinde for the first time at the Met, to an ovation, on December 28, 1939, Flagstad was still there to impersonate Brünnhilde.[207] Traubel, whose part could have been sung by Lehmann as allowed by her regular contract, would be the one to replace the Nowegian as the leading Wagnerian at the Met, rather than Lotte Lehmann.[208] Predictably, by June 1941 and after Flagstad's farewell, Lehmann held Traubel responsible for making certain that she remained "in the back row," although Hope was reassuring her that Traubel was hardly any competition.[209]

All things considered, and especially since Traubel at first limited herself to Brünnhildes and Isoldes, this was undoubtedly correct, and yet the forty-two-year-old Traubel was a daunting phenomenon, well equipped to instil the fear of God in Lehmann. In a time of war she was a native American and, with unbound energy, mightier almost than her frequent partner Melchior.[210] She had met the Danish tenor during 1938 in Minneapolis and, as she recalls, "we talked less about music than we did about recipes and eating. We ate from morning until night – stuffing ourselves with all the good things you can find in the Midwest."[211] Erich Leinsdorf, who had conducted the 1939

Walküre performance and who was fond of Lehmann, might have consoled the Santa Barbara soprano, as he found Traubel lazy, if vocally and otherwise well endowed. "Her favorite posture was sitting and her favorite activity eating. She was a good soul, full of laughter, and could be a delightful companion until serious concentration on learning roles was asked of her."[212] Lehmann and Traubel sang a couple of performances together, until Lehmann's retirement from the Met in 1945; a lieder singer Traubel never was.[213] In January 1951, when Traubel essayed the Marschallin, further limitations became apparent, for she could no more measure up to the older singer in that role than had Flagstad.[214] Nonetheless, it signaled to Lehmann that her artistic successors were in the wings. Although one could "hardly call it a great Marschallin," commented Irving Kolodin in the *Saturday Review*, Traubel sang the music "as no one heard here since Lotte Lehmann has – with an intelligence, a keenness, and a warmth remarkable for a first performance."[215]

During the decade of the forties, Lehmann sustained uneasy relationships with two colleagues with whom she worked frequently: Lauritz Melchior and Risë Stevens. Melchior, only two years younger, remained consistently successful in opera, and the even younger Stevens, who was rising through the ranks of opera starlets quickly, was for her a foil. If one key to their celebrity was opera, on which Lehmann was losing her grip, an even more important one was that, in contradistinction to herself, both artists became proficient in show business, as she herself had enjoyed it alongside Bing Crosby. But just as the Crosby show was eluding her, Melchior and Stevens were becoming ever more important in Hollywood films. And this presented problems.

The avuncular Melchior had known Lehmann since 1924, and because he was a more famous opera singer in the United States than she was, and as a Danish national could live without restrictions there even in wartime, she tended to feel patronized by him. He was also earning very healthy fees, due, not least, to the superb business sense of his wife, Kleinchen. From early 1940 until spring 1942, spurred by their shared publicity agent, Hope, Lehmann and Melchior did joint duets that could net each singer as much as $1,250 per event. These took them from Carnegie Hall in New York (the first time) to Seattle on the West Coast to the university town of Oxford in Ohio. The last recital was in Fort Wayne, Indiana, on March 17, 1942, because thereafter Lehmann quit.[216] Despite the good money, which she needed badly, the reasons for this rupture were manifold. On the journeys to these venues Kleinchen would talk incessantly and Melchior would practice his jokes in a way that tired Lehmann out and sometimes, after laughing, rendered her voice almost too hoarse for singing. She also found the programs repetitive and aesthetically unbalanced, for whereas by herself she sang only German *Kunstlieder* – apart from the inevitable *Walküre* or *Tannhäuser* duets with her partner – Melchior would intone lusty Scandinavian folk and perhaps other melodies that disturbed her sense of style. Moreover, the soprano felt that for the same amount of money she had to carry more of the load, for Melchior tended to shift all the weight to her, and when he sang with her, he overpowered her with his own organ. The most important reason, however, must have been the fact that although

FIGURE 17. Lotte Lehmann, Lauritz Melchior, Mia and Robert Hecht, and Paul Ulanowsky with Kleinchen in Atlanta, December 1939. Courtesy Special Collections, Davidson Library, UCSB.

she was known as a superb lyric soprano, Melchior was already famous as the preeminent heldentenor of his generation, in a class of prominence against which she could no longer compete. So after she stopped doing the duets with him, Lehmann cynically remarked that from now on he could try them with Traubel, implying that she possessed the appropriate physique and a similarly simplistic mentality, but of course that was not even half the story.[217]

Over the years, Lehmann became pathologically envious of Melchior, doubtless because of his vocal prowess, but also because his material fortunes were rising immeasurably. In 1941 he bought himself a large house in Beverly Hills, named it "Viking," and had it furnished to suit his overboard tastes: the pigskin leather chairs and seal-upholstered sofas were twice as large as normal, there was a huge pool with floating trays for instant libation; and the view of both the San Fernando Valley and Los Angeles was breathtaking.[218]

Lehmann thought she would "burst with envy" even more when Melchior started a movie career in Hollywood, after he had begun doing successful radio comedy shows in 1943, with Fred Allen and often joined by Frank Sinatra – on a much more regular basis than Lehmann had done with Crosby.[219] Melchior's first film was *Thrill of a Romance* with Van Johnson and Esther Williams at MGM, produced by Joe Pasternak. The lighthearted love story featured lots of songs, with Melchior playing Nils Knudsen, who sang "Schubert's Serenade."

Melchior's screen début turned out to be the fourth-highest-grossing film of 1945. His second film came out in 1946, *Two Sisters from Boston*, again produced by Pasternak for MGM. This was a musical comedy with Jimmy Durante, Peter Lawford, and Kathryn Grayson – Melchior could not have been assigned more popular partners!

Lehmann, who adored anyone who had anything at all to do with movies and desperately wanted to be in them herself, was beside herself with envy, both of Melchior's movie fame, which had not yet hurt his opera career, and of his profligate affluence. Kleinchen's constant chatter and her public relations shenanigans, which ideally complemented Hope's cooly systematic efforts, irked Lehmann even more. She could not stop complaining to brother Fritz about the Melchior couple, and while he agreed with her in matters of taste, judging Lauritz a mere clown, he also thought that she suffered from an incurable case of cupidity and spite, which he identified as her "Melchior complex."[220] She had to try hard to overcome this when on February 17, 1946, Melchior celebrated his twentieth Metropolitan anniversary and was given a huge party there – in itself an affront to Lehmann because she never got one.[221] In the event, she was invited to sing Sieglinde arias on stage, with and for her colleague. Using the excuse of a cold, she almost canceled, but then thought better of it and joined in honoring her longtime partner. She tried to put a gracious face on it all by paying him tribute three days later, again not without envy: "You have preserved all. You are the same. You have the very same vocal technique that you had in younger years and you combine this young art with the wisdom of experience. You are very blessed, dear Lauritz."[222]

Risë Stevens came to be the Octavian opposite Lotte Lehmann's Marschallin beginning with her début at the Metropolitan, during one of its contractual tours to Philadelphia, in November 1938.[223] It is said that immediately there was close rapport between the prima donna and the younger mezzo-soprano and that Lehmann, implying some tutelage, prophesied a brilliant future for the extremely attractive New Yorker with that marvellous vocal range.[224] As it turned out, Lehmann would continue to keep her eye on Stevens, benevolently, to be sure, but always with the subliminal pain of the older woman who was in the gradual process of irreversible decline, whereas this Juilliard graduate could look forward to the fulfilment of great dreams. Once again, Lehmann envied Stevens for her stunning appearance, her fresh voice, her youth, her American-born status, and what would early be yet another career in films.[225]

Lehmann decided in 1940 that because Stevens excelled in so many respects, it was necessary to bring her down to earth by pointing out some weaknesses. And it behooved no one but herself, Lotte Lehmann, to teach her certain lessons. Hence she told Stevens that she was overplaying Octavian's role because of the negative influence of bassists Alexander Kipnis and Emanuel List, who took turns singing the Baron Ochs. However, Stevens was paying no heed, in fact even resented such advice, so that Lehmann was left with no alternative than to let her "go to hell."[226]

The next disappointment for Lehmann came when in autumn of 1941 – Flagstad had left for Norway – Bruno Walter offered Stevens the role of Fidelio, after it was clear that Lehmann herself had better leave it alone. Lehmann was

hoping that if Stevens accepted, she could then again exert her influence by coaching her in it. However, Stevens thought, correctly, that her mezzo voice was not right for the part and declined, which curiously not only upset Walter, but also annoyed Lehmann.[227] Indeed, Stevens was busy doing something more important for herself at the time, and that was starring in *The Chocolate Soldier* at MGM in Hollywood, opposite Nelson Eddy. She played the opera star Maria Lanyi, married to a colleague who tests her fidelity by wooing her in the guise of an intruding suitor (essentially the well-tried theme of *Così fan tutte*). Of course, the issue is resolved amorously for both, and in the film Stevens and Eddy croon songs such as "Forgive," "My Hero," and "Sympathy."

Not surprisingly, Lehmann was envious again, of Risë for being in Hollywood, and of her working with Eddy, whom Lotte had known somewhat previously through Crosby. In addition, Stevens was married to a dashing Hungarian who obviously had business smarts (which her Hungarian, Krause, so lacked). The near-parallels and contrasts were too crass not to hurt. Thus in a mixture of admiration and envy, Lehmann commented on Stevens: "She has all the advantages for today: she is young, beautiful, slender, American, a movie star."[228] And she informed agent Coppicus that it was understandable if he wanted "young and beautiful 'Risës' and no fat, ordinary 'Lottes'."[229] In early summer of 1942, it looked as if she would still have a chance with the intriguing Risë, whom she was going to invite to Hope Ranch to help her perform for Thomas Mann. From what she knew, Stevens was sitting around in Hollywood unemployed. Wouldn't Stevens now have time to come and take some free lessons? Having heard her in the film, Lehmann was going to show Stevens how to sing a song right. "I would so much like to help her. How is it possible that she does not come??? When I was young, I would pretty well have walked for miles to take advantage of such an opportunity."[230] Lehmann had conveniently forgotten that when Gutheil-Schoder, with whom Stevens had already studied in Europe, had once offered her similar free advice, she had been utterly insulted.[231] Later Stevens did allow Lehmann to give her some instructions in the art of lieder, but soon withdrew, because she found the diva "such a strong personality" that she observed herself "imitating her."[232]

In any case, after Fritz warned his sister to tone it down with Stevens, the young singer was kept busy again making another film. It was to be with Crosby. This was even harder to take for Lehmann, so she tried to disparage Stevens by writing that doing a film with Crosby did not exactly amount to a "film career." Yet low and behold, *Going My Way*, released in 1944, proceeded to win seven Academy Awards, albeit none for Stevens, who was playing the young priest Crosby's former love interest and got to sing Schubert's "Ave Maria." Stevens made one other film in this decade – *Carnegie Hall* in 1947, in which she played a visiting artist on the concert stage and which featured other real-life artists such as Walter, Pinza, and Lily Pons, but nowhere a Lotte Lehmann.

The key to making "a lot of money" in those years, thought Lehmann, was to be like Stevens, "young and slender and so pretty," and then to work very hard in the movie industry.[233] Stevens eluded her influence, nor was the younger singer instrumental in getting the older one into Hollywood, because at the end of the 1940s she left for Europe. But there was another young soprano who

might yet be useful in this regard, and that was Nelson Eddy's habitual partner in film, the redhead Jeanette MacDonald.

Lehmann hitched up with MacDonald in the summer of 1944, and as she wrote to Fritz, the possibility of making it into the movies was now greater than ever.[234] MacDonald, the star of many musical films, had been dallying with opera for several years and in the film *Oh, for a Man!* (1931) had played a prima donna. She made *Naughty Marietta* with Eddy in 1935, in which she played a French princess. Both Jeritza, whom MacDonald had seen and admired as a girl, and Pons now encouraged her to further pursue opera. With the vocal coach Grace Newell she trained toward that goal. After her singing successes in *Rose Marie* and *San Francisco*, both released in 1936, Edward Johnson developed an interest in her for the Met. By that time, Flagstad and Melchior were huge fans; Melchior became a lifelong friend. In 1937, *Maytime* was released, in which MacDonald played the faded opera star Marcia Mornay, and which became that year's highest-grossing movie worldwide. As the actress's biographer Edward Baron Turk observes, "MacDonald immortalized herself as the silver screen's *prima donna assoluta.*" In 1939, fifty American newspapers crowned MacDonald "Queen of the Movies," whereas Eddy was ranked third among male stars after Clark Gable and Spencer Tracy. According to polls later that year, MacDonald emerged as America's most famous singer and its most popular female movie star. With the help of Newell, her concertizing had proceeded apace as well, so that a year hence she was rated the third-biggest draw, behind Pons and Marian Anderson and well ahead of Flagstad.[235]

By the spring of 1943, MacDonald had indeed found her way to opera via a Canadian tour that led her through Montreal, Quebec City, and Toronto. Now Johnson was making further advances at the Met, enticing MacDonald with a benefit concert offer, whereas the star insisted on a full and legitimate entry. By now, at the latest, she was working with Constance Hope. It was Hope who in the spring of 1944 encouraged her to approach Lotte Lehmann for special coaching, as MacDonald had been commissioned to sing the role of Marguerite in Gounod's *Faust*, at the resurrected Chicago Opera.[236] Sensing her chances and being supported in this at first by Fritz, Lehmann immediately accepted.[237] She invited MacDonald to Santa Barbara, where she could be taught at Hope Ranch. But when the movie star was sexually assaulted in her hotel room by a servant, the pattern shifted to one of Lehmann visiting her in her Beverly Hills home. Lehmann gave her program suggestions for recitals and also helped her in interpreting Marguerite.[238]

The tone of Lehmann's correspondence with Jeanette suggests that she was craven and overly solicitous, in hope of gaining entry to the film studios. There was instant "love" for Jeanette on her part; she was in fact treating her as an imaginary daughter. Fittingly, Turk has characterized Lehmann's attitude as a "schoolgirl crush."[239] Being the warm and generous person that MacDonald was, she responded much in kind – after all, Lehmann *was* one of the most famous singers in the world – and MacDonald paid her handsomely: twenty-five dollars an hour.[240] But the cloying quality of Lehmann's letters certainly suggests something disingenuous in her affection for the movie star, a quality determined, no doubt, by her overweaning desire to break into the Hollywood set. The irony

was, of course, that MacDonald could not have been more uninterested in such a plot, for she herself at that time wished to accomplish quite the opposite: exiting the movie scene in order to be taken seriously at the Met. This did not happen in the end; while she continued to concertize, garnering respectable plaudits at opera houses such as Chicago's and at the Hollywood Bowl, she eventually returnend to film making and had left "serious" music behind by the end of 1945.[241]

Lehmann regretted this; she had wanted MacDonald to essay Mimi of *La Bohème*.[242] And above all, she wanted to keep her friendship with a member of the Golden Circle. She was in love with the idea of loving Jeanette MacDonald, although Fritz could sense that the old demons were creeping back into her thinking ineluctably: unhealthy notions of being superrich and glamorous, never mind that she was long famous. So in September 1944 he wrote her: "That external things, especially riches, should still impress you! You, whom Providence has granted everything that 'the others' so zealously want!"[243] This reproach came after she had complained to him, upon seeing MacDonald's house, that the star was able "to live in the greatest luxury, and what do I have?"[244] But Fritz remained unmoved, asking her not to have Holden drive her to that Hollywood house any more, for it was "unworthy."[245]

Nobody knows where Lotte Lehmann's fervent wish to be in the movies originated, or when. The fact is that many opera stars had been making films on the side ever since the beginning of the motion picture industry and that she may have thought only movie roles would round out her cachet as a prima donna. It could not have been the acting factor. For even in opera she had occasion to develop acting as much as she desired; she always took pride in her histrionics and was fond of calling herself a "singing actress."[246] So to that extent her oft-repeated assertion that were she to be reborn, it would be as an actress, lacks the ring of truth.[247] Rather, Lehmann being Lehmann, it must have been the surfeit of glamor movie stars enjoyed over opera singers that intrigued her, plus the (imagined) greater wealth.[248] Such an image was easily suggested by America, where Lehmann was earning progressively less than she had at her zenith in Europe and where the Hollywood dreamworks were burgeoning after the introduction of sound film in 1928.

Among her colleagues, of course, she was in excellent company. Her heroine Geraldine Farrar had moved to Hollywood when she felt her voice was getting tired, in 1915. From Vienna, Alfred Piccaver made a film, *Adventures at the Lido*, in 1933. Grace Moore always combined a successful opera career with film. Other opera stars who appeared on screen were Ezio Pinza, Gladys Swarthout, and Lawrence Tibbett.[249]

In 1935, Lehmann herself was to have made a film in Vienna, *Holidays from Fame*, featuring a prima donna, but it never materialized. On her tours to the United States after 1934 she could not stop talking about how much she idolized Greta Garbo. When she was in Los Angeles, her friend Lily Petschnikoff, whose son Sergey worked as a manager for MGM, took her to studios, where she met such actors as Ken Maynard, Al Jolson, William Powell, Luise Rainer, and, fleetingly, Jeanette MacDonald.[250] After her German pulp novel had been published in English translation, Hope tried to sell the film rights to Paramount

and MGM, suggesting to Lehmann that she herself might want to play the opera singer Aimée Françoise, while Marlene Dietrich could take on the twin sisters. The admired Dietrich in one of her scripts! Lehmann was ecstatic.[251]

There is some evidence that later, when Lehmann was coaching MacDonald, the film star talked about her teacher to one of her producers, the Hungarian-born Joe Pasternak.[252] But even if this was so, nothing came of it for the purposes of movies. Pasternak's more recent claim to fame was that he had resuscitated Dietrich's faltering career with the Western hit *Destry Rides Again*, in 1939.[253] Then, when in the mid-1940s Melchior was working with Pasternak on his first two films, it was his wife, Kleinchen, who suggested Lehmann to the producer as someone who could be cast in the role of Mrs. Feldman, the Jewish grandmother of a parentless child, to be played by Margaret O'Brien. Evidently, Sergey Petschnikoff also put in a good word for her. Pasternak offered Lehmann a contract in late summer of 1947, for the film *The Big City*, based on the novella *Bridgit* (1945) by Robert Nathan, which would also star Danny Thomas, as a Jewish cantor and the girl's adoptive father.[254]

The chemistry between the people involved in all this was combustible, for cabal was in the air. Apparently, Kleinchen had at first suggested Traubel, with whom her husband enjoyed such a splendid working relationship. But Traubel did not pass the screen test. After Lehmann had taken that hurdle, she was aghast that Pasternak had never heard of her, which was indeed somewhat strange for a native Hungarian. In her gossipy way, Kleinchen thereupon set about telling everybody that Lehmann's contract was due to her alone, which infuriated the singer. Even though she had every reason to be grateful to the Melchiors, it looked as if she were going to continue her petty feuding with the heldentenor via the silver screen. Fritz too was confident that it would soon be obvious who, in this new arena, was the greater gladiator.[255]

There is no question that in the fall of 1947 Lehmann believed she was about to begin a second serious career, in films. The best indicator of this was that she was not just to portray an opera singer – as had most of her filming colleagues – but instead would be playing a character role, even if she would have to sing. This showed that Hollywood had acknowledged the actress in her, what she had always wanted. Altogether, the second career would be preferable to her first, because of the ongoing slump at the Met and the disappointing recital bookings. There would, of course, be much more money now. What dashed her hopes immediately, however, was that she was to receive only $1,650 per week, and Fritz had to open her eyes to the fact that, all things considered, she was merely a beginner in this new field.[256] Nonetheless, in anticipation of a second role in summer 1948, and even though she would work for only ten weeks rather than the planned three months, she was paid enough money to buy herself a house in the Hollywood Hills above Sunset Strip, for $15,450. Not as grand as Melchior's or MacDonald's, its living room, with a stone fireplace, had a beamed ceiling and a terrace with French doors opening onto it. It would be for her and Frances to live in while she made all the other movies.[257]

The shooting began in October 1947 and was completed in November. Lehmann loved the work and could even produce tears instantly when asked by director Norman Taurog. She sang Brahms's "Lullaby" and, at the end, with the

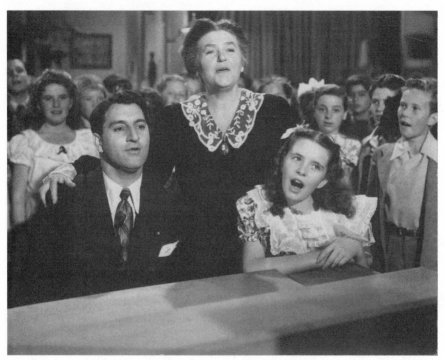

FIGURE 18. Danny Thomas, Lotte Lehmann, and Margaret O'Brien singing "God Bless America" in *The Big City*, Hollywood, 1947. Courtesy Special Collections, Davidson Library, UCSB.

other actors, "God Bless America," which received extra emphasis because she had only recently become a U.S. citizen. She met Clark Gable, Spencer Tracy, and Katherine Hepburn at the luncheon canteen, and Ronald Reagan would frequently drop by.[258] But the film, whose heartrending theme was the search for a new mother for the orphan O'Brien, once released, turned out to be a box-office flop, with miserable reviews. Critic Clive Hirschhorn denigrated it as merely a "sentimental story," and *Halliwell's Film Guide* carped that it was a movie "for which the young star is really too old and all else is excessively sentimental and sprawling." Others could not help agreeing, Farrar confessing that she could have cried at the role Lehmann accepted, "as grandmother to this little moppet. How could such a warm and fine singer lend herself to this?"[259]

Lehmann, by contrast, told her friends about all the good reviews the film had received and how she herself had been singled out. Did not Frances and Fritz applaud her? Hence she was sure – because she had a seven-year contract – that she would be making her next film, with Kathryn Grayson, in June 1948. She wrote Frances's brother Arthur that "everybody says that I am on the threshold of a new and great career." Her agent Levine thought of synergies: concert halls would fill more easily after people had seen her film.[260]

Yet MGM was then going through a crisis, behind the other film companies in terms of profit and, in 1947, for the first year having missed winning an Academy Award nomination for best picture. Against this background and

with the failure of *Big City* stinging, Lehmann's contract was allowed to lapse. Tragically, she had never realized that the "option" part of her contract was meant to work only in favor of MGM. So in the fall of 1948 she found herself in a situation where she had cancelled recital opportunities with Levine in order not to miss Hollywood studio work, which never materialized; she had therefore lost doubly. Sadly, by October it was clear to her that her film career had ended, although she pretended to some – for instance, her friend Mia – that another picture was in the offing. Nonetheless, Fritz assured her in 1949 that it was better this way; she would have had to change her ways too much. Realizing this, Lehmann still had to solve the problem of the useless house. She was hoping for a while that Fritz and Theresia would inhabit it, but when this proved impossible, she eventually sold it, barely recouping her investment.[261]

In addition to film, to overcome any frustration she might have experienced over the slowdown of her singing career, Lehmann turned increasingly to writing. She had always composed poems and continued that pastime through the 1920s and 1930s. She kept all of them private, exchanging some only with very good friends, such as Erika von der Schulenburg, who sent her verses from the hand of her deceased father, Baron Konrad zu Putlitz. But because she was world famous, a few of hers found their way into print. One was published in an obscure German-Amerian serial, in December 1932. As usual, it expressed past experiences in strongly emotional terms. Another, "With Bruno Walter at the Piano," appeared in a eulogy for the conductor in 1936, on the occasion of his sixtieth birthday.[262] These poems were representative of many others she wrote in her lifetime, most of them introspectively solemn, others witty and comical. In 1940, Lehmann appeared to be taken seriously as a poetess by the *New York Times* when it announced that "she has written poetry" as part of her ongoing "effort in the literary field."[263]

What is to be made of these stanzas as works of art? For the purpose of this book, the two samples just mentioned were subjected to concise analysis by three current scholars. Jens Malte Fischer of the University of Munich finds them "touching, but not more, for after all they are very epigonal and suffused with emotion." Further, they remind Frank Trommler of the University of Pennsylvania of works of the Romantic or neo-Romantic era (Eichendorff, Dehmel, Rilke, and George). According to Trommler, in the paean to Walter, Lehmann evokes a flowing together of erotic and musical elements, something akin to a well-composed declaration of love. But although Trommler does not discount traces of originality in these works, he judges them typical period pieces. Moreover, Hans Rudolf Vaget of Smith College finds both poems "harmless," the product of "a modest, but amiable poetic talent. They speak in conventional poetic language of the extraordinary experience of making music." Although all three appraisers stress the conventionality as well as the sincerity of the two poems, qualitatively they do not detect anything extraordinary. One may imagine her early partner in poetry, Baron Putlitz, to have written in a very similar style (examples of his work are in private hands). It was the custom of the day, especially in educated, *Bildungsbürger* circles, that such verses were composed and often recited on festive occasions, sometimes to be published in

local broadsheets or family chronicles.[264] One of their main characteristics was
that they would rhyme.

If anything, the poems are yet another sign that Lotte Lehmann, with her
high intelligence, despite a merely rudimentary formal education at the sec-
ondary level, was intensely ambitious. Easily stimulated emotionally, she used
the poems to complement her singing art, in which field she was a natural genius,
but also as an additional vehicle of upward mobility from humble lower-middle-
class origins, something that brother Fritz constantly reminded her of in his
many letters. Possibly she thought that, socially speaking, it would help her to
deal more easily with a world of sophistication and high culture, whose cham-
pions – Richard Strauss, Bruno Walter, Thomas Mann – often surrounded her.

Lehmann wrote and sometimes published short prose pieces, as early as
the 1910s, for the same reason, even if they reeked of hyperbole. She could
impress readers more effectively with them than with poetry because they told
of far-away places she had visited, demonstrating her urbanity, and conveyed
her impressions of certain cultural phenomena – experiences reserved for a
social elite.[265] Thus she tried to move Walter early on with a reflection on
Turandot (whose Puccini role she had just performed under Schalk) in Octo-
ber 1926; the conductor, still distant, thanked her politely.[266] Because she was
Lotte Lehmann, newspapers such as *Wiener Allgemeine Zeitung* sought her
collaboration, asking her to contribute small travelogues or sketches. Hence
she published innocuous pieces about her vacations in Westerland and told of
her first impression of New York, in the process describing Constance Hope as
her American private secretary, a gross but characteristically parvenu-like mis-
representation of Hope's true functions.[267] These attempts, which may have
mixed fiction with fact in ever-increasing proportions, as her vivid imagina-
tion got the better of her, led straight to her pulp novel, for which she used
real-life experiences and characters as models, but in which she also crystalized
personal expectations and dreams. Because she was now famous on both con-
tinents, it was published in the United States in 1937, shortly after it came out
in the German original in Vienna. As the *New York Times*, no less, announced
in a preview, this was about "the adventures of the twin sisters Elizabeth and
Anna-Maria, professional dancers known as Lia and Ria Vernova. The chief
dramatis personae are Aimée Françoise, disillusioned, love-renouncing Wagne-
rian soprano; Francesco Morelli, composer, the cause of Aimée's disconsolate
state; Will Morton, American millionaire, who, spurned by Aimée, takes an
overseas airplane trip from which he never returns; Dr. Eric Johannsen, bril-
liant scientist in love with Ria, and Rosenberg, the impresario. The action takes
place in Vienna, Paris, New York and San Francisco" – places, tellingly, that
Lehmann was now well familiar with.[268]

The original of this work had been published as *Orplid, mein Land*, after
Mörike (in itself a conceited title choice), by Breitner in Vienna, and the efficient
Hope managed to secure the American edition under the title *Eternal Flight*
with Putnam's.[269] Revealingly, Lehmann portrayed herself as both twin sisters,
representing the two sides of her personality: flightiness, a penchant for the
superficial, and greed, as manifested by Lia, and goodness of heart, generosity,
and modesty, as shown by Ria. (Alternately, from her vantage point, Lia could

be Jeritza and Ria Lehmann.) Morelli was of course Toscanini and Johannsen the dream companion whom she had once imagined Krause to be but who had eluded her ever since the time of her marriage in 1926. As an abstract composite, Françoise was a more complex figure, part Lehmann as the prima donna but also as the woman who sacrificed attainable joys in life to her art, fated to be perennially unhappy. Lehmann had expressed similar sentiments about herself to Baroness Putlitz early in her career, and they would repeatedly be triggered, with clockwise regularity, as she was moving on. They were evoked in the 1940s by times of frustration over the lags in her schedule, self-doubt before a European tour in 1947, and feelings of neglect by agents and impresarios. Their physiological symptoms were crying fits, depression, sleeplessness, and headaches.

In retrospect, it is astounding that the busy diva would have found the time, at the height of her fame, to write such a book and get it published so prominently. The fact that she did so points to the possibility of doubts about her vocal art even then, unjustified, perhaps, as such doubts are normal at her artistic stage, but significant nevertheless, after the difficulties with Helena, Arabella, and, as of late, Fidelio. From a literary vantage point, she always knew that she had written trash, but still flirted with the recognition of greatness, delighting in the idea that as a famous opera star she was able to do this and even had a chance, however remote, for a Hollywood film version.[270] And yet, as earlier with her anecdotes in Vienna, she must have been aware that the reason she had found instant publishers was precisely because she was already famous, and this should have given her pause to reflect on her true merits as a writer.[271]

There is no indication that she probed her soul. In jest, but still revealingly, she compared herself to Goethe because so many other, worse, examples of writing abounded.[272] She continued this style of prose in the 1940s when she conceived the fable of two ghosts and the angel Asrael. This she was going to illustrate herself. To Hope she wrote, confidently, that it was "a crazy story," but rather promising and very funny and that, because she was writing it in German, Erika Mann should be the translator.[273] This genre was perpetuated in 1950, after her disappointing if fascinating experiences in the film industry, when she wrote a complete first draft for a new novel, "Of Heaven, Hell and Hollywood," of which she exclaimed, undaunted: "Of all my brain children, this is my favorite." She had composed it in English, with Holden polishing up her language thereafter. As Lehmann noted, "she did it with ungracious groans I must say. And she often hurt my feelings by asking: 'For heaven's sake what do you mean by this?'"[274] Alas, there was no ready publisher, undoubtedly because this time neither Hope nor Levine saw any reason to offer help.

But she did publish her autobiography in translation with Bobbs-Merrill in 1938, only one year after the original had been brought out in Vienna.[275] Although the German version had got some things wrong and left a lot out in her favor, as far as autobiographies went it was a respectable achievement: well written, reasonably honest, and interesting to read. To that extent it was false to say that writing books was not Lehmann's "forte," as did Paul Lachmann, the Hamburg-based bookseller on the steamer *Bremen*, on which the diva crossed the Atlantic many times, who was to remain friends with her until after World

War II. He had formed his opinion after reading *Orplid*, a misleading yardstick of Lehmann's literary talents if used alone.[276]

The singer wanted to extend this memoir through the 1940s, all the while collecting material for it, foremost her Australian travelogue of 1937. However, the dramatic events of the following years, including her first settling-in at Santa Barbara, prevented her from finding the necessary peace and quiet to follow through with this. Fragments of an "Australian Diary" exist, approximately seventy typed pages, including some shorter versions repeating parts of the longer chronicle, but the whole story is, in this first draft form, a fairly dull affair.[277] It lacks the ingenuous freshness of her first memoir, and to be commercially viable it would have had to be redeemed by much more drama – the introduction, for the 1940s, of interesting people such as Thomas Mann and Lehmann's new adventures in America, if, stretching her imagination, she could paint them so. Sketches for this purpose were done and collected, but they were much shorter than the travelogue and remained few and far between, although she had begun to organize her material.[278] (One of these was specious and artificially embellished only for the sake of legend building: an outline of the Göring–lion story in both German and English.) When she became more serious again about this book in 1948 (which by then was to have included wondrous tales from Hollywood), a literary agent wrote to her regarding an encounter with Toscanini that he felt was described with too little drama. What she was missing, wrote the agent, was "that singular event, worthy of recording only because it pertained specifically to you, Lotte Lehmann."[279]

Lehmann's best literary work was begun in the 1940s, as she was, ever so slowly, switching from singing to teaching, and it had to do with the interpretation of arias and song. Here she showed herself to be a veritable master. The first of these books was *More than Singing*, published in 1945 by Boosey and Hawkes; the second, *My Many Lives*, followed three years later, published by the same company. Both had been written in German and professionally translated by Holden.[280] As the name implied, the first volume dealt with the subject she knew best, the art of lieder singing; it had been preceded in 1941 by an article thus entitled, which she had published in the *New York Times*. In it – although she was clearly the world's champion in that area – Lehmann graciously described Elisabeth Schumann as "the singer who best represents the style of lieder singing in its purest form."[281] The article drew at least one rave response from a knowledgeable expert, whose long letter was published in the *Times* in full.[282] But when the 1945 lieder book came out, with a foreword by Bruno Walter, Lehmann once again waxed impatient in anticipation of superb reviews and complained bitterly to her brother and the agent that she was being overlooked. She also thought that her book was for a wider, commercially accessible audience, when in fact it was a tightly circumscribed technical treatise.[283] Finally, Chicago's Claudia Cassidy wrote that this interpretation of eighty-seven songs from her repertoire was "done with a comprehensive brilliance possible only to an artist as articulate as she is distinguished."[284] Always needing praise, Lehmann was gratified to find that after some of her recitals members of the audience were bringing this book to her for autographs.[285] When *My Many Lives* appeared, dealing as it did with the opera roles she had

played, cleverly interwoven with personal reminiscenes, Lehmann could chalk up more plaudits from the *Times*, where Moses Smith ceded her the compliment that she was the last celebrity in need of a "ghost writer." According to Smith, Lehmann had accomplished something that for her, in her writing at least, was not always a given, namely that her prose was "free from vainglory and of its almost equally objectionable opposite, false modesty."[286] The royalties from these volumes, incidentally, were quite respectable.[287]

In the 1940s, Lehmann found yet another outlet for her creativity, in painting. This had been invented for her by Holden in the winter of 1939, still in New York, when Lehmann was nervous, fidgeting around between performances. At one time Holden, who herself was an accomplished painter, had placed paints and brushes in her friend's hands and calmed her down. Energetic as she was, Lehmann rushed outside and painted the Riverdale house in the snow. After that, she never looked back.[288]

Primarily, then, painting had a salutary, therapeutic effect on the singer; it helped her overcome depressions and crying fits, cheering her up and often shortening those devastating cross-country junkets, as she always took a sketch-book with her. Nevertheless, under the severest mood swings, her paintbrush would rest.[289] Along with Holden, Fritz Lehmann was supportive from the start. In 1942, he advised her to take lessons with Charlotte Berend-Corinth, the widow of Lovis Corinth, one of the Berlin Secessionists along with Max Liebermann and Käthe Kollwitz, who had died in 1925. She had been Corinth's pupil and then his wife, joining the Secession herself in 1906 and becoming fond of portraying, in an Expressionist manner, personalities from the theater world, such as the operetta star Fritzi Massary. In Berlin, she had had her own painting school, but left for Italy in 1931. As a Jew, she immigrated to the United States in 1939, where in New York she chanced upon Fritz Lehmann.[290] The lessons never took place, at least not in a systematic fashion, but Fritz encouraged Lotte further, and so certainly did Berend.[291]

Lehmann started from an untrained, naïve position; according to one of Fritz's letters, she had yet to learn how to draw.[292] As a realistic painter, her perspective was often off. Characteristically, this did not faze her. Never one for abstracts, Lehmann used her brush in a quasi-Expressionist fashion; her images, at first meant to be a correct likeness of objects that she saw, later became more manneristic.[293] In the beginning she was proud to have produced for Fritz a picture of a "stormy sea with sailors," and then a "lighthouse with stormy sea," painted "from nature," because he had loved those impressions since his time in Westerland.[294] She went from nature scenes to portraits, epigonally after Camille Corot or Vincent van Gogh, intuitively learning some ground rules. In the opinion of one expert observer, she picked up on "situation and atmosphere."[295] In one of her more original œuvres, she painted in watercolor the twenty-four episodes from *Die Winterreise*, mostly in blue, white, and black. She had a young man model for her as the disillusioned wanderer, and the whole work looked like a mixture of German Expressionism and American cartoon art. The cartoon quality derived from the fact that rather than sketching the outlines of the man as he modeled for her, she had photographed him in various poses, then traced his outline with pencil onto paper. Hence the male figure

FIGURE 19. Lotte Lehmann's sketch of scenes from *Der Rosenkavalier*, date unknown.
Courtesy Special Collections, Davidson Library, UCSB.

appeared fairly rigid against the more fluid images of his surroundings. Fooling
the onlooker with these tracings – which I discovered during research in the
Lehmann Papers – may not signify great art, but it was nothing short of original,
and in visual as in most other arts (John Cage's "Prepared Piano" comes to
mind), any technique may justify acceptable results.[296]

Had she been sufficiently introspective, Lehmann might have kept her paint-
ing as a serious hobby, realizing its psychological benefits, and become a more
easily satisfied woman. But her relentlessly competitive nature did not allow
for this; as with films and writing, she saw in the new medium another chance
to successfully compensate for the seeming accretive failures in her singing.
Because she tried to take painting outside of her private life and into the public
realm, while never attaining the truly professional standards she observed with
her music, she again caused herself bouts of despair and constant frustration.
Holden knew this when she once said, after Lehmann had actually sold some
paintings: "It takes less time to paint a picture (if you are Lotte) than to sing a
concert!!!!! I am afraid that will become an increasingly repeated refrain!"[297]

The chain of publicity began when Lehmann entered a drawing of Toscanini in an auction sale at New York's Hotel Roosevelt to raise funds for the relief of Finland, in February 1940. (Obviously, this was a much earlier attempt of hers.)[298] She was spurred to suppress well-justified self-doubt as an artist by the flattery of sympathizers, who encouraged her in the public arena. Thus, after Klemperer had cynically questioned her skills at the moonscape lodge during the summer of 1940, and Fritz too had reminded her that singing was still her foremost art, Klaus Mann temporarily rescued her from self-doubt by asking her for pictures for yet another benefit. She happily complied, and he then called her donated collection a "sensation."[299] Lehmann thereupon asked Hope, pretentiously, to get the journal *Musical America* to publish her oil portrait of Fritz, for the sake of his New York publicity.[300] Although Holden and Lehmann were suspect in Santa Barbara at first, her works were given a public showing at the local art gallery on State Street in October 1944. Proudly, she sent a regional newspaper critique to MacDonald: "My pictures looked lovely to me. And all the people who came – a lot – expressed their amazement that I can do this."[301] Since Berend was there, and later again in New York, word soon got around in the metropolis.[302] Nagging doubts, however, still could not be suppressed. For she was not so stupid as to think that people would laud her pictures "if I would not be Lotte Lehmann." Later she admitted openly to Fritz that she did not know enough "to have an exhibition as a painter."[303] That was in 1949, when a show at New York's Schaeffer Gallery was offered. (Mrs. Schaeffer was a student of Fritz Lehmann – another case of collusion.) Immediately, she got in touch with the impresario Richard Pleasant, for a reproduction of some of her paintings in *Life* magazine.[304]

Those pictures were first shown at the Pasadena Art Institute in October 1949, until early in 1950 the show moved to New York. They had to bear competition from prints by Picasso at the Museum of Modern Art – an artist whom she abhorred.[305] In the event, the *New York Herald Tribune* printed a positive review and commended her on the fact that her works were "snapped up by buyers." But Aline B. Louchheim of the *Times* minimized her achievements when she spoke of indulgence "with the absorbing hobbies of a great artist" and then averred that her pictures attempted "illustration rather than interpretation."[306] A year later a colleague of Arthur Holden, a connoisseur of art, examined her works in more detail, and his verdict was rather mixed. "Her black and white illustrative attempts seemed somewhat childlike and unformed," but she did better "under the stimulus of color. It is closer to music for her." When Lehmann told him that she had been criticized for her drawing, he advised that she not take this seriously, "because it means not only closer observation but the use of the thinking process which is her weakness. It would hurt her imagination." She could amuse herself with studies of nature, but not too seriously, as a "gifted child of the musical world." As such, she was capable of translating her gifts into form, pattern, and color. "This should satisfy." And again the obvious: "She sells due to her reputation as a singer, but naturally would prefer to receive acclaim on an art reputation alone, but this cannot happen." In all her dealings with him, Lehmann just hated this man.[307]

Lehmann's most reliable, and most natural, alternative to singing, as she matured in age, was teaching. This too was not without its problems, for in the career of an artist like Lehmann it always existed in an inverse relationship to performing. During her most active time as a singer she did not have to teach, despite occasional requests to do so.[308] For a world famous artist, teaching also brought in much less money. However, Lehmann knew that other opera stars had turned to teaching in advancing age – Lilli Lehmann, for instance, and Gutheil-Schoder – and she herself had taken lessons from retired singers such as Mathilde Mallinger. Lehmann's dilemma was that she knew people from the outside could use an aging diva's teaching practice as a reflection of her voice quality: the more she took to coaching others, the less she was able to sing herself. Moreover, in financial terms increased teaching activity could be interpreted as a sign of creeping indigence. Lehmann was not comfortable with either of those notions, but by the mid-1940s teaching began to appear to her, realistically, as a new and productive calling, and she more fully embraced it by the end of the decade.[309]

Lehmann felt as early as August 1939 that teaching out of New York would help her fill the time between engagements and bring in extra money. But rather than attracting individual students, she favored a singing school, or some kind of master class. The latter could also be held during summers, in Santa Barbara, for example, where she was just now vacationing. This plan persisted through 1940–41, when economic necessities were, sadly, becoming more and more apparent to her.[310] But as late as 1942, Hope discouraged her, on the grounds that there would never be enough earnings, as Lehmann had no name yet as a pedagogue. This would hold especially after Lehmann's more permanent move to Santa Barbara, because easterners would be reluctant to travel west. (That Hope was also worried about her commissions has already been observed.)[311]

But in early summer of 1942 the opportunity for just that presented itself, in that two wealthy twenty-year-old women from New York were willing to move to Santa Barbara for lessons, one being Harriet Delafield, a recent debutante. Ironically, the deal was brokered through Hope. Lehmann was very nervous before they arrived and then found the first few lessons devastating, as she thought the girls absolutely without talent. But they were willing to pay $30 per lesson twice a week for six weeks, and after Lehmann had sent them to Fritz for rudimentary preparations, matters slowly improved, so that at the end of the course she was rather enjoying the experience.[312]

In 1942, the idea of Lehmann teaching a master class at New York's Juilliard School of Music surfaced, but Fritz advised against it, as he disliked its faculty. The plan was put on ice; according to Holden, Juilliard's faculty had been turned against Lehmann by her former friend Lucia Dunham, because of her loss of Anne Brown. Since Lehmann was not willing to travel east much any more, she rejected an offer, when it finally did arrive, in 1947.[313]

By the end of 1942, Lehmann had had a few students, all in Santa Barbara and all more experienced, if not already professional singers. The advantage of teaching at a more advanced level there was twofold: these pupils were able to pay generously (she normally charged from twenty to twenty-five dollars an

hour), and she did not have to waste any time with the fundamentals of voice training. This way she even gained some regional students. One of those was twenty-six-year-old Eleanor Murtaugh from Oakland, who had been trained at Curtis and had read about Lehmann in *Musical America*. After a written inquiry, the prima donna bade her come down for an audition in late 1942, at a time when Walter happened to be at Hope Ranch and was able to accompany her. Eleanor resided downtown and was taught by Lehmann in a theater. She did well, and Madame Lehmann was about to send her to New York, so she could spread her wings, when she married a navy pilot stationed nearby.[314]

It was during 1942–43 that Lehmann also began to coach the career singers Anne Brown, Mary van Kirk, Rose Bampton, and Mona Paulee. A lesser talent was contralto Ruth Terry Koechig, who then disappeared into oblivion, and a greater was the soprano Eleanor Steber, who appeared at the Met altogether 431 times.[315] Born in 1916, she had made her début in Boston in 1936 and won the 1940 Metropolitan Auditions of the Air. She had already sung Sophie to Lehmann's Marschallin at the Met a number of times, since 1941 when, in January 1943, Lehmann was able to do with her what she had wanted to do with Stevens: coach her further in a Strauss role she herself had, in her younger years, sung many times. But now it was the student, not the teacher, who made the first move. Lehmann instructed Steber in New York starting on January 28, 1943. They worked all winter long, and quickly turned to songs.[316]

Lehmann's teaching was becoming a success, and by the mid-1940s – she was now also teaching MacDonald and Bollinger – she was turning new candidates away.[317] Lehmann eschewed a technical approach; her own disappointing experiences with teachers of Etelka Gerster's ilk had shown her, as a pupil, how damaging such methods could be. Although she agreed that – unlike Gerster's – sensible technical instruction at a certain stage of voice formation was desirable and even necessary, she herself was not the one to engage in it. Instead, she concentrated on interpretation, and her main contention was that each individual could interpret an aria or song in a variety of ways. Never did she want a student to copy her – this is what happened with Stevens, to the detriment of their relationship. One's own personal emotions, of love or sadness, of contempt, pity, or wrath, had to become part of the interpretive art on stage. (That's what she hinted at sometimes when she maintained that illicit sexual affairs, while morally questionable, would always help to make any vocalist a better artist.)[318] As she progressed with her teaching, she even found that she herself was learning something technically, perhaps as she was explaining breath control to students. Her emphasis on the interpretation of human feelings, her sincerity with students, coupled with her generosity and overall enthusiasm once she had committed herself in a teacher-pupil relationship, soon made her an unqualified success as a vocal coach, so that younger singers such as Steber, Bampton, and MacDonald were full of praise for her.[319]

Despite her own growing pains, there is no question that Lotte Lehmann was a natural teaching talent, what with her personal charisma, her passion for sharing values with people she liked, and her vast professional experience. If properly channeled, such talent could not help but bear fruit, on the largest scale. One such opportunity, albeit by its nature relatively limited, had offered

itself through the increasingly gratifying individual voice-coaching relationships of recent years. Yet another, and more lasting, opportunity became available after the founding of the Music Academy of the West near Santa Barbara.

This Academy came about after the confluence of several ideas regarding musical education at a higher level and international music festivals à la Salzburg. Lehmann herself had wanted a music school or dedicated master class for years. Fritz expanded on this by talking about "a school for Hollywood," where he naturally saw a place for himself. There were even one or two very rich ladies in Santa Barbara who might help finance such a venture. But during the war years Lehmann also came to see difficulties in its realization, contingent on her German status.[320] Holden had been to Salzburg and found that California was the ideal venue to emulate such a music festival; moreover, after World War II an "American Salzburg" was being talked about in New York music circles, but not necessarily on the West Coast.[321]

Specific planning for a music school in the Santa Barbara area began in 1946, after, so it appears, Lehmann had met with a music critic of the *Los Angeles Times*, Isabel Morse Jones, to agree on the basic notion. What evidence we have points to the likelihood that both women also talked about the Salzburg model. To drum up support for the concept, Lehmann gave a recital at Santa Barbara's Lobero Theater on September 19, accompanied by Gwendolyn Koldofsky. (It is possible that her self-arranged concert there almost exactly three years before had served the same, then not-much-publicized purpose.) One day later, there was a luncheon at the Montecito Country Club, one of Santa Barbara's swankiest locales, at which the case for a West Coast music school was most eloquently made. Among others, it was attended by Jones, Lehmann, Holden, Grace Denton, who had managed pre-war music festivals in the Santa Barbara Bowl, the singer-actress Doris Kenyon, who had appeared at the Met in her teens, and the conductor-composer Werner Janssen. A former student of Felix Weingartner, Janssen was in Los Angeles leading the Janssen Symphony Orchestra, which was dedicated specifically to the performance of new works. Interestingly, there was also Pearl Chase, a Santa Barbaran who expressed the interest of the town in the new venture and pledged the townspeople's full support – proof that Lehmann's old impression of Santa Barbara as unmusical was in the process of being overturned.[322]

The arguments presented at the meeting, which would then be repeated many times, were that the preeminent music schools of the East – Juilliard, Curtis, and the Eastmann School of Music – had signaled their unwillingness to take on any more applicants from the West, even on scholarships, as they were full. These were supported by eastern impresarios who claimed that their stages were being flooded by too many schooled applicants for jobs as it was – singers, instrumentalists, and actors. Westerners like Jones, Denton, and Janssen could only agree, pointing to the existence of their own opera house in San Francisco, the Hollywood Bowl and nearby symphony orchestras, and, not least, the Hollywood film industry. It would be a growing imposition for young West Coast men and women to travel east for an audition at one of the established schools, only to be rejected on technicalities. Therefore, one should develop one's own resources. Santa Barbara provided a beautiful location, and the name of Lotte

Lehmann served as a natural magnet. The problems, it was felt, were threefold: as yet there was a notable lack of money; one had to attract a sterling faculty in order to woo the right students; and the format for the academy-to-be had to be defined: lower-, intermediate-, or higher-level; full-time or part-time, university-affiliated and degree-granting or issuing mere diplomas.[323]

However satisfactorily, these problems were subsequently dealt with. For the time being, under fiscal restraints, the school, for which Denton had coined the name "Music Academy of the West," was to be a seasonal affair. After Lawrence Tibbett, a native of nearby Bakersfield, had taken charge of a scholarship committee later in 1946, other fundraising drives were under way, to which Lehmann also contributed with personal appeals. On a trial basis, an eight-week summer course was planned for 1947. As the months went by, money came in from the likes of MacDonald, Eddy, Walter Pidgeon, Jascha Heifetz, and Hollywood film executives. The largest individual endowment of $5,000 was provided by the former Polish soprano Ganna Walska, an eccentric beauty with an attraction for millionaires, who had once owned Théâtre Champs-Elysées, a private opera house in Paris where Melchior had sung the *Ring* cycle. Now she resided in a villa nearby, surrounded by a fabulous tropical garden. But the same amount was donated by both the city of Los Angeles and the town of Santa Barbara.[324]

Under the institutional roof of the Southern California Society for Music Education, Jones was appointed administrative director and Denton executive secretary. From the Pasadena Civic Orchestra they hired as musical director Ernst Lert, originally a Viennese Jew with an intendant's experience in Milan, Darmstadt, and Berlin, who along the way had married the harpist Vicki Baum before she published her best-selling novel *Menschen im Hotel* in 1929.[325] Lert had been working as a director for the Met since October 1929, but had been dismissed on the express orders of Gatti-Casazza in 1931. He had been the choice of Denton, who herself had a somewhat checkered reputation as an impresario, tended to claim full credit for the Academy's creation, and, significantly enough, was asked to resign in 1950.[326]

Since Lert had come to the United States before 1933, he could not properly qualify as a refugee from Nazism; it is not entirely clear how good a conductor he was. Others, including former refugees, were at least as qualified. Among them, for the July–August 1947 semester, was the violinist Roman Totenberg, a former student of Carl Flesch and Pierre Monteux, who had been born in Poland in 1911 and had won the Mendelssohn Prize in Berlin in 1932. Arriving from the Peabody Institute in Baltimore, he was made chairman of the string department. One after another, the composer Ernest Bloch joined him, then the cellist Gregor Piatigorsky, the Metropolitan baritones Richard Bonelli and Martial Singher, as well as the pianist Harry Kaufman. The Griller String Quartet came from London to give instruction in chamber music. A newly constituted advisory board initially included no less a musician than Yehudi Menuhin, along with Monteux, William Primrose, Artur Rodzinski, Artur Rubinstein, Helen Traubel, and Lehmann herself. On the summer faculty in the late 1940s were Arnold Schoenberg, Igor Stravinsky's pianist son Soulima, George Antheil, and Darius Milhaud. Students received room and board as well as instruction at

the rented, near-bankrupt Cate School for Boys in Carpinteria, on the outskirts of Santa Barbara, until a more appropriate property was acquired in 1951.[327] For all intents and purposes, the school remained a summer academy, where already-accomplished young students would receive finishing lessons before being sent out into the world of high performance. Several were able to study on scholarships, some returning for several semesters. By the summer of 1950 the school was still modest in size, with only eighty-five students, up from sixty-five in 1947, but the favorable student-to-teacher ratio guaranteed quality instruction. The Academy remained dependent on private donations, with wealthy Santa Barbarans slowly giving more as it became a local hallmark. Unlike Juilliard, Eastman, or Curtis, which were either affiliated with universities or already degree-granting schools, academic honors were not conferred.[328]

In the last years of the 1940s through 1950, Lotte Lehmann's roles in the new Academy were many, and altogether very satisfying. Having reached the matronly status of a veteran prima donna, she served as the guiding spirit during its conception and early planning. Through her established reputation in the field, she attracted top names among benefactors, patrons, administrators, and musician-teachers alike. Thus she sang a key benefit concert on July 7, 1947, in the Lobero Theater at the beginning of the first semester, raising funds then as well as subsequently, through many new appeals. (At that concert, though asked, Walter did not accompany her; instead it was Koldofsky.)[329] She would become "a shameless beggar for the Academy," as she told a radio interviewer years later. She would hold official positions in the Academy herself, among them, not least, that of honorary president.[330] She also became the most important teacher of master classes in opera and song – starting in 1951, when her recital routine had terminated.[331] So at the dusk of her life, it looked as if her career would not end abruptly, but could be elegantly rounded off and that personally, she might yet find some of the happiness that had been escaping her in those last stormy years.

6

Triumphs and Burdens of Old Age, 1951–1976

The Music Academy of the West

In January of 1951, Lotte Lehmann was feeling dreadful. She was in New York for her usual series of recitals and about to travel further, to Toronto and Washington and Chicago. She had had a terrible journey from California to the East Coast; it had been uncomfortable and cold, and she was hoarse. For the previous few months she had been thinking she was not up to the top performance level any more, and she felt her voice was giving out. The thought of cheating on audiences and on herself had made her so unhappy that she had been crying through the nights. And in the last few weeks, she had been missing Frances, who had stayed at home, and Frances had missed her. "It seems as though all the life went out of me with your departure," Frances wrote to her in January.[1]

What was Lotte to do? Suffering from a cold did not impact her singing at Town Hall on January 28, when she interpreted songs by Hahn, Schubert, and Wolf. In fact, the Brahms group excited the critics. "It came the closest in its convincing evocation of moods, its volume of tone and deftness of coloring to the artist's work when she was still in her vocal prime."[2] But did she have to be reminded of her "vocal prime"? She felt guilty. It was "this dreadful inner repulsion that I have to go away from home," she wrote to Frances, "that had made me absolutely sick." And as she was about to sing in Washington on February 1, she wrote to her friend that she was losing her voice. She was lucky to cancel the trip to Toronto because of a strike, but sang at Town Hall on February 11. She offered *Die Winterreise*, that hauntingly depressing tale of a love-struck man whose luck was running out.[3] Two days later, she sat down in her New York hotel room to write a letter to the sympathetic Chicago critic Claudia Cassidy, trying to explain why she had canceled the Chicago date for March 4. "My recital on the 16th here in Town hall [*sic*] will be the last. I have not announced it beforehand because that makes it such a dreadfully official 'Farewell Performance' – but I think that I shall say it myself during the concert." There were only two other people whom she had told of her resolve beforehand, and neither Frances nor her accompanist, Paul Ulanowsky, were among them.[4]

So finally she had decided to make the Marschallin's maxim come true, that one had to resign oneself to an end when the time had arrived.[5] On that fateful night of February 16, 1951, Lehmann chose to sing favorites by Schubert,

Schumann, Mendelssohn, Cornelius, and Franz. She started with "Widmung" by Schumann, by way of a dedication to her audience, and finished with Schubert's "An die Musik" – a proper thanks to the art that had made her great. This was by way of an encore, which she could not finish, because she broke down, holding her hands to her eyes, while Ulanowsky played the final phrase alone. Even listening to this historic, reissued CD today is moving.[6]

Not included on that record are her parting words, which she spoke just before the intermission. "Tonight is my farewell recital in New York," she began. The audience protested: "No! No." – "Thank you. I hoped you would protest. But please don't argue with me." She then mentioned inner tension and nervous strain, and that she was entitled to take it easy. She recited the famous example of the Marschallin and complimented her "perfect" public, here, at her fifty-fifth recital in New York, where she had started singing lieder nineteen years before.[7] Throughout, she was interrupted by shouts of "No! No!" and "We love you!" After she was done and made her way to her car, she was followed by thousands of people who created a traffic jam for several blocks around until, after fifteen minutes, they finally let her depart.[8] The scene was reminiscent of Geraldine Farrar's departure from the Metropolitan some thirty years earlier. Who else had had such a send-off?

From among the American public, reaction to the news of her retirement was unequivocal: Lehmann received scores of personal letters deploring her decision. One Town Hall patron wrote in the *New York Times* that she had spent nearly half her life – "the aware half" – filled with Lehmann's voice. [9] Risë Stevens spoke of "the end of an epoch" and how it gave her "a lump in my throat."[10] The RCA Victor recording executive George Marek, who had heard the soprano as a young standee at the Vienna Opera more often than he could remember, "bitterly" regretted that he would never listen to her in recital again.[11] Her agent Marks Levine thought she had made "a beautiful exit."[12]

Those closest to her extended more personal sympathies, except for Bruno Walter, who wrote one of his typically pompous letters, speaking of "greatness," the "grand avenue to maturity" and the "blossom of your artship." Elisabeth Schumann was counting her own years, finding herself just as old and still not officially retired; did Lotte really have to do this? Fritz was understanding, thinking that she would know best what was good for her, but adding the obvious – that *le tout* New York was sad. Frances, who had borne the brunt of Lotte's more recent miseries, agreed with Fritz. Her response was cool and collected, assuring her friend that she had not been hysterical and promising her a quiet time at Hope Ranch, interrupted only by constructive periods of teaching.[13]

But Lehmann was not quite done yet. She had contracts to fulfill at the University of Wisconsin, where she sang on February 21, and Berkeley, where she performed twice, in June and July. She thought, quite sensibly, that as long as she had some voice left, she could concertize, with due caution, on the West Coast, which she proceeded to do with a benefit for the Music Academy in Santa Barbara, on August 7, and at the Pasadena Playhouse, on November 11. Concerts at Stanford and Los Angeles, however, failed to materialize. This may have had something to do with her belief that despite her earlier confidence

about her voice continuing to be functional, it was starting to give way to more hoarseness and complete dysfunction. Lotte agreed with Frances that she was not "hysterical," but superstitious as she was, she took these, possibly imagined, troubles as a warning and a sign of having made the right decision after all.[14]

Her main life's work done, Lehmann would proceed to build an artistic legacy until the time of her death in 1976; since that time it has been honed and extended to the present day by public media, biographies, dedicated newsletters, and devotee associations. As early as January 1952, a double-set recording of her last Town Hall concert was marketed, including her farewell address.[15] And that set the tone. More recordings were reissued, and new performances by younger artists, of her lieder or key opera roles, were routinely judged against hers. In important genres of classical music-making in America, she became the standard.

This was apparent almost immediately after her so-called formal retirement. Her voice was always heard and her opinion published when she spoke up, invited or not, as she did on behalf of the *Braille Musician*, "the only Braille music magazine in the United States," for which she solicited donations in May 1952.[16] In 1957, she acted as a member of the Concert Artists Guild of New York, a nonprofit organization helping young artists advance their careers. Other members included Yehudi Menuhin and Lily Pons.[17] A few months later, she spoke at the fourth annual conference of the Central Opera Service, sponsored by the Met. It was concerned with problems of community opera production, and Lehmann saw it as her duty to plead for the construction of opera houses in all major cities throughout the United States. She was joined in this by the Met's new director, Rudolf Bing.[18] Around that time, Lehmann made history of another kind when it was announced that apart from guitarist Andrés Segovia and harpsichordist Wanda Landowska, the soprano was the only artist in the last ten years to have jammed Town Hall with attendance records "three times in a single season."[19]

Meanwhile, as several of her recordings – ranging from renditions of Schubert lieder to Marschallin and Fidelio arias – kept being reissued, she was being held up as the exemplar to be emulated by other sopranos on the stage.[20] Already in November 1952 it was noted that recitalist Martha Holmes "somewhat overmatched herself with a Lotte Lehmann-type of program."[21] When five years later Lisa della Casa was heard as the Marschallin at the Met, she was lauded as the best to adorn that stage since the departure of Lehmann, although she had "not completely plumbed the role."[22] In 1960, Elisabeth Schwarzkopf, on the verge of becoming the leading Marschallin of her own generation, announced that she was glad she never witnessed Lehmann in that role, because her performance was always so overwhelming "that it dominated the thinking of anyone who saw it." Schwarzkopf wanted to develop her own style.[23] Lehmann's historic Fidelio performances were elevated to benchmarks in a similar manner.[24] When in October 1972 the storied English mezzo-soprano Janet Baker was featured in Haydn's *Arianna a Naxos* and Brahms's *Vier Ernste Gesänge*, the *New York Times* found that she lacked "the personal magnetism that, say, Lotte Lehmann or Marian Anderson had."[25]

Lehmann began her official career at the Music Academy of the West after signing a contract on January 8, 1951, stipulating that she teach between July 7 and August 31 of that year. This agreement was renewed for subsequent seasons. At first she was paid only $1,600 for one weekly master class, but this was increased to $3,600 for the 1953 summer session, an amount that remained constant, for two master classes, until she stopped working. In addition, she was appointed director of the vocal department in 1953. She was to audition singers for classes at times approved by her. From the beginning, she reserved the right to teach private students.[26] She stopped after the 1961 season, after beginning to experience some fatigue in 1960, but partially resumed her teaching in August 1969, when she contracted for four classes. Yet another contract for August 1970 was not honored.[27]

On the whole, these were excellent arrangements for her, not least financially, guaranteeing her the security she needed without taking away the potential for additional private instruction. Regarding a central role for her in the Academy, she had agreed on the master class idea with Grace Denton as early as 1947.[28] In 1951, after some initial nervousness, she came to enjoy her work immensely.[29] And to the extent that as a celebrity she immediately attracted capacity crowds and continued to do so, among which only the best could be accommodated – those who were acquiring or already had performance degrees or were on the verge of a professional career – her enjoyment did not abate.[30]

Lehmann's idea of a master class, in the conception of which the ingenious Frances Holden had collaborated, was novel and a typical brainchild of this artistically original woman.[31] Each week, she taught a class in opera and one in song (including the subthemes of "dramatic expression" and "stage deport-ment"), and they were public, insofar as the students as well as faculty members and interested outsiders could observe them from the auditorium of the medium-sized performance hall.[32] Here Lehmann was in her element, sitting on the side of the stage in an ornate chair but often getting up, as she could preach what she had been practicing throughout her entire career: the interpretation of opera roles and lieder. As a 2005 DVD rerelease of historic film footage showing Academy master classes in the summer of 1961 reveals, she consistently did this with the verve of her best performances. Never interested in vocal technique per se (which she simply took for granted, as it was additionally tweaked by Academy coaches), she concentrated on the intensity of expression and emotion produced by the carriage of a series of tones. She watched facial miens and how a singer acted or walked on stage. When students performed, expertly accom-panied on piano by the coaches, she would interrupt and give advice, often in her droll, German-accented English, which was nothing if not lovable in the context of the scenarios. She was stern, but frequently her remarks were full of humor, as she was winking at the students with her eyes, and they always cut to the quick. "Don't look at the audience if you don't like them," she exhorted tenor Roy Neal, before he offered "Die liebe Farbe" from *Die schöne Müllerin*. "You have to take the music out of the piano," Ronald Mitchell was ordered, as he essayed Brahms's "Da unten im Tale." "You don't quite get the character of Elsa, you are too dramatic," to Evangeline Noël. She could get more annoyed, as she did that summer with Olga Chronis, a German student who could not

even enunciate the a-vowels of her text correctly (in Schumann's "Nun hast du mir den ersten Schmerz getan"), but she also showed enthusiasm and glowing pride, such as when the lovely Judith Allen pulled off a spectacular "Mignon" by Hugo Wolf. Sometimes Lehmann would demonstrate a stanza or snippets of a role with her own, now baritone-like but still magnificently controlled voice. "Shall I do it for you? I am so glad for this excuse," as she commenced to sing the Marschallin for Kay McCracken Duke. In all of this, the main message she was trying to convey was that as a singer one had to change into the personality of the character one was singing, something she had always been so beautifuly expert at: "You have to be this woman; the voice is only the instrument," and: "I was very often in tears and I think it was quite right what I did." At the end of a piece, her grades were "very good," "fine, very good," and, as Allen curtsied, "very, very good." Predictably, the eerie calm in the audience would erupt in applause.[33]

Lehmann continued such coaching off the stage and, as always, was perfectly frank, especially with criticism and reprimand. "You progress very nicely," she wrote to one student in 1955, "but I have not yet the feeling that I really penetrate into your heart. Only *once* during these lessons I felt your heartbeat: An ein Veilchen was very beautiful. But Frauenliebe und Leben was rather on the surface. To be sure: You always do what I say. But it does not quite convince me. . . . And yet I have the feeling as if you hide a burning soul under the surface of 'expression'."[34]

In any event, all the students adored her to a fault; they were mesmerized by her charisma. The native Santa Barbaran Elizabeth Erro, who had previously been taught privately by Lehmann's former student Eleanor Murtaugh, today recalls her stage presence. "When she walked from the wings onto the stage, she commanded the entire auditorium. She was just kind of regal. A commanding presence."[35]

Because Lehmann wanted her students to have the right stage comportment as well, she endeavored early on to produce operas within the Academy. Despite her almost boundless ambition and imagination, however, these efforts were always hampered by the Academy's limited means.[36] In the fall of 1953, in somewhat makeshift fashion, she produced *An Evening with Lotte Lehmann*, self-referentially flattering to her ego, but at the same time highly instructive for budding opera artists, not to mention entertaining for the audience. Operatic episodes from Lehmann's past career were presented by young singers appearing in costume singly or in pairs. Lehmann, as hostess, told anecdotes and chatted with the auditors, the stage having been partially made up to resemble a Lotte Lehmann living room. Here she herself was sometimes dimly visible, "as though listening to a broadcast," as the *New York Times* observed. Fritz Zweig, by now exiled to California but a kapellmeister she had worked with many years before, under Bruno Walter in Berlin, was the piano accompanist. Subsequently, to raise money and garner publicity for the Academy, the show went on tour to Pasadena, San Diego, Los Angeles, and up the coast to San Francisco.[37]

It took her until 1954 to produce and direct scenes from Debussy's *Pelléas et Mélisande* at the Lobero. Musically, Zweig was again in charge. For stage sets, Holden had crafted a tower and a fountain (which Lehmann had then

painted) in her wizardly workshop at Hope Ranch. The actors, singing in French, were in costumes lent by Ganna Walska and accompanied by Zweig's piano, with Lehmann serving as narrator, so this was far from a regular opera event. Nonetheless, it was put on twice in late August, and there was a local paying audience.[38]

A year later, Lehmann finally offered her first real opera, Strauss's *Ariadne auf Naxos*, which she had been preparing since 1952. This time, thirty-five musicians selected from the Academy's symphony orchestra were directed by Maurice Abravanel, now principal conductor of the Salt Lake Symphony. As stage director Lehmann had able assistants in musicians Jan Popper and Carl Zytowski. It was to Lehmann's credit that once more this production rated a mention in the *New York Times*.[39] Thereafter she produced more operas: *Die Fledermaus* in 1957 and *Der Rosenkavalier* in August of 1958.[40] After she had done *Fidelio* as her last production in 1961, her mentor Walter congratulated her for having concluded her Academy career with this, "the most noble work," and one that had had such special significance in her own life.[41]

For her private students, of whom she did not wish to take more than three a week, Frances had built for Lotte a special studio at Hope Ranch. Holden remembered before her death in 1996: "Once in a while she would go up there and sing just as she had done in the past. But nobody would hear. I never mentioned that I heard her, but I would listen from a distance. Fritzi was the only one who could hear it close." The German shepherd was to be envied, for even her students would not hear her sing. In demonstrations, Lehmann would continue imitation singing, with everything transposed an octave lower.[42]

Her students were mostly from among the master classes of the Academy, during her tenure there and well after 1961. She preferred coaching in the mornings, and not for more than an hour at a time. But sessions could be longer, especially if she taught entire song cycles or a complete opera role. The advantage here was that she could charge fairly well what she thought she was worth – on average, $30 an hour. Occasionally, she would teach exceptionally gifted, indigent students for free, but then they had to be quiet about it.[43] By now she could afford to be so generous – her livelihood was guaranteed. Hence she never kept a student on just for the sake of earning a fee. As she wrote to one hapless Jennie in 1963: "I hope this letter will hurt you, but perhaps also help. I cannot continue to teach you before your voice gets into a better shape. You throw your money away.... Interpretation is only then important when the foundation on the voice [sic] stands on secure ground."[44]

As a teacher, Lehmann lastingly molded her students as artistic personalities, and in rare cases she influenced their entire outlook on life. A typical example of the former category, to which most of her Academy students belonged, was Luba Tcheresky, who had come to the United States from Russia as a nine-year-old. She studied with Lehmann for three years at the Academy, before singing professionally both in aria and song in America and Europe, until she settled in New York City as a teacher. "To begin work on a role with Lehmann is like embarking on an exciting adventure," Tcheresky recalls, after studying Tchaikovsky's Tatiana from *Eugen Onegin*. "I have my music learned, I have translated and studied my libretto, and have a conception of the role, but I

FIGURE 20. Lotte Lehmann with Music Academy students Grace Bumbry and Luba Tcheresky (seated right) at the Metropolitan Opera, New York, March 26, 1958. Courtesy Special Collections, Davidson Library, UCSB.

love to leave the detailed intricacies of the character to be worked out with her. How interesting and exhilarating it is to discuss, at the very outset, the conflict of inner emotions in this character, the wonderful feeling of the ease and naturalness with which this role unfolds, grows, and blossoms."[45]

The relationship Lehmann developed with Shirley Sproule was considerably deeper and, by Sproule's own admission, changed the young woman's life. Sproule was a young Montrealer who had studied singing with Jean Millar at McGill University. Millar was familiar with Lehmann from her own training in Vienna around 1929. She once mentioned Lehmann as the model to be followed, and Sproule then listened to her recording of Brahms's "Die Mainacht." Sproule was smitten. Eventually she got a job as music teacher at a junior college in Regina, Saskatchewan, whence friends took her on a trip down the U.S. West Coast, right to Santa Barbara. After auditioning at the Academy, what she had never dreamed did happen: she was accepted for the 1953 semester on a half-scholarship, when she was already twenty-nine. It took only her first semester with Lehmann to make her into a complete disciple. Having returned to Regina in September, she wrote to a Montreal friend: "We adore the ground she walks on for the artistry and warmth and great humility she has which transmits itself through her music." Full scholarships brought Sproule back to the Academy in the summers of 1954 through 1956, and also during two winters

in those years, when the school was operating as it tried to metamorphose into a full-time, full-season, accredited institution.[46]

Since Lehmann and Sproule had hit it off, they kept in close touch, even after the retired diva had not succeeded in setting something up for Sproule at London's Covent Garden. But motivated by Lehmann, Sproule moved on to Munich to sing smaller roles and from there to Trier and Mainz, with Lehmann constantly backing her. In the early 1960s, Lehmann wanted Sproule to return to her native Canada, preferably to Sackville, New Brunswick, where she herself had been teaching master classes at Mount Allison University. But Sproule eventually was hired by the music faculty of the newly constituted University of Regina, where she built a distinguished career for herself, always with Lehmann in her heart.[47]

Gary Hickling came from a different background, and yet, ironically, although he was never formally taught by Lehmann, it was he who success-fully organized the singer's legacy and made sure, more than anybody else could apart from Lehmann's recorded testimony, that the prima donna would be remembered for decades after her death. He himself has referred to his pre-occupation with Lehmanniana as an "obsession," and this alone exemplifies the almost magical powers by which this charismatic woman held sway over younger people, especially in her later years.

Hickling was twenty when he first met Lotte Lehmann in the fall of 1961, when she had just retired. He had studied music, with his specialty the dou-ble bass, at UCLA and would continue to do so at the Manhattan School of Music from 1963 through 1966. But he also spent three summers at the Music Academy, from 1962 to 1964. His initial meetings with Lehmann were serendip-itous. He was driving a friend, the young baritone Katsuumi Niwa from Japan, from UCLA to Santa Barbara for private lessons at Hope Ranch and then went to sleep on a couch, thinking little of singers who were being taught by someone called Madame Lehmann. "But in subsequent visits, as I observed this venerable old lady, I felt as if I were entering a new musical world, where words existed on an equal plane with music. Through her I found myself gaining a newfound respect for all singers."

What Hickling learned, then, was that Lehmann was treating singers as instrumentalists, full-fledged musicians, apart from their capacity to act on stage. As his friend Katsuumi continued to take lessons, instead of going to sleep Hickling studied the scores and observed Lehmann's intensive coaching, and when she tried Schumann's *Dichterliebe* with his friend, he was under her spell as well. "No longer did I hear merely a string of notes," he remembers, "instead, under her tutelage, a wealth of meaning revealed itself to me in each word, each phrase." After he had sought out her recordings, she impressed him both in opera and song by the directness and spontaneity of her utterances, as well as by her instinctive musicality. Thus she had an immediate and lasting impact on him as an instrumentalist, as he was polishing up on his bass at the Academy, where he studied with Peter Mercurio. "Not only did her ideas or musical phrasing inform my playing, but I always included a Lied or two on my solo double bass recitals."[48]

Hickling would continue to run into Lehmann during official functions at the Academy. Lehmann had taken a special liking to this sensitive young man who was not even one of her students. As with Sproule and Niwa himself, she personally cared about what would happen to him after his entry into the professional world. Lehmann followed his progress after graduation from the Manhattan School in 1966, when Hickling started playing with the Manila Symphony. She agreed to a telephone interview with him on her eighty-fifth birthday for a New York City radio broadcast special, and when in September 1973 Hickling moved to Germany, Lehmann wrote him letters of recommendation for auditions that eventually led to an appointment with the Symphonisches Orchester Berlin. They kept in touch from then on, Hickling always writing her in German. This continued until her death, at which time Hickling was also friends with Frances Holden. "I will always be grateful to Lotte Lehmann for the many personal kindnesses she showed me, but mostly through the humanity that shone through her artistry." Hickling thanked her by becoming her chief discographer, founding the Lotte Lehmann Foundation and disseminating her art and Lehmann lore worldwide, through the mails and more recently the internet.[49]

Lehmann's continued interest in Tcheresky, Sproule, and Hickling after their graduation from the Academy was actually typical of the way she cared for all her students, as they transferred somewhere else or entered the professional world, for better or worse. In the case of Tcheresky, she commiserated with a young woman who was having difficulty finding appropriate singing engagements in New York, before settling down as a teacher. "Poor Luba has no success what so ever in New York, I don't know what will happen to her."[50] She was equally concerned about a former student called Jane, also in New York, but this time blamed it on her attitude: "How can one be so lacking in the necessary driving force! I think she waits that everything is arranged for her. That is not the way to make a career."[51] When Chieko Sakata received a scholarship to Juilliard in 1958, Lehmann was sure she would be "the eternal student."[52] She recommended Gary Hickling's friend Katsuumi Niwa to Jennie Tourel at Juilliard because, although she had taught him interpretation, "always the voice worried me. It would be dreadful if this marvellous boy could not make a career just because of his faulty technique." She had talked so much to him, she recalled, and he would always listen and then say: Yes, Madame Lehmann – "and do what he wanted to do." (Katsuumi did not do well at Juilliard either but returned to Japan, where he built up a career, singing Wagner and eventually developing a counter-tenor specialty.)[53] Years later, Lehmann was critical of anyone trying immediately to succeed at the shrine of American singing: the Metropolitan Opera. "They are stuck there in minor roles and it is really a time wasted."[54]

More numerous were the occasions on which Lehmann could rejoice with her students. She thanked Albert Goldberg, music critic of the *Los Angeles Times*, for his positive reportage about Margery McKay's recital. "Margery deserves help and encouragement. I enjoy working with her tremendously."[55] To her pride, Marni Nixon began a career in classical recitals, opera, Broadway

musicals, and, especially, dubbing singing voice for movie stars. One of the first characters she dubbed was the governess in *The King and I*, played by Deborah Kerr (1956), and thereafter characters in *West Side Story* and *My Fair Lady*.[56] Success of another kind came to Kay McCracken when she married Vernon Duke, the composer of "April in Paris"; Duke had another life in classical music.[57] In 1961, Otto Klemperer in Zurich was employing Dorothy Sandlin and Jean Cook from the Academy, the former as Fidelio, the latter as Marzelline.[58] Benita Valente did respectably well, first in Freiburg, then at the Metropolitan, and one year before her teacher's death the *New York Times* quoted her like an oracle: "I got the sense of the importance of words from Lotte Lehmann."[59] In April 1966, Lehmann was proud to be able to attend Mildred Miller's Town Hall recital; "she studied her program with me."[60] Three years later another of her students, heldentenor William Cochran, was one of two candidates awarded the largest cash prize ever won by a singer, by the Lauritz Melchior Heldentenor Foundation in New York; the judges included Melchior, Alexander Kipnis, and Birgit Nilsson.[61] Yet such joy was inevitably mixed with grief. Lehmann was struck with sadness when her longtime student Betty Bollinger, lately very successful in Europe, was felled by cancer at the age of thirty-nine in 1962. "I am deeply sad. I saw her just now in Zurich and she told me that she has to live only two months, according to her doctors. She was sure that a miracle would happen."[62]

Lehmann's teaching activities at the Music Academy of the West spurred the interest of other American institutions as early as 1951. As it turned out, these opportunities would provide her with good additional income, valuable experience and, more often than not, professional satisfaction. First in line was the Civic Music Academy in Pasadena, where the Santa Barbara Academy's first musical director, Richard Lert, was permanently based, and where "public spirited citizens" financed master classes to be held at Cal Tech from 1952 to 1954.[63] After another unsuccessful attempt by the Juilliard School to hire her for master classes for 1955–56, which foundered on Lehmann's reluctance to go east no less than on the proposed class format, the soprano began teaching at Northwestern University in Evanston, which she kept up until 1967.[64] She could usually be found there in April of each year – with a hiatus in the early 1960s – and although she taught master classes in her inimitable style, she also instructed less qualified voice students. This she sometimes experienced as a chore, and the arduous travel to Chicago did not help.[65] In the 1960s, she also taught master classes in Sackville, where she received a particularly high honorarium; at the University of Missouri in Kansas City; and, after 1967, when travel was becoming more cumbersome, at UCSB, just around the corner from her home.[66]

Although Lehmann herself, not least through these extracurricular activities, was able to improve her financial lot, this did not apply to the Music Academy, which remained dependent on private donations.[67] When Lehmann started there in the summer of 1951 the school was moving its operations from Carpinteria to a spacious new villa, Miaflores, in the foothills of Montecito near the ocean, on an eighteen-acre site. While the property had been philanthropically

donated, its upkeep was very expensive, and most students still had to be bussed to classes from fraternity residences on the campus of UCSB.[68] The administrative staff was skeletal, with idealists like Frances Holden working there for nothing, in her case as the registrar.[69]

Lehmann was tied into the administration through her position on the planning committee and, after 1953, as honorary president. That office's sole function was to generate the prestige necessary for soliciting more private money, attracting the best summer faculty for the smallest fees and further paving the way to a year-round schedule and hence full accreditation of the school as a degree-granting institution, which had been the initial goal and one the singer herself consistently supported.[70] Taking her fund raising seriously in the manner of a Prussian civil servant, in June 1951 Lehmann asked and was informed by the Rockefeller Foundation that its support of music in America was "not likely in the near future." A few months later she asked Maxim Karolik, a former tenor with the Petrograd Grand Opera Company who had married a rich Boston heiress twice his age and had taken a fancy to collecting American art, to grant an endowment. As she wrote, her heart was aching when she saw the poverty of so many pupils "and the urgent need for scholarships." Yet she received no answer.[71] Then in 1954, when an experimental winter session was to be started, a step toward redefining the Academy's overall mission, she asked her old friend Bing Crosby, because she knew that he "gave a lot for charity," but again there was no response.[72] She then asked another Hollywood acquaintance, Hedda Hopper, how to go about winning benefactors, but the gossip columnist's answer was anything but encouraging. "You do not need to apologize for approaching me," barked Hopper, "everybody does." Raising money for music in Los Angeles, apart from the Symphony and the Bowl, was like pulling teeth. "No music lover here seems to be so imbued with the appreciation of music that he would go afar, even as far as Santa Barbara."[73]

Someone whom Lehmann also begged for money but who tenaciously ignored the request was Bruno Walter, ensconced in his villa in nearby Beverly Hills. Lotte reminded her old friend Bruno of the obvious, that the entire board of governors of the Academy was only waiting for him to make a move, not just with donations, but by taking over any role there he might choose for himself, such as president, because if he did, chances were that all of the school's problems would be solved in one fell swoop. Yet apart from recommending Maurice Abravanel as Lert's successor effective July 1955, Walter could not be stirred.[74]

During her time on the board of governors, Lehmann became rather bitter about its chronic impotence, both in securing funds and in improving the academic status of the institution she had helped to found. One of the symptoms, if not an underlying cause, she realized, was the frequent turnover of wholly mediocre executive directors, with the fourth one, Virginia Cochran, assuming her duties in 1967, after Lehmann had officially retired. At that time Lotte complained to Frances that Cochran was only twenty-six years old (younger than some of the students), although, it could be said in her defense, she already had work experience with the San Francisco Opera, the Monterey County Symphony, and the Carmel Beach Festival.[75] However, what the stage-experienced

Lehmann had correctly understood was that thus far, the Academy had failed to attract to its top position a personality of the stature of Bruno Walter.

One other problem Lehmann encountered was with teachers of instruments. She could not schedule proper opera productions during the first few years of her tenure at the Academy because the orchestra, in its early state, was not up to that challenge. This was due to the fact that in its teaching policy the Academy followed a mixed, and confusing, path that combined star mentoring and regular instruction. Among the stars occasionally invited – as they had been more frequently in the early years – was the cellist Gregor Piatigorsky, after his initial visit in 1950. Of him, Lehmann reported in 1952 that he had said one should give one's art more or less freely to the world and not charge for teaching. "But when we said that he should *do* it now instead of only saying so he started to be very vague." Still, as it turned out, of all the famous musicians at the Academy during its early period, Piatigorsky worked there more than anyone: from 1950 to 1953.[76] The composer Darius Milhaud, too, returned once, in June 1953, to lead a composers' symposium including Virgil Thomson, Roger Sessions, George Antheil, Mario Castelnuovo-Tedesco, Ernst Krenek, and Lukas Foss. But although the students found the symposium "stimulating and educational," critics judged it "inconclusive overall."[77] Piatigorsky, Milhaud, and the other prominent composers all had other fulfilling jobs and were not dependent for their livelihood on a few weeks of work in Santa Barbara. The same held true for yet another celebrity who assumed the musical directorship from the little-known Richard Lert: Maurice Abravanel, whose main occupation was as conductor of a major symphony orchestra.

The bread-and-butter instructors at the Academy, those who still taught students the basic techniques of mastering an instrument, all had regular jobs at other institutions and therefore did not see in the Academy, which was not yet prestigious, a vehicle for their own professional advancement. Hence they would invest less there than they might have otherwise. Gwendolyn Koldofsky, for example, taught piano accompaniment both at the Academy (as well as accompanying master classes there) and, in year-round employment, at the University of Southern California. Carl Zytowski, the operatic stage coach, concentrated on his career path as a young faculty member at UCSB; the pianist György Sándor was on the faculty of Southern Methodist University and trombone teacher Davis Shuman at Juilliard.[78] If the Academy had managed, until 1961, to become a full-fledged, all-season, degree-granting institution, perhaps not Piatigorsky (mainly heard concertizing) and Milhaud (at Mills College and the Paris Conservatoire) or Sessions (at Berkeley and Princeton), but those lesser musicians might have changed over permanently, for its ultimate benefit, rather than viewing some eight weeks every summer or so as a pleasant diversion near a sandy California beach. It was a circular conundrum: the Academy could not attract top names because it was not full-time, and it was not full-time because it could not attract top names. Top names would have served as magnets for younger and lesser-known teachers to move there.

Owing to the same lack of a sense of stability, the vocal department under Lehmann's direction changed personnel often, with different designations. In 1950, Martial Singher was "voice teacher"; one year later it was John Charles

Thomas.[79] In 1954, Tilly de Garmo was responsible for "vocal technique"; in 1955, Armand Tokatyan was "voice teacher"; and in 1956, William Tarrash was "vocal coach."[80] In any event, these instructors schooled singing students in technical details short of the interpretive skills Lehmann herself specialized in during her master classes. She got along better with some of her junior colleagues than with others. In 1956 she would have preferred to work with Jan Popper, her erstwhile repertory assistant, who regularly taught at UCLA, but in that year Abravanel wanted Tarrash, in order to prevent Popper from also conducting operatic performances.[81] This evidently led to tension between the prima donna and her musical director, even though Popper was allowed to teach voice in subsequent years.

At the turn of the 1950s, as Lehmann was contemplating retirement, she wanted the German soprano Ruth Michaelis to come over to succeed her in her post. Michaelis was renowned as a teacher both in Munich and in Istanbul. She did indeed arrive to complete the last four weeks of Lehmann's master class in August 1961.[82] But then Abravanel appointed Singher as her successor, apparently without having consulted Lehmann.[83] Although Lehmann had left the Academy's faculty by then, this step led to more friction with Abravanel. Her ongoing disagreements with Singher over the years further clouded the soprano's view of an institution that at one point she had hoped would be her very own singers' academy.

The baritone Singher was born in 1904 in the French Pyrenees. He had had early successes at the Paris Opéra and the Teatro Colón in Buenos Aires when the Nazi army occupied France in 1940 and began hunting down Jews. Leaving his mother behind, he fled to New York, where Edward Johnson accepted him on the staff of the Metropolitan. There he sang until 1958, but also taught, briefly, at the Academy and then at Philadelphia's Curtis Institute.[84]

At the Academy again by 1962, Singher displayed a much more technical approach to voice molding than Lehmann herself liked. One young woman whom he coached early in Santa Barbara was Marilyn Horne, who lauded him later for his training of her vocal cords. Another one, a generation hence, was Jeannine Altmeyer, who found that Singher was a "hard taskmasker who terrified a lot of students" and who herself submitted to his training routines until she thought he had purged the naturalness from her high notes.[85]

After Lehmann had resigned she wrote to Sproule, with unusual sarcasm, that she was not being missed at the Academy at all, especially since Singher, as her successor, had become "a big success."[86] Because his lessons were overly scholarly, she doubted that students were getting much out of his teaching efforts.[87] In 1968, Singher resigned from Curtis, moving permanently to Santa Barbara. This was just when Lehmann was scheduled to do more master classes at the Academy – in 1969 and 1970. Holden, who after Lehmann's death maintained – along with other Academy members – that Singher had always been jealous, wrote in 1969 that he was probably praying her friend would be unable "to fulfill her contract."[88] When Lehmann went ahead as planned in the summer of 1969, however, she was able to observe that she "even got the students of Singher who at first perhaps were full of suspicion and too much accustomed to intellectual teaching – but I had the feeling that they succumbed to me."[89]

There is no doubt, however, that the soprano's decision not to honor her contract for 1970 was made in large part because she had learned that not she and Koldofsky, but Martial Singher himself, would be able to decide who should be her students.[90] Whereas Lehmann retained the loyalty of certain critics such as Albert Goldberg who disdained Singher's entire style, the Frenchman had his own following until he himself retired from the Academy in 1981.[91]

Lehmann's disenchantment with the Academy was not dispelled, right after her resignation, by the executive director's telling her how "perfectly wonderfully" the school was getting on without her. Apart from the disagreements with Singher, her relationship with that institution remained fragile, and there was little traffic between her and any Academy personnel, with the exception of the few she liked, such as Popper.[92] This did not change even when the leaders of the Academy were trying to put a good face on it all by celebrating her eightieth birthday on February 27, 1968. They created a special planning committee with celebrities on it, from Elisabeth Schwarzkopf and Marian Anderson to Claudia Cassidy and Vincent Sheean. Their ulterior purpose was to raise $200,000 for a "Lotte Lehmann Chair." On February 27, as prescribed, the actress Dame Judith Anderson and the tenor Lauritz Melchior spoke a few polite words at a gala dinner before the cold beef broth with grapes "Sieglinde" was being served, and in the evening Zubin Mehta perfunctorily conducted the Los Angeles Philharmonic in excerpts from Haydn and Tchaikovsky symphonies and Strauss's *Der Rosenkavalier*.[93] Records reveal that the event hardly registered with Lehmann, who almost always accepted, and then talked about, any honor on earth bestowed on her. The time at the Music Academy of the West had been just another episode in her life, disappointing her in the end, however full of promise it had been at the beginning.

Master Pupils

Not all of Lotte Lehmann's relationships with Academy students were smooth. Notably, problems arose with two vocal pupils, and they were, perhaps not coincidentally, the very top ones the Academy ever produced. These were Marilyn Horne and Grace Bumbry.

The seventeen-year-old mezzo-soprano Marilyn ("Jackie") Horne was studying with William Vennard and Gwendolyn Koldofsky at the University of Southern California when, from 1951 on, she also participated in Madame Lehmann's master classes, first in Pasadena and then in Santa Barbara.[94] By 1956 she was in Europe and on her way to international fame, and she was writing devout letters of gratitude to her former mentor in Santa Barbara. On January 5, 1957, for instance, she penned from Vienna: "Dearest Madame Lehmann, thank you so much for your most kind & touching letter. It was very sweet of you to be so concerned about Christmas for me this year." She concluded the postcard with "Thank you so much for your most loyal support. Love Jackie." Another postcard a few days later ended with "Oodles of love x x x always Jackie." Moreover, in an undated birthday greeting Horne assured Lehmann that "your inspiration and legacy will live forever."[95]

In the 1960s, Horne's duets with Joan Sutherland made music history, and in 1982 she was called "probably the greatest singer in the world."[96] In 1997, after singing two hundred and fifty times at the Met and receiving many international honors, Horne assumed Lehmann's earlier position as director of the voice department in the Music Academy of the West. Her position was the chair named after Lehmann.[97]

Before that, when Horne published her autobiography in 1983, she had had several negative things to say about her former teacher. Her statements culminated in the description of an encounter with Lehmann at the Music Academy that was most unflattering to the older woman. Horne had performed at a student concert in the Lobero Theater and then was to sing, before the usual audience, in one of Lehmann's Academy master classes. "Before I could open my mouth," Horne writes, "the great Lehmann lit into me with such venom that I believed I could actually feel the physical sting of her words. 'Your Cherman vas a disgrrrace in ze Loberrro conzert,' she began. 'You haf no rrright to zink a lenkvich zo poorly. A zinker must haf commant of ze lenkvich, und not learnink anozer tonk prrroperrly is ze zign of laziness. You vill neverr be grrreat becauss you cannot master ze lenkvich!'" Horne reports that she felt anguish and fear. "The realization that she hadn't mastered *my* tongue, however, didn't help my stomach, and I froze as Lehmann continued her tirade. When she didn't stop, the audience began to squirm, and I looked over to Gwen, the official accompanist, at the piano. She lowered her head in a feeble gesture of sympathy, but there was nothing Gwen could do." Horne relates that Lehmann went on and on, with the audience sitting aghast and wondering. "Finally, Lehmann stopped and, throwing me a look which could have destroyed Tebaldi, Stignani and Maria Callas combined, she commanded me to 'Zink!'" According to Horne, she rendered her Brahms song well and the audience broke into cheers. At that point she was sure that she would "never, ever sing for that woman again!" When the class was dismissed, "I was surrounded by friends expressing outrage at the teacher's behavior and admiration for my performance. I never went back."[98] But not only did Horne see Lehmann again, she also wrote her sweetly endearing letters.

Having seen and heard Lehmann on the recently released VAI footage of her 1961 master class, it is hardly believable that she would have behaved like this. There and in various interviews over the years, her German accent is thickly noticeable but, if anything, enticingly on the charming side. Of course, in a fit of anger and fury, it might have had the hiss and sting about it that Horne mentions in her memoirs. But all speculation aside, the Academy has retained a verbatim record of what Lehmann really said to Jackie Horne. Gary Hickling has faithfully transcribed and published it: "'Do you study with anybody German? You sang lovely [at Lobero] but your German is absolutely [word not clear]. You have to study with somebody German. You want to become a first class singer, don't you?' Horne replies: 'Oh yes...' and Lehmann continues: 'You have to learn German. If you want to sing a concert and want to sing in German, you can't make such abominable (is that the right word?) mistakes as you did. I sat there and cringed. It was very good. The whole concert was, I mean, it is perhaps even ridiculous that I say anything, it was excellent. I was

very happy and very proud. But the diction was terrible. So promise me will you? Look around for a German teacher and learn German.' At this point LL gives her English translation of Brahms' 'Botschaft' which Horne then sings. Afterwards LL tries to get Horne to correctly pronounce the word *'spricht'* with the 'sch' sound at the beginning. When Horne finally gets it, even Horne laughs."[99]

What is puzzling about all this is not only the discrepancy between Horne's remembrances and the tone of her 1950s communications to Lehmann, but also the fact that although Hickling had pointed Horne's attention to the historic Academy transcript and asked her for a comment, Horne simply ignored this, republishing her original version, with variations on the horrible accent, in a 2004 reedition of her book.[100] Hickling reports that in every interview Horne speaks about her "confrontation" with Lotte Lehmann. "She's mentioned it to me, even though she knows I've corrected the matter! Each negative incident that she mentions in her book is written in stone in her mind and comes out robot-like in repetition."[101] When I repeatedly asked Horne for an interview to clear the matter up, making myself avalaible to her both in Santa Barbara and in the New York area where she maintains residences, she always claimed to be too busy.

Why Horne should dissemble in such a manner and gratuitously insult the memory of her former benefactor remains a mystery, particularly since the singer had been offered several opportunities to set the record straight. Was it to embellish her memoir with humor – a humor that appears in other places, always somewhat forced? Did she bear a justified grudge against Lehmann for wrongs her mentor had once done her, but which do not surface in the surviving records, because Horne withheld Lehmann's letters to her from any archive? Could it be that she could never stand Lehmann to begin with and simply mimicked friendship, even devotion, to the diva, in her early letters from Europe, because it was opportune to do so? The example of Sproule and others shows that for meek and well-behaved students, Lehmann could open doors. And why would Horne not admit that she had grossly misrepresented the Music Academy stage encounter after Hickling had confronted her with the genuine transcription, and even decide to include a similarly butchered version in a second edition of her memoirs? Or was it because in the media, not Marilyn Horne but Grace Bumbry has frequently been identified as Lotte Lehmann's most famous pupil, certainly in Europe?[102]

That unresolved questions such as these abound reflects on the personality complexities of both mentor and disciple and is yet another reminder that human relations involving Lotte Lehmann could be utterly difficult, indescribable, and indeed inexplicable. Whatever the emotions between the diva and Marilyn Horne may have been, a different chemistry was at work in the teacher-student relationship between Madame Lehmann and Grace Bumbry, and some of these evolving problems resist analysis no less. Others, however, open themselves more easily to persistent probing.

Grace Bumbry was made of the stuff of "genius" that Frances Holden was so interested in studying. She was born on January 4, 1937, in St. Louis, into

an African-American musical family; her father was a freight handler on the cotton-belt railroad. At her Methodist Church, the organist was a progressive musician; at age eleven Grace learned Handel's *Messiah*. Still too young to be in the church choir, she was allowed to join and sang that oratorio's mezzo and soprano solo parts. After voice lessons and in high school around the age of sixteen, she entered a twenty-week music contest for instrumentalists and singers from all the area schools, and of five hundred students was declared the overall winner. One prize was a scholarship to the St. Louis School of Music, but this being a time of racial segregation, entrance was denied her. As a compromise solution, the school offered her private instruction, but Bumbry's family decided not to accept that. As she recently explained, "it's a matter of pride, principle and dignity, so we turned it down."[103]

Along with cash, Grace had also won a trip to New York, where a CBS station manager arranged an audition for her on the *Arthur Godfrey's Talent Scouts* show. On the air, "all of America heard about this little girl on the Godfrey Show." As a result, Grace received six scholarship offers to music schools, including Juilliard, but decided to go to Boston University, and after a year transferred to Northwestern. Her stay there was financed with various prize monies.

Grace had looked up Lehmann's name in the library and learned how important she was. Utterly nervous, she auditioned and then noticed that Lehmann was "overwhelmed when I had sung, and so were the other people present." At the end of that two-week course in the autumn of 1955, Lehmann was determined to bring Bumbry to Santa Barbara and got one of the wealthy local ladies, Alice Schott, to provide $3,700 in scholarship funds for her.[104]

At the Music Academy of the West in the summer of 1956, Bumbry's technical voice coach was Armand Tokatyan. She instantly stood out. "I was the best student they had there," she later said without flinching, "whether soprano or mezzo, because I could sing everything the sopranos sang, and sing it better than they did, and I sang everything the mezzos sang." Proud and impetuous, she gradually learned to overcome her shyness, as she was becoming ever more conscious of her great gift. She was tall and slender and attractive; this and her outstanding voice set her apart from an already very talented crowd and made her not a few enemies.[105] Grace not only appreciated the particulars of Lehmann's unique instruction, but also saw in that artist "her great sense of poetry." When her mother came to visit once, Lehmann explained lieder and opera scenes so graphically that Mrs. Bumbry burst into tears. For Grace, studying with Madame Lehmann was everything. "I had no time for other stuff. I would not even see our friendship as a private, personal relationship, because I saw Lotte Lehmann as this goddess, and I had my responsibility to be prepared every week for what she had asked of me. Every week we had something new to learn, and I just could not go to my lesson unprepared." This was in a year when the Academy had both a summer and a winter season. Rather than returning to Northwestern, Bumbry continued to study with Lehmann privately, at Hope Ranch.[106]

Lehmann planned Bumbry's débuts very carefully. In 1958, she had her master pupil with that beautiful mezzo-soprano voice sing publicly, first at the local

Lobero Theater, then in San Francisco. For the spring of 1959, she and Holden were to take Bumbry to Europe. Grace took part in Lehmann's master classes at Wigmore Hall in London and then was introduced to Vienna, where she had additional lessons with Erik Werba. Those studies continued later in Salzburg. Both women were in Bayreuth, where a first audition was unsuccessful. In September, Bumbry moved on to Paris, where the baritone Pierre Bernac, a noted specialist in the art of lieder, instructed her. All of this was paid for with competition prize money she had collected over time.[107]

Thereafter success chased success. In March 1960, Bumbry made her début at the Paris Opéra as Amneris in *Aida* and later appeared in Tokyo with that production. Then followed, in the 1961 Bayreuth season, her first sensation: on Wieland Wagner's insistence, she sang the Venus in *Tannhäuser* and immediately became known as "Black Venus," something that prompted Wieland's mother, Winifred, to remark that it had been "totally unnecessary" and elicited over two hundred protest letters from old and neo-Nazis.[108] But having signed with the Basel Opera for the fall of 1960, she was now also getting known in the German-speaking world as a fine interpreter of lieder – thanks to the Lehmann cachet.[109] Covent Garden was ready to engage her after she signed with Basel, yet she remained there until 1963.[110] It was only then that she made a cameo appearance in London as Eboli, from *Don Carlo*, establishing the aria "O don fatale" as her signature theme.[111] Her 1964 Salzburg Festival performance as Lady Macbeth of Verdi's eponymous opera again "caused a sensation."[112]

Bumbry's American progress was less spectacular. She first came to U.S. national attention as the guest of Jacqueline Kennedy, entertaining Supreme Court justices and congressional politicians after dinner at the White House on February 20, 1962; she was flown there and back from Paris. The highbrow first lady with an affinity for things French had heard of Bumbry's great success in Europe.[113] In November, the young mezzo gave a mixed aria and lieder recital at Carnegie Hall, which prompted Alan Rich of the *New York Times* to comment that what was lacking was "the musical insight that sets the musician apart from the mere singer."[114] Her Metropolitan début did not occur until October 7 of 1965, when the critic Raymond Ericson hailed her, after her Eboli, as a worthy addition to the Opera's star roster.[115] (It had only been in 1950 that the new Met director, Bing, had decided to throw overboard the old taboo against black singers by engaging Marian Anderson for 1955.)[116] Another recital at Carnegie Hall a few weeks later was again somewhat problematic, giving rise to the question whether it was wise for Bumbry to move – as her selections now demonstrated – with apparent ease between the mezzo-soprano and soprano ranges.[117]

Indeed, there were two things that made Bumbry stand out from among her peers. One was that she developed the ability to negotiate tones from the mezzo level to that of a soprano, but could move back again without difficulty. The other, driven by her growing self-assurance, was her flamboyance, as both a person and a performer (here she resembled Jeritza, who later regularly attended her Met performances). Her elevation into the higher vocal range, already demonstrated in the Music Academy, was developed professionally in

the 1960s and continued into the 1970s, when she regarded herself as both a mezzo and a soprano, until in the 1980s and 1990s – she was getting older – she settled once more for the mezzo range. Many critics accepted these iterations with equanimity, even praise.[118] Others, however, charged that she was never fully a soprano and that at greater heights her sound was suffering.[119] Bumbry herself has always maintained that she was only making the most of a God-given talent – encouraging colleagues who were similarly gifted to do likewise.[120]

Bumbry's personal extravaganzas have had as much to do with her temperament as with her resolve, certainly in her early years of stardom, to use her physical endowments to the greatest professional effect – and which aspiring prima donna would not do so? Knowing that in her world, ruled by white men, she was exotically irresistible, an impression that seemed to be hauntingly reinforced by her early success as "Black Venus," she learned how to dress expensively and with exquisite taste and mastered making an entrance, cutting a figure, creating a spectacle. She did so while enjoying the peaks of her success from the late 1960s through the early 1990s, impressing critics and friends alike with an apartment on New York's Upper West Side, show horses in California, a villa in Lugano, and an assemblage of high-end sports cars, not to mention a Rolls Royce, in both Europe and North America. She gave celebrity interviews to the *New York Times* about her favorite recipes, and on more than one occasion talked about the men in her life, although the aura of promiscuity, which, by design, surrounded so many public stars of her generation, was absent.[121] If one examined her career up close and without misgivings, say by 1970, one could not help but feel that here was an extraordinarily talented young woman who, after having been almost entirely cheated out of life's chances because of her color, was receiving what was due to her and was joyously taking advantage of it. "No one gave me anything," she once said, "what I have, I earned, and of course I'm going to enjoy it."[122]

Lotte Lehmann claimed bragging rights for bringing Bumbry from Evanston to Santa Barbara. She announced her new discovery to all her friends, never forgetting to mention that if the girl was beautiful, she also was a "very dark negro."[123] By 1957, she was advertising her more widely, thinking that Bumbry was ready to make her professional début. But Lehmann continued to emphasize Bumbry's color as she was doing so, with the result that the composer Gian Carlo Menotti informed her that he might indeed write a part in his new opera for "a colored mezzo-soprano."[124] Even as this did not materialize, Lehmann went on to draw a connection between the quality of Bumbry's singing and her skin: "Here is a voice of a strange earthy quality – so as if it comes out of the depth of her being, dark, vibrant, passionately alive."[125]

Color aside, Lehmann attempted to arrange a tour to Australia for Bumbry, one in which she herself could join as chaperone.[126] This having failed, she tried to get Constance Hope to come out to audition her at the first Lobero recital, and could Hope not bring along that powerful agent, Sol Hurok? Lehmann also contacted Walter, so that he would hear Bumbry at a recital of Mahler's *Kindertotenlieder* planned for the spring 1958 festival at nearby Ojai. Alas, neither Hope nor Hurok, nor even Walter, came.[127]

By early 1958, Grace had won a $1,000 Metropolitan Opera award and later would win another one in San Francisco. But by this time, as Bumbry was taking her first steps in the limelight, problems were developing between her and her mentor, some of which harkened back to the days of Risë Stevens. The prima donna feared that Grace was "not too bright" and noted with concern that after the San Francisco concerts, she neglected to pay her agent, as well as her accompanist, who was from the Music Academy. As her teacher, Lehmann also had not been informed about the San Francisco prize: "She has a lot to learn yet – how one behaves." As Lehmann (with Holden) was taking Grace under her wing on her first European trip in the spring of 1959, she could not help but notice that during the sea voyage Grace always slept until after lunch, which, she implied, was a sign of sloth, although, in Vienna, Lehmann once again had to marvel at her student's naturalness and poise. After the diva had returned to California later that summer, Bumbry went her own way in Europe and, as far as Lehmann was concerned, in her straightforward manner often did so tactlessly, which to her was upsetting. Holden supported her friend when in the fall of 1960 she reminded Bumbry that she had affronted an Italian conductor who had been in a position to help her; she would not have told her, Holden concluded her letter, had she not heard "of other people's reactions before. You do want to make a career, don't you?"[128]

The early 1960s, however, were also years of triumph for Grace Bumbry, and Lehmann found it easy to identify with this success. In fact, she came to view Bumbry as a daughter and, even more, as an extension of her own self. If only Grace had "brain enough" to make the right decisions, abstain from foolish actions, and avoid the temptations of stardom. She was such a child! So while on the one hand Lehmann was sufficiently sensible to recognize that Bumbry had to emancipate herself and continue developing her artistic personality on her own, she could not resist a compulsive urge to keep the young woman under control.[129] One area where this became obvious was concert management, for she wanted Bumbry to hire Hope as her agent for America, her own former problems with that manager notwithstanding. But after meeting with Hope in New York, Bumbry decided against such a partnership, which flew in the face of her mentor's designs.[130] Another area concerned men. It would have been unusual for a girl as attractive as Bumbry not to have boyfriends, but even at the Music Academy, in the last few months, Lehmann had driven a potential suitor away by writing him a stern letter.[131] In 1961, rumors were reaching Lehmann from Basel that Bumbry was "very irresponsible" and had "a lot of boyfriends."[132] When in 1962 Bumbry met the German, Basel-based tenor Andreas Jaeckel, whom she would marry in 1963, Lehmann's possessive instincts were acutely violated. She viewed him as boastful and conceited and as someone who would hinder her protégé's success. To Frances, she called him "a blown up frog."[133]

Lotte Lehmann's identity fixation with her prodigal child deepened. In January 1963, she wrote to the Chicago critic Robert March: "Grace is not only 'a former student' for me – I love the girl personally – and artistically she is like a rebirth of myself – only I never had such an outstandingly beautiful voice."[134] Was it envy, then, that propelled the diva to persist in finding all

manner of fault with her "former student"? Although never to Bumbry's face, there was Lehmann's perennial criticism of externals: whether Grace dressed sexily in tight dresses, wore an exotic wig, posed lasciviously near her sports car, or allegedly conducted a seductive, "undignified," dance in front of a Monte Carlo television camera – Grace increasingly struck her as vulgar, childish, vain, or ruled by Callas-like whims. On the other hand, for the 1964 Salzburg Festival in *Macbeth*, "she looked marvellous and quite white, they must have a new kind of makeup. She did not look like a negro at all."[135] What really irked Lehmann was that Grace never seemed to have enough time for her benefactor, who had taken to visiting the Austrian spa of Badgastein every year, close to Salzburg and even Vienna, whence the rising star, working in both places, could have come to see her.[136] Bumbry admitted later that, although ignorant of particulars, she always suffered from a bad conscience, having been given the feeling that she was bestowing too little attention on the older woman.[137]

Around the mid-1960s, Lehmann got exercised by two new issues. One involved Bumbry's increasing essays in the higher voice register, and the other the way she prepared for and performed as Carmen under Herbert von Karajan. By July 1964, as Lehmann heard Bumbry sing as Lady Macbeth alongside Dietrich Fischer-Dieskau in Salzburg, and Bumbry was obviously tapping higher registers, she was regretting the fact that "one has to forget the velvet quality of her voice."[138] A year later, undaunted, Bumbry informed the diva that she was improving on that role with a voice coach Jaeckel had introduced to her. "Now I must get the high voice out of the cellar and soaring upwards again."[139] Lehmann was not happy; she had always wanted Bumbry to be a mezzo, but she must have been aware that it had been Tokatyan who, already in the 1950s, had set her student on the soprano path.[140] In December, she wrote Bumbry a letter. "Don't force your voice into a higher register than is good for you." She thought that "the deep beauty" of her voice, that which resembled "black velvet," lay "mostly in the middle and low register." She urged Grace to discard the soprano roles. "The mezzo soprano roles are so wonderful. You have no equal, I believe, no real rival. O please, Grace, stick to them."[141] At Hope Ranch, friends saw Lehmann shedding bitter tears over Bumbry, suspicious that her protégé merely wanted to catch more glamor as a pure soprano. In all of this, Bumbry was said to act "as stupid as the night."[142]

Meanwhile, the younger woman persisted with her plan to be an excellent mezzo-soprano, in addition to making her mark as a soaring soprano. She as much as told her teacher this in summer 1966, and she in turn continued to lament it.[143] Yet two years hence Bumbry went so far as wanting to add more soprano roles to her repertoire, even with Lehmann's help. She thought of Giovanni Pacini's Medea and Jean-Baptiste Lully's Alceste and then perhaps Brünnhilde, and wished to come to Santa Barbara to study these parts at Hope Ranch. She also thought of Fidelio, which Lehmann had had her problems with in mature age. It speaks for Lehmann that she was willing to accommodate Bumbry; still she was placing a bet with Erika Mann that the young singer would not show up. And so it happened. Bumbry apologized to her teacher that Chicago's Lyric Opera no longer wanted to schedule *Alceste*. Wagner, Bumbry explained, turned out to be too difficult for her, and Medea was

within a range in which, by her own admission, Lehmann herself did not feel comfortable.[144]

The last disagreement over vocal ranges occurred in regard to *Salome*. Not only was this lead soprano role one that Lehmann could never have attempted, but the personality of the necrophilic princess was endowed with physical features the older singer had always lacked. On June 12, 1970, Bumbry performed as Salome at Covent Garden and, as she had promised, took off all her seven veils until only "jewels and perfume" covered her "like a modest bikini."[145] Although Lehmann had to acknowledge that her student had had "a tremendous success," she quoted some authority as saying that the high notes had been "a little forced" – a criticism not even broached in the *New York Times*. Her main problem with Bumbry's performance, however, was not even her singing, but "her nakedness."[146] Still unaware of what rancor she might cause, Bumbry wrote to her in January 1972 that "at the moment I am riding two horses, soprano and mezzo" and, two months later: "My voice is going through a fantastic period!! It seems the higher I sing, the better it is."[147] That was the last thing Lehmann wanted to hear. When in September 1973 Bumbry was giving Salome under James Levine at the Met, Donald Henehan of the *New York Times* found that she acted with "credible sensuality" and that, while her voice was not quite of dramatic size, "it penetrated the dense orchestration successfully most of the time."[148] Before that staging, Lehmann had sent Bumbry a cable from Hope Ranch. Bumbry thanked her later, saying that she was so happy knowing that her dearest Lotte was thinking of her.[149] She would not have been so happy had she known what her dearest Lotte really thought.

There remains the case of Karajan's Salzburg production of *Carmen*. When Lehmann wrote to Holden late in 1962 that Lotte Walter was "furious that Grace behaved so arrogantly toward me," she was referring to Bumbry's refusal to accept the older woman's unwanted advice regarding specific roles.[150] To refuse the advice may have been as undiplomatic on Bumbry's part as it was presumptuous on Lehmann's to continue treating someone who was now a colleague as an immature student. In essence, Bumbry had every right, as she was continuing her coming-out process, to develop artistically on her own terms and to ask Madame Lehmann for advice only in those instances that she herself thought crucial. Bumbry must have been well aware that whenever she had sung the classic mezzo-soprano part of Carmen, Lehmann had not approved of the manner in which she had attacked it, for this opinion Lehmann had spread far and wide.[151] Lehmann considered herself an authority on that role; although she herself had never sung it, she had written about Bizet's lead character and thought she knew its exact psychology.[152] But that was of small comfort to Bumbry, as she had never had the chance to study this role, one of the staples in the mezzo repertory, with Lehmann, either privately or at the Music Academy.[153]

In early 1966, as Bumbry was beginning *Carmen* rehearsals for the Salzburg Festival under Karajan, Lehmann had managed to slip her unsolicited written instructions detailing how this role ought to be dealt with. But in this case Bumbry was relying more on the advice of her husband, as well as on what she might learn in the Karajan rehearsals. Lehmann made very sure to attend

the performance on July 27, and while she found Grace "surprisingly good" in the first act, in the second "she was simply boring. She has no *real* inner fire." According to Lehmann, the auditors in the row behind her were dismissing Bumbry – proof enough that her outline had never been looked at. For the next few days Lehmann waited in vain for Grace to call her at her hotel.[154] Grace, however, knew all too well that she had had an immense success, the *New York Times* alone noting the "thunderous applause for her singing and for her unconventionally sexy Carmen." Even before that, as she had told Lehmann, she had received offers to sing Carmen "everywhere of importance" – La Scala, San Francisco, and the Metropolitan.[155] In September, Lehmann resigned herself to the fact that "unfortunately every operahouse [*sic*] wants her Carmen." In her mind, apart from Jaeckel's ill advice, the "insane" Karajan had put on one of those detestably modern productions – it was like a revue "and had nothing to do with the good old Carmen."[156] Bumbry wrote Lehmann later how "fantastic" her Carmen had been at the Naples Opera, and Lehmann herself could have gleaned from the *New York Times* in January 1969 that at the Met Bumbry had been "a natural as Carmen, fiery, sexy, and with a gesture or a nuance to motivate every note. Her voice, rich as ever, was beautifully controlled."[157] That was the opposite of the imagery Lehmann had conjured up for her former charge at the time of Bumbry's Salzburg performance in 1966.

As far as Lotte Lehmann was concerned, her relationship with Grace Bumbry was becoming strained to excess; on balance, Bumbry was a disappointment. The young singer herself never saw this difficulty, as her many admiring letters to her former benefactor show. For in almost all the cases on record, Lehmann's criticism went on behind her back; Bumbry was confronted with it only during my research for this book in 2004. To her, this came as a shock, the more so since some of it was based on manufactured or nonexisting evidence.[158]

Three examples will suffice to prove the latter. In July 1964, Lehmann was aghast to find that Bumbry, during rehearsals for *Macbeth* in Salzburg, had told Fischer-Dieskau, whom she herself admired, "what to do in one scene. He answered her that he is 20 years on the stage and nobody has ever dared to tell him." According to Lehmann's letter, this time Andreas Jaeckel served as a mediator between the two. Asked about this in 2006, Fischer-Dieskau could not remember the incident. And neither could Jaeckel or Bumbry, who said about Lehmann: "I think she believed gossip or even fabricated it herself."[159]

On another occasion, Lehmann wrote Holden that she had passed through Lugano and taken a look at Bumbry's house: "forlorn looking, without care, and without a flower." Bumbry commented in 2004: It is possible that Lehmann took the trouble to visit her Lugano villa on one of her rare trips through Switzerland. But she could not possibly have been in the area where the flowers were, namely, at the front, which, fenced off and guarded by a dog, was inaccessible. And why would she visit Bumbry's house surreptitiously when the singer was not there?[160] What this suggests is that Lehmann was putting down Bumbry's house with manufactured evidence, as a means to disparage her protégé.

The last example provides a clue to why Lehmann would fantasize like that, cutting as it does to the core of her problems with Bumbry. According

to Lehmann, during the 1964 Salzburg Festival rehearsals, Regisseur Oscar Fritz Schuh had had a fight with Bumbry, during which he told her to lean against something lazily, like an animal, as only Negroes knew how to do. At this, Lehmann expressed great outrage. But a day later, after Schuh allegedly apologized to Bumbry with flowers in his hands, Lehmann thought that while this was good for the rehearsals, it was bad for Bumbry personally: "it helps her on the way to be a very unpleasant Primadonna [sic]. I am sorry, but she is terribly arrogant."[161] Apart from the fact that Lehmann should have been pleased at Schuh's contrition, rather than blaming Bumbry for arrogance, the singer told me in 2004 that this incident never happened in the way Lotte Lehmann said. Rather, Schuh had deplored Bumbry's star attitude (*Starallüren*) after her complaint that she had had to wait from morning until afternoon on a Saturday, legally not a working day, for her role rehearsal and was preparing to depart by 4 P.M. It was Lehmann who had introduced a racist element into the plot, and she clearly expected Bumbry to apologize to Schuh, for whatever she had done or had not done.[162]

When Lehmann commented on Schuh's disagreement with Bumbry in July 1964 by saying that "here starts the fight against negroes," she knew subconsciously that for her, that fight had already begun. When sixteen months later she wrote to Mia Hecht that she regretted her friend's prejudice against Bumbry because she was a "negress," she was really addressing that letter to herself.[163] Like many of her contemporaries in Europe and pre-desegragation America, Lehmann was ruled by racial prejudices.

As a youth, she had been socialized in an empire whose heads had begun to acquire colonies in Africa only a few years before she was born. Karl Lehmann developed racialist views of African natives in the same way that he had developed them about Jews, and he freely shared them with the members of his family, as his letters to his son Fritz in the 1940s make crystal clear. Condescension reigned over what were described in the press and travel literature as inferior but, to a degree, educable human beings. Suspicion was harbored against foreign tribes with dark skin and kinky hair, signifying evil, an imagery that was publicized in conjunction with heathendom, primitive weapons, and cannibalism. Hostility was fueled by easily accessible reports telling of individual killings of German colonials in Africa, or of wholesale insurrection, as by the Wahehe tribe in East Africa in 1891. In Perleberg's *Kreisblatt für die Westprignitz*, relevant stories were routinely printed.

Backed by pseudoscience, pan-germanic ideology and missionary zeal made the German aims in Africa widely public and disseminated them in the nation's schools. Colonialists held that Negroes were lazy and greedy, unreliable and mendacious. They allegedly possessed a superficiality of mind, and although they had practical intelligence, compared to a German they could only be called stupid. For their cultural comprehension was not even remotely on a par with that of white people, particularly Germans, who had inbred *Kultur*, deriving from a Dürer, a Goethe, or a Beethoven. When they dressed in Western clothes to adapt to the masters' ways, they were derided as *Hosen-Nigger*, or "trouser niggers," because pants looked ridiculous on them, as they were supposed to be either naked or scantily covered by palm leaves. They were heathens beholden

to sorcerers. They were prone to vanity and hence easily satisfied with cheap trinkets, such as mass manufactured pearls. Especially because they were susceptible to alcoholism, it was difficult for them to control an innately vicious temper. Under the German colonials' stern guidance, however, a Negro could work reasonably well, even develop a sense of fealty to his master. Hence, in order to function properly, a Negro always needed a strong German overlord.[164] Erotically, Negro men could show great prowess, and Negro women could be temptresses. Those women constituted a constant danger to German men in the colonies who had left their wives behind.[165]

Anthropologically, Negroes were likened to animals, and whatever skills they had were classified as motile and compared to those of monkeys swinging from tree to tree. Such skills were not to be compared to art. Moreover, Negroes could never reach the maturity of German adults, even after formal education; they resembled children and as such were in constant need of guidance and protection. They could be cuddly, cute and lovable, and redolent of innocence, which, however, could lead to mischief unless monitored. Their inbred irresponsibility always called for the German masters to take charge.[166]

In May 1896, the Colonial Office shipped African natives to Berlin's Treptow Park for a public showing – a sensational success. Over two million Germans from Berlin and surroundings streamed to the park to enjoy this spectacle. Several hundred Negroes from the four German African colonies had been brought over to be gawked at in their native garb, replete with indigenous musical instruments and weapons, and conducting war dances and chants. Their native huts had been reconstructed, and they were shown in the context of stuffed wild beasts. In 1906 in Berlin, black Abessynians (not German-ruled) were on display. The Hagenbeck Zoo in Hamburg enlarged on this concept when it featured members of the Kikuyu and Massai tribes in a setting of live animals in 1910–11, only one in a series of what in all of imperial Germany soon became popularly known as *Völkerschauen* (ethnic exhibitions).[167]

When Lotte Lehmann was growing up in Perleberg in the 1890s, she absorbed a lot about this not only from her father, but also through osmosis in a pronouncedly Prussian small town, as well as from what she learned in school. Teachers of geography and history in the Second Empire were taking care to indoctrinate the children patriotically, and current colonial history was emphasized in that context.[168] Since the Treptow Park display was one of the Berlin sensations of the year, it is virtually certain that father Lehmann took his family to see it. Moreover, it is possible that Lotte saw acts by African-Americans on the stage of Hotel Deutscher Kaiser. Be this as it may, the impressionable child was fascinated with Negroes even in Perleberg. On her daily walk to school, which took her past a doll shop, Lotte was impressed by the shop's Negro dolls, and this explains why in all her doll collections, Negroes were her "preferred darlings."[169]

Once Lotte had moved to Berlin in 1902, she may have been influenced further by museums and subsequent *Völkerschauen*. Later in Hamburg, two separate phenomena could have impacted her. One was the establishment of the German Colonial Institute in 1908, which then exerted a considerable influence on the entire Hamburg public, from which the young singer could hardly

have escaped. In fact, Hamburg, spurred by its massive commerce, became the national interface for all things colonial.[170] The other was the afore-mentioned Hagenbeck *Völkerschau*, placing East African tribes on display just as she arrived in the Hanse town, where they were exhibited for months, easily visited during idle weekends.

Lehmann's interest in African-rooted peoples was rekindled during her first tour to the United States in 1930, in two ways. Early on, she met the black porters on long-distance trains. They all looked "as if they had just risen from a bubble bath. Black, curly hair covers their darkly shining skin like a jolly woollen cap." This imagery conformed to the colonial stereotype of the good, clean Negro, but also suggested the derision accorded to a *Hosen-Nigger* when he tried to dress like a white man. Those Negroes were all model servants, always ready to help white people, and "exactly drilled" in the execution of their prescribed functions: "In the dining car every movement happens mechanically like a well-working machine."[171] Was this not how Negroes in the German colonial service were supposed to behave?

After her 1930 tour, Lehmann saw equally servile Negroes in the house of her wealthy friend Mia Hecht in the posh suburb of Atlanta. She took photographs. Poetically gifted, she then decided to call them all *Mohrchen*, or "blackies," probably because they reminded her of the adorable Negro dolls she had once played with. *Mohrchen* were expected to behave well at all times, and it took Lehmann some time to be convinced by Mia, a fierce segregationist, that beyond their exotic allure, Negroes could also be a liability.[172]

Lehmann's next conscious encounter with blacks occurred in early 1934, when she concertized in Cuba. There Lehmann, in ignorance of that country, detected "Negroes and Cubans." Her heart went out to a picturesque small boy, dressed in shreds. It was not his poverty that moved her, it was his picture-book beauty, as he was dancing the rumba and asking her for money. "Little robbers," he and his friends were lovable with their "large black eyes, the wild, shiny hair." Then she saw the "incredibly wretched Negro huts." And while she could discern a level of poverty, she concluded that compassion was not called for here, because "they do not desire more from life, they eat sugarcane, fruits which actually grow into their mouths, fishes that are laughably cheap – and they are immeasurably slothful. They laze about in the sun until they get hungry, and then they work only for the few cents needed for fish and bread – God help them if they work too much!"[173] On the other hand, there was no denying that Negro babies especially were "enchanting."[174]

After 1937 and with residence in the United States, Lehmann's romanticizing view of ethnic realities was modified. Like many Americans, especially from the South, she adopted a more hardened attitude toward colored persons on the railway, as she was traversing the continent. Soon she and Holden had their own African-American domestics, in whom she could substantiate what were racialist clichés from the German colonial as well as the more recent American past. Two worlds of prejudice converged. It was clear that for her, even if they were agreeable and pleasant to look at, Negro porters, maids, and chauffeurs were on a lower existential plane and that as much as they strived to be like white people, they would never reach them. This accorded with her own experience

auf, with a Negro as its hero and performed in Vienna in 1928, had been as trashy as it was modern, and where George Gershwin's *Porgy and Bess* – not to mention jazz – was a cheap form of entertainment, unfit for a comparison to German high culture.

The matter of color per se confounded the singer's residual coloniality. When she was teaching Anne Brown, Lehmann found her "absolutely white. I don't see a trace of Negro in her." This she thought strange, for she knew from Fritz that Brown's daughter Paola was "quite raven-black." Had someone defied the rules?[175]

Mia Hecht had played a decisive role in cluing Lehmann into the system of racial segregation that pervaded American society well into the 1960s. The second influence on her was Fritz, who never failed to indoctrinate his sister with his own, almost pornogaphic, brand of Social Darwinism, with Jews and Negroes as the main principals. Once Fritz related to Lotte the story about a visit in New York from Mia Hecht. Mia had said people always exaggerated; the Southerners would not treat the Negroes badly, for this would amount to non-sense. After all, the Southerners also "treated their dogs, pigs and cows decently, because they are useful."[176] Lotte, who loved to disagree with Fritz when she had a chance, did not find fault with that statement. Over time, she received many doses of her brother's racism, which appears to have bolstered her own, however sublimated it may have been. Fritz's always engaged in variations on the same theme, centering mostly on their shared black student, Brown, and her Jewish manager, Albert Morini. Implying that Morini was having a perma-nent affair with Brown, although the soprano was really trying to seduce him, Fritz described her varyingly as lazy, lecherous, devious, stupid, and beholden to voodoo sorcery. Analogies from the animal world he applied to her included monkeys, pigs, snakes, and sex-crazed rabbits. Fritz found what he perceived as a (sexual) combination of this Negress with a Jew particularly repulsive, although he averred that she was still so primitive as to barely know how to use cutlery. Her primitive state also would forever make it impossible for her to understand higher notions of culture, such as German Romanticism, as in Schubert, Schumann, and Brahms.[177] If they had not already been there, Fritz was planting more seeds into Lotte's impressionable imagination, which were certain to bear fruit in her deteriorating relationship with Bumbry.

Hence there was a long if sometimes invisible red thread running from the point where little Lotte Lehmann kissed those black dolls in that Perleberg toy shop in the 1890s to the point in the 1960s when she realized that she had edu-cated a black singer now maturing on her own, who could speak four European languages fluently, whereas she could speak only two, and who was able to sing Schumann's *Frauenliebe und -Leben*, the essence of German *Innigkeit*, at that time better than a white soprano. It was an extension of herself Lehmann had not wished for in this way.

At Dusk

In the mid-1950s Lotte Lehmann became, once again, interested in visiting the Old World she had left almost twenty years before. Reasons that had prevented

under no pressure to perform; living and traveling conditions had improved; and the shadows of her own past involving Göring and the Third Reich were not as likely to haunt her as they might have earlier. She was also much less busy at home in California and unburdened by a heavy continental touring schedule, with her Academy teaching keeping her occupied only in the summers and other appointments flexible.

Interestingly enough, apart from other European venues such as Paris and Rome, she decided to return to Vienna, the site of her greatest triumphs, and not to Hamburg or Berlin, where she might expect complications. And she might not even have gone back to Vienna had the occasion not presented itself, on account of the reopening of the Vienna Oper after its demise in World War II, planned for November 5, 1955. It helped that Bruno Walter was also going to be there and presumably would share the box with her. The administrative supervisor of the Opera at the time, Ernst Marboe, was an old fan of the soprano, and he invited her more than a year ahead of time. Lehmann reserved a couple of seats for herself, but she was of course expecting not to have to pay. The program would include *Aida*, *Don Giovanni*, and *Der Rosenkavalier*, but also *Die Frau ohne Schatten*, *Die Meistersinger*, and *Fidelio*, operas therefore, which she knew well from personal experience. But they would also be presenting Alban Berg's *Wozzeck* and Boris Blacher's ballet *Der Mohr von Venedig*, modern works she would care less about. The native Austrian Karl Böhm, whom she did not know yet, would conduct.[178]

Before Lehmann traveled to Vienna, via Paris and up through Italy by car, she was curious to see how the Austrian capital had held up during and after the war, and she wanted to find out how some of her old colleagues at the Opera had fared, such as her old friend Alfred Muzzarelli ("Muzzi") and Maria Olszewska, who was rumored still to be there. She also wondered about her old maids and the clutch of formerly young women who had followed her around, such as Hertha Stodolowsky and Hella Müller, to both of whom she had sent care packages. When she got there, she was flattered by all the attention – no one seemed to have forgotten her. In fact, when for the opening ceremonies on November 5 she made sure to enter the auditorium last, the entire audience quietly rose. The presentation that evening was *Fidelio*. Of course, she was not alone; Walter had indeed arrived, and she was joined in the auditorium by her old partner Alfred Piccaver, now a sick man, Hilde Konetzni, Maria Nemeth, and Hans Duhan. There were 250 journalists covering the event, from 27 different countries.[179]

But after her return to California, although she professed to have enjoyed Vienna and really had met with old acquaintances and friends, in truth she had been disappointed. She had found the place what she called "provincial" and its people overly obsequious, in the customary overstated Habsburg way, and while she had been able to live with that then, now it was getting on her nerves. She had become too used to American forthrightness and felt that her new friends in California were more sympathetic to her needs, without the false Baroque of Viennese theatrics.[180]

Nonetheless, Lehmann's visit to Vienna had an additional, positive side. She was able to use her extremely friendly relations with Marboe in order to

pursue her pension claim with the Vienna Opera, which had rested since about the beginning of the war. As far as she could tell, she had never received any of her pension money since formally resigning from the Opera in 1938, although she had been legally entitled to it. When she had tried to broach the matter two years after the war's end, she had gotten nowhere.[181] Of course, she had to be careful, for if the officials dug deeply enough, details of her dealings with Göring could be revealed and her carefully constructed legend exposed. But as long as she stuck to the main points of that legend, insisting that as a victim of the Third Reich she had been blacklisted, she could hope that administrators in Vienna would not probe too carefully and go along with her story, with which they themselves could easily identify. After all, in the years following 1945 the great majority of Austrians, to calm their collective conscience, "thought of their country as Hitler's victim rather than his accomplice."[182]

Already by the early 1950s the Austrian government had come around to an interpretation more favorable to Lehmann by claiming that, presuming her victim status was proved (which this government was happy not to doubt), she could enjoy her pension, albeit not retroactively, on condition that she renounce her American citizenship and return to live in Austria as a repatriated Austrian.[183] By the summer of 1955 Lehmann, knowing Marboe to be firmly on her side, was reemphasizing her status as "always a great friend of Schuschnigg" and as an "enemy of the Nazis," and her near-fatal destiny as a concentration camp inmate.[184] After her glorious reception at the Vienna Opera in November of that year, the Austrian government had no choice but to relent completely and agree to granting the soprano her pension even while she continued living in the United States as an American citizen. The matter was treated as a prominent exception to the rules and took a few years to be sorted out, by an Austrian bureaucracy that had never been famous for speed and efficiency in the first place.[185] Nonetheless, by early 1957 Lehmann was successful in being granted a regular monthly gross pension, by order of the Austrian chancellor personally, of over 67,000 schillings annually, which worked out to a monthly net amount of $170.[186] Comfortably enough off in California, henceforth Lehmann decided to leave that money in Austria and use it only on subsequent European visits.[187]

As her 1955 Vienna reception had demonstrated, Lehmann had reason enough to consider herself fortunate in the postwar era, especially if compared to most other former Staatsoper colleagues. The four-years-younger Maria Olszewska, for instance, so Lehmann was hearing, although she had invested lavishly in real estate, had become a mentally unstable alcoholic and was living, alone, in a retired singers' home in Baden near Vienna.[188] Maria Jeritza had tried a Vienna Opera comeback in 1950 and persisted in other opera houses there-after – typical Jeritza affairs that were now more pathetic than art-inspired and that impressed only her most diehard fans.[189] She missed the 1955 gala event, ostensibly because she was denied a free ticket for her American husband – a Newark umbrella manufacturer – but everybody knew that she knew Lehmann would occupy a prominent space at the festival.[190]

After her great honor and finally having had her Austrian pension granted, Lehmann decided to return to Austria on a more regular basis, not least for health reasons, for she could lodge at a famous spa in Badgastein, not far

from Salzburg, where during summers she could also take in the festival, if she liked. This became more important to her as her mature students, especially Bumbry, were establishing bases all around. And so she would visit Badgastein's Kaiserhof, a venerable institution with its own warm water cure, every spring to summer, starting in 1958. It was close enough to the old centers of culture for receiving fans who wished to visit; at the same time, she could withdraw to her hotel suite if she wanted to be left alone. Those two extremes had always resided in Lotte Lehmann.[191]

That meant establishing a more permanent presence for the Austrian culture brokers, who were flattered by Lehmann's renewed attention to their country, with the result that they continued to return flattery of their own. Hence in 1962 she received the Austrian Honor Cross First Class in Vienna, and one year later the Honor Ring of the Opera.[192] In 1964, Lehmann also taught a special master class at the Opera, but she sounded offended when this could not be extended into 1965.[193] Indeed, she thought that she now had earned the right to honors of all kinds, and by 1967 she desperately wanted a street in Salzburg or Vienna to be named after her.[194]

As comfortable as she was beginning to feel around Vienna again, Lehmann was having considerable difficulty readjusting to the rest of Europe. Even on her way to Vienna in the fall of 1955 she had experienced problems, which had as much to do with her failure to be instantly recognized as the diva of old as with her inability to empathize with the kind of Europe she was now encountering. She was dumbstruck while walking in the streets of Paris that no one would pay attention to her, even though she was wearing the rosette of the French Legion of Honor in her lapel. Later, as she was being driven up to Vienna from Rome in a chauffeured car, she hated the noisy traffic, got annoyed by the narrow, dirty roads, and was not at all amused by the naked statues she encountered in Florence. Venice to her was a stinking bowl, and she was glad to have left Italy behind, as she had never particularly liked it.[195]

A year later she finally dared to return to Germany, but not for long. She was briefly in Hamburg, only to discover how badly the Stadttheater had been bombed, and then traveled to Westerland, which she found "terrible," with Fritz's old house totally neglected. But London, where she had celebrated many triumphs, she thought most congenial – not least because there she was fêted as in the olden days. "*I am quite unforgotten!* The people were simply wonderful to me, there were parties in my honor and I saw a lot of old friends." She made a recitation record for Caedmon (monologs of the Marschallin, texts by Goethe and Mörike), was interviewed for the BBC, and got into discussions about holding master classes.[196]

Those classes became a reality in the following autumn, and they were held at Wigmore Hall in London, with Ivor Newton accompanying her on the piano. Much as she had on the stage of the Music Academy, she enacted scenes from *Der Rosenkavalier*, *Fidelio*, or *Eugen Onegin*, coaching her students in her typically all-engrossing manner. Everybody was spellbound. "She was immediately note-perfect and word-perfect to provide any necessary illustration or to help any singer in any part. She knew, and could throatily but expressively sing Don José's 'Flower Song', and had learned the part of Ortrud in *Lohengrin* by

singing that of Elsa. This was by no means all her repertory. Never once did I see her consult a score," marveled Newton.[197] The effect of this success was not lost on Frances, who over the years had had to endure Lotte's ever-changing moods. "She returned from England in a triumphant state with the age complex a thing of the past and is all set to spend the next ten years touring the globe," Frances mused. "At the moment she is in such a volcanic state that anything might happen."[198]

The Wigmore Hall classes were repeated in the spring of 1959, when Lehmann was accompanied by Bumbry, and apart from visiting Vienna once more, she also took her fledgling to Bayreuth. But, as previously, she did not like Germany or the Germans; she found them gathered together in thick clusters and perspiring, so that they made her ill.[199] The last Wigmore Hall master classes occurred in the spring of 1964, again with Ivor Newton.[200] A year later she ventured to Berlin and Munich, but enjoyed not a minute of it; her base was always Badgastein.[201] Then, in 1969, she entertained plans to travel to East German Perleberg, to meet old school friends and surviving members of the dispossessed Putlitz clan. But she strung the Putlitz family along until she got cold feet, for fear that her presence in East Germany could be used for communist propaganda. In canceling her visit, she dissembled, pretending that she had scheduling problems when there really were none.[202] For the balance of her life, Lehmann continued to take the waters at Badgastein, with the occasional trip to London or Zurich and one excruciating cruise to the Norwegian fjords, which some of her younger admirers had talked her into.[203]

Back in the United States, Lehmann's professional relations were mainly confined to people she knew, but they also included a certain revival of her business dealings with the Metropolitan Opera. This revival had its origins in her former Met signature role as Marschallin; her newly earned legacy as the grand old lady of German song after her famous farewell concert at Town Hall in February 1951; and finally, her much-publicized activities at the Music Academy of the West. Largely because of her stature there, the Met had begun admitting officially registered Academy students to its regional auditions program by 1957, with students being brought to New York, and it was at the 1958 tryout that Bumbry won. In 1950, Rudolf Bing from Glyndebourne had succeeded Edward Johnson as general manager of the Met, and as fond as Johnson had always been of Lehmann personally, the coldly calculating Bing was certain that she was still a power to be reckoned with.[204] For publicity reasons of her own, Constance Hope coaxed Bing into offering Lehmann the directorship of a replay of *Der Rosenkavalier* – a production that had already once been visited by the diva, in March 1958, at which time Bing had fully capitalized on her presence in the auditorium.[205] The publicity-savvy Hope suggested Lehmann as director for November 1962, a month when the diva would be almost seventy-five years old. Bing was hesitant at first, because he had his own full-time director – scenery and costumes were set, and so were the artists; but then he approached Lehmann with the plan, thinking of the potential rewards for all concerned.[206]

Lehmann at first played hard to get, although she had staged the opera at the Lobero Theater a few years earlier and naturally knew all the roles forwards and backwards. She was not too happy with the less-than-generous honorarium

being offered and also did not know how the main singers of the core group – Marschallin, Octavian, and Sophie – would react to instructions from a retired colleague. As it turned out, those would be the French, Austrian, and German artists Régine Crespin, Hertha Töpper, and Anneliese Rothenberger, all three of whom signaled approval. After Germaine Lubin, Adolf Hitler's favorite soprano, Crespin, who was born in 1927, was the first French singer "to command the heroic roles of German and French opera with equal authority."[207] This was to be Crespin's Metropolitan début. Because of the centrality of her role, which Lehmann had made her own, the Met officials feared that she might resent the German prima donna's direction, but quite on the contrary – Crespin seemed flattered. Rothenberger was a sweet-voiced soprano who was then singing regularly at the opera houses of Munich and Vienna, Töpper a mezzo from Graz permanently based in Munich. Crespin's favorable reaction and the persuasive powers of John Gutman, Bing's assistant manager, finally motivated Lehmann to accept, for "money is not everything in life."[208]

However, Lehmann was not yet through manipulating people. The contract was signed on March 16, 1962, and she told Bing that she wanted to cancel it in August. The reason she cited was fear of a nervous breakdown, and indeed, one may give her the benefit of the doubt. For this was one of those periods in her life when she was professionally very insecure, as she had just resigned her position with the Academy and had seen Bumbry off to Europe with – for her – an entirely uncertain outcome. Also, Bruno Walter had died in February, and she felt lost without this mentor. Moreover, she had read in a recent book that although many connoisseurs of opera loved her as Marschallin, several now preferred Crespin.[209] On the other hand, she was professional enough to know that once a contract was signed, it was a near-impossibility to break it, unless one was in mortal peril. Whatever the case – it is likely that she wanted more pampering, from Bing and also from Gutman, and possibly also more money. In the event, she received the pampering, while her fee remained unchanged.

The festive staging of November 19 went well, with Lorin Maazel conducting. While Crespin and Rothenberger presented no problems during rehearsals with Lehmann, and this showed to advantage in the final performance, Töpper's Octavian was not boylike enough for her, as Töpper had resisted her advice.[210] Lehmann's feelings in the end were mixed. The work had exhausted her, and all of the ovation, she was sure, had been meant for Lotte Lehmann the once-celebrated soprano, not the new director. While the former realization was heartwarming, there was a final note of disapproval in the air, of her as a stage regisseur, and that she found disconcerting. Now a pensioned-off prima donna, she had failed in film and had not quite succeeded as a teacher. The directorship had not been incompetent but was forgettable. The sum total proved that she was truly getting old.[211]

An additional factor contributing to Lehmann's unhappiness during that Metropolitan exploit was that she was confronted with Jeritza again. This was certainly not of her own choosing, but the brainchild of Gutman, who garnered even more promotion for the Met by broadcasting the interview he conducted, between *Rosenkavalier* rehearsals, with both Jeritza and Lehmann. It may have provided glee to the glitzy prima donna of yore, who appeared with a large

hat and dark glasses, but caused only agony to Lehmann. Gutman's innocent-sounding questions about the divas' mutual past were devious, making sparks fly as intended, under the guise of affection. The nadir in the exchange was reached when Lehmann referred to her beginnings in Vienna and her historic break, being allowed to perform the Composer in *Ariadne auf Naxos* in 1916. Jeritza interrupted and chimed: "You forget the main thing: It was I who told Strauss he should give you the role," whereupon Lehmann acidly retorted: "I am glad that I can thank you now after all these years." At the end, Jeritza ridiculed Lehmann's artistic efforts by declaring that she loved her paintings, but that Lehmann had never sent her one. Lehmann's tempestuous reply: "Oh, you love them ahead, without knowing them. Thank you." And so it went. After Lehmann had returned to her hotel, she broke into tears, wondering how it was possible "that after four decades she is the same beast she always was." Years later, while in a London hotel, she came across a picture of her rival in a book and spat at it. Lehmann never got over Jeritza; she felt "deep resentment, fear and envy" in her heart and, for this, so she said, she was disgusted with herself.[212]

The Metropolitan may have partially compensated her for that agony when in April 1966 Bing invited Lehmann to join other celebrities in saying goodbye to the Old Met, as the Opera was about to move. Marian Anderson was there and Lili Pons; Gladys Swarthout came from Florence; and Elisabeth Rethberg and Risë Stevens showed themselves. As Lehmann's luck would have it, Jeritza could not appear, and neither could the equally illustrious Geraldine Farrar – both might have stolen her thunder. So this became very much an event like the one in Vienna, with everybody rising as Lehmann entered the auditorium last.[213] Bing had been especially courteous in inviting and then thanking her; Lehmann later claimed that she liked this haughty man who was unpopular with so many opera stars.[214] But it is doubtful that she meant it.[215]

In the last two decades or so of her life, Lotte Lehmann was surrounded by an inner and an outer circle of friends, whose members were few but who remained loyal to the soprano until the end, as did she – for the most part. The inner circle included Frances, Fritz, and perhaps Mia Hecht and Viola Douglas, whereas the outer circle was represented by four or five people, whom she had known over a long period of time and who were, in most cases, connected to something she was doing, or had done, professionally. They were Bruno Walter, Otto Klemperer, Lauritz Melchior, Erika Mann, and one or two members of the Putlitz family.

Relations with Walter had sometimes been strained, as long as she was working as a lieder singer, with him as her accompanist. She resented his urge to be as much, if not more, in the limelight as she, but could not escape the reality that he had been one of her foremost masters. As the musical aspect receded after she had stopped singing in 1951, that relationship stabilized somewhat, especially since she continued to see in the twelve-years-older man the father figure he had always been for her. She herself would have liked to tie him more to the Academy after 1951, something he resisted – just as she would have liked him to assume the directorship of the Vienna Opera in 1929, for in both

instances her own position would have been strenghtened. But he remained her adviser in almost anything, including music, even though he continued to give himself a precious air and was often grandiose. Apart from Lehmann's musical genius, Walter admired her unconventional attitudes, her honesty, naturalness, and forthrightness. Frequently he thought her too naïve and impulsive, deficiencies she was the first to acknowledge. She, on the other hand, marveled at the great conductor and historic friend of Mahler (although as a composer Mahler never meant anything to her); he exuded a protective atmosphere and was, of course, wealthily established in the center of Beverly Hills.[216]

In the 1950s and early 1960s, Walter proved his wisdom to Lehmann in a number of important situations. In 1955, as she was beginning her quest for a restoration of her Austrian pension, he served her well as a character witness for the Austrian authorities. Because Walter was innocent of any knowledge regarding Lehmann's compromising dealings with Göring, he was able to write to State Counselor Marboe that Lehmann "could never have been a Nazi."[217] Lehmann could not have been better served.

By 1957 Walter was fully retired from his duties, devoting himself exclusively to his old lover Delia Reinhardt, who had joined him in Beverly Hills (thereby replacing Erika Mann), and the anthroposophic philosophy of Rudolf Steiner that Reinhardt had converted him to. Lehmann, who had never given much thought to spiritual things, in old age became interested in the value of an afterlife and reincarnation. She was trying to read books such as those by Paul Brunton, who concerned himself with East Indian meditation, yoga, gurus, and that entire mystical culture. The soprano found it difficult to comprehend reincarnation, but if there was an afterlife, she wanted to make sure to be reborn as an actress. She asked Walter about Steiner and how his anthroposophic cult dealt with reincarnation. A small introduction would do. Walter ponderously lectured her that Steiner's were not concepts one could learn by way of a crash course and urged her to engage in deeper study. Death was a serious matter, and one should carefully cleanse one's soul as long as there was time.

Lehmann, revisited, as she periodically was, by her old guilt feelings regarding her elopement with Krause, the resulting abandonment of his children, whatever other affairs she had been having, and jealousies toward Jeritza and more recent singers, explained her spiritual needs to Walter. But the conductor was neither psychiatrist nor priest, and he was getting at least as tired from old age as Lehmann herself was becoming. In November 1961, Lehmann confessed to him that she had tried to understand Steiner, but short of intensive study could not manage. She had made no progress in her search for "eternal truth."[218] Walter was sympathetic, but could not help her. He died three months later, and all that remained for his dedicated disciple Lotte to do was to eulogize him publicly as "a great teacher, a noble man, a beloved friend."[219]

Lehmann's relationship with Klemperer was much less complicated. She had played with his lust for young girls when they were both in Hamburg; obviously she had been hurt after he had chosen Elisabeth Schumann over her. But as they met time and again, they remained good friends, and neither Klemperer's manic depression nor his sexual insatiability affected her.

After World War II, Klemperer lived most of his life in Europe, because he hated America. Although in that respect he was the opposite of Lehmann, the two made every effort to see each other in Europe, whenever that was possible – mostly in London, when he was conducting there and she gave master classes, or in Switzerland, where he resided. She could abide his sarcasm, which in its poignancy was much more brilliant than her brother's, and she delighted in his erotic allusions, which, for her, were always in good taste.[220] As time passed by, they had in common the gradual deterioration of their limbs and were able to joke about it, to the point that Klemperer recommended to Lehmann an electric wheelchair, almost as if she could see the world with it. Klemperer kidded Lehmann about the vast amount of world literature he, as the polymath that he was, had read and that she knew nothing about – she took it cheerily. He also joked about her lack of interest in symphonies, some of which he still conducted expertly.[221] After he had had a stroke in 1972, Lehmann visited him in Zurich – a journey that, from Badgastein, was always a chore, but it gave her joy. "Klemperer was rather touchingly happy to see me again," she exulted to Frances, "he looks almost beautiful inspite of his distortion. But almost only spiritual – and he has lost his cynic behavior."[222] In February 1973, Lehmann wrote him a detailed letter decrying the modernism on opera stages that she had deplored for years – knowing well that earlier in his career he had been one of the pioneers of modern styles. A few months later, he lay in a coma; he passed away on July 7 in Zurich. "The last one of the great!" Lehmann observed correctly, "with him dies an era."[223]

If there was always a humorous element in the friendship between these two artists, Lehmann's relationship with Lauritz Melchior, until his death, rather resembled a plot from one of the Hollywood comedies he liked to star in later in life. He, his wife, Kleinchen, and Lotte got along well enough, especially after Bing had decided not to renew his contract at the Met in 1950 because of his Hollywood capers. The fact that her large colleague had traded fame at the Metropolitan for commercial success in Tinseltown Lehmann registered not without schadenfreude, because, as she wrote hypocritically in 1952, "what good does it to make so very much money nowadays?"[224] When in early 1964 Kleinchen died unexpectedly, Lehmann was sure that there was now one fewer person in the world to spread gossip about her, but neither could she continue spreading gossip about Kleinchen. In any event, she waited weeks until she sent Lauritz her condolences, writing, with zero power of conviction, that she felt Kleinchen's absence "very deeply."[225] Not even a year later, she feigned outrage that Melchior was planning to remarry, calling him an "old fool" and "a tactless, heartless ass."[226] Had she expected him to marry her? She thought it a scandal that five hundred guests attended the televised wedding with his secretary, Mary Markham, and, salaciously, that she would now sleep "in the same bed where he slept with Kleinchen and where she died."[227]

Melchior himself never neglected a chance to mention "my dear Lotte," publicly or privately, but he could still arouse Lehmann's envy, as he did when he received the CBE from the Queen of England and could have called himself "Sir

Lauritz," had he become a British citizen. The fact that this manic collector of medals – he had ninety-two, noted Lehmann in disbelief in 1968 – did so anyway infuriated the soprano, who herself was not a "Dame," like her Santa Barbara friend, the Australian actress Judith Anderson.[228] During the preparations for Lehmann's eightieth birthday at the Academy, Melchior gracefully accepted membership on the honorary committee and agreed to say a few words at the celebratory dinner. But he contributed only fifty dollars to the new Lotte Lehmann Chair – a paltry amount for such a millionaire, in an act that was sure to slight Lehmann.[229] After the dinner on February 27, 1968, as the cavalcade of cars was making its way to Santa Barbara's Granada Theater for the concert by the Los Angeles Philharmonic, Melchior made certain his chauffeur lost his way, so that the heldentenor could end up at a friend's house, watching television with the children.[230] Lehmann thought she had the last laugh on Melchior when after his death from a liver tumor in March 1973 she purposely missed the Los Angeles funeral, sending a large bouquet instead and promising "a private service in listening to the first act of *Walküre.*" Yet when Melchior's will was read, it was found that all his friends-in-mourning would get nothing for free, but were allowed to buy things from his giant "Viking" hearth instead. Lehmann, who herself did not spend a cent, was incensed that Holden stooped to purchase items.[231]

Lehmann's friendship with Erika Mann dated from earlier New York and California days and was always based on a mutual emotional empathy as well as a love for each other's arts and letters. Moreover, for decades Mann had owned many of Lehmann's records, even though the two never seem to have made music their subject of conversation. Erika's adoration of her father, "The Magician," was respected by her singer friend; but after the early 1940s, Lehmann herself had not continued to see Thomas Mann. After Klaus Mann committed suicide in 1949, the family settled near Zurich in the early 1950s.

Like Klaus, Erika had been abusing drugs and alcohol forever; a chain smoker, she was in fragile health after her return to Europe. After her father's death in 1955, she lost her raison d'être, for her principal calling since the war's end had been as his public relations manager and editor. While the editing continued furiously, she found herself in ever-deteriorating health until she succumbed to a bone disorder by 1964. In early 1965 she was a patient in a Zurich *Kanton* hospital, with that disease, which could never be reliably diagnosed. Fairly regular visitors were Klemperer's daughter and Walter's daughter, both named Lotte, but Lotte Lehmann found it difficult, because of her own unremitting maladies, to visit from Badgastein.[232]

Erika Mann struggled on, against her failing health and attempting to finish editing her father's works. She read Lehmann's new manuscript, "Of Heaven, Hell and Hollywood," recognized various concealed characters in it, among them her own father, and on the whole found it charming. At one point she made detailed suggestions for improvement. It was obvious that Lehmann hoped her friend would find her a publisher, but on that score Mann had to disappoint. In the spring of 1969 she was operated on in a Zurich clinic for a tumor. Until she lost consciousness, a companion was reading to her from Lotte's script. Lotte, seventeen years older, was scared of this prolonged death and in

June wrote from Badgastein to Frances: "Of course I don't go there and only hope that at this time she may be gone." Erika Mann died on August 27. Her mother, Katia Mann, only four years older than Lotte, wrote to Erika's friend that after the death of her two children and her husband, fate had excluded her from "the natural sequence." Even in death, all the Manns were, oh, so eloquent![233]

Lotte Lehmann's other old German friend, Erika zu Putlitz, had never been that close, but nevertheless had remained loyal through the decades and had acted as a liaison with other members of the Putlitz clan. She was the last surviving witness to Lotte's auspicious beginnings as an artist, her progress, climax, and eventual departure from Europe. After the war she resurfaced as the married Erika von der Schulenburg and as an unchanged friend. In the early 1960s, Lehmann had visited Erika in West Germany, and her younger sister, Elisabeth, had come to Santa Barbara. Moreover, Lehmann had met Wolfgang Baron zu Putlitz, the two sisters' cousin, before the war, while he was still in the German diplomatic service; after the war he returned to communist East Germany and tried to get her to visit.[234]

So the connections were manifold and variously strong. In the summer of 1972, Elisabeth's son Bernhard von Barsewisch, a Munich University opthalmologist, was set to visit Lehmann in Santa Barbara; he remembered well the care packages the singer had sent the impoverished family after the war. Lehmann, who was always wary of houseguests, could do nothing but hail any impending visit by a Putlitz, for she owed her career to them. She was also hoping that the good doctor could do something for her failing health. Barsewisch arrived, savoring Hope Ranch and California, enjoying the hospitality of Lehmann and Holden and making notes about that mutually loving if rather peculiar pair with the many animals. The following summer, Barsewisch visited Lehmann with his Aunt Erika in Badgastein. The diva received them with mixed feelings, for, as always, while she did want people to court her, she had to be consistently at the center of things, and now she tired easily. Characteristically, she reported to Holden: "The Putlitzes are strange: the whole world is their family. No interest in anybody else . . . She talks and talks – always about herself and the family. I just listen. And say from time to time, 'yes' or 'no'." But subsequently she assured Barsewisch that the Badgastein days had been "much too short." No matter, in 1974, when Lehmann traveled to Badgastein again, she asked aunt and nephew to keep their visit brief.[235]

Von der Schulenburg, Mann, Melchior, and Klemperer, along with other personages, were asked in 1968 to contribute to a festschrift honoring Lehmann on the occasion of her eightieth birthday. This venture was the idea of Berndt W. Wessling, a thirty-three-year-old journalist with North German Radio in Hamburg, who, as a failed student of the bass-baritone Rudolf Bockelmann, had already published a few musical biographies. Wessling's original idea had been to interview Lehmann and perhaps obtain key letters from her, but the singer felt that she could not tell the salient stories from her life that would make such a book truly interesting; on the other hand, if she left more superficial research solely to Wessling, a true picture of herself would not emerge. The result was a sort of compromise. He would solicit contributions from persons

who had known Lehmann over much of her lifetime; she would selectively tell him a few things; and he would use what for him was already reliably at hand.[236]

From the beginning, the project was fraught with difficulties. One was that in 1968 there were not enough people of stature around who could testify about Lehmann's career and private life, going historically as far back as was sensible; after all, she herself had published an autobiography in 1937. Another was that over testimonials of persons who might contribute Lehmann had to have some kind of quality control, so that facts would be undistorted, the rules of good taste observed, and her name uncompromised. All of this could have been accomplished had Wessling been an older, more experienced biographer, such as a musicologist, who possessed the confidence of his interlocutors. He would also have had to be old enough for Lehmann not to be able to exert any influence on him. But since he was young and impressionable and in total awe of the famous prima donna, Lehmann took it upon herself to direct the entire enterprise. In the end, the book became a homily to Lotte Lehmann, by some famous and several not-so-famous people, inspired, edited, censored, and approved by Lotte Lehmann.

Problems with the most obviously prominent candidates were immediately apparent. Bruno Walter and Thomas Mann were already dead, and while Walter may have written something for his dear Lotte in his uplifting prose, Mann would undoubtedly not have, except perhaps for an acid epithet that would have harmed Lehmann more than it pleased her. In this spirit, the much more benign but still cynical Klemperer wrote ten lines of commendation, which were hardly useful for this book as planned. Melchior, typically, refused outright, save for "a short line" – a smack more than a smile. Maria Olszewska in her seniors' residence was deemed too crazy, and Frida Leider replied that she had already written on Lehmann in her own autobiography (mentioning her in passing, as it were). Even though the Vienna bass-baritone Alfred Jerger was thought to have been too much of a Nazi and therefore was passed by, Lehmann would have welcomed an available letter from the egregiously National Socialist Bockelmann. Fritz Wolff she did not want at all, for if he had ever been her lover, he too was already dead, although Wessling wished his letters included. Her old rival Jeritza was certainly out of the question. So who else was old and famous enough to honor Lotte Lehmann from a lifelong perspective? Lehmann and Erika Mann – she an amused and willing conspirator – thought of Karajan, but he was comparatively young, and the singer had just spread the word that he left her "cold." She thought him too radical and really knew him only through the tales of her student Bumbry, who had been his Carmen.[237]

Erika Mann herself, of course, would contribute, and so would Erika von der Schulenburg, and even the longtime-distant Constance Hope, but who were they in the pantheon of cultural glitterati? Ignoring fame and after-fame, Lehmann micromanaged Mann and Hope, the former because she had falsely written that the soprano was living in her own house, whereas it was really owned by Holden, and Hope because she, for obvious reasons, merely wished to reuse the chapter on Lehmann published in her autobiography, *Publicity Is Broccoli*. It took much effort on Lehmann's part to persuade Hope

to compose something fresh, and their exchange did not exactly improve the already strained relationship.[238]

Lehmann and Wessling could have resorted to the fond memories of conductors such as Erich Leinsdorf and Maurice Abravanel, singers such as Risë Stevens and Lily Pons, and Hollywood types like Bing Crosby and Joe Pasternak, but for unknown reasons they were left alone. And so were all of the *New York Times* critics, and writers such as John Coveney, Claudia Cassidy, and Vincent Sheean, not to mention Met directors Johnson and Bing. Two obvious candidates were Marilyn Horne and Grace Bumbry. But Horne was never approached (perhaps she really *was* upset over an imagined slight at the Music Academy of the West), and Lehmann's feelings toward Bumbry were ambivalent. Perhaps Lehmann once again imagined it when she wrote to Frances in June 1968 that Wessling had been sounding out Bumbry and her husband, only to be told by Jaeckel that an interview with the Black Venus would cost him five hundred dollars. (In 2004, Bumbry denied to me ever having been contacted by Wessling and did not even know his name.)[239] In December, Lehmann told Wessling to stop ringing Bumbry, for the publication of her contribution would probably "depress the niveau."[240] Instead, Wessling and Lehmann were happy to accept the reminiscences of Richard Strauss's son Franz, whom music lovers in Germany barely knew as the man whose own son had married the daughter of bass-baritone Hans Hotter – himself an illustrious name but hardly one who had known Lehmann well.[241] Another famous singer, Fischer-Dieskau, knew Lehmann even less well, whereas Elisabeth Schwarzkopf, who had met and admired the older diva, was never asked. Lehmann wanted Holden to appear in those pages but must have realized that her name would not bear much currency.[242] Embarrassingly, she even asked Lotte Walter, whom nobody knew, whether Wessling had been in touch with her – Lehmann had never liked Walter's other Lotte.[243]

The soprano scrutinized the smallest detail of the manuscript before it went to the Residenz publishing house in Salzburg. Ideally, she had wanted Wessling to introduce the book as "a collection of tributes, which friends dedicated to me"; one of her own poems should take the lead.[244] But Wessling's own introduction was sufficiently fulsome. Proud of what she had accomplished, she began to advertise the project by the end of 1968. It was set to be presented publicly at a special ceremony during the Salzburg Festival of 1969, somewhere between *Der Rosenkavalier* and *Fidelio*, Karl Böhm conducting. She herself would be received by the Austrian president, Franz Jonas.[245]

In the end, the book delighted her. "Wessling has done exactly what I wanted: it is no biography, but encompasses my entire life."[246] The ceremonies in Salzburg had also been very much to her liking. In thanking the Salzburg magistrate, she asked for a long-coveted favor, namely that a local street be named after her. No sooner had this been uttered than it was done. The Lotte Lehmann Promenade was created in the tony neighborhood of Aigen in 1970. Again, Lehmann had successfully enhanced her own legacy, this time with the Göring escapade artfully avoided.[247]

Its Salzburg publisher called the festschrift *Lotte Lehmann: More than Just a Singer*. But it demonstrated hubris on the part of Wessling and Lehmann to have

chosen such a title, for in what sense should Lehmann have been considered more than just a singer, if singing was what she was internationally famous for? Most singers eventually taught, as did she. But was she also an actress, Hollywood producer, or philanthropist? Or was she some other kind of Renaissance Woman? Perhaps Lehmann was thinking of her writing and painting as additional facets of her creativity. Now it is true that she was practicing her writing skills as she corrected Wessling's prose and rehashed some of her earlier autobiographical material to be included in the book. This happened in the context of her various other attempts at writing, poetry and prose, but after 1950 she was not any more, or less, successful with that than she had previously been.

After her historic Town Hall concert of February 1951, she strung together various anecdotes she had composed about her life since 1937 and tried to sell them as the continuation of her first autobiography.[248] Under the working title "Memoirs at Random," they included a draft of the Göring episode, as she had shaped it over time, a piece on her domestic servants, reminiscences about colleagues and conductors, and portraits of friends and aquaintances, a favorite dog, and other incidental topics. This was a strange assortment of stories, most of them much too short and none of them going into any depth, and they were all disjointed. Many were filled with awkward humor and marked by contrived climaxes. Evidently she still thought that because in the world of music hers was a household name, publishers would fall all over themselves wanting to print this collage. However, by April 1951 the manuscript had been returned to her new literary agent by several publishers, and she realized that it needed work.[249]

In January 1962, after her new agent had died, she had to swallow hard when an editor from Simon and Schuster wrote her what she had already been told in 1909 by Perleberg's well-meaning Nanni von Saldern: "Unless one has devoted a lifetime to writing (as you have to singing), it is sometimes difficult to put the final high polish on a book that the reading public seems to demand." By this time Lehmann thought she had lost her ambition to write for good.[250]

But she got to it again, now doing what she did best: technical writing, if not to say analysis. In the early 1960s she put together five chapters on her experience of singing Strauss operas under the composer's direction, on which subject she was one of the few surviving authorities. They were the works she had gone through with the maestro over time: *Ariadne*, *Die Frau ohne Schatten*, *Intermezzo*, *Arabella*, and *Der Rosenkavalier*. These chapters combined, as she knew how to do well, "anecdotes and reminiscences." The book was issued in both London and New York – to mixed critiques.[251] All the same, in 1952 she had published a well-balanced review of a biography of Hugo Wolf, whose songs she very much loved, in the *New York Times*, for which she proudly collected seventy-five dollars (this was the time when every penny counted, though she was beginning to be comfortably off). In it, she had managed to impart her enthusiasm for singing with a few well-chosen words, which were utterly convincing. "It is both the challenge and the charm of being an interpreter that there never has to be just one *correct* interpretation. There is no right or wrong if the true artist speaks from his own heart," she remarked wisely.[252]

In 1964, perhaps spurred by the appearance of her Strauss book, she was once more back, indomitable, at her memoirs, adding new material, including

some on Karajan and even on her nemesis Jeritza. Alas, again she had her manuscript returned, this time from Macmillan. The work was "fragmentary in its current form – actually it is almost formless." Although it showed her trademarks, "warmth and charm," the reader was merely "tantalized, but hardly ever satisfied." The editor found it superficial, especially considering what she might have written about![253]

Meanwhile, Lehmann had taken to poetry again. Of all literary genres, she had had the least success with that. Since they were in German, she tried to get her poems from the last decades published in Germany, using the good offices of her old Hamburg friend Paul Lachmann, the former bookseller from the liner *Bremen*. Lachmann was aghast. Her poetry was jarring and comical; did she want to spoil her sterling reputation as a singer by risking the wrath of the critics? Again, these poems were filled with music, forests, storm, and clouds. And all the stanzas rhymed. These were the kind of verses Erika Mann would compose for the amusement of her family's dinner guests. Undaunted, Lehmann had them printed by the Residenz festschrift publishers in Salzburg at her own expense; what she had thought would carry the imprimatur of a reputable firm in the end was delivered into her hands as the private printing of a vanity press.[254]

There was a final serious book, describing and analyzing eighteen song cycles such as Strauss's *Vier Letzte Lieder* and Schubert's *Die Schöne Müllerin*, thirteen of which were German and all of which were well known to her. Like *Singing with Richard Strauss*, this was translated from her original German. Her strength lay in the ability to convey to the reader, wrote Desmond Shawe-Tayor, "with a remarkable command of phrase, the emotional essence of song." The same could have been said about her actual singing. But the reviewer criticized other aspects of the book, and Lehmann herself found this review from the *London Times* "not a very good one."[255]

Lehmann's writing career ended, remarkable as it had been even after several bumps, when a final attempt on her part to sell her "Heaven, Hell and Hollywood" manuscript failed, as had the extension of her memoirs, even in German translation.[256] In 1973 – she was eighty-five – she stopped all of her commercial writing ventures. "I don't have the verve any more, nor the expressive light touch," she explained to Mia Hecht.[257]

Lehmann's third art was painting, and here she elevated herself somewhat from the beginner's level of the forties decade. In 1951, she could derive satisfaction from the fact that the Museum of the City of New York would exhibit a winter landscape she had gifted to the Metropolitan Opera. But the painting was not accepted on its own artistic merits, for it was to be shown under the specific rubric of "Hobbies of Great Artists."[258] Lehmann tried to enrich her artistic activities further by drawing cartoons and adding them to her "Memoirs" manuscript, but her agent thought they lacked bite.[259] In canvas painting, she felt she was working more in abstracts now and besieged friends such as the music critic Albert Goldberg to visit an exhibition someone had arranged for her in San Francisco.[260]

One could not fault her for lack of endeavor, however. By the middle of 1953 she was into ceramics and tried her skill at sculpture, finding it "great

FIGURE 21. Lotte Lehmann's watercolor depiction of Frances Holden at Hope Ranch, date unknown. Courtesy Special Collections, Davidson Library, UCSB.

fun."[261] She exhibited a glass mosaic Madonna in Los Angeles and made a glazed face mask of Toscanini, whose family, however, did not acknowledge its receipt. When a friend told her that her art now resembled that of the German Expressionists, she proudly let Charlotte Berend know that in her own opinion, "I am now painting better than ever."[262] As she was selling to more friends and fans and there were more showings of her art, her opinion of it rose even further, so that by the late 1960s she thought her output was not unlike that of Grandma Moses.[263]

By that time she had taken to felt appliquing, which was rather original in the estimation of many. In late 1967 there was an exhibition of her felt appliques at the Santa Barbara County Museum, where she exhibited twenty-six artifacts, of which she managed to sell eight, the cheapest for $25 and the most expensive, an Austrian Alp scape, for $1,500. She was beside herself with joy when a piece entitled *Mainacht*, which had been on loan with the museum beforehand, was stolen, because, as Frances Holden commented drily later, "it showed that somebody appreciated her work." Altogether, she made $2,870 from the sale, and she judged the whole event "a huge success."[264] Holden testifies that she had to do some painting every day and that she painted right up to the end. Painting, playing with the dogs, and taking sunbaths were mostly what mattered to her in the final years.[265]

Lehmann's paintings were of more interest to the members of the outer circle and hangers-on than to her few relatives and intimate friends. Fritz, who had

so encouraged Lotte's art in the beginning, had been portrayed a few times and possessed a picture of Viola Douglas that he found particularly intriguing, as he found the woman herself. Frances had been painted more times than she cared to remember, often in the most awkward situations.[266] More than anything, Fritz saw in Lotte a target for his poison pen letters, as he became ever more immersed in the rankest prejudice. Just after Lotte had done her last Town Hall concert, he advised her that the Met's new director, Bing, was a law-and-order man and that she should consider herself lucky to be retired from there. He asked whether she knew that Bing was a Jew. And even one from Austria! Was it not strange for an Austrian Jew to be so "Prussian"? This would be tantamount to anti-Semitism, for which even Jews were known.[267]

At first Lehmann thought she could keep Fritz at bay by continuing to send him money and buying him a used car, which overjoyed him.[268] But at the same time, she wanted him back in Santa Barbara, because he was of her own flesh and blood. In the summer of 1951, Fritz seriously pursued the idea of returning to the warmer climate, especially since, through his sister, he might connect with the newly founded Music Academy. Two years later, he and Theresia were back, living in a more upscale house than the previous one, which Lotte, increasingly better off, had recently bought. And just as he had hoped, Fritz attracted students from the Academy.[269]

In 1954, he suffered a stroke that paralyzed his left side. Mentally, Lotte thought, her brother was all the worse for it. He was becoming forgetful, and whatever thoughts he had proved to be even more scurrilous.[270] Whenever Lotte was in Europe, Fritz would write her the kind of vituperative letters that had become an obsession with him, condemning all mutual acquaintances and conjuring up racism.[271] The singer was beginning to suffer from the hate-love syndrome again. "I really start to feel a kind of hatred for him," she sighed in October 1956 in London, "who does he think he is that he judges everybody, only not himself???"[272] This went on for a number of years. When their common student Betty Bollinger lay dying of cancer in Zurich in 1962, Fritz was at his cynical worst, and Lotte thought him inhumanely cruel.[273] Later on in that year, she wanted Frances to get him to stop his letter writing, for her "hatred for him" was "ever increasing."[274] Yet because of her never-ending feeling of guilt toward this one important member of her family, who had got her started on her career, she failed to control their relationship. This meant that she continued to see him and to be the butt of his sarcasm. Fritz died of a second stroke on April 26, 1964, just after entering his car at Hope Ranch. They had been talking about their childhood. His death bestirred Lotte's guilt.[275]

With Constance Hope having dropped into the background, Lehmann's two best friends from olden days were still Mia Hecht and Viola Douglas. Hecht had turned into a typical suburban housewife, and Lehmann had long tired of her, save for the sounding-board value she possessed as one who had known her longest. Mia's U.S. lifestyle (red-dyed hair) and constant babble about this or that tired Lotte quickly, had it not been for the fact that she herself took the liberty of telling Mia everything that moved her. Apart from Frances, Mia remained Lotte's closest confidante.[276]

FIGURE 22. Theresia Heinz-Lehmann and Fritz Lehmann in Santa Barbara, early 1950s. Courtesy Janice Cloud, Santa Barbara.

Viola Douglas had evidently separated from her second husband and was living near Chicago with a woman in what was clearly a lesbian relationship.[277] In that constellation, she could not come between Lotte and Frances as she had tried to so many years ago, and hence Lotte's relations with her were cordial. Some of that old fire was still burning, however, for over the years Lotte begged Viola repeatedly to visit Santa Barbara, which the former beauty seldom was inclined to do.[278] But as was happening ever more frequently in the 1960s and '70s, Viola was reminding Lotte that time was moving on and that people younger than herself would pass away. In 1968 – Viola was only sixty-one – she developed lung cancer and died at the end of the year. One of the great loves of Lotte Lehmann was no more.[279]

Frances Holden was Lehmann's most faithful, her ultimate partner. Judging by appearances, they lived like a married couple. They continued to miss each other when apart and conveyed expressions of profound affection, even if Frances was emotionally much more reticent.[280] Despite the other's idiosyncrasies, they were wholly dependent on one another, trying to shrug off whatever they found hard to bear. One proclivity they shared and that actually helped in their mutual bonding was watching the CBS soap operas *The Edge of Night* and *The Secret Storm.* When one of them was away, the other had to tell her exactly what had happened. "Edge of Night is near conclusion," Lotte, the

expert on dozens of opera plots, informed Frances in March 1964, "he almost has Emmery – and it is terribly exciting. But the next story is – of all things – Beth and Lee... I swear I stop!!! Secret storm is now switching to Peter and that woman whom he met in Nassau: Valery. I don't know what will happen to Amy and Mr. Britton. I feel some tragedy developing..."[281]

Lotte still had difficulty accepting Frances's physical involvement with things of nature and the elements, to the point of total exhaustion. Frances would swim in cold water, haul stones, build animal cages, and make never-ending alterations to the house. She would play tennis to exhaustion.[282] In Lotte's opinion, she was a "strange person" who, when in pain, eschewed pity.[283] But intellectually, too, she puzzled Lotte. She would read every book in the house and actually did listen to Lotte's and other records. At one time she was preparing for a trip to the Middle East with like-minded acquaintances and for days was in the kitchen at the crack of dawn studying books. When Lotte descended, she was served enlightenment. "I came down from my bedroom at 7 o'clock, ready for my coffee and not for Egypt."[284] At the same time, Lotte acquired the notion that Frances wanted to socialize more outside, which implied leaving her at home alone. Whether that impression was based on truth or not, Lotte resented it, as it contributed to feelings of guilt and the suspicion that Frances, the house owner, was suffering her like a millstone around her neck.[285]

Lotte struck Frances as equally odd. She could not understand why Lotte always hated to be alone in the house. After Frances had an operation in 1961, she remarked that it had been a great success, because during that period Lotte had begun "to enjoy taking care of herself! She also got over her fear of being alone."[286] It bewildered Frances that she should constantly fire up two kilns so that the singer could bake and glaze her ceramics.[287] As Lotte became older, she got depressed and weepy more often, and then nothing interested her. "Boredom got the better of Lotte's judgment. Of course that happens frequently and I have to cope with the results. This time I suspect I should have a straight jacket [*sic*] on hand." This Frances noted in 1968.[288] Five years later, she remarked that "Lotte is completely irrational and jumps to conclusions without any premises or completely wrong ones. I am sorry I haven't kept a catalogue of the incredible thoughts and motives she has credited me with."[289]

Lotte and Frances almost went their separate ways on a number of occasions. Around the mid-1950s, a German woman by the name of Elisabeth (Betty) Mont, one of her many fans, became interested in Lotte, and not just platonically. She also courted Fritz, probably the better to get to his sister. Presumably wealthy, she showered both of them with money and other courtesies. Eventually Lehmann was forced to tell her that, although she was grateful, she could not love her as it was expected of her; "thank God, I am not thus inclined." As a result of this involvement, she had been noticing Frances's increasing distance. For many months their common existence hung in the balance. In April 1958, Frances finally took charge and wrote Lotte, without mincing words. Why could Betty come between them? "It is true that when Betty is around you are often unbearable. The 'Queen' complex is one I never could weather either in Elizabeth or you. I am just allergic to queens. However when Betty's

influence wears off you are often your most enchanting self." A few months hence Lotte broke whatever relationship this had been and reestablished peace with Frances.[290]

The second major crisis of this period occurred in the mid-1960s when Lotte became jealous of Betty Krause, a woman Frances traveled with abroad, in the company of a local homosexual male couple. Lotte was sulking because she had to stay home alone and complained, "do you want me to sit here and pine for you? You have a wonderful time and I am convinced that your new friend Betty is much more a companion for you than I am." Frances's friendship with the other Betty undoubtedly fed into Lotte's complex of being a millstone around Frances's neck, but of course she wanted to be contradicted. Still, she seriously considered moving into a small apartment in town, especially since she remembered Frances once saying to her that she, Lotte, knew very well on which side her bread was buttered. But it was not long until Lotte confessed to her friend once more that "of course I need you as much as ever" and that "anything is better than being separated."[291]

Frances too wanted to leave at one time, when Fritz and Theresia had come to dinner and Theresia started to wash the dishes afterward. The self-denying Frances forbade her to do it and began washing the dishes herself. At that point Lotte entered the kitchen and had a fit. She insisted that Theresia should wash the dishes, and the two friends had a fight, during which Lotte gave Frances "a wallop" and Frances stepped outside, trying to figure things out. "I wanted to part company, but I realized that I couldn't leave and Lotte wouldn't have any place to go. We had to get along and we did."[292]

Lotte Lehmann's long and committed partnership with Frances Holden leads to a final, if still tentative, discussion of her sexuality. For most outsiders, Lehmann was consistently heterosexual. This showed early, as she had crushes on her teachers and eventually acquired a boyfriend, whom she planned to marry. In Hamburg, she was interested in affairs with Klemperer and Brecher and dated the choirmaster Hermanes; she also fantasized about a romance with Caruso. In Vienna, she met eligible bachelors such as Wilhelm Dessauer, whom she almost married, and shortly thereafter Otto Krause, whose mistress she became. After they had wed in 1926, she started having casual affairs with other men, among them possibly the tenor Fritz Wolff. Her affair with Toscanini in 1934 may never have been consummated, but she could not have fooled a connoisseur of women like him, as to whether her preference for men was in doubt. For the period thereafter, we know little about her love life, except that eventually she showed an erotic interest in Krause's son Peter and Jeanette MacDonald's husband, Gene Raymond. She was interested in wealthy Noel Sullivan from Carmel, but Sullivan was most certainly gay.

This takes us to Lehmann's undeniable interest in women. Stanford's English-literature scholar Terry Castle has explained that whereas a disproportionate number of gay men tend to become loyal fans of prima donnas, so do homosexual women. Divas excite an ardor "often implicitly tinged, if not openly charged, with homoeroticism."[293] Viola Westervelt-Douglas, who lived in a lesbian union toward the end of her life, was most certainly a bisexual woman

in 1931, when her eyes met Lotte's from that first row in the Paris Opéra, which so excited the singer. More precisely, she was a lesbian married, at the time, to a man, with whom she later also had a child. She would be married to another man thereafter and in all likelihood had an affair with Fritz. The situation is only marginally less clear in the case of Mia de Peterse-Hecht, who had pursued Lehmann even in Hamburg but who, once again, took a husband and had a child. Significantly, the child was named Mialotte.

What is interesting here is not that young women like Mia and Viola were attracted to Lotte, as were scores of others later in Vienna, London, and New York, but how Lehmann dealt with this attraction. Why did she show such an enormous interest in Mia, after Mia's first letters of love and those flowers? Why did she insist that they meet? Years later, why did she pursue Viola with what today can only be described as one woman's love letters to another woman? Why did she allow Hella Müller and Hertha Stodolowsky in Vienna to get to know her privately; why did she sponsor Müller for employment; why did she insist that she had to discover the identity of Frances Holden in New York, again after baskets of flowers?

History knows of at least three lesbian prima donnas: Emma Calvé (1858–1942), Olive Fremstad (1871–1951), and Mary Garden (1874–1967).[294] Lotte Lehmann might have been a fourth. Although she was interested in men, she also showed a strong emotional and most likely sexual interest in women, even if she forwent sexual practices, something that is not proved one way or the other. Neither do we know whether she was interested more in men than in women; possibly, she did not know herself.

Given the times she lived in, it would have been folly for Lehmann to admit unconventional sexual preferences to any but her closest friends, especially since, as an opera singer, she had to preserve a respectable public image. Yet on the winding road from Perleberg to Santa Barbara, there are interesting signposts. While still in Perleberg as a young girl, she preferred the company of her brother's rough-and-tumble friends, and in her autobiography she does not mention any significant girlfriends. Instead, she dwells on her devotion to Fritz. After she had outgrown puberty and visited the Putlitz family, it was not their son, Gisbert, with whom she struck up a friendship, but the two sisters, the older, Erika, in particular. (This does not in the least imply that Erika was homoerotically inclined.) In Hamburg or in Hiddensee, her relationship with the painter Jaensch was so strange, if not to say asexual, for a man and woman in their age group, that he could well have been an early homosexual admirer. Later, in Vienna, the person she evidently preferred to associate with most was Countess Rechberg, who was clearly not married. Whether Lehmann was intimate with any of her female fans in Vienna, or anywhere else in Europe where she concertized, is not known. The same applies to her female fans in New York in the early 1930s; among the "Lehmaniacs," perhaps a few were at least bisexual. Was her idol, Geraldine Farrar?

On stage, Lehmann had always preferred among her roles that of Fidelio, a woman dressed up as a man (a "butch," as queer lingo would have it), on whom the jail keeper's daughter Marzelline has a crush.[295] Singing at the

Met, Lehmann monopolized and actually liked impersonating the Marschallin. Depending on the stage director, at the beginning of the first scene (or even before the curtain lifted?) there was always hanky-panky in bed with Octavian, who was really a female. Later that female turned out to be the alluring Risë Stevens, and to this day rumors have persisted that Lehmann was romantically interested in Stevens, and Stevens herself had homoerotic tendencies.

When Frances Holden – who, it was not difficult for insiders to see, was an avowed lesbian – arrived on the scene, was it not clear to Lehmann what kind of relationship she was entering into, as soon as she had moved into a house with Holden in Riverdale by 1939? Given her own experiences with young women in the past, whatever they might have been, and being able to read Holden's signals correctly, Lehmann must eventually have known she would be in a lesbian relationship for life, whether it would never be physical – as they both always claimed – or not. Circumstances like the episode during their later phase of cohabitation when Betty Mont was able to make demands on Lehmann, and Lehmann obviously submitted for years and almost broke Holden's heart, speak volumes about the intensity of their partnership. So do Lotte's jealous remarks regarding Frances's friend Betty Krause. That this partnership, excepting its rocky beginnings, was always marked by warmth and understanding, devotion and admiration, and that the two women missed each other when apart, must mean that they loved each other, physical contact or not. When Viola Douglas came to visit with her friend Hadassah McGiffin, they clearly came as a couple visiting another couple of the same persuasion and lifestyle, and were received as such. Lehmann had offered a standing invitation to both.

What this all signifies for Lotte Lehmann as a woman is that she was ambi-sexual, with physicality again beside the point. What it signified for her as an artist is that an aura of pansexuality heightened her powers of interpreta-tion of aria and song. Famous for her impersonations, for the sincerity of her vocal expression, she was able to insinuate herself into her characters so that she *became* those characters, whether they were women or men (Octavian, Fidelio). With these interpretations, she embraced men and women in the audience alike. Members of both genders felt her vibrations, as they beheld a hypersensitive artist with a special talent. That is why she could sing male roles also in song, when no other female singer (except perhaps for Elena Gerhardt) had done this, and while she might cause eyebrows to rise, she had created something new. Later, in America, she repeated such song performances with her interpre-tation of the love-lost man in Schubert's *Die Winterreise*, which became one of the greatest of her mature successes. To the extent that she could *be* that female, and sometimes also that male character in whatever scenario she had chosen, and extend the character's specific empathy to the audience, male and female auditors returned such empathy. Having the ability to project her per-sona as both man and woman, she neutralized sexual divides. In the end, she lifted herself and her art beyond the realm of sexuality, not to say of the merely human.

Was this the essence of Lehmann's "genius" that Frances Holden was deter-mined to explore? Lotte had never known of her initial plan, but two years

before her death she might have been given cause to suspect it. In a particularly bitter letter, the grumpy old lady wrote to her companion of many decades: "You say you want me to be happy. How could I be with you always pushing me? I should write, paint and what not. I think that I have a *right* to *relax*. I have done a lot in my life. Opera, concerts, teaching, writing books, painting mediocre pictures. Now I want to do *nothing*. And you don't understand that. You compare me with women like that one with crippled hands. I admire her, but has she done in life what I did? Have I to work till the end of my days just to please you?"[296] Frances's reaction to this accusation is not known, but if Lotte Lehmann had failed to convince her that she was a genius early on in their relationship, the occasion for that had now surely passed.

At the time, Lehmann did not have crippled hands, but her arthritis was very painful. Ever since she began to think her voice had disappeared in 1951, she had been feeling her age. As time progressed, she developed the various nasty maladies of physical degeneration no mortal can escape. By the middle of the 1950s, arthritic pain was in her shoulder. Officially, her main reason for annually visiting the spa in Badgastein was to cure her arthritis through massage and baths.[297] Until the 1970s she could still take longer walks, but thereafter felt much exhausted. She was not able to endure company for long and more than ever felt she was becoming a burden to Frances.[298] In the mid-1960s she was also suffering from arteriosclerosis, which in her case affected the eyes. As her arthritis was now in her hips and knees, she experienced increasing trouble walking, using first one cane and then two, until by the mid-1970s she moved around mostly by wheelchair. Breathing problems complicated this.[299] These ailments were further exacerbated by low blood pressure and her chronic tendency to be overweight, although her overall appearance in old age was improving to the point that she often struck visitors as regal.[300] There was a certain spirituality that shone through her face; the sparkle of her eyes continued to charm everyone who met her. Her eyes had always reflected the fact that she was as generous as she was mischievous.

Over time, the physiological disorders were aggrevated by psychological problems, some of which had haunted her in the past. She had suffered guilt complexes and depression as a young woman certainly since Hamburg, as some of her letters to Baroness Putlitz no less than her correspondence with Fritz prove. Memories of past bad judgments pursued her, in addition to professional frustrations she found hard to resolve, whether it be the envy of other artists or the grief over her fading voice. Always at emotional extremes, in the late 1960s she tended to be on the verge of tears more than ever before, as the cool and collected Frances never failed to register.[301] She was losing her composure and throwing tantrums – behavior she used to ascribe exclusively to other "divas." By 1970 she was taking antidepressant pills, but at that time the state of medicine in this area was not sufficiently advanced for the medication to be effective.[302] "I am horribly alone and weep very much," she confided in May of 1970 to Dr. Herman Schornstein, the opera-obsessed psychiatrist who befriended her. "People look at me with pity in their eyes. I don't want pity. I was accustomed to see admiring glances, but now? Now I am an old decrepit

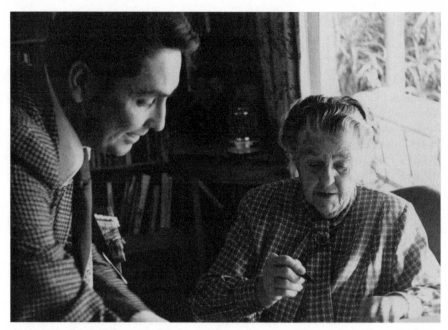

FIGURE 23. Lotte Lehmann with an unknown friend at Hope Ranch, Santa Barbara, 1973. Courtesy Special Collections, Davidson Library, UCSB.

woman.... I wish I were dead."[303] Frances Holden remembers that ever since she had become so incapacitated, Lehmann had expressed the desire to die.[304]

In the last few months of her life, Lehmann's pain in her hips and knees was so bad that she could not climb stairs anymore. It was impossible for her to travel to Badgastein that spring in 1976, as she had done regularly in the past, and at the beginning of August she complained to Bernhard von Barsewisch about "this botched-up summer."[305] A few days later, she mentioned difficulties with her heart and head in a letter to her Viennese friend Hertha Stodolowsky. On August 17, she asked her for help in securing extra funds from her Austrian pension account, in order to finance additional medical care. She added that she was having "a bad time," but was hoping for improvement.[306] Holden wrote to Schornstein on the twenty-first: "She is rather miserable and all the medications she is taking seem to make her more so. It is very difficult for her to concentrate on anything and she is getting hard of hearing and tires very rapidly."[307] Then, on the night of the twenty-fifth, Maurice Abravanel came for a visit but overstayed; he wanted her to tell some funny stories. Lotte burst into tears and finally went to sleep. The next morning, a Thursday, she would not get up, even when a dog came in and started barking. Later it became clear that she had had a fatal stroke.[308]

Her body was cremated and the ashes buried in an "honorary grave" in Vienna's Zentralfriedhof, next to other famous artists.[309] In accordance with her will, several individuals and the Music Academy of the West received respectable amounts of money realized from her bank savings and the sale of stock investments. Theresia inherited the house on Samarkand Avenue she and

Fritz had been living in, Frances what was left of the cash, amounting to tens of thousands of dollars. Much earlier, Lotte had written to Fritz that "without Frances I would have left debts I am sure...." Frances Holden said later that the thirty-seven years she spent with Lotte Lehmann had been the happiest of her life.[310]

Epilogue

For any but the most hagiographic of biographers, Lotte Lehmann is a difficult person to explain, let alone to categorize. This is because opposites and contradictions determined the complexity of her personality, and no one knew this better than Frances Holden. She, the psychologist, told her in 1958 that "after almost nineteen years of living together one of the few things of which I am certain about you is that what you want at one time is just the opposite of what you want at other times." Twelve years later, Holden observed about Lehmann that "there is nothing one can say about her of which the opposite isn't equally true. She has no medium degree of anything, only extremes." Holden even went so far as to state that Lehmann was not "a human being," but "a phenomenon."[1]

What defined Lehmann as an artist, if not as a person, was her singing voice and the way she used it. It may be true that the extraordinary quality of her art was due to physiological peculiarities of her vocal cords – as Rudolf Bing, no doubt sarcastically, assumed a "throat disease" in the case of *all* the great singers.[2] But even in comparison to those other greats, Lehmann's art was unique, appealing to the widest audience with its magnetism, today no less than in her time. For the pure quality of her sound, however produced technically, was enhanced by her interpretation of aria or song, the feeling she inspired it with, that quality of *Innigkeit*, not to mention the histrionic support, her superb acting or posturing. The sum of all this was discernible proof of her genius, another aspect of which was that as a young singer she had learned easily, seemingly effortlessly and quickly, as if singing were her first nature. If, to speak with Holden, the perfection of her art resided at the one end of a spectrum of extremes, then her growing pathological fears of vocal decline – after her string of successes reaching into the early 1930s – resided at the other. These fears were characterized, for example, by anxieties about not meeting the Straussian standard established for the high tessituras of a Helena, an Arabella, and eventually the Marschallin, and then about failure as Fidelio. As much as Lehmann could accommodate her rise to and stay at the top of her profession, she had difficulty accepting that a subsequent decline was normal, that age would naturally affect her vocal cords as it would her entire womanly body, and these anxieties were compounded as she grew older. As she was singing the Marschallin in her last years at the Metropolitan, might it have consoled her to hear what a much younger singer, Christa Ludwig, later said of these complications, that the beginning of the final Tercetto in the third act of *Der Rosenkavalier*, for instance, always presented a problem, "because it was set

very high and had to be rendered pianissimo"?[3] But then Ludwig was a mezzo, not a lyric soprano like Lotte Lehmann.

In 1970 Holden went on to say that as a person Lehmann could not exude warmth, only "as an artist."[4] As mistaken as she was on the first count, she was certainly correct on the second. Lehmann exuded human warmth on the stage and, for her thousands of followers, off the stage as well. The Viennese and even Hamburg's citizens proprietarily called her "unsere Lotte," and her lieder recitals in New York inspired cults. On the occasion of her seventy-fifth birthday, Harold C. Schonberg, one of the sternest music critics ever to write for the *New York Times*, said of her that "she generated love. This is given to very few artists in any generation." He reminded his readers that in her best days "she used to walk on stage to reduce the audience to a melting blob" and that after her last Town Hall concert in February 1951 "there were enough tears to wash clean the street outside."[5]

But, contrary to what Holden uttered spitefully on a bad day, such communicative charisma also marked Lehmann's private character. At her best and most contented, she was open and cheerful, voluble and impulsively generous to the point of giving money away – she was someone whom everybody liked. Hence she obviously impressed her fellow pupils in the Perleberg girls' school, where she repeatedly helped a physically challenged friend even without being asked and, judging by her correspondence, was much missed after her move to Berlin. The teachers were fond of her, as she showed gratitude for their instruction. At the Hamburg Stadttheater all her colleagues welcomed the young newcomer, referring to her endearingly as "The Child." The young women of the "Lehmaniac" circle in New York led by Constance Hope in the 1930s were drawn to her inexorably, to say nothing of claques of young admirers in Vienna and later in New York, whom she embraced, rather than haughtily turning them away. After World War II, her old Vienna colleague Alfred Muzzarelli asked her when she was coming home, for everybody, including the other singers, thought she was one of them.[6]

As far as Lehmann's personal charisma was concerned, it was in fact so powerful that brother Fritz spoke of an "atmospheric dictatorship," and Bernhard von Barsewisch remembers from the 1960s that she was so strongly the center of every group that it hit one upon entering the room.[7] Her charm triumphed even over the most awkward of situations. When in February 1964 the German consul general wished to present her with a decoration in his Los Angeles offices, he was holding the ribbon in one hand and the honor list in the other. He stood before Lehmann awkwardly, not knowing how to decorate her. But the old lady broke the tension by resolutely walking up to him, taking the ribbon with the medal and firmly placing it around her neck.[8]

Students experienced and loved Lehmann's spellbinding presence also, both at the Music Academy of the West and, privately, at Hope Ranch. Shirley Sproule, Gary Hickling, and Luba Tcheresky have attested to that most eloquently. If she had problems with one or two, such as Marilyn Horne, that was still within the norms. What was not was that sometimes Lehmann extended her support too far, at first without realizing it – and then empathy turned into control. Her motive was a noble one: she wanted to impart her expert knowledge

as an ideal teacher, having the best interests of that pupil, sometimes even a junior colleague like Risë Stevens, at heart. But in the case of Stevens and especially of Grace Bumbry, something else was at play that went beyond an ordinary teacher-student relationship. As she was aging and becoming less capable of singing herself, which was an immense problem for her, she attempted to insinuate herself into the lives of those younger women, talented enough to be made into small Lotte Lehmanns who would then grow and perpetuate her legacy, hence ensuring her own artistic immortality. Whether she stylized these liaisons as mother-daughter relationships, as she did with Bumbry, or whether a genuine erotic element was present, as there allegedly was with Stevens, is beside the point. What matters is that when she met with resistance, her initial kindness turned into personal disappointment, then professional envy (and then anger). In the case of Stevens, the envy was manifested over the medium of Hollywood films. In the case of Bumbry, whom she had "discovered" and wanted to love beyond measure, the professional-envy stage expressed itself through a condemnation of the black singer, morally and artistically, predicated, however subliminally, on stereotypical racist arguments.

Part of Lehmann's silent discourse with Bumbry was that the African-American – although, to her teacher's amazement, she had learned fluent German – ultimately had to be doubted as someone qualified to sing German lieder, because the tradition in which she had been raised was unconnected to the German culture that had spawned Schumann, Brahms, and Wolf. (In the case of opera this was less of an issue; many operatic roles were not German but of broader European valence; Bumbry might well star in *Salome,* where she would – characteristically – shed all seven veils, even if the music for that role had been composed by a Richard Strauss.)

Lehmann as juxtaposed to Bumbry – the question surfacing here is how conversant she herself was with German culture. In Germany and Austria during the nineteenth and twentieth centuries, culture was a function of social class. Lehmann was born into a provincial, lower-middle-class if upwardly mobile family, which barely placed at her disposal the means to formal education, so as to enable her eventually to rise above her social level. Early opera training and operatic experience were then working to the same effect. But how instrumental could formal schooling in the Perleberg and Berlin educational systems and even the Musikhochschule be, the latter of which lacked university accreditation and which, in any event, the young woman never completed? How much about culture did she absorb in her parental home, how much by osmosis in the public spheres of Berlin and Hamburg? Admittedly, she went to the Berlin Opera, but did she visit theaters and galleries and did she read books, journals, and informed newspapers? Perhaps some of the latter, because she herself tried to write poetry and prose and had a poem published in Berlin's *Der Tag.* But how much could she have been interested in literature, philosophy, and history, that of Germany specifically and that of other cultures of the civilized world? Did not her boyfriend Willy Hilke complain that she did not know enough and could scarcely be motivated to learn more?

There is no evidence that after moving to Hamburg in 1910 Lehmann did anything to improve her knowledge of the wider world, beyond the immediate

cosmos she moved in. One reason for that was that she kept herself busy with matters of opera – studying her roles and getting to know her colleagues, which she did quickly and successfully. Learning libretti must have opened her mind more; eventually she was singing lieder and hence got to know poetry from the German Classic and Romantic eras, by Goethe, Heine, Hölderlin, and Mörike. But how much she internalized these we do not know, and, as her own mediocre poems later demonstrate, she may not have been able to separate the gems from the chaff authored by lesser writers. Later she never mentioned a favorite poet, in letters or in her published writings, nor a favorite poem; authors of prose are ignored. One poem that had stuck in her mind was Mörike's "Gesang Weylas," for she named her pulp novel of 1937 after Orplid (for reasons she never explained); later Holden picked that up for baptizing her house. So when Lehmann assured her friends during her American phase that she did not read books, this must have been true, as she repeated it so often, and it would certainly have applied to Hamburg. Moreover, the journey to London in July 1914 finds no mention in her memoirs as a welcome occasion to broaden her horizon.[9] Perhaps one purpose of her strange relationship with the painter Jaensch at the time was to make her more sophisticated.

One major criterion of class being wealth, there are many letters by Fritz to Lotte after the 1930s reminding her in what poverty their family had always lived, from Perleberg through Hamburg. And in that context, he never failed to stress their comparatively low class status.[10] Apart from Hamburg, it is known that Lehmann inhabited a modest *Pension* even in Vienna for several years and that her aunt Lieschen never surrendered her dry goods stall at the Berlin market. Because her father, Karl, preferred loafing to working, because Fritz could never get a decent job and mother Marie was constantly sick, the lack of money in that family was chronic. It is true that Lotte entered some of Hamburg's higher echelons through wealthy male acquaintances who, like the older Gerstenberg, may have cast an amorous eye on her. Hence she was introduced to the shipowner Albert Ballin's family, for whom she sang at soirées, and she got to know a few other such Hamburg clans. But in the Hanse town Lotte the provincial always felt awkward in good society and, regardless of her popularity at the end, was never integrated there. In that respect, even her friendship with the professorial Loewengard family changed nothing. And her occasional visits to the noble Putlitz estate were too fleeting to be of any consequence. After one Hamburg soirée in 1910 she wrote, full of wonderment, to Fritz about the formal dinner she had enjoyed, which she found simply "unbelievable," ministered by six servants. She thought it funny that champagne was offered even with soup. Thereafter she had venison, salmon, and a salad containing "very strange, terribly tasting black spheres (a fruit, I think)" – almost certainly olives.[11]

Being as charming as she was and pleasant-looking, if not beautiful, it is actually surprising that she did not meet, at these musicales or through the Opera, a young professional from the better-off strata, or some rich young man whose father owned one of those typical Hamburg import-export businesses, on a more lasting basis. Perhaps she did and spurned such opportunities, because she needed time for herself (but then she would have told her confidant

Fritz about any such encounters). That may have placed her in the vanguard of liberated women at the time, without, as yet, destroying the individually limiting class barriers. Although she boasted much to the contrary in later years, in order to construct a reputation as a femme fatale (part of her sexual politics), she retained her proper lower-middle-class, *spiessig* set of values, in which especially her father always supported her and which Hofmannsthal later indicted.[12] And this did include courtship. When her close friend Elisabeth Schumann eloped with Klemperer, she may have been envious of the romantic aura, but found such action truly horrible, against all conventions.[13] As late as 1927, in *Das Wunder der Heliane*, she refused to reveal her body on the Vienna stage.

It was while in Vienna as her career approached full bloom that Lehmann's dualistic profile acquired stronger relief. For whereas socially she remained lower-middle-class-bound, by self-schooling she attained an uncanny comprehension of opera, which insights she later worked through in a literary fashion. That she may have done so almost autodidactically, albeit influenced by established mentors, was a function not only of her high intelligence, but also of the capacity for vertical mobility inherent in her family. Operatic libretto and song, in whose interpretation she would once be a master, became her first terra firma, commensurate with her stupendously growing stage successes in Vienna and elsewhere in Europe. Interaction with her elite-class mentors provided necessary impetus and also held social promise, but significantly, Strauss invited her to Garmisch only once and never to his villa in Vienna's Jacquingasse, and her relationship with the venerated Schalk was always tenuous because erotically, he was oriented elsewhere, and hierarchically, he presided over her promotions and wages.

Such profound knowledge of her genre as she did obtain demanded much application in the Opera, on and off her own performances, leaving Lehmann little time for social dallying, such as it was. She obviously circulated in salons, if only after invitations for singing, and there met new friends like the Countess Rechberg and Rudolf Kassner. But that Bertha Zuckerkandl once referred to her well-known proclivity to shun salons, which were the mainstays of established Viennese circles, suggests that her human, artistic, and intellectual experiences in that capital remained limited. It is clear that she felt awkward in Central European high society, even as she became rich and richer. The increasing wealth did not alter her intellectual or social status, because it did not aid her in an intercourse with the elite, as whose ultimate aim she might have advanced herself by hypergamy. When she met the wealthy young artist Wilhelm Dessauer and thought of marriage in the early 1920s, she could finally have elevated herself to exalted heights, but the man's neuroses offended her survival instincts. Thereupon she joined Otto Krause, a virile, straightforward-seeming man with a social background admittedly better than her own. He was the junior officer her beloved mother had lost in the Franco-Prussian War and of whom she knew from many tales. This *Rittmeister* had a municipal official for a father, already superior to her own father's station, and had moved himself up further through his first marriage. Krause acted from the gut, not from the head; he was showy and physical as she wanted to be; he loved horses as she loved dogs. And the

fact that he cherished opera in the context of higher acculturation was not to be overlooked, for it gave him the air of a sophisticate. (There could have been real promise for Lehmann in this liaison socially, for how long might this mountebank have pretended to her that he was a connoisseur of culture *and* independently wealthy?) Later, although Lehmann would have to support him, he could keep up his various charades as "banker"; in the United States she herself introduced him as such, in addition to making him a "Doktor."[14] As a front for elitist integration, which still had not taken place by the time Lehmann reached America, Krause had his uses for pretense, and his death in 1939, by Old Continental standards, created a social crisis for the singer, although she knew that he had been a failure in society.

In certain respects America liberated Lehmann socially. Here she could fit into a class system that was much less stratified than Europe's. In the New World, more emphasis was placed on wealth per se than on learning and high birth, and wealth Lehmann had plenty of until the 1938 Austrian debacle and her permanent move to the United States. Now she could show off her seven-seater Lincoln for full credit. The significant exception, of course, was New York, where high culture reigned next to Old Money and where Lehmann never felt at home. This is the deeper reason for her constant longing for the open skies of California, beginning in 1932, and her permanent move there by 1940. Tellingly, however, she did not settle in Los Angeles, which by then had come to serve as a depository for displaced Central European intellectuals presided over by Thomas Mann. That her third mentor, Bruno Walter, was also there provided her with a shield, especially vis-à-vis the forbidding Olympian who knew well why in his late 1940s novel *Doktor Faustus* he had mentioned Walter and Klemperer by name, but had taken care not even to find a cipher for Lotte Lehmann (whom he could at least have caricatured, as he caricatured others), although he was such a lieder lover.[15] If Lehmann after 1938 consistently maintained that she was happy in America, she meant it, for her work and residency there had lifted from her the European pressure to function as an integral part of traditional sociocultural elites. Whether in early 1934 she knew that she would not have to play this role in Nazi Germany (because Hitler cared merely for a modern functional elite), had Göring accepted her advances, is doubtful; she was interested in the Third Reich only for the money and never planned to spend time there exclusively.

In the United States, Lotte Lehmann had to be content with being the ranking Marschallin and, in good time, the preeminent lieder singer. About lieder – her second terra firma – she would also write with authority, like an academic musicologist. That alone raised her to the top of whatever there was in terms of a sociocultural elite in that country, at least at the public level. At the private level, there now was no more need for pretense, as she had tucked herself away with Frances Holden, in the Nirvana of Santa Barbara.

Socially liberated, after 1940 Lehmann would tease everyone with the fact that now she was the nemesis of the German *Bildungsbürger*, that respected persona of culture and standing. In a manner of speaking, her own survival and that of her own, comparaticly limited cultural cosmos had rendered this caste

obsolete. The ongoing destruction of traditional Central European societies in World War II was proving her right. She obviously enjoyed the shocks she administered as she proceeded to clue in her followers and friends. "I don't read much," she boasted once again in 1943, "and Frances says that till today she does not know what kind of literature I like," and continued: "I was never interested in painting since I started to paint myself," and: "I am not fond of music. . . . I am bored to death in Symphonyconcerts. I never go to a Recital if I have not a personal reason."[16] Impishly, she played the same teasing game with Arthur, Frances's esteemed brother. She took delight in shocking him: "I am terribly unsophisticated and don't understand anything about books."[17] In 1961, she could not get down to the published correspondence between Strauss and Hofmannsthal (which John Gutman had alluded to in his Metropolitan Opera interview with her and Jeritza) because she found it "too sophisticated."[18] In 1975, she admitted publicly that she "very seldom" listened to records, and Holden has substantiated as recently as the mid-1990s that she did not read and "didn't like music."[19] During World War II and after, Lotte Lehmann did not change much from the time she was a young woman and catapulted into world fame; she *did* remain unsophisticated and a petite bourgeoise, but rather than being overawed by Old European values as she had been in Vienna, she now delighted in her open contempt of them. (Her feelings of German cultural superiority over Bumbry conveniently worked at another level of emotional and social interaction.) At no time was this more obvious than when she traveled through Italy north to Vienna in 1955, almost in revenge against the higher, educated classes. The famous art treasures of the Renaissance in Florence elicited only disgust. "The famous David looks indecent," she cried, otherwise not a prude, "all those statues so indecently naked. Makes me embarrassed, that is my *only* reaction." And she knew well where such a reaction came from: "I know that it is a terrible lack of education and understanding in my past."[20] Lehmann was demonstratively defying Europe and it symbolisms, which she had had occasion to suffer from.

The singer's reactionary aesthetics ultimately resulted from the fact that she had been reared in an ultraconservative home. This held true first of all politically, in an environment where her father was a hyper-loyal servant to his king, where even in progressive Hamburg it was accepted that conservative patrician families ruled supreme, and especially in Vienna, where the Habsburg dynasty actually owned the Hofoper. Deriving from the Putlitzes, her admiration of nobility was as mindless as it was irradicable, even in America, where it remained an anachronistic relic. In an Austrian Republic that was to veer steadily to the right, Lehmann married a cashiered member of the formerly conservative officer caste who may, like many of his peers, have had connections to a fascist militia. Lehmann abhorred revolution, Social Democracy, and communism, ignored liberal concepts, and instead felt protected by Catholic-inspired authoritarianism, right up to her personal friendship with the dictatorial Chancellor Schuschnigg. This constellation certainly was not the cause of her initiative with Göring, but her mentality evidently questioned the fascist profile of National Socialism and the Third Reich as little as it questioned

Austrofascist ideology and practice. Never in those years would she have thought that Mussolini was a bad character; on the contrary – she was flattered to be allowed to sing for him.

This brings up the question of the Jews. There is sufficient evidence that she joined in the colloquial anti-Semitism common in her Prussian lower-middle-class milieu, led therein by her prejudiced father and her opinionated brother Fritz. She despised her Hamburgian suitor Gerstenberg because he was alleged to be a predatory Jew, naturally out to seduce her. Here she believed the stereotype rampant soon after World War I and later used by National Socialist propaganda a thousand times over. But in public and, judging by her letters, much in private, she learned to hold her tongue, because in the culture business many principals were Jewish, and she was dependent on Jews like Loewenfeld, Brecher, Loewengard, and Klemperer for her progress. This situation did not change appreciably in Vienna. Although Strauss and especially Schalk were then known anti-Semites, many of her illustrious colleagues such as Selma Kurz and Marie Gutheil-Schoder were Jewish, as was the leading critic, her acolyte Julius Korngold, to say nothing, during the Republic, of cultural and governmental administrators, most of whom wished her well. When by 1924 she had met Walter who, like Mahler and Klemperer, had converted to Catholicism, she was even more cautious, especially since by then her paramour Krause had separated from an influential Jewish family. Contrary to what she liked to claim later, Jews were not an issue during her deliberations with Göring (meaning that she was lying when she later averred that she had broken off her talks because of her grave concern for the welfare of Jews). Instead, Jews became an issue in the United States, *after* the talks' failure, because her eager supporters in New York were Jewish.

In America, which as her new home country she was devoted to, Lehmann experienced democracy without really understanding it. She took American democratic practice, in whatever shape she encountered it, for granted in the same way that she had countenanced authoritarianism and protofascism in Austria and Nazism in Germany, without, however, altering her fundamentally conservative worldview. In this she was supported, after 1938, by the exclusivist Holden. It is not clear how she voted in elections, after becoming a citizen in June 1945, if she voted at all. Judging by the correspondence with her brother, if she listened to him in these matters, as was likely, it would have been Republican.

Lehmann's lifelong reactionary stance, however it may have manifested itself politically, predicated traditionalist tastes in the arts, which strengthened her in her immediate milieu of opera and song, at the same time blocking off any notions of progressive modernism. When she entered Vienna in 1916, fin-de-siècle Secessionist culture was on the way out; Mahler having died five years before, the musical landscape was dull-conservative. For her entire life the avant-garde remained anathema to her. Her narrow-mindedness showed early, for even as a young artist she tolerated only what was orthodox and on the beaten track. When in 1914 she was asked to sing Eurydice in Offenbach's *Orphée aux enfers*, she was petrified. To Baroness Putlitz she wrote: "Singing operetta is something horrible. It gives me no pleasure and is not up my alley."[21] (Five years later she was willing to sing Lehár, but, tellingly, only for a lot of

cash.) In this artistic regard she was trumped by Jeritza, who, *verismo*-indulgent as she was, always had a much more open mind for modernist phenomena and experimentation, including certain products of popular culture, from which she had originated and to which she would return toward the end of her career, as were operettas, musicals, and film scores. That such flexibility could be a boon and not a hindrance was something the narrow-minded Lehmann never appreciated, although – yet another paradox – she badly needed to be in the movies. In Vienna, she spurned the role of Marie in Berg's *Wozzeck*, staunchly hewing to the traditionalism of Schalk and Strauss, whose own modernism had largely passed with *Elektra* in 1909. When the progressivist Clemens Krauss arrived on the scene with his stage master Wallerstein, both from modernist-oriented Frankfurt, there were constant clashes. From the vantage point of the Nazis' cultural war against modernism, Lehmann would have fitted well into the Third Reich.[22]

Meanwhile she was being supported in her stance by the conservative Bruno Walter, who has gone on record as disliking Krenek's *Jonny spielt auf* (hugely popular after 1927), Gershwin, and anything having to do with jazz.[23] Lehmann herself spoke publicly against jazz when on her U.S. tours of 1930 and 1932, pronouncing it "terrible," and that reprehensible topic came up again in 1949 when she agreed with Fritz on the "nonsense" Picasso was painting.[24] Around that time, when at the Music Academy of the West the modern American composer Roy Harris was among the visiting faculty, she had no truck with him.[25] The fact that in the 1950s one of her students, Kay McCracken, married Vernon Duke, who under his real name, Vladimir Dukelsky, was known as an avant-garde composer, impressed her not in the least.[26] As long as she lived, she wanted operas to be staged traditionally, and for that reason hated the experiments of the Wagner brothers in Bayreuth as much as she hated less conventional inter-pretations of operatic roles and innovative ways of acting, or of conducting, as in the case of Karajan.[27] Bumbry's modernist essays, as in *Salome*, offended her deeply. In this connection it is significant that Lehmann succeeded in arriving on the American musical scene comparatively late, a full decade after Jeritza, who would annually move back and forth. There was historic justice in this. As Carol Oja has so persuasively shown, one of the hallmarks of modern music since the 1920s, in both the United States and Europe, was that its creators were open to new ideas and repeatedly traveled for inspiration – the Americans, such as Gershwin and George Antheil, to Europe, and the Europeans like Ravel and Milhaud, both of whom were, not coincidentally, extremely fond of jazz, to the United States. Their mobility was manifold – geographic and mental, across the boundaries of many lands and many styles.[28]

Although as an artist Lehmann became hugely successful and as a person people generally liked, even adored her, insecurity always haunted her. Apart from her doubts regarding her vocal range, the reasons for this were many: her humble origins, ever-lasting deficiencies in formal knowledge, difficulties with social integration as she ascended the ladder of artistic prominence, repeated geographic dislocations, the loss of loved ones, and attendant material costs. The rejection by Göring must have shaken her pride immeasurably, and far beyond 1934. Thinking that she was being perceived as a diva, she was worried

about not being able to uphold such an image in public, as she found that rivals such as Jeritza were always managing this without effort. Self-doubt prompted her, especially in America, where there were many Jeritzas in Hollywood, to deny that she had ever been a diva.[29] Deep in her heart she knew that the opposite was true, as her capricious behavior with European agents and the conductor Clemens Krauss, even with Strauss, shows, no less than the attempt to land in Hollywood herself, which would grant her eternal star status.

This insecurity also caused her to engage herself at other levels of creativity, apart from the film business, such as writing poetry, making pottery, painting, and composing prose. Holden got to the point when she said: "A kind of inner restlessness compelled her. She always had to create something, to occupy herself. She could seldom allow herself to do nothing."[30] When the sardonic Erika Mann once referred to the "boundlessness" of her talents and gifts, she was acknowledging Lehmann's multiple creativity on the one hand, while on the other palpably mocking it.[31]

Although at the end of her life Lehmann admitted to Holden, with regard to painting, that she was a dilettante,[32] she was constantly plugging her art, as if she could make her wish to be remembered as a Renaissance Woman come true. To Else Walter she wrote on the occasion of her pulp novel being published that she knew it was kitsch, "but nice kitsch."[33] As she started painting in 1939, something Holden had suggested she should do, she stopped after a short while, and when Holden asked why, Lehmann said it was because she, Holden, was painting better than she did. Henceforth Holden did not touch a paintbrush.[34] Later, only half-jokingly, Lehmann described herself to the Los Angeles critic Goldberg as "the new Raphael."[35] And could not Louis Biancolli, who had published a book about the prima donna Mary Garden, also write up her memoirs?[36] By 1955 Lehmann sincerely believed she was "a great personality" and should have a television hour, and why did this not happen?[37] In 1964, she informed Goldberg that her agent was quite amazed that she could write a book in two months, "when real writers do it in two years."[38] Apart from singing, her own claims to greatness were substantiated when she made sure to inform her friends about the various honors she received as the years passed by: four honorary doctorates, "Woman of the Year" in Santa Barbara, the Austrian accolades, the German medal, and a Lotte Lehmann Hall at UCSB. It was with a calculated naiveté that she announced those tributes, a disingenuousness she also used to manipulate people to her own advantage.

Her greatest manipulation, of course, was of the adoring public, as she art-fully deceived it regarding her Third Reich schemes. But she began manipulating the people around her early. Even in Hamburg she had gone out with Gerstenberg, whom she otherwise despised, to secure private singing engagements. She offered Loewengard's songs in recital halls, knowing that he was one of Hamburg's influential music critics, who would write her up. After she began singing regularly in London, she was constantly followed around by a rich, idiosyncratic Englishwoman by the name of Constance Parrish, who had nothing else to do. She was a sort of older Viola Westervelt-Douglas. According to Lehmann, Parrish drove her "slowly and surely insane."[39] Parrish even pursued the singer to Australia, where she announced herself to the press as "just

a wanderer...wherever Madame Lehmann goes, I go too."[40] But although Lehmann through all those years tried to avoid her and vilified her in front of her friends, she had no qualms about using Parrish whenever she needed her, whether she wanted her typewriter or a proper English translation of songs. In 1938, it was Parrish who held her in her arms behind the London stage when Lehmann had fainted, and later Parrish advanced her several hundred dollars for the assistance of one of her stepsons.[41]

But in the world of high art, where there is shadow, there is light. In the final analysis, Lotte Lehmann transcends all those reservations; she rose above them as the phenomenal soprano that she was. In this respect, from youth to old age, she set one milestone after another. One cannot but admire how she pursued her voice training, against all odds, as a young woman. Having been dismissed from Gerster's studio would have crushed the self-confidence of students with equal or greater talent, but Lotte persevered. In Hamburg, she managed within three years to advance to the status of a prima donna, leaving all her colleagues behind, so that Hans Gregor knew why he was hiring her away to Vienna. And there she impressed Strauss immediately, to the point where he wanted her to premiere *all* his future heroines. At the height of her career, as Lehmann was beginning to perform both in Europe and the United States, the lyricism of her voice brought tears to strong men's eyes. By this time, she had made a virtue of earlier deficiencies such as shortness of breath, which now added to her finesse in phrasing. She was able to negotiate some heights (which she did whenever she sang Mozart, or, for the longest time, in *Fidelio* and Strauss roles), while earlier rhythmic irregularities had fallen away. As she was handed fewer roles in America than she deserved, reviewers like Olin Downes became convinced that the overall quality of her singing was such that it was superfluous to apply criticism to detail. Taking her singing and her superb acting as one, she delivered a *Gesamtkunstwerk* of her own. Lehmann continued her unique success as a denizen of the New World with the invention of a lieder-singing tradition for the American continent; she became the standard. Press reports that New York's Town Hall was chronically overflowing with audiences whenever she performed there attest to her sheer musical greatness. In human terms, Lotte Lehmann undeniably led a full life, over mountain peaks and through valleys. But it was as one of the greatest singers of the twentieth century, if not of all time, that she made music history.

Notes

1. Childhood and Apprentice Years

1. LL, *Anfang und Aufstieg: Lebenserinnerungen* (Vienna, 1937), 7.
2. Barsewisch.
3. Ibid.; *Perleberg und seine Umgebung* (Perleberg, 1911), 14–23; *700 Jahre Perleberger Stadtgeschichte* (Perleberg, 1939), 7–22.
4. "Hotel Deutscher Kaiser," ms., n.d., PA Hotel Deutscher Kaiser, Perleberg.
5. Lotte Pauline Sophie Lehmann birth certificate, Perleberg, March 1, 1888, GC.
6. Barsewisch; Bernhard von Barsewisch and Torsten Foelsch, *Sieben Parks in der Prignitz: Geschichte und Zustand der Gutsparks der Gans Edlen Herren zu Putlitz* (Berlin, 2004), 21–24; Gustav zu Putlitz, *Mein Heim: Erinnerungen aus Kindheit und Jugend* (Berlin, 1885), 32.
7. See his *Rolf Berndt: Schauspiel in fünf Akten* (Berlin, 1881) and *Walpurgis* (Berlin, 1886, 6th ed.).
8. Barsewisch; [Preface in] Gustav zu Putlitz, ed., *Theater-Briefe* (Berlin, 1851), iii–x; zu Putlitz, *Heim*, 19–23, 133–44; Lita zu Putlitz, *Aus dem Bildersaal meines Lebens, 1862–1931* (Leipzig, 1931), 15–17, 42–57; Wolfgang zu Putlitz, *Unterwegs: Nach Deutschland: Erinnerungen eines ehemaligen Diplomaten* (Berlin, 1967, 13th ed.), 31.
9. Barsewisch; Konrad zu Putlitz and Lothar Meyer, eds., *Landlexikon: Ein Nachschlagewerk des allgemeinen Wissens unter besonderer Berücksichtigung der Landwirtschaft, Forstwirtschaft, Gärtnerei, der ländlichen Industrien und der ländlichen Justiz- und Verwaltungspraxis* (Stuttgart, 1911–14), vol. 5, 390; Lita zu Putlitz, 37–38; Wolfgang zu Putlitz, 32.
10. Elisabeth zu Putlitz, *Gustav zu Putlitz: Ein Lebensbild aus Briefen, zusammengestellt und ergänzt*, vol. 3 (Berlin, 1894), 1–2; Lita zu Putlitz, 13, 16.
11. Max von Seemen, *Die Rechtsverhältnisse des niederen Adels in den landrechtlichen Gebieten Preussens* (Berlin, 1905), esp. 4–13. Also Heinz Reif, *Adel im 19. und 20. Jahrhundert* (Munich, 1999).
12. Von Barsewisch to author, Feb. 23, 2005; Gerhard Masur, *Imperial Berlin* (New York, 1970), 47; critically: Hans-Ulrich Wehler, *Deutsche Gesellschaftsgeschichte*, vol. 3 (Munich, 1995), 725–26, 806–7, 822–23.
13. Lita zu Putlitz, 62–63, 183.
14. Ibid., 130, 156; Erich Eyck, *A History of the Weimar Republik*, vol. 1 (New York, 1970), 147–60.
15. Barsewisch; *Perleberg*, 6; Lita zu Putlitz, 97.
16. Jobst von Saldern, "Elisabeth von Saldern," ms., n.d., APA; Mathilde Gräfin von Keller, *Vierzig Jahre im Dienst der Kaiserin: Ein Kulturbild aus den Jahren 1881–1921* (Leipzig, 1935), 272; *The Kaiser's Daughter: Memoirs of H. R. H. Viktoria*

Luise, Duchess of Brunswick and Lüneburg, Princess of Prussia (Englewood Cliffs, NJ, 1977), 41.

17. Wehler, 863; LL, *Anfang*, 33; Thomas Nipperdey, *Deutsche Geschichte, 1866–1918*, vol. 1 (Munich, 1990), 374–81.

18. "Fragebogen zur Durchführung des Gesetzes zur Wiederherstellung des Berufs-beamtentums vom 7.4.33"; KL to LL, Nov. 18, 1924, GC.

19. KL to LL, March 30, April 19, 1924; ML to LL, March 29, [1924], GC.

20. ML to LL, May 12, 1922, GC.

21. KL to MH, Sept. 11, 1923; FL to LL, Nov. 23, 1944, GC; LL, *Anfang*, 7.

22. KL to LL, March 15, 1923, GC.

23. LL, *Anfang*, 14; LL to Delafield, [post stamped Nov. 4, 1942]; FL to LL, Dec. 25, 1942, [April 1, 1944], GC; LL, "Growing Up," n.d., CW; Holden.

24. LL to Schornstein, [Sept. 1970], GC; LL, "Growing Up," n.d., CW; Holden.

25. See LL to Lachmann, May 31, 1963, ATW/TNLL.

26. Robert B. Douglas, *Sophie Arnould: Actress and Wit* (Paris, 1898); LL, "Growing Up," n.d., CW; LL, *Anfang*, 9, 13–14; FL to LL, June 28, 1945, GC.

27. LL to CH, [fall 1940], CU/1; LL, "Growing Up," n.d., CW; LL, *Anfang*, 9, 17, 22–23.

28. *Kreisblatt für die Westprignitz*, Jan. 11, 1896, Aug. 29, 1900.

29. Ibid., July 8, Oct. 12, 1902.

30. Ibid., Dec. 25, 1898; "Hotel Deutscher Kaiser," ms., n.d., PA Hotel Deutscher Kaiser, Perleberg.

31. LL, "Growing Up," n.d., CW; LL, *Anfang*, 20–21 (quote).

32. *Kreisblatt für die Westprignitz*, Jan. 10, 1902; *Die Stadt Perleberg in den letzten hundert Jahren* (Perleberg, [1908]), 23–24.

33. Brünig to LL, April 12, 1951, GC.

34. Ratig to LL, April 3, 1968; LL to Ratig, April 10, 1968, HMP/Lehmann; LL, *Anfang*, 25–26 (quote).

35. FL to LL, Oct. 2, 1944, Nov. 16, 1945, Aug. 13, 1949, GC; LL, "Growing Up," n.d., CW; LL, *Anfang*, 8, 11.

36. Keller, 72–75; *Kreisblatt für die Westprignitz*, March 20, 1888.

37. *Kreisblatt für die Westprignitz*, March 22, April 7, 1888; David Clay Large, *Berlin* (New York, 2000), 52–53.

38. *Kreisblatt für die Westprignitz*, June 6, 1896, Feb. 2, 1902.

39. Ibid., Feb. 2, 1902, July 1, 10, 1902, Oct. 12, 1902.

40. Ibid., Jan. 26, 1902.

41. Ibid., April 16, 1898, Jan. 29, 1902.

42. LL, *Anfang*, 16, 20.

43. Large, 103.

44. Ibid., 10.

45. LL, *Anfang*, 29.

46. Large, 62–63.

47. Ibid., 57–61; Masur, 211–15 (quote 212); Peter Fritzsche, *Reading Berlin 1900* (Cambridge, MA, 1996), 200.

48. Fritzsche, 166–67; Döblin quoted in Peter Jelavich, *Berlin Alexanderplatz: Radio, Film and the Death of Weimar Culture* (Berkeley, 2006), 3.

49. Fritzsche, 66–67, 163; Large, 86–87.

50. Robin Lenman et al., "Imperial Germany: Towards the Commercialization of Culture," in Rob Burns, ed., *German Cultural Studies: An Introduction* (New York, 1996), 30–42.

51. Gordon A. Craig, *Theodor Fontane: Literature and History in the Bismarck Reich* (New York, 1999); Peter Paret, *Berlin Secession: Modernism and Its Enemies*

in Imperial Germany (Cambridge, MA, 1980), 9–199; Masur, 225–27; Large, 64–65.

52. Quoted in Johannes Penzler, ed., *Die Reden Kaiser Wilhelms II.*, vol. 3 (Leipzig, [1907]), 61.

53. Strauss to his parents, Berlin, Oct. 6, 1903, in Willi Schuh, ed., *Richard Strauss: Briefe an die Eltern, 1882–1906* (Zurich, 1954), 280; Michael Walter, *Richard Strauss und seine Zeit* (Laaber, 2000), 186–87, 216–20; Masur, 238–39.

54. Geraldine Farrar, *Such a Compulsion: The Autobiography of Geraldine Farrar* (New York, 1938), 35 (quote); Klaus W. Jonas, *The Life of Crown Prince William* (Pittsburgh, 1961), 26.

55. Frida Leider, *Das war mein Teil: Erinnerungen einer Opernsängerin* (Berlin, 1959), 27; Jelavich, 3.

56. LL, *Anfang*, 28, 33, 42; LL, "Geraldine Farrar," n.d., CW; Large, 94.

57. Leider, 22; *Kreisblatt für die Westprignitz*, June 6, 1896.

58. LL, "Growing Up," n.d., CW; LL, *Anfang*, 28–29, 35–37.

59. LL to "Meine Lieben," Feb. 2, 1904, HMP/Lehmann.

60. LL, *Anfang*, 37–38, 57.

61. Ibid., 35–37.

62. LL calls this student Erna Tiedke in her memoirs, Else Thiele in "Growing Up," n.d., CW.

63. LL, *Anfang*, 41–48.

64. LL, "Growing Up," n.d., CW; LL, *Anfang*, 44–45, 49, 52.

65. See LL, "Mein Bruder," n.d., CW; FL to LL, Oct. 29, 1944, GC; G. M., "Bei...," [1917], NC; LL, *Anfang*, 49–52.

66. Regierung to LL, June 24, 1907, GC; LL, *Anfang*, 50–55; Dietmar Schenk, *Die Hochschule für Musik zu Berlin: Preussens Konservatorium zwischen romantischem Klassizismus und Neuer Musik, 1869–1932/33* (Stuttgart, 2004), 49–52, 68–69, 103, 123–34.

67. LL, *My Many Lives* (New York, 1948), 55.

68. LL, *Anfang*, 57; Schenk, 291.

69. LL, *Anfang*, 62; Schenk, 59.

70. Irving Kolodin, *The Metropolitan Opera, 1883–1966: A Candid History* (New York, 1966, 4th ed.), 52; Andrea Olmstead, *Juilliard: A History* (Urbana, 1999), 23; Jens Malte Fischer, *Grosse Stimmen: Von Enrico Caruso bis Jessye Norman* (Stuttgart, 1993), 170.

71. LL, *Anfang*, 62–65.

72. LL, *Lives*, 56 (quote), 90.

73. LL, *Anfang*, 66–75; Saldern to LL, [April 20, 1908]; Reinhold to LL, [June 23, 1908]; Joachim zu Putlitz to LL, Sept. 16, 1908; LL to Bake [draft], Jan. 3, 1909, GC. (Note: As could be verified, LL's drafts were like carbon copies of letters she actually sent.)

74. LL to Mallinger [draft], Jan. 9, 1909, GC; LL, *Anfang*, 75.

75. Elizabeth Forbes, "Mallinger, Mathilde," *Grove*.

76. Mallinger to LL, Feb. 18, 1909, and to KL, Feb. 25, 1909, GC; LL, *Anfang*, 76, 78–79; Albert Hoppe, "Episoden aus dem Leben eines alten Keilers," ms., n.d., attached to Barsewisch to author, Jan. 20, 2005 (quote). See Erika von der Schulenburg, née zu Putlitz, in Berndt W. Wessling, *Lotte Lehmann: Mehr als eine Sängerin* (Salzburg, 1969), 44–46.

77. LL, *Anfang*, 77–78, 80–81.

78. Ibid., 81 (quotes), 82.

79. LL to EP, March 7, 1909, and to Konrad zu Putlitz, [spring 1909]; EP to LL, March 8, 1909, GC; LL, *Anfang*, 84–87 (quote 85).

Notes to Pages 14–18

80. LL to her parents and brother, Aug. 12, 1909, and to FL, Aug. 13, 1909, GC; LL, *Anfang*, 88–91.
81. See *Die neuen Königl. Hof-Theater zu Stuttgart: Zur Weihe und bleibenden Erinnerung*…(Stuttgart, [1912]), esp. Baron [Joachim] zu Putlitz, "Zur neuen Arbeit," 7–12; Marcel Prawy, *The Vienna Opera* (New York, 1970), 88.
82. LL to Dahn, Jan. 3, 1910; Dahn to LL, Jan. 21, 1910, GC; LL, *Anfang*, 82–83, 90.
83. LL to Bartels, Sept. 30, 1909; Bartels to LL, Oct. 5, 1909; Saldern to LL, [Nov. 19, 1909], GC.
84. Harder to LL, Feb. 3, 7, 1910; LL to FL, March 22, 1910; LL to Konrad zu Putlitz, March 26, 1910, GC; LL, *Anfang*, 91–92.
85. LL to Harder [draft], June 4, 1910; Mallinger to LL, June 14, 1910; Harder to LL, June 27, 1910; LL to Exzellenz [draft], [July 1910], GC; LL, *Anfang*, 92.
86. Harder to LL, July 1, 1910, GC.
87. Mallinger to LL, July 5 (quote) and 29, 1910; FL to LL, [1945], GC.
88. *Statistisches Jahrbuch für die Freie und Hansestadt Hamburg* (Hamburg, 1926), 9; Adolf Freydag, *Eine hamburgische Jugend um die Jahrhundertwende 1900* (Hamburg, 1963), 118, 122.
89. Ernst Baasch, *Geschichte Hamburgs, 1814–1918* (Stuttgart, 1925), vol. 2, 73; Freydag, 136–38.
90. Baasch, 352–53.
91. Freydag, 112–13; Edith Oppens, *Hamburg zu Kaisers Zeiten* (Hamburg, 1976), 202.
92. Richard J. Evans, *Death in Hamburg: Society and Politics in the Cholera Years, 1830–1910* (New York, 1987); Baasch, 33–34, 37; Eckart Klessmann, *Geschichte der Stadt Hamburg* (Hamburg, 1981, 2nd ed.), 526–30, 559.
93. Freydag, 165; Baasch, 72; Oppens, 12, 16, 22–23, 149; Klessmann, 558–59.
94. Freydag, 88; Klessmann, 255–56.
95. Lamar Cecil, *Albert Ballin: Business and Politics in Imperial Germany, 1888–1918* (Princeton, 1967), 36–37.
96. Baasch, 106–8; 335, 353; Günter Albrecht et al., *Lexikon deutschsprachiger Schriftsteller von den Anfängen bis zur Gegenwart*, vol. 1 (Leipzig, 1972), 342.
97. Freydag, 147; Oppens, 74–77; Albrecht et al., *Lexikon*, vol. 1, 150; vol. 2 (1974), 44–45; Mathias Mainholz et al., *Artist, Royalist, Anarchist: Das abenteuerliche Leben des Baron Detlev Freiherr von Liliencron, 1844–1909* (Herzberg, 1994); Sabine Henning et al., *WRWlt – o Urakkord: Die Welten des Richard Dehmel* (Herzberg, 1995). Liliencron and Dehmel are omitted from David E. Wellbery et al., eds., *A New History of German Literature* (Cambridge, MA, 2004).
98. Carl E. Schorske, *Fin-de-Siècle Vienna: Politics and Culture* (New York, 1981), 358.
99. Paret, 204, 218.
100. Baasch, 348–50; Paret, 12, 71, 127, 224; Carolyn Kay, *Art and the German Bourgeoisie: Alfred Lichtwark and Modern Painting in Hamburg, 1886–1914* (Toronto, 2002), 6, 37, 41–69; Jennifer Jenkins, *Provincial Modernity: Local Culture and Liberal Politics in Fin-de-Siècle Hamburg* (Ithaca, 2003), 57–78.
101. Baasch, 350.
102. Kay, 76–96; Jenkins, 186.
103. Kay, 121.
104. Freydag, 70, 119; Baasch, 338; Oppens, 84–88.
105. Baasch, 347; Heinrich Chevalley, *Hundert Jahre Hamburger Stadt-Theater* (Hamburg, 1927), 159–61; Max W. Busch in Busch and Peter Dannenberg, eds., *Die Hamburgische Staatsoper* (Zurich, 1990), vol. 1, 83; Michael H. Kater, *The Twisted Muse: Musicians and Their Music in the Third Reich* (New York, 1997), 104.

106. Jürgen Schebera, *Gustav Brecher und die Leipziger Oper, 1923–1933* (Leipzig, 1990), 27–31; Gustav Brecher, *Opern-Übersetzungen* (Berlin, 1911), 4–13.

107. Peter Heyworth, *Otto Klemperer: His Life and Times*, vol. 1 (Cambridge, 1983), 49–50; Busch, 83; Chevalley, 160–63, 187–88.

108. Chevalley, 163–75 (quote 175).

109. Heyworth, 51–52.

110. Facs. in Berndt W. Wessling, *Lotte Lehmann: "Sie sang, dass es Sterne rührte"*: *Eine Biographie* (Cologne, 1995), 44.

111. LL to FL, Sept. 3, 1910 (quote), Sept. 7, 16; KL to FL, Sept. 3, 1910, GC; LL, *Anfang*, 99.

112. Reviews by M. L. [Max Loewengard] and R. Ph. (quotes) in NC; LL to FL, Sept. 24, 26, 1910; ML to FL, [Oct. 1910], GC.

113. "Hamburger Stadt-Theater," Nov. 27, 1910; LL to FL, Sept. 26, 1910; KL to FL, Nov. 27, 1910, GC; reviews, "Die lustigen Weiber...," NC; LL, *Anfang*, 100 (quote).

114. R. Ph., "Rosenkavalier"; M. L., "Rosenkavalier" (quote), [both April 1911], NC; Joachim E. Wenzel, *Geschichte der Hamburger Oper, 1678–1978* (Brunswick, [1978]), 248.

115. Hans Loewenfeld, *Leonhard Kleber und sein Orgeltabulaturbuch als Beitrag zur Geschichte der Orgelmusik im beginnenden XVI. Jahrhundert* (Hilversum, 1968, 1st pr. 1897), esp. 5–6, 82; Peter William, *ibid.*, n.p.; Loewenfeld, *Kleber*, n.p.; Chevalley, 188–96; Heyworth, 69.

116. Reviews, "Liederabend..."; "Geburtstag...," [1911], NC.

117. *Hamburgischer Correspondent, Neue Hamburger Zeitung*, [Oct. 1912], NC; Hickling.

118. LL to EP, Oct. 18, 1912, GC; LL, *Anfang*, 115.

119. LL to EP, Dec. 2, 1912 (1st quote); LL to Lotte Klemperer, Oct. 5, 1972, GC; *Hamburger Fremdenblatt, Hamburgischer Correspondent*, [Dec. 1912] (2nd and 3rd quotes), NC; Martin Anderson, ed., *Klemperer on Music: Shavings from a Musician's Workbench* (Exeter, 1986), 195–96; LL, *Anfang*, 117–19; Hickling.

120. LL, *Lives*, 31 (quote); G. M., "Bei Lotte Lehmann," [1917], NC.

121. Reviews in *Hamburger Nachrichten, Hamburgischer Correspondent*, [1913], NC.

122. "Schauspiele," May 15, 1913, ATW/16.

123. M. L., "Lohengrin," NC. LL's eighth Elsa was performed on Sept. 3, 1913 (Hickling).

124. Reviews by Chevalley and others [1913] in NC. For Loewenfeld, see R. Ph. in *General-Anzeiger*, Sept. 8, 1913.

125. Wagner to LL, Dec. 1, 1913; Festspielleitung Bayreuth to LL, Dec. 2, 1913; LL to EP, April 8, 1914, GC.

126. Reviews, Dec. 29, 30, 1913, NC.

127. LL to EP, Dec. 28, 1913, and Baron Konrad Putlitz, Jan. 22, 1914 (quote), GC.

128. Axel Schröder, Landesarchiv Berlin, to author, May 21, 2003.

129. LL/K.k. Hof-Operntheater, contract, March 11, 1914, ATW/15; LL to EP, Dec. 2, 1913, GC; Hans Gregor, *Die Welt der Oper – die Oper der Welt: Bekenntnisse* (Berlin, 1931), 176; LL, *Anfang*, 121–22; Leider, 44. LL had sung Micaëla eight times in autumn 1913, before writing EP (Hickling).

130. LL/Beecham Opera Co. contract, London, April 6, 1914, ATW/3; LL, answers to questions by Charles Moses, n.d., BC; LL in *Wiener Neues Journal*, Oct. 29, 1916; LL, *Anfang*, 124; Harold Rosenthal, *Two Centuries of Opera at Covent Garden* (London, 1958), 388, 424 (quote); Hickling.

131. "Probegastspiel," contract as in n. 129.

132. LL to EP, Oct. 18, 22, 1914, GC.

133. LL to EP, April 8, 1914, GC; *Wiener Fremdenblatt*, Oct. 31, 1914 (quote by R. B.); reviews, [Oct. 1914], NC.

134. LL in *Neues Wiener Journal*, Oct. 29, 1916; LL, *Anfang*, 124; Pfitzner to LL, June 17, 1914, GC; Karl Wolff, "Kölner...," June 29, [1914], NC.

135. LL contract, May 20, 1914, ATW/2; LL, "Richard Tauber," n.d., CW; LL, *Anfang*, 124–27.

136. LL–Harvith interview, Jan. 2, 1975, in John Harvith and Susan Harvith, eds., *Edison, Musicians and the Phonograph: A Century in Retrospect* (New York, 1987), 71 (quote); Horst Wahl, "Lotte Lehmann's Earliest Recordings," *LLLN*, 3, no. 1 (1991), MAWA; Gary Hickling, "Lotte Lehmann Discography," in Beaumont Glass, *Lotte Lehmann: A Life in Opera and Song* (Santa Barbara, 1988), 304. The arias can be heard on the three-disk set *The Young Lotte Lehmann*, Preiser Records, no. 89302, Feb. 7, 2005.

137. Chevalley, 198–99; facs. in Wenzel, 88; LL to EP, Sept. 8, 1914, GC.

138. Chevalley, 199.

139. Reviews: R. Ph., "Rosenkavalier"; W. Z., "Stadttheater," [Oct. 1914]; M. L., "Figaro" (of Nov. 14, 1914 [Hickling]); "Tannhäuser," [March 30, 1915], NC; LL to Konrad zu Putlitz, Feb. 21, 1915, GC.

140. "Feier," Nov. 7, 1915; "Wohltätigkeits-Konzert," Feb. 3, 1916 [reviews NC]; "Konzert," Feb. 20, 1916, ATW/16.

141. LL to EP, Nov. 29, 1914, GC; "Lotte...," [Dec. 1914], NC.

142. LL in *Allgemeine Künstlerzeitung*, vol. 5, no. 31 (1916), n.p.

143. "Eugen...," [March 1916], NC (quote); LL, "Hamburg," n.d., CW; LL in *Neues Wiener Journal*, Oct. 29, 1916.

144. Reviews, "Abschieds-Liederabend...," June 3, 1916, ATW/16; "Abschiedskonzert...," [June 1916], NC.

145. Reviews of Drill-Oridge as Ortrud in *Lohengrin* (Sept. 3, Oct. 1913) and as Klytämnestra in *Iphigenie* (Sept. 8, 1913), NC; Chevalley, 195. Also Freydag, 172.

146. M. L. in "Lohengrin" (quote); "Hamburger...," Sept. 3, 1913, NC.

147. Reviews (Sept./Oct. 1913), NC.

148. W. Z. in *Neue Hamburger Zeitung*, Sept. 4, 1913.

149. W. Z. in "Stadt-Theater...," [Sept. 30, 1914], NC.

150. M. in "Tannhäuser...," [March 31, 1915], NC.

151. *Hamburger Nachrichten*, Feb. 20, 1916.

152. M. L. in "Tannhäuser...," [April 8, 1916], NC.

153. R. Ph., "Rosenkavalier...," [April 1911], NC.

154. Reviews for Sept. 1913 (quote from Sept. 3), NC; Ronald Crichton, "Weingartner, Felix,"*Grove*.

155. See Hamburg reviews of 1914, NC.

156. Hamburg reviews (1914–16), NC.

157. LL to EP, Oct. 18, 1911, GC (1st quote); Alfred Clayton, "Goldmark, Karl," *Grove* (2nd quote).

158. LL to EP, Oct. 18, 1911, GC.

159. "Konzert...," March 7, 1912, ATW/16; LL to Jaensch, July 20, 1912, GC; LL, *Anfang*, 113. LL performed Loewengard publicly at least one more time; see *Hamburger Fremdenblatt*, Feb. 8, 1913, NC. On Loewengard, see Donna K. Anderson, "Griffes, Charles T.," *Grove*.

160. Hans Loewenfeld, *Unser Opernrepertoire: Ein Vortrag* (Leipzig, 1911), 20 (last quote), 21–25 (1st and 2nd quotes), 26–37.

161. M. L., "Hamburger...," NC.

162. W. Z., "Stadttheater...," [Dec. 9, 1915], NC.

163. R. Ph. in his critique, [1916] (quote), NC. Also see *Hamburger Fremdenblatt*, Feb. 8, 1916; Loewenfeld, *Opernrepertoire*, 17.

164. *Die toten Augen* reviews in newspapers, [March 1916], NC.

165. LL to FL, Sept. 1, Oct. 27, 31, Nov. 24, 1910; KL to FL, Sept. 3, Nov. 10, 15, 1910; ML to FL, Sept. 7, Oct. 13, 1910, GC.

166. LL to EP, May 1, Sept. 8, 1914, April 18, 1915; FL to LL, July 10, 1946, GC.

167. LL to FL, Nov. 5, 1910, GC.

168. LL to FL, [end Nov. 1910], GC.

169. A larger but otherwise comparable Isestrasse flat is described in Oppens, 110–11, for 1907. It cost 1,400 marks and was inhabited by a young married lawyer with an annual salary of 3,600 marks, on which he could not afford it, so that his parents and in-laws had to help. (LL's flat cost about 700 marks.) – See LL to EP, Aug. 24, 1910; ML to FL, Sept. 7, 1910; KL to FL, Nov. 26, 1910; LL to FL, Dec. 4, 1910, GC; LL, *Anfang*, 114–15.

170. KL to FL, Sept. 9, Nov. 26, 1910, GC.

171. KL to FL, Sept. 2, 1910, GC.

172. LL to FL, Oct. 1, 1910, GC. Contrary to the undocumented book by Glass, 46, Barsewisch – a more credible authority on the Putlitz family – asserted in his interview that the monies were never repaid.

173. LL to FL, Sept. 1, 1910; KL to FL, Sept. 2, 1910; LL to EP, June 14, 17, 1912, GC.

174. EP to LL, [Aug. 29, 1910], ATW/15.

175. LL to FL, Sept. 16 (quote), Oct. 17, 27, 31, Nov. 24, 1910; KL to FL, Nov. 26, 1910, GC.

176. Hamburg-Amerika-Linie to LL, March 9, 1914; Kurdirektion Bad Neuenahr to LL, May 22, 1914, GC; LL, *Anfang*, 124.

177. Baasch, 165; Oppens, 203–5; Large, 131–32.

178. LL to EP, Sept. 8, Dec. 21 (quote), 1914, Feb. 21, 1915, GC.

179. LL/Stadttheater contract, Dec. 3, 1914, ATW/2; LL to EP, Dec. 21, 1914, GC; Gerd Puritz, *Elisabeth Schumann: A Biography* (London, 1993), 72.

180. LL in Studs Terkel, *And They All Sang: Adventures of an Eclectic Disc Jockey* (New York, 2005), 280.

181. LL to FL, Sept. 3 (quote), 7, 12, Nov. 28, 1910, GC.

182. LL, *Lives*, 31.

183. LL, "Paul Schwarz," n.d., CW.

184. "Die Zauberflöte," Sept. 2, 1910, facs. in Wessling, *Sterne*, 44. LL falsely writes in *Anfang*, 95, that the First Boy was her third best friend, Magda Lohse (later Magda Hansing).

185. LL, *Lives*, 32. Also see LL to FL, Nov. 28, 1910, GC.

186. LL, "Twelve Singers and a Conductor," in Charles Osborne, ed., *Opera 66* (London, 1966), 65 (1st quote); Nigel Douglas, *More Legendary Voices* (London, 1994), 234 (2nd quote).

187. LL to FL, Sept. 1 and 3 (quote), 1910, GC.

188. LL to FL, Nov. 21, 22, 1910; KL to FL, Nov. 26, 1910; ML to FL, Dec. 1, 1910, GC.

189. Puritz, 48–49; LL, *Anfang*, 101–2; LL, *Singing with Richard Strauss* (London, 1964), 129; LL to FL, Sept. 1, 1910, GC.

190. LL to Jaensch, Feb. 23, 1912, GC. Also see LL, *Anfang*, 101–2.

191. Heyworth, 52.

192. See the apt judgment of Fischer, 171.

193. Photograph in Wessling, *Sängerin*, 30; photograph 9 in Wessling, *Sterne*; Busch, 109.

194. With respect to this for Hamburg at that time, see Oppens, 171–72, and LL's own wise reflections in *Lives*, 10. On Voigt, *NYT*, March 14, 2004.
195. LL to FL, Sept. 1, 1910, GC.
196. See LL to FL, Sept. 7, 24, 1910, GC. Also Busch, 109.
197. LL, *Lives*, 34; LL to CH, June 15, 1951, CU/2.
198. LL to Waage, March 27, 1943; LL to Tubeuf, June 29, 1969, GC. Quote is from Schornstein.
199. See Shirlee Emmons, *Tristanissimo: The Authorized Biography of Heroic Tenor Lauritz Melchior* (New York, 1990), 127–28.
200. Thus the observation of one of LL's colleagues, as reported by LL to FL, Nov. 8, 1910, GC.
201. LL to FL, Sept. 1 (1st quote), 24, Oct. 17, 31, Nov. 5, 8, 1910, GC; LL, *Anfang*, 95 (2nd quote).
202. LL to FL, Sept. 24, Oct. 1, 16, 17, 22, 27, 31, Nov. 8, 24, 1910; KL to FL, Nov. 10, 15, 1910, and to LL, April 8, 1924, GC; LL, *Anfang*, 100 (quote).
203. LL to Jaensch, June 16, 1912, GC (quotes).
204. LL to FL, Sept. 26 (1st quote), Oct. 16 (2nd quote), 17 (3rd quote), Nov. 28, 1910; KL to FL, Nov. 24 and 27, 1910, GC.
205. LL to FL, Sept. 16, Oct. 17, 22, 27, Nov. 5, 8, 24, Dec. 12, 1910, GC; LL, "Die Dirigenten," n.d., CW; LL, *Anfang*, 95.
206. Klemperer to LL, June 26, 1961, GC. The rhyme read: "Es waren zwei Königskinder / Die hatten einander so lieb / Sie konnten zusammen nicht kommen / denn das Wasser war viel zu tief."
207. Puritz, 45.
208. LL to EP, Dec. 31, 1912, GC (quote), also Dec. 2, 1912, GC.
209. Heyworth, 76–79; Puritz, 54–60.
210. The official, mendacious version is in LL, *Anfang*, 109–11; LL, "Caruso," n.d., CW; LL, "Twelve Singers," 63–64. The truth is contained in LL to EP, Oct. 18, 25, 1911; LL to Jaensch, Oct. 20, 1911, GC.
211. Barsewisch.
212. Hickling; LL to EP, April 8, 1914, GC (quote). See LL to Konrad zu Putlitz, April 19, 24, 1914, GC.
213. LL to Konrad zu Putlitz, Jan. 22, 1914, GC.
214. Barsewisch.
215. LL's correspondence with Jaensch, 1911–16, GC. Typical letters are dated Aug. 26, Sept. 3, Oct. 20, 1911, June 16, 1912, July 9, 1914.
216. LL to Jaensch, Aug. 26, 1911, GC.
217. LL to FL, Nov. 28, 1910; LL to de Peterse, May 25, June 23, 1916; Mia de Peterse, "An Lotte," June 1916; FL to LL, June 28, 1945, GC; LL, *Anfang*, 132–34.

2. Rise to Fame in Vienna

1. Robert Pick, *The Last Days of Imperial Vienna* (New York, 1976), 1–5 (Adler's quotes); Eric J. Hobsbawm, *Interesting Times: A Twentieth-Century Life* (New York, 2005), 3, 132 (last quote); Manfried Rauchensteiner, *Der Tod des Doppeladlers: Österreich-Ungarn und der Erste Weltkrieg* (Graz, 1994, 2nd ed.), 36, 149–50.
2. *Illustrirtes Wiener Extrablatt*, Oct. 4, 1916; *Ostdeutsche Rundschau*, Oct. 5, 1916; *Neuigkeits-Welt-Blatt*, Oct. 5, 1916.
3. *Illustrirtes Wiener Extrablatt*, Sept. 30, 1916; LL, *Anfang und Aufstieg: Lebenserinnerungen* (Vienna, 1937), 141.

4. Marie Gutheil-Schoder, *Erlebtes und Erstrebtes: Rolle und Gestaltung* (Vienna, 1937), 6–9; LL–Fischer-Karwin interview, 1969 (tape, PA Hertha Schuch).

5. LL, *Singing with Richard Strauss* (London, 1964), 21 (quotes); Hans Gregor, *Die Welt der Oper – Die Oper der Welt: Bekenntnisse* (Berlin, 1931), 177–79.

6. LL, *Anfang*, 144.

7. *Hamburger Fremdenblatt*, Nov. 25, 1916.

8. LL to Jaensch, Nov. 3, 1916, GC (1st quote); LL to Uebel, Aug. 31, 1970, GC (2nd quote); LL, "Blitzlichter," n.d.; LL, "Richard Strauss," n.d., CW.

9. *Neue Freie Presse*, Oct. 5, 1916. Also see *Wiener Allgemeine Zeitung*, Oct. 5, 1916; *Illustrirtes Wiener Extrablatt*, Oct. 5, 1916; *Fremden-Blatt*, Oct. 5, 1916; *Der Abend*, Oct. 5, 1916; *Ostdeutsche Rundschau*, Oct. 6, 1916; *Wiener Montags-Journal*, Oct. 9, 1916.

10. Stefan Zweig, *Die Welt von Gestern: Erinnerungen eines Europäers* (Berlin, 1965), 110.

11. William M. Johnston, *The Austrian Mind: An Intellectual and Social History, 1848–1938* (Berkeley, 1983), 141–43 (quote 142).

12. Carl E. Schorske, *Fin-de-Siècle Vienna: Politics and Culture* (New York, 1981), 24–115.

13. Ibid., 85.

14. Ibid., 84.

15. Johnston, 54. See Arthur Schnitzler, "Leutnant Gustl," in Schnitzler, *Casanovas Heimfahrt* (Frankfurt am Main, 1973), 29–56.

16. See Schorske, 214, 238.

17. Reinhold Federmann in Bertha Zuckerkandl, *Österreich intim: Erinnerungen, 1892–1942* (Vienna, 1981), 214.

18. Theophila Wassilko, *Fürstin Pauline Metternich* (Vienna, [1958]), 266–86.

19. Ibid., 276.

20. Pick, 212; Zuckerkandl, 87–89; Ernst Hanisch, *Der lange Schatten des Staates: Österreichische Gesellschaftsgeschichte im 20. Jahrhundert* (Vienna, 1994), 247.

21. Wassilko, 272; Johnston, 126; George E. Berkley, *Vienna and Its Jews: The Tragedy of Success, 1880s-1980s* (Cambridge, MA, 1988), 5; Jens Malte Fischer, *Gustav Mahler: Der fremde Vertraute: Biographie* (Vienna, 2003), 290–304; Anna Bahr-Mildenburg, *Erinnerungen* (Vienna, 1921), 31–58.

22. Marcel Prawy, *The Vienna Opera* (New York, 1970), 87; Paul Stefan, *Die Wiener Oper* (Vienna, 1922), 102–3.

23. Wilhelm Beetz, *Das Wiener Opernhaus, 1869 bis 1945* (Zurich, 1949), 59.

24. Egon Seefehlner, "Die Direktoren und ihre Ensembles," in Andrea Seebohm, ed., *Die Wiener Oper: 350 Jahre Glanz und Tradition* (Vienna, 1986), 90.

25. Heinrich Kralik, *Die Wiener Oper* (Vienna, 1962), 75.

26. Richard Specht, *Das Wiener Operntheater: Von Dingelstedt bis Schalk und Strauss* (Vienna, 1919), 58–65; Bruno Walter, *Theme and Variations: An Autobiography* (New York, 1966), 188–90. Also see Stefan, 106; Prawy, 88, 94–95.

27. Walter H. Perl, ed., *Hugo von Hofmannsthal – Leopold von Andrian: Briefwechsel* (Frankfurt am Main, 1968), 265–70, 286; Stefan, 104–12; Prawy, 88–101; Alexander Witeschnik, *Wiener Opernkunst: Von den Anfängen bis zu Karajan* (Vienna, 1959), 176–80; Seefehlner, 90–94.

28. Günter Brosche, ed., *Richard Strauss – Franz Schalk: Ein Briefwechsel* (Tutzing, 1983), 22–23, 27, 29; Franz Grasberger, *Richard Strauss und die Wiener Oper* (Tutzing, 1969), 38; Grasberger, ed., *Der Strom der Töne trug mich fort: Die Welt um Richard Strauss in Briefen* (Tutzing, 1967), 232.

29. Grasberger, *Strauss*, 40, 68–72; Gerhard Botz, *Gewalt in der Politik: Attentate, Zusammenstösse, Putschversuche, Unruhen in Österreich, 1918 bis 1938* (Munich, 1983), 33.

30. LL, *Anfang*, 139; LL/K.k. Hof-Operntheater contract , March 11, 1914, ATW/15.

31. LL, *Anfang*, 140; Brosche, 19.

32. *Neues Wiener Journal*, Aug. 19, 1916.

33. *Die Zeit*, Aug. 19, 1916 (1st quote); *Österreichische Volks-Zeitung*, Aug. 18, 1916 (2nd quote); *Deutsches Volksblatt*, Aug. 19, 1916; *Neue Freie Presse*, Aug. 19, 1916; *Sport und Salon*, Sept. 2, 1916.

34. LL, *Anfang*, 140.

35. Dési Halban, ed., *Selma Kurz: Die Sängerin und ihre Zeit* (Stuttgart, 1983); Kralik, 131; Prawy, 69; Jens Malte Fischer, *Grosse Stimmen: Von Enrico Caruso bis Jessye Norman* (Stuttgart, 1993), 67–68.

36. LL, *My Many Lives* (New York, 1948), 211 (quote); Kralik, 133; Fischer, *Stimmen*, 381–82; Josef Krips and Harrietta Krips, *Erinnerungen: Ohne Liebe kann man keine Musik machen* (Vienna, 1994), 124–25.

37. Desmond Shawe-Taylor, "Slezak, Leo," *Grove*; Kralik, 131–32; LL, "Leo Slezak," n.d., CW.

38. LL, "Twelve Singers and a Conductor," in Charles Osborne, ed., *Opera 66* (London, 1966), 73 (quote); Gutheil-Schoder, 18–22; Marie Gutheil-Schoder, "Mahler bei der Arbeit," *Der Merker*, 3, no 1 (Jan.–March 1912): 165; Kralik, 130–31; Prawy, 69; Brendan G. Carroll, *The Last Prodigy: A Biography of Erich Wolfgang Korngold* (Portland, OR, 1997), 80; Fischer, *Mahler*, 375; Jens Malte Fischer to author, Aug. 5, 2005.

39. Willi Schuh, ed., *Richard Strauss – Hugo von Hofmannsthal: Briefwechsel: Gesamtausgabe* (Zurich, 1970, 4th ed.), 261, 335, 354, 363; Brosche, 10, 16, 18, 22.

40. LL, *Lives*, 131–32 (quote); Nigel Douglas, *Legendary Voices* (New York, 1995), 157–70; Kralik, 136–37; Fischer, *Stimmen*, 207–8.

41. Hobsbawm, 10.

42. Maria Jeritza, *Sunlight and Song: A Singer's Life* (New York, 1977, 1st pr. 1924), 44–46; 62–63 (quote). In the imprimatur of that 1977 version, her birth year is given as 1893, in the United States often as 1891. See *NYT*, July 11, 1982; Jeritza interview, newspaper excerpt, [1928], WTA; William Armstrong, *The Romantic World of Music* (New York, 1922), 199–204; Prawy, 97, 108.

43. Jeritza, 145–47; *Archiv für publizistische Arbeit*, Sept. 23, 1937; LL, "Singers," 73; Armstrong, 209–10; Nigel Douglas, *More Legendary Voices* (London, 1994), 109–13, 115; Geraldine Farrar, *Such a Compulsion: The Autobiography of Geraldine Farrar* (New York, 1938), 139.

44. Strauss to Levin, May 6, 1912, in Grasberger, *Strom*, 198.

45. Jeritza to Strauss, July 4, 1912, RG.

46. Strauss to Schalk, June 7, 1916, in Brosche, 15–16.

47. Schuh, 261; Schalk to Strauss, [after June 7, 1916], in Brosche, 18 (quotes).

48. Schuh, 363; Brosche, 23.

49. *Wiener Salonblatt*, Feb. 23, 1918; Brosche, 29.

50. LL, "Singers," 73; LL, *Lives*, 36 (quote).

51. Aug. 19, 1916.

52. LL/K.k. Hof-Operntheater contract, March 11, 1914, ATW/15; *Neues Wiener Journal*, Jan. 20, 1917.

53. Maureen Healy, *Vienna and the Fall of the Habsburg Empire: Total War and Everyday Life in World War I* (Cambridge, 2004), 21; Manès Sperber, *Die Wasserträger Gottes: All das Vergangene...* (Vienna, 1974), 123, 174–75.

54. Healy, 43.

55. Ibid., 12, 45–46.

56. Ibid., 40–41, 73, 75–76; *Illustrirtes Wiener Extrablatt*, Oct. 4, 1916; Sperber, 223–24; Pick, 17–18, 87.

57. Pick, 20; Healy, 54–56.

58. Hans Kernbauer and Fritz Weber, "Von der Inflation zur Depression: Österreichs Wirtschaft, 1918–1934," in Emmerich Tálos and Wolfgang Neugebauer, eds., *"Austrofaschismus": Beiträge über Politik, Ökonomie und Kultur, 1934–1938* (Vienna, 1988, 4th ed.), 6; Hanisch, 202, 281; Healy, 44, 46.

59. Pick, 32–33; Hanisch, 202; Healy, 67.

60. Botz, 45–55.

61. Kernbauer and Weber, 8, 11–12; F. L. Carsten, *The First Austrian Republic, 1918–1938: A Study Based on British and Austrian Documents* (Aldershot, 1986), 30; Hanisch, 282–83; Roman Sandgruber, *Ökonomie und Politik: Österreichische Wirtschaftsgeschichte vom Mittelalter bis zur Gegenwart* (Vienna, 1995), 363.

62. *Wiener Salonblatt*, March 30, 1919; Pick, 195; Sandgruber, 346.

63. Sandgruber, 337; Pick, 142; Carsten, 37.

64. Gina Kaus, *Und was für ein Leben...: Mit Liebe und Literatur, Theater und Film* (Hamburg, 1979), 92–93; Gerd Puritz, *Elisabeth Schumann: A Biography* (London, 1993), 93; Carsten, 29.

65. *Illustrirte Kronen-Zeitung*, July 15, 1919; Sandgruber, 345–46; Berkley, 147; Pick, 159; Carsten, 15.

66. See *Der Abend*, Jan. 11, 1921, and the ads in *Illustrirte Kronen-Zeitung*, July 15, 1919; *Der Abend*, Oct. 18, 1921.

67. Pick, 143–44.

68. *Der Abend*, Oct. 18, 1921; Bernd Widdig, *Culture and Inflation in Germany* (Berkeley, 2001), 212.

69. *Der Abend*, Aug. 30, Dec. 24, 1921; *Die Fackel*, 22 (April 1920): 25, 39, (Nov. 1920): 19; Sandgruber, 346; Puritz, 93; Berkley, 147; Carsten, 14, 16–17, 36, 39–43.

70. Zweig, 269–70; Carsten, 43–44; Sandgruber, 356; Hanisch, 282.

71. *Illustrirte Kronen-Zeitung*, Dec. 20, 1919; *Der Abend*, Feb. 23, 1920, Dec. 24, 1921; Carsten, 15–16.

72. Pick, 195; Hanisch, 283.

73. Pick, 181.

74. *Die Fackel*, 22 (Jan. 1921): 6; ibid., 25 (beginning of April 1923): 175; Carsten, 13–14 (quote); *Illustrirte Kronen-Zeitung*, July 15, 1919; *Der Abend*, Dec. 24, 1921; Kernbauer and Weber, 7–8.

75. Brosche, 49; Pick, 27, 47, 88, 106; Healy, 87–121; Sandgruber, 326; Sperber, 224.

76. LL, *Singing*, 22 (quote); *Wiener Salonblatt*, Oct. 16, 1920, Jan. 13, May 26, 1923; *Die Stunde*, Jan. 4, 1924; Stefan, 119; Kralik, 76, 78; Prawy, 102; Puritz, 97; Jeritza, 77; Zweig, 272.

77. *Wiener Salonblatt*, March 10, 1917 (quote). On Brandts Buys, see Jan ten Bokum, "Brandts Buys, Jan," *Grove*.

78. Beaumont Glass, *Lotte Lehmann: A Life in Opera and Song* (Santa Barbara, 1988), 59. Also Hickling.

79. Julius Korngold, "Konzert Lotte Lehmann – Richard Mayr," ms., Dec. 22, 1916, GC; *Wiener Fremdenblatt*, Dec. 27, 1916 (quote).

80. Frauen-Hilfsaktion to LL, Jan. 19, 1917, GC.

81. *Wiener Fremdenblatt*, Jan. 14, 1918 (1st quote); *Neues Wiener Tagblatt*, Jan. 14, 1918 (2nd quote); *Wiener Gemeindeblatt*, Jan. 14, 1918.

82. *Die Zeit*, Jan. 20, 1919; *Wiener Fremdenblatt*, Jan. 20, 1919; *Neue Freie Presse*, Jan. 21, 1919; *Illustrirtes Wiener Extrablatt*, Jan. 22, 1919.

83. See text below at note 111.

84. Newspaper fragment, [May 1920], NC; *Arbeiterzeitung*, May 19, 1920.

85. Puccini to LL, [Oct. 1920], GC; LL, "Puccini," n.d., CW; *Neues Wiener Tagblatt*, Oct. 21, 1920; *Neue Freie Presse*, Oct. 21, 1920; *Neues Wiener Journal*, Oct. 21, 1920; *Wiener Salonblatt*, Oct. 30, 1920.

86. *Neue Freie Presse*, Feb. 7, 1921.

87. *Wiener Mittags-Zeitung*, March 14, 1921; *Illustrirtes Wiener Extrablatt*, March 14, 1921; *Neuigkeits-Welt-Blatt*, March 15, 1921; *Neues 8-Uhr-Blatt*, March 15, 1921; *Deutsche Tageszeitung*, March 15, 1921.

88. *Neue Freie Presse*, April 12, 1921 (quote); *Neues Wiener Journal*, April 10, 1921; *Neues 8-Uhr-Blatt*, April 10, 1921; *Wiener Montags-Zeitung*, April 11, 1921; *Wiener Salonblatt*, April 16, 1921.

89. *Der Morgen*, Oct. 24, 1921 (quote); *Österreichische Volkszeitung*, Oct. 19, 1921; *Illustrirtes Wiener Extrablatt*, Oct. 19, 1921; *Reichspost*, Oct. 20, 1921; *Wiener Zeitung*, Oct. 20, 1921; *Deutsches Volksblatt*, Oct. 20, 1921.

90. *Wiener Salonblatt*, Feb. 10, 1923 (1st quote); newspaper fragment, "Zum...," [Jan./Feb. 1923] (2nd quote).

91. Puccini to LL, Oct. 19, 1923, GC (quote); Puccini to LL, [postmarked Dec. 26, 1923], GC; *Der Tag*, Oct. 16, 1923; *Wiener Salonblatt*, Oct. 27, 1923.

92. *Neue Wiener Zeitung*, Dec. 3, 1923.

93. See below at note 121.

94. Erik Levi, "Braunfels, Walter," *Grove* (1st quote); review, "Staatsoper...," [May 1925], NC (2nd quote).

95. *Wiener Fremdenblatt*, Jan. 26, 1919; *Neues Wiener Tagblatt*, Oct. 23, 1919, June 4, 1921; *Deutsches Volksblatt*, Jan. 17, 1921; *Neues Wiener Journal*, Jan. 23, 1922; *Der Tag*, Oct. 16, 1923.

96. Frida Leider, *Das war mein Teil: Erinnerungen einer Opernsängerin* (Berlin, 1959), 161 (quote); Bundesminister to LL, Feb. 17, 1926, OSAW/GZ6/1926.

97. LL to Schalk, Oct. 1, 1923, ONBW/F18/Schalk.

98. Otto Strasser, *Und dafür wird man noch bezahlt: Mein Leben mit den Wiener Philharmonikern* (Vienna, 1974), 30; Puritz, 94–95; Witeschnik, 187.

99. LL to Lachmann, Dec. 17, 1946, ATW/TNLL (first quotes); LL, "Franz Schalk: Ein Festgruss," fragment, [1922], GC (last quote); interview as in note 4; LL, *Lives*, 85.

100. LL, *Lives*, 33, 85, 88 (quote); interview as in note 4; Schalk to LL, June 18, 1919; LL, "Franz Schalk: Ein Festgruss," fragment, [1922], GC.

101. Schalk to Verwaltung, June 16, 1920, OSAW/GZ15–2/1920 (quote); Schalk to LL, July 29, 1920, Oct. 21, 1922, GC.

102. LL, "Franz Schalk," n.d., CW; Prawy, 106.

103. LL, *Lives*, 200; LL to Shawe-Taylor, [fall 1967], GC.

104. LL, *Singing*, 27; LL, *Lives*, 197, 199.

105. LL, "Richard Strauss," n.d., CW.

106. A hint of this is in LL to EP, Dec. 15, 1919, GC.

107. See LL, *Singing*, 74.

108. LL to Strauss, Oct. 22, 1918, RG; Prawy, 102–3; Seefehlner, 96.

109. Schuh, 362; Hickling.

110. *Fremdenblatt*, Jan. 31, 1918; *Neue Freie Presse*, April 30, 1918.

111. Brosche, 27, 75; Strauss to Schalk, Jan. 4, 1919, ibid., 84 (quote).

112. Schalk to LL, June 18, 1919; Strauss to LL, June 27, July 15, 22, 1919; Karpath to LL, July 25, 1919, GC; LL to Strauss, July 16, ONBW/F18/Schalk; LL, *Singing*, 23–27.

113. "Richard Strauss," *Die Theater- und Musikwoche*, 1 (1919): 10–12. Also see *Neues Wiener Journal*, Oct. 19, 1919.

114. LL, *Singing*, 28–31; LL, *Lives*, 197–98; fountain anecdote told to author by Gabriele Strauss, Garmisch, Oct. 5, 2004.

115. Facs. in Prawy, 103.

116. Bryan Gilliam, "Strauss's *Intermezzo*: Innovation and Tradition," in Gilliam, ed., *Richard Strauss: New Perspectives on the Composer and His Work* (Durham, NC, 1992), 259 (1st quote); LL, *Singing*, 31 (2nd quote).

117. Michael Kennedy, *Richard Strauss: Man, Musician, Enigma* (Cambridge, 1999), 212; Prawy, 106. Also see Ludwig Klinenberger, "'Die Frau ohne Schatten' in der Wiener Oper," *Die Woche* (Berlin, Nov. 15, 1919): 1265–68; Michael Walter, *Richard Strauss und seine Zeit* (Laaber, 2000), 239–47.

118. LL to EP, Dec. 15, 1919, GC.

119. *8-Uhr-Blatt*, Oct. 11, 1919 (1st quote); *Wiener Mittags-Zeitung*, Oct. 11, 1919 (2nd quote).

120. *Neues Wiener Journal*, Feb. 20, 1921; *Wiener Allgemeine Zeitung 6-Uhr-Blatt*, Feb. 28, 1921; Hickling.

121. Strauss to LL, March 22, 1924, GC.

122. Kennedy, 230; Gilliam, 259.

123. LL, *Singing*, 71–75 (first quotes 71, 73), 89 (last quote); LL to Shawe-Taylor, Jan. 13, 1970, GC.

124. LL according to KL to LL, Nov. 10, 1924, GC; Paul Stefan in *Die Bühne*, 1, no. 2 (1924): 5–6.

125. Oscar Bie, "Wie..." (1st quote); Otto Reuter, "Nachklänge..."; "Eine Meisterleistung ersten Ranges" (2nd quote); "Das Stück...," reviews, [Nov. 1924], NC.

126. On *Intermezzo*'s success, see Gilliam, 279–81.

127. See KL to LL, Nov. 10, 1924, GC.

128. Specht, 66–68; Brosche, 47–50; Schuh, 429.

129. See Grasberger, *Strauss*, 68–72.

130. Ibid., 91–92, 109–10, 124; Prawy, 102–5; Seefehlner, 96–100; *Wiener Salonblatt*, Dec. 25, 1924.

131. Specht, 66; Grasberger, *Strauss*, 41, 91–92; Prawy, 103.

132. Beetz, 59; Grasberger, *Strauss*, 206–7; Grasberger, *Strom*, 277–78, 281–86; Prawy, 114–15; Seefehlner, 102.

133. Witeschnik, 188; Grasberger, *Strauss*, 227–28.

134. LL/Bukum contract, Oct. 20, 1925, ATW/2, Nov. 30, 1925, ATW/3.

135. For Prague, see *Prager Tagblatt*, Nov. 1, 4, 6, 1919; reviews, [1921–23], NC; for Budapest, reviews, [Dec. 1923], NC; for Pressburg, *Pressburger Tagblatt*, [Oct. 1920]; for Dresden, reviews, [1924–25], NC; for Breslau, reviews, [April 1926], NC. For Constantinople, see LL, *Anfang*, 146.

136. Reiner to LL, Dec. 25, 1921; *Die Stunde*, Jan. 9, 1924; reviews regarding Buenos Aires, etc., [1922], NC; Wildbrunn cited in Glass, 80; LL, *Anfang*, 149–51, 156.

137. Alan Jefferson, *Lotte Lehmann, 1888–1976* (London, 1988), 232.

138. Review, "Lotte...," [May 1921], NC (quote).

139. Zinne in *Neue Hamburger Zeitung*, May 14, 1917; Chevalley in *Hamburger Fremdenblatt*, May 18, 1917; Jefferson, 232.

140. *Neue Hamburger Zeitung*, April 29, 1919.

141. Ibid., May 1, 1919; Jefferson, 233.

142. *Neue Hamburger Zeitung*, May 5, 1920; *Hamburgischer Correspondent*, May 5, 1920.

143. *Hamburgischer Correspondent*, April 24, 1920; *Generalanzeiger für Hamburg-Altona*, April 24, 1920.

144. *Hamburger Generalanzeiger*, Dec. 10, 1920; *Hamburger Fremdenblatt*, [Nov. 1921]; *Hamburger 8-Uhr-Blatt*, [Nov. 1921]; *Hamburger Nachrichten*, [Nov. 1921], NC.

145. *Neue Hamburger Zeitung*, May 3, 1921; *General-Anzeiger*, May 6, 1921; *Hamburger Fremdenblatt*, [Oct. 1925], NC (quotes).

146. *Hamburger Correspondent* and other Hamburg reviews, [Dec. 1921], NC; review, "Arien-...," [Nov. 1921], NC.

147. *Hamburger Fremdenblatt*, Dec. 7, 1920; *Hamburger Nachrichten*, May 10, 1921; review, "Lotte...," [Oct. 1925], NC.

148. Hamburg reviews, [May 1921–Oct. 1925], NC.

149. Konzert-Direktion to LL, April 10, 1917, GC; review, "Ein...," *Berliner Zeitung*, [May 1917], NC.

150. Reviews, "'Die...," [Sept. 1921], NC (1st quote); *Berliner Lokalanzeiger*, Sept. 1, 1921 (2nd quote).

151. LL to Schillings, [Feb. 1922], GStAB. LL's 1914 contract with Vienna was to last from 1916–17 to 1921–22 (see text in Chapter 1 at note 129). Glass, quoting *Neues Wiener Tagblatt* of Feb. 13, 1922, on p. 77, that LL sought release from her existing contract, uncritically gives credence to that newspaper's false assumption that she had to break a contract in order to leave Vienna. Obviously, neither the paper nor Glass was aware of the terms of LL's 1914 contract with Gregor.

152. Correspondence (1921–24) in GStAB.

153. Axel Schröder, Landesarchiv Berlin, to author, May 21, 2003.

154. Reviews, including "Berliner...," [April 1924] (quote), NC; *Neues Tagblatt*, April 17, 1924; Carroll, 174.

155. Michael H. Kater, *The Twisted Muse: Musicians and Their Music in the Third Reich* (New York, 1997), 40–41; Harold Rosenthal, *Two Centuries of Opera at Covent Garden* (London, 1958), 422; Vincent Sheean, *First and Last Love* (Westport, CT, 1979), 74–76; Bruno Walter, 259–60.

156. LL quoted in *Opera News* (March 24, 1962): 14. Also see LL, *Anfang*, 154; LL, *Lives*, 259.

157. Puritz, 133.

158. Rosenthal, 426; Walter Legge in Elisabeth Schwarzkopf, *On and Off the Record: A Memoir of Walter Legge* (New York, 1982), 18; Erik Ryding and Rebecca Pechefsky, *Bruno Walter: A World Elsewhere* (New Haven, 2001), 165.

159. Cardus in Robin Daniels, *Conversations with Cardus* (London, 1976), 98; Ivor Newton, *At the Piano – The World of an Accompanist* (London, 1966), 176; Sheean, 77.

160. *NYT*, June 15, 1924.

161. Bruno Walter, 260.

162. Reviews of *Ariadne*, [May 1924], NC; Rosenthal, 427–28; Jefferson, 239; Robert Crichton, "Walter, Bruno," *Grove*.

163. LL, *Anfang*, 155.

164. Friedrich Lange, *Gross-Berliner Tagebuch, 1920–1933* (Berlin-Lichtenrade, 1951), 63–65; Imre Fabian, "Berlin," *Grove*; Heyworth, *Klemperer*, 236–37; Tietjen in Hannes Reinhardt, ed., *Das bin ich* (Munich, 1970), 178–81.

165. Review, "Städtische...," [Sept. 1925], NC (quotes); Ryding and Pechefsky, 176.
166. Ryding and Pechefsky, 176.
167. Review, "Der dritte...," [Sept. 20, 1925] (quote); other reviews, NC.
168. Erik Levi, "Schillings, Max von," *Grove* (quote); Simon to Ziegler, Dec. 7, 28, 1925, MOA; Lange, 76, 78; Heyworth, 237; Tietjen in Reinhardt, 182.
169. Telegraphic exchanges among LL, Walter, and Tietjen, Jan.–April 1926; Walter to LL, Jan. 20, Apr. 23, 1926, ATW/15.
170. [Vienna] Staatsoper to LL, Jan. 4, 1926; Walter to LL, Jan. 20, 1926, ATW/15; reviews, Berlin, [Feb. 1926], NC; Hickling.
171. Contract as in note 30; Brosche, 34.
172. *Illustrirtes Wiener Extrablatt*, Sept. 10, Oct. 4, 1916; *Der Abend*, Oct. 5, 1916; *Ostdeutsche Rundschau*, Oct. 6, 1916.
173. LL, *Anfang*, 144.
174. LL to EP, May 6, 1918, GC.
175. Brosche, 34, 39, 41, 44, 47–48, 50, 58.
176. Ibid., 69, 77, 79; Article 16 of contract, as in note 30.
177. LL to Verwaltung, Dec. 17, 1919; Schalk to Verwaltung, Dec. 31, 1919, Feb. 9, April 19, 1920, OSAW/GZ15–2/1020; *Illustrirte Kronen-Zeitung*, July 15, Dec. 20, 1919.
178. LL to EP, Dec. 15, 1919, GC; Article 5 of contract, as in note 30.
179. Schalk, "Additional-Artikel," Jan. 15, 1920, ATW/15; Schalk to Verwaltung, OSAW/GZ15–2/1920; Schalk to LL, July 29, 1920, GC (quote).
180. Schalk to Verwaltung, Oct. 1, 1920, OSAW/GZ15–2/1920; "Additionalartikel," signed by Schalk and LL, Dec. 21, 1920, ATW/15; Puritz, 97–98.
181. Schalk, "Additionalartikel," May 19, 1921, ATW/17; Schalk to Verwaltung, Oct. 26, 1921, OSAW/GZ15–2/1921; *Der Abend*, Oct. 18, 1921; LL to EP, Dec. 7, 1921, GC.
182. Schalk to Bundestheater-Verwaltung, April 20, 1923, OSAW/GZ15–2/1923.
183. KL to LL, Nov. 15, 18, 1924, GC; LL and Schalk, "Additional-Artikel," June 25, 1924, ATW/17; LL and Schalk, "Additional-Artikel," Jan. 14, 1925, ATW/2; *Die Stunde*, Jan. 24, 1924.
184. Brosche, 47–48, 50, 58, 61, 64, 69–70, 75–76, 82.
185. Schalk to Verwaltung, March 4, June 30, 1920 (quotes), OSAW/GZ15–2/1920.
186. See *Wiener Salonblatt*, Oct. 26, 1918 (first quotes); Strasser, 36 (last quote).
187. *8-Uhr-Blatt*, Oct. 11, 1919.
188. Kralik in *Neues Wiener Tagblatt*, May 20, 1920 (first two quotes); Konta in *Wiener Mittags-Zeitung*, May 19, 1920 (last quotes).
189. *Wiener Salonblatt*, Oct. 30, 1920; Prawy, 110.
190. "Maria Jeritza," *Neues Wiener Journal*, [March 1921], WTA.
191. Strauss to LL, July 22, 1919, GC.
192. Brosche, 67.
193. Ibid., 58.
194. LL to EP, April 22, 1919, GC.
195. "Additional-Artikel," as in note 179; LL to Franz Strauss, June 8, 1920, RG (quote).
196. Gatti-Casazza quoted for 1920 in Robert Tuggle, *The Golden Age of Opera* (New York, 1983), 208; Giulio Gatti-Casazza, *Memories of the Opera* (New York, 1973, 1st pr. 1941), 215; Jeritza, 137–38; Irving Kolodin, *The Metropolitan Opera, 1883–1966: A Candid History* (New York, 1966, 4th ed.), 301.
197. Joseph Horowitz, *Classical Music in America: A History of its Rise and Fall* (New York, 2005), 10.

198. Ibid., 50; Bruce McPherson and James A. Klein, *Measure by Measure: A History of New England Conservatory from 1867* (Boston, 1995), 49–50; Charles Riker, *The Eastman School of Music: Its First Quarter Century, 1921–1946* (Rochester, NY, 1948), 15.

199. Joseph A. Mussulman, *Music in the Cultural Generation: A Social History of Music in America, 1870–1900* (Evanston, 1971), 142–45; Hans Rudolf Vaget, "'Ohne Rat in fremdes Land?': *Tristan und Isolde* in Amerika: Seidl, Mahler, Toscanini," *wagnerspectrum*, no. 1 (2005): [3]-[7].

200. Kolodin, 88–93; Joseph Horowitz, *Wagner Nights: An American History* (Berkeley, 1994), 115–17, 125–26.

201. Lilli Lehmann, *How to Sing* (Northbrook, IL, 1972), 7; Henry Pleasants, *The Great Singers: From the Dawn of Opera to Our Own Time* (New York, 1966), 234; Farrar, 61–62.

202. Kolodin, 106–98; Rose Heylbut and Aimé Gerber, *Backstage at the Metropolitan Opera* (New York, 1977, 1st pr. 1937), 9.

203. *NYT*, Nov. 6, 1932; Mary Ellis Peltz, *Metropolitan Opera Milestones* (New York, 1944), 32–33, 36; Theresa M. Collins, *Otto Kahn: Art, Money and Modern Times* (Chapel Hill, NC, 2002), 70, 75–76, 81–83, 86–87; Robert Goelet, *The Old Order Changes* (New York, 1940), 28–31.

204. Otto H. Kahn, *Art and the People* (New York, [1916]); Collins, 35–36, 45–47; *NYT*, March 30, 1934.

205. Otto Hermann Kahn, *The American Stage: Reflections of an Amateur* ([New York], 1925); Kahn, *The Metropolitan Opera: A Statement* ([New York], 1925); *NYT*, March 30, 1934.

206. *NYT*, March 30, 1934; Otto Hermann Kahn, *Prussianized Germany: Americans of Foreign Descent and America's Cause* (Chicago, 1917); Kahn, *The Poison Growth of Prussianism* ([New York], 1918); Collins, 81–82, 86; Mary Jane Matz, *The Many Lives of Otto Kahn* (New York, 1963), 164–94.

207. Quaintance Eaton, *The Miracle of the Met: An Informal History of the Metropolitan Opera, 1883–1967* (New York, 1967), 188, 193; Kolodin, 263; Peltz, 40.

208. Frances Alda, *Men, Women and Tenors* (Freeport, 1970, 1st pr. 1937), 216.

209. Peltz, 41; Eaton, 193–95; Horowitz, *Nights*, 296–99; Andrea Olmstead, *Juilliard: A History* (Urbana, 1999), 52–53; McPherson and Klein, 84–85.

210. Eaton, 201–3; Peltz, 43–44; Kolodin, 282–83.

211. Puritz, 108–21.

212. Jeritza, 138–39, 154; Collins, 10 (quote), 84, 130, 149–51; John Kobler, *Otto the Magnificent: The Life of Otto Kahn* (New York, 1989), 166. Jeritza is giving away all but the essence of her relationship with Kahn in *Neue Freie Presse*, May 2, 1923.

213. Collins, 132–33.

214. *NYT*, Nov. 20, 1921 (quotes); Sheean, 58–59; Peltz, 45.

215. *NYT*, Dec. 2, 1921; Gatti-Casazza, 215; Edward Baron Turk, *Hollywood Diva: A Biography of Jeanette MacDonald* (Berkeley, 1998), 36–37; Kolodin, 302.

216. Jeritza, 150.

217. Peltz, 46; Douglas, *Legendary Voices*, 114; Eaton, 211–16; Farrar, 191.

218. Grace Moore, *You're Only Human Once* (Garden City, 1944), 91.

219. Jeritza, 143–44.

220. On New York: *NYT*, Nov. 6, 8, 1924; Peltz, 48; Kolodin, 17, 321, 330; Max de Schauensee, "Toscas of Yesterday," *Opera News* (Dec. 8, 1952): 6–8.

221. According to eyewitness Rudolf Bing, *A Knight at the Opera* (New York, 1981), 90.

222. *NYT*, Nov. 8, Dec. 30, 1930, April 19, 1931; *Neue Freie Presse*, April 17, 18, 1931; *Neues Wiener Tagblatt*, Feb. 13, March 15, 1932; Douglas, *More Voices*, 119.

223. *Neue Freie Presse*, May 14, 1925; Marcel Prawy, *Marcel Prawy erzählt aus seinem Leben* (Vienna, 1996), 45.

224. See *Wiener Salonblatt*, May 13, 1922; front page, *Die Bühne*, 1, no. 3 (1924); Maria Jeritza in *Neues Wiener Tagblatt*, March 30, 1924.

225. *Die Fackel*, 24 (July 1922): 104; *Wiener Salonblatt*, June 28, 1925; *Neues Wiener Journal*, March 29, 1929; Jeritza, 72; Ernst Decsay, *Maria Jeritza* (Vienna, 1931), 22; Rosenthal, 435–36.

226. Jeritza to Strauss, Aug. 22, 1923, Jan. 16, Aug. 3, 1924, RG.

227. See *NYT*, Dec. 20, 2004.

228. Prawy, *Opera*, 97; Legge in Schwarzkopf, *Memoir*, 124; author's interview with Peter Dusek, ORF Archives, Vienna, Oct. 9, 2003.

229. Reviews, M. M., "Lotte...," [1923]; "Lotte...," [March 1923], NC.

230. LL cited in KL to LL, Dec. 10, 1922, GC.

231. Review, "Lotte...," [Jan. 1923], NC (quote); text above at note 43.

232. *Wiener Salonblatt*, May 12, 1923 (quote); *Neue Freie Presse*, May 6, 1923. See also Robert Werba, *Maria Jeritza: Primadonna des Verismo* (Vienna, 1981), 118.

233. LL to Schalk, Oct. 1, 1923, ONBW/F18/Schalk.

234. KL to LL, April 27, 1923, GC; Ziegler to Simon, Dec. 19, 1925, MOA; Tuggle, 216.

235. *NYT*, July 1, 1923, June 15, 1924, and March 7, 1926.

236. Jeritza quoted in FL to LL, Oct. 13, 1946, GC.

237. Robert Tuggle, MOA, to author, March 4, 2004; author's interview with Tuggle, New York, May 9, 2005. Also see Douglas, *More Voices*, 124.

238. Iron. in *Neues Wiener Journal*, Oct. 4, 1925; LL, *Anfang*, 143.

239. See Brosche, 45; Grasberger, *Strauss*, 138; Ernest Bartolo, *Die Wiener Oper: Die aufregenden Jahre seit 1625* (Leipzig, 1992) 73; Tamara Barzantny, *Harry Graf Kessler und das Theater: Autor, Mäzen, Initiator, 1900–1933* (Cologne, 2002), 243.

240. Review, "Zum...," [Jan. 1923], NC.

241. LL, *Lives*, 63–64.

242. *Österreichisches Biographisches Lexikon, 1815–1950*, vol. 2 (Graz, 1959), 111; Beetz, 60. See Gutheil-Schoder, *Erlebtes*, 33–58.

243. Gutheil-Schoder to LL, Feb. 24, 1926, ATW/17.

244. LL to Gutheil-Schoder, [1926] [draft], ATW/17.

245. Gutheil-Schoder, *Erlebtes*, 26–27; O.W. Neighbour, "Erwartung," *Grove*.

246. Götz Kende, *Höchste Leistung aus begeistertem Herzen: Clemens Krauss als Direktor der Wiener Staatsoper* (Salzburg, 1971), 14, 68; Legge in Schwarzkopf, 125. Also see text in Chapter 3 at note 51.

247. LL, *Lives*, 64 (quote).

248. For Strauss, see Grasberger, *Strom*, 283–84.

249. Paul Stefan, "Der Zustand unseres Opernthetaters," *Die Stunde* (Jan. 25, 1924): 3. Also Stefan, *Oper*, 121–22; Marcel Rubin, "Das musikalische Leben Wiens in der Zwischenkriegszeit," in Norbert Leser, ed., *Das geistige Leben Wiens in der Zwischenkriegszeit: Ring-Vorlesung, 19. Mai – 20. Juni 1980* (Vienna, 1981), 295–99; Günter Brosche, ed., *Richard Strauss – Clemens Krauss Briefwechsel: Gesamtausgabe* (Tutzing, 1997), 76–77; Hilde Spiel, *Vienna's Golden Autumn, 1866–1938* (London, 1987), 208–10.

250. *Wiener Fremdenblatt*, Jan. 26, 1919.

251. LL to EP, Dec. 7, 1921, GC.

252. Contract between LL and Borchard, Oct. 1, 1917, ATW/15. Also see *Die Stimme*, Nov. 1917.

253. *LLLN*, Summer 1989, MAWA.

254. Gary Hickling,"Lotte Lehmann Discography," in Glass, 303–5.

255. LL/Carl Lindström AG contract, Feb. 13, 1924, ATW/3.

256. Hickling, "Discography," 306; Prawy, *Leben*, 31.

257. "Serie Luxus-Etikett," Odeon record catalog, "Nachtrag Nr. 15," April 1924, ATW/16; Carl Lindström Aktiengesellschaft to LL, Oct. 30, 1925, Jan. 27, 1926; Wisocky to LL, Feb. 20, 1926, ATW/6. See text above at note 97.

258. *The Young Lotte Lehmann*, Preiser Records, no. 89302, Feb. 7, 2005.

259. See Prawy, *Leben*, 43; "Lotte Lehmann," *Notizen: Zeitschrift für Theater und Konzert* (May 15, 1921): 144–46; "Lehmann in the New Yorker," *LLLN*, Fall 1991, MAWA; Jürgen Kesting, *Die grossen Sänger unseres Jahrhunderts* (Düsseldorf, 1993), 262; Daniels, 99; J. B. Steane, *The Grand Tradition: Seventy Years of Singing on Record* (Portland, OR, 1993, 2nd ed.), 231–32.

260. LL, *Lives*, 67–68 (first quotes); LL, "Madama Kascowska," n.d., CW (last quote).

261. Horst Wahl in *LLLN*, Summer 1989, MAWA; Kesting, 262 (quote); Prawy, *Leben*, 43; Steane, 232–33.

262. See LL's later self-criticism: "Konzertbegleiter," n.d., CW.

263. *Die Stunde*, Jan. 23, 1924 (Stefan's quote); *Wiener Salonblatt*, March 1, 1924; LL, "Konzertbegleiter," n.d., CW (LL's quote).

264. Gregor quoted in LL, *Anfang*, 139; LL, *Singing*, 1–2; LL, *Lives*, 54, 66; LL to de Peterse, Oct. 13, 1916; LL to Konrad zu Putlitz, Sept. 5, 1916; LL to EP, Dec. 15, 1919, May 7, 1920, GC; LL, unspecified reminiscences of Vienna, n.d., CW; LL, answers to questions by Charles Moses, n.d., BC.

265. LL to EP, March 24, 1922, GC; *Wiener Salonblatt*, July 26, 1925; Brosche, 90.

266. Ballin to LL, Aug. 7, 1916; G. M., "Bei...," [1917], NC; LL to EP, May 6, 1918, Dec. 15, 1919; KL to LL, Nov. 24, 1924, GC; Newton, 178; *Wiener Mittags-Zeitung*, Jan. 15, 1918 (quotes).

267. LL to EP, Dec. 7, 1921, GC.

268. On her forebear Count Bernhard von Rechberg, see Friedrich Engel-Janosi, *Graf Rechberg: Vier Kapitel zu seiner und Österreichs Geschichte* (Munich, 1927), vii, 1, 5–6, 8–10, 13, 18, 123–24.

269. Wassilko, 297–313.

270. Kralik, 131; Carroll, 79.

271. See his sardonic sketch, "Kulturbund," *Die Fackel*, 24 (Dec. 1922): 23–25.

272. Federmann in Zuckerkandl, 214–15; Jens Malte Fischer, *Fin de Siècle: Kommentar zu einer Epoche* (Munich, 1978), 26; Milan Dubrovic, *Veruntreute Geschichte: Die Wiener Salons und Literaturcafés* (Frankfurt am Main, 1987), 161–66.

273. Dubrovic, 73, 75–77; Susanne Keegan, *The Bride of the Wind: The Life and Times of Alma Mahler* (New York, 1992), 219; Oliver Hilmes, *Witwe im Wahn: Das Leben der Alma Mahler-Werfel* (Munich, 2004), 175.

274. LL to Wessling, Dec. 21, 1968, GC; Dubrovic, 75–76; Hilmes, 233–36, 247–48; Bruno Walter, 319.

275. See LL, *Anfang*, 140.

276. For an early example of the latter, see LL to Jaensch, Nov. 3, 1916, GC.

277. LL to EP, May 30, 1918, GC.

278. See LL to Schillings, [Feb. 1922], GStAB; Glass, 77.

279. LL, *Singing*, 2–3.

280. LL, "Rudolf Bing," n.d., CW (quote); Rudolf Bing, *5000 Nights at the Opera* (Garden City, 1972), 14–15, 18; Bing, *Knight*, 84–86, 89.

281. LL, "Du, den ich wachend nie gesehn," in *Wiener Salonblatt*, Jan. 25, 1919.

282. LL, *Lives*, 89.

283. LL, "Am Meer," *Neues Wiener Journal*, [July 1917], fragment in archive of RS; LL, "Sturmlied," *Neues Wiener Journal*, April 28, 1918; "Was Lotte Lehmann erzählt," *Hamburger Fremdenblatt*, Dec. 22, 1924.

284. LL, "Richard Strauss" (as in note 113).

285. Schalk to Strauss, Aug. 22, 1919, in Grasberger, *Strom*, 247; Hofmannsthal to Strauss, June 21, 1919, in Schuh, 445.

286. KL to LL, Nov. 18, 1924, GC. Also see ML to LL, Oct. 28, 1924, CG.

287. ML to LL, [June 16, 1922], Nov. 18, 1923, [Oct. 28, 1924], Nov. 10, 1924; FL to LL, Dec. 28, 1950, GC.

288. ML to LL, [Nov. 16, 1923], [March 29, 1924], [Nov. 10, 1924]; KL to LL, April 12, Oct. 17, 1923, Nov. 7, 1924, GC.

289. KL to LL, Nov. 28, 30, Dec. 8, 1922, Jan. 7, April 6, 18, June 23, 28, Sept. 7, Oct. 21, 1923, March 18, 30, April 8 , 19, 1924; LL, *Anfang*, 154.

290. ML to LL, [Oct. 28, 1924], [Jan. 10, 1925]; KL to LL, Nov. 18, 1924, GC; author's interview with Hertha Schuch, Vienna, Sept. 19, 2003; Ivar Oxaal, "The Jews of Young Hitler's Vienna: Historical and Sociological Aspects," in Oxaal et al., eds., *Jews, Antisemitism and Culture in Vienna* (London, 1987), 29–31.

291. G. M., "Bei...," [1917], NC.

292. LL to Julius [Korngold?], May 13, 1920, ONBW/Autogr./580/51–1.

293. Heiny to Verwaltung, Dec. 23, 1920, OSAW/GZ15–1/1920; Wildgans to Verwaltung, Sept. 1, 1921, OSAW/GZ15–1/1921; FL to LL, Oct. 4, 1945, GC.

294. ML to LL, May 12, 1922, Nov. 10, 1924; KL to LL, July 14, 1922; FL to LL, [1945], Dec. 28, 1950, GC.

295. ML to LL, March 29, [1924]; KL to LL, July 14, 1922, Nov. 7, 15, 18, 1924; FL to LL, Dec. 7, 1946, July 20, 1947; LL to MH, [summer 1931], GC.

296. FL to LL, July 19, 1945, GC; LL to Ascoli, Feb. 16, 1972, BC (quote). Also see LL to Hansing, Sept. 1, 1938, GC.

297. Behrend to LL, Aug. 16, 1916, GC; Wisocky to LL, Feb. 20, 1926, ATW/6.

298. LL, "Maria Olszewska," n.d., CW; LL, "Singers," 68 (quotes).

299. LL, "Singers," 65.

300. ML to LL, May 19, 1922, April 10, 1923, [July 16, 1924]; KL to LL, Nov. 10, 1924, GC.

301. LL to EP, April 22, May 9, 1919, GC.

302. On the fawning, see W. Z.[inne], "Konzert," [May 1921], NC; *Die Stunde* (Jan. 23, 1924).

303. LL to de Peterse, [summer 1916], March 17, 1917, Nov. 5, 1917 (quote), GC.

304. LL to de Peterse, April 8, 1918, June 23, 1919, [April 30, 1920], July 29, 1923, GC; LL to MH, [1923–24], ATW/15; Robert [Hecht] to LL, Nov. 4, 1930, GC.

305. LL to EP, April 22, 1919, CG (quote); Adolf Dessauer, *Grossstadtjuden* (Vienna, 1910), esp. i–iii; *Wiener Salonblatt*, May 30, 1919.

306. *Wiener Salonblatt*, May 30, 1919; *Österreichisches Biographisches Lexikon, 1815–1950*, vol. 5 (Vienna, 1972), 226; *Grosses Sängerlexikon* (Munich, 1997, 3rd ed.), 2085–86.

307. LL to EP, April 22, 1919 (quote); ML to LL, May 19, 1922; FL to LL, Aug. 4, 1947, GC; author's telephone interview with Shirley Sproule, Oakville–Tuscon, Dec. 7, 2004; Glass, 65–66.

308. Dessauer, 180.

309. This was Peter Krause, born March 10, 1919 (author's telephone interview with Peter Krause, Oakville–Yardley, PA, June 12, 2004). – A *Rittmeister* (captain) commanded a company, 200–250 enlisted men, in the field. István Deák, *Beyond Nationalism: A Social and Political History of the Habsburg Officer Corps, 1848–1918* (New York, 1990), 15.
310. Author's interview with Peter Krause, June 12, 2004; Hervay and Boxberg to Krause, Aug. 1930; Heynig to Krause, Nov. 26, 1930, ATW/11.
311. István Deák to author, July 8, 2005; Deák, 95, 101–2.
312. Author's interview with Peter Krause, June 12, 2004; author's interview with Shirley Sproule, Dec. 7, 2004; Marie-Therese Arnbom, *Friedmann, Gutmann, Lieben, Mandl und Strakosch: Fünf Familienportraits aus Wien vor 1938* (Vienna, 2002), 87–88. Otto Krause's birthdate according to LL, memo for Wessling-Mappe, [1968], GC.
313. LL to EP, March 24, 1922, GC; Prawy, *Leben*, 43.
314. See Johnston, 52; Hanisch, 219–20.
315. For underrepresentation, see Deák, 92, 171, 175–78.
316. Ibid., 130–34; Hanisch, 87, 218–20; Berkley, 4, 15; Wolfgang Doppelbauer, *Zum Elend noch die Schande: Das altösterreichische Offizierskorps am Beginn der Republik* (Vienna, 1988), 54–56; Johnston, 39, 51; Vicki Baum, *Es war alles ganz anders: Erinnerungen* (Zurich, 1964), 266; Schnitzler, 29, 50.
317. "Die Not in Wien," *Die Fackel*, 23 (Nov. 1921): 24; Doppelbauer, 23–27, 65–68; Ernst Bruckmüller, *Sozialgeschichte Österreichs* (Vienna, 1985), 467; Pick, 172–73; Deák, 209–10.
318. Arnbom, 67, 226–27; Andrea Resch, *Industriekartelle in Österreich vor dem Ersten Weltkrieg: Machtstrukturen, Organisationstendenzen und Wirtschaftsentwicklung von 1900 bis 1913* (Berlin, 2002), 108–9; *Wiener Salonblatt*, Oct. 28, 1916. On banks, see Hanisch, 282; Sandgruber, 357.
319. Hans Tietze, *Die Juden Wiens: Geschichte – Wirtschaft – Kultur* (Vienna, 1987, 1st pr. 1933), 205; Berkley, 54; Marsha L. Rozenblit, *The Jews of Vienna, 1867–1914: Assimilation and Identity* (Albany, 1983), 127–40.
320. Arnbom, 86.
321. Author's interview with Peter Krause, as in note 309.
322. Ibid.; Arnbom, 76.
323. Pick, 193; Bruckmüller, 423; Hanisch, 73.
324. István Deák to author, Feb. 20, 2006.
325. Arnbom, 63–76; Rozenblit, 73, 88.
326. Arnbom, 68; Tietze, 231.
327. Berkley, 36–37, 70.
328. Tietze, 235; Arnbom, 71–74, 76–82.
329. Kaus, 39 (quote); Tietze, 107, 231; Berkley, 35, 70; Rozenblit, 6; Deák, 171.
330. Krips, 13; Arnbom, 82–85; Tietze, 211.
331. Zweig, 31 (quote); Halban, 30; Berkley, 39.
332. Arnbom, 88; author's interview with Peter Krause, as in note 309.
333. *Neues Wiener Tagblatt*, Feb. 13, 1922, quoted in Glass, 78.
334. LL to EP, March 24, 1922, GC.
335. ML to LL, [June 21, 1922], GC.
336. KL to LL, April 27, 1923; LL to MH, July 29, 1923 (quote), GC.
337. KL to LL, Sept. 6, 7, 1923, GC.
338. KL to LL, March 30, 1924, GC; BW to LL, April 23, 1926, ATW/15. On Vienna gossip, see Prawy, who was a nephew, once removed, of Grete Gutmann: *Leben*, 43.

339. LL to MH, [1926], GC.
340. LL to MH, March 16, 1926 (quote); KL to LL, Feb. 13, 1923, GC; *Das interessante Blatt*, May 6, 1926; *NYT*, Sept. 16, 1938; LL as interviewed by Studs Terkel, Evanston, 1960, soundtrack, LLFA; author's interview with Peter Krause, as in note 309.
341. See figures and photographs in *Das interessante Blatt*, May 6, 1926; LL, *Anfang*, opposite 236; Arnbom, 89. Also author's interview with Hertha Schuch, Vienna, Sept. 27, 2003; ML to LL, [June 28, 1922], GC; CH to LL, Aug. 5, 1937, BC; *Women's Weekly* (Sydney), April 15, 1939; Marcia Davenport, *Too Strong for Fantasy* (New York, 1967), 246.
342. One of these men was Fritz Lehmann, who later emphasized the singularity of his charm. See FL to LL, June 14, 1945, Aug. 13, 1949, GC. Quote is from Marcia Davenport, "Song and Sentiment," *The New Yorker* (Feb. 23, 1935): 19.
343. For the legend, see *Women's Weekly*, April 15, 1939.
344. Constance Hope, *Publicity Is Broccoli* (New York, 1941), 32.
345. FL to LL, May 30, 1946, GC.
346. FL to LL, May 3, Nov. 4 (1st quote), 1944, March 25, June 7, 1945, April 20, Dec. 19, 1947, Aug. 13, 1949 (2nd quote), GC.
347. FL to LL, July 11, 1947, GC; LL, "Singers," 77.
348. LL to MH, July 29, 1923, GC; LL to CH, June 10, 1942, CU/2; LL, "Helene Wildbrunn," n.d., CW; author's interview with Hertha Schuch, Vienna, Sept. 29, 2003.
349. LL to MH, Dec. 20, 1943; LL to Hansing, April 7, 1939; FL to LL, July 19, 1945, GC; LL, *Anfang*, 158; LL, *Lives*, 260. On KL's death, see Strauss to LL, Jan. 21, 1925, GC.
350. FL to LL, May 12, 1946, Dec. 19, 1947; KL to LL, Dec. 8, 1922, June 28, 1923, March 31, Nov. 7, 1924; ML to LL, [Nov. 3, 1924], GC; *Das interessante Blatt*, May 6, 1926; Arnbom, 88.
351. KL to LL, March 16, 1923, April 8, 1924; ML to LL, May 19, 1922, [June 21, 1922], [June 28, 1922], [July 10, 1922], April 10, 1923, March 22, 1924, [Oct. 28, 1924].

3. Climax and Crises

1. Stransky to LL, April 18, 1928, GC (1st quote); Hugo Strasser, *Und dafür wird man noch bezahlt: Mein Leben mit den Wiener Philharmonikern* (Vienna, 1974), 38; LL, *My Many Lives* (New York, 1948), 238 (2nd quote); LL to Schadow, Jan. 25, 1927, ATW/5 (3rd quote); LL to Natz, Jan. 23, 1927, ATW/5 (4th quote).
2. Hickling.
3. Ibid.
4. Jens Malte Fischer writes that for this reason it had difficulty becoming the favorite of either traditionalists or modernists (to author, Jan. 5, 2006).
5. See LL, *Anfang und Aufstieg: Lebenserinnerungen* (Vienna, 1937), 159; Vincent Sheean, *First and Last Love* (Westport, CT, 1979), 195 (also quote).
6. LL–Gaussmann interview, Salzburg, Aug. 1969, soundtrack LLFA; LL, *Lives*, 120; *LLLN*, May 1988, MAWA.
7. Review, "Musikalisch...," [April 1927], NC (quote). Also see Sachse to LL, April 10, 1927, ATW/4.
8. Korngold to LL, Sept. 29, 1927; LL to Korngold, [Sept. 1927], ATW/17. Further on Korngold's ego, see Luzi Korngold to LL, Sept. 11, 1930, ATW/17.

9. LL to MH, [Fall 1927], GC (quote); S. L., "Die…," [Nov. 1927], NC; *Wiener Salonblatt*, Nov. 13, 1927; Hickling; Brendan G. Carroll, *The Last Prodigy: A Biography of Erich Wolfgang Korngold* (Portland, OR, 1997), 50–51, 195–97, 201–2; Marcel Prawy, *The Vienna Opera* (New York, 1970), 122.

10. Correspondence of Nov. 1928, March 1929, OSAW/GZK519, 1065/3/1929; reviews, "Die…," "Das…," [Feb. 1929], NC; Kull to LL, ATW/8; Hickling. LL has the year wrong: *Anfang*, 165.

11. *Neues Wiener Journal*, May 6, 19, 1928; LL, *Anfang*, 161; Hickling.

12. Marcel Prawy, *Marcel Prawy erzählt aus seinem Leben* (Vienna, 1996), 97.

13. LL to Schalk, June 21, 1927, July 19, 1929 (3rd quote), Aug. 18, 1931, ONBW/F18/Schalk; LL to Schalk, Nov. 13, 1927, GC [draft ATW/6]; Schalk to LL, [May 16, 1926], ATW/3; Schalk to LL, July 20, 1929 (1st, 2nd quotes), Sept. 12, Dec. 20, 1929, ATW/10; LL to MH, Oct. 18, 1931, GC (4th quote).

14. Schalk to Mitglieder, June 1929, ATW/10; *Neues Wiener Journal*, Jan. 6, 17, 21, 1928; *Österreichisches Biographisches Lexikon*, vol. 10 (Vienna, 1994), 390; Carroll, 198, 216; Hugo Burghauser, *Philharmonische Begegnungen: Erinnerungen eines Wiener Philharmonikers* (Zurich, 1979), 33; Prawy, *Opera*, 122; Prawy, *Leben*, 49; Ernest Bartolo, *Die Wiener Oper: Die aufregenden Jahre seit 1625* (Leipzig, 1992), 76; Franz Farga, *Die Wiener Oper von ihren Anfängen bis 1938* (Vienna, 1947), 320; Heinrich Kralik, *Die Wiener Oper* (Vienna, 1962), 81.

15. On the clashes, see Gerhard Botz, *Gewalt in der Politik: Attentate, Zusammenstösse, Putschversuche, Unruhen in Österreich, 1918 bis 1938* (Munich, 1983), 54; Ernst Hanisch, *Der lange Schatten des Staates: Österreichische Gesellschaftsgeschichte im 20. Jahrhundert* (Vienna, 1994), 287–94.

16. *Neues Wiener Journal*, Jan. 15, Feb. 4, 5, 19, March 11, April 8, 1928; Hanisch, 279; Hans Kernbauer and Fritz Weber, "Von der Inflation zur Depression: Österreichs Wirtschaft, 1918–1934," in Emmerich Tálos and Wolfgang Neugebauer, eds., *"Austrofaschismus": Beiträge über Politik, Ökonomie und Kultur, 1934–1938* (Vienna, 1988, 4th ed.), 5.

17. Colin Nettelbeck, *Dancing with DeBeauvoir: Jazz and the French* (Carlton, Victoria, 2004), 39 (quote); *Neues Wiener Journal*, Jan. 27, Feb. 15, 16, 23, 29, March 4, April 4, 6, July 4, 1928. See Rosenberg to LL, Nov. 11, 1927, ATW/4.

18. *Neues Wiener Journal*, Jan. 8, 13, March 3, 1928.

19. On vacations, see, e.g., LL to Boehme, Dec. 29, 1926, ATW/3; Schalk to LL, July 11, 1927, ATW/5.

20. LL to Tietjen, Sept. 17, 1927, ATW/4; Emilio to LL, Dec. 12, 1927, ATW/17; Theatermertens to LL, Jan. 31, 1928, ATW/7; *Der Morgen*, Jan. 1928; *Wiener Allgemeine Zeitung*, Feb. 14, 1928.

21. LL to Fischer, Oct. 15, 1927, ATW/5; LL to Schalk, Jan. 18, 1928; [Krause memo], Feb. 18, 1928, GC; Fürst to LL, Feb. 20, 1928, ATW/7; *Wiener Allgemeine Zeitung*, Feb. 14, 1928.

22. *Neue Freie Presse*, Jan. 30, 1928; *Neues Wiener Journal*, Feb. 19, 1928; fragment, "Stürmische…," [Feb. 1928], NC.

23. *Neues Wiener Journal*, Feb. 21, 1928.

24. [Max Fürst], draft contract, Feb. 21, 1928, ATW/7; LL/Gion contract, March 1, 1928, OSAW/GZ3701/7/3/1931; *Neues Wiener Journal*, March 2, 1928.

25. Schalk application, Sept. 21, 1928, OSAW/GZ2654/1928; LL to "…Freunde," Oct. 4, 1928, HMWA; Wilhelm Beetz, *Das Wiener Opernhaus, 1869 bis 1945* (Zurich, 1949), 85.

26. LL to Reucker, March 22, 1928, GC.

27. On sick leave: Fürst to Eckmann, July 4, 1928, OSAW/GZ2095/1928; Fürst to Schneiderhan, [July 1928], GC; Fürst to LL, July 16, 1928; LL to Fürst, [July 19, 1928], GC; Fürst to LL, June 23, and to Krause, July 4, 1928, ATW/7. On vacations: LL to Friedlaender, Oct. 11, 1928, ATW/7; LL to Schalk, [March 1929], ATW/10; Hohenberg to LL, Jan. 11, 1929, ATW/9; LL to MH, Sept. 3, 1928, GC.

28. Schalk to LL, March 8, 1929, ATW/10; LL to Schalk, March 12, 1929, ONBW/F18/Schalk [Krause draft at ATW/10].

29. Kerber to LL, April 2, 1929, ATW/9, and May 6, 1929, ATW/17; Schneiderhan to LL, May 10, 11, 1929, ATW/10; LL to Schalk, May 15, 1929, ONBW/F18/Schalk.

30. *Neues Wiener Journal*, Feb. 5, 1928; Prawy, *Opera*, 131; Berta Geissmar, *Musik im Schatten der Politik* (Zurich, 1985), 44–48; Carroll, 217; B. H. Haggin, "Vienna's Great Conductors: Burghauser's Memoirs," *Encounter*, 49, no. 1 (July 1977): 24–25.

31. Michael H. Kater, *Composers of the Nazi Era: Eight Portraits* (New York, 2000), 210–63.

32. LL to BW, Sept. 17, 1927, ATW/15 (1st quote); Else Walter to LL, Sept. 21, 1927, ATW/15; LL to BW, Dec. 10, 1928, GC; *Neues Wiener Journal*, Jan. 4, Feb. 5, Dec. 20, 1928 (2nd quote); Bruno Walter, *Theme and Variations: An Autobiography* (New York, 1966), 291; Strauss to Krauss, December 9, 1928, in Günter Brosche, ed., *Richard Strauss – Clemens Krauss Briefwechsel: Gesamtausgabe* (Tutzing, 1997), 48 (3rd quote); Brosche, 49.

33. Strasser, 88–90.

34. Roswitha Schlötterer, ed., *Singen für Richard Strauss* (Vienna, 1986), 28–30; Prawy, *Opera*, 132; Signe Scanzoni, *Wiener Oper: Wege und Irrwege: Ein Bericht* (Stuttgart, [1956]), 28; Götz Kende and Signe Scanzoni, *Der Prinzipal: Fakten, Vergleiche, Rückschlüsse* (Tutzing, 1988), 103–7; Joseph Gregor, *Clemens Krauss: Seine musikalische Sendung* (Bad Bocklet, 1953), 98–99, 105.

35. *Neues Wiener Journal*, Jan. 28, Feb. 10, March 4, 1928; Willi Schuh, ed., *Richard Strauss – Hugo von Hofmannsthal: Briefwechsel: Gesamtausgabe* (Zurich, 1970, 4th ed.), 559–60; Brosche, 31, 35, 46, 54, 58, 63–66; Alexander Witeschnik, *Wiener Opernkunst: Von den Anfängen bis zu Karajan* (Vienna, 1959), 193; Egon Seefehlner, "Die Direktoren und ihre Ensembles," in Andrea Seebohm, ed., *Die Wiener Oper: 350 Jahre Glanz und Tradition* (Vienna, 1986), 107; Strasser, 86.

36. Schlötterer, 52; Scanzoni, 35.

37. *NYT*, Aug. 11, 1931; Kernbauer and Weber, 3, 15, 20; Roman Sandgruber, *Ökonomie und Politik: Österreichische Wirtschaftsgeschichte vom Mittelalter bis zur Gegenwart* (Vienna, 1995), 376–77, 389; George E. Berkley, *Vienna and Its Jews: The Tragedy of Success, 1880s–1980s* (Cambridge, MA, 1988), 197; Botz, 212; Hanisch, 64, 301; Brosche, 104.

38. *NYT*, July 10, 1931.

39. Review, "Operntheater...," [May 1933], NC; Staatsoper to Gion, March 23, 1931, OSAW/GZ2870/7/3/1931; Kende and Scanzoni, 141; Brosche, 103, 105; Götz Kende, *Höchste Leistung aus begeistertem Herzen: Clemens Krauss als Direktor der Wiener Staatsoper* (Salzburg, 1971), 5, 51, 64–65, 87–90, 96–97.

40. *NYT*, Aug. 16, 1931 (quote); Bartolo, 79.

41. LL to Strauss, April 12, 1932, RG; Kende and Scanzoni, 148–49; reviews, "Das...," [April 1932]; "In...," [May 1932]; "(Staatsoper.)," [March 1933], NC; Farga, 322; Kende and Scanzoni, 142; Kende, 94.

42. Fürst–Krauss–Krause correspondence, Oct.–Nov. 1929, ATW/9.

43. See Krauss to Fürst, Nov. 4, Fürst to Krause, Nov. 5, 1928, ATW/9.

44. Gion, addendum to contract of March 1, 1928, Vienna, Jan. 18, 1930, OSAW/ GZ3701/7/2/1931; Fürst to Krauss, Feb. 20, 1930; Gion to Fürst, OSAW/GZ3701/ 7/3/1931; "Der...," [April 1930], NC; *Neues Wiener Journal*, April 8, 1930; Scanzoni, 34.

45. LL in newspaper fragment, [April 1930], NC.

46. LL memo, June 24, 1931, OSAW/GZ2870/7/5/1931; LL to MH, Oct. 18, 1931, GC; NYT, Oct. 18, 1931, *Neues Wiener Tagblatt*, Dec. 25, 1931.

47. Gion memo, Jan. 5, 1932, OSAW/GZ3701/7/2/1931; figures in Prawy, *Opera*, 134.

48. Figures in Kende and Scanzoni, 146–47.

49. Hans Hotter, *Der Mai war mir gewogen...: Erinnerungen* (Munich, 1996), 120.

50. Kralik, 141; Seefehlner, 108.

51. Ideally, Krauss had wanted to perform *Wozzeck* once a month, but, as Berg had feared, the Vienna audience would not stand for that. See Kende, 50. Also *Wiener Salonblatt*, April 13, 1930; Scanzoni, 20, 39; Strasser, 87–90; Prawy, *Leben*, 47; Seefehlner in Prawy, *Leben*, 233; Carroll, 217; Franz Grasberger, ed., *Der Strom der Töne trug mich fort: Die Welt um Richard Strauss in Briefen* (Tutzing, 1967), 436.

52. LL, *Anfang*, 185; Gerd Puritz, *Elisabeth Schumann: A Biography* (London, 1993), 171–72; Kende, 66.

53. Tamara Barzantny, *Harry Graf Kessler und das Theater: Autor, Mäzen, Initiator, 1900–1933* (Cologne, 2002), esp. 125–39; Laird M. Easton, *The Red Count: The Life and Times of Harry Kessler* (Berkeley, 2002), 133–39.

54. LL to Schalk, Nov. 2, 1927, ONBW/F18/Schalk (quote); LL to Schumann, July 6, 1929, ATW/17; LL, *Lives*, 225–26; LL, *Singing*, 154; Gregor, 107–8; Seefehlner, 106.

55. See "Gespräch...," fragment, [Dec. 1929], NC. Also LL to Schaffler, April 24, 1971, BC; LL, "Franz Schalk," n.d., CW; LL, *Singing*, 49.

56. See LL, *Singing*, 49; LL, *Lives*, 85.

57. On Aug. 18 and 25, 1926. See Hickling; Krauss to LL, Sept. 20, 1926, ATW/3.

58. Simon to LL, April 13, May 30, 1928 (quote), ATW/7; Hickling.

59. Krauss to LL, Feb. 14, 1929; LL to Krauss, Feb. 16, 1929, ATW/8; Hickling.

60. Krauss to LL, March 29, 1929; Krauss to Hochwohlgeboren, Sept. 6, 1929, ATW/9; Brosche, 59, 67, 75.

61. Kende, 68–71, 80–81, 83–84, 108; Krauss to Strauss, Nov. 18, 1931, ibid., 60 (quote); Krauss to LL, June 19, 1930, ATW/17; Heger to LL, July 13, 1933, ATW/ 15; *Wiener Salonblatt*, July 5, 1931; NYT, July 12, 1931; Brosche, 77–78, 82, 86.

62. See Beaumont Glass, *Lotte Lehmann: A Life in Opera and Song* (Santa Barbara, 1988), 111.

63. See Kende and Scanzoni, 119.

64. See LL, *Singing*, 49; LL as interviewed (1936) in Lanfranco Rasponi, *The Last Prima Donnas* (New York, 1982), 480; Prawy, *Opera*, 135; Kralik, 141.

65. Sheean, 86 (quote); Brosche, 86, 133; Rasponi, 136; facs. in Schlötterer, 72, also see 9–14, 51–53.

66. Hickling; *Wiener Salonblatt*, May 22, 1932, Aug. 27, 1933, Jan. 1, 1934.

67. Cf. LL, *Lives*, 33; Robert Tuggle, MOA, to author, Nov. 6, 2005.

68. LL in Rasponi, 482.

69. LL, *Lives*, 199 (quote). On voice, see Rasponi, 482; Jens Malte Fischer, *Grosse Stimmen: Von Enrico Caruso bis Jessye Norman* (Stuttgart, 1993), 174.

70. Schuh, 494; LL to Strauss, Dec. 28, 1927, RG [draft in GC]. Strauss to LL, May 16, 1926, ATW/17 (quote).

71. On Rethberg, see Horst Henschel and Ehrhard Friedrich, *Elisabeth Rethberg: Ihr Leben und Künstlertum* (New York, 1977, 1st pr. 1928), esp. 16–20, 106–15; Irving Kolodin, *The Metropolitan Opera, 1883–1966: A Candid History* (New York, 1966, 4th ed.), 310; Robert Tuggle, *The Golden Age of Opera* (New York, 1983), 216; Fischer, 216; Brosche, 106.
72. Reucker to Strauss, May 10, Nov. 1, 1927, RG; Schuh, 585–600, 604.
73. LL to Strauss, Dec. 12, 1927; Reucker to Strauss, June 15, 1927, RG.
74. Strauss to Jeritza, Dec. 30, 1927, RG.
75. Jeritza to Strauss, Jan. 17, 24, 26, 28, 1928; Reucker to Strauss, Jan. 24, 1928, and to Jeritza, Jan. 24, 1928, RG.
76. *Neues Wiener Journal*, March 1, 1928.
77. Strauss, "Dementi," April 6, 1928, German and English versions (quotes from the English original), RG; "Intrigenschlacht...," fragment, [early April 1928], NC; *Neues Wiener Journal*, March 25, May 24, 25, 30, 1928; Schuh, 619, 621; Grasberger, 313–15.
78. See *Neues Wiener Tagblatt*, May 26, 1928; *Der Tag*, May 27, 1928.
79. LL to Heynig, Jan. 6, 1928, ATW/7; LL to Sachse, Jan. 6, 1928, ATW/16; Schuh, 616–17; "Nach...," fragment, [Feb. 1928], NC; Strauss to LL, April 9, 1928, GC; LL to Strauss, April 10, 1928, RG.
80. LL to Reucker, March 22, 1928, GC; Reucker to LL, March 24, 1928, ATW/14; Reucker to LL, April 3, June 1, 1928, ATW/7; Strauss to Reucker, April 13, 1928; Reucker to Strauss, April 13, 1928, RG; *Neues Wiener Journal*, June 5, 1928.
81. Hans Heinz Stuckenschmidt, *Zum Hören geboren: Ein Leben mit der Musik unserer Zeit* (Munich, 1979), 133 (1st quote); 2nd quote from Michael Walter, *Richard Strauss und seine Zeit* (Laaber, 2000), 347; Paul Stefan, "Die Dresdener Uraufführung der 'Ägyptischen Helena'," *Die Bühne*, 5, no. 188 (1928): 4–5; *Wiener Salonblatt*, June 24, 1928; *Neues Wiener Journal*, June 16, July 4, 1928; Grasberger, 315.
82. *NYT*, Nov. 7, 1928. See Michael H. Kater, "Much Ado about Helena: Musings about One of Richard Strauss's Lesser-known Operas," *Richard-Strauss-Blätter*, no. 57 (June 2007): 3–14.
83. Guest list in *Neues Wiener Journal*, June 12, 1928. For schedule, see Hickling.
84. *Neues Wiener Journal*, June 14, 1928.
85. LL to Strauss, July 15, 1928, RG [draft in GC].
86. Strauss to LL, July 19, 1928, GC; LL to Strauss, [July/Aug., 1938], RG. See note 78, above.
87. Strauss to LL, Aug. 11, 1928, GC. Also Strauss to LL, Sept. 6, 1928, GC.
88. LL to Strauss, Sept. 11, 1928, RG [draft in GC].
89. Grasberger, 320–21.
90. Karpath to LL, Nov. 5, 1928, GC; Schuh, 679; Grasberger, 322; Günter Brosche, ed., *Richard Strauss – Franz Schalk: Ein Briefwechsel* (Tutzing, 1983), 406, 409; Glass, 101.
91. Hofmannsthal to Strauss, Nov. 28, 1928, in Schuh, 680.
92. The last time LL had sung the Dyer's Wife was on Jan. 23, 1921, under Schalk; she sang it again under Krauss on Feb. 25, 1931 (Hickling). Also Strauss to LL, April 1, 1929, ATW/17; Brosche, *Krauss*, 55, 58, 65, 93, 97–98, 101–2, 106, 111, 132, 138; Grasberger, 335.
93. LL to MH, Jan. 8, 1931, GC; reviews, "Lotte...," [for Oct. 19, 1929]; "Einst...," [for Oct. 23, 1929]; "Neue...," [Odeon recordings, Berlin, May 1931]; "Kammersängerin...," [for Jan. 7, 1932]. See Hickling for all of LL's Strauss parts, then or after.

94. LL, *Singing*, 50 (quote). This occurred on Aug. 19 or 26, 1932 (Hickling).
95. *Neues Wiener Journal*, July 4, 1928. Also Schuh, 625–42, 701.
96. LL to EP, June 28, 1933, and to Petschnikoff, July 19, 1933, ATW/12; LL, *Anfang*, 206.
97. Documentation in AAKB, Nachlass Reucker, "Mein Weg," 45/46.
98. LL–Gaussmann interview, Salzburg, Aug. 1969, soundtrack at LLFA.
99. See text above at note 67.
100. LL to EP, June 28, 1933, and to Lili Petschnikoff, July 19, 1933, ATW/12; LL, *Anfang*, 206.
101. LL interview as in note 98; LL, "Richard Strauss," n.d., CW; LL, *Singing*, 91.
102. LL, *Singing*, 110.
103. This corrects Nigel Douglas, *Legendary Voices* (New York, 1995), 141.
104. Michael H. Kater, *The Twisted Muse: Musicians and Their Music in the Third Reich* (New York, 1997), 120–23.
105. Adolph to Strauss, March 14, 1933, RG; Ministerium to Reucker, May 26, 1933, AAKB, Nachlass Reucker, "Mein Weg," 46.
106. See Heinz Joachim, "'Arabella' von Richard Strauss," *Melos*, 12 (1933): 247.
107. Strauss to Fürstner, March 10, 11, 1933, BS/Ana/330/I/Fürstner; Grete Busch, *Fritz Busch: Dirigent* (Frankfurt am Main, 1970), 71; Fritz Busch, *Pages from a Musician's Life* (Westport, CT, 1971), 210.
108. Adolph to Strauss, March 14, 1933; Strauss to Adolph, March 17, 1933, RG.
109. Brosche, *Krauss*, 129.
110. Strauss to Fürstner, March 28, April 2, 8, 1933, BS/Ana/339/I/Fürstner; Tietjen to Richard Strauss, [April 1933], April 1, 1933; Strauss to Fanto, April 7, 1933, RG; Brosche, *Krauss*, 129, 132–35.
111. Adolph to Strauss, April 12, 1933, RG; Strauss to Fürstner, April 13, 1933, BS/Ana/339/I/Fürstner; Brosche, *Krauss*, 136.
112. Fragment, May 6, 1933, AAKB, Nachlass Reucker, "Mein Weg," 46; Adolph to Franz Strauss, May 11, 1933, RG.
113. LL to Krause, March 9, 1933, ATW/15; Jens Malte Fischer to author, Nov. 16, 2005 (quote). Fischer remarks that even the all-time best Arabella, Lisa della Casa, sometimes audibly strained her voice.
114. Tietjen to Strauss, April 1, 1933; Adolph to Strauss, April 12, 1933, RG; Adolph to LL, April 15 and 22, 1933, ATW/13.
115. Strauss to LL, April 20, 1933, ATW/17 (1st quote); LL to Strauss, April 23, 1933, RG (2nd quote).
116. LL to Adolph, April 24, 1933, ATW/13; LL to Strauss, May 29, 1933 (quote) [draft in ATW/17]; LL to Westervelt, May 23, 1933, GC; Brosche, *Krauss*, 137.
117. Strauss to Oertel, June 1, 1933, BS/Ana/339/I/Fürstner.
118. *Dresdner Neueste Nachrichten*, July 4, 1933; Hugo Rasch, "'Arabella': Das neue Meisterwerk von Richard Strauss," *Deutsche Kultur-Wacht*, no. 15 (1933): 9–11; Fürstner to Reucker, July 7, 1933, AAKB, Nachlass Reucker, "Mein Weg," 46; Tietjen to Strauss, Jan. 3, 1934, RG; André Tubeuf, "Ein Leben für Richard Strauss," *Journal der Bayerischen Staatsoper* (1991/92): 11–12; Hotter, 147–48; Brosche, *Krauss*, 142, 153.
119. Brecher to LL, June 18, 1933; Hase to LL, June 7, 1933, ATW/12.
120. Heger to LL, July 13, Oct. 11, 1933, ATW/15.
121. Notice, "Lehmann...," [July 1933], NC.
122. LL to Westervelt, Oct. 25, 1933, GC. This became her official line later. See LL, *Lives*, 58.

123. Furtwängler as quoted in Heger to LL, [summer 1933]; Heger to LL, Oct. 11, 1933; Furtwängler to LL, Sept. 13, 1933, ATW/15; LL to Krause, June 19, 1933; LL, *Singing*, 92.

124. On continuing friction with Krauss, see Josef Krips and Harrietta Krips, *Erinnerungen: Ohne Liebe kann man keine Musik machen* (Vienna, 1994), 105–6.

125. *Wiener Salonblatt*, Nov. 5, 1933; "The...," [Oct. 1933] (quote), NC; LL, "Maestro Toscanini," n.d., CW; Strasser, 91.

126. Hickling.

127. See Tietjen to Richard Strauss, Oct. 26, 1933, RG.

128. Friedrich Lange, *Gross-Berliner Tagebuch, 1920–1933* (Berlin-Lichtenrade, 1951), 69, 81–83; notice, "Während...," [May 1926], NC.

129. Reviews, "Sie...," [March 1928]; "In...," [March 1928], NC; Lange, 92, 122.

130. Bing to LL, May 7, 1927, ATW/4.

131. LL to Stadtoper, Sept. 14, 1926; Städtische Oper to LL, Sept. 17, 1926; LL to BW, Oct. 28, 1926, ATW/15; LL to Städtische Oper, Jan. 25, 1927; Pauly to LL, Jan. 27, Feb. 2, 1927, ATW/4.

132. Reviews, "Die...," [spring 1927]; "Lotte...," [March 1928], NC; *Berliner Börsenblatt*, Jan. 1, 1929.

133. Tietjen in Hannes Reinhardt, ed., *Das bin ich* (Munich, 1970), 182–84, 187–88; Lange, 88; Bruno Walter, 272–73; Peter Heyworth, *Otto Klemperer: His Life and Times*, vol. 1 (Cambridge, 1983), 240.

134. Pringsheim, "Fidelio...," [April 1928], NC; Lange, 155; BW and Lotte Walter-Lindt, *Briefe, 1894–1962* (Frankfurt am Main, 1969), 223.

135. Bruno Walter, 273; David Clay Large, *Berlin* (New York, 2000), 216.

136. BW to Tietjen, May 20, 1927, AAKB, Nachlass Tietjen, Korr. Walter, Hbr/Dhpe.

137. Tietjen to BW, [May 1927], AAKB, Nachlass Tietjen, Korr. Walter, Hbr/Dhpe.

138. Entry for May 17, 1927, in Lange, 96.

139. BW to Tietjen, May 31, 1927, AAKB, Nachlass Tietjen, Korr. Walter, Hbr/Dhpe.

140. Else Walter to LL, Sept. 21, 1927, ATW/15.

141. Lange, 123; BW and Walter-Lindt, 217–21, 223–25; Erik Ryding and Rebecca Pechefsky, *Bruno Walter: A World Elsewhere* (New Haven, 2001), 198–99.

142. Lange, 103, 127–28, 135; Heyworth, 288; Pamela M. Potter, "The Nazi Seizure of the Berlin Philharmonic or the Decline of a Bourgeois Musical Institution," in Glenn R. Cuomo, ed., *National Socialist Cultural Policy* (New York, 1995), 43–45; Large, 216; Hugh Canning, "Deutsche Staatsoper and Kroll Oper," *Grove*.

143. On the Berlin bureaucracy, see Lange, 88.

144. Wolff to LL, June 29, 1926, ATW/3, Jan. 7, 1927, ATW/4.

145. Zander to LL, Jan. 10, 1927; Bing to LL, July 4, 1927; LL to Tietjen, July 14, 1927; LL to Tietjen and BW, Oct. 24, 1927, ATW/4; LL to Ascher, Jan. 16, 1928, ATW/7; *Der Morgen*, Jan. 30, 1928; *Neues Wiener Journal*, Oct. 12, 1928.

146. LL to BW, March 26, 1929, GC (quotes); LL to Hohenberg, [Jan. 1929]; LL to BW, Feb. 6, 1929; Singer to LL, March 4, 1929; Guttmann to LL, March 29, 1929; BW to LL, April 4, 1929, ATW/9.

147. LL to Tietjen, [fall 1929], ATW/9.

148. Preussische Staatstheater correspondence regarding LL, June–Sept. 1929, GStAB; Axel Schröder, Landesarchiv Berlin, to author, May 21, 2003; Hickling.

149. The Kroll Opera had folded in 1931, and Tietjen had given up direction of Städtische Oper to Carl Ebert that year, with Bing as his business manager (Lange, 162).

150. Hickling.

151. BW to LL, Sept. 13, 1926, ATW/15; *Berliner Börsenzeitung*, Feb. 14, 1927.

152. *Berliner Börsenzeitung*, Jan. 7, 1929.

153. Criticisms of March 30, 1928, performance [March 1928], NC.

154. *NYT*, Nov. 6, 1932 (1st quote); Deutsch, "Eine...," [Oct. 1932] (2nd quote); reviews, "Das...," [Oct. 1932] (3rd quote); "Für...," [Oct. 1932] (4th quote), NC.

155. Simon to Ziegler, Oct. 8, 1932, MOA.

156. Reviews, "Furtwängler-Konzert...," [1927]; Stuckenschmidt, "Von...," [spring 1932], NC.

157. Walter Legge's entries for May 6 and June 8, 1927, in Elisabeth Schwarzkopf, *On and Off the Record: A Memoir of Walter Legge* (New York, 1982), 19–20.

158. Quoted in Robin Daniels, *Conversations with Cardus* (London, 1976), 237.

159. Reviews, "Madame...," "Perfection...," [Nov. 1926], NC; Hecht to LL, Dec. 22, 1926, LL to Hecht, Dec. 29, 1926, ATW/3; Hecht to LL, Jan. 4, 1927, ATW/4.

160. LL to BW, Oct. 28, 1926, ATW/15; LL to Hecht, Nov. 30, 1926, ATW/3; Mossel to LL, June 18, 1928, GC; Blois to LL, Feb. 27, 1929, ATW/8.

161. Blois to LL, Nov. 27, 1926; LL to Blois, Dec. 14, 1926, ATW/3; Kulka to LL, July 4, 1927, ATW/5, and Feb. 28, 1928, ATW/14; Kulka to LL, Dec. 6, 1927; Blois to LL, Dec. 30, 31, 1927; Cruesemann to LL, May 23, 1928, ATW/7.

162. Harold Rosenthal, *Two Centuries of Opera at Covent Garden* (London, 1958), 443–44, 476–78.

163. *NYT*, Aug. 11, 1931; Gisela Prossnitz, "Salzburg: Perhaps Art's Last Existing Sanctuary from the Political World – The Salzburg Festival in the Thirties," in Kenneth Segar and John Warren, eds., *Austria in the Thirties: Culture and Politics* (Riverside, 1991), 240; Stephen Gallup, *A History of the Salzburg Festival* (London, 1987), 65–66; Brigitte Hamann, *Winifred Wagner oder Hitlers Bayreuth* (Munich, 2002), 249–61.

164. *NYT*, Aug. 14, 1929, Aug. 6, 1930, Sept. 21, 1930.

165. Reviews, "Um..."; "Im...," [Aug. 1933], NC; *Musical Courier*, Sept. 23, 1933.

166. Reviews, "Neben...," [Aug. 1929] (quote); "Das..."; "Wie...," [Aug. 1929], NC.

167. Correspondence in ATW and newspaper fragments in LL's scrapbooks, 1926–33, NC.

168. Böhme to LL, March 7, June 10, 1927; Sachse to LL, March 14, April 10, 1927, ATW/4; Chevalley, "Wie...," [Dec. 1927], NC.

169. Friedlaender to LL, April 10, July 31, Sept. 21, Nov. 11, 1927; LL to Friedlaender, Sept. 17, Oct. 15, 1927, ATW/4.

170. Program, "Soirée du 29 Juin 1928," ATW/14.

171. LL/Friedlaender Correspondence, 1927–33, ATW/4, 7, and 9.

172. Hickling; notice, "Lotte...," [Jan. 1929], NC (quote).

173. *Neues Wiener Journal*, Dec. 1, 1929; notice, "Lotte...," [Dec. 1929], NC.

174. Certificate, March 18, 1931, PA Hertha Schuch; notice, "Lotte...," [March 1931], NC; *NYT*, Nov. 1, 1931.

175. LL to Schornstein, Dec. 23, 1967 (1st quote) and April 16, 1967 (2nd quote), GC; LL to Lachmann, Dec. 21, 1961, ATW/TNLL (3rd quote).

176. LL to Hohenberg, June 22, 1926, ATW/3; LL to Sachse, [March 1927], ATW/4.

177. Hohenberg to LL, July 6, 1927; LL to Hohenberg, July 14, 1927, ATW/4.

178. Friedlaender to LL, May 29, Sept. 16, 1929, ATW/9.

179. Simon to LL, March 29, April 21, 1928, ATW/7.

180. Friedlaender to LL, April 3, 4, 12, 1929, ATW/9.

181. Friedlaender to LL, Oct. 24, 1929, ATW/9.

182. LL to Friedlaender, Dec. 19, 1933, ATW/13.

183. LL to Westervelt, [March 11, 1932], GC.
184. Wolff and Sachs to LL, Aug. 11, 20, 28, Sept. 4, 1926, ATW/3; Sachs to LL, March 16, 1927, ATW/5 (quote).
185. Astrid Varnay, *Fifty-Five Years in Five Acts: My Life in Opera* (Boston, 2000), 147–48, 178, 182–83; Helen Traubel, *St. Louis Woman* (New York, 1959), 222–25; Beverly Sills, *Bubbles: A Self-Portrait* (Indianapolis, 1976), 211; Shirlee Emmons, *Tristanissimo: The Authorized Biography of Heroic Tenor Lauritz Melchior* (New York, 1990), 318–19.
186. Bing to LL, April 14, 21, May 7, June 6, Aug. 25, 1927, ATW/4; LL to Bing, Oct. 15, 1927, ATW/4.
187. Hohenberg to LL, May 14, 1926, ATW/3 (quote), and Oct. 8, 1927, ATW/4.
188. Bernstein to LL, May 11, 1928, ATW/7.
189. Bing to LL, June 4, 1926, ATW/3. See Hohenberg to LL, March 29, 1927, ATW/4.
190. Bing to LL, Sept. 6, 1926, ATW/3.
191. Wolff and Sachs to LL, June 27, 1927; LL to Simon, July 14, 1927; Simon to LL, July 21, Aug. 15, 1927; Union to LL, July 25, 1927, ATW/5.
192. Sachs to LL, July 27, 1927, ATW/5.
193. Simon to LL, April 21, 1928 (1st quote), June 7, 1928 (2nd quote), ATW/7.
194. Correspondence, 1928–29, in ATW/7, 9, and 14. Also LL to BW, March 26, 1929, GC.
195. Hohenberg to LL, June 22, 1929, ATW/9.
196. LL to BW, March 26, 1929, GC; Krug to LL, April 5, 1929, ATW/9.
197. Friedlaender to LL, Oct. 29, Nov. 6, 1929, ATW/9.
198. Notice, "Singer...," [Nov. 1926], NC.
199. Reviews, "Die...," [May 1927]; "Bremer...," [March 1928]; "Lotte...," [Oct. 1928]; "Madame...," [Feb. 1930]; "Miss...," [May 1930], NC; Hickling.
200. Reviews, "Singer...," [Nov. 1926]; "At...," [Oct. 1929]; "Lotte...," [April 1932], NC; Hickling.
201. Reviews, "Arienabend..."; "Arienabend von...," [May 1927], NC.
202. LL to Westervelt, March 9, 1934, GC.
203. Reviews, "Nicht...," [1926]; "Cases...," [Feb. 1930]; "Ein...," [April 1932]; "Konzert...," [April 1932], NC; Hickling.
204. Review, "Mme...," [March 1931], NC.
205. MONO 89189, Austro Mechana, Historic Recordings, (P) 1999.
206. Traubel, 141 (1st quote); LL as interviewed (1936) in Rasponi, 481–82 (2nd quote). See Kende and Scanzoni, 107.
207. Schornstein; LL, "Franz Schalk," n.d., CW; LL, *Anfang*, 172–73.
208. Review, "Lotte...," [May 1927]; Hickling; notice, "Ein...," [March 1928], NC; *Neues Wiener Journal*, April 11, 1928.
209. Strauss quoted in Karpath to LL, Nov. 5, 1928, GC; Brosche, 680. See Glass, 101.
210. LL to Schalk, March 12, 1929, ONBW/F18/Schalk.
211. Jens Malte Fischer to author, April 6, 2006.
212. Notice, "Lotte...," [Dec. 1929], NC; Ruoff to LL, May 25, 1930, ATW/11.
213. Review, "Unter...," [May 1931], NC; Hickling.
214. Kende, 68–70, 80–81; notice, "Begegnung...," [Oct. 1932], NC. See Simon to Villa, July 19, 1932, MOA.
215. Kende, 83–84.
216. LL to EP, June 28, 1933, ATW/12 (quote); review, "Grosser...," [March 1933], NC; Hickling.
217. LL to BW, July 20, 1933, ATW/15.

218. Weill, "Eine...," [Nov. 1933], NC; Hickling.
219. Notice, "Reitler-Feier," [Dec. 1933], NC; Hickling.
220. Review "'Otello'...," [May 1932], NC.
221. *NYT*, Aug. 16, 1931; *Neues Grazer Tagblatt*, Nov. 12, 1927; Robert Werba, *Maria Jeritza: Primadonna des Verismo* (Vienna, 1981), 118; Emmons, 72.
222. Schalk to LL, [May 28, 1930], ATW/11.
223. *Wiener Salonblatt*, May 16, Sept. 19, 1926, May, 1 Oct. 2, 1927, May 21, 1933; *Neues Wiener Journal*, March 22, April 12, 14, 15, 20, 1928; *NYT*, Sept. 7, 1930; Rosenthal, 447.
224. *Wiener Salonblatt*, July 11, 1926; *Neues Wiener Journal*, April 15, 1928; *NYT*, Aug. 24, 1930, Jan. 30, April 30, July 12, 1932.
225. See Introduction in Ernst Decsey, *Maria Jeritza* (Vienna, 1931), [3]; *Wiener Salonblatt*, Aug. 16, 1931; *Neue Freie Presse*, Aug. 25, 1931.
226. Nigel Douglas, *More Legendary Voices* (London, 1994), 119.
227. *NYT*, July 11, 1982; Frida Leider, *Das war mein Teil: Erinnerungen einer Opernsängerin* (Berlin, 1959), 82–83; Rosenthal, 446; Emmons, 72–73; Carroll, 192–93.
228. Friedlaender to LL, June 6, 1928, ATW/7; Else Walter to LL, June 10, 1928, GC; *Neues Wiener Journal*, May 15, 1928; Strasser, 39.
229. *Neues Wiener Journal*, May 1, 8, 1928; *Neue Freie Presse*, May 22, 1928; Friedlaender to LL, Oct. 13, 1928, ATW/7, and Sept. 27, 1929, ATW/9.
230. *Neues Wiener Journal*, June 19, 1928; *Wiener Salonblatt*, June 19, 1932; *NYT*, Oct. 18, 1931.
231. See text above at note 24; invoice, Breuer-Blaskopf, March 1927, ATW/2.
232. Prawy, *Leben*, 42; "Salzburger Festspiele" (1928), ATW/7.
233. RAVAG to LL, Oct. 20, 1927, ATW/6.
234. Carl Lindström AG to LL, April 22, Oct. 19, 1926, ATW/6. Exchange rates according to a table in *Vossische Zeitung*, Oct. 13, 1932.
235. "Hotel Deutscher Kaiser," ms., n.d., PA Hotel Deutscher Kaiser, Perleberg; Continental Hotel invoice, Feb. 27, 1927, ATW/2.
236. *Statistisches Jahrbuch für das Deutsche Reich 1928* (Berlin, 1928), 341, 343, 369.
237. Bock to LL, Feb. 18, 1927, ATW/4. Also Hotel Berg invoice, [July 28, 1927], ATW/2.
238. *Statistisches Jahrbuch für das Deutsche Reich 1932* (Berlin, 1932), 253–54, 284; Staatsoper memo, June 23, 1932; Staatsoper to Simon, Sept. 2, 1932, GStAB; text above at note 149; Hickling; Michael H. Kater, *Doctors Under Hitler* (Chapel Hill, NC, 1989), 260.
239. Witt to LL, Oct. 8, 1929, ATW/9; Trummer to LL, Dec. 12, 1929, ATW/10; LL to Bader, Sept. 30, 1930, ATW/11.
240. Schumann to LL, March 19, 1929, ATW/17.
241. LL to Westervelt, Oct. 25, 1933; LL to Else Walter, Feb. 22, 1937, GC; author's interview with Hertha Schuch, Vienna, Sept. 19, 2003.
242. LL to Westervelt, May 23, 1933, GC; LL, *Anfang*, 163, 193.
243. LL to Blois, Oct. 15, 1929, ATW/8; notice, "Rechts...," [Aug. 1930], NC; Erich to Lachmann, [1932], ATW/TNLL.
244. Staatstheater memos, June 31 and Sept. 8, 1926, OSAW/GZ1623/1926.
245. LL to Steueradministration, Sept. 8, 1926, ATW/3.
246. Eisler to LL, [postmarked March 25, 1927]; Credit-Anstalt to LL, Sept. 15, 1927, ATW/4.
247. LL to MH, Oct. 19 (quote), 23, 1927, GC.

248. LL to MH, Feb. 26, Sept. 3, 1928; FL to LL, June 28, 1945, GC.

249. See Brünner AG to LL, Dec. 1927, ATW/2; Steyr-Werke AG to LL, Dec. 5, 1928, ATW/7.

250. LL memo, Feb. 18, 1928, GC.

251. Eisler to LL, May 19, ATW/2, and July 17, 1928, GC.

252. LL to MH, Dec. 2, 1928, GC.

253. LL to Oper, Sept. 30, 1927, ATW/4; Blois to LL, Dec. 9, 1928, ATW/7; Staatstheater memo, June 23, 1932, GStAB.

254. Rechnungsabteilung to LL, March 2, 1929, ATW/2; Versicherungsanstalt to LL, March 6, 1929, and to Müller, April 12, 1929; Quittungsabschrift, Apr. 15, 1929, ATW/10.

255. Eisler to LL, Oct. 18, Nov. 7, 1929, ATW/2.

256. Eisler to LL, Sept. 11, 26, Oct. 22, 1930, ATW/2.

257. Eisler to LL, Oct. 30, 1930, ATW/2; LL to MH, Feb. 1, 1932, GC (quote).

258. Krause and LL to Betz, [fall 1927]; Betz to LL, Oct.1, 5, 1927; Betz to LL, Oct. 16, 1927, ATW/4.

259. Loewenherz to Krause, Jan. 2, 7, 1928, GC.

260. Westphal to Krause, Nov. 16, 1927, GC; Konrad to Krause, Feb. 11, 1929, ATW/8.

261. LL to MH, Oct. 19, 1927, GC.

262. LL to [Betty] Krause, Jan. 1, 1930; MH to Krause, March 31, 1930, ATW/11.

263. Hohenberg to LL, July 3, 1928, ATW/7; Erich Leinsdorf, *Cadenza: A Musical Career* (Boston, 1976), 21.

264. Fürsten Kinsky to "Herrn u. Frau Bankier Otto Krause," June 9, 1933, ATW/12; *NYT*, Feb. 10, 1934. Krause also used the military title of *Oberstleutnant* (lieutenant colonel), two rungs above his captain rank. Correspondence (1927), ATW/3.

265. Cf. the erroneous description in Glass, 128.

266. LL to MH, Oct. 18, 1931, Feb. 1, 1932; LL to EP, June 28, 1933, ATW/12; Burgau-Akselrad to Krause, Jan. 9, 1933, ATW/12.

267. Isabella Ackerl, "Der Phönix-Skandal," in *Das Juliabkommen von 1936: Vorgeschichte, Hintergründe und Folgen* (Munich, 1977), 241–79; Alexander Spitzmüller, *"Und hat auch Ursach, es zu lieben"* (Vienna, 1955), 367.

268. According to Herman Schornstein. See Schornstein to LL, Sept. 18, 1973, GC.

269. See LL to CH, Dec. 16, 1939, CU/1. On her first post–World War II visit to Vienna, LL was reminded of her husband's practices by her former maid and then told Bernhard von Barsewisch (Barsewisch).

270. LL to MH, Jan. 23, 1927, ATW/4.

271. LL to Schumann, July 6, 1929, ATW/17.

272. LL to Schalk, May 15, 1929, ONBW/F18/Schalk (quote); notices, "Nun...," [1930]; "Die...," [1930]; "Lotte...," [Nov. 1930], NC; Lehmann, *Lives*, 125.

273. Author's interview with Hertha Schuch, Vienna, Sept. 27, 2003; Erika Putlitz-von der Schulenburg in Berndt W. Wessling, *Lotte Lehmann: Mehr als eine Sängerin* (Salzburg, 1969), 48; LL, *Anfang*, 163; LL to MH, Oct. 19, 1927, Dec. 20, 1943, GC; MH to Krause, Nov. 13, 1930, ATW/11.

274. For 1933 alone, see Krause to LL, April 28, 1933; LL to Krause, June 13, 1933, ATW/7; LL to Krause, Feb. 22, Nov. 23, 27, 1933, ATW/2.

275. *Neues Wiener Journal*, Dec. 1, 1929; correspondence, ATW.

276. Hohenberg to LL, July 3, 1928, ATW/7, June 12, 22, 1929, ATW/9. Also see LL to MH, Feb. 26, 1928, GC.

277. Gydtin to LL and Krause, Dec. 12, 1933, ATW/11; LL and Krause to Betty Krause, [Dec. 1933], ATW/12.

278. Betty Krause to LL and Krause, July 23, 25, 1933, ATW/12.
279. Betty Krause to LL and Krause, Oct. 14, 1933, and to Otto Krause, Nov. 27, 1933, ATW/12.
280. LL to Manon Krause, [1930] [draft], ATW/11.
281. Gutmann to Krause, Dec. 2, 1933; Manon to Otto Krause, Dec. 13, 1933, ATW/12.
282. LL to Schornstein, [Sept. 1970], GC.
283. FL to LL, [summer 1944] (quote), Nov. 20/23, 1945, GC.
284. Gary Hickling to author, June 4, 2004; Barsewisch; Schornstein.
285. See text in Chapter 2 at note 253.
286. Hickling; *LLLN*, Summer 1989, Fall 1990 (quotes), MAWA; Judith Sutcliffe (who has this from LL's later companion, Frances Holden) to author, June 3, 2004.
287. Berndt W. Wessling, *Lotte Lehmann: "Sie sang, dass es Sterne rührte": Eine Biographie* (Cologne 1995), 146, 171–72.
288. LL to Wessling, Dec. 13, 1968, GC.
289. Emmons, 74, 104–5.
290. Rosenthal, 478, 482.
291. Harold Rosenthaler, "Wolff, Fritz," *Grove.*
292. Kende, 35–36, 38–39, 41; Brosche, *Krauss*, 79.
293. Simon to Villa, June 22, July 19, 1932; Simon to Ziegler, July 18, 1932; Ziegler to Blois, July 27, 1932; Blois to Ziegler, Aug. 3, 1932, MOA.
294. P. E., "Tones...," [1926], NC.
295. Treu, "Nach...," [March 1929], NC (quote); Hickling.
296. Friedlaender to LL, March 26, 1929, ATW/9.
297. H. H., "Last...," [April 1929], NC. The performance was on April 24, 1929 (Hickling).
298. "When...," [May 1929], NC. The Performance was on May 8, 1929 (Hickling).
299. Hickling.
300. LL, "Maestro Toscanini," n.d., CW.
301. LL to Schnabl-Rossi, Oct. 2, 9, 1933, ATW/17; Joseph Horowitz, *Understanding Toscanini: How He Became an American Culture-God and Helped Create a New Audience for Old Music* (Minneapolis, 1988), 254–55 (quote 254), 55, 66; Harvey Sachs, *Toscanini* (Philadelphia, 1978), 36, 170, 271.
302. LL, "Maestro Toscanini," n.d., CW (quotes); LL to Westervelt, March 9, 1934, GC; Metmusic to LL, LL to Metmusic [all late fall 1933], ATW/13; *The Cadillac Concert*, Feb. 11, 1934, GC; Hickling.
303. LL to Westervelt, March 9, 1934, GC (emphasis LL's).
304. Harvey Sachs, ed., *The Letters of Arturo Toscanini* (New York, 2002), 168; Hickling.
305. LL to Hecht, [March 1934], GC.
306. LL to Lotte Walter, [March 21, 1969], GC.
307. Author's interview with David Russell, oral historian, UCSB, April 16, 2003.
308. Toscanini to LL, March 7, 1934, GC (quotes). Also see Toscanini to "my dear – my divine Lotte," [March 1934], GC.
309. Toscanini to LL, March 22, 1934, GC.
310. Toscanini to LL, April 4, 1934, GC.
311. Quoted in LL to MH, [March 1934], GC.
312. LL to MH, March 21, 1934, GC.
313. MH to LL, March 31, May 2, 1930, ATW/11.
314. This is the gist of my correspondence with Gary Hickling, who knew both LL and her friend Frances Holden, and Judith Sutcliffe, with whom he started the LL newsletters in the 1980s and who knew Holden well and, through many talks with

Holden, also knew LL. Gary Hickling to author, June 4, 2004; Judith Sutcliffe to author, June 3, Dec. 8, 2004.

315. LL to Hohenberg, June 22, July 10, 1926; Hohenberg to LL, June 30, 1926. ATW/3; Knepler to LL, Jan. 8, 1927, ATW/6; Müller to "meine geliebte Lotte," [1929], ATW/8; Müller to Krause, May 15, 1929, ATW/14; Müller, "Mein hohes Lied" [poem for LL, 1933?], ATW/12; Balogh to LL, [July 18, 1933], ATW/14.

316. Author's interview with Hertha Stodolowsky-Schuch, Vienna, Sept. 27, 2003; LL to Stodolowsky, [May 1931], [May 5, 1931], [Sept. 1931], Jan. 25, 1932, PA Hertha Schuch. See Stodolowsky's devout listings of LL performances, "Kleine Chronik vom 'Lotte-Lehmann-Jahr' 1931," Dec. 1931, PA Hertha Schuch.

317. Davenport, *Of Lena Geyer* (New York, 1936), esp. 219–20; Terry Castle, *The Apparitional Lesbian: Female Homosexuality and Modern Culture* (New York, 1993), 215–17.

318. See NYT, Nov. 18, 1989; *Times Herald Record*, Nov. 17, 1989; LL to CH, Dec. 17, 1968, CU/3; LL to Westervelt, March 5, 1933, GC.

319. FL to LL, May 13, 1944, GC.

320. See Holden; William D. Westervelt, *Legends of Gods and Ghosts (Hawaiian Mythology)* (Boston, 1915); Caroline Castle, *Early Church Music* (Honolulu, 1914).

321. LL, *Anfang*, 174–75.

322. LL to Westervelt, March 26, 1931, GC.

323. LL to Westervelt, April 10, 1931, GC.

324. LL, *Anfang*, 190–92; LL to Westervelt, Jan. 4, 1932, GC.

325. LL to Westervelt, [March 11, 1932] and June 16, 1932, GC.

326. LL to Westervelt, Oct. 31, 1932, GC.

327. LL to Westervelt, Nov. 5, 16, 1932, March 5, May 23, Sept. 13, 1933, GC.

328. LL to Westervelt, Oct. 25, 1933, [Nov. 1933], Jan. 2, 28, March 9, 29, 1934, GC; LL to Westervelt, Dec. 24, 1933, ATW/12.

329. Quoted example from PC.

330. Bundespräsident to LL, invitations for March 9, 1927 (ATW/4), Nov. 17, 1928, GC, and March 20, 1929, ATW/8.

331. Invitation of mayor for Nov. 3, 1928, and of Reinhardt for Aug. 24, 1928, GC. For Mann's intimate relationship with music, see Hans Rudolf Vaget's seminal *Seelenzauber: Thomas Mann und die Musik* (Frankfurt am Main, 2006).

332. Dorsch to LL, [two undated letters, 1933], ATW/17; Zuckerkandl to LL, Sept. 23, 1927, ATW/17.

333. LL to Telegraphendirektion, Jan. 23, 1927, ATW/5.

334. Kassner to LL, May 7, Aug. 30, [Dec. 10], 1928, GC; LL to Kassner, [May 1929], ATW/8; Milan Dubrovic, *Veruntreute Geschichte: Die Wiener Salons und Literaturcafés* (Frankfurt am Main, 1987), 198–200. See Walter Kleindel, ed., *Das grosse Buch der Österreicher: 4500 Personendarstellungen in Wort und Bild* (Vienna, 1987), 236.

335. EP to LL, Aug. 6, 1928, GC; correspondence (1929–33) in ATW/8, 11–12; Erika von der Schulenburg's poem dedicated to LL, Feb. 25, 1929, ATW/8; Schulenburg to LL, Nov. 2, 1933, ATW/12.

336. LL/Rechberg correspondence (1929–30), ATW/8 and 11; LL, *Anfang*, 165, 175.

337. Robert de Rothschild to LL, April 17, 1930, ATW/11; Auguste Victoria [self-styled Queen of Portugal] to LL, Aug. 20, 1930, ATW/11; notice, "Exkönig…," [May 1930], NC.

338. *NYT*, March 7, 11, 1926, June 6, 1926, June 19, Nov. 27, 1927, March 18, May 20, June 10, 1928, April 7, Aug. 14, 1929, April 13, Sept. 21, 1930. Also see *Musical America*, Sept. 1929, repeating an entry from the *New York Evening Post*.

339. *NYT*, July 4, 11, 1926, Jan. 16, Feb. 13, Oct. 30, Nov. 27, 1927, May 26, 1929, March 30, April 13, May 18, Oct. 15, 1930; *New York Herald*, Feb. 2, 1929.

340. *NYT*, Nov. 21, 28, 1926, Oct. 9, 1927.

341. H. Howard Taubman, *Opera: Front and Back* (New York, 1938), 350.

342. Grasberger, 262.

343. Adalbert Graf von Sternberg, "Lotte Lehmann," *Die Tribüne* (June 8, 1928): 2.

344. LL to Hecht, Dec. 29, 1926, ATW/3; Hecht to LL, Jan. 10, 1927, ATW/4; LL, *Anfang*, 178; LL, *Lives*, 164; LL, "Die Metropolitan Opera," n.d., CW (quote).

345. LL to Simon, Dec. 14, 1926, ATW/3 (quote). Also see LL, *Anfang*, 178.

346. Salter to LL, March 11, July 5, 14, Oct. 10, 1927, ATW/5; Salter to LL, Jan. 18, 23, March 10, 1928, ATW/7; LL to Salter, Jan. 17, 19, Feb. 15, 1928, ATW/7.

347. Salter to LL, May 21, Nov. 1, 1928, ATW/7, Sept. 19, 1928, ATW/16, Sept. 13, 1929, ATW/9; LL to Salter, [June 1928], ATW/7. Also see [Norbert Salter], *The World Musical and Theatrical Guide* (New York, 1929), vol. 1, 5–6, vol. 2, 30, 38.

348. Simon to Ziegler, April 23, 1926; Salter to LL, Nov. 15, 1928, MOA; Simon to LL, Nov. 15, 1928, ATW/7; LL to MH, March 30, 1929, ATW/8.

349. Geissmar, 26.

350. Geissmar to LL, Oct. 13, 1926; Hecht to LL, Dec. 22, 1926; LL to Hecht, Dec. 29, 1926, ATW/3; Hecht to LL, Jan. 4, 10, 1927; Böhme to LL, Feb. 14, 21, 24, March 7, 1927, ATW/4.

351. Siegfried Lavoie-Herz (Judson agency) to LL, Nov. 18, 1926, ATW/3.

352. Melchior to LL, [Sept. 1926], ATW/3.

353. Simon to LL, Sept. 3, 6, 16, 1926, ATW/3.

354. LL to Wolff, Sept. 8, 1926 (quote); LL to Musikwolf, [Sept. 1926], ATW/3.

355. Bing to LL, Sept. 6, 1926; LL to Wolff, Sept. 8, 1926, ATW/3. For the attractiveness of the Chicago offer, see Heller to LL, Dec. 13, 1926, ATW/6; LL, *Anfang*, 178.

356. Simon to LL, Oct. 8, 22, Nov. 2, 1926; LL to Simon, Oct. 28, 1926; Hohenberg to LL, Dec. 6, 1926, ATW/3.

357. LL to Simon, Nov. 30, 1926 (quote), Dec. 14, 1926, ATW/3.

358. Hohenberg to Simon, Nov. 26, 1926; Simon to Bing, Dec. 4, 1926; Simon to LL, Dec. 4, 1926, ATW/3.

359. LL to Simon, Dec. 7, 1926; Simon to LL, Dec. 10, 1926, ATW/3.

360. Simon to LL, July 21, Aug. 15, 26, 1927, ATW/5; Simon to LL, Dec. 29, 1927; Sachs to LL, Feb. 3, 1928, ATW/7; LL to Simon, July 14, Sept. 17, 1927, ATW/5; LL to Simon, Jan. 6, Sept. 11, 1928, ATW/7.

361. Simon to LL, April 25, May 16, Sept. 22, 1928, ATW/7; LL to Simon, Sept. 24, 1928, ATW/7.

362. Simon to LL, Sept. 26 (quote), Oct. 4, 1928, ATW/7. Under Schalk, LL sang Fidelio on Aug. 20, 24, and 28 (Hickling).

363. Ziegler to Simon, Nov. 21, 1928, MOA.

364. Simon to Ziegler, Nov. 12, 1928, Jan. 8, 11, 1929, MOA; Sachs to LL, April 23, 1929; Simon to LL, May 18, 28, Oct. 18, 1929; LL to Simon, Oct. 15, 1929, ATW/9; LL to MH, April 7, 1930, ATW/11.

365. *NYT*, March 17 (quote), May 26, 1926.

366. Indications of earnings differ, but those were probably not under $2,000 per Met event. See Emmons, 66; Taubman, 351; Tuggle, 211.

367. *NYT*, Oct. 20, 1926; Douglas, *More Voices*, 115; Mary Ellis Peltz, *Metropolitan Opera Milestones* (New York, 1944), 49.

368. *NYT*, Oct. 30, 1927 (1st quote), Jan. 14, 1928 (remaining quotes).

369. William J. Henderson as quoted in Kolodin, 344. Also see Quaintance Eaton, *The Miracle of the Met: An Informal History of the Metropolitan Opera, 1883–1967* (New York, 1967), 218. By contrast, note the fawning critique by Viennese observers in *Neues Wiener Journal*, Jan. 18, 1928.

370. Jeritza to Strauss, Oct. 14, 31, 1928, RG.

371. *NYT*, Nov. 6, 1928. Strauss's draft for the telegram in his own hand is on the back of Jeritza's telegram of Oct. 31 and mentioned in the newspaper.

372. Lawrence Gilman as quoted in George R. Marek, *Richard Strauss: The Life of a Non-Hero* (London, 1967), 262. See also Kolodin, 346, and the gratuitously benevolent review in *Neues Wiener Journal*, Nov. 9, 1928.

373. *NYT*, Nov. 4, 1929 (quotes). Also ibid., Nov. 2, 1929.

374. Jeritza to Strauss, Nov. 29, 1929, RG; *NYT*, Nov. 6, 9, 1932.

375. *NYT*, Feb. 10, 1931, Jan. 3, 7, 17, Oct. 18, Nov. 12, 1932; *Neues Wiener Journal*, Oct. 21, 1928; [Salter], *Guide*, vol. 2, 39; Kolodin, 357, 363, Douglas, *More Voices*, 115.

376. *NYT*, June 4, 1930, April 25, Oct. 6, 1931, May 1, 2, 21, Sept. 28, 1932, March 30, 1934; Theresa M. Collins, *Otto Kahn: Art, Money and Modern Times* (Chapel Hill, NC, 2002), 212, 217–19; Tuggle, 211; Douglas, *More Voices*, 125 (quote).

377. According to LL to MH, Feb. 26, 1928, GC.

378. *NYT*, Nov. 3, 18, 1927.

379. Kende, 26.

380. William J. Henderson as quoted in Kolodin, 336.

381. *Ibid.*, 342; Fischer, 216; Peltz, 49.

382. Kahn as quoted in Tuggle, 168. Also see Emmons, 95; Peltz, 50; Kolodin, 349.

383. Simon to Ziegler, Dec. 13, 1930, MOA.

384. Kolodin, 361, 364, 366; Peltz, 51–52; Collins, 239.

385. *NYT*, May 29, 1932; Paul Jackson, *Saturday Afternoons at the Old Met: The Metropolitan Opera Broadcasts, 1931–1950* (Portland, OR, 1992), 29, 31–34; Eaton, 250–51; Kolodin, 27, 31, 34, 368; Collins, 253.

386. *NYT*, Jan. 8, 1932.

387. Simon to Ziegler, May 12, 1932; Ziegler to Simon, May 23, 1932, MOA. Also see *NYT*, Sept. 28, 1932.

388. *Musical America* (Feb. 2, 1933): 29.

389. Simon to LL, April 7, 1933; Ziegler to Simon, May 2, 19, 1933; Simon to Ziegler, May 3, 1933, MOA; *NYT*, June 9, 1966.

390. *NYT*, May 3, 7, 1933; LL/Metropolitan Opera Association contract, June 21/27, 1933, MOA.

391. *NYT*, Nov. 13, 1933.

392. Ibid., May 30, 1930; Ronald L. Davis, *Opera in Chicago* (New York, 1966), 147–48, 177, 332; Leider, 111.

393. LL to MH, Sept. 30, 1930, GC.

394. Correspondence with Robert Hecht et al., Aug.–Dec. 1930, ATW/11.

395. LL, "Civic Opera," *Neues Wiener Tagblatt*, June 13, 1937; LL, *Anfang*, 179–83.

396. Ibid.

397. LL, *Anfang*, 181–82.

398. Davis, 338–40; Hickling.

399. LL, "Civic Opera"; LL, *Anfang*, 184.

400. Review, "We...," [Oct. 1930], NC.

401. Review, "The...," [Oct. 1930], NC.

402. Review, "Lotte...," [Nov. 1930], NC.

403. Notices, "Lehmann praises…"; "Lehmann Finds…," [Oct. 1930], NC.
404. *NYT*, Oct. 15, 1930.
405. Notice, "Lotte…," [Nov. 1930], NC.
406. LL to Wolfgang zu Putlitz, June 20, 1966, PA Bernhard von Barsewisch; Wolfgang zu Putlitz, *Laaske, London und Haiti: Zeitgeschichtliche Miniaturen* (Berlin, 1965), 231–32; Donald Spoto, *Blue Angel: The Life of Marlene Dietrich* (New York, 1992), 81–82; Michael H. Kater, *Different Drummers: Jazz in the Culture of Nazi Germany* (New York, 1992), 4–5.
407. LL to MH, Jan. 8 (quote), Oct. 18, 1931, GC; LL, *Anfang*, 184; Hickling.
408. Henderson in the *New York Sun*, Jan. 8, 1932; Weil, "Lotte…," [Jan. 1932], NC.
409. LL, *Anfang*, 190–93.
410. Hickling; Davis, 345–46.
411. Stinson, "Mme.…," [Jan. 1932]; review, "Three…," [Jan. 1932], NC.
412. LL to MH, [mid-Jan. 1932], GC.
413. *NYT*, Feb. 8, 1932 (quote); Hickling.
414. Hickling.
415. Balogh quoted in Gary Hickling, "Balogh on Lehmann," *LLLN*, Spring 1992, MAWA; LL quoted in her "Konzertbegleiter," n.d., CW. Also Balogh to LL, Feb. 25, 1933, ATW/14; *NYT*, June 7, 1989; LL, *Anfang*, 195.
416. LL to MH, Nov. 16, 1932; LL to Westervelt, March 5, 1933, GC; LL to EP, June 28, 1933, ATW/12; LL, "Konzertbegleiter," n.d., CW; LL, *Anfang*, 195–96.
417. LL to MH, [Nov.], Nov. 16, 30, 1932 (quote); LL to Balogh, March 2, 1933, GC; LL interview, [Feb. 1973], LLFA; *Newsweek* (March 3, 1949): 86; LL, *Anfang*, 200–3; LL, *Lives*, 53; David Noh, "Sieglinde in Santa Barbara," *Opera News*, 58, no. 10 (April 2004): 42.
418. LL to MH, [Nov. 1932], GC; *NYT*, Nov. 18, 1906, Nov. 29, 1932; LL to Petschnikoff, July 19, 1933, ATW/12; LL, *Anfang*, 202.
419. Reviews, "Lotte…," [Nov. 1932]; "Recital…," [Feb. 1933], NC.
420. Reviews, "Lehmann, German…"; "Lotte, the…," [Nov. 1932], NC; *NYT*, Jan. 28, 1933.
421. Review, "Lotte…," [Nov. 1932], NC.
422. Contract between LL and RCA Manufacturing Company Inc., Feb. 11, 1933, BC; Balogh to LL, July 6, 18, Oct. 5, 1933; LL to Balogh, Sept. 30, 1933, ATW/14.
423. Eleanor Robson Belmont, *The Fabric of Memory* (New York, 1980, 1st pr. 1957), 265 (quote); contract as in note 390; *NYT*, May 7, Nov. 13, 1933; Kolodin, 33; Jackson, 44.
424. *NYT*, Dec. 24, 1933.
425. LL itinerary, Jan. 17 – Feb. 1, 1934, ATW/18; *NYT*, March 5, 1934; LL, *Anfang*, 214–16.
426. *NYT*, Dec. 24, 1933; LL, *Anfang*, 213.
427. John Coveney, "Lotte Lehmann Remembered," *High Fidelity/Musical America* (June 1977): 16 (1st quote); *NYT*, Jan. 12, 1934 (2nd quote).
428. *NYT*, Feb. 25, 1934 (1st quote), March 16, 1934 (2nd quote).
429. *The Cadillac Concert*, Feb. 11, 1934, GC; Hickling.
430. LL to Westervelt, March 9, 1934, GC.
431. Coppicus to LL, March 19, 1934, BC.
432. Notices, "Lotte…," [Nov. 1930] (1st two quotes); "Song…," [Jan. 1932] (last quote), NC; LL, *Anfang*, 197–98; LL, "Constance Hope," n.d., CW.
433. Balogh to LL, Sept. 2, Oct. 22, Dec. 7, 1933, ATW/14.
434. LL, "Constance Hope," n.d., CW; Constance Hope, *Publicity Is Broccoli* (New York, 1941), 20–24 (in this self-serving memoir, Hope gets her dates and some facts mixed up).

435. *NYT*, May 20, 1932, March 16, 1938, June 14, 1977; LL, *Anfang*, 211–12; Collins, 149, 151; Peltz, 49; John Kobler, *Otto the Magnificent: The Life of Otto Kahn* (New York, 1989), 168–71; Grace Moore, *You're Only Human Once* (Garden City, 1944), 89, 181–83.
436. Jackson, 192.
437. CH to LL, March 5, 21, 26, 1934, ATW/18; *NYT*, Feb. 10, 1934.
438. LL to CH, March 27, 1934, CU/1.

4. Between Third Reich Seduction and American Opportunity

1. LL, "Göring, the Lioness and I," in Charles Osborne, ed., *Opera 66* (London, 1966), 187–99.
2. LL to Friedlaender, Aug. 29, Sept. 20, 1934 (quote), ATW/18.
3. Marcia Davenport, "Song and Sentiment," *The New Yorker* (Feb. 23, 1935): 22. Davenport repeated this in *Too Strong for Fantasy* (New York, 1967), 246.
4. *NYT*, Nov. 10, 1935.
5. LL to Hansing, Sept. 5, 1936, GC.
6. LL to Lachmann, ATW/TNLL.
7. Marboe memo, Nov. 10, 1955, LLFA (1st quote); LL to Burgau, July 31, 1956, GC (2nd quote).
8. According to Holden. Also see LL to BW, Jan. 14, 1956, GC.
9. Example: LL to Erika Mann, Nov. 28, 1968, EMA/914/78. See Christa Ludwig, *Und ich wäre so gern Primadonna gewesen: Erinnerungen* (Berlin, 1994), 79.
10. LL to Hansing, April 10, 1935, and to MH, Feb. 14, Nov. 23, 1938, GC.
11. LL to Bundestheaterverwaltung, Jan. 18, 1955, LLFA (quote); LL to Luise Klee, Feb. 28, 1955; LL to Shawe-Taylor, Nov. 22, 1974, GC; *Kurier*, Jan. 22, 1955.
12. LL to Marboe, Dec. 29, 1955, GC.
13. Friedelind Wagner, *The Royal Family of Bayreuth* (London, 1948), 121.
14. Vincent Sheean, *First and Last Love* (Westport, CT, 1979), 238 (quote); Shirlee Emmons, *Tristanissimo: The Authorized Biography of Heroic Tenor Lauritz Melchior* (New York, 1990), 160.
15. David Ewen, *Men and Women Who Make Music* (New York, 1946, 1st pr. 1939), 148 (quote); Berta Geissmar, *Musik im Schatten der Politik* (Zurich, 1985), 244; Erika Mann in Thomas Mann, *Briefe, 1937–1947*, ed. E. Mann (Frankfurt am Main, 1963), 622; Astrid Varnay, *Fifty-Five Years in Five Acts: My Life in Opera* (Boston, 2000), 6; Beaumont Glass, *Lotte Lehmann: A Life in Opera and Song* (Santa Barbara, 1988), xvi. See Erika Mann to LL, Jan. 11, 1967, EMA/722/96. I myself copied the legend uncritically from Alan Jefferson's Lehmann biography: see my *The Twisted Muse: Musicians and Their Music in the Third Reich* (New York, 1997), 120.
16. *Münchner Merkur*, Feb. 27/28, 1988; Susan Miles Gulbransen, "Lotte Lehmann on the Wings of Emotion," *Santa Barbara Magazine* (July/Aug. 1989): 22; *Frankfurter Allgemeine Zeitung*, Aug. 30, 1996.
17. Lanfranco Rasponi, *The Last Prima Donnas* (New York, 1982), 484.
18. *Weltpresse*, Dec. 16, 1954.
19. Tietjen in Hannes Reinhardt, ed., *Das bin ich* (Munich, 1970), 191–94; Kater, 28–29, 62.
20. Kater, 83, 89–90.
21. Strauss to Knappertsbusch, Dec. 9, 1933, BS/Ana/485/I; Göring to Strauss, Jan. 5, 1934, RG.
22. Strauss to Göring, Jan. 9, 1934, RG.

23. Göring to Strauss, Jan. 19, 1934, RG.

24. Clemens Hellsberg, *Demokratie der Könige: Die Geschichte der Wiener Philharmoniker* (Zurich, 1992), 464.

25. Review, "Schon die Stimme," *Völkischer Beobachter*, [Oct. 1932], NC. Also see ibid., Oct. 12, 1932.

26. Erik Ryding and Rebecca Pechefsky, *Bruno Walter: A World Elsewhere* (New Haven, 2001), 218; Hickling; *NYT*, Feb. 2, 1933.

27. EP to LL, March 7, 1933, ATW/12; Kater, 115.

28. George E. Berkley, *Vienna and Its Jews: The Tragedy of Success, 1880s-1980s* (Cambridge, MA, 1988), 213.

29. *NYT*, April 2, 1933; Harvey Sachs, *Toscanini* (Philadelphia, 1978), 222–26.

30. BW to LL, Sept. 5, 1933, ATW/15; Balogh to LL, Aug. 13, 1933, ATW/14; Ziegler to Lauterstein, May 16, 1933, MOA; LL to Wysocki, July 13, 1933, ATW/12 (quote).

31. On Furtwängler, see LL, *Anfang und Aufstieg: Lebenserinnerungen* (Vienna, 1937), 210.

32. Hickling; LL to Krause, June 21, 1933, ATW/7.

33. Fragment,*Völkischer Beobachter*, [Nov. 1933], NC (quote). Also see Hugo Rasch, "Wilhelm Furtwängler [and LL!] in der Berliner Philharmonie," ibid., Nov. 1, 1933; Hickling.

34. Else Walter to LL, Nov. 29, 1933, ATW/15.

35. Günter Brosche, ed., *Richard Strauss – Clemens Krauss Briefwechsel: Gesamtausgabe* (Tutzing, 1997), 102.

36. Heger to LL, July 9, 1933, ATW/15.

37. BAB, RKK/Heger.

38. Heger to LL, June 6, July 7, 29, 1933, ATW/15.

39. Furtwängler to LL, Sept. 13, 22, 1933, ATW/15.

40. Review, "Lotte...," [Oct. 1933], NC.

41. Heger to LL, Nov. 11, 1933, ATW/15; LL to Heger, Sept. 15, ATW/15, and Dec. 7, 1933, ATW/12.

42. Tietjen to LL, Feb. 2, 5, March 31, 1934, ATW/17.

43. Göring to LL, April 2, 1934, ATW/17.

44. LL to Göring, April 2, 1934, ATW/17.

45. Bing to LL, April 2, 1934, ATW/17.

46. LL to Tietjen, April 17, 1934; unsigned photographs, [April 20, 1934], ATW/17; Hickling.

47. LL to Tietjen, Nov. 11, 1955, AAKB, Nachlass Tietjen/corr. LL, 80/70/258–260.

48. LL to Krause, April 20, 1934, ATW/15.

49. LL to Krause, April 22, 1934; Krause to LL, April 22, 27, 1934, ATW/15; Hickling.

50. LL to CH, May 4, 1934, CU/1; Simon to LL, May 5, 1934.

51. LL to Krause, April 23, 30, 1934, ATW/15; Tietjen to Krause, May 4, 1934, ATW/17.

52. Tietjen to LL, April 26, 1934 (2nd quote), and attachments: contract [draft], Aryan certification (signed by LL May 1); LL to Tietjen, [May 11, 1934] (1st quote) [draft]; Tietjen to LL, May 16, 1934, ATW/17. (Note: On the authenticity of LL's drafts, see note 73 to Chapter 1.)

53. LL to Göring, [May 20, 1934], ATW/17.

54. LL to Tietjen, [May 20, 1934] [draft], ATW/17.

55. Tietjen to LL, June 5, 1934, ATW/17.

56. Tietjen to LL, Dec. 12, 1955, AAKB, Nachlass Tietjen/corr. LL, 80/70/258–260.

57. *Skizzen* (June/July 1934): 15; Friedlaender to LL, June 6, 1934, ATW/18.

58. LL to MH, June 23, 1934, GC; Demuth to LL, June 18; Carl Lindström AG to LL, May 5, 1934, ATW/18.

59. Simon to LL, July 4, 1934, ATW/8.
60. Brentano to LL, June 25, Aug. 25, 1934, ATW/18; Hickling.
61. Quoted in Friedlaender to LL, Aug. 29, 1934, ATW/18.
62. NS-Kulturgemeinde memo, Nov. 19, 1934, BAB, NS/15.
63. LL to Kerber, April 4, 1938, OSAW/GZ4083/1939.
64. Correspondence OSAW/GZ2624/1939/1940 (quote Eckmann to NS-Gauleitung Wien, July 12, 1939).
65. Reichsstatthalter Wien memo, Feb. 17, 1943, OSAW/AdR/Personalia/LL/378a; Finanzministerium Wien memo, Dec. 2, 1955; Luise Klee to Fellner, Jan. 30, 1956, LLFA.
66. Attachment, n.d., with Klee to Juch, Nov. 27, 1939, OSAW/GZ4083/1939.
67. Densow to Oberfinanzpräsident, Feb. 24, 1941, LLFA.
68. Koch to Johst, Dec. 1, 1938; Promi to Gestapa, Dec. 12, 1938, BAB, RKK/LL; BAB, RMK/LL, Film Rk/2302/R16/A.2164–68. See Oliver Rathkolb, *Führertreu und gottbegnadet: Künstlereliten im Dritten Reich* (Vienna, 1991).
69. Luise Klee to Fellner, Jan. 30, 1956, LLFA.
70. Joseph Horowitz, *Understanding Toscanini: How He Became an American Culture-God and Helped Create a New Audience for Old Music* (Minneapolis, 1988), 148, 244.
71. *NYT*, Oct. 8, Nov. 12, 1933.
72. Balogh to LL, Sept. 30, 1933, ATW/14 (quote); MH to LL, Oct. 23, 1933, ATW/17.
73. CH to LL, March 26, 1934; Behrens to LL, April 4, 1934, ATW/18.
74. CH to LL and Krause, April 11, 1934, ATW/18.
75. Krause to CH, April 18, 1934, CU/9.
76. Coppicus to LL, April 28, 1934, ATW/18.
77. CH to LL, May 17, 1934, ATW/18.
78. Metmusic to LL, May 24, 1934, ATW/18.
79. LL to Simon, June 6, 1934, ATW/18.
80. LL to Simon, June 19, 1934, ATW/18.
81. CH to LL, June 20, 1934, ATW/18.
82. *Wiener Salonblatt*, Aug. 12, 1934.
83. See the articles in Günter Bischof et al., eds., *The Dollfuss/Schuschnigg Era in Austria: A Reassessment* (New Brunswick, 2003), 1–162; F. L. Carsten, *The First Austrian Republic, 1918–1938: A Study Based on British and Austrian Documents* (Aldershot, 1986); Gerhard Botz, *Gewalt in der Politik: Attentate, Zusammenstösse, Putschversuche, Unruhen in Österreich, 1918 bis 1938* (Munich, 1983), 87–292.
84. Ernst Rüdiger Starhemberg, *Memoiren* (Vienna, 1971), 64–65.
85. Ernest Bartolo, *Die Wiener Oper: Die aufregenden Jahre seit 1625* (Leipzig, 1992), 80.
86. Angelika Königseder, "Antisemitismus, 1933–1938," in Emmerich Tálos and Wolfgang Neugebauer, eds., *Austrofaschismus: Politik – Ökonomie – Kultur, 1933–1938* (Vienna, 2005, 5th ed.), 54–65.
87. For culture generally, see Horst Jarka, "Zur Literatur- und Theaterpolitik im 'Ständestaat'," in Franz Kadrnoska, ed., *Aufbruch und Untergang: Österreichische Kultur zwischen 1918 und 1938* (Vienna, 1981), 499–538.
88. Roman Sandgruber, *Ökonomie und Politik: Österreichische Wirtschaftsgeschichte vom Mittelalter bis zur Gegenwart* (Vienna, 1995), 377; Gisela Prossnitz, "Salzburg: Perhaps Art's Last Existing Sanctuary from the Political World – The Salzburg Festival in the Thirties," in Kenneth Segar and John Warren, eds., *Austria in the Thirties: Culture and Politics* (Riverside, 1991), 240.

89. Isabella Ackerl, "Der Phönix-Skandal," in *Das Juliabkommen von 1936: Vorgeschichte, Hintergründe und Folgen* (Munich, 1977), 257–58.

90. The coauthor was Puccini's librettist Giovacchino Forzano. See *Wiener Salonblatt*, May 7, 1933.

91. Review, "Wie...," [March 1933], NC; Hickling.

92. "Ehrenkarte" for Sept 16, 1933, ATW/12.

93. "The British Empire Salzburg Society," [1934], ATW/18.

94. LL to Waage, May 22, 1945; LL to Burgau, July 31, 1956; FL to LL, Sept. 11, 1945, GC; LL, *Anfang*, 230–31.

95. *Neue Freie Presse*, Oct. 16, 1934.

96. Bruno Walter, *Theme and Variations: An Autobiography* (New York, 1966), 303, 317.

97. Notice, "Gala-Abend," [Aug. 1934], NC; *Wiener Salonblatt*, July 28, 1935; Hickling; Hotel Europe photo, 1934, PC.

98. LL to CH, Feb. 26, 1938, CU/1.

99. *Neue Freie Presse*, Dec. 11, 1934; Milan Dubrovic, *Veruntreute Geschichte: Die Wiener Salons und Literaturcafés* (Frankfurt am Main, 1987), 237–39; Marcel Prawy, *The Vienna Opera* (New York, 1970), 139.

100. Wilhelm Beetz, *Das Wiener Opernhaus, 1869 bis 1945* (Zurich, 1949), 60; Prawy, 150–51.

101. LL to CH, May 25, 1935, CU/1; Kerber to LL, March 3, 1934, ATW/18; Eckmann to Finanzministerium, Oct. 18, 1934, OSAW/GZ3091/1934.

102. LL/Kerber contract, Oct. 30, 1934, plus Eckmann codicil, Dec. 18, 1934; "Additional-Artikel," LL/Kerber, July 2, 1936, BC.

103. LL to Else Walter, Feb. 22, 1937, GC.

104. Hohenberg to LL, March 30, 1934; Friedlaender to LL, Sept. 6, Oct. 10, 1934, ATW/18.

105. Hickling; Walter, 309.

106. LL, "Kritiker," n.d., CW; Erich Leinsdorf, *Cadenza: A Musical Career* (Boston, 1976), 55–56; Glass, 182.

107. LL to MH, Aug. 31, 1934, March 4, 1935 (quote); Toscanini to LL, 1934–35, esp. March 7, 1934, GC; Hickling.

108. *NYT*, Jan. 2, 1935.

109. Ibid.

110. Emmons, 79.

111. Ibid., xii, 27–28, 84; Leinsdorf, 98–100; Charles O'Connell, *The Other Side of the Record* (New York, 1947), 82–86 (quote 82); Melchior to CH, Aug. 15, 1938, CU/5.

112. Reviews reprinted MOA/O.

113. Ibid.

114. Stevens as quoted in Glass, 205. See *NYT*, Dec. 20, 1938, Dec. 5, 1939; *New York Herald Tribune*, Dec. 21, 1938.

115. Hickling; review, "Big...," [Feb. 1935], NC (quote).

116. MOA/O; *NYT*, March 11, 1935.

117. *NYT*, March 22, 1935.

118. Henderson in the *New York Sun* (1st quote); Sanborn's unidentified review (last two quotes) and other fragments, NC.

119. LL to Ziegler, [March 1935], MOA.

120. LL to CH, May 25, 1935, CU/1 (1st quote); LL to FH, April 3, 1935, GC (2nd quote).

121. Rasponi, 479 (quote); *Musical Courier*, April 13, 1935.

122. Flagstad in Louis Biancolli, *The Flagstad Manuscript* (New York, 1977, 1st pr. 1952), 47, 64; Quaintance Eaton, *The Miracle of the Met: An Informal History of the Metropolitan Opera, 1883–1967* (New York, 1967), 234; Jens Malte Fischer, *Grosse Stimmen: Von Enrico Caruso bis Jessye Norman* (Stuttgart, 1993), 264–65.

123. MOA/O; Frida Leider, *Das war mein Teil: Erinnerungen einer Opernsängerin* (Berlin, 1959), 176, 178.

124. Eleanor Robson Belmont, *The Fabric of Memory* (New York, 1980, 1st pr. 1957), 266; Irving Kolodin, *The Metropolitan Opera, 1883–1966: A Candid History* (New York, 1966, 4th ed.), 34.

125. Sheean, 116 (quote); Emmons, 134; *NYT*, Feb. 3, 1935.

126. *NYT*, Feb. 7, 1935 (quote); *Time* (Feb. 18, 1935): 48.

127. Rasponi, 79.

128. Geraldine Farrar, *Such a Compulsion: The Autobiography of Geraldine Farrar* (New York, 1938), 233, 252; Edwin McArthur, *Flagstad: A Personal Memoir* (New York, 1965), vii (quote); Flagstad in Biancolli, 75; see, e.g., Aida Craig Truxall, ed., *All Good Greetings, G.F.: Letters of Geraldine Farrar to Ilka Marie Stotler, 1946–1958* (Pittsburgh, 1991), 171.

129. *NYT*, March 24, 1935.

130. Ibid., Aug. 24, 1935.

131. Ibid., Jan. 2, 1936.

132. Ibid., Feb. 11, 24, March 2, 1936 (quotes).

133. Ibid., March 8, 1936.

134. Review, "Beethoven's...," [May 1934], NC.

135. Eaton, 258; Kolodin, 393; Fischer, 178.

136. Robert Tuggle, "A Season of Valkyries," *Opera News*, 70, no. 4 (Oct. 2005): 46.

137. Gatti-Casazza to LL, June 18, 1934, MOA.

138. *NYT*, June 23, 1934.

139. CH to LL, Sept. 5, 1934, ATW/18.

140. Review, "Lotte...," [Dec. 1934], NC (quote); *NYT*, Feb. 15, 1935.

141. Günter Brosche, ed., *Richard Strauss – Clemens Krauss Briefwechsel: Gesamtausgabe* (Tutzing, 1997), 81–82.

142. Johnson quoted in Paul Jackson, *Saturday Afternoons at the Old Met: The Metropolitan Opera Broadcasts, 1931–1950* (Portland, OR, 1992), 175.

143. Hugo Strasser, *Und dafür wird man noch bezahlt: Mein Leben mit den Wiener Philharmonikern* (Vienna, 1974), 123; Leinsdorf, 40–41; Thomas Mann, *Tagebücher 1935–36*, ed. Peter de Mendelssohn (Frankfurt am Main, 1978), 164 (quote).

144. Hans Hotter writes that this was common knowledge among all conductors before World War II (*Der Mai war mir gewogen...: Erinnerungen* [Munich, 1996], 194–95). For the 1936 festival, see Prawy, 151.

145. Letter to author, Nov. 6, 2005.

146. MOA/O.

147. LL to CH, May 12 (1st quote), June 20, 26, 1936, CU/1; Johnson to LL, Aug. 12, 1941, GC (2nd quote); Hickling; Ruby Mercer, *The Tenor of His Time: Edward Johnson at the Met* (Toronto, 1976), 216.

148. LL to CH, July 12, 1938, CU/1.

149. *Esquire* (June 1935): 143, 149; *Time* (Oct. 31, 1938): 24; *Philadelphia Record*, Nov. 23, 1938.

150. O'Connell, 148.

151. Ibid., 154; Rasponi, 80.

152. *Time* (Dec. 23, 1935): 23; Henry Pleasants, *The Great Singers: From the Dawn of Opera to Our Own Time* (New York, 1966), 345.

153. See Flagstad on her register range in Rasponi, 82; also McArthur, 8; LL, "The Singing Actor," in Morton Eustis, *Players at Work: Acting According to the Actors* (Freeport, 1967, 1st pr. 1937), 118–27.

154. Sheean, 117 (quote), 194–95.

155. O'Connell, 155.

156. Nigel Douglas, *Legendary Voices* (New York, 1995), 80–81; also Jürgen Kesting, *Die grossen Sänger unseres Jahrhunderts* (Düsseldorf, 1993), 269; Jackson, 176.

157. Hickling.

158. MOA/O.

159. LL, "Twelve Singers and a Conductor," in Charles Osborne, ed., *Opera 66* (London, 1966), 75–76.

160. CH to LL, May 28, 1935, CU/9; LL to CH, Aug. 26, 1938, CU/1.

161. *NYT*, Jan. 24, 1937.

162. Ibid., Jan. 24, Feb. 7, 1939; McArthur, 47–52; Emmons, 366–67.

163. LL to Else Walter, Feb. 22, 1937, GC.

164. LL to CH, Dec. 15, 1937, GC.

165. LL to CH, Sept. 1, 9, 1938, CU/1.

166. LL to CH, Oct. 10, 1938, [Jan. 1939], May 27, 1939, CU/1.

167. FL to LL, Nov. 2, 1945, GC.

168. Gatti-Casazza to LL, June 18, 1934, MOA; Kolodin, 33, 389.

169. LL to CH, [Nov. 1934], CU/1; Gatti-Casazza to LL, Jan. 23, 1935, MOA.

170. LL to MH, April 4, 1935, GC (quote); LL/Johnson contract, May 27, 1935, MOA; CH to LL, May 28, 1935, CU/1; MOA/O.

171. *Time* (Feb. 18, 1935): 48–49 (quotes); ibid. (Dec. 23, 1935): 20.

172. Simon to Villa, April 28, 1936, MOA; LL to MH, Dec. 25, 1935, GC; MOA/O.

173. LL to CH, May 31, June 20, 26, 1939, CU/1; LL/Johnson contract, July 7, 1936, MOA; Emmons, 142.

174. *NYT*, Jan. 24, 1937.

175. LL/Johnson contracts, [July 1937], March 17, 1938, April 26, 1939, Feb. 23, 1940, MOA.

176. CH to Ziegler, April 28, 1939, MOA; Hickling.

177. LL to CH, July 12, 1938, June 10, 1939, CU/1.

178. Rasponi, 477.

179. San Francisco and Philadelphia reviews, [Nov. 1934], NC; Arthur Bloomfield, *50 Years of the San Francisco Opera* (San Francisco, 1972), 60–61; Hickling.

180. Toronto reviews, [Dec. 1934], NC.

181. David E. Campbell and N. E. Tawa, "Cadman, Charles Wakefield," *Grove*.

182. Review, "Lotte...," [March 1935], NC.

183. Review, "Lotte...," [Feb. 1935], NC.

184. *NYT*, Nov. 10, 1937.

185. Ibid., Oct. 19, 1938; *New York Evening Post*, Oct. 18, 1939.

186. LL to CH, Aug. 30, 1937, GC, and Oct. 21, 1937, Oct. 26, 1938, CU/1; LL to FH, June 19, 1937, GC; *New York Herald Tribune*, March 5, 1934.

187. LL to CH, Aug. 30, 1937, GC, and Feb. 26, 1938, CU/1; CH to LL, Sept. 10, 1937, BC.

188. LL, "Konzertbegleiter," n.d., CW; LL to CH, May 2, 1937; LL to FH, June 19, 1937, GC; *NYT*, Aug. 6, 1968.

189. LL/Coppicus contract, March 29, 1935 (also for 1936–1939/40), BC; LL to Coppicus, Dec. 11, 1937, GC.
190. LL to CH, Sept. 16, 1935, CU/1.
191. LL to CH, June 20, 26, 1936; CH to LL, July 1, 1936, CU/1.
192. LL to Coppicus, Dec. 11, 1937, GC.
193. LL to FH, [spring 1938], GC; LL to CH, Aug. 17, 26, Sept. 1, 9, 1938, CU/1.
194. LL to CH, April 7, May 16, 1939, CU/1.
195. RCA to LL, Jan. 10, 1936, Jan. 30, 1937, Dec. 21, 1939, BC; LL to Sarnoff, [Nov. 1939], CU/1; LL/Wallerstein contract, April 5, 1940, CU/9.
196. LL, *Anfang*, 218; LL to MH, Dec. 25, 1935, GC.
197. LL to CH, Nov. 16, 25, 1936, GC; LL to MH, Nov. 21, 1936, GC; LL to CH, June 28, 1938, May 1, 16, 1939, CU/1; Carroll Carroll, *None of Your Business: My Life with J. Walter Thompson* (New York, 1970), 156–64; Charles Thompson, *Bing: The Authorized Biography* (New York, 1976), 74–76; Gary Giddins, *Bing Crosby: A Pocketful of Dreams: The Early Years, 1903–1940*, 385–464 (quote).
198. LL to MH, March 4, 1935, GC; LL to CH, May 25, 1935, CU/1; *Time* (Feb. 18, 1935): 49; CH to LL, May 1, 1934, ATW/18; Deutsche Bank to Behrens, Dec. 2, 1936, BC; Ackerl, 248.
199. Krause to LL, [Aug. 1937], GC.
200. LL to Hansing, [Aug. 1937]; LL to CH, Aug. 22, 1937, GC, and Sept. 3, 1937, CU/1.
201. LL to CH, Sept. 9, 13, 1937, GC, and Sept. 21, 1937, CU/1.
202. LL to Robert Hecht, Nov. 9, 1937; Krause to LL, Jan. 7, 1938, GC.
203. Sheean, 201; LL to Robert Hecht, March 31, 1938, GC; LL to Friedl, April 10, 1938, LLFA; Hickling.
204. LL's "resistance" version is in LL to Schornstein, Jan. 3, 1969, GC; LL, *Singing with Richard Strauss* (London, 1964), 169. She did not mention this during her press conference in London: *Daily Mail*, May 9, 1938. Also see Geissmar, 217–18; Konetzni in Rasponi, 103–4; Walter Legge in Elisabeth Schwarzkopf, *On and Off the Record: A Memoir of Walter Legge* (New York, 1982), 127; Harold Rosenthal, *Two Centuries of Opera at Covent Garden* (London, 1958), 534–35; and Alan Jefferson, *The Operas of Richard Strauss in Britain, 1910–1963* (London, 1963), 86–87, which uncritically assumes Lehmann's interpretation.
205. LL to CH, May 6, 1938, CU/1; Constance Parrish in Glass, 199–200.
206. Gerd Puritz, *Elisabeth Schumann: A Biography* (London, 1993), 223; LL to CH, May 28, 30, June 29, July 11, 12, Aug. 17, 1938, CU/1; Hickling.
207. Author's telephone interview with Peter Krause, Oakville-Yardley/PA, June 12, 2004; LL to CH, Aug. 23, 1938, CU/1; LL to Else Walter, Nov. 7, 1938; LL to MH, Nov. 14, 1938, Feb. 25, 1939, GC.
208. LL to CH, Sept. 1, 1938, CU/1.
209. LL to Krause, Nov. 6, 1938, GC; LL to CH, Dec. 29, 1938, CU/1.
210. Leetch to LL, Jan. 19, 1939, GC.
211. LL to CH, Feb. 21, May 6, 1939, CU/1; LL to Hansing, April 7, 1939, GC; Hickling.
212. LL, "Mein Bruder," n.d., CW.
213. "Hamburg-Altonaer"; "Chronikbeilage"; "Sylter Winterspiele," [all 1927], ATW/4.
214. "Aus Hamburg"; Door to LL, Feb. 3, 1928; FL to LL, Oct. 8, 1928, GC; "Freilichtbühne," [Aug. 1933]; LL, *Anfang*, 162.
215. Programs, "Neues Wiener Konservatorium," June 21, Dec. 19, 1933; LL to EP, June 28, 1933, ATW/12; LL, *Anfang*, 194.
216. LL to CH, Oct. 3, 1934, CU/1; LL to Westervelt, Oct. 28, 1934, GC.

217. FL to LL, Aug. 7, 1945, June 25, 1946, GC; LL to CH, May 25, 1935, CU/1.
218. Krause to LL, [1937], Oct. 15, 1937, GC.
219. LL to MH, Nov. 14, 23, 1938; FL to LL, July 28, 1947, GC; LL to CH, [June 1938], Jan. 12, 1939, CU/1.
220. LL to CH, April 15, May 12, 1939, GC.
221. LL to CH, July 30, Aug. 2, 14, 1939; LL to Rauch, Aug. 13, 1939, CU/1.
222. *NYT*, Nov. 7, 8, 1934, Oct. 6, 1935, July 8, 1937.
223. LL to CH, Aug. 22, 30, Dec. 4, 1937, GC.
224. Constance Hope, *Publicity Is Broccoli* (New York, 1941), 255.
225. CH to LL, May 25, 1935, May 31, June 20, 1936, CU/1; CH to LL, March 3, 1937, BC.
226. LL to MH, [Aug. 1937], GC.
227. CH to LL, May 3, June 2, 1937, BC; LL to CH, Feb. 25, 1939, CU/1.
228. LL to CH, Aug. 17 (1st quote), Oct. 26 (2nd quote), 1938, CU/1.
229. LL to CH, July 30, Aug. 18, 1939, CU/1.
230. LL to CH, Sept. 1, 1938, CU/1.
231. LL to CH, June 15, 1939; Schumann to CH, June 15, 1939, CU/1; Nigel Douglas, *More Legendary Voices* (London, 1994), 249.
232. LL to CH, Sept. 1, Oct. 26, 1938, March 3, 1939, CU/1; LL to CH, July 28, 1937; CH to LL, May 20, 1937; LL to MH, April 5, 1939 (quote), GC.
233. CH to LL, Sept. 2, 1937, GC; LL to CH, Aug. 10, 1939, CU/1. See LL, *Eternal Flight* (New York, 1937), and *Midway in My Song: The Autobiography of Lotte Lehmann* (New York, 1938).
234. Leinsdorf, 74.
235. Hope, 138; Emmons, 178–79; *NYT*, Feb. 17, 1946; Lauritz Melchior, "Die drei Vaterländer," in Josef Müller-Marein and Hannes Reinhardt, eds., *Das musikalische Selbstporträt: Von Komponisten, Dirigenten, Journalisten, Sängerinnen und Sängern unserer Zeit* (Hamburg, 1963), 152; Douglas, *More Voices*, 175.
236. *Time* (Feb. 18, 1935): 49.
237. Ibid., (Oct. 31, 1938): 24.
238. LL to CH, Nov. 11, 1938, CU/1.
239. LL to Kleinchen Melchior, April 24, 1939, in Emmons, 165.
240. LL to CH, Feb. 22, May 29, 1939, CU/1.
241. LL to CH, March 4, 1937, CU/1.
242. LL to CH, Sept. 3, 1938, CU/1.
243. LL to CH, May 16, 1939, CU/1.
244. LL to Rauch, Aug. 2, 1939, CU/1.
245. Davenport, *Fantasy*, 35–36, 53, 62–63, 80, 140, 156; Marcia Davenport, *Mozart* (New York, 1932); *NYT*, Jan. 20, 1996; Horowitz, 153.
246. Davenport, *Fantasy*, 157–58.
247. Ibid., 198–99; CH to LL, Nov. 13, 1934, CU/9.
248. Davenport, "Song," 18–22 (quote at 18); Davenport, *Fantasy*, 198–99; LL, *Anfang*, 212; Krause to LL, Jan. 7, 1938, GC.
249. LL to Westervelt, April 30, May 8, 23, 31, 1934, GC.
250. LL to Westervelt, Oct. 28, 1934, GC (quote); *NYT*, Jan. 6, 1935.
251. LL to CH, July 28, Sept. 9, 1937; CH to LL, Sept. 21, 1937, GC.
252. LL to FH, June 19, 1937, GC.
253. LL to CH, Dec. 15, 1937, GC.
254. Holden.
255. LL to CH, Feb. 17, 1939, CU/1.
256. Margaret Rich, Rare Books and Special Collections, Princeton University Library, to author, March 23, 2005; Robert J. Casey and William Douglas, *The Lackawanna*

Story: The First Hundred Years of the Delaware, Lackawanna and Western Rail-road (New York, 1951).

257. Arthur C. Holden in *Grolier: A Biographical Retrospective to Celebrate the Seventy-Fifth Anniversary of the Grolier Club in New York* (New York, 1959), 111; Holden.

258. *Price List of the Edwin Babcock Holden Collection* (New York, 1919); *The Splendid Library of the Late Edwin B. Holden* (New York, 1920).

259. Judy Sutcliffe to author, Dec. 8, 2004; Hvøllboll.

260. Judy Sutcliffe to author, Dec. 8, 2004; Holden (quote); Arthur C. Holden, "Recollections of the Grolier Club," *Gazette of the Grolier Club*, 26/27 (1977): 64.

261. Holden; FH to Alice Cort Holden, [March 13, Oct. 24, 1918], PA Luisa Holden.

262. Published by Williams and Wilkins in Baltimore (1926): *A Study of the Effect of Starvation upon Behavior by Means of the Obstruction Method*, 1–2 (quote). Also Holden; *NYT*, June 1, 1927.

263. Holden; Alissa S. Kleinman, New York University Archives, to author, Dec. 14, 2004; *NYT*, Aug. 23, 1931.

264. Arthur Cort Holden, *The Settlement Idea: A Vision of Social Justice* (New York, 1922); Meryle Secrest, *Frank Lloyd Wright: A Biography* (Chicago, 1998), 87–88; *NYT*, Dec. 21, 1993.

265. Ben Yagoda, *About Town: The New Yorker and the World It Made* (New York, 2000), 107; Raymond P. Holden, *Natural History: Poems* (New York, 1938).

266. Holden; Alissa S. Kleinman to author (as in note 263); *NYT*, May 17, 1932; Judy Sutcliffe to author, Dec. 8, 2004.

267. Judy Sutcliffe to author, Dec. 8, 2004; *NYT*, Jan. 22, 1924, April 3, 1959.

268. Holden; FH to LL, March 1, 1934, CU/1 (quotes).

269. FH to LL, May 29, 1934, ATW/18; LL to FH, [March 13, 1935], April 3, 1935; FH to LL, [April 1935], GC; LL, "Frances," n.d., CW.

270. Holden (quote); LL, "Frances," n.d., CW.

271. *NYT*, Oct. 17, 24, 1935; Hvølboll.

272. FH to LL, July 28, 1937 (quotes); LL to FH, Nov. 22, 1936, March 3, 31, June 19, July 22, Sept. 3, 1937; Holden.

273. LL to FH, Dec. 15, 1937, GC.

274. Barsewisch; Judy Sutcliffe to author, Dec. 8, 2004.

275. Holden (quotes); Glass, 208.

5. Between Touring and Teaching, 1940–1950

1. Walter A. Hawley, *The Early Days of Santa Barbara, California: From the First Discoveries by Europeans to December, 1846* (Santa Barbara, 1987, 3rd ed.); Walker A. Tompkins, *Santa Barbara: Past and Present: An Illustrated History* (Santa Barbara, 1975), 5–83.

2. *NYT*, June 30, 1925 (quote); Tompkins, 83–107.

3. LL to FH, June 19, 1937, GC; LL to CH, Aug. 2, 1939, CU/2.

4. LL to Stodolowsky, Feb. 13, 1940, PA Schuch; Hickling.

5. Holden.

6. LL to CH, April 19, 1940, CU/2.

7. LL to CH, April 16 (quote), 19, 1940, CU/2; Holden.

8. LL to CH, May 20, 27, 1940; Sept. 5, 1941 (quote), CU/2; Holden.

9. LL to CH, July 4, 1940, CU/2; Hvølboll; Judith Sutcliffe, "A Fiery Finale: A History of the Knapp Estate on East Camino Cielo, First Santa Barbara Home of Soprano Lotte Lehmann," *La Reata: Santa Barbara Corral of the Westerners*, no. 9 (Autumn 1989): 1–16 (quote at 7).

10. Exact dates according to LL to Rauch, July 12, 1940, CU/2; Thomas Mann, *Tagebücher 1940–1943*, ed. Peter de Mendelssohn (Frankfurt am Main, 1982), 131.

11. MH to Rauch, Aug. 19, 1940, GC (quote); LL, "Die Berge brennen," n.d., CW; Holden. Also Sutcliffe, 12–16; LL to CH, [Aug. 1940], CU/9; LL to CH, [autumn 1940], CU/1. On Orplid: Jens Malte Fischer to author, July 31, 2006.

12. Hvølboll; author's interview with Donald Jackson, Santa Barbara, April 26, 2002; LL to CH, Aug. 5, 1940, CU/2 (quote); LL to MH, Sept. 17, Dec. 10, 1949, GC; Holden.

13. CH to FH, Aug. 3, 1942; CH to LL, Aug. 2, 1943, BC; LL to CH, [July 1942], Aug. 19, 1943, CU/2; LL to CH, [1943], CU/1.

14. CH to FH, Oct. 9, 1941; Gilman to FH, April 1, 1943; FH to CH, Sept. 22, 1943; CH to LL, Dec. 16, 1943, BC; LL to MH, Sept. 27, 1950, GC.

15. LL to MH, March 12, 1947, GC.

16. *NYT*, Jan. 9, Dec. 14, 1941; FL to LL, Sept. 8, 1946, GC.

17. Barsewisch.

18. FL to LL, Aug. 28, 1947; LL quoted in FL to LL, May 3, 1947, GC.

19. LL to McGiffin, July 21, 1948; LL to Robert Hecht, May 24, 1949, GC; LL, "Unsere Hausangestellten," n.d., CW.

20. LL to CH, June 13, 1940, CU/2; LL to CH, [1942], CU/1; CH to FH, Aug. 3, 1942; CH to LL, Aug. 31, 1943, Aug. 28, 1944, BC. Gerd Puritz wrongly mentions merely $1,000 (*Elisabeth Schumann: A Biography* [London, 1993], 292).

21. *NYT*, May 30, 1941; LL to CH, April 28, 1942, [July] 21, 1942, Aug. 19, 1943, CU/2; CH to LL, Sept. 11, 1941; CH to FH, Aug. 3, 1942, BC.

22. LL quoting FH in Schornstein.

23. Herman Schornstein to author, May 26, 2003.

24. Barsewisch; FH in Beaumont Glass, *Lotte Lehmann: A Life in Opera and Song* (Santa Barbara, 1988), 278; Shirley Sproule in telephone conversation with author, Oakville/Tuscon, Dec. 7, 2004; Judy Sutcliffe to author, Dec. 8, 2004; Herman Schornstein to author, May 24, 2003.

25. Author's interview with Liz Thompson, Santa Barbara, July 17, 1997.

26. LL to MH, June 19, 1947, GC.

27. FH to LL, Feb. 21, 1951, GC.

28. LL to Waage, April 16, 1947, GC; LL to Pleasant, Aug. 18, 1949, BC.

29. Holden.

30. Holden; LL to MH, [summer 1944]; LL to Waage, Sept. 6, 1944; LL to Arthur Holden, May 13, 1949, GC; FH to Wentz, June 24, 1945, PA Turk; Glass, 10.

31. LL to CH, April 28, 1941, CU/2; LL to Waage, March 27, 1943; FL to LL, May 24, 1944, GC.

32. Holden; LL to Temianka, Dec. 17, 1950, MAWA; FH to BW, Aug. 14, 1947; FH to Levine, Sept. 2, 1947; FL to LL, Aug. 28, 1944, June 20, 1945, July 24, 1946; LL to MH, June 1, 1941; LL to FH, Nov. 30, 1946, GC; LL to CH, [Aug. 1940], CU/9.

33. LL to FH, Jan. 24, 1951; FH to LL, [Jan. 1951]; Jan. 27, 28, 30, 1951, GC.

34. Holden; FH to Dunham, March 3, 10, 1943; Dunham to FH, March 4, 8, 1943; FH to Brown, March 3, 1943; FL to LL, Feb. 21, 1943, GC.

35. LL, "Unsere Hausangestellten," n.d., CW.

36. LL to MH, [fall 1943], GC; Holden.

37. Holden.

38. Glass, 215.

39. LL to Pleasant, Aug. 18, 1949, BC.

40. LL to CH, May 15, 1940, CU/2; LL to CH, [fall 1943], CU/1; photographs, PC.
41. FL to LL, Feb. 14, 25, March 2, 1943, April 27, 1944, May 30, Sept. 1, 1946, July 11, 23, Aug. 4, 1947, GC.
42. *NYT*, Jan. 28, May 5, 1940; LL to MH, [Jan. 1940]; LL to CH, [June 1941]; FL to LL, [Dec. 1942], CH to FH, May 24, 1940, GC; CH to LL, June 19, 1941, BC; LL to CH, [spring 1941], CU/1; LL to CH, May 15, 27, 1940; LL to Rauch, July 3, 1943, CU/2.
43. MOA/O; FL to LL, Dec. 18, 1942, Jan. 25, 1943 (quote), Nov. 7, 1946; LL to CH, [Sept. 1943], GC; LL to CH, [July 1942], Aug. 2, Sept. 13, 1943, CU/2.
44. LL to MH, [fall 1943]; FL to LL, Sept. 20, 1943, GC; *NYT*, Oct. 30, 1943.
45. *NYT*, June 1, 1941; FL to LL, Nov. 1, 1943, and n.d., GC; Peter Heyworth, *Otto Klemperer: His Life and Times*, vol. 2 (Cambridge, 1996), 119; Eric Blom and Harold Barnes, "Walker, Edyth," *Grove*.
46. FL to LL, July 16, 1944, May 23–28, 1945, Nov. 22, 1947, GC.
47. *NYT*, Oct. 11, 1935.
48. MOA/O; Eleanor Steber, *Eleanor Steber: An Autobiography* (Ridgewood, NJ, 1992), 44.
49. *NYT*, June 23, 1940, June 8, 1943, Jan. 5, Dec. 6, 13, 27, 1944, Nov. 23, 24 (quotes), 1947; Heyworth, 104–7, 119, 127–28, 139.
50. *The New Yorker* (Aug. 4, 1945): 51; FL to LL, Dec. 9, 1944, Dec. 14, 1946, GC.
51. Author's telephone conversation with Janice Cloud, Oakville/Santa Barbara, June 6, 2006; FL to LL, Oct. 29, [Oct. 30], 1943, Oct. 19, 1944, Aug. 26, 1945, Oct. 13, Nov. 29, 1946, June 27, 1947, GC; *Chicago Defender*, Jan. 28, 1950.
52. FL to LL, Oct. 29, Nov. 17, 1943, July 24, Sept. 8, 1946, July 23, 1947; LL to CH, [June 1941]; LL to Waage, Oct. 16, 1950 (quote), GC.
53. LL to CH, [fall 1941], CU, Hope/2; LL to CH, [1942], CU/1; LL to Delafield, March 19, 1943, GC.
54. FL to LL, June 26, 1947, GC.
55. FL to LL, Nov. 4, 1944, GC.
56. FL to LL, Dec. 18, 23, 1942, Jan. 21, Sept. 23, Oct. 23, Nov. 17, 1943, June 27, Sept. 23, 1944, May 30, June 21, Oct. 23, Nov. 2, 1946, June 7, Aug. 4, 1947, GC.
57. His part of the correspondence (1942–50) is in GC.
58. Hvølboll; FL to LL, July 19, Aug. 7, 1945, May 12, 1946, May 23, 1947, GC.
59. Telephone conversation as in note 51.
60. Ibid.; FL to LL, May 12, 1946; Theresia Lehmann to FH, May 22, 1947, GC (quote).
61. Author's telephone conversations with Janice Cloud, Oakville/Santa Barbara, Sept. 12, 2004, June 6, 2006; FL to LL, June 8, 13, July 18, Sept. 12, Oct. 13, Nov. 7, [Dec. 6], 1946, April 30, May 3, June 13, 1947; Lehmann/Heinz marriage certificate, May 20, 1947, GC.
62. LL to MH, Feb. 18, 1943, June 9, 1949, LL to Robert Hecht, May 24, 1949, GC.
63. LL to CH, [spring 1941], CU/1; LL to FL, [June 1943]; FL to LL, Sept. 26, 1943, May 13, Aug. 11, 1944, May 23–28, July 6, [July 8], July 19, 20, 23, 24, 27, Aug. 7, Oct. 25, 1945, May 20, 26, June 25, July 24, 1946, Aug. 28, Sept. 5, 1947; Douglas to FH, Oct. 31, 1949, GC.
64. On her extinguished flame Toscanini, see LL to MH, [1940], GC.
65. LL to CH, [July 1942], CU/1; FL to LL, Jan. 2, Feb. 14, 25, 1943, [April 1, 1944], July 11, 1947, GC.
66. LL to MH, [June 1941], GC.
67. MacDonald to LL, Aug. 8, 1944; LL to Raymond, Nov. 28, 1944, PA Turk.
68. See LL to Else Walter, Nov. 7, 1938, GC.

69. Holden.

70. LL to Rauch, Oct. 29, 1938, CU/1; *NYT*, Dec. 2, 1938 (quote).

71. *NYT*, Jan. 9, 1940; LL to MH, [Jan. 1940], GC; LL to CH, [Aug. 1940], CU/9; LL to CH, [fall 1940], CU/1; Jörg Nagler, "Internment of German Enemy Aliens in the United States during the First and Second World Wars," in Kay Saunders and Roger Daniels, eds., *Alien Justice: Wartime Internment in Australia and North America* (St. Lucia, 2000), 75–76.

72. Nagler, 74.

73. Richard D. Saunders, "Opera Slated in English for Next Fall," unidentified newspaper fragment attached to LL to CH, [fall 1940], CU/1. See also Heike B. Görtemaker, *Ein deutsches Leben: Die Geschichte der Margret Boveri, 1900–1975* (Munich, 2005), 150, 157–58.

74. Nagler, 75–79 (Roosevelt quoted at 75); LL to CH, [late 1941], CU/1; *NYT*, Jan. 9, 1942 (remaining quotes).

75. Jones to FH, Jan. 25, 1942, GC.

76. *NYT*, Jan. 28, 1942.

77. LL to MH, Feb. 11, 1942, GC.

78. Cooley to FH, Feb. 18, 1942, GC.

79. *NYT*, Feb. 25 (quotes), 26, March 1, 2, 1943; Hawley, 108.

80. Holden; Glass, 219; Hickling.

81. LL to CH, April 24, June 4, 10, 1942, CU/2; Rauch to LL, June 4, 1942, GC; *NYT*, Dec. 26, 1953.

82. LL to MH, July 1, 1945, GC; *NYT*, June 18, 1945.

83. *NYT*, Feb. 18, 1948.

84. LL to MH, June 9, 1949, GC.

85. FL to LL, July 28, 1947, GC.

86. Görtemaker, 162–65.

87. Alexander Stephan, *"Communazis": FBI Surveillance of German Emigré Writers* (New Haven, 2000), 93, 97–106; Hans Rudolf Vaget in *Frankfurter Allgemeine Zeitung*, July 29, 1993.

88. Michael H. Kater, "Die vertriebenen Musen: Von den Schwierigkeiten deutschsprachiger Künstler und Intellektueller im Exil," in Hartmut Lehmann and Otto Gerhard Oexle, eds., *Nationalsozialismus in den Kulturwissenschaften*, vol. 2 (Göttingen, 2004), 492.

89. Michael H. Kater, *The Twisted Muse: Musicians and Their Music in the Third Reich* (New York, 1997), 109, 118–19.

90. Ibid., 109, 126–27; Stephen Lehmann and Marion Faber, *Rudolf Serkin: A Life* (New York, 2003), 90–92.

91. Schoenberg circular, Dec. 25, 1934, LBI, AR-7049/10 (quotes); Michael H. Kater, *Composers of the Nazi Era: Eight Portraits* (New York, 2000), 183–210.

92. Erich Leinsdorf, *Cadenza: A Musical Career* (Boston, 1976), 65–66, 104; *NYT*, June 1, 1941.

93. FH to CH, Oct. 7, 1944 (quote); LL to MH, Oct. 7, 1944, GC.

94. *NYT*, Dec. 21, 1928, Aug. 18, 1940, Aug. 23, 1941.

95. Vosberg to LL, March 1, 1943; LL to CH, Sept. 4, 1941, CU/2; LL to CH, [March 1942], CU/1 (quote).

96. LL to MH, [Jan. 1940]; Kirkpatrick to LL, Feb. 18, 1942; LL to Waage, Oct. 1, 1943, GC; *NYT*, Jan. 30, 1942 (quote).

97. *NYT*, Nov. 26, 1940, Feb. 25, Nov. 18, 1941.

98. LL to CH, April 27, July 3, 1943, CU/2; Fales to LL, May 27, 1943, GC; *NYT*, April 25, 1943, May 9, 1943 (quote).

99. Salka Viertel, *Kindness of Strangers* (New York, 1969); Anthony Heilbut, *Exiled in Paradise: German Refugee Artists and Intellectuals in America, from the 1930s to the Present* (Boston, 1984).
100. Zytowsky; Kater, *Composers*, 118, 143.
101. LL to Waage, Oct. 21, 1944; Alma Mahler-Werfel to LL, Sept. 1, 1945, GC; Peter Stephan Jungk, *Franz Werfel: Eine Lebensgeschichte* (Frankfurt am Main, 1987, 2nd ed.), 304–5, 337–38.
102. LL to CH, [fall 1940], CU/1.
103. Klemperer, pencil score, "Gebet für eine Singstimme und Klavier," dedicated to LL, Sept. 20, 1946; also see FL to LL, May 27, 1944, GC.
104. Erika Mann and Klaus Mann, *Escape to Life: Deutsche Kultur im Exil* (Reinbek, 1996, 1st pr. 1939), 264.
105. Mann, *Tagebücher 1940–1943*, 465; Erika Mann to LL, Feb. 2, 1941, Dec. 23, 1943, Dec. 31, 1950, GC; LL to CH, [1943], CU/1; LL to Erika Mann, Jan. 7, 1951, EMA/914/78.
106. Irmela von der Lühe, *Erika Mann: Eine Biographie* (Frankfurt am Main, 1996), 284–88.
107. Klaus Mann to LL, Oct. 11, 1943, CU/2.
108. Erika Mann to LL, June 1949, GC.
109. See Chapter 4 at note 143.
110. Thomas Mann, *Tagebücher 1937–1939*, ed. Peter de Mendelssohn (Frankfurt am Main, 1980), 329; *Thomas Mann – Agnes Meyer: Briefwechsel, 1937–1955*, ed. Hans Rudolf Vaget (Frankfurt am Main, 1992), 138.
111. *Seelenzauber: Thomas Mann und die Musik* (Frankfurt am Main, 2006), 48–77.
112. Mann, *Tagebücher 1940–1943*, 118.
113. Ibid., 126; Mann to Meyer, Sept. 3, 1940, in *Mann – Meyer*, 232 (quotes).
114. LL, "Die Berge brennen," n.d., CW (quotes); Holden.
115. Mann, *Tagebücher 1940–1943*, 129, 762; Thomas Mann to LL, Aug. 10, 1940, GC.
116. LL to CH, [June 1941]; Thomas Mann to Frau Sonne, Aug. 2, 1941, GC (quote); Mann, *Tagebücher 1940–1943*, 281, 303, 447–48; Thomas Mann, *Tagebücher, 1944–1.4.1946*, ed. Inge Jens (Frankfurt am Main, 1986), 572; *Mann – Meyer*, 416; Thomas Mann photo, 1942, PC.
117. Opus 98. See Paul Douliez and Hermann Engelhard, eds., *Das Buch der Lieder und Arien* (Gütersloh, 1956), 146–48; Joseph Kerman et al., "Beethoven, Ludwig van," *Grove*.
118. FL to LL, Dec. 26, 1947, GC.
119. Erik Ryding and Rebecca Pechefsky, *Bruno Walter: A World Elsewhere* (New Haven, 2001), 267–68; Lühe, 217, 284–86.
120. LL to CH, Aug. 5, 1940, CU/2 (quote); LL to BW, Aug. 9, 1938, GC.
121. LL to CH, [fall 1940], CU/1; LL to CH, [June 1941], GC (quote).
122. CH to FH, Oct. 9, 1941, BC; LL to CH, April 27, 1943, CU/2.
123. BW to LL, Aug. 14, 1944; FL to LL, Nov. 29, 1945, GC.
124. *NYT*, Feb. 11, 1940, Jan. 12, 1941; Kater, *Muse*, 114–15.
125. *NYT*, Feb. 15, 1941.
126. LL to CH, [fall 1940], CU/1; LL to CH, [fall 1940], CU/2.
127. *NYT*, March 23, 1941, March 15, July 25, 1943; FL to LL, Sept. 17, 1943; BW to LL, Dec. 25, 1943, Aug. 28, 1944, GC.
128. Mann, *Tagebücher 1940–1943*, 618 (1st quote); FL to LL, Dec. 26, 1947 (2nd quote); LL to FH, Feb. 16, 1950, GC.

129. In listening to recordings of the period, Walter's heavy-handedness is noticeable, in contrast with Ulanowsky's sensitive touch: LL's recordings of Robert Schumann, "Ich kann's nicht fassen" and "Ich grolle nicht," with BW, piano (1941), and of Richard Strauss, "Allerseelen" and "Morgen," with Paul Ulanowsky, piano (1941), soundtracks PA Hickling. I thank Gary Hickling for his guidance. See LL to CH, May 15, 1940, April 28, May 4, 1941, April 27, 1943; FH to CH, May 12, 1940, CU/2; LL to CH, [June 1941], LL to Levine, April 8, 1946 (quote), GC; LL to CH, July 25, [1941], [summer 1943], CU/1.

130. LL to BW, Aug. 15, Dec. 23, 1947; BW to LL, Dec. 28, 1947, GC; Ryding and Pechevsky, 286, 312 (BW quoted); Puritz, 284.

131. *NYT*, Aug. 18, 1947; FH to BW, Aug. 14, 1947; FL to LL, Aug. 23, 1947; LL to BW, Nov. 30, 1949, GC.

132. See her pensive letter to Waage, May 22, 1945, GC.

133. Tietjen to BW, March 13, 1950; BW to Tietjen, May 31, 1950, AAKB, Nachlass Tietjen, Korr. B. Walter, Hbr/Dhpe.

134. *NYT*, Feb. 10, 1946.

135. LL to MH, May 22, 1945, GC. Subsequently, see LL to Hansing, Nov. 8, 1946, Jan. 4, April 22, 1947, GC.

136. David Clay Large, *Berlin* (New York, 2000), 329–30, 348; Glass, 260.

137. Friedlaender to Levine, [summer 1945], GC.

138. Muzzarelli to LL, April 26, 1946; FL to LL, Aug. 7, LL to Hansing, April 22, 1947, GC; *Wiener Kurier*, Nov. 7, 1946.

139. FL to LL, Dec. 23, 1945, June 25, 1946, GC; LL to CH, April 29, 1946, CU/2.

140. Barsewisch.

141. Muzzarelli to LL, Dec. 30, 1945, April 23, 1946; FL to LL, Sept. 12, 1946, June 26, 1947, Alois Klee to LL, June 4, 1947, GC; Stodolowsky to LL, May 15, 1946, April 4, 1950, PA Hertha Schuch.

142. Levine to LL, May 24, 1945; Friedlaender to Levine, [summer 1945], GC; LL, "Mein Hollywood-Abenteuer," n.d., CW.

143. Levine to LL, Aug. 14, Dec. 19, 1945, GC; LL to Stodolowsky, April 14, 1945, PA Hertha Schuch.

144. Levine to LL, July 1, 18, Aug. 22, Sept. 19, 1946; Bing to LL, Aug. 9, Nov. 28, 1946, GC; *NYT*, Nov. 17, 1946.

145. *NYT*, Feb. 12, March 30, 1947; LL to Stodolowsky, April 11, 1947, PA Hertha Schuch; Semon [sic] to LL, April 12, 16, 1947, GC.

146. LL to BW, April 15, 1947; LL to Waage, April 16, 1947; LL to MH, June 19, 1947; FL to LL, April 20, Aug. 19, Sept. 5, 1947, GC.

147. FH to BW, Aug. 14, 1947, GC.

148. Gary Hickling in *LLLN*, Spring 1992, MAWA.

149. *NYT*, Jan. 29, 1940.

150. Ibid., Feb. 1, 1940.

151. Ibid., Feb. 11, 1940.

152. Ibid., April 23, 1940.

153. Ibid., March 30, 1940; LL to MH, June 1, 1941, GC.

154. Schang to LL, Jan. 8, 1942, BC.

155. *NYT*, March 15, 1943, Jan. 1, 31, March 6, 1944, Jan. 15, 22, 1945, Jan. 14, 21, 28, 1946, Jan. 20, Feb. 3, 6, 1947, Feb. 16, 1948, Feb. 21, 1949; *New York Sun*, Feb. 21, 1949; *New York World Telegram*, Feb. 21, 1949.

156. Waage to Milton, Jan. 25, 1943, GC.

157. *NYT*, Feb. 24, 1945.

158. CH to LL, Feb. 26, 1945 (1st two quotes); Johnson to LL, Feb. 25, 1946, GC (last quote).

159. LL to Waage, April 8, 1946, GC; *Chicago Daily Tribune*, Jan. 23, 1948.
160. *NYT*, Feb. 13, 1950.
161. Ibid., Feb. 3, 1941. Also ibid., March 13, Nov. 28, 1941, Jan. 8, Feb. 9, 1942, Jan. 9, 1943, Jan. 15, 1945; *New York Sun*, Feb. 21, 1949; *New York Herald Tribune*, Feb. 21, 1949.
162. *NYT*, March 30, 1941.
163. Ibid., Dec. 29, 1940 (quote), Sept. 7, 1941.
164. Ibid., June 1, 1941 (quote); LL to MH, June 1, 1941, GC.
165. Just listen to her interpretation of *Die Winterreise*, accompanied by Ulanowsky, Pearl, GEM 0033, [1998]. This is a composite of her 1940 RCA Victor and 1941 Columbia recordings, thus constituting the full cycle.
166. *NYT*, Sept. 7, 1941 (quote); Vincent Sheean, *First and Last Love* (Westport, CT, 1979), 277.
167. *NYT*, Jan. 25, 1942.
168. Ibid., May 8, Sept. 20, 1942, July 25, 1943, Jan. 9, 1944 (quote).
169. LL to CH, Sept. 4, 1941, CU/2; LL to MH, [Oct. 1941], GC.
170. CH to FH, June 12, 1944; FH to CH, Oct. 7, 1944, GC; CH to FH, Sept. 27, 1944; CH to LL, Nov. 2, 1944; CH to Darnell, Dec. 18, 1944; LL/McMurray, contract, Feb. 12/14, 1945; LL to Lieberson, May 16, 1945 (quotes); FH to Rauch, Nov. 2, 1945; Lieberson to LL, March 5, 1946; Strunsky memo, March 5, 1947, BC; *NYT*, March 11, 1947.
171. Pleasant to LL, Nov. 14, 1949, BC.
172. Glass, 240; Gary Hickling's discography, ibid., 315; *NYT*, March 26, 1950.
173. Pleasant to LL, Feb. 20, 1950, BC.
174. LL to Balogh, Dec. 10, 1950, GC.
175. LL/Johnson, contracts, Nov. 4, 1940, Aug. 21, 1942, MOA; Hickling.
176. Hickling; MOA/O.
177. *NYT*, March 16, 1941.
178. LL to CH, [spring 1941], CU/1; Johnson to LL, June 8, 1941, BC, and Aug. 12, 1941, GC; LL to MH, Sept. 3, 1941, GC.
179. LL to CH, [July 1942], July 3, 1943, CU/2; CH to FH, Aug. 3, 1942, BC; Johnson to LL, Jan. 26, 1942; LL to Johnson, Feb. 1, 1942; CH to Ziegler, March 6, 1942; Ziegler to CH, March 9, 1942, MOA.
180. FH to CH, Oct. 7, 1944, GC; Paul Jackson, *Saturday Afternoons at the Old Met: The Metropolitan Opera Broadcasts, 1931–1950* (Portland, OR, 1992), 175; *NYT*, Feb. 24, 1945 (1st quote); LL to Strauss, April 10, 1947 (2nd quote), RG.
181. *NYT*, Dec. 8, 1940.
182. Astrid Varnay, *Fifty-Five Years in Five Acts: My Life in Opera* (Boston, 2000), 94 (quote); *NYT*, Dec. 7, 1941.
183. *NYT*, Jan. 17, 1944.
184. LL to CH, [spring 1941], CU/1.
185. *NYT*, Oct. 5, 1941; Steber, 48; Varnay, 95.
186. See LL to CH, [March 24, 1943], CU/2.
187. Holden.
188. LL to MH, [1940–41], May 9, 1942, GC; LL to CH, June 7, 1940, June 3, 1941, [July 1942], CU/2; FH to CH, Sept. 30, 1940, CU/9; CH to LL, May 7, 1941, BC; LL to CH, [1941], [1942], CU/1.
189. *NYT*, March 14, 1940; FH to CH, [summer 1941], CU/9; CH to LL, Sept. 11, 1941, BC.
190. LL to CH, [summer 1942], July 2, 1942, CU/1.
191. Hearst to CH, Nov. 18, 1942; CH to FH, Nov. 18, 1942; LL/Levine contract, Dec. 15, 1942; Levine to LL, Dec. 15, 1942, BC; LL to CH, [summer 1943], CU/1.

192. *NYT*, Sept. 19, 1943; LL to CH, Oct. 29, 1943, CU/2; LL to FH [Nov. 5, 1943], GC; Hickling; calculations according to CH to LL, Dec. 16, 1943, BC, and Hickling.

193. Levine to LL, Oct. 12, 1948, GC.

194. Levine to LL, Jan. 15, 30, 1949, GC.

195. LL to Levine, Sept. 24, 1949; Levine to LL, Nov. 23, Dec. 29, 1949, GC; Pleasant to LL, Feb. 20, 1950; Pleasant to FH, June 21, 1950, BC.

196. LL to FH, Feb. 14, 1950, GC.

197. LL to CH, Aug. 5, 1940, Sept. 9, 1941, [Jan. 11, 1942], June 4, 1942, CU/2; LL to CH, [spring 1941], [March 1942], CU/1; LL to MH, [1941], [Oct. 1941], Oct. 7, 1942, Feb. 18, 1943, March 2, 1945; LL to Waage, April 8, 1946, Aug. 6, 1948, [1949], Oct. 16, 1950, GC; LL to Lieberson, May 16, 1945, BC.

198. CH to FH, Sept. 25, 1940, CU/9, and Aug. 12, Oct. 9, 1941, BC; LL to CH, [July 1942], CU/2; Levine to LL, April 27, 1948, GC.

199. Holden; LL/FH correspondence, 1940–51, GC.

200. Puritz, 243; *NYT*, Aug. 3, 1947.

201. *NYT*, Aug. 13, 1935, July 26, 1945.

202. Ibid., April 30, 1946.

203. FL to LL, May 5, 18, July 24 (quote), Aug. 7, 1946, GC; *NYT*, Nov. 11, Dec. 5, 1946, April 11, 1948.

204. LL to CH, Nov. 6, 1940, June 1, 3, 1941, CU/2; LL to CH, [summer 1941], CU/1; CH to LL, June 19, 1941, BC; LL to CH, [June 1941], GC (quote); *NYT*, June 29, 1941.

205. Edwin McArthur, *Flagstad: A Personal Memoir* (New York, 1965), 250–52, 269; Nigel Douglas, *Legendary Voices* (New York, 1995), 84, 87.

206. Marcel Prawy, *Marcel Prawy erzählt aus seinem Leben* (Vienna, 1996), 59.

207. *NYT*, Dec. 29, 1939; Helen Traubel, *St. Louis Woman* (New York, 1959), 117.

208. Traubel, 118–19.

209. LL to CH, [June 1941], GC (quote); CH to LL, Aug. 19, 1941, BC.

210. See LL to CH, Sept. 4, 1941, CU/2; Jackson, 267; Traubel, 110–12.

211. Traubel, 123.

212. Leinsdorf, 104.

213. *NYT*, Jan. 29, 1942; Shirlee Emmons, *Tristanissimo: The Authorized Biography of Heroic Tenor Lauritz Melchior* (New York, 1990), 189, 191; Hickling.

214. For Flagstad, see her own admission in Ivor Newton, *At the Piano – The World of an Accompanist* (London, 1966), 183.

215. Quoted at MOA/O.

216. Hickling. See also *NYT*, Jan. 9, 1940.

217. LL to CH, May 20, July 12, 1940, July 8, 1941, CU/2; CH to FH, Sept. 25, 1940, CU/9; LL to MH, [1941], [June 1941]; LL to CH, [June 1941], GC; CH to LL, May 7, June 19, 1941, BC.

218. Emmons, 196–97; LL to CH, [spring 1941], CU/1; CH to FH, June 16, 1941, BC; LL to CH, [July] 21, 1942, CU/2.

219. Emmons, 209–21. LL's quote according to FL to LL, July 9, 1944, GC.

220. FL to LL, Feb. 25, 1943, July 16, 21, Aug. 1, 24, 28 (quote), Oct. 19, [Oct. 25], 1944, March 25, Aug. 16, Oct. 13, 1945, GC.

221. *NYT*, Feb. 17, 18, 1946; Emmons, 203–4.

222. LL quoted in Emmons, 205. Also Glass, 226.

223. Hickling.

224. Kyle Crichton, *Subway to the Met: Risë Stevens' Story* (Garden City, 1959), 232.

225. FL to LL, Aug. 24, 1944, GC.

226. LL to CH, June 7, 1940, CU/2.

227. LL to CH, Sept. 4, 1941, CU/2; Crichton, 232–33; Stevens in interview with Gary Hickling (Hickling to author, July 10, 2006).

228. LL to CH, [summer 1942], CU/1.

229. LL to Coppicus, October 7, 1942, CU/9.

230. LL to CH, June 16, 1942, CU/2.

231. See text near note 244 in Chapter 2.

232. Stevens interview (as in note 227); Glass, 221.

233. LL to CH, July 8, 1941, CU/2.

234. See FL's reply to LL, July 5, 1944, GC.

235. Edward Baron Turk, *Hollywood Diva: A Biography of Jeanette MacDonald* (Berkeley, 1998), 103, 154, 183, 194–95, 196 (quote), 237–38, 242.

236. Ibid., 265–69.

237. FL to LL, July 21, 1944, GC.

238. Holden.

239. LL to MacDonald, [fall 1944], [Oct. 1944], Oct. 7, Nov. 20, 28, 1944, [April 1945], PA Turk; Turk, 269 (quote).

240. MacDonald to LL, Sept. 29, Oct. 10, 1944, PA Turk.

241. Turk, 270–78; Ronald L. Davis, *A History of Opera in the American West* (Englewood Cliffs, 1965), 72–73.

242. LL to MacDonald, Nov. 21, 1945, PA Turk; Turk, 278.

243. FL to LL, Sept. 4, 1944 (quote), also [Oct. 25, 1944], GC.

244. LL cited in FL to LL, Sept. 4, 1944, GC.

245. FL to LL, May 26, 1946, GC.

246. LL, *My Many Lives* (New York, 1948), 2.

247. Holden; Gary Hickling's telephone interview with LL, 1973, soundtrack at LLFA.

248. LL to CH, June 15, 1939, CU/1.

249. Geraldine Farrar, *Such a Compulsion: The Autobiography of Geraldine Farrar* (New York, 1938), 149–50, 165–88; *Wiener Salonblatt*, Aug. 13, 1933; Joseph Horowitz, *Understanding Toscanini: How He Became an American Culture-God and Helped Create a New Audience for Old Music* (Minneapolis, 1988), 216.

250. LL to CH, Nov. 25, 1936, GC, and [March 1937], CU/1; LL diary, March 30, 1937, CW; *New York World-Telegram*, Jan. 10, 1934; *Time* (Feb. 18, 1935): 49; fragment, *Musical Courier*, [1935], NC.

251. CH to LL, June 2, Sept. 10, 1937, BC; LL to CH, Aug. 30, 1937, GC, and Sept. 21, 1937, CU/1.

252. LL, "Mein Hollywood-Abenteuer," n.d., CW.

253. Donald Spoto, *Blue Angel: The Life of Marlene Dietrich* (New York, 1992), 143–58; Turk, 281.

254. *NYT*, Aug. 18, 1947; LL, "Mein Hollywood-Abenteuer," n.d., CW.

255. LL, "Mein Hollywood-Abenteuer," n.d., CW; FL to LL, Aug. 14, 20, 21, 23, 26, 28, 31, Sept. 10, 1947, GC.

256. FL to LL, Aug. 28, 1947, GC.

257. Renovated, the house was on sale in early 2001 for $1,445,000 (*Los Angeles Times*, March 18, 2001); Holden; LL to MH, Sept. 27, 1950, GC.

258. LL, "Mein Hollywood-Abenteuer," n.d., CW; Holden; LL to MH, Nov. 10, 1947, GC.

259. "Big City," America On Line Hometown (online); Farrar quoted in Aida Craig Truxall, ed., *All Good Greetings, G.F.: Letters of Geraldine Farrar to Ilka Marie Stotler, 1946–1958* (Pittsburgh, 1991), 70.

260. FL to LL, Nov. 22, 1947; LL to BW, Dec. 23, 1947, April 16, 1948; LL to Arthur Holden, Jan. 2, 1948 (quote); Levine to LL, Jan. 6, 1948; LL to Hansing, Feb. 2, 1948; LL to McGiffin, July 21, 1948; LL to Waage, Aug. 6, 1948, GC.

261. Turk, 284; LL, "Mein Hollywood-Abenteuer," n.d., CW; Levine to LL, Oct. 12, 1948; LL to Levine, Oct. 15, 1948; LL to MH, June 9, 1949; FL to LL, July 5, 1949; LL to Armistead, June 27, 1950, GC; LL to Berend, Oct. 23, 1948, AKB/CCA.

262. In *Deutsch-Amerika und SportRundschau*, no. 49 (Dec. 3, 1932):

> Es klingt ein starker Klang in mir,
> ein süsses, wundersames Lied.
> Das mich mit weicher linder Hand
> In weite, weite Ferne zieht.
>
> Durch meiner Nächte Träume schwebt
> der mir ein hohes Ziel verheisst,
> der meine Tage jauchzend macht
> und sonnenwärts mich siegend reisst.

In Paul Stefan, *Bruno Walter: Mit Beiträgen von Lotte Lehmann, Thomas Mann, Stefan Zweig* (Vienna: Herbert Reichner, 1936), [5]:

> Mit Bruno Walter am Klavier…
>
> Es trägt sein Spiel, das sich mir tief verwebt,
> Mich fort auf wunderbaren Schwingen.
> Ich fühle im Zusammenklingen
> Hinströmend meine Seele singen,
> Die nun im Willen seiner Hände lebt
> Und aufwärts schwebt zu lichten Höhen.
>
> Vermählt in einer Melodie –
> Geführt und führen – hingerissen
> Eines dem andern folgen müssen
> In tiefstem Voneinanderwissen:
> Geheimnis ist's der Harmonie.
> Und wahres, reines Sichverstehen.

263. *NYT*, March 31, 1940.

264. The many poems – e.g., by upper-class Else Frobenius, who self-assertively included them in her memoirs – are of the same ilk: see her *Erinnerungen einer Journalistin: Zwischen Kaiserreich und Zweitem Weltkrieg* (Cologne, 2005), 93, 180.

265. See text near note 323 in Chapter 2.

266. LL to BW, Oct. 28, 1926; BW to LL, Nov. 3, 1926, ATW/15; Hickling.

267. Kontor to LL, April 29, 1929, ATW/9; LL, "Ferienwochen an der Nordsee," newspaper fragment [July 1933], NC; LL, "Zurück aus Amerika," *Neue Freie Presse* (Vienna), April 21, 1935.

268. *NYT*, July 25, 1937.

269. LL, *Orplid, mein Land* (Vienna, 1937); idem, *Eternal Flight* (New York, 1937).

270. LL to CH, [summer 1936]; LL to Else Walter, Feb. 22, 1937, GC; Paramount Pictures to CH, Jan. 22, 1937, BC.

271. Doubleday to CH, Jan. 11, 1937, BC.

272. LL to Else Walter, Feb. 22, 1937, GC; LL to CH, April 16, 1940, CU/2.

273. LL to Hope, [1943], CU/1 (quote), and Dec. 8, 1943, CU/2.

274. LL, "Of Heaven, Hell, and Hollywood: A Satirical Fantasy," [March 1950], CW.

275. LL, *Midway in My Song: The Autobiography of Lotte Lehmann* (Indianapolis, 1938).

276. Lachmann to LL, May 26, 1966, ATW/TNLL.
277. LL, "Australian Diary," [1937], CW.
278. LL to Waage, Aug. 6, 1948, GC.
279. Horch to LL, May 17, 1948, BC.
280. LL, *More than Singing: The Interpretation of Songs* (New York, 1945); idem, *Lives*.
281. LL, "The Fine Art of Lieder Singing," *NYT*, March 23, 1941.
282. *NYT*, March 30, 1941.
283. FL to LL, Oct. 25, 1945, GC; Horch to LL, Oct. 29, 31, 1945; Heinsheimer to FH, Nov. 3, 1945, and to LL, Nov. 21, 1945, BC.
284. Copy of review attached to Heinsheimer to FH, Nov. 5, 1945, BC.
285. LL to CH, April 29, 1946, CU/2.
286. *NYT*, June 27, 1948.
287. See Horch to LL, Feb. 22, 1947, BC.
288. LL, "Unsere Hausangestellten," n.d., CW; Holden; Barsewisch.
289. FH to CH, May 12, 1940, CU/2; FL to LL, [May 4, 1944]; LL to Waage, April 16, 1947, GC; FH to CH, Sept. 11, 1944, BC.
290. FL to LL, Dec. 10, 1942, GC; *Aufbrüche: Frauengeschichte(n) aus Tiergarten, 1850–1950* (Berlin 1999), 36–37; Charlotte Berend-Corinth, *Mein Leben mit Lovis Corinth* (Hamburg-Bergedorf, 1948).
291. FL to LL, Jan. 7, 25, Feb. 2, 14, Nov. 7, 1943, April 28, 1946, [Dec. 1950], GC.
292. FL to LL, Oct. 19, 1944, GC.
293. Photographs of works in the University of California at Santa Barbara, Davidson Library, Special Collections, Lotte Lehmann Papers, Art Collection. See LL to CH, [fall 1943], GC.
294. LL to CH, May 27, 40, CU/2.
295. Jens Malte Fischer to author, May 18, 2006.
296. Three of the images are reproduced in *SBNP*, Aug. 21, 1949. All twenty-four are on a private video, including her *Winterreise* music, prepared after an exhibition of her paintings and now at APA, courtesy of Shirley Sproule. See also sketches for *Die Winterreise*, PC.
297. FH to CH, Oct. 25, 1943, GC.
298. *NYT*, Feb. 29, 1940.
299. LL, "Die Berge brennen," n.d., CW; LL to MH, Oct. 7, 1942; FL to LL, Feb. 14, 1943, GC; Klaus Mann to LL, Aug. 31, 1943, EMA, 3554/75, and Oct. 11, 1943, CU/2 (quote).
300. LL to CH, Sept. 13, 1943, CU/2.
301. FH to CH, Oct. 7, 1944, GC; LL to MacDonald, [Oct. 1944] (quote), and attached critique by Donald Bear, PA Turk.
302. FL to LL, Oct. 20, 1944, GC.
303. LL to Waage, Oct. 21, 1944 (1st quote); LL quoted in FL to LL, July 10, 1949, GC.
304. *SBNP*, Aug. 21, 1949; LL to Pleasant, Aug. 18, 1949, BC.
305. *NYT*, Oct. 13, 1949, Jan. 23, 1950.
306. *New York Herald Tribune*, Jan. 24, 1950; *NYT*, Jan. 24, 1950.
307. Williams to Arthur Holden, March 10, 1950, GC; Holden.
308. See Sandreuter to LL, April 3, 1929, ATW/8.
309. See her ongoing correspondence with FL, 1941–50, GC.
310. LL to CH, Aug. 2, 10, 1939, CU/1, and April 19, 1940, CU/2; LL to MH, [1940–41], GC.
311. CH to FH, Oct. 9, 1941, May 25, 1942, BC.

312. LL to CH, June 10, 16, [July], Aug. 27, 1942, CU/2; and [July 2, 1942], [1942], CU/1; Rauch to LL, June 4, 1942, GC; CH to LL, July 1, 1942, BC; *NYT*, Nov. 16, 1941.

313. LL to CH, [July] 21, 1942, CU/2; FL to LL, Dec. 10, 1942, April 20, 1947; Hufstader to LL, March 29, 1947; LL to Hufstader, April 8, 1947, GC; Holden.

314. Author's interview with Mary Collier, Santa Barbara, April 20, 2006; Mary Collier to author, May 26, 2006.

315. MOA/O. On Koechig, see *NYT*, June 29, 1941, Nov. 14, 1942; LL to CH, [1942], CU/1; LL to MH, Jan. 2, 1943; FL to LL, Feb. 25, 1943, GC.

316. *NYT*, Nov. 28, 1941; Hickling; Steber, 55–57.

317. LL to MH, [summer 1944]; FL to LL, May 27, 1944, June 7, July 6, 1945; MacDonald to LL, June 24, 1944, PA Turk; CH to LL, Aug. 28, 1944, BC; *The New Yorker* (Aug. 4, 1945): 51.

318. LL, *Lives*, 56; *NYT*, March 23, 30, 1941, April 4, 1948; Bampton in Glass, 221–22; Steber, 55–57.

319. LL to CH, Aug. 2, 1943, CU/2; FH to CH, Sept. 11, 1944, BC; *Chicago Sunday Tribune*, Oct. 28, 1945.

320. LL to CH, [1942], CU/1; FL to LL, July 21, 1944, Aug. 7 (quote), 26, Sept. 4, 1945; FH to Koldofsky, [fall 1945], GC.

321. Holden; *NYT*, Aug. 12, 1945.

322. *SBNP*, Sept. 21, 1946; Sharon Crawford, *Music Academy of the West, Santa Barbara: Fifty Years, 1947–1997* (Santa Barbara, 1997), 7–8; Hickling.

323. *SBNP*, Sept. 21, Oct. 26, 1946, April 2, 1947; Crawford, 7–8.

324. *NYT*, March 19, 1947; *SBNP*, Oct. 26, 1946, Jan. 21, 1947; Hellmann, "History of the Music Academy," n.d.; MAWA; Ganna Walska, *Always Room at the Top* (New York, 1943), 499–501; Emmons, 94.

325. Published in the United States as *Grand Hotel* in 1930.

326. "The Impresario," n.d., MAWA; *SBNP*, Nov. 16, 1950; MOA/O, and Ziegler to Simon, April 20, 1931, MOA; *NYT*, April 25, 1931; Vicki Baum, *Es war alles ganz anders: Erinnerungen* (Zurich, 1964), 125, 296–97, 315; Grace Denton Esser, *Madame Impresario: A Personal Chronicle of an Epoch* (Yucca Valley, CA, 1974), 31–91.

327. *NYT*, July 8, 1947; program, "Music Academy of the West," Aug. 7, 1947, MAWA; Crawford, 8–13; Darius Milhaud, *My Happy Life* (London, 1955), 221–22.

328. "First Summer Session 1947," MAWA; Madeline Lewis, "The Birth of an Institution . . . The Music Academy of the West," *Santa Barbara Arts* (July 1986); *SBNP*, March 7, June 6, 1948. On Juilliard, see Andrea Olmstead, *Juilliard: A History* (Urbana, 1999); on Eastmann, Charles Riker, *The Eastman School of Music: Its First Quarter Century, 1921–1946* (Rochester, NY, 1948); on Curtis, *The Curtis Institute of Music* ([Philadelphia,] 1974).

329. Denton to LL, Feb., 15, 1947, MAWA; LL to BW, April 15, 1947, GC.

330. LL's quote (1960) in Kathy H. Brown, "Lotte Lehmann: Her Artistic Legacy," (1995), 23 (MAWA).

331. LL to Denton, Feb. 17, 1947, MAWA.

6. Triumphs and Burdens of Old Age, 1951–1976

1. FH to LL, Jan. 27 (quote), 28, 1951; LL to FH, Jan. 30, 31, Feb. 1, 1951, GC; *NYT*, Jan. 29, 1951.

2. *NYT*, Jan. 29, 1951.

3. *NYT*, Feb. 11, 12, 1951; Hickling.

4. LL as quoted in *Chicago Tribune*, Feb. 19, 1951; LL to Waage, Feb. 14, 1951, GC; *LLLN*, Spring 1992, MAWA; Holden.

5. LL, Town Hall, Feb. 16, 1951, Recollection, n.d., CW.

6. Lotte Lehmann: *The Farewell Recital (1951)*, VAI Audio, Vaia 1038.

7. Partial transcript in Studs Terkel, *And They All Sang: Adventures of an Eclectic Disk Jockey* (New York, 2005), 275–76.

8. *NYT*, Feb. 17, 1951; *New York Herald Tribune*, Feb. 17, 1951; *Musical Courier*, March 1, 1951.

9. *NYT*, Feb. 25, 1951.

10. Stevens to LL, [spring 1951], GC.

11. Marek to LL, March 12, 1951, BC.

12. Levine to LL, April 11, 1951, GC.

13. FH to LL, Feb. 21, 1951; FL to LL, Feb. 23, 1951; LL to BW, Feb. 28, 1951, GC; Bruno Walter and Lotte Walter-Lindt, *Briefe, 1894–1962* (Frankfurt am Main, 1969), 323 (quotes); Gerd Puritz, *Elisabeth Schumann: A Biography* (London, 1993), 317–18.

14. LL to BW, March 8, July 17, 1951; LL to Waage, March 16, 1951; Coveney to Laursen, Jan. 2, 1975, GC; LL to CH, April 7, 1952, CU/2; Hickling.

15. *NYT*, Jan. 20, 1952.

16. Ibid., May 20, 1952.

17. Ibid., Dec. 11, 1957.

18. Ibid., March 22, 1958.

19. Ibid., April 24, 1957.

20. For recordings: Ibid., Feb. 1, 22, 1953, Sept. 25, 1955, Sept. 30, Dec. 2, 1962.

21. Ibid., Nov. 27, 1952.

22. Ibid., Nov. 23, 1957.

23. Ibid., Dec. 11, 1960.

24. Ibid., Aug. 2, 1959, Oct. 14, 1962.

25. Ibid., Oct. 23, 1972.

26. LL/MAW contracts, Jan. 8, 1951 through Sept. 12, 1960, BC and MAWA.

27. LL to MH, May 23, 1960; LL/MAW contracts, Sept. 23, 1968, Oct. 21, 1969, MAWA.

28. LL to Denton, Feb. 17, 1947, MAWA.

29. LL to CH, May 6, 1951, CU/2; FL to LL, July 15, 1951; LL to BW, July 17, 1951; LL to MH, Feb. 21, 1952, GC.

30. *NYT*, July 11, 1954; LL to Goldberg, June 8, 1952; LL to McGiffin, July 12, 1958; LL to Sproule, Jan. 30, 1959, GC.

31. Holden.

32. MAW, "Eighth Summer Session 1954," BC.

33. *The Lotte Lehmann Master Classes*, vols. 1 and 2, VAI DVD 4326/27 (2005); Zytowski. Also see the plastic examples of former coach Glass, in his *Lotte Lehmann: A Life in Opera and Song* (Santa Barbara, 1988), 248–51, 254–57. Technical and organizational details are in Kathy H. Brown, "Lotte Lehmann: Her Artistic Legacy" (1995), 31–45 (MAWA).

34. LL to Page [?], April 28, 1955, GC.

35. Author's interview with Elizabeth Erro-Hvølboll, Santa Barbara, April 20, 2006.

36. See LL to MH, Sept. 23, 1952; LL to BW, [1951/52]; LL to Sproule, April 6, 1954, GC.

37. *NYT*, Oct. 12, 1953 (quote); Hickling; Glass, 250.

38. LL to BW, Aug. 13, 1954, GC; *Opera News* (Oct. 31, 1955): 16.

39. *Opera News* (Oct. 31, 1955): 16; *NYT*, Aug. 25, 1955.

40. *NYT*, Aug. 22, 1957; Hickling.

41. Walter and Walter-Lindt, 375.

42. Holden (quote); LL to MH, Feb. 21, 1952, GC.

43. Brown, "Lehmann," 33–34; FH to Bollinger, April 16, 1951; LL to [Natalie], Oct. 20, 1969; LL to Westwood, Nov. 5, 1969, GC.

44. LL to Jennie, Nov. 11, 1963, GC.

45. *LLLN*, Summer 1989, MAWA.

46. Shirley Sproule, "Prelude and Joy"/"Vignettes," n.d., PA Sproule; Sproule to Makin, Oct. 12, 1953, ibid. (quote); author's telephone interview with Shirley Sproule, Oakville/Tuscon, Dec. 7, 2004.

47. Author's interview (as in note 46); LL to BW, July 13, 1954; LL to Newton, Jan. 21, 1957; LL to McGiffin, June 7, 1958; LL/Sproule correspondence, 1956–63, GC.

48. Gary Hickling to author, Sept. 24, 2005.

49. Gary Hickling to author, Sept. 24, 2005, Sept. 1, 2006. Cf. lottelehmann.org (online).

50. LL to McGiffin, June 7, 1958, GC.

51. LL to Sproule, Oct. 14, 1954, GC.

52. LL to Sproule, March 17, 1958, GC.

53. LL to Popper, July 12, 1963, MAWA (1st quote), Aug. 4, 1963 (2nd quote); author's telephone interview with Gary Hickling, Oakville/Kailua, Sept. 1, 2006.

54. LL to Merwin, March 19, 1975, GC.

55. LL to Goldberg, Nov. 18, 1953, GC.

56. Marni Nixon, *I Could Have Sung All Night: My Story* (New York, 2006), 84–102, 120–54.

57. *NYT*, Nov. 1, 1957.

58. Klemperer to LL, March 1, Sept. 13, Oct. 25, 1961, GC.

59. *NYT*, Aug. 17, 1975 (quote); Cori Ellison, "Valente, Benita," *Grove*.

60. LL to Schornstein, Dec. 23, 1965, GC.

61. Betty Smith Associates, press release, [Feb. 25, 1969], GC.

62. *NYT*, July 17, 1962; LL quoted for July 1962 in John Coveney, "Lotte Lehmann Remembered," *High Fidelity/Musical America* (June 1977): 35.

63. *Los Angeles Times*, March 2, 1952 (quote); Merwin to LL, Dec. 17, 1951, MAWA; LL to MH, Feb. 21, 1952, GC; LL to CH, March 1, 1954, CU/2.

64. Hufstader to LL, Sept. 17, 1952; LL/Juilliard correspondence, 1955–56, GC.

65. LL to Sproule, Oct. 14, 1954, April 2, 1957; LL to Balogh, Jan. 23, 1957; LL to FH, April 13, 1960; LL to Goldberg, Nov. 16, 1964, GC; LL to CH, Sept. 3, 1964, CU/3; *NYT*, Jan. 27, 1957; *Chicago Defender*, Aug. 22, 1964; Studs Terkel's interview with LL, Evanston, 1960, soundtrack LLFA; Schornstein.

66. LL to Popper, April 2, 1961, MAWA, AL; LL to MH, Jan. 13, March 1, 1962; LL to Sproule, May 22, 1962; LL to Goldberg, Nov. 16, 1964; Jones to LL, Oct. 9, 1964, GC; Buchanan to LL, Sept. 16, 1968, BC; Hickling.

67. LL to CH, March 1, 1954, CU/2; *SBNP*, Oct. 30, 1966.

68. Memo, "The Music Academy," [1952], MAWA; Sharon Crawford, *Music Academy of the West, Santa Barbara: Fifty Years, 1947–1997* (Santa Barbara, 1997), 15–17, 20.

69. Crawford, 19.

70. Planning committee memo, Sept. 24, 1948, MAWA; memo, "The Music Academy," [1952], MAWA; LL to BW, [spring 18951]; LL to Sproule, Sept. 14, 1953, GC; Crawford, 24.

71. Marshall to Wack, June 13, 1951, MAWA (1st quote); LL to Karolik, Oct. 2, 1951, BC (2nd quote).

72. LL to Crosby, Jan. 5, 1954, MAWA.

73. LL to Hopper, Feb. 8, 1954; Hopper to LL, Feb. 10, 1954 (quote), MAWA.

74. LL to BW, March 8, 1951, Dec. 28, 1953, GC; Cowan to LL, Oct. 8, 1957, BC; Lowell M. Durham, *Abravanel!* (Salt Lake City, 1989), 145.

75. *SBNP*, Oct. 30, 1966; LL to FH, Oct. 22, 1955, Feb. 24, 1967, GC; Cochran to Morse, Oct. 21, 1967, MAWA; Crawford, 36.

76. LL to Barrows, April 9, 1952, GC; Crawford, 35.

77. Crawford, 21.

78. Ibid., 26, 28–29; Zytowski.

79. *Opera News* (Oct. 31, 1955): 16.

80. MAW, "Eighth Summer Session 1954," BC (1st quote); *Opera News* (Oct. 31, 1955): 16 (2nd quote); Crawford, 27 (3rd quote).

81. LL to Popper, July 21, 1956, GC.

82. LL to Michaelis, Jan. 31, 1958, GC; Crawford, 31.

83. *Chicago Defender*, Dec. 9, 1961.

84. Crawford, 34; Ruby Mercer, *The Tenor of His Time: Edward Johnson at the Met* (Toronto, 1976), 236–38.

85. Altmeyer to LL, Oct. 15, 1974, GC; Altmeyer quoted in *SBNP*, July 9, 2003; Marilyn Horne, *The Song Continues* (Fort Worth, 2004), 69. See Martial Singher, *An Interpretive Guide to Operatic Arias: A Handbook for Singers, Coaches, Teachers, and Students* (University Park, 1983).

86. LL to Sproule, July 13, 1962, GC.

87. LL to Sproule, Feb. 19, 1963, GC.

88. Holden; FH to Schornstein, Aug. 2, 1969 (quote); Faulkner to Schornstein, Jan. 29, 1970, GC.

89. LL to Schornstein, Aug. 11, 1969, GC.

90. LL to Cochran, Feb. 10, 1970, MAWA.

91. Durham, 149–50; Crawford, 34.

92. FH to Barrows, July 16, 1962 (quote), LL to MH, Feb. 21, 1973, GC; Popper to LL, July 26, 1969, MAW, AL.

93. Invitation, "Mme. Lotte Lehmann Eightieth Birthday Dinner," [Feb. 1968]; dinner program script, Feb. 27, 1968, MAWA; *SBNP*, Feb. 27, 28, 1968; *Los Angeles Times*, March 10, 1968.

94. MAW, *Summer Festival Program Book* (Santa Barbara, 2005), 81.

95. Horne to LL, Jan. 5 (1st quote), Jan. 23, 1957 (2nd quote), [Feb. 1957] (3rd quote), GC.

96. Robert M. Jacobson, *Opera People* (New York, 1982), 38; Jens Malte Fischer, *Grosse Stimmen: Von Enrico Caruso bis Jessye Norman* (Stuttgart, 1993), 450–52; Jürgen Kesting, *Die grossen Sänger unseres Jahrhunderts* (Düsseldorf, 1993), 944–50.

97. As in note 94; MOA/O.

98. Marilyn Horne, *My Life* (New York, 1983), 60–61.

99. *LLLN*, Summer 1993, MAWA; News Briefs, April 22, 2004, lottelehmann.org (online).

100. Horne, *Song*, 52–53.

101. Gary Hickling to author, May 30, 2004.

102. See Fred A. Morsell, "Grace Bumbry," *The Crisis*, 84 (Nov. 1977): 446.

103. Bumbry.

104. Ibid.; LL to CH, July 15, 1957, CU/2.

105. Bumbry quoted in Morsell, 448; Bumbry; author's interview (as in note 46).

106. Bumbry.

107. Ibid.; Alan Blyth in *Mezzo-Sopranos in Opera: Profiles of Fifteen Great Mezzo-Sopranos* (London, 2004), 32.

108. Wagner quoted in Brigitte Hamann, *Winifred Wagner oder Hitlers Bayreuth* (Munich, 2002), 582; *NYT*, July 22, 23, 24, 26, 1961.

109. Fischer, 498; unidentified Hamburg review, Nov. 21, 1964, ATW/TNLL.

110. *Chicago Daily Defender*, Oct. 3, 1962.

111. Alan Blyth in *Mezzo-Sopranos*, 33.

112. Patrick O'Connor in *Gramophone* (Dec. 2004): 36.

113. *NYT*, Feb. 17, 21, 1962.

114. Ibid., Nov. 9, 1962.

115. Ibid., Oct. 16, 1965. See also Irving Kolodin, *The Metropolitan Opera, 1883–1966: A Candid History* (New York, 1966, 4th ed.), 727–28.

116. Rudolf Bing, *5000 Nights at the Opera* (Garden City, 1972), 133–34; Kolodin, 745.

117. *NYT*, Nov. 22, 1965.

118. Rudolf Bing, *A Knight at the Opera* (New York, 1991), 119; Fischer, 498–99; O'Connor, 36–38.

119. *NYT*, Nov. 22, 1965; Lanfranco Rasponi, *The Last Prima Donnas* (New York, 1982), 26; Kesting, 771–72.

120. Alan Blyth in *Mezzo-Sopranos*, 31; Stephen Rubin, "Amazing Grace," *Opera News* (Oct. 1981): 11–13; Bumbry as interviewed by Joel Kasow, <culturekiosque.com/opera/intervie/rhebumb.htm>.

121. *NYT*, Dec. 12, 1967, Oct. 27, 1970; Rubin, 11–13, 50.

122. O'Connor, 36–38 (Bumbry quoted at 37); *NYT*, Nov. 9, 1962; Robert M. Jacobson, *Opera People* (New York, 1982), 76–77; Harold C. Schonberg, "A Bravo for Opera's Black Voices," *NYT Magazine* (Jan. 17, 1982): 24.

123. LL to Tannhauser, [early 1956], GC.

124. Menotti to LL, Jan. 31, 1957, GC.

125. LL to Goldberg, July 14, 1957, GC.

126. Moses to LL, June 7, 1957; LL to Moses, June 13, 1957, BC.

127. LL to CH, July 15, 1957, CU/2; LL to BW, May 5, 1958, GC; Bumbry.

128. LL to Sproule, May 8, 1958 (1st quote); LL to Barrows, April 18 (2nd quote), April 27, June 12, 1959, Jan. 26, 1961; LL to FH, April 21, 27, 1960; FH to Bumbry, Oct. 22, 1960 (3rd quote), GC.

129. LL to Barrows, May 29, Nov. 30, 1961; LL to FH, April 22, 30, May 26, 1962, GC; LL to CH, Sept. 24, 1961 (quote), Feb. 11, 1962, CU/3; LL, "Schüler," n.d., CW.

130. LL to Bumbry, Sept. 24, 1961, CU/3; Bumbry to CH, Feb. 8, 1964, CU/9.

131. Bumbry.

132. LL to Barrows, Jan. 26, 1961, GC.

133. LL to FH, April 20, 1962, Aug. 6, 1964 (quote), GC.

134. LL to March, Jan. 5, 1963, PA Bumbry.

135. LL to FH, July 28, 1964, June 1, 1967, GC; LL to CH, Sept. 3, 1964, CU/3 (quote).

136. See LL to FH, Aug. 1, 1964, GC.

137. Bumbry.

138. LL to FH, July 23, 1964, GC.

139. Bumbry to LL, Aug. 3, 1965, GC.

140. See Bumbry's admission, *NYT*, Jan. 2, 1977.

141. LL to Bumbry, Dec. 28, 1965, GC.

142. LL's quote in Schornstein.

143. Bumbry to LL, July 12, 1966; LL to FH, July 19, 1966, GC.

144. Bumbry to LL, Aug. 2, 30, Nov. 24, [1968], GC; LL to Erika Mann, Sept. 7, 1968, EMA, 914/78.

145. *NYT*, June 13, 1970.

146. LL to FH, June 15 (1st two quotes), 24 (last quote), 1970, GC.

147. Bumbry to LL, Jan. 13 (1st quote), March 16, 1972 (2nd quote), GC.

148. *NYT*, Sept. 21, 1973.

149. Bumbry to LL, Nov. 16, 1973, GC.

150. LL to FH, May 31, Nov. 15, 1962 (quote); LL to CH, Sept. 19, 1964, CU/3.

151. LL to Goldberg, Nov. 16, 1964; LL to Barrows, Aug. 5, 1965, GC.

152. LL, *My Many Lives* (New York, 1948), 174–75.

153. Bumbry; author's telephone conversation with Grace Bumbry, Oakville/Salzburg, Jan. 10, 2005.

154. LL to FH, July 28 (quotes), 30, Aug. 1, 1966, GC.

155. *NYT*, July 28, 1966 (1st quotes); Bumbry to LL, March 21, 1966, GC (last quote).

156. LL to CH, Sept. 6, 1966, CU/3.

157. Bumbry to LL, April 3, 1968, GC (1st quote); *NYT*, Jan. 14, 1969 (2nd quote).

158. Bumbry.

159. LL to FH, July 20, 1964, GC (1st quote); Bumbry (2nd quote). Fischer-Dieskau's remembrance per Jens Malte Fischer to author, Nov. 6, 2006.

160. LL to FH, May 2, 1973, GC (quote); Bumbry.

161. LL to FH, July 27, 28 (quote), GC.

162. Bumbry.

163. LL to FH, July 27, 1964 (1st quote); LL to MH, Nov. 5, 1965 (2nd quote), GC.

164. Franz Giesebrecht, ed., *Die Behandlung der Eingeborenen in den deutschen Kolonien: Sammelwerk* (Berlin, 1898), 40–42, 44–46, 54, 92–93, 103, 107, 160–61; Heinrich Leutz, *Die Kolonien Deutschlands: Ihre Erwerbung, Bevölkerung, Bodenbeschaffung und Erzeugnisse* (Karlsruhe, 1900), 44–45, 55, 57, 59, 65; Hans Meyer, ed., *Das Deutsche Kolonialreich: Eine Länderkunde der deutschen Schutzgebiete*, vol. 1 (Leipzig, 1909), 466–67; Julius Tischendorf, *Die aussereuropäischen Erdteile: Ein methodischer Beitrag zum erziehenden Unterricht* (Leipzig, 1914), 352; Michael Schubert, *Der Schwarze Fremde: Das Bild des Schwarzamerikaners in der parlamentarischen und publizistischen Kolonialdiskussion in Deutschland von den 1870er bis in die 1930er Jahre* (Stuttgart, 2003), 29, 71, 73–74, 93, 240–43, 304–6; Marieluise Christadler, "Zwischen Gartenlaube und Genozid: Kolonialistische Jugendbücher im Kaiserreich," *Aus Politik und Zeitgeschichte*, B21/77 (May 28, 1977): 18, 22; Helmut Fritz, "Der essbare Neger: Afrika in Büchern, Liedern und Alltagsmythen," in Dieter Brauer et al., *Afrika den Afrikanern: Vorkoloniales Erbe und nachkoloniale Entwicklung* (Frankfurt am Main, 1980), 181.

165. Adjaï Paulin Oloukpona-Yinnon, *Unter deutschen Palmen: Die "Musterkolonie" Togo im Spiegel deutscher Kolonialliteratur (1884–1944)* (Frankfurt am Main, 1998), 306–11.

166. Meyer, 466; Schubert, 117; Giesebrecht, 28, 64–65, 102–3, 106, 126, 142–43; Fritz, 174–76; Walter Sperling, "Zur Darstellung der deutschen Kolonien im Erdkundeunterricht (1890–1914) mit besonderer Berücksichtigung der Lehrmittel," *Internationale Schulbuchforschung*, 11 (1989): 387.

167. Carl Hagenbeck, *Von Tieren und Menschen* (Berlin, 1908), 93–99; Hilke Thode-Arora, *Für fünfzig Pfennig um die Welt: Die Hagenbeckschen Völkerschauen* (Frankfurt am Main, 1989), 173, 178; Stefan Arnold and Roland Richter in Robert Debusmann and János Riesz, eds., *Kolonialausstellungen, Begegnungen mit Afrika*

(Frankfurt am Main, 1995), 1–18, 28–36; Volker Mergenthaler, *Völkerschau –
Kannibalismus – Fremdenlegion* (Tübingen, 2005), 39–43.

168. Sperling, 387–410.

169. LL, "Growing Up," n.d., CW (quote); LL, *Anfang und Aufstieg: Lebenserinnerungen* (Vienna, 1937), 26.

170. Edith Oppens, *Hamburg zu Kaisers Zeiten* (Hamburg, 1976), 37–38.

171. LL, *Anfang*, 180 (quotes); LL, "Zum erstenmal: Amerika," newspaper fragment, [Vienna, 1930], GC.

172. LL to Ruoff, Dec. 21, 1930, ATW/11; LL to MH, Oct. 18, Nov. 30, 1931, [Jan. 1932]; Schlusnus to LL, Dec. 2, 1930, GC.

173. LL, *Anfang*, 215–16.

174. LL in the newspaper *Austria*, Jan. 1934, ATW/16.

175. LL to MH, [Jan. 2, 1943], GC.

176. FL to LL, Aug. 23, 1947, GC.

177. FL to LL, Aug. 23, Dec. 11, 1943, May 3, 8, 13, June 21, Aug. 7, 17, Oct. 2, 1944, May 23/28, Aug. 25, 26, Nov. 10, 1945, Aug. 7, 1946, GC.

178. LL to Marboe, Oct. 14, 1954, GC; LL to Marboe, March 25, 1955; Marboe to LL, Oct. 20, 1954, BC; *NYT*, Feb. 6, 1955.

179. LL, "Wieder-Eröffnung der Wiener Oper 1955," n.d., CW; Elisabeth Schwarzkopf, *On and Off the Record: A Memoir of Walter Legge* (New York, 1982), 130; Vincent Sheean, *First and Last Love* (Westport, CT, 1979), 202–7; Alexander Witeschnik, *Wiener Opernkunst: Von den Anfängen bis zu Karajan* (Vienna, 1959), 263–64; *Die Presse* (Vienna), Oct. 28, 1955.

180. LL to Tannhauser, [1955]; LL to FH, Oct. 30, Nov. 1, 1955 (quote), GC; LL to Stodolowsky, Nov. 4, 1955, PA Hertha Schuch.

181. Wersbach to Bundestheaterverwaltung, June 23, 1947, LLFA.

182. Tony Judt, *Postwar: A History of Europe since 1945* (New York, 2005), 813.

183. Weninger to LL, Oct. 19, 1954; Marboe to LL, April 4, 1955, LLFA; *NYT*, Oct. 16, 1954; *Neues Oesterreich*, Jan. 22, 1955.

184. LL to Burgau, July 31, 1956, GC.

185. Latzka to LL, Oct. 20, 1956; Marboe to LL, Jan. 3, Feb. 6, 1957, LLFA.

186. Drimmel to LL, Feb. 22, 1957, GC; LL to CH, Dec. 13, 1957, CU/2.

187. LL to Schornstein, Dec. 31, 1974, GC.

188. LL to FH, June 17, 1967, May 29, 1968, GC.

189. *Arbeiterzeitung*, Sept. 4, 8, 1951; *Die Presse*, Oct. 6, 1977.

190. *Neueste Illustrierte Wochenschau*, Nov. 6, 1955; *Wiener Samstag*, Nov. 19, 1955; Marcel Prawy, *Marcel Prawy erzählt aus seinem Leben* (Vienna, 1996), 56.

191. *Neues Wiener Journal*, April 8, 1928; LL to MH, Oct. 3, 1958, GC.

192. Bundestheaterverwaltung memo, May 23, 1962, LLFA; LL to Bing, Feb. 28, 1962, MOA; Jonas to LL, May 6, 1963; LL to Barrows, June 21, 1964, GC.

193. LL to Lee, June 18, 1964; LL to Barrows, June 21, 1964; LL to MH, Sept. 8, 1964, Jan. 9, March 13, 1965, GC; Christine Moleta, *To Music* (Claremont, 1989), 120–25.

194. LL to FH, June 14, 1967, GC.

195. LL to FH, Oct. 19, 23, 24, 1955, GC; LL, "Wieder-Eröffnung der Wiener Oper 1955," n.d., CW.

196. LL to MH, Nov. 12, 1956; LL to FH, [Oct. 13], 14 (1st quote), 17; LL to Goldberg, [winter 1956] (2nd quote), GC; Hickling.

197. Ivor Newton, *At the Piano – The World of an Accompanist* (London, 1966), 179–82 (quote); Sir Neville Cardus, *The Delights of Music: A Critic's Choice* (London,

1966), 121–24; *Times* (London), Sept. 24, 1957; *Sunday Times* (London), Nov. 3, 1957.

198. FH to CH, Nov. 12, 1957, CU/9.

199. LL to MH, June 29, 1959; Bumbry.

200. Hickling.

201. LL to MH, May 4, 1965; LL to FH, May 25, 1965; LL to Koldofsky, May 29, 1965, GC.

202. LL to Hoppe, April 28, 1969, HMP/Lehmann; LL to Barrows, May 5, 1969, GC; LL to Wolfgang zu Putlitz, April 27, May 16, June 17, 1969, PA Barsewisch; Barsewisch.

203. LL to FH, July 3, 7, 1967; LL to MH, Aug. 2, 1971, GC.

204. Bing to LL, Dec. 17, 1956; LL to Bing, Dec. 26, 1956; Met press release, June 11, 1957; Gutman to LL, Jan. 11, 1958; Hook to LL, Jan. 15, 1958, BC; Crawford, 28; Bumbry.

205. *NYT*, March 23, 1958.

206. CH to Bing, Nov. 15, 1961; Bing to CH, Nov. 21, 30, 1961; Wilford to Bing, Nov. 29, 1961, MOA.

207. Max Loppert, "Crespin, Régine," *Grove* (quote).

208. CH to LL, Dec. 6, 1961, Feb. 7, 1962, CU/9; LL to CH, Dec. 14, 1961, Jan. 27, Feb. 7, 11 (quote), 1962; CH to LL, Feb. 6, 1962, CU/3; LL to Bing, Dec. 14, 1961; Bing to LL, Feb. 22, 1962; LL to Gutman, Feb. 25, 1962, MOA.

209. Alex Natan, *Primadonna: Lob der Stimmen* (Stuttgart, 1962), 26.

210. LL/Bing contract, March 16, 1962; LL to Bing, Aug. 17, 1962; Gutman to LL, Aug. 24, 1962; LL to Gutman, Sept. 14, 1962, MOA; LL to MH, Aug. 18, Sept. 9, 1962, GC; Paul Jackson, *Saturday Afternoons at the Old Met: The Metropolitan Opera Broadcasts, 1931–1950* (Portland, OR, 1992), 307–9; LL, *Singing with Richard Strauss* (London, 1964), 199–203; Régine Crespin, *On Stage, Off Stage: A Memoir* (Boston, 1997), 73–78.

211. LL to Goldberg, Dec. 9, 1962, GC; LL to Gutman, April 23, 1963, MOA; *NYT*, Nov. 10, 25, 1962.

212. The spitting was witnessed by Herman Schornstein (letter to author, May 28, 2003). See LL to Goldberg, March 2, 1963, GC (*Ariadne* quote); minutes of Gutman interview, [1962], MOA (paintings quote); LL to FH, June 4, 1969, GC (last quote); LL, *Singing*, 203; Jackson, 322.

213. *Chicago Tribune*, April 11, 17, 1966; *Saturday Review* (April 30, 1966): 48, and (May 14, 1966): 55; Kolodin, 745; Jackson, 539.

214. Bing to LL, April 20, May 4, 1966; LL to Barrows, May 10, 1972, GC. See note 185 in Chapter 3.

215. See LL, "Rudolf Bing," n.d., CW; Shirlee Emmons, *Tristanissimo: The Authorized Biography of Heroic Tenor Lauritz Melchior* (New York, 1990), 292.

216. LL to BW, [spring 1951], March 8, July 17, 1951; BW to LL, March 17, 1951, GC.

217. LL to BW, Dec. 29, 1955, Jan. 1, 14, March 23, Dec. 27, 1956; BW to LL, March 18, 1956, GC; BW to Marboe, Jan. 13, 1956, LLFA (quote).

218. LL to BW, June 14, 21, Aug. 7, 24, Nov. 19 (quote), 1961, Jan. 5, 1962; BW to LL, June 19, 1961, GC; BW to LL, Sept. 2, 1961, Jan. 3, 1962 (facs. in Berndt W. Wessling, *Lotte Lehmann: "Sie sang, dass es Sterne rührte": Eine Biographie* [Cologne, 1995], 16–17, 114–15).

219. *Opera News* (March 24, 1962): 14.

220. Klemperer to LL, Feb. 27, 1958, Dec. 30, 1960, April 8, May 16, 1961; LL to FH, April 20, 1964, GC; Holden.

221. Klemperer to LL, Oct. 17, 1961, Oct. 4, 1970, Dec. 13, 1971, Feb. 10, 1972, GC.
222. LL to FH, July 19, 1972, GC.
223. LL to Klemperer, Feb. 23, 1973; LL to FH, July 1, 1973 (quote), GC.
224. LL to CH, April 7, 1952, CU/2 (quote); LL to Kleinchen Melchior, Aug. 2, 1952, GC; *NYT*, March 20, 1973.
225. LL quoted in Emmons, 297.
226. LL to FH, March 31, May 29, 1964, GC.
227. LL to CH, Sept. 19, 1964, CU/3.
228. Emmons, 318 (quote); LL to FH, June 19, 1967, June 6, 1968, GC.
229. Melchior to Cochran, July 13, 1967, Jan. 30, 1968, MAWA.
230. Melchior to Cochran, March 8, 1968, MAWA.
231. LL quoted in Emmons, 324; LL to FH, June 29, 1973, GC.
232. Irmela von der Lühe, *Erika Mann: Eine Biographie* (Frankfurt am Main, 1996), 338–52; Erika Mann to LL, Jan. 13, 1965; LL to FH, May 15, 1967, GC; Erika Mann to LL, May 3, 1966, EMA, 722/96.
233. Erika Mann to LL, Feb. 16, March 20, May 7, 1968; LL to FH, June 7, 1969 (1st quote); Katia Mann to LL, June 5, Oct. 20 (2nd quote), 1969; Naef to LL, Sept. 1, 1969, GC; Lühe, 366.
234. LL to Wolfgang zu Putzlitz, June 1, 1966, PA Barsewisch.
235. LL to FH, July 4, 1973, GC (1st quote); LL to Barsewisch, Aug. 19, 29, Oct. 13, 1972, July 30, 1973 (2nd quote); LL to Schulenburg, March 9, 1973, April 27, 1974; Barsewisch to LL, Aug. 22, 1972, PA Barsewisch; Barsewisch.
236. Berndt W. Wessling, *Lotte Lehmann: Mehr als eine Sängerin* (Salzburg, 1969), 7, 12, 15; LL/Wessling correspondence (1968), GC; LL to Erika Mann, Sept. 7, 1968, EMA, 914/78; LL in Gaussmann interview, Salzburg, Aug. 1969, soundtrack LLFA.
237. LL to Wessling, Dec. 13, 21, 1968, Jan. 3., 1969, GC; LL to CH, Sept. 7, 1968, CU/3 (quote); LL to Erika Mann, Sept. 7, 1968, EMA, 914/78; Erika Mann to LL, Sept. 16, 1968, EMA, 722/96; LL, "Twelve Singers and a Conductor," in Charles Osborne, ed., *Opera 66* (London, 1966), 89 (quote); Frida Leider, *Das war mein Teil: Erinnerungen einer Opernsängerin* (Berlin, 1959), 80, 90, 93–94, 153, 160–61.
238. See note 434 in Chapter 3; Erika Mann to LL, April 12, May 20, June 9, 1968; LL to FH, June 24, 1968; CH to LL, Sept. 30, Dec. 2, 1968, GC; LL to CH, Sept. 27, 1968; CH to LL, Dec. 13, 20, 1968, CU/3; Wessling, *Sängerin*, 131–34.
239. Grace Bumbry to author, July 28, 2004; LL to FH, June 17, 1968, GC.
240. LL to Wessling, Dec. 10, 1968, GC. Bumbry is mentioned in two sentences, but without a contribution (Wessling, *Sängerin*, 178).
241. Franz Strauss to Wessling, Sept. 21, 1968, GC.
242. LL to Wessling, Jan. 9, 1969, GC.
243. LL to Lotte Walter, [March 21, 1969], GC.
244. LL to Wessling, Dec. 21 (quote), 1968, Jan. 3, 9, 1969, GC.
245. LL to MH, Nov. 26, 1968; LL to Bumbry, Dec. 1, 1969, GC; LL to CH, Dec. 6, 1968, CU/3; Schaffler to LL, Jan. 13, 1969, BC.
246. LL to Lachmann, May 3, 1969, ATW/TNLL.
247. LL to Schaffler, Aug. 5, 1969, Jan. 15, 1970; LL to Buchmann, Aug. 30, 1969, BC.
248. They are in CW.
249. LL to CH, April 22, May 6, 1951, CU/2; Horch to LL, Sept. 14, 1951, BC.
250. Leiper to LL, Jan. 3, 1952, BC (quote); LL to CH, April 7, 1952, CU/2.
251. LL, *Singing* (New York, 1964); LL to Goldberg, Dec. 9, 1962, GC (quote); *NYT*, Oct. 11, 25, 1964.

252. *NYT*, May 23, 1952. The book was Frank Walker, *Hugo Wolf: A Biography* (New York, 1952).
253. LL to Barrows, June 21, 1964; LL to FH, July 4, 1964, GC; Markel to Lantz, Oct. 28, 1964, BC (quote).
254. Lachmann to LL, May 19, 1966, ATW/TNLL (quotes); LL to Schaffler, Sept. 25, 1969; LL to Schafleitner, Nov. 24, 1969, BC; LL to MH, Nov. 7, 1969, GC; LL, *Gedichte*, © LL, printed by Rudolf Reischl OHG (Salzburg, 1969).
255. LL, *Eighteen Song Cycles: Studies in Their Interpretation* (London, 1971); *Sunday Times* (London), Oct. 17, 1971 (1st quote); LL to Murphy, March 30, 1972, BC (2nd quote).
256. LL to FH, May 19, June 5, 1968, Erika Mann to LL, May 7, June 9, 1968, GC; Rowohlt Verlag to Lachmann, March 16, 1972; Engelhornverlag to Lachmann, April 20, 1972, ATW/TNLL.
257. LL to MH, Oct. 12, 1970, GC.
258. Seymour to LL, March 14, 1951; Hoover to LL, April 29, 1951, BC.
259. LL to CH, May 6, 1951, CU/2; Horch to LL, Sept. 14, 1951, BC.
260. LL to CH, April 7, 1952, CU/2; LL to Goldberg, Oct. 2, 1952, BC.
261. LL to Waage, June 5, 1953, GC (quote); LL to MH, May 6, 1954, GC.
262. LL to CH, March 1, 1954, CU/2; LL to Berend, Feb. 29, 1960, AKB/CCA (quote).
263. LL to Schornstein, Sept. 22, Oct. 1, 12, 1964; LL to FH, June 2, 1967, GC.
264. Holden (1st quote); LL, arts exhibits list, Dec. 5, 1967, PC; LL to Schornstein, Dec. 7, 1967 (2nd quote); LL to MH, Dec. 8, 1967, Jan. 25, 1968, GC.
265. Holden.
266. Ibid.
267. FL to LL, March 1, 1951, GC.
268. FL to LL, June 25, 1951, GC.
269. FL to LL, July 4, 1951; LL to Waage, June 5, 1953, GC; *NYT*, April 26, 1963.
270. LL to BW, Aug. 13, 1954; LL to Balogh, Oct. 2, 1954; LL to MH, April 29, 1955, Jan. 2, 1956, GC.
271. See LL to FH, May 2, 1962, GC.
272. LL to FH, Oct. 18, 1956, GC.
273. LL to FH, April 28, 1962, GC.
274. LL to FH, June 15, 1962, GC.
275. *NYT*, April 29, 1964; LL, "Mein Bruder," n.d., CW.
276. LL to FH, Feb. 1, 1967; LL to MH, [Sept. 28, 1972], GC.
277. FL to LL, March 1, 1951, GC.
278. LL to Waage, June 5, 1953; LL to FH, Oct. 17, 1955; LL to McGiffin, June 14, 1958; LL to Barrows, Sept. 13, 1961, GC.
279. LL to FH, May 29, 1968; LL to MH, Nov. 16, 1968, GC.
280. LL to FH, Oct. 22, 29, 1955, April 7, 1964, June 2, 1968, July 13, 1971; FH to LL, March 24, 1964, March 30, 1967, GC.
281. LL to FH, March 29, 1964, GC.
282. LL to Barrows, Sept. 13, 1961; LL to MH, Oct. 17, 1969, GC.
283. LL to MH, Sept. 29, 1966, GC.
284. LL, "Frances," n.d., CW.
285. LL to FH, July 8, 1965, Aug. 9, 15, 1966, July 2, 1972, GC; Schuch to FH, Sept. 16, 1976, PA Schuch.
286. FH to MH, Feb. 3, 1961, GC.
287. FH to Barrows, July 16, 1962, GC.
288. FH to Schornstein, [1968], GC.
289. FH to Schornstein, Jan. 21, 1972, GC.

290. LL to Mont, Feb. 24, 1955 (1st quote); LL to FH, Oct. 1, 1955; FH to CH, Nov. 12, 1957; FH to LL, April 21, 1958 (2nd quote); LL to McGiffin, July 12, 1958, GC.

291. LL to FH, April 8, 1964 (1st quote), April 28, May 10, 21 (2nd quote), 1965, GC.

292. Holden.

293. *The Apparitional Lesbian: Female Homosexuality and Modern Culture* (New York, 1993), 202 (quote), 207.

294. Elizabeth Wood, "Sapphonics," in Philip Brett et al., eds., *Queering the Pitch: The New Gay and Lesbian Musicology* (New York, 1994), 27–66.

295. On Leonore/Fidelio as a transsexual figure, see Wendy Bashant, "Singing in Greek Drag: Gluck, Berlioz, George Eliot," in Corinne E. Blackmer and Patricia Juliana Smith, eds., *En Travesti: Women, Gender Subversion, Opera* (New York, 1995), 217.

296. LL to FH, June 6, 1974, CG.

297. LL to Waage, June 5, 1963; LL to MH, Feb. 28, 1954; LL to Barrows, June 21, 1964, GC.

298. LL to FH, July 4, 1964, April 28, July 8, 1965, Feb. 1, 26, 1967, June 1, 1969, GC.

299. LL to MH, March 27, 1966, Feb. 17, 1970, Aug. 12, 1975; LL to FH, July 13, 1969, May 2, 1973; FH to Hammergren, Oct. 17, 1970, GC.

300. LL to FH, June 24, July 8, 1969, GC.

301. LL to FH, May 29, 31, 1970, June 15, 1972, GC; LL to Schulenburg, July 19, 1974, PA Barsewisch.

302. FH to Schornstein, [1968], April 9, 1970, GC.

303. LL to Schornstein, May 31, 1970, GC.

304. Holden.

305. Barsewisch to FH, Aug. 27, 1976, PA Barsewisch.

306. LL to Schuch, Aug. 17, 1976 (quote); Schuch to FH, Aug. 25, 1976; FH to Schuch, Oct. 1, 1976, PA Schuch.

307. FH to Schornstein, Aug. 21, 1976, GC.

308. Holden; *NYT*, Aug. 28, 1976.

309. *Kurier*, Feb. 24, 1977.

310. Holden; LL, Post-Testament, Santa Barbara County, Final Executor's Order, Aug. 7, 1978, MAWA; "To my brother Fritz Lehmann," n.d., GC (quote).

Epilogue

1. FH to LL, April 21, 1958; FH to Hammergren, Oct. 17, 1970, GC.

2. On LL, see Marilyn Horne, *The Song Continues* (Fort Worth, 2004), 106; Rudolf Bing, *5000 Nights at the Opera* (Garden City, 1972), 354–55.

3. Christa Ludwig, *Und ich wäre so gern Primadonna gewesen: Erinnerungen* (Berlin, 1994), 108.

4. FH to Hammergren, Oct. 17, 1970, GC.

5. *NYT*, Nov. 4, 1962.

6. Muzzarelli to LL, April 23, 1946, GC.

7. FL to LL, June 7, 1945, GC; Barsewisch.

8. Author's interview with Santa Barbara surgeon George Wittenstein, who witnessed this, Santa Barbara, May 4, 2003; Hickling.

9. LL, *Anfang und Aufstieg: Lebenserinnerungen* (Vienna, 1937), 124.

10. FL to LL, May 23/28, 1945, May 12, 1946, GC. Also LL, "Growing Up," n.d., CW.

11. LL to FL, Nov. 28, 1910, GC.
12. See KL to FL, Nov. 15, 1910, GC.
13. LL to EP, Dec. 2, 1912, GC.
14. LL quoted by Alden, newspaper notice, [Feb. 1934], NC.
15. Hans Rudolf Vaget, *Seelenzauber: Thomas Mann und die Musik* (Frankfurt am Main, 2006), 47.
16. LL to Waage, March 27, 1943, GC.
17. LL to Arthur Holden, Jan. 2, 1948, GC.
18. LL to Barrows, Jan. 26, 1961, GC.
19. LL quoted in John Harvith and Susan Harvith, eds., *Edison, Musicians, and the Phonograph: A Century in Retrospect* (New York, 1987), 75; Holden (2nd quote).
20. LL to FH, Oct. 24, 1955, GC.
21. LL to EP, April 8, 1914, GC.
22. See Francis R. Nicosia and Jonathan Huener, eds., *The Arts in Nazi Germany: Continuity, Conformity, Change* (New York, 2006).
23. Eric Ryding and Rebecca Pechefsky, *Bruno Walter: A World Elsewhere* (New Haven, 2001), 187, 309, 320.
24. Notice, "Singer...," *Pittsburgh Sun Telegraph*, [Nov. 1932], NC (1st quote); LL to FL, Aug. 30, 1944, GC (2nd quote); text at note 305 in Chapter 5.
25. *SBNP*, June 6, 1948; Sharon Crawford, *Music Academy of the West, Santa Barbara: Fifty Years, 1947–1997* (Santa Barbara, 1997), 11; Carol J. Oja, *Making Music Modern: New York in the 1920s* (New York, 2000), 62, 234.
26. *NYT*, Nov. 1, 1957; Oja, 199, 264, 377.
27. LL to MH, Jan. 13, 1962, GC; LL, "Twelve Singers and a Conductor," in Charles Osborne, ed., *Opera 66* (London, 1966), 80; LL, *Singing with Richard Strauss* (London, 1964), 155; Gary Hickling's telephone interview with LL, 1973, soundtrack LLFA.
28. Oja, 65, 179, 192–93, 295–96, 361. Also see Alex Ross, *The Rest Is Noise: Listening to the Twentieth Century* (New York, 2007), 33–212. For the converse, see Adelheid von Saldern, "Selbstbild im Spiegel: Amerikanische Identität im Verhältnis zu Europa," in Angelika Linke and Jakob Tanner, eds., *Attraktion und Abwehr: Die Amerikanisierung der Alltagskultur in Europa* (Cologne, 2006), 124–29.
29. LL interviewed by Jim Beveridge, Sept. 27, 1963, in *The Lotte Lehmann Master Classes*, vol. 2, VAI DVD 4327 (2005); LL to Goldberg, Oct. 13, 1954; LL to Schornstein, Feb. 23, 1974, GC.
30. Holden quoted in Rita Nasser, "The Voice from the Heart" (1992), MAWA.
31. Erika Mann to LL, Feb. 16, 1968, EMA, 722/96.
32. See Chapter 6 at note 296.
33. LL to Else Walter, Feb. 22, 1937, GC.
34. Holden.
35. LL to Goldberg, Oct. 2, 1952, GC.
36. *Mary Garden's Story* (New York, 1951). See LL to CH, April 7, 1952, CU/2.
37. LL to Barrows, Sept. 23, 1955, GC.
38. LL to Goldberg, Aug. 29, 1964, GC.
39. LL to Barrows, Nov. 26, 1957, GC.
40. *Sun* (Sydney), March 21, 1939.
41. LL to CH, Aug. 26, 1938, Feb. 19, May 6, 1939, CU/1; LL to FH, May 10, 1965, GC; Beaumont Glass, *Lotte Lehmann: A Life in Opera and Song* (Santa Barbara, 1988), 196.

Index